Contents

D0124764

Critics

Context

NINE *Identity and Technology* *418*

Artists

Critics

Context

Preface

Artists, Critics, Context is an anthology of readings on American art and culture that begins in the 1940s with Abstract Expressionism and the Cold War and ends in the 1990s with the ubiquity of video installations and the broad cultural changes arising from technological developments in telecommunications and biotechnology. Each chapter is divided into the three categories designated in the book's title: artists, critics, and context. This tripartite approach aims to connect the words of artists—from both their writings as well as the interviews they granted—with concurrent critical writings, exhibition reviews, and museum catalog essays. Readings from outside the visual arts have been added to connect the issues and impulses raised by the work of these artists to trends and ideas that were gaining prominence within the broader culture at the time that the art was being created. My goal was to place artistic development firmly within the context of the major political, cultural, and sociological trends and ideas that have emerged in the United States since World War II.

Rather than being an exhaustive survey of post–World War II readings about art, this collection is designated to give a clear, concise, and historically rooted sense of some of the key developments in American avant-garde art. In order to achieve this goal, I was forced to make some tough decisions and leave out many compelling voices. The voices that are heard in this anthology are unedited, however. I have made every effort to maintain the integrity of the original writings and not pare them down to their essence— which seems to be the trend in recent anthologies. Only in rare instances when the length or the format of a given piece was too cumbersome to include did I select a representational sample of the reading.

Current approaches to the study of contemporary art frequently place a tremendous amount of emphasis on criticism and theory. Although valuable, these methods tend to function outside historical analysis and, as such, can overshadow the specific historical connections between artists, art critics, galleries, and museums. Increasingly during the years following World War II, artists attempted to engage with political or social issues that

transcended the particulars of art making, yet paradoxically, many of the writings and teachings about this art have tended to treat it as an activity separate from the society as a whole.

The readings and interviews in the Artists section are generally from the time period during which the artist was first acknowledged as a strong force in the art world. In a few instances I have used articles that are a bit later in the artist's career, primarily because of the quality of the writing or interview and its lack of representation in other books of this kind. These readings have been chosen because they give a clear insight into the major issues—both cultural and formal—that the artist's work raises. In addition to providing a glimpse into the creative process, the Artists section lays the groundwork for the formation of a critical dialog between the artists' writings and the criticism that was written about the art that they created. In certain instances artists such as Donald Judd and Allan Kaprow also wrote criticism. Such writings, even if they arguably function in the realm of criticism, have been placed in the Artists section.

As with the readings in the Artists section, those in the Critics section are concurrent with the emergence of the artist or artistic trend into the cultural dialog. The readings in this section were selected based on how influential they were at the time in legitimizing the artist's work. In this section particular attention has been paid to writings for and about groundbreaking gallery and museum exhibitions, with emphasis placed decidedly on the latter. Because the history of exhibitions is an increasingly important factor in the understanding of the art that has come to represent the second half of the twentieth century, many of the readings in this section are by individuals who function more as curators than as critics in the strict sense of the word. Many of the essays in the Critics sections were initially published as part of exhibition catalogs; many of the others, although written by professional critics for art magazines and journals, were reviews of key exhibitions.

The articles in the Critics section were selected based on the dialogs that they create with the ideas presented in the Artists section. At times the reader will find real tension between what the artist says about his or her work and what is written by a curator in an exhibition essay or by a critic in one of the art magazines. This section will give the reader a clearer idea of how criticism creates a language through which emerging artistic trends are codified.

The overarching goal of the Context section was to situate artistic practice within a broad cultural framework by presenting the reader with writings from a wide variety of disciplines outside the fine arts. This section changes from chapter to chapter, depending on the issues posed by that particular set of creative practices and on how these issues converged with influential cultural ideas. For instance, to understand Pop art, it helps to be generally familiar with the developments in media theory from the 1960s. So Chapter Three includes Marshall McLuhan's groundbreaking essay "Television: The

Timid Giant" from *Understanding Media*. Also included in this section is Norman Mailer's "Perspective from the Biltmore Balcony," which is part of his article "Superman Comes to the Supermarket." This eyewitness account of the Democratic convention held in Los Angeles in 1960 contains a superb description of how the little-known John F. Kennedy was able to harness the power of image in securing the Democratic nomination for president.

The widely divergent methodologies that have set the tone for the artistic dialog of the past fifty years tend to overshadow the level to which art reflects larger societal tensions and aspirations. This book attempts to position artistic practice within a broad historical context. Although individual chapters may be characterized by broad themes, the open-ended nature of the anthology format (in which many voices speak in turn) does not allow the dialog to be pigeonholed into a neat search for what might be perceived as the zeitgeist of a particular period or decade. Rather, the individuals speak for themselves. At times the voices in a particular chapter seem to converge around a set of issues and at other times connections are either strained or nonexistent. The picture of American art of the past fifty years is complex and our distance from this material is short. *Artists, Critics, Context* attempts to give the reader access to the major questions that have been raised in avant-garde American artistic practice since 1945. My hope is that this book will help expand our sense of and give further context to the historical and cultural study of contemporary art.

ACKNOWLEDGMENTS

It is hard to imagine how I would have completed *Artists, Critics, Context* without the inexhaustible energy, insight, and thoughtful criticism of my wife, Alison Hagge. Her selfless dedication to helping me make this book the best it could be is evident on every page.

Artists, Critics, Context grew out of a course I teach on contemporary art at St. John's University. I would like to thank all the students who have taken this course for contributing in a substantial way to this book. The intensity and range of the discussions that took place during those late afternoons in St. John's Hall were in many ways the motivation for this project.

I would like to formally thank St. John's University for giving me both a Research Grant in the summer of 2000 and a Research Reduction during the 2000–2001 academic year. Certainly the generosity and support of St. John's contributed substantially to this project.

I would also like to thank Bud Therien, Wendy Yurash, and Linda B. Pawelchak at Prentice Hall for believing in this project and for helping it come to fruition.

Other individuals and organizations I would like to thank are Michele Kiela and Jay Venute for helping me compile the initial material and also

the staff at both the St. John's University Library and the New York Public Library.

The following reviewers made helpful suggestions for the text: Frances Colpitt, University of Texas at San Antonio; Jeffrey A. Hughes, Webster University; Diane Kirkpatrick, University of Michigan; Elaine O'Brien, California State University–Sacramento; Howard Smagula, Kean University; and Lisa Stokes, Seminole Community College.

In closing I would like to thank all of those individuals and institutions that granted permission to reprint the articles and images in this volume.

Paul F. Fabozzi

The American Avant-Garde

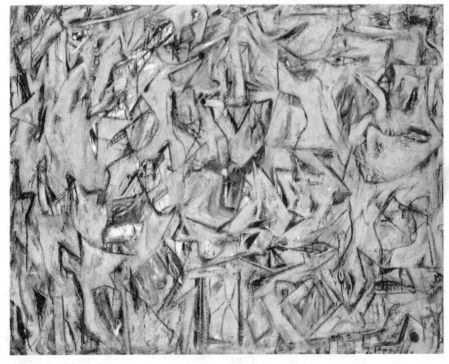

Willem de Kooning (American, b. The Netherlands, 1904–1997), *Excavation*. 1950. Oil on canvas, 206.2 x 257.3 cm. Mr. and Mrs. Frank G. Logan Purchase Prize; gift of Mr. and Mrs. Noah Goldowsky and Edgar Kaufmann, Jr. 1952.1. Photograph © 2001, The Art Institute of Chicago. All Rights Reserved. © 2000 Willem de Kooning Revocable Trust/Artists Rights Society (ARS), New York.

Jackson Pollock
My Painting (1947–1948)

Jackson Pollock was part of a group of post–World War II American painters who pushed painting toward a purer level of abstraction than had been attempted by progressive European painters before him. By the time "My Painting" was published in the short-lived journal *Possibilities* in the winter of 1947–1948, Pollock was at the forefront of the first American avant-garde movement. Pollock is most well known for large-scale paintings such as *Number #1* from 1948 that engulfs the viewer in a dense thicket of swirling marks. In this statement Pollock gives a matter-of-fact account of his unorthodox methodology, which cuts to the heart of what separated him from previous generations of painters. Pollock describes a situation in which the finished image is the residue of a process; in his case this process was a direct and intuitive encounter between himself and his materials. His description of tacking the canvas to the floor, as a way of getting closer to the painting, underscores the idea later expressed by the critic Harold Rosenberg that "nothing should get in the way of the act of painting."

The fluid pouring of paint in a dance around the unstretched canvas on his studio floor was for Pollock a process whereby the painting and the individual become one. The notion of the act of painting as a process of self-discovery has parallels in the existentialist philosophy of Jean-Paul Sartre. Pollock's individualism as well as his desire to find a pure form of expression became keys to the critical dialogue that began to surround not only his work, but also the work of other artists of his generation. Sections of this statement were used in the now-famous article "Jackson Pollock, Is He the Greatest Living Painter in the United States?" which was published in *Life* magazine in 1949.

My painting does not come from the easel. I hardly ever stretch my canvas before painting. I prefer to tack the unstretched canvas to the hard wall or the floor. I need the resistance of a hard surface. On the floor I am more at ease. I feel nearer, more a part of the painting, since this way I can walk around it, work from the four sides and literally be *in* the painting. This is akin to the method of the Indian sand painters of the West.

I continue to get further away from the usual painter's tools such as easel, palette, brushes, etc. I prefer sticks, trowels, knives and dripping fluid paint or a heavy impasto with sand, broken glass and other foreign matter added.

When I am *in* my painting, I'm not aware of what I'm doing. It is only after a sort of "get acquainted" period that I see what I have been about. I have no fears about making changes, destroying the image, etc., because the painting has a life of its own. I try to let it come through. It is only when I lose contact with the painting that the result is a mess. Otherwise there is pure harmony, an easy give and take, and the painting comes out well.

Mark Rothko
The Romantics Were Prompted (1947–1948)

For Mark Rothko abstract painting had the potential to communicate universal emotions. Rothko is best known for utilizing subtly layered veils of color counterbalanced by diffused rectilinear forms in images that evoke a powerful sense of atmosphere and space. Positioning both the romantic and the archaic artist as well as examples of like-minded creators, Rothko states that for painting to be "a revelation" it must transcend the particulars of the familiar world. Rothko felt alienated from society; however, he believed this alienation gave him the freedom to articulate the transcendent. If viewed within the context of the Cold War, Rothko's cynicism about the place of the artist in society could be seen as a result of feeling suffocated by the stark political choices of the postwar world.

It is interesting to trace Rothko's political affiliations and consider the possible links between his life and his art. In the 1930s Rothko was heavily involved in leftist politics—through the Artists Union as well as the easel painting division of the Federal Art Project. As his paintings became more abstract into the 1940s, Rothko's connection to particular political causes became harder to define. This article was published in *Possibilities* in the winter of 1947–1948, the same year as his first solo show at the Betty Parsons Gallery, which signaled the beginning of his mature style.

The romantics were prompted to seek exotic subjects and to travel to far off places. They failed to realize that, though the transcendental must involve the strange and unfamiliar, not everything strange or unfamiliar is transcendental.

The unfriendliness of society to his activity is difficult for the artist to accept. Yet this very hostility can act as a lever for true liberation. Freed from a false sense of security and community, the artist can abandon his plastic bank-book, just as he has abandoned other forms of security. Both the sense of community and of security depend on the familiar. Free of them, transcendental experiences become possible.

I think of my pictures as dramas: the shapes in the pictures are the performers. They have been created from the need for a group of actors who are able to move dramatically without embarrassment and execute gestures without shame.

Neither the action nor the actors can be anticipated, or described in advance. They begin as an unknown adventure in an unknown space. It is at the moment of completion that in a flash of recognition, they are seen to have the quantity and function which was intended. Ideas and plans that existed in the mind at the start were simply the doorway through which one left the world in which they occur.

The great cubist pictures thus transcend and belie the implications of the cubist program.

The most important tool the artist fashions through constant practice is faith in his ability to produce miracles when they are needed. Pictures must be miraculous: the instant one is completed, the intimacy between the creation and the creator is ended. He is an outsider. The picture must be for him, as for anyone experiencing it later, a revelation, an unexpected and unprecedented resolution of an eternally familiar need.

On shapes:

They are unique elements in a unique situation.

They are organisms with volition and a passion for self-assertion.

They move with internal freedom, and without need to conform with or to violate what is probable in the familiar world.

They have no direct association with any particular visible experience, but in them one recognizes the principle and passion of organisms.

The presentation of this drama in the familiar world was never possible, unless everyday acts belonged to a ritual accepted as referring to a transcendent realm.

Even the archaic artist, who had an uncanny virtuosity, found it necessary to create a group of intermediaries, monsters, hybrids, gods and demigods. The difference is that, since the archaic artist was living in a more practical society than ours, the urgency for transcendent experience was understood, and given an official status. As a consequence the human figure and other elements from the familiar world could be combined with or participate as a whole in the enactment of the excesses which characterize this improbable hierarchy. With us the disguise must be complete. The familiar identity of things has to be pulverized in order to destroy the finite association with which our society increasingly enshrouds every aspect of our environment.

Without monsters and gods, art cannot enact our drama: art's most profound moments express this frustration. When they were abandoned as untenable superstitions, art sank into melancholy. It became fond of the dark, and enveloped its objects in the nostalgic intimations of a half-lit world. For me the great achievements of the centuries in which the artist accepted the probable and familiar as his subjects were the pictures of the single human figure—alone in a moment of utter immobility.

But the solitary figure could not raise its limbs in a single gesture that might indicate its concern with the fact of mortality and an insatiable appetite for ubiquitous experience in face of this fact. Nor could the solitude be overcome. It could gather on beaches and streets and in parks only through coincidence, and, with its companions, form a *tableau vivant* of human incommunicability.

I do not believe that there was ever a question of being abstract or representational. It is really a matter of ending this silence and solitude, of breathing and stretching one's arms again.

Willem de Kooning
What Abstract Art Means to Me (1951)

Six artists were asked to respond to the statement "What abstract art means to me." Their responses were the basis for a symposium at the Museum of Modern Art, which was organized in conjunction with the exhibition *Abstract Painting and Sculpture in America*. All six statements were published in *The Museum of Modern Art Bulletin* in the spring of 1951. In his statement de Kooning gives a personal and somewhat critical account of developments in European abstract art. In particular de Kooning is uneasy about the tendency in European abstract painting to be preoccupied with an attempt to be useful. These earlier abstract artists looked for justification in politics and in, as de Kooning puts it, "strange forms of spiritualism." De Kooning reiterates Rothko's sentiment that art is free precisely because it is deemed to be useless to society. In one of the most telling parts of the statement, de Kooning rails against the notion implied in pre–World War II abstraction that painting should communicate purity and comfort. It is curious that what was useful and pure to the generation prior to World War II has, for de Kooning, become useless and agitating. In an irreverent statement that epitomizes de Kooning's conviction that individual necessity is the basis for painting, he says simply: "If I *do* paint abstract art, that's what abstract art means to me."

The first man who began to speak, whoever he was, must have intended it. For surely it is talking that has put "Art" into painting. Nothing is positive about art except that it is a word. Right from there to here all art became literary. We are not yet living in a world where everything is self-evident. It is very interesting to notice that a lot of people who want to take the talking out of painting, for instance, do nothing else but talk about it. That is no contradiction, however. The art in it is the forever mute part you can talk about forever.

For me, only one point comes into my field of vision. This narrow, bi-ased point gets very clear sometimes. I didn't invent it. It was already here. Everything that passes me I can see only a little of, but I am always looking. And I see an awful lot sometimes.

The word "abstract" comes from the light-tower of the philosophers, and it seems to be one of their spotlights that they have particularly focused on "Art." So the artist is always lighted up by it. As soon as it—I mean the "abstract"—comes into painting, it ceases to be what it is as it is written. It changes into a feeling which could be explained by some other words, prob-ably. But one day, some painter used "Abstraction" as a title for one of his paintings. It was a still life. And it was a very tricky title. And it wasn't really a very good one. From then on the idea of abstraction became something extra. Immediately it gave some people the idea that they could free art from itself. Until then, Art meant everything that was in it—not what you could take out of it. There was only one thing you could take out of it sometime when you were in the right mood—that abstract and indefinable sensation, the esthetic part—and still leave it where it was. For the painter to come to the "abstract" or the "nothing," he needed many things. Those things were always things in life—a horse, a flower, a milkmaid, the light in a room through a window made of diamond shapes maybe, tables, chairs, and so forth. The painter, it is true, was not always completely free. The things were not always of his own choice, but because of that he often got some new ideas. Some painters liked to paint things already chosen by others, and after being abstract about them, were called Classicists. Others wanted to select the things themselves and, after being abstract about them, were called Ro-manticists. Of course, they got mixed up with one another a lot too. Anyhow, at that time, they were not abstract about something which was already ab-stract. They freed the shapes, the light, the color, the space, by putting them into concrete things in a given situation. They *did* think about the possibility that the things—the horse, the chair, the man—were abstractions, but they let that go, because if they kept thinking about it, they would have been led to give up painting altogether, and would probably have ended up in the philosopher's tower. When they got those strange, deep ideas, they got rid of them by painting a particular smile on one of the faces in the picture they were working on.

The esthetics of painting were always in a state of development paral-lel to the development of painting itself. They influenced each other and vice versa. But all of a sudden, in that famous turn of the century, a few peo-ple thought they could take the bull by the horns and invent an esthetic beforehand. After immediately disagreeing with each other, they began to form all kinds of groups, each with the idea of freeing art, and each demand-ing that you should obey them. Most of these theories have finally dwindled away into politics or strange forms of spiritualism. The question, as they saw

it, was not so much what you *could* paint but rather what you could *not* paint. You could *not* paint a house or a tree or a mountain. It was then that subject matter came into existence as something you ought *not* to have.

In the old days, when artists were very much wanted, if they got to thinking about their usefulness in the world, it could only lead them to believe that painting was too worldly an occupation and some of them went to church instead or stood in front of it and begged. So what was considered too worldly from a spiritual point of view then, became later—for those who were inventing the new esthetics—a spiritual smokescreen and not worldly enough. These latter-day artists were bothered by their apparent uselessness. Nobody really seemed to pay any attention to them. And they did not trust that freedom of indifference. They knew that they were relatively freer than ever before *because* of that indifference, but in spite of all their talking about freeing art, they really didn't mean it that way. Freedom to them meant to be useful in society. And that is really a wonderful idea. To achieve that, they didn't need *things* like tables and chairs or a horse. They needed ideas instead, social ideas, to make their objects with, their constructions— the "pure plastic phenomena"—which were used to illustrate their convictions. Their point was that until they came along with their theories, Man's own form in space—his body—was a private prison; and that it was because of this imprisoning misery—because he was hungry and overworked and went to a horrid place called home late at night in the rain, and his bones ached and his head was heavy—because of this very consciousness of his own body, this sense of pathos, they suggest, he was overcome by the drama of a crucifixion in a painting or the lyricism of a group of people sitting quietly around a table drinking wine. In other words, these estheticians proposed that people had up to now understood painting in terms of their own private misery. Their own sentiment of form instead was one of comfort. The beauty of comfort. The great curve of a bridge was beautiful because people could go across the river in comfort. To compose with curves like that, and angles, and make works of art with them could only make people happy, they maintained, for the only association was one of comfort. That millions of people have died in war since then, because of that idea of comfort, is something else.

This pure form of comfort became the comfort of "pure form." The "nothing" part in a painting until then—the part that was not painted but that was there because of the things in the picture which were painted—had a lot of descriptive labels attached to it like "beauty," "lyric," "form," "profound," "space," "expression," "classic," "feeling," "epic," "romantic," "pure," "balance," etc. Anyhow that "nothing" which was always recognized as a particular something—and as something particular—they generalized, with their book-keeping minds, into circles and squares. They had the innocent idea that the "something" existed "in spite of" and not "because of" and that this

something was the only thing that truly mattered. They had hold of it, they thought, once and for all. But this idea made them go backward in spite of the fact that they wanted to go forward. That "something" which was not measurable, they lost by trying to make it measurable; and thus all the old words which, according to their ideas, ought to be done away with got into art again: pure, supreme, balance, sensitivity, etc.

Kandinsky understood "Form" as *a* form, like an object in the real world; and an object, he said, was a narrative—and so, of course, he disapproved of it. He wanted his "music without words." He wanted to be "simple as a child." He intended, with his "inner-self," to rid himself of "philosophical barricades" (he sat down and wrote something about all this). But in turn his own writing has become a philosophical barricade, even if it is a barricade full of holes. It offers a kind of Middle-European idea of Buddhism or, anyhow, something too theosophic for me.

The sentiment of the Futurists was simpler. No space. Everything ought to keep on going! That's probably the reason they went themselves. Either a man was a machine or else a sacrifice to make machines with.

The moral attitude of Neo-Plasticism is very much like that of Constructivism, except that the Constructivists wanted to bring things out in the open and the Neo-Plasticists didn't want anything left over.

I have learned a lot from all of them and they have confused me plenty too. One thing is certain, they didn't give me my natural aptitude for drawing, I am completely weary of their ideas now.

The only way I still think of these ideas is in terms of the individual artists who came from them or invented them. I still think that Boccioni was a great artist and a passionate man. I like Lissitzky, Rodchenko, Tatlin and Gabo; and I admire some of Kandinsky's painting very much. But Mondrian, that great merciless artist, is the only one who had nothing left over.

The point they all had in common was to be both inside and outside at the same time. A new kind of likeness! The likeness of the group instinct. All that it has produced is more glass and an hysteria for new materials which you can look through. A symptom of love-sickness, I guess. For me, to be inside and outside is to be in an unheated studio with broken windows in the winter, or taking a nap on somebody's porch in the summer.

Spiritually I am wherever my spirit allows me to be, and that is not necessarily in the future. I have no nostalgia, however. If I am confronted with one of those small Mesopotamian figures, I have no nostalgia for it but, instead, I may get into a state of anxiety. Art never seems to make me peaceful or pure. I always seem to be wrapped in the melodrama of vulgarity. I do not think of inside or outside—or of art in general—as a situation of comfort. I know there is a terrific idea there somewhere, but whenever I want to get into it, I get a feeling of apathy and want to lie down and go to sleep. Some painters, including myself, do not care what chair they are sitting on. It does not even have to be a comfortable one. They are too nervous to find out

where they ought to sit. They do not want to "sit in style." Rather, they have found that painting—any kind of painting, any style of painting—to be painting at all, in fact—is a way of living today, a style of living so to speak. That is where the form of it lies. It is exactly in its uselessness that it is free. Those artists do not want to conform. They only want to be inspired.

The group instinct could be a good idea, but there is always some little dictator who wants to make his instinct the group instinct. There *is* no style of painting now. There are as many naturalists among the abstract painters as there are abstract painters in the so-called subject-matter school.

The argument often used that science is really abstract, and that painting could be like music and, for this reason, that you cannot paint a man leaning against a lamp-post, is utterly ridiculous. That space of science—the space of the physicists—I am truly bored with by now. Their lenses are so thick that seen through them, the space gets more and more melancholy. There seems to be no end to the misery of the scientists' space. All that it contains is billions and billions of hunks of matter, hot or cold, floating around in darkness according to a great design of aimlessness. The stars *I* think about, if I could fly, I could reach in a few old-fashioned days. But physicists' stars I use as buttons, buttoning up curtains of emptiness. If I stretch my arms next to the rest of myself and wonder where my fingers are—that is all the space I need as a painter.

Today, some people think that the light of the atom bomb will change the concept of painting once and for all. The eyes that actually saw the light melted out of sheer ecstasy. For one instant, everybody was the same color. It made angels out of everybody. A truly Christian light, painful but forgiving.

Personally, I do not need a movement. What was given to me, I take for granted. Of all movements, I like Cubism most. It had that wonderful unsure atmosphere of reflection—a poetic frame where something could be possible, where an artist could practice his intuition. It didn't want to get rid of what went before. Instead it added something to it. The parts that I can appreciate in other movements came out of Cubism. Cubism *became* a movement, it didn't set out to be one. It has force in it, but it was no "force-movement." And then there is that one-man movement, Marcel Duchamp—for me a truly modern movement because it implies that each artist can do what he thinks he ought to—a movement for each person and open for everybody.

If I *do* paint abstract art, that's what abstract art means to me. I frankly do not understand the question. About twenty-four years ago, I knew a man in Hoboken, a German who used to visit us in the Dutch Seamen's Home. As far as he could remember, he was always hungry in Europe. He found a place in Hoboken where bread was sold a few days old—all kinds of bread: French bread, German bread, Italian bread, Dutch bread, Greek bread, American bread, and particularly Russian black bread. He bought big stacks of it for very little money, and let it get good and hard and then he crumpled

it and spread it on the floor in his flat and walked on it as on a soft carpet. I lost sight of him, but found out many years later that one of the other fellows met him again around 86th Street. He had become some kind of a Jugend Bund leader and took boys and girls to Bear Mountain on Sundays. He is still alive but quite old and is now a Communist. I could never figure him out, but now when I think of him, all that I can remember is that he had a very abstract look on his face.

Critics

Clement Greenberg
Towards a Newer Laocoön (1940)

Clement Greenberg attempted to establish a historical necessity for abstract painting by writing a series of articles between the late 1930s and the 1960s. "Towards a Newer Laocoön" was originally published in the July–August 1940 issue of *The Partisan Review,* the foremost Marxist–Trotskyist intellectual journal. In this essay Greenberg is motivated by a desire to articulate the criteria by which abstract art can be both understood and judged. He argues that abstraction can be better comprehended by analyzing artistic development from the seventeenth century to the present than if it is disassociated from historical analysis. Greenberg understood that by firmly rooting avant-garde painting within the inevitable flow of history, it would become more convincing to those people who had been uninterested in and uneducated about abstract painting. Nevertheless, the most powerful aspect of his argument may actually have been that he outlined the criteria by which abstract art could be judged.

Greenberg states that it is imperative for the practitioners of each of the arts to define his or her art in terms of the limits of the medium being used; doing so would reveal characteristics particular to that discipline. According to Greenberg, this kind of self-criticism allowed abstract painting to come into being and defines where its value ultimately rests. Although he does not specifically mention any contemporary American artists in this article, Greenberg establishes the historical precedent for American contributions to abstract painting and specifically those that, in his judgment, continue to find new ways of uncovering the qualities that are specific to the discipline of painting.

The dogmatism and intransigence of the "non-objective" or "abstract" purists of painting today cannot be dismissed as symptoms merely of a cultist attitude towards art. Purists make extravagant claims for art, because usually they value it much more than any one else does. For the same reason they are much more solicitous about it. A great deal of purism is the translation of an extreme solicitude, an anxiousness as to the fate of art, a concern for its identity. We must respect this. When the purist insists upon excluding "literature" and subject matter from plastic art, now and in the future, the most we can charge him with off-hand is an unhistorical attitude. It is quite easy to show that abstract art like every other cultural phenomenon reflects the social and other circumstances of the age in which its creators live, and that there is nothing inside art itself, disconnected from history, which compels it to go in one direction or another. But it is not so easy to reject the purist's assertion that the best of contemporary plastic art is abstract. Here the purist does not have to support his position with metaphysical pretentions. And when he insists on doing so, those of us who admit the merits of abstract art without accepting its claims in full must offer our own explanation for its present supremacy.

Discussion as to purity in art and, bound up with it, the attempts to establish the differences between the various arts are not idle. There has been, is, and will be, such a thing as a confusion of the arts. From the point of view of the artist engrossed in the problems of his medium and indifferent to the efforts of theorists to explain abstract art *completely*, purism is the terminus of a salutory reaction against the mistakes of painting and sculpture in the past several centuries which were due to such a confusion.

I

There can be, I believe, such a thing as a dominant art form; this was what literature had become in Europe by the seventeenth century. (Not that the ascendancy of a particular art always coincides with its greatest productions. In point of achievement, music was the greatest art of this period.) By the middle of the seventeenth century the pictorial arts had been relegated almost everywhere into the hands of the courts, where they eventually degenerated into relatively trivial interior decoration. The most creative class in society, the rising mercantile bourgeoisie, impelled perhaps by the iconoclasm of the Reformation (Pascal's Jansenist contempt for painting is a symptom) and by the relative cheapness and mobility of the physical medium after the invention of printing, had turned most of its creative and acquisitive energy towards literature.

Now, when it happens that a single art is given the dominant role, it becomes the prototype of all art: the others try to shed their proper characters and imitate its effects. The dominant art in turn tries itself to absorb the functions of the others. A confusion of the arts results, by which the subservient

ones are perverted and distorted; they are forced to deny their own nature in an effort to attain the effects of the dominant art. However, the subservient arts can only be mishandled in this way when they have reached such a degree of technical facility as to enable them to pretend to conceal their *mediums*. In other words, the artist must have gained such power over his material as to annihilate it seemingly in favor of *illusion*. Music was saved from the fate of the pictorial arts in the seventeenth and eighteenth centuries by its comparatively rudimentary technique and the relative shortness of its development as a formal art. Aside from the fact that in its nature it is the art furthest removed from imitation, the possibilities of music had not been explored sufficiently to enable it to strive for illusionist effect.

But painting and sculpture, the arts of illusion par excellence, had by that time achieved such facility as to make them infinitely susceptible to the temptation to emulate the effects, not only of illusion, but of other arts. Not only could painting imitate sculpture, and sculpture, painting, but both could attempt to reproduce the effects of literature. And it was for the effects of literature that seventeenth and eighteenth century painting strained most of all. Literature, for a number of reasons, had won the upper hand, and the plastic arts—especially in the form of easel painting and statuary—tried to win admission to its domain. Although this does not account completely for the decline of those arts during this period, it seems to have been the form of that decline. Decline it was, compared to what had taken place in Italy, Flanders, Spain and Germany the century before. Good artists, it is true, continue to appear—I do not have to exaggerate the depression to make my point— but not good *schools* of art, not good followers. The circumstances surrounding the appearance of the individual great artists seem to make them almost all exceptions; we think of them as great artists "in spite of." There is a scarcity of distinguished small talents. And the very level of greatness sinks by comparison to the work of the past.

In general, painting and sculpture in the hands of the lesser talents— and this is what tells the story—become nothing more than ghosts and "stooges" of literature. All emphasis is taken away from the medium and transferred to subject matter. It is no longer a question even of realistic imitation, since that is taken for granted, but of the artist's ability to interpret subject matter for poetic effects and so forth.

We ourselves, even today, are too close to literature to appreciate its status as a dominant art. Perhaps an example of the converse will make clearer what I mean. In China, I believe, painting and sculpture became in the course of the development of culture the dominant arts. There we see poetry given a role subordinate to them, and consequently assuming their limitations: the poem confines itself to the single moment of painting and to an emphasis upon visual details. The Chinese even require visual delight from the handwriting in which the poem is set down. And by comparison to their

pictorial and decorative arts doesn't the later poetry of the Chinese seem rather thin and monotonous?

Lessing, in his *Laokoon* written in the 1760s, recognized the presence of a practical as well as a theoretical confusion of the arts. But he saw its ill effects exclusively in terms of literature, and his opinions on plastic art only exemplify the typical misconceptions of his age. He attacked the descriptive verse of poets like James Thomson as an invasion of the domain of landscape painting, but all he could find to say about painting's invasion of poetry was to object to allegorical pictures which required an explanation, and to paintings like Titian's *Prodigal Son* which incorporate "two necessarily separate points of time in one and the same picture."

II

The Romantic Revival or Revolution seemed at first to offer some hope for painting, but by the time it departed the scene, the confusion of the arts had become worse. The romantic theory of art was that the artist feels something and passes on this feeling—not the situation or thing which stimulated it—to his audience. To preserve the immediacy of the feeling it was even more necessary than before, when art was imitation rather than communication, to suppress the role of the medium. The medium was a regrettable if necessary physical obstacle between the artist and his audience, which in some ideal state would disappear entirely to leave the experience of the spectator or reader identical with that of the artist. In spite of the fact that music, considered as an art of pure feeling, was beginning to win almost equal esteem, the attitude represents a final triumph for poetry. All feeling for the arts as métiers, crafts, disciplines—of which some sense had survived until the eighteenth century—was lost. The arts came to be regarded as nothing more or less than so many powers of the personality. Shelley expressed this best when in his *Defense of Poetry* he exalted poetry above the other arts because its medium came closest, as Bosanquet puts it, to being no medium at all. In practice this aesthetic encouraged that particular widespread form of artistic dishonesty which consists in the attempt to escape from the problems of the medium of one art by taking refuge in the effects of another. Painting is the most susceptible to evasions of this sort, and painting suffered most at the hands of the Romantics.

At first it did not seem so. As a result of the triumph of the burghers and of their appropriation of all the arts, a fresh current of creative energy was released into every field. If the Romantic revolution in painting was at first more a revolution in subject matter than in anything else, abandoning the oratorical and frivolous literature of eighteenth century painting in search of a more original, more powerful, more sincere literary content, it

also brought with it a greater boldness in pictorial means. Delacroix, Géricault, even Ingres, were enterprising enough to find new form for the new content they introduced. But the net result of their efforts was to make the incubus of literature in painting even deadlier for the lesser talents who followed them. The worst manifestations of literary and sentimental painting had already begun to appear in the painting of the late eighteenth century—especially in England, where a revival which produced some of the best English painting was equally efficacious in speeding up the process of degeneration. Now the schools of Ingres and Delacroix joined with those of Morland and Greuze and Vigée-Lebrun to become the official painting of the nineteenth century. There have been academics before, but for the first time we have academicism. Painting enjoyed a revival of activity in nineteenth-century France such as had not been seen since the sixteenth century, and academicism could produce such good painters as Corot and Theodore Rousseau, and even Daumier—yet in spite of this, academicians sank painting to a level that was in some respects an all-time low. The name of this low is Vernet, Gérome, Leighton, Watts, Moreau, Böcklin, the Pre-Raphaelites, etc., etc. That some of these painters had real talent only made their influence the more pernicious. It took talent—among other things—to lead art that far astray. Bourgeois society gave these talents a prescription, and they filled it—with talent.

It was not realistic imitation in itself that did the damage so much as realistic illusion in the service of sentimental and declamatory literature. Perhaps the two go hand in hand. To judge from Western and Greco-Roman art, it seems so. Yet it is true of Western painting that in so far as it has been the creation of a rationalist and scientifically-minded city culture, it has always had a bias towards a realism that tries to achieve allusions by overpowering the medium, and is more interested in exploiting the practical meanings of objects than in savoring their appearance.

III

Romanticism was the last great tendency following *directly* from bourgeois society that was able to inspire and stimulate the profoundly responsible artist—the artist conscious of certain inflexible obligations to the standards of his craft. By 1848 Romanticism had exhausted itself. After that the impulse, although indeed it had to originate in bourgeois society, could only come in the guise of a denial of that society, as a turning away from it. It was not to be an about-face towards a new society, but an emigration to a Bohemia which was to be art's sanctuary from capitalism. It was to be the task of the avant-garde to perform in opposition to bourgeois society the function of finding new and adequate cultural forms for the expression of that same

society, without at the same time succumbing to its ideological divisions and its refusal to permit the arts to be their own justification. The avant-garde, both child and negation of Romanticism, becomes the embodiment of art's instinct of self-preservation. It is interested in, and feels itself responsible to, only the values of art; and, given society as it is, has an organic sense of what is good and what is bad for art.

As the first and most important item upon its agenda, the avant-garde saw the necessity of an escape from ideas, which were infecting the arts with the ideological struggles of society. Ideas came to mean subject matter in general. (Subject matter as distinguished from content: in the sense that every work of art must have content, but that subject matter is something the artist does or does not have in mind when he is actually at work.) This meant a new and greater emphasis upon form, and it also involved the assertion of the arts as independent vocations, disciplines and crafts, absolutely autonomous, and entitled to respect for their own sakes, and not merely as vessels of communication. It was the signal for a revolt against the dominance of literature, which was subject matter at its most oppressive.

The avant-garde has pursued, and still pursues, several variants, whose chronological order is by no means clear, but can be best traced in painting, which as the chief victim of literature brought the problem into sharpest focus. (Forces stemming from outside art play a much larger part than I have room to acknowledge here. And I must perforce be rather schematic and abstract, since I am interested more in tracing large outlines than in accounting for and gathering in all particular manifestations.)

By the second third of the nineteenth century, painting had degenerated from the pictorial to the picturesque. Everything depends on the anecdote or the message. The painted picture occurs in blank, indeterminate space; it just happens to be on a square of canvas and inside a frame. It might just as well have been breathed on air or formed out of plasma. It tries to be something you imagine rather than see—or else a bas-relief or a statue. Everything contributes to the denial of the medium, as if the artist were ashamed to admit that he had actually painted his picture instead of dreaming it forth.

This state of affairs could not be overcome at one stroke. The campaign for the redemption of painting was to be one of comparatively slow attrition at first. Nineteenth-century painting made its first break with literature when in the person of the Communard, Courbet, it fled from spirit to matter. Courbet, the first real avant-garde painter, tried to reduce his art to immediate sense data by painting only what the eye could see as a machine unaided by the mind. He took for his subject matter prosaic contemporary life. As avant-gardists so often do, he tried to demolish official bourgeois art by turning it inside out. By driving something as far as it will go you often get back to where it started. A new flatness begins to appear in Courbet's painting,

and an equally new attention to every inch of the canvas, regardless of its relation to the "centers of interest." (Zola, the Goncourts, and poets like Verhaeren were Courbet's correlatives in literature. They too were "experimental"; they too were trying to get rid of ideas and "literature," that is, to establish their art on a more stable basis than the crumbling bourgeois ecumene.) If the avant-garde seems unwilling to claim naturalism for itself, it is because the tendency failed too often to achieve the objectivity it professed, i.e., it succumbed to "ideas."

Impressionism, reasoning beyond Courbet in its pursuit of materialist objectivity, abandoned common sense experience and sought to emulate the detachment of science, imagining that thereby it would get at the very essence of painting as well as of visual experience. It was becoming important to determine the essential elements of each of the arts. Impressionist painting becomes more an exercise in color vibrations than representation of nature. Manet meanwhile, closer to Courbet, was attacking subject matter on its own terrain by including it in his pictures and exterminating it then and there. His insolent indifference to his subject, which in itself was often striking, and his flat color-modeling were as revolutionary as Impressionist technique proper. Like the Impressionists he saw the problems of painting as first and foremost problems of the medium, and he called the spectator's attention to this.

IV

The second variant of the avant-garde's development is concurrent in time with the first. It is easy to recognize this variant, but rather difficult to expose its motivation. Tendencies go in opposite directions, and cross-purposes meet. But tying everything together is the fact that in the end cross-purposes indeed do meet. There is a common effort in each of the arts to expand the expressive resources of the medium, not in order to express ideas and notions, but to express with greater immediacy sensations, the irreducible elements of experience. Along this path it seemed as though the avant-garde in its attempt to escape from "literature" had set out to treble the confusion of the arts by having them imitate every other art except literature.[1] (By this time literature had had its opprobrious sense expanded to include everything the avant-garde objected to in official bourgeois culture.) Each art would demonstrate its powers by capturing the effects of its sister arts or by taking a sister art for its subject. Since art was the only validity left, what better subject was there for each art than the procedures and effects of some other art? Impressionist painting, with its progressions and rhythmic suffusions of color, with its moods and atmospheres, was arriving at effects to

which the Impressionists themselves gave the terms of Romantic music. Painting, however, was the least affected by this new confusion. Poetry and music were its chief victims. Poetry—for it too had to escape from "litera-ture"—was imitating the effects of painting and sculpture (Gautier, the Panassians, and later the Imagists) and, of course, those of music (Poe had narrowed "true" poetry down to the lyric). Music, in flight from the undisci-plined, bottomless sentimentality of the Romantics, was striving to describe and narrate (program music). That music at this point imitates literature would seem to spoil my thesis. But music imitates painting as much as it does poetry when it becomes representational; and besides, it seems to me that Debussy used the program more as a pretext for experiment than as an end in itself. In the same way that the Impressionist painters were trying to get at the structure beneath the color, Debussy was trying to get at the "sound underneath the note."

Aside from what was going on inside music, music as an art in itself began at this time to occupy a very important position in relation to the other arts. Because of its "absolute" nature, its remoteness from imitation, its al-most complete absorption in the very physical quality of its medium, as well as because of its resources of suggestion, music had come to replace poetry as the paragon art. It was the art which the other avant-garde arts envied most, and whose effects they tried hardest to imitate. Thus it was the princi-pal agent of the new confusion of the arts. What attracted the avant-garde to music as much as its power to suggest was, as I have said, its nature as an art of immediate sensation. When Verlaine said, "De la musique avant toute chose," he was not only asking poetry to be more suggestive—suggestive-ness after all, was a poetic ideal foisted upon music—but also to affect the reader or listener with more immediate and more powerful sensations.

But only when the avant-garde's interest in music led it to consider music as a *method* of art rather than as a kind of effect did the avant-garde find what it was looking for. It was when it was discovered that the advan-tage of music lay chiefly in the fact that it was an "abstract" art, an art of "pure form." It was such because it was incapable, objectively, of communi-cating anything else than a sensation, and because this sensation could not be conceived in any other terms than those of the sense through which it en-tered the consciousness. An imitative painting can be described in terms of nonvisual identities, a piece of music cannot, whether it attempts to imitate or not. The effects of music are the effects, essentially, of pure form; those of painting and poetry are too often accidental to the formal natures of these arts. Only by accepting the example of music and defining each of the other arts solely in the terms of the sense of faculty which perceived its effect and by excluding from each art whatever is intelligible in the terms of any other sense or faculty would the nonmusical arts attain the "purity" and self-sufficiency which they desired; which they desired, that is, in so far as

they were avant-garde arts. The emphasis, therefore, was to be on the physical, the sensorial. "Literature's" corrupting influence is only felt when the senses are neglected. The latest confusion of the arts was the result of a mistaken conception of music as the only immediately sensuous art. But the other arts can also be sensuous, if only they will look to music, not to ape its effects but to borrow its principles as a "pure" art, as an art which is abstract because it is almost nothing else except sensuous.[2]

V

Guiding themselves, whether consciously or unconsciously, by a notion of purity derived from the example of music, the avant-garde arts have in the last fifty years achieved a purity and a radical delimitation of their fields of activity for which there is no previous example in the history of culture. The arts lie safe now, each within its "legitimate" boundaries, and free trade has been replaced by autarchy. Purity in art consists in the acceptance, willing acceptance, of the limitations of the medium of the specific art. To prove that their concept of purity is something more than a bias in taste, painters point to Oriental, primitive and children's art as instances of the universality and naturalness and objectivity of their ideal of purity. Composers and poets, although to a much lesser extent, may justify their efforts to attain purity by referring to the same precedent. Dissonance is present in early and non-Western music, "unintelligibility" in folk poetry. The issue is, of course, focused most sharply in the plastic arts, for they, in their non-decorative function, have been the most closely associated with imitation, and it is in their case that the ideal of the pure and the abstract has met the most resistance.

The arts, then, have been hunted back to their mediums, and there they have been isolated, concentrated and defined. It is by virtue of its medium that each art is unique and strictly itself. To restore the identity of an art the opacity of its medium must be emphasized. For the visual arts the medium is discovered to be physical; hence pure painting and pure sculpture seek above all else to affect the spectator physically. In poetry, which, as I have said, had also to escape from "literature" or subject matter for its salvation from society, it is decided that the medium is essentially psychological and sub- or supra-logical. The poem is to aim at the general consciousness of the reader, not simply his intelligence.

It would be well to consider "pure" poetry for a moment, before going on to painting. The theory of poetry as incantation, hypnosis or drug—as psychological agent then—goes back to Poe, and eventually to Coleridge and Edmund Burke with their efforts to locate the enjoyment of poetry in the "Fancy" or "Imagination." Mallarmé, however, was the first to base a consistent practice of poetry upon it. Sound, he decided, is only an auxiliary

of poetry, not the medium itself; and besides, most poetry is now read, not recited: the sound of words is a part of their meaning, not the vessel of it. To deliver poetry from the subject and to give full play to its true affective power it is necessary to free words from logic. The medium of poetry is isolated in the power of the word to evoke associations and to connote. Poetry subsists no longer in the relations between words as meanings, but in the relations between words as personalities composed of sound, history and possibilities of meaning. Grammatical logic is retained only in so far as it is necessary to set these personalities in motion, for unrelated words are static when read and not recited aloud. Tentative efforts are made to discard metric form and rhyme, because they are regarded as too local and determinate, too much attached to specific times and places and social conventions to pertain to the essence of poetry. There are experiments in poetic prose. But as in the case of music, it was found that formal structure was indispensable, that some such structure was integral to the medium of poetry as an aspect of its resistance. . . . The poem still offers possibilities of meaning—but only possibilities. Should any of them be too precisely realized, the poem would lose the greatest part of its efficacy, which is to agitate the consciousness with infinite possibilities by approaching the brink of meaning and yet never falling over it. The poet writes, not so much to *express*, as to create a thing which will operate upon the reader's consciousness to produce the emotion of poetry. The content of the poem is what it does to the reader, not what it communicates. The emotion of the reader derives from the poem as a unique object—pretendedly—and not from referents outside the poem. This is pure poetry as ambitious contemporary poets try to define it by the example of their work. Obviously, it is an impossible ideal, yet one which most of the best poetry of the last fifty years has tried to reach, whether it is poetry about nothing or poetry about the plight of contemporary society.

It is easier to isolate the medium in the case of the plastic arts, and consequently avant-garde painting and sculpture can be said to have attained a much more radical purity than avant-garde poetry. Painting and sculpture can become more completely nothing but what they do; like functional architecture and the machine, they *look* what they *do*. The picture or statue exhausts itself in the visual sensation it produces. There is nothing to identify, connect or think about, but everything to feel. Pure poetry strives for infinite suggestion, pure plastic art for the minimum. If the poem, as Valéry claims, is a machine to produce the emotion of poetry, the painting and statue are machines to produce the emotion of "plastic sight." The purely plastic or abstract qualities of the work of art are the only ones that count. Emphasize the medium and its difficulties, and at once the purely plastic, the proper, values of visual art come to the fore. Overpower the medium to the point where all sense of its resistance disappears, and the adventitious uses of art become more important.

The history of avant-garde painting is that of a progressive surrender to the resistance of its medium; which resistance consists chiefly in the flat picture plane's denial of efforts to "hole through" it for realistic perspectival space. In making this surrender, painting not only got rid of imitation—and with it, "literature"—but also of realistic imitation's corollary confusion between painting and sculpture. (Sculpture, on its side, emphasizes the resistance of its material to the efforts of the artist to ply it into shapes uncharacteristic of stone, metal, wood, etc.) Painting abandons chiaroscuro and shaded modelling. Brush strokes are often defined for their own sake. The motto of the Renaissance artist, *Ars est artem celare*, is exchanged for *Ars est artem demonstrare*. Primary colors, the "instinctive," easy colors, replace tones and tonality. Line, which is one of the most abstract elements in painting since it is never found in nature as the definition of contour, returns to oil painting as the third color between two other color areas. Under the influence of the square shape of the canvas, forms tend to become geometrical—and simplified, because simplification is also a part of the instinctive accommodation to the medium. But most important of all, the picture plane itself grows shallower and shallower, flattening out and pressing together the fictive planes of depth until they meet as one upon the real and material plane which is the actual surface of the canvas; where they lie side by side or interlocked or transparently imposed upon each other. Where the painter still tries to indicate real objects, their shapes flatten and spread in the dense, two-dimensional atmosphere. A vibrating tension is set up as the objects struggle to maintain their volume against the tendency of the real picture plane to re-assert its material flatness and crush them to silhouettes. In a further stage realistic space cracks and splinters into flat planes which come forward, parallel to the plane surface. Sometimes this advance to the surface is accelerated by painting a segment of wood or texture *trompe l'oeil*, or by drawing exactly printed letters, and placing them so that they destroy the partial illusion of depth by slamming the various planes together. Thus the artist deliberately emphasizes the illusoriness of the illusions which he pretends to create. Sometimes these elements are used in an effort to preserve an illusion of depth by being placed on the nearest plane in order to drive the others back. But the result is an optical illusion, not a realistic one, and only emphasizes further the impenetrability of the plane surface.

The destruction of realistic pictorial space, and with it, that of the object, was accomplished by means of the travesty that was cubism. The cubist painter eliminated color because, consciously or unconsciously, he was parodying, in order to destroy, the academic methods of achieving volume and depth, which are shading and perspective, and as such have little to do with color in the common sense of the word. The cubist used these same methods to break the canvas into a multiplicity of subtle recessive planes, which seem to shift and fade into infinite depths and yet insist on returning to the surface

of the canvas. As we gaze at a cubist painting of the last phase we witness the birth and death of three-dimensional pictorial space.

And as in painting the pristine flatness of the stretched canvas constantly struggles to overcome every other element, so in sculpture the stone figure appears to be on the point of relapsing into the original monolith, and the cast seems to narrow and smooth itself back to the original molten stream from which it was poured, or tries to remember the texture and plasticity of the clay in which it was first worked out.

Sculpture hovers finally on the verge of "pure" architecture, and painting, having been pushed up from fictive depths, is forced through the surface of the canvas to emerge on the other side in the form of paper, cloth, cement and actual objects of wood and other materials pasted, glued or nailed to what was originally the transparent picture plane, which the painter no longer dares to puncture—or if he does, it is only to dare. Artists like Hans Arp, who begin as painters, escape eventually from the prison of the single plane by painting on wood or plaster and using molds or carpentry to raise and lower planes. They go, in other words, from painting to colored bas-relief, and finally—so far must they fly in order to return to three-dimensionality without at the same time risking the illusion—they become sculptors and create objects in the round, through which they can free their feelings for movement and direction from the increasing ascetic geometry of pure painting. (Except in the case of Arp and one or two others, the sculpture of most of these metamorphosed painters is rather unsculptural, stemming as it does from the discipline of painting. It uses color, fragile and intricate shapes, and a variety of materials. It is construction, fabrication.)

The French and Spanish in Paris brought painting to the point of the pure abstraction, but it remained, with a few exceptions, for the Dutch, Germans, English and Americans to realize it. It is in their hands that abstract purism has been consolidated into a school, dogma and credo. By 1939 the center of abstract painting had shifted to London, while in Paris the younger generation of French and Spanish painters had reacted against abstract purity and turned back to a confusion of literature with painting as extreme as any of the past. These young orthodox surrealists are not to be identified, however, with such pseudo- or mock surrealists of the previous generation as Miró, Klee and Arp, whose work, despite its apparent intention, has only contributed to the further deployment of abstract painting pure and simple. Indeed, a good many of the artists—if not the majority—who contributed importantly to the development of modern painting came to it with the desire to exploit the break with imitative realism for a more powerful expressiveness, but so inexorable was the logic of the development that in the end their work constituted but another step towards abstract art, and a further sterilization of the expressive factors. This has been true, whether the artist was Van Gogh, Picasso or Klee. All roads led to the same place.

VI

I find that I have offered no other explanation for the present superiority of abstract art than its historical justification. So what I have written has turned out to be an historical apology for abstract art. To argue from any other basis would require more space than is at my disposal, and would involve an entrance into the politics of taste—to use Venturi's phrase—from which there is no exit—on paper. My own experience of art has forced me to accept most of the standards of taste from which abstract art has derived, but I do not maintain that they are the only valid standards through eternity. I find them simply the most valid ones at this given moment. I have no doubt that they will be replaced in the future by other standards, which will be perhaps more inclusive than any possible now. And even now they do not exclude all other possible criteria. I am still able to enjoy a Rembrandt more for its expressive qualities than for its achievement of abstract values—as rich as it may be in them.

It suffices to say that there is nothing in the nature of abstract art which compels it to be so. The imperative comes from history, from the age in conjunction with a particular moment reached in a particular tradition of art. This conjunction holds the artist in a vise from which at the present moment he can escape only by surrendering his ambition and returning to a stale past. This is the difficulty for those who are dissatisfied with abstract art, feeling that it is too decorative or too arid and "inhuman," and who desire a return to representation and literature in plastic art. Abstract art cannot be disposed of by a simple-minded evasion. Or by negation. We can only dispose of abstract art by assimilating it, by fighting our way through it. Where to? I do not know. Yet it seems to me that the wish to return to the imitation of nature in art has been given no more justification than the desire of certain partisans of abstract art to legislate it into permanency.

NOTES

1. This is the confusion of the arts for which Babbitt [Irving Babbitt, *The New Laokoön: An Essay on the Confusion of the Arts*, 1910] made Romanticism responsible.
2. The ideas about music which Pater expresses in *The School of Giorgione* reflect this transition from the musical to the abstract better than any single work of art.

Harold Rosenberg
The American Action Painters (1952)

Whereas critic Clement Greenberg analyzed the formal developments of American abstract art, critic and poet Harold Rosenberg examines the importance of the act of painting itself. Rosenberg's discussion of the inextricable connection between the act of making the painting and its meaning has direct parallels in the statements of Pollock, Rothko, and de Kooning. Rosenberg also reiterates the sentiments expressed by both Rothko and de Kooning when he states that painters of the postwar generation felt a sense of liberation from art's previous link with specific societal, political, or moral ideas. Rosenberg sees the development of postwar American art in terms of intuitive gestures by individual artists whose ultimate goal was nothing less than the breakdown of the distinction between art and life. Though Rosenberg and Greenberg differed in manner, both wanted to justify the importance of postwar American painting and in so doing helped shift the attention of the international art community from Paris to New York.

"The American Action Painters" is loaded with the rhetoric of American optimism and ingenuity. The artist feels no weight from history and no moral imperatives, just the desire to take "to the white expanse of the canvas as Melville's Ishmael took to the sea." By the time Rosenberg wrote this article for *Art News* in December 1952, artists such as de Kooning and Pollock were firmly established as the leaders of the new developments in abstract art.

J'ai fait des gestes blanc parmi les solitudes.

<div style="text-align: right">Apollinaire</div>

The American will is easily satisfied in its efforts to realize itself in knowing itself.

<div style="text-align: right">Wallace Stevens</div>

What makes any definition of a movement in art dubious is that it never fits the deepest artists in the movement—certainly not as well as, if successful, it does the others. Yet without the definition something essential in those best is bound to be missed. The attempt to define is like a game in which you cannot possibly reach the goal from the starting point but can only close in on it by picking up each time from where the last play landed.

MODERN ART? OR AN ART OF THE MODERN?

Since the War every twentieth-century style in painting is being brought to profusion in the United States: thousands of "abstract" painters—crowded teaching courses in Modern Art—a scattering of new heroes—ambitions

stimulated by new galleries, mass exhibitions, reproductions in popular magazines, festivals, appropriations.

Is this the usual catching up of America with European art forms? Or is something new being created? . . . For the question of novelty, a definition would seem indispensable.

Some people deny that there is anything original in the recent American painting. Whatever is being done here now, they claim, was done thirty years ago in Paris. You can trace this painter's boxes of symbols to Kandinsky, that one's moony shapes to Miró or even back to Cézanne.

Quantitatively, it is true that most of the symphonies in blue and red rectangles, the wandering pelvises and birdbills, the line constructions and plane suspensions, the virginal dissections of flat areas that crowd the art shows are accretions to the "School of Paris" brought into being by the fact that the mode of production of modern masterpieces has now been all too clearly rationalized. There are styles in the present displays that the painter could have acquired by putting a square inch of a Soutine or a Bonnard under a microscope. . . . All this is training based on a new conception of what art is, rather than original work demonstrating what art is about to become.

At the center of this wide practicing of the immediate past, however, the work of some painters has separated itself from the rest by a consciousness of a function for painting different from that of the earlier "abstractionists," both the Europeans themselves and the Americans who joined them in the years of the Great Vanguard.

This new painting does not constitute a School. To form a School in modern times not only is a new painting consciousness needed but a consciousness of that consciousness—and even an insistence on certain formulas. A School is the result of the linkage of practice with terminology—different paintings are affected by the same words. In the American vanguard the words, as we shall see, belong not to the art but to the individual artists. What they think in common is represented only by what they do separately.

GETTING INSIDE THE CANVAS

At a certain moment the canvas began to appear to one American painter after another as an arena in which to act—rather than as a space in which to reproduce, re-design, analyze, or "express" an object, actual or imagined. What was to go on the canvas was not a picture but an event.

The painter no longer approached his easel with an image in his mind; he went up to it with material in his hand to do something to that other piece of material in front of him. The image would be the result of this encounter.

It is pointless to argue that Rembrandt or Michelangelo worked in the same way. You don't get Lucrece with a dagger out of staining a piece of cloth or spontaneously putting forms into motion upon it. She had to exist

someplace else before she got on the canvas, and the paint was Rembrandt's means for bringing her here. Now, everything must have been in the tubes, in the painter's muscles, and in the cream-colored sea into which he dives. If Lucrece should come out she will be among us for the first time—a surprise. To the painter, she *must* be a surprise. In this mood there is no point in an act if you already know what it contains.

"B. is not modern," one of the leaders of this mode said to me the other day. "He works from sketches. That makes him Renaissance."

Here the principle, and the difference from the old painting, is made into a formula. A sketch is the preliminary form of an image the *mind* is try-ing to grasp. To work from sketches arouses the suspicion that the artist still regards the canvas as a place where the mind records its contents—rather than itself the "mind" through which the painter thinks by changing a sur-face with paint.

If a painting is an action, the sketch is one action, the painting that fol-lows it another. The second cannot be "better" or more complete than the first. There is just as much significance in their difference as in their similarity.

Of course, the painter who spoke had no right to assume that the other had the old mental conception of a sketch. There is no reason why an act can-not be prolonged from a piece of paper to a canvas. Or repeated on another scale and with more control. A sketch can have the function of a skirmish.

Call this painting "abstract" or "Expressionist" or "Abstract-Expressionist," what counts is its special motive for extinguishing the object, which is not the same as in other abstract or Expressionist phases of modern art.

The New American Painting is not "pure art," since the extrusion of the object was not for the sake of the aesthetic. The apples weren't brushed off the table in order to make room for perfect relations of space and color. They had to go so that nothing would get in the way of the act of painting. In this gesturing with materials the aesthetic, too, has been subordinated. Form, color, composition, drawing, are auxiliaries, any one of which—or practi-cally all, as has been attempted, logically, with unpainted canvases—can be dispensed with. What matters always is the revelation contained in the act. It is to be taken for granted that in the final effect, the image, whatever be or be not in it, will be a *tension*.

DRAMAS OF AS IF

A painting that is an act is inseparable from the biography of the artist. The painting itself is a "moment" in the adulterated mixture of his life—whether "moment" means, in one case, the actual minutes taken up with spotting the canvas or, in another, the entire duration of a lucid drama conducted in sign

language. The act-painting is of the same metaphysical substance as the artist's existence. The new painting has broken down every distinction between art and life.

It follows that anything is relevant to it. Anything that has to do with action—psychology, philosophy, history, mythology, hero worship. Anything but art criticism. The painter gets away from Art through his act of painting; the critic can't get away from it. The critic who goes on judging in terms of schools, styles, form, as if the painter were still concerned with producing a certain kind of object (the work of art), instead of living on the canvas, is bound to seem a stranger.

Some painters take advantage of this stranger. Having insisted that their painting is an act, they then claim admiration for the act as art. This turns the act back toward the aesthetic in a petty circle. If the picture is an act, it cannot be justified *as an act of genius* in a field whose whole measuring apparatus has been sent to the devil. Its value must be found apart from art. Otherwise the "act" gets to be "making a painting" at sufficient speed to meet an exhibition date.

Art—relation of the painting to the works of the past, rightness of color, texture, balance, etc.—comes back into painting by way of psychology. As Stevens says of poetry, "it is a process of the personality of the poet." But the psychology is the psychology of creation. Not that of the so-called psychological criticism that wants to "read" a painting for clues to the artist's sexual preferences or debilities. The work, the act, translates the psychologically given into the intentional, into a "world"—and thus transcends it.

With traditional aesthetic references discarded as irrelevant, what gives the canvas its meaning is not psychological data but *role*, the way the artist organizes his emotional and intellectual energy as if he were in a living situation. The interest lies on the kind of act taking place in the four-sided arena, a dramatic interest.

Criticism must begin by recognizing in the painting the assumptions inherent in its mode of creation. Since the painter has become an actor, the spectator has to think in a vocabulary of action: its inception, duration, direction—psychic state, concentration and relaxation of the will, passivity, alert waiting. He must become a connoisseur of the gradations among the automatic, the spontaneous, the evoked.

"IT'S NOT THAT, IT'S NOT THAT, IT'S NOT THAT"

With a few important exceptions, most of the artists of this vanguard found their way to their present work by being cut in two. Their type is not a young painter but a reborn one. The man may be over forty, the painter around

seven. The diagonal of a grand crisis separates him from his personal and artistic past.

Many of the painters were "Marxists" (WPA unions, artists' congresses)—they had been trying to paint Society. Others had been trying to paint Art (Cubism, Post-Impressionism)—it amounts to the same thing.

The big moment came when it was decided to paint. . . . Just *To Paint*. The gesture on the canvas was a gesture of liberation, from Value—political, aesthetic, moral.

If the war and the decline of radicalism in America had anything to do with this sudden impatience, there is no evidence of it. About the effects of large issues upon their emotions, Americans tend to be either reticent or unconscious. The French artist thinks of himself as a battleground of history; here one hears only of private Dark Nights. Yet it is strange how many segregated individuals came to a dead stop within the past ten years and abandoned, even physically destroyed, the work they had been doing. A far-off watcher, unable to realize that these events were taking place in silence, might have assumed they were being directed by a single voice.

At its center the movement was away from rather than toward. The Great Works of the Past and the Good Life of the Future became equally nil.

The refusal of Value did not take the form of condemnation or defiance of society, as it did after World War I. It was diffident. The lone artist did not want the world to be different, he wanted his canvas to be a world. Liberation from the object meant liberation from the "nature," society, and art already there. It was a movement to leave behind the self that wished to choose its future and to nullify its promissory notes to the past.

With the American, heir of the pioneer and the immigrant, the foundering of Art and Society was not experienced as a loss. On the contrary, the end of Art marked the beginning of an optimism regarding himself as an artist.

The American vanguard painter took to the white expanse of the canvas as Melville's Ishmael took to the sea.

On the one hand, a desperate recognition of moral and intellectual exhaustion; on the other, the exhilaration of an adventure over depths in which he might find reflected the true image of his identity.

Painting could now be reduced to that equipment which the artist needed for an activity that would be an alternative to both utility and idleness. Guided by visual and somatic memories of paintings he had seen or made—memories which he did his best to keep from intruding into his consciousness—he gesticulated upon the canvas and watched for what each novelty would declare him and his art to be.

Based on the phenomenon of conversion, the new movement is, with the majority of the painters, essentially a religious movement. In every case,

however, the conversion has been experienced in secular terms. The result has been the creation of private myths.

The tension of the private myth is the content of every painting of this vanguard. The act on the canvas springs from an attempt to resurrect the saving moment in his "story" when the painter first felt himself released from Value—myth of past self-recognition. Or it attempts to initiate a new moment in which the painter will realize his total personality—myth of future self-recognition.

Some formulate their myths verbally and connect individual works with their episodes. With others, usually deeper, the painting itself is the exclusive formulation, it is a Sign.

The revolution against the given, in the self and in the world, which since Hegel has provided European vanguard art with theories of a New Reality, has re-entered America in the form of personal revolts. Art as action rests on the enormous assumption that the artist accepts as real only that which he is in the process of creating. "Except the soul has divested itself of the love of created things . . ." The artist works in a condition of open possibility, risking, to follow Kierkegaard, the anguish of the aesthetic, which accompanies possibility lacking in reality. To maintain the force to refrain from settling anything, he must exercise in himself a constant No.

APOCALYPSE AND WALLPAPER

The most comfortable intercourse with the void is mysticism, especially a mysticism that avoids ritualizing itself.

Philosophy is not popular among American painters. For most, thinking consists of the various arguments that TO PAINT is something different from, say, to write or criticize: a mystique of the particular activity. Lacking verbal flexibility, the painters speak of what they are doing in a jargon still involved in the metaphysics of *things*: "My painting is not Art; it's an Is." "It's not a picture of a thing; it's the thing itself." "It doesn't reproduce Nature; it is Nature." "The painter doesn't think; he knows." Etc., etc. "Art is not, not not not not . . ." As against this, a few reply, art today is the same as it always has been.

Language has not accustomed itself to a situation in which the act itself is the "object." Along with the philosophy of TO PAINT appear bits of Vedanta and popular pantheism.

In terms of American tradition, the new painters stand somewhere between Christian Science and Whitman's "gangs of cosmos." That is, between a discipline of vagueness by which one protects oneself from disturbance while keeping one's eyes open for benefits; and the discipline of the Open Road of risk that leads to the farther side of the object and the outer spaces of the consciousness.

What made Whitman's mysticism serious was that he directed his "cosmic 'I'" toward a Pike's-Peak-or-Bust of morality and politics. He wanted the ineffable in *all* behavior—he wanted it *to win the streets.*

The test of any of the new paintings is its seriousness—and the test of its seriousness is the degree to which the act on the canvas is an extension of the artist's total effort to make over his experience.

A good painting in this mode leaves no doubt concerning its reality as an action and its relation to a transforming process in the artist. The canvas has "talked back" to the artist not to quiet him with Sibylline murmurs or to stun him with Dionysian outcries but to provoke him into a dramatic dialogue. Each stroke had to be a decision and was answered by a new question. By its very nature, action painting is painting in the medium of difficulties.

Weak mysticism, the "Christian Science" side of the new movement, tends in the opposite direction, toward *easy* painting—never so many unearned masterpieces! Works of this sort lack the dialectical tension of a genuine act, associated with risk and will. When a tube of paint is squeezed by the Absolute, the result can only be a Success. The painter need keep himself on hand solely to collect the benefits of an endless series of strokes of luck. His gesture completes itself without arousing either an opposing movement within itself or his own desire to make the act more fully his own. Satisfied with wonders that remain safely inside the canvas, the artist accepts the permanence of the commonplace and decorates it with his own daily annihilation. The result is an apocalyptic wallpaper.

The cosmic "I" that turns up to paint pictures but shudders and departs the moment there is a knock on the studio door brings to the artist a megalomania that is the opposite of revolutionary. The tremors produced by a few expanses of tone or by the juxtaposition of colors and shapes purposely brought to the verge of bad taste in the manner of Park Avenue shop windows are sufficient cataclysms in many of these happy overthrows of Art. The mystical dissociation of painting as an ineffable event has made it common to mistake for an act the mere sensation of having acted—or of having been acted upon. Since there is nothing to be "communicated," a unique signature comes to seem the equivalent of a new plastic language. In a single stroke the painter exists as a Somebody—at least on a wall. That this Somebody is not he seems beside the point.

Once the difficulties that belong to a real act have been evaded by mysticism, the artist's experience of transformation is at an end. In that case what is left? Or to put it differently: What is a painting that is not an object nor the representation of an object nor the analysis or impression of it nor whatever else a painting has ever been—and that has also ceased to be the emblem of a personal struggle? It is the painter himself changed into a ghost inhabiting The Art World. Here the common phrase, "I have bought an O" (rather than a painting by O) becomes literally true. The man who started to remake himself has made himself into a commodity with a trademark.

MILIEU: THE BUSY NO-AUDIENCE

We said that the new painting calls for a new kind of criticism, one that would distinguish the specific qualities of each artist's act.

Unhappily for an art whose value depends on the authenticity of its mysteries, the new movement appeared at the same moment that Modern Art *en masse* "arrived" in America: Modern architecture, not only for sophisticated homes, but for corporations, municipalities, synagogues; Modern furniture and crockery in mail-order catalogues; Modern vacuum cleaners, can openers; beer ad "mobiles"—along with reproductions and articles on advanced painting in big-circulation magazines. *Enigmas for everybody.* Art in America today is not only nouveau, it's news.

The new painting came into being fastened to Modern Art and without intellectual allies—in literature everything had found its niche.

From this isolated liaison it has derived certain superstitions comparable to those of a wife with a famous husband. Superiorities, supremacies even, are taken for granted. It is boasted that modern painting in America is not only original but an "advance" in world art (at the same time that one says "to hell with world art").

Everyone knows that the label Modern Art no longer has any relation to the words that compose it. To be Modern Art a work need not be either modern or art; it need not even be a work. A three-thousand-year-old mask from the South Pacific qualifies as Modern and a piece of wood found on a beach becomes Art.

When they find this out, some people grow extremely enthusiastic, even, oddly enough, proud of themselves; others become infuriated.

These reactions suggest what Modern Art actually is. It is not a certain kind of art object. It is not even a style. It has nothing to do either with the period when a thing was made or with the intention of the maker. It is something that someone has had the power to designate as psychologically, aesthetically, or ideologically relevant to our epoch. The question of the driftwood is: *Who* found it?

Modern Art in America represents a revolution of taste—and serves to identify power of the caste conducting that revolution. Responses to Modern Art are primarily responses to claims to social leadership. For this reason Modern Art is periodically attacked as snobbish, Red, immoral, etc., by established interests in society, politics, the church. Comedy of a revolution that restricts itself to weapons of taste—and which at the same time addresses itself to the masses: Modern-design fabrics in bargain basements, Modern interiors for office girls living alone, Modern milk bottles.

Modern Art is educational, not with regard to art but with regard to life. You cannot explain Mondrian's painting to people who don't know anything about Vermeer, but you can easily explain the social importance of admiring Mondrian and forgetting about Vermeer.

Through Modern Art the expanding caste of professional enlighteners of the masses—designers, architects, decorators, fashion people, exhibition directors—informs the populace that a supreme Value has emerged in our time, the Value of the NEW, and that there are persons and things that embody that Value. This Value is a completely fluid one. As we have seen, Modern Art does not have to be actually new; it only has to be new to *somebody*—to the last lady who found out about the driftwood—and to win neophytes is the chief interest of the caste.

Since the only thing that counts for Modern Art is that a work shall be *new*, and since the question of its newness is determined not by analysis but by social power and pedagogy, the vanguard painter functions in a milieu utterly indifferent to the content of his work.

Unlike the art of nineteenth-century America, advanced paintings today are not bought by the middle class. Nor are they by the populace. Considering the degree to which it is publicized and feted, vanguard painting is hardly bought at all. It is *used* in its totality as material for educational and profit-making enterprises: color reproductions, design adaptations, human-interest stories. Despite the fact that more people see and hear about works of art than ever before, the vanguard artist has an audience of nobody. An interested individual here and there, but no audience. He creates in an environment not of people but of functions. His paintings are employed, not wanted. The public for whose edification he is periodically trotted out accepts the choices made for it as phenomena of The Age of Queer Things.

An action is not a matter of taste.

You don't let taste decide the firing of a pistol or the building of a maze.

As the Marquis de Sade understood, even experiments in sensation, if deliberately repeated, presuppose a morality.

To see in the explosion of shrapnel over No Man's Land only the opening of a flower of flame, Marinetti had to erase the moral premises of the act of destruction—as Molotov did explicitly when he said that Fascism is a matter of taste. Both M's were, of course, speaking the driftwood language of the Modern Art International.

Limited to the aesthetics, the taste bureaucracies of Modern Art cannot grasp the human experience involved in the new action paintings. One work is equivalent to another on the basis of resemblances of surface, and the movement as a whole a modish addition to twentieth-century picture making. Examples in every style are packed side by side in annuals and in the heads of newspaper reviewers like canned meats in a chain store—all standard brands.

To counteract the obtuseness, venality, and aimlessness of the Art World, American vanguard art needs a genuine audience—not just a market. It needs understanding—not just publicity.

In our form of society, audience and understanding for advanced painting have been produced, both here and abroad, first of all by the tiny circle of poets, musicians, theoreticians, men of letters, who have sensed in their own work the presence of the new creative principle.

So far, the silence of American literature on the new painting all but amounts to a scandal.

Alfred H. Barr Jr.
The New American Painting (1959)

As the first director of the Museum of Modern Art in New York, Alfred H. Barr Jr. was instrumental in bringing European abstract painting to an American audience from 1929 (when the museum was founded) through the 1930s. After World War II, Barr became an influential champion of American developments in abstract painting. This essay was originally published in the exhibition catalog for *The New American Painting as Shown in Eight European Countries 1958–1959,* which was published by the Museum of Modern Art in 1959 to correspond with the traveling show of the same name. By the time this exhibition was organized, the critical language surrounding Abstract Expressionism was firmly in place. Throughout the late 1940s and early 1950s, exhibitions at the few New York galleries that promoted abstract art, including Peggy Guggenheim's Art of This Century gallery and the Betty Parsons Gallery, along with the writing of critics, gave solidity to the differing sensibilities of these painters. By the mid-1950s many of the artists were at the peaks of their careers and the time was right for a triumphant tour of Europe that could solidify the prominence of American painting in the postwar years.

This essay begins by asserting the individuality of the artists included in the show. It is hard not to see this emphasis on the freedom of individual expression without thinking of the fact that the lines had been clearly drawn in Europe between communism and capitalism and that America was generally regarded as the bastion of freedom and individualism. Ironically both the artists and the critics continued to reiterate the notion that, as Barr puts it, the artists "defiantly reject the conventional values of the society that surrounds them." In the 1950s notions like freedom and individualism could not help but become entangled in political rhetoric. This calls into question the level to which an artist's work can be removed from society.

We are now committed to an unqualified act, not illustrating outworn myths or contemporary alibis. One must accept total responsibility for what he executes.
 Clyfford Still, 1952

Voyaging into the night, one knows not where, on an unknown vessel, an absolute struggle with the elements of the real.
 Robert Motherwell

There is no more forthright a declaration, and no shorter a path to man's richness, nakedness and poverty than the painting he does. Nothing can be hidden on its surface—the least private as well as the most personal of worlds.

James Brooks, 1956

Art never seems to make me peaceful or pure. . . . I do not think . . . of art as a situation of comfort.

Willem de Kooning, 1951

The need is for felt experience—intense, immoderate, direct, subtle, unified, warm, vivid, rhythmic.

Robert Motherwell, 1951

Subject is crucial and only that subject matter is crucial which is tragic and timeless.

Mark Rothko

What happens on the canvas is unpredictable and surprising to me. . . . As I work, or when the painting is finished, the subject reveals itself.

William Baziotes, 1952

Usually I am on a work for a long stretch, until a moment arrives when the air of the arbitrary vanishes and the paint falls into positions that feel destined. . . . To paint is a possessing rather than a picturing.

Philip Guston, 1956

The function of the artist is to make actual the spiritual so that it is there to be possessed.

Robert Motherwell

Of the seventeen painters in this exhibition, none speaks for the others any more than he paints for the others. In principle their individualism is as uncompromising as that of the religion of Kierkegaard whom they honor. For them, John Donne to the contrary, each man is an island.

Though a painter's words about his art are not always to be taken at face value, the quotations preceding this preface—like the statements printed further on—suggest that these artists share certain strong convictions. Many feel that their painting is a stubborn, difficult, even desperate effort to discover the "self" or "reality," an effort to which the whole personality should be recklessly committed: *I paint, therefore I am.* Confronting a blank canvas they attempt "to grasp authentic being by action, decision, a leap of faith," to use Karl Jaspers' Existentialist phrase.

Indeed one often hears Existentialist echoes in their words, but their "anxiety," their "commitment," their "dreadful freedom" concern their work primarily. They defiantly reject the conventional values of the society which surrounds them, but they are not politically *engagés* even though their paintings have been praised and condemned as symbolic demonstrations of freedom in a world in which freedom connotes a political attitude.

In recent years, some of the painters have been impressed by the Japanese Zen philosophy with its transcendental humor and its exploration of the self through intuition. Yet, though Existentialism and Zen have afforded some encouragement and sanction to the artists, their art itself has been affected only sporadically by these philosophies (by contrast with that of the older painter, Mark Tobey, whose abstract painting has been deeply and directly influenced by Tao and Zen).

Surrealism, both philosophically and technically, had a more direct effect upon the painting of the group. Particularly in the early days of the movement, during the war, several painters were influenced by André Breton's program of "pure psychic automatism . . . in the absence of all control exercised by reason and outside of all aesthetic and moral preoccupation." Automatism was, and still is, widely used as a technique but rarely without some control or subsequent revision. And from the first, Breton's dependence upon Freudian and Marxian sanctions seems less relevant than Jung's concern with myth and archaic symbol.

The artists in the exhibition comprise the central core as well as the major marginal talent in the movement now generally called "Abstract Expressionism" or, less commonly, "Action Painting." Both terms were considered as titles for this exhibition.

Abstract Expressionism, a phrase used ephemerally in Berlin in 1919, was re-invented (by the writer) about 1929 to designate Kandinsky's early abstractions that in certain ways do anticipate the American movement—to which the term was first applied in 1946. However, almost to a man, the painters in this show deny that their work is "abstract," at least in any pure, programmatic sense; and they rightly reject any significant association with German Expressionism, a movement recently much exhibited in America.

Action Painting, a phrase proposed in preference to Abstract Expressionism by the poet-critic, Harold Rosenberg, in an important article* published in 1952, now seems to overemphasize the physical act of painting. Anyway, these artists dislike labels and shun the words "movement" and "school."

The briefest glance around the exhibition reveals a striking variety among the paintings. How could canvases differ more in form than do Kline's broad, slashing blacks from Rothko's dissonant mists, or Pollock's Dionysiac *perpetuum mobile* from Newman's single, obsessive, vertical line? What then unites these paintings?

First, their size. Painted at arm's length, with large gestures, they challenge both the painter and the observer. They envelop the eye, they seem immanent. They are often as big as mural paintings, but their scale as well as their lack of illusionistic depth are only coincidentally related to architectural decoration. Their flatness is, rather, a consequence of the artist's concern with the actual painting process as his prime instrument of expression,

*Harold Rosenberg, "American Action Painters," *Art News*, Vol. 51, December 1952.

a concern which also tends to eliminate imitative suggestion of the forms, textures, colors and spaces of the real world, since these might compete with the primary reality of paint on canvas.

As a consequence, rather than by intent, most of the paintings seem abstract. Yet they are never formalistic or non-objective in spirit. Nor is there (in theory) any preoccupation with the traditional aesthetics of "plastic values," composition, quality of line, beauty of surface, harmony of color. When these occur in the paintings—and they often do—it is the result of a struggle for order almost as intuitive as the initial chaos with which the paintings begin.

Despite the high degree of abstraction, the painters insist that they are deeply involved with subject matter or content. The content, however, is never explicit or obvious even when recognizable forms emerge, as in certain paintings by de Kooning, Baziotes, and Gottlieb. Rarely do any conscious associations explain the emotions of fear, gaiety, anger, violence, or tranquillity which these paintings transmit or suggest.

In short these painters, as a matter of principle, do nothing deliberately in their work to make "communication" easy. Yet in spite of their intransigence, their following increases, largely because the paintings themselves have a sensuous, emotional, aesthetic and at times almost mystical power which works and can be overwhelming.

The movement began some fifteen years ago in wartime New York. American painting in the early 1940s was bewilderingly varied and without dominant direction. The "old masters" such as John Marin, Edward Hopper, Max Weber, Stuart Davis, were more than holding their own. The bumptious Mid-Western regionalism of the 1930s, though still noisy, was dying along with its political analogue, "America First" isolationism. Most of the artists who during the decade of the Great Depression had been naïvely attracted by Communism had grown disillusioned both with the machinations of the party and with Socialist Realism. There were romantic realists who looked back nostalgically to the early nineteenth century, and "magic realists," and painters of the social scene such as the admirable Ben Shahn. The young Boston expressionists Hyman Bloom and Jack Levine had considerable success in New York, while from the Pacific coast came the visionary art of Mark Tobey and Morris Graves, reflecting Oriental influence in spirit and technique. There was also a lively interest in modern primitives, but no one discovered an American *douanier* Rousseau.

Late in the artistically reactionary 1930s, the American Abstract Artists group had stood firm along with their allies, *Abstraction-Création* in Paris and Unit One in England. Working principally in rather dry cubist or non-objective styles, they did not seem much affected by the arrival in the United States of Léger, Mondrian and several Bauhaus masters. Quite other young painters, not yet identified as a group, were, however, strongly influenced by the surrealist refugees from the war, notably Max Ernst, André Masson, Marcel Duchamp (who had been the leader of New York Dadaism during World

War I), the poet André Breton, and the young Chilean-Parisian painter Matta Echaurren. Equally important was the influence of the former surrealist associates, Picasso, Miró and Arp, who had stayed in Europe.

Chief among the supporters of the surrealist group in New York was Peggy Guggenheim, whose gallery, "Art of This Century," opened in the autumn of 1942 and served as the principal center of the *avant-garde* in American painting until the founder returned to Europe in 1947. Her brilliant pioneering was then carried on by the new galleries of Betty Parsons, Charles Egan and Sam Kootz. "Art of This Century" gave one-man shows to Motherwell, Baziotes, Rothko and Still, and no less than four to Jackson Pollock. Arshile Gorky, the most important early master of the movement, showed at another (and prior) surrealist center, the Julien Levy Gallery, with the poetic blessing of Breton.

The work of certain older American painters, notably Ryder, Marin and Dove, interested some of the artists, and for a time Rothko, Pollock, Gottlieb and Still were influenced by the symbolic imagery of primitive art, especially of the American north-west coast. All during this early period and afterwards, Hans Hofmann, a Parisian-trained German of Picasso's generation, taught the young inspiringly and became their *doyen* colleague, though with little obvious effect on the leaders.

Before 1950 most of the artists in this show had hit their stride. And they had won general, though usually reluctant, recognition as the flourishing vanguard of American painting, thanks to the courageous dealers just mentioned, enthusiastic critics such as Clement Greenberg, a handful of editors, teachers, collectors, and museum officials, and above all to their own extraordinary energy, talent, and fortitude.

They were not, however, a compact phalanx. Gorky had been a quite well-known but rather derivative painter for fifteen years before he found himself about 1943. Pollock and Baziotes, both born in 1912, worked in obscurity until 1942–1943, when they emerged along with the youthful and articulate Motherwell. Pollock exhibited his first highly abstract pictures about 1945 and invented his "drip" technique in 1947. [Exhibitions early in 1959 confirmed that Pollock had painted abstract expressionist paintings as early as 1937; and that Hofmann was using a drip technique as early as 1940.] By 1947, Rothko and Still, working some of the time in California, were developing their characteristic styles; Gottlieb was turning away from his "pictographic" forms; and Stamos, twenty years younger than they, had had his first show. In 1948, de Kooning, then forty-four, publicly entered the movement and quickly became a major figure; Tomlin was nearly fifty. Kline, Newman, Brooks and Guston, all mature painters, also transformed their art, Guston after having relinquished a brilliant success in a more realistic style. Since 1950, hundreds upon hundreds of American artists have turned to "abstract expressionism," some of them, like Tworkov, in mid-career, others like Hartigan and Francis while they were still students. Sam Francis is unique as

the only expatriate in the show and the only painter whose reputation was made without benefit of New York, having moved directly to Paris from San Francisco where Still and Rothko had been honored and influential teachers. Sculptors related to, and sometimes closely allied with, the painters' movement should be mentioned, notably Herbert Ferber, David Hare, Ibram Lassaw, Seymour Lipton, Theodore Roszak and David Smith.

The movement, after several tentative early years, has flourished in its maturity since about 1948, roughly the starting point of this show. Naturally, because of its dominance, it has aroused much resistance in the United States among other artists and the public, but it has excited widespread interest and even influenced the painting of some of its most stubborn adversaries. Others are staunchly resisting what has inevitably become fashionable. There will be reactions and counter-revolutions—and some are already evident. Fortunately, the undogmatic variety and flexibility inherent in the movement permits divergence even among the leaders; a few years ago, for instance, both Pollock and de Kooning painted a number of pictures with recognizable figures, to the dismay of some of their followers who had been inclined to make an orthodoxy of abstraction.

For over a dozen years now, works by some of these artists have been shown abroad, first in Europe, then in Latin America and the Orient. They have met with controversy but also with enthusiasm, thanks in part to artists working along similar lines, and to other champions.

To have written a few words of introduction to this exhibition is an honor for an American who has watched with deep excitement and pride the development of the artists here represented, their long struggle—with themselves even more than with the public—and their present triumph.

Context

C. G. Jung
The Spiritual Problem of Modern Man (1933)

Although the Swiss-born psychotherapist and writer C. G. Jung wrote "The Spiritual Problem of Modern Man" before World War II, this essay discusses many of the themes of alienation that preoccupied American artists and writers after the war. For Jung, materialist European culture did not offer humanity the spiritual support

"The Spiritual Problem of Modern Man," from *Modern Man in Search of a Soul* by C. G. Jung, reprinted by permission of Harcourt, Inc.

it needed for a healthy psychic life. Modern man is essentially alone in the world, and because of this he needs to understand his own internal workings as a way to connect to his spiritual self. Jung says, "Indeed, he [man] is completely modern only when he has come to the very edge of the world, leaving behind him all that has been discarded and outgrown, and acknowledging that he stands before a void out of which all things may grow." Harold Rosenberg echoes this notion close to twenty years later in his essay "The American Action Painters" when he states that "the lone artist did not want the world to be different, he wanted his canvas to be a world."

Jung's discussion of man's need for deep psychic meaning and his realization that this meaning could only come from a process of self-understanding unconnected to larger religious, political, or social institutions is also strangely similar to the writings of Pollock and Rothko. These connections are not coincidental. Pollock underwent periods of Jungian psychoanalysis and Rothko's interest in the universal implications of myth parallel Jung's notion of the collective unconscious. The English translation of this essay first appeared in 1933 in the book *Modern Man in Search of a Soul.*

The spiritual problem of modern man is one of those questions which belong so intimately to the present in which we are living that we cannot judge of them fully. The modern man is a newly formed human being; a modern problem is a question which has just arisen and whose answer lies in the future. In speaking, therefore, of the spiritual problem of modern man we can at most state a question—and we should perhaps put this statement in different terms if we had but the faintest inkling of the answer. The question, moreover, seems rather vague; but the truth is that it has to do with something so universal that it exceeds the grasp of any single human being. We have reason enough, therefore, to approach such a problem with true moderation and with the greatest caution. I am deeply convinced of this, and wish it stressed the more because it is just such problems which tempt us to use high-sounding words—and because I shall myself be forced to say certain things which may sound immoderate and incautious.

To begin at once with an example of such apparent lack of caution, I must say that the man we call modern, the man who is aware of the immediate present, is by no means the average man. He is rather the man who stands upon a peak, or at the very edge of the world, the abyss of the future before him, above him the heavens, and below him the whole of mankind with a history that disappears in primeval mists. The modern man—or, let us say again, the man of the immediate present—is rarely met with. There are few who live up to the name, for they must be conscious to a superlative degree. Since to be wholly of the present means to be fully conscious of one's existence as a man, it requires the most intensive and extensive consciousness, with a minimum of unconsciousness. It must be dearly understood that the mere fact of living in the present does not make a man modern, for in

that case everyone at present alive would be so. He alone is modern who is fully conscious of the present.

The man whom we can with justice call "modern" is solitary. He is so of necessity and at all times, for every step towards a fuller consciousness of the present removes him further from his original *"participation mystique"* with the mass of men—from submersion in a common unconsciousness. Every step forward means an act of tearing himself loose from that all-embracing, pristine unconsciousness which claims the bulk of mankind almost entirely. Even in our civilizations the people who form, psychologically speaking, the lowest stratum, live almost as unconsciously as primitive races. Those of the succeeding stratum manifest a level of consciousness which corresponds to the beginnings of human culture, while those of the highest stratum have a consciousness capable of keeping step with the life of the last few centuries. Only the man who is modern in our meaning of the term really lives in the present; he alone has a present-day consciousness, and he alone finds that the ways of life which correspond to earlier levels pall upon him. The values and strivings of those past worlds no longer interest him save from the historical standpoint. Thus he has become "unhistorical" in the deepest sense and has estranged himself from the mass of men who live entirely within the bounds of tradition. Indeed, he is completely modern only when he has come to the very edge of the world, leaving behind him all that has been discarded and outgrown, and acknowledging that he stands before a void out of which all things may grow.

These words may be thought to be but empty sound, and their meaning reduced to mere banality. Nothing is easier than to affect a consciousness of the present. As a matter of fact, a great horde of worthless people give themselves the air of being modern by overleaping the various stages of development and the tasks of life they represent. They appear suddenly by the side of the truly modern man as uprooted human beings, bloodsucking ghosts, whose emptiness is taken for the unenviable loneliness of the modern man and casts discredit upon him. He and his kind, few in number as they are, are hidden from the undiscerning eyes of mass-men by those clouds of ghosts, the pseudo-moderns. It cannot be helped; the "modern" man is questionable and suspect, and has always been so, even in the past.

An honest profession of modernity means voluntarily declaring bankruptcy, taking the vows of poverty and chastity in a new sense, and—what is still more painful—renouncing the halo which history bestows as a mark of its sanction. To be "unhistorical" is the Promethean sin, and in this sense modern man lives in sin. A higher level of consciousness is like a burden of guilt. But, as I have said, only the man who has outgrown the stages of consciousness belonging to the past and has amply fulfilled the duties appointed for him by his world, can achieve a full consciousness of the present. To do this he must be sound and proficient in the best sense—a man who has

achieved as much as other people, and even a little more. It is these qualities which enable him to gain the next highest level of consciousness.

I know that the idea of proficiency is especially repugnant to the pseudo-moderns, for it reminds them unpleasantly of their deceits. This, however, cannot prevent us from taking it as our criterion of the modern man. We are even forced to do so, for unless he is proficient, the man who claims to be modern is nothing but an unscrupulous gambler. He must be proficient in the highest degree, for unless he can atone by creative ability for his break with tradition, he is merely disloyal to the past. It is sheer juggling to look upon a denial of the past as the same thing as consciousness of the present. "Today" stands between "yesterday" and "tomorrow," and forms a link between past and future; it has no other meaning. The present represents a process of transition, and that man may account himself modern who is conscious of it in this sense.

Many people call themselves modern—especially the pseudo-moderns. Therefore the really modern man is often to be found among those who call themselves old-fashioned. He takes this stand for sufficient reasons. On the one hand he emphasizes the past in order to hold the scales against his break with tradition and that effect of guilt of which I have spoken. On the other hand he wishes to avoid being taken for a pseudo-modern.

Every good quality has its bad side, and nothing that is good can come into the world without directly producing a corresponding evil. This is a painful fact. Now there is the danger that consciousness of the present may lead to an elation based upon illusion: the illusion, namely, that we are the culmination of the history of mankind, the fulfilment and the end-product of countless centuries. If we grant this, we should understand that it is no more than the proud acknowledgment of our destitution: we are also the disappointment of the hopes and expectations of the ages. Think of nearly two thousand years of Christian ideals followed, instead of by the return of the Messiah and the heavenly millennium, by the World War among Christian nations and its barbed-wire and poison-gas. What a catastrophe in heaven and on earth!

In the face of such a picture we may well grow humble again. It is true that modern man is a culmination, but tomorrow he will be surpassed; he is indeed the end-product of an age-old development, but he is at the same time the worst conceivable disappointment of the hopes of humankind. The modern man is aware of this. He has seen how beneficent are science, technology and organization, but also how catastrophic they can be. He has likewise seen that well-meaning governments have so thoroughly paved the way for peace on the principle "in time of peace prepare for war," that Europe has nearly gone to rack and ruin. And as for ideals, the Christian church, the brotherhood of man, international social democracy and the "solidarity" of economic interests have all failed to stand the baptism of fire—the test of reality. Today, fifteen years after the war, we observe once

more the same optimism, the same organization, the same political aspirations, the same phrases and catch-words at work. How can we but fear that they will inevitably lead to further catastrophes? Agreements to outlaw war leave us skeptical, even while we wish them all possible success. At bottom, behind every such palliative measure, there is a gnawing doubt. On the whole, I believe I am not exaggerating when I say that modern man has suffered an almost fatal shock, psychologically speaking, and as a result has fallen into profound uncertainty.

These statements, I believe, make it clear enough that my being a physician has colored my views. A doctor always spies out diseases, and I cannot cease to be a doctor. But it is essential to the physician's art that he should not discover diseases where none exist. I will therefore not make the assertion that the white races in general, and occidental nations in particular, are diseased, or that the Western world is on the verge of collapse. I am in no way competent to pass such a judgment.

It is of course only from my own experience with other persons and with myself that I draw my knowledge of the spiritual problem of modern man. I know something of the intimate psychic life of many hundreds of educated persons, both sick and healthy, coming from every quarter of the civilized, white world; and upon this experience I base my statements. No doubt I can draw only a one-sided picture, for the things I have observed are events of psychic life; they lie within us—on the *inner side,* if I may use the expression. I must point out that this is not always true of psychic life; the psyche is not always and everywhere to be found on the inner side. It is to be found on the *outside* in whole races or periods of history which take no account of psychic life as such. As examples we may choose any of the ancient cultures, but especially that of Egypt with its imposing objectivity and its naïve confession of sins that have not been committed.* We can no more feel the Pyramids and the Apis tombs of Sakkara to be expressions of personal problems or personal emotions, than we can feel this of the music of Bach.

Whenever there is established an external form, be it ritual or spiritual, by which all the yearnings and hopes of the soul are adequately expressed—as for instance in some living religion—then we may say that the psyche is outside, and no spiritual problem, strictly speaking, exists. In consonance with this truth, the development of psychology falls entirely within the last decades, although long before that man was introspective and intelligent enough to recognize the facts that are the subject-matter of psychology. The same was the case with technical knowledge. The Romans were familiar with all the mechanical principles and physical facts on the basis of which they could have constructed the steam-engine, but all that came of it was the

*According to Egyptian tradition, when the dead man meets his judges in the underworld, he makes a detailed confession of the crimes he has *not* committed, but leaves unmentioned his actual sins. (*Trans.*)

toy made by Hero of Alexandria. There was no urgent necessity to go further. It was the division of labor and specialization in the nineteenth century which gave rise to the need to apply all available knowledge. So also a spiritual need has produced in our time our "discovery" of psychology. There has never, of course, been a time when the psyche did not manifest itself, but formerly it attracted no attention—no one noticed it. People got along without heeding it. But today we can no longer get along unless we give our best attention to the ways of the psyche.

It was men of the medical profession who were the first to notice this; for the priest is concerned only to establish an undisturbed functioning of the psyche within a recognized system of belief. As long as this system gives true expression to life, psychology can be nothing but a technical adjuvant to healthy living, and the psyche cannot be regarded as a problem in itself. While man still lives as a herd-being he has no "things of the spirit" of his own; nor does he need any, save the usual belief in the immortality of the soul. But as soon as he has outgrown whatever local form of religion he was born to—as soon as this religion can no longer embrace his life in all its fullness—then the psyche becomes something in its own right which cannot be dealt with by the measures of the Church alone. It is for this reason that we of today have a psychology founded on experience, and not upon articles of faith or the postulates of any philosophical system. The very fact that we have such a psychology is to me symptomatic of a profound convulsion of spiritual life. Disruption in the spiritual life of an age shows the same pattern as radical change in an individual. As long as all goes well and psychic energy finds its application in adequate and well-regulated ways, we are disturbed by nothing from within. No uncertainty or doubt besets us, and we *cannot* be divided against ourselves. But no sooner are one or two of the channels of psychic activity blocked, than we are reminded of a stream that is dammed up. The current flows backward to its source; the inner man wants something which the visible man does not want, and we are at war with ourselves. Only then, in this distress, do we discover the psyche; or, more precisely, we come upon something which thwarts our will, which is strange and even hostile to us, or which is incompatible with our conscious standpoint. Freud's psychoanalytic labors show this process in the clearest way. The very first thing he discovered was the existence of sexually perverse and criminal fantasies which at their face value are wholly incompatible with the conscious outlook of a civilized man. A person who was activated by them would be nothing less than a mutineer, a criminal or a madman.

We cannot suppose that this aspect of the unconscious or of the hinterland of man's mind is something totally new. Probably it has always been there, in every culture. Each culture gave birth to its destructive opposite, but no culture or civilization before our own was ever forced to take these psychic undercurrents in deadly earnest. Psychic life always found expression in a metaphysical system of some sort. But the conscious, modern man,

despite his strenuous and dogged efforts to do so, can no longer refrain from acknowledging the might of psychic forces. This distinguishes our time from all others. We can no longer deny that the dark stirrings of the unconscious are effective powers—that psychic forces exist which cannot, for the present at least, be fitted in with our rational world-order. We have even enlarged our study of these forces to a science—one more proof of the earnest attention we bring to them. Previous centuries could throw them aside unnoticed; for us they are a shirt of Nessus which we cannot strip off.

The revolution in our conscious outlook, brought about by the catastrophic results of the World War, shows itself in our inner life by the shattering of our faith in ourselves and our own worth. We used to regard foreigners—the other side—as political and moral reprobates; but the modern man is forced to recognize that he is politically and morally just like anyone else. Whereas I formerly believed it to be my bounden duty to call other persons to order, I now admit that I need calling to order myself. I admit this the more readily because I realize only too well that I am losing my faith in the possibility of a rational organization of the world, that old dream of the millennium, in which peace and harmony should rule, has grown pale. The modern man's skepticism regarding all such matters has chilled his enthusiasm for politics and world-reform; more than that, it does not favor any smooth application of psychic energies to the outer world. Through his skepticism the modern man is thrown back upon himself; his energies flow towards their source and wash to the surface those psychic contents which are at all times there, but lie hidden in the silt as long as the stream flows smoothly in its course. How totally different did the world appear to medieval man! For him the earth was eternally fixed and at rest in the center of the universe, encircled by the course of a sun that solicitously bestowed its warmth. Men were all children of God under the loving care of the Most High, who prepared them for eternal blessedness; and all knew exactly what they should do and how they should conduct themselves in order to rise from a corruptible world to an incorruptible and joyous existence. Such a life no longer seems real to us, even in our dreams. Natural science has long ago torn this lovely veil to shreds. That age lies as far behind as childhood, when one's own father was unquestionably the handsomest and strongest man on earth.

The modern man has lost all the metaphysical certainties of his medieval brother, and set up in their place the ideals of material security, general welfare and humaneness. But it takes more than an ordinary dose of optimism to make it appear that these ideals are still unshaken. Material security, even, has gone by the board, for the modern man begins to see that every step in material "progress" adds just so much force to the threat of a more stupendous catastrophe. The very picture terrorizes the imagination. What are we to imagine when cities today perfect measures of defense against poison-gas attacks, and practice them in "dress rehearsals"? We cannot but suppose that such attacks have been planned and provided for—

again on the principle "in time of peace prepare for war." Let man but accu-
mulate his materials of destruction and the devil within him will soon be un-
able to resist putting them to their fated use. It is well known that fire-arms
go off of themselves if only enough of them are together.

An intimation of the law that governs blind contingency, which Hera-
clitus called the rule of *enantiodromia* (conversion into the opposite), now
steals upon the modern man through the by-ways of his mind, chilling him
with fear and paralyzing his faith in the lasting effectiveness of social and
political measures in the face of these monstrous forces. If he turns away
from the terrifying prospect of a blind world in which building and destroy-
ing successively tip the scale, and if he then turns his gaze inward upon
the recesses of his own mind, he will discover a chaos and a darkness there
which he would gladly ignore. Science has destroyed even the refuge of the
inner life. What was once a sheltering haven has become a place of terror.

And yet it is almost a relief for us to come upon so much evil in the
depths of our own minds. We are able to believe, at least, that we have dis-
covered the root of the evil in mankind. Even though we are shocked and
disillusioned at first, we yet feel, because these things are manifestations of
our own minds, that we hold them more or less in our own hands and can
therefore correct or at least effectively suppress them. We like to assume that,
if we succeeded in this, we should have rooted out some fraction of the evil
in the world. We like to think that, on the basis of a widespread knowledge
of the unconscious and its ways, no one could be deceived by a statesman
who was unaware of his own bad motives; the very newspapers would pull
him up: "Please have yourself analyzed; you are suffering from a repressed
father-complex."

I have purposely chosen this grotesque example to show to what ab-
surdities we are led by the illusion that because something is psychic it is
under our control. It is, however, true that much of the evil in the world is
due to the fact that man in general is hopelessly unconscious, as it is also true
that with increasing insight we can combat this evil at its source in ourselves.
As science enables us to deal with injuries inflicted from without, so it helps
us to treat those arising from within.

The rapid and world-wide growth of a "psychological" interest over the
last two decades shows unmistakably that modern man has to some extent
turned his attention from material things to his own subjective processes.
Should we call this mere curiosity? At any rate, art has a way of anticipating
future changes in man's fundamental outlook, and expressionist art has taken
this subjective turn well in advance of the more general change.

This "psychological" interest of the present time shows that man ex-
pects something from psychic life which he has not received from the outer
world: something which our religions, doubtless, ought to contain, but no
longer do contain—at least for the modern man. The various forms of religion

no longer appear to the modern man to come from within—to be expressions of his own psychic life; for him they are to be classed with the things of the outer world. He is vouchsafed no revelation of a spirit that is not of this world; but he tries on a number of religions and convictions as if they were Sunday attire, only to lay them aside again like worn-out clothes.

Yet he is somehow fascinated by the almost pathological manifestations of the unconscious mind. We must admit the fact, however difficult it is for us to understand, that something which previous ages have discarded should suddenly command our attention. That there is a general interest in these matters is a truth which cannot be denied. Their offense to good taste notwithstanding. I am not thinking merely of the interest taken in psychology as a science, or of the still narrower interest in the psychoanalysis of Freud, but of the widespread interest in all sorts of psychic phenomena as manifested in the growth of spiritualism, astrology, theosophy, and so forth. The world has seen nothing like it since the end of the seventeenth century. We can compare it only to the flowering of Gnostic thought in the first and second centuries after Christ. The spiritual currents of the present have, in fact, a deep affinity with Gnosticism. There is even a Gnostic church in France today, and I know of two schools in Germany which openly declare themselves Gnostic. The modern movement which is numerically most impressive is undoubtedly Theosophy, together with its continental sister, Anthroposophy; these are pure Gnosticism in a Hindu dress. Compared with these movements the interest in scientific psychology is negligible. What is striking about Gnostic systems is that they are based exclusively upon the manifestations of the unconscious, and that their moral teachings do not balk at the shadow-side of life. Even in the form of its European revival, the Hindu *Kundalini-Yoga* shows this clearly. And as every person informed on the subject of occultism will testify, the statement holds true in this field as well.

The passionate interest in these movements arises undoubtedly from psychic energy which can no longer be invested in obsolete forms of religion. For this reason such movements have a truly religious character, even when they pretend to be scientific. It changes nothing when Rudolf Steiner calls his Anthroposophy "spiritual science," or Mrs. Eddy discovers a "Christian Science." These attempts at concealment merely show that religion has grown suspect—almost as suspect as politics and world-reform.

I do not believe that I am going too far when I say that modern man, in contrast to his nineteenth-century brother, turns his attention to the psyche with very great expectations; and that he does so without reference to any traditional creed, but rather in the Gnostic sense of religious experience. We should be wrong in seeing mere caricature or masquerade when the movements already mentioned try to give themselves scientific airs; their doing so is rather an indication that they are actually pursuing "science" or knowledge instead of the *faith* which is the essence of Western religions. The modern man

abhors dogmatic postulates taken on faith and the religions based upon them. He holds them valid only in so far as their knowledge-content seems to accord with his own experience of the depths of psychic life. He wants to know—to experience for himself. Dean Inge of St. Paul's has called attention to a movement in the Anglican Church with similar objectives.

The age of discovery has only just come to a close in our day when no part of the earth remains unexplored; it began when men would no longer *believe* that the Hyperboreans inhabited the land of eternal sunshine, but wanted to find out and to see with their own eyes what existed beyond the boundaries of the known world. Our age is apparently bent on discovering what exists in the psyche outside of consciousness. The question asked in every spiritualistic circle is: What happens when the medium has lost consciousness? Every Theosophist asks: What shall I experience at higher levels of consciousness? The question which every astrologer puts is this: What are the effective forces and determinants of my fate beyond the reach of my conscious intention? And every psychoanalyst wants to know: What are the unconscious drives behind the neurosis?

Our age wishes to have actual experiences in psychic life. It wants to experience for itself, and not to make assumptions based on the experience of other ages. Yet this does not preclude its trying anything in a hypothetical way—for instance, the recognized religions and the genuine sciences. The European of yesterday will feel a slight shudder run down his spine when he gazes at all deeply into these delvings. Not only does he consider the subject of this research all too obscure and uncanny, but even the methods employed seem to him a shocking misuse of man's finest intellectual attainments. What can we expect an astronomer to say when he is told that at least a thousand horoscopes are drawn today to one three hundred years ago? What will the educator and the advocate of philosophical enlightenment say to the fact that the world has not been freed of one single superstition since Greek antiquity? Freud himself, the founder of psychoanalysis, has thrown a glaring light upon the dirt, darkness and evil of the psychic hinterland, and has presented these things as so much refuse and slag; he has thus taken the utmost pains to discourage people from seeking anything behind them. He did not succeed, and his warning has even brought about the very thing he wished to prevent: it has awakened in many people an admiration for all this filth. We are tempted to call this sheer perversity; and we could hardly explain it save on the ground that it is not a love of dirt, but the fascination of the psyche, which draws these people.

There can be no doubt that from the beginning of the nineteenth century—from the memorable years of the French Revolution onwards—man has given a more and more prominent place to the psyche, his increasing attentiveness to it being the measure of its growing attraction for him. The enthronement of the Goddess of Reason in Nôtre Dame seems to have been a

symbolic gesture of great significance to the Western world—rather like the hewing down of Wotan's oak by the Christian missionaries. For then, as at the Revolution, no avenging bolt from heaven struck the blasphemer down.

It is certainly more than an amusing coincidence that just at that time a Frenchman, Anquetil du Perron, was living in India, and, in the early eighteen-hundreds, brought back with him a translation of the *Oupnek'hat*—a collection of fifty *Upanishads*—which gave the Western world its first deep insight into the baffling mind of the East. To the historian this is mere chance without any factors of cause and effect. But in view of my medical experience I cannot take it as accident. It seems to me rather to satisfy a psychological law whose validity in personal life, at least, is complete. For every piece of conscious life that loses its importance and value—so runs the law—there arises a compensation in the unconscious. We may see in this an analogy to the conservation of energy in the physical world, for our psychic processes have a quantitative aspect also. No psychic value can disappear without being replaced by another of equivalent intensity. This is a rule which finds its pragmatic sanction in the daily practice of the psychotherapist; it is repeatedly verified and never fails. Now the doctor in me refuses point blank to consider the life of a people as something that does not conform to psychological law. A people, in the doctor's eyes, presents only a somewhat more complex picture of psychic life than the individual. Moreover, taking it the other way round, has not a poet spoken of the "nations" of his soul? And quite correctly, as it seems to me, for in one of its aspects the psyche is not individual, but is derived from the nation, from collectivity, or from humanity even. In some way or other we are part of an all-embracing psychic life, of a single "greatest" man, to quote Swedenborg.

And so we can draw a parallel: just as in me, a single human being, the darkness calls forth the helpful light, so does it also in the psychic life of a people. In the crowds that poured into Nôtre Dame, bent on destruction, dark and nameless forces were at work that swept the individual off his feet; these forces worked also upon Anquetil du Perron, and provoked an answer which has come down in history. For he brought the Eastern mind to the West, and its influence upon us we cannot as yet measure. Let us beware of underestimating it! So far, indeed, there is little of it to be seen in Europe on the intellectual surface: some orientalists, one or two Buddhist enthusiasts, and a few somber celebrities like Madame Blavatsky and Annie Besant. These manifestations make us think of tiny, scattered islands in the ocean of mankind; in reality they are like the peaks of submarine mountain-ranges of considerable size. The Philistine believed until recently that astrology had been disposed of long since, and was something that could be safely laughed at. But today, rising out of the social deeps, it knocks at the doors of the universities from which it was banished some three hundred years ago. The same is true of the thought of the East; it takes root in the lower social levels

and slowly grows to the surface. Where did the five or six million Swiss francs for the Anthroposophist temple at Dornach come from? Certainly not from one individual. Unfortunately there are no statistics to tell us the exact number of avowed Theosophists today, not to mention the unavowed. But we can be sure that there are several millions of them. To this number we must add a few million Spiritualists of Christian or Theosophic leanings.

Great innovations never come from above; they come invariably from below; just as trees never grow from the sky downward, but upward from the earth, however true it is that their seeds have fallen from above. The upheaval of our world and the upheaval in consciousness is one and the same. Everything becomes relative and therefore doubtful. And while man, hesitant and questioning, contemplates a world that is distracted with treaties of peace and pacts of friendship, democracy and dictatorship, capitalism and Bolshevism, his spirit yearns for an answer that will allay the turmoil of doubt and uncertainty. And it is just people of the lower social levels who follow the unconscious forces of the psyche; it is the much-derided, silent folk of the land—those who are less infected with academic prejudices than great celebrities are wont to be. All these people, looked at from above, present mostly a dreary or laughable comedy; and yet they are as impressively simple as those Galileans who were once called blessed. Is it not touching to see the refuse of man's psyche gathered together in compendia a foot thick? We find recorded in *Anthropophyteia* with scrupulous care the merest babblings, the most absurd actions and the wildest fantasies, while men like Havelock Ellis and Freud have dealt with the like matters in serious treatises which have been accorded all scientific honors. Their reading public is scattered over the breadth of the civilized, white world. How are we to explain this zeal, this almost fanatical worship of repellent things? In this way: the repellent things belong to the psyche, they are of the substance of the psyche and therefore as precious as fragments of manuscript salvaged from ancient ruins. Even the secret and noisome things of the inner life are valuable to modern man because they serve his purpose. But what purpose?

Freud has prefixed to his *Interpretation of Dreams* the citation: *Flectere si nequeo superos Acheronta movebo*—"If I cannot bend the gods on high, I will at least set Acheron in uproar." But to what purpose?

The gods whom *we* are called to dethrone are the idolized values of our conscious world. It is well known that it was the love-scandals of the ancient deities which contributed most to their discredit; and now history is repeating itself. People are laying bare the dubious foundations of our belauded virtues and incomparable ideals, and are calling out to us in triumph: "There are your man-made gods, mere snares and delusions tainted with human baseness—whited sepulchers full of dead men's bones and of all uncleanness." We recognize a familiar strain, and the Gospel words, which we never could make our own, now come to life again.

I am deeply convinced that these are not vague analogies. There are too many persons to whom Freudian psychology is dearer than the Gospels, and to whom the Russian Terror means more than civic virtue. And yet all these people are our brothers, and in each of us there is at least *one* voice which seconds them—for in the end there is a psychic life which embraces us all.

The unexpected result of this spiritual change is that an uglier face is put upon the world. It becomes so ugly that no one can love it any longer—we cannot even love ourselves—and in the end there is nothing in the outer world to draw us away from the reality of the life within. Here, no doubt, we have the true significance of this spiritual change. After all, what does Theosophy, with its doctrines of *karma* and reincarnation, seek to teach except that this world of appearance is but a temporary health-resort for the morally unperfected? It depreciates the present-day world no less radically than does the modern outlook, but with the help of a different technique; it does not vilify our world, but grants it only a relative meaning in that it promises other and higher worlds. The result is in either case the same.

I grant that all these ideas are extremely "unacademic," the truth being that they touch modern man on the side where he is least conscious. Is it again a mere coincidence that modern thought has had to come to terms with Einstein's relativity theory and with ideas about the structure of the atom which lead us away from determinism and visual representation? Even physics volatilizes our material world. It is no wonder, then, in my opinion, if the modern man falls back upon the reality of psychic life and expects from it that certainty which the world denies him.

But spiritually the Western world is in a precarious situation—and the danger is greater the more we blind ourselves to the merciless truth with illusions about our beauty of soul. The Occidental burns incense to himself, and his own countenance is veiled from him in the smoke. But how do we strike men of another color? What do China and India think of us? What feelings do we arouse in the black man? And what is the opinion of all those whom we deprive of their lands and exterminate with rum and venereal disease?

I have a Red Indian friend who is the governor of a pueblo. When we were once speaking confidentially about the white man, he said to me: "We don't understand the whites; they are always wanting something—always restless—always looking for something. What is it? We don't know. We can't understand them. They have such sharp noses, such thin, cruel lips, such lines in their faces. We think they are all crazy."

My friend had recognized, without being able to name it, the Aryan bird of prey with his insatiable lust to lord it in every land—even those that concern him not at all. And he had also noted that megalomania of ours which leads us to suppose, among other things, that Christianity is the only truth, and the white Christ the only Redeemer. After setting the whole East in turmoil with our science and technology, and exacting tribute from it, we

send our missionaries even to China. The stamping out of polygamy by the African missions has given rise to prostitution on such a scale that in Uganda alone twenty thousand pounds sterling is spent yearly on preventatives of venereal infection, not to speak of the moral consequences, which have been of the worst. And the good European pays his missionaries for these edifying achievements! No need to mention also the story of suffering in Polynesia and the blessings of the opium trade.

That is how the European looks when he is extricated from the cloud of his own moral incense. No wonder that to unearth buried fragments of psychic life we have first to drain a miasmal swamp. Only a great idealist like Freud could devote a lifetime to the unclean work. This is the beginning of our psychology. For us acquaintance with the realities of psychic life could start only at this end, with all that repels us and that we do not wish to see.

But if the psyche consisted for us only of evil and worthless things, no power in the world could induce a normal man to pretend to find it attractive. This is why people who see in Theosophy nothing but regrettable intellectual superficiality, and in Freudian psychology nothing but sensationalism, prophesy an early and inglorious end for these movements. They overlook the fact that they derive their force from the fascination of psychic life. No doubt the passionate interest that is aroused by them may find other expressions; but it will certainly show itself in these forms until they are replaced by something better. Superstition and perversity are after all one and the same. They are transitional or embryonic stages from which new and riper forms will emerge.

Whether from the intellectual, the moral or the aesthetic viewpoint, the undercurrents of the psychic life of the West present an uninviting picture. We have built a monumental world round about us, and have slaved for it with unequalled energy. But it is so imposing only because we have spent upon the outside all that is imposing in our natures—and what we find when we look within must necessarily be as it is, shabby and insufficient

I am aware that in saying this I somewhat anticipate the actual growth of consciousness. There is as yet no general insight into these facts of psychic life. Westerners are only on the way to a recognition of these facts, and for quite understandable reasons they struggle violently against it. Of course Spengler's pessimism has exerted some influence, but this has been safely confined to academic circles. As for psychological insight, it always trespasses upon personal life, and therefore meets with personal resistances and denials. I am far from considering these resistances meaningless; on the contrary I see in them a healthy reaction to something which threatens destruction. Whenever relativism is taken as a fundamental and final principle it has a destructive effect. When, therefore, I call attention to the dismal undercurrents of the psyche, it is not in order to sound a pessimistic note; I wish rather to emphasize the fact that the unconscious has a strong attraction not only for the sick, but for healthy, constructive minds as well—and this in

spite of its alarming aspect. The psychic depths are nature, and nature is creative life. It is true that nature tears down what she has herself built up—yet she builds it once again. Whatever values in the visible world are destroyed by modern relativism, the psyche will produce their equivalents. At first we cannot see beyond the path that leads downward to dark and hateful things—but no light or beauty will ever come from the man who cannot bear this sight. Light is always born of darkness, and the sun never yet stood still in heaven to satisfy man's longing or to still his fears. Does not the example of Anquetil du Perron show us how psychic life survives its own eclipse? China hardly believes that European science and technology are preparing her ruin. Why should we believe that we must be destroyed by the secret, spiritual influence of the East?

But I forget that we do not yet realize that while we are turning upside down the material world of the East with our technical proficiency, the East with its psychic proficiency is throwing our spiritual world into confusion. We have never yet hit upon the thought that while we are overpowering the Orient from without, it may be fastening its hold upon us from within. Such an idea strikes us as almost insane, because we have eyes only for gross material connections, and fail to see that we must lay the blame for the intellectual confusion of our middle class at the doors of Max Müller, Oldenberg, Neumann, Deussen, Wilhelm and others like them. What does the example of the Roman Empire teach us? After the conquest of Asia Minor, Rome became Asiatic; even Europe was infected by Asia, and remains so today. Out of Cilicia came the Mithraic cult—the religion of the Roman army—and it spread from Egypt to fog-bound Britain. Need I point to the Asiatic origin of Christianity?

We have not yet clearly grasped the fact that Western Theosophy is an amateurish imitation of the East. We are just taking up astrology again, and that to the Oriental is his daily bread. Our studies of sexual life, originating in Vienna and in England, are matched or surpassed by Hindu teachings on this subject. Oriental texts ten centuries old introduce us to philosophical relativism, while the idea of indetermination, newly broached in the West, furnishes the very basis of Chinese science. Richard Wilhelm has even shown me that certain complicated processes discovered by analytical psychology are recognizably described in ancient Chinese texts. Psychoanalysis itself and the lines of thought to which it gives rise—surely a distinctly Western development—are only a beginner's attempt compared to what is an immemorial art in the East. It should be mentioned that the parallels between psychoanalysis and yoga have already been traced by Oskar A. H. Schmitz.

The Theosophists have an amusing idea that certain Mahatmas, seated somewhere in the Himalayas or Tibet, inspire or direct every mind in the world. So strong, in fact, can be the influence of the Eastern belief in magic upon Europeans of a sound mind, that some of them have assured me that I

am unwittingly inspired by the Mahatmas with every good thing I say, my own inspirations being of no account whatever. This myth of the Mahatmas, widely circulated and firmly believed in the West, far from being nonsense, is—like every myth—an important psychological truth. It seems to be quite true that the East is at the bottom of the spiritual change we are passing through today. Only this East is not a Tibetan monastery full of Mahatmas, but in a sense lies within us. It is from the depths of our own psychic life that new spiritual forms will arise; they will be expressions of psychic forces which may help to subdue the boundless lust for prey of Aryan man. We shall perhaps come to know something of that circumscription of life which has grown in the East into a dubious quietism; also something of that stability which human existence acquires when the claims of the spirit become as imperative as the necessities of social life. Yet in this age of Americanization we are still far from anything of the sort, and it seems to me that we are only at the threshold of a new spiritual epoch. I do not wish to pass myself off as a prophet, but I cannot outline the spiritual problem of modern man without giving emphasis to the yearning for rest that arises in a period of unrest, or to the longing for security that is bred of insecurity. It is from need and distress that new forms of life take their rise, and not from mere wishes or from the requirements of our ideals.

To me, the crux of the spiritual problem of today is to be found in the fascination which psychic life exerts upon modern man. If we are pessimists, we shall call it a sign of decadence; if we are optimistically inclined, we shall see in it the promise of a far-reaching spiritual change in the Western world. At all events, it is a significant manifestation. It is the more noteworthy because it shows itself in broad sections of every people; and it is the more important because it is a matter of those imponderable psychic forces which transform human life in ways that are unforeseen and—as history shows—unforeseeable. These are the forces, still invisible to many persons today, which are at the bottom of the present "psychological" interest. When the attractive power of psychic life is so strong that man is neither repelled nor dismayed by what he is sure to find, then it has nothing of sickliness or perversion about it.

Along the great highroads of the world everything seems desolate and outworn. Instinctively the modern man leaves the trodden ways to explore the by-paths and lanes, just as the man of the Greco-Roman world cast off his defunct Olympian gods and turned to the mystery-cults of Asia. The force within us that impels us to the search, turning outward, annexes Eastern Theosophy and magic; but it also turns inward and leads us to give our thoughtful attention to the unconscious psyche. It inspires in us the selfsame skepticism and relentlessness with which a Buddha swept aside his two million gods that he might come to the pristine experience which alone is convincing.

And now we must ask a final question. Is what I have said of the modern man really true, or is it perhaps the result of an optical illusion? There can be no doubt whatever that the facts I have cited are wholly irrelevant contingencies in the eyes of many millions of Westerners, and seem only regrettable errors to a large number of educated persons. But I may ask: What did a cultivated Roman think of Christianity when he saw it spreading among the people of the lowest classes? The biblical God is still a living person in the Western world—as living as Allah beyond the Mediterranean. One kind of believer holds the other an ignoble heretic, to be pitied and tolerated if he cannot be changed. What is more, a clever European is convinced that religion and such things are good enough for the masses and for women, but are of little weight compared to economic and political affairs.

So I am refuted all along the line, like a man who predicts a thunderstorm when there is not a cloud in the sky. Perhaps it is a storm beneath the horizon that he senses—and it may never reach us. But what is significant in psychic life is always below the horizon of consciousness, and when we speak of the spiritual problem of modern man we are dealing with things that are barely visible—with the most intimate and fragile things—with bowers that open only in the night. In daylight everything is clear and tangible; but the night lasts as long as the day, and we live in the night-time also. There are persons who have bad dreams which even spoil their days for them. And the day's life is for many people such a bad dream that they long for the night when the spirit awakes. I even believe that there are nowadays a great many such people, and this is why I maintain that the spiritual problem of modern man is much as I have presented it. I must plead guilty, indeed, to the charge of one-sidedness, for I have not mentioned the modern spirit of commitment to a practical world about which everyone has much to say because it lies in such full view. We find it in the ideal of internationalism or supernationalism which is embodied in the League of Nations and the like; and we find it also in sport and, very expressively, in the cinema and in jazz music.

These are certainly characteristic symptoms of our time; they show unmistakably how the ideal of humanism is made to embrace the body also. Sport represents an exceptional valuation of the human body, as does also modern dancing. The cinema, on the other hand, like the detective story, makes it possible to experience without danger all the excitement, passion and desirousness which must be repressed in a humanitarian ordering of life. It is not difficult to see how these symptoms are connected with the psychic situation. The attractive power of the psyche brings about a new self-estimation—a re-estimation of the basic facts of human nature. We can hardly be surprised if this leads to the rediscovery of the body after its long depreciation in the name of the spirit. We are even tempted to speak of the body's revenge upon the spirit. When Keyserling sarcastically singles out the

chauffeur as the culture-hero of our time, he has struck, as he often does, close to the mark. The body lays claim to equal recognition; like the psyche, it also exerts a fascination. If we are still caught by the old idea of an antithesis between mind and matter, the present state of affairs means an unbearable contradiction; it may even divide us against ourselves. But if we can reconcile ourselves with the mysterious truth that spirit is the living body seen from within, and the body the outer manifestation of the living spirit—the two being really one—then we can understand why it is that the attempt to transcend the present level of consciousness must give its due to the body. We shall also see that belief in the body cannot tolerate an outlook that denies the body in the name of the spirit. These claims of physical and psychic life are so pressing compared to similar claims in the past, that we may be tempted to see in this a sign of decadence. Yet it may also signify a rejuvenation, for as Hölderlin says:

> Danger itself
> Fosters the rescuing power.*

What we actually see is that the Western world strikes up a still more rapid tempo—the American tempo—the very opposite of quietism and resigned aloofness. An enormous tension arises between the opposite poles of outer and inner life, between objective and subjective reality. Perhaps it is a final race between aging Europe and young America; perhaps it is a desperate or a wholesome effort of conscious man to cheat the laws of nature of their hidden might and to wrest a yet greater, more heroic victory from the sleep of the nations. This is a question which history will answer.

In coming to a close after so many bold assertions, I would like to return to the promise made at the outset to be mindful of the need for moderation and caution. Indeed, I do not forget that my voice is but one voice, my experience a mere drop in the sea, my knowledge no greater than the visual field in a microscope, my mind's eye a mirror that reflects a small corner of the world, and my ideas—a subjective confession.

*Wo Gefahr ist,
 Wächst das Rettende auch. (Hölderlin.)

TWO

Art and Materialism in the Beat Generation

Robert Rauschenberg (American, b. 1925), *Canyon*. 1959. Combine painting, 81.75 x 70 in. Courtesy Sonnabend Gallery. © Robert Rauschenberg/Licensed by VAGA, New York, N.Y.

Artists

Claes Oldenburg
I am for an art . . . (1961/1967)

After moving to New York in 1956, Claes Oldenburg met Allan Kaprow and became involved with the early Happenings. Happenings were a cross between theater, sculpture, and installation—an environment in which improvisational performance and junk came together to create a radically new art form. An early example of a Happening that Oldenburg created was *The Street,* which he performed at the Judson Gallery in 1960. At about the same time, Oldenburg was using common materials such as plaster, chicken wire, and enamel paint to create whimsical sculptures based on everyday objects, such as his *Pie à la Mode* from 1962.

In December 1961 Oldenburg opened the Store at 107 East Second Street in New York, a small storefront space in which he created both a total artistic environment and a place to sell his art. Oldenburg was part of a generation of artists who wanted to move art out of the museums and into the streets. These artists created work that spoke about the debris of American culture, which emphasized the consumption of material goods. Instead of allowing his art to become engulfed in subjective experience (as had many of the Abstract Expressionists), Oldenburg wanted to surround the viewer with an environment that reflected the discarded objects of a booming button-down American society. This impulse is discussed in his statement "I am for an art . . . ," which was originally published in the catalog that corresponded with the exhibition *Environments, Situations, and Spaces* at the Martha Jackson Gallery in the summer of 1961; the version reproduced here is from the book *Store Days,* by Claes Oldenburg and Emmett Williams, which was published in 1967.

I am for an art that is political-erotical-mystical, that does something other than sit on its ass in a museum.

I am for an art that grows up not knowing it is art at all, an art given the chance of having a starting point of zero.

I am for an art that embroils itself with the everyday crap & still comes out on top.

I am for an art that imitates the human, that is comic, if necessary, or violent, or whatever is necessary.

"I am for an art . . ." from *Store Days,* 1967. Reprinted by permission of the author.

I am for an art that takes its form from the lines of life itself, that twists and extends and accumulates and spits and drips, and is heavy and coarse and blunt and sweet and stupid as life itself.

I am for an artist who vanishes, turning up in a white cap painting signs or hallways.

I am for art that comes out of a chimney like black hair and scatters in the sky.
I am for art that spills out of an old man's purse when he is bounced off a passing fender.
I am for the art out of a doggy's mouth, falling five stories from the roof.
I am for the art that a kid licks, after peeling away the wrapper.
I am for an art that joggles like everyones knees, when the bus traverses an excavation.
I am for art that is smoked, like a cigarette, smells, like a pair of shoes.
I am for art that flaps like a flag, or helps blow noses, like a handkerchief.
I am for art that is put on and taken off, like pants, which develops holes, like socks, which is eaten, like a piece of pie, or abandoned with great contempt, like a piece of shit.

I am for art covered with bandages. I am for art that limps and rolls and runs and jumps. I am for art that comes in a can or washes up on the shore.
I am for art that coils and grunts like a wrestler. I am for art that sheds hair.
I am for art you can sit on. I am for art you can pick your nose with or stub your toes on.
I am for art from a pocket, from deep channels of the ear, from the edge of a knife, from the corners of the mouth, stuck in the eye or worn on the wrist.
I am for art under the skirts, and the art of pinching cockroaches.

I am for the art of conversation between the sidewalk and a blind mans metal stick.
I am for the art that grows in a pot, that comes down out of the skies at night, like lightning, that hides in the clouds and growls. I am for art that is flipped on and off with a switch.
I am for art that unfolds like a map, that you can squeeze, like your sweetys arm, or kiss, like a pet dog. Which expands and squeaks, like an accordion, which you can spill your dinner on, like an old tablecloth.
I am for an art that you can hammer with, stitch with, sew with, paste with, file with.

I am for an art that tells you the time of day, or where such and such a street is.

I am for an art that helps old ladies across the street.

I am for the art of the washing machine. I am for the art of a government check. I am for the art of last wars raincoat.

I am for the art that comes up in fogs from sewer-holes in winter. I am for the art that splits when you step on a frozen puddle. I am for the worms art inside the apple. I am for the art of sweat that develops between crossed legs.

I am for the art of neck-hair and caked tea-cups, for the art between the tines of restaurant forks, for the odor of boiling dishwater.

I am for the art of sailing on Sunday, and the art of red and white gasoline pumps.

I am for the art of bright blue factory columns and blinking biscuit signs.

I am for the art of cheap plaster and enamel. I am for the art of worn marble and smashed slate. I am for the art of rolling cobblestones and sliding sand. I am for the art of slag and black coal. I am for the art of dead birds.

I am for the art of scratchings in the asphalt, daubing at the walls. I am for the art of bending and kicking metal and breaking glass, and pulling at things to make them fall down.

I am for the art of punching and skinned knees and sat-on bananas. I am for the art of kids' smells. I am for the art of mama-babble.

I am for the art of bar-babble, tooth-picking, beerdrinking, egg-salting, in-sulting. I am for the art of falling off a barstool.

I am for the art of underwear and the art of taxicabs. I am for the art of ice-cream cones dropped on concrete. I am for the majestic art of dog-turds, rising like cathedrals.

I am for the blinking arts, lighting up the night. I am for art falling, splashing, wiggling, jumping, going on and off.

I am for the art of fat truck-tires and black eyes.

I am for Kool-art, 7-UP art, Pepsi-art, Sunshine art, 39 cents art, 15 cents art, Vatronol art, Dro-bomb art, Vam art, Menthol art, L&M art, Exlax art, Venida art, Heaven Hill art, Pamryl art, San-o-med art, Rx art, 9.99 art, Now art, New art, How art, Fire sale art, Last Chance art, Only art, Diamond art, Tomorrow art, Franks art, Ducks art, Meat-o-rama art.

I am for the art of bread wet by rain. I am for the rats' dance between floors. I am for the art of flies walking on a slick pear in the electric light. I am

for the art of soggy onions and firm green shoots. I am for the art of clicking among the nuts when the roaches come and go. I am for the brown sad art of rotting apples.

I am for the art of meowls and clatter of cats and for the art of their dumb electric eyes.

I am for the white art of refrigerators and their muscular openings and closings.

I am for the art of rust and mold. I am for the art of hearts, funeral hearts or sweetheart hearts, full of nougat. I am for the art of worn meathooks and singing barrels of red, white, blue and yellow meat.

I am for the art of things lost or thrown away, coming home from school. I am for the art of cock-and-ball trees and flying cows and the noise of rectangles and squares. I am for the art of crayons and weak grey pencil-lead, and grainy wash and sticky oil paint, and the art of windshield wipers and the art of the finger on a cold window, on dusty steel or in the bubbles on the sides of a bathtub.

I am for the art of teddy-bears and guns and decapitated rabbits, exploded umbrellas, raped beds, chairs with their brown bones broken, burning trees, firecracker ends, chicken bones, pigeon bones and boxes with men sleeping in them.

I am for the art of slightly rotten funeral flowers, hung bloody rabbits and wrinkly yellow chickens, bass drums & tambourines, and plastic phonographs.

I am for the art of abandoned boxes, tied like pharaohs. I am for an art of watertanks and speeding clouds and flapping shades.

I am for U.S. Government Inspected Art, Grade A art, Regular Price art, Yellow Ripe art, Extra Fancy art, Ready-to-eat art, Best-for-less art, Ready-to-cook art, Fully cleaned art, Spend Less art, Eat Better art, Ham art, pork art, chicken art, tomato art, banana art, apple art, turkey art, cake art, cookie art.

add

I am for an art that is combed down, that is hung from each ear, that is laid on the lips and under the eyes, that is shaved from the legs, that is brushed on the teeth, that is fixed on the thighs, that is slipped on the foot.

square which becomes blobby

Allan Kaprow
Happenings in the New York Scene (1961)

In October 1958 *Art News* published Allan Kaprow's groundbreaking essay "The Legacy of Jackson Pollock." In this essay Kaprow discusses the experiential nature of Pollock's painting process, which he viewed as the jumping-off point for making works of art based directly in performance. Kaprow's now-famous statement about Pollock can be read as part of Alan Solomon's article "The New Art" in the critics' section of this chapter. At about the same time that Kaprow wrote this article about Pollock, he was studying with John Cage and was influenced by Cage's collaborative performances, particularly *Theater Piece #1* (Cage's now-famous collaboration with Robert Rauschenberg, David Tudor, Merce Cunningham, and others that was performed at Black Mountain College in 1952).

By May 1961, when *Art News* published "Happenings in the New York Scene," Kaprow, Claes Oldenburg, Jim Dine, Red Grooms, and Robert Whitman had created a series of "artistic events" (which they called "Happenings") that blurred the line between art and performance. These activities were the culmination of the ideas that Kaprow had introduced in his earlier essay. Interaction, chance, spontaneity, and impermanence were the catchwords of the early Happenings. The ephemeral nature of these works made it difficult, if not impossible, to sell them. Although Kaprow's dept to Pollock is well documented, one wonders whether the underground and impermanent nature of the Happenings was not in part a reaction against the canonization of Abstract Expressionism. Kaprow may also have been reacting to the rapid ascent of a new generation of painters, which included Robert Rauschenberg and Jasper Johns. Either way, within the context of the boom in the American economy, some artists felt caught between the art world's desire for new, cutting-edge work that could keep the post–Abstract Expressionism momentum going and the desire to take an anti-establishment posture. In the end of this essay Kaprow voices his concern about the speed with which fame is bestowed upon progressive artists, and the effect that this legitimization has on the quality of the art. These tensions will come into even sharper focus in the next chapter.

If you haven't been to the Happenings, let me give you a kaleidoscope sampling of some of their great moments.

Everybody is crowded into a downtown loft, milling about, like at an opening. It's hot. There are lots of big cartons sitting all over the place. One by one they start to move, sliding and careening drunkenly in every direction, lunging into one another, accompanied by loud breathing sounds over four loudspeakers. Now it's winter and cold and it's dark, and all around little blue lights go on and off at their own speed while three large brown gunnysack constructions drag an enormous pile of ice and stones over bumps, losing most of it, and blankets keep falling over everything from the ceiling.

A hundred iron barrels and gallon wine jugs hanging on ropes swing back and forth, crashing like church bells, spewing glass all over. Suddenly, mushy shapes pop up from the floor and painters slash at curtains dripping with action. A wall of trees tied with colored rags advances on the crowd, scattering everybody, forcing them to leave. There are muslin telephone booths for all with a record player or microphone that tunes you in to everybody else. Coughing, you breathe in noxious fumes, or the smell of hospitals and lemon juice. A nude girl runs after the racing pool of a searchlight, throwing spinach greens into it. Slides and movies, projected over walls and people, depict hamburgers: big ones, huge ones, red ones, skinny ones, flat ones, etc. You come in as a spectator and maybe you discover you're caught in it after all, as you push things around like so much furniture. Words rumble past, whispering, dee-daaa, baroom, love me, love me; shadows joggle on screens; power saws and lawn mowers screech just like the I.R.T. at Union Square. Tin cans rattle and you stand up to see or change your seat or answer questions shouted at you by shoeshine boys and old ladies. Long silences when nothing happens, and you're sore because you paid $1.50 contribution, when bang! there you are facing yourself in a mirror jammed at you. Listen. A cough from the alley. You giggle because you're afraid, suffer claustrophobia, talk to someone nonchalantly, but all the time you're *there*, getting into the act . . . Electric fans start, gently wafting breezes of New-Car smell past your nose as leaves bury piles of a whining, burping, foul, pinky mess.

So much for the flavor. Now I would like to describe the nature of Happenings in a different manner, more analytically—their purpose and place in art.

Although widespread opinion has been expressed about these events, usually by those who have never seen them, they are actually little known beyond a small group of interested persons. This small following is aware of several different kinds of Happenings. There are the sophisticated, witty works put on by the theater people; the very sparsely abstract, almost Zen-like rituals given by another group (mostly writers and musicians); and those in which I am most involved, crude, lyrical, and very spontaneous. This kind grew out of the advanced American painting of the last decade, and those of us involved were all painters (or still are). There is some beneficial exchange among the three, however.

In addition, outside New York there is the Gutai group in Osaka; reported activity in San Francisco, Chicago, Cologne, Paris, and Milan; and a history that goes back through Surrealism, Dada, Mime, the circus, carnivals, the traveling saltimbanques, all the way to medieval mystery plays and processions. Of most of this we know very little; only the spirit has been sensed. Of what *I* know, I find that I have decided philosophical reservations. Therefore, the points I make are intended to represent, not the views of all those who create works that might be generically related, or even of all

those whose work I admire, but of those whose works I feel to be the most adventuresome, fruitfully open to applications, and the most challenging of any art in the air at present.

Happenings are events that, put simply, happen. Though the best of them have a decided impact—that is, we feel, "here is something important"—they appear to go nowhere and do not make any particular literary point. In contrast to the arts of the past, they have no structured beginning, middle, or end. Their form is open-ended and fluid; nothing obvious is sought and therefore nothing is won, except the certainty of a number of occurrences to which we are more than normally attentive. They exist for a single performance, or only a few, and are gone forever as new ones take their place.

These events are essentially theater pieces, however unconventional. That they are still largely rejected by devotees of the theater may be due to their uncommon power and primitive energy, and to their derivation from the rites of American Action Painting. But by widening the concept "theater" to include them (like widening the concept "painting" to include collage), we can see them against this basic background and understand them better.

To my way of thinking, Happenings possess some crucial qualities that distinguish them from the usual theatrical works, even the experimental ones of today. First, there is the *context*, the place of conception and enactment. The most intense and essential Happenings have been spawned in old lofts, basements, vacant stores, natural surroundings, and the street, where very small audiences, or groups of visitors, are commingled in some way with the event, flowing in and among its parts. There is thus no separation of audience and play (as there is even in round or pit theaters); the elevated picture-window view of most playhouses is gone, as are the expectations of curtain openings and *tableaux vivants* and curtain closings...

The sheer rawness of the out-of-doors or the closeness of dingy city quarters in which the radical Happenings flourish is more appropriate, I believe, in temperament and un-artiness, to the materials and directness of these works. The place where anything grows up (a certain kind of art in this case), that is, its "habitat," gives to it not only a space, a set of relationships to the various things around it, and a range of values, but an overall atmosphere as well, which penetrates it and whoever experiences it. Habitats have always had this effect, but it is especially important now, when our advanced art approaches a fragile but marvelous life, one that maintains itself by a mere thread, melting the surroundings, the artist, the work, and everyone who comes to it into an elusive, changeable configuration.

If I may digress a moment to bring this point into focus, it may reveal why the "better" galleries and homes (whose decor is still a by-now-antiseptic neoclassicism of the twenties) desiccate and prettify modern paintings and sculpture that had looked so natural in their studio birthplace. It may also

explain why artists' studios do not look like galleries and why when an artist's studio does, everyone is suspicious. I think that today this organic connection between art and its environment is so meaningful and necessary that removing one from the other results in abortion. Yet the artists who have made us aware of this lifeline deny it; for the flattery of being "on show" blinds them to every insensitivity heaped upon their suddenly weakened offerings. There seems no end to the white walls, the tasteful aluminum frames, the lovely lighting, fawn gray rugs, cocktails, polite conversation. The attitude, I mean the worldview, conveyed by such a fluorescent reception is in itself not "bad." It is unaware. And being unaware, it can hardly be responsive to the art it promotes and professes to admire.

Happenings invite us to cast aside for a moment these proper manners and partake wholly in the real nature of the art and (one hopes) life. Thus a Happening is rough and sudden and often feels "dirty." Dirt, we might begin to realize, is also organic and fertile, and everything, including the visitors, can grow a little in such circumstances.

To return to the contrast between Happenings and plays, the second important difference is that a Happening has no plot, no obvious "philosophy," and is materialized in an improvisatory fashion, like jazz, and like much contemporary painting, where we do not know exactly what is going to happen next. The action leads itself any way it wishes, and the artist controls it only to the degree that it keeps on "shaking" right. A modern play rarely has such an impromptu basis, for plays are still *first written*. A Happening is *generated* in action by a headful of ideas or a flimsily jotted-down score of "root" directions.

A play assumes that words are the almost absolute medium. A Happening frequently has words, but they may or may not make literal sense. If they do, their sense is not part of the fabric of "sense" that other nonverbal elements (noise, visual stuff, action) convey. Hence, they have a brief, emergent, and sometimes detached quality. If they do not make sense, then they are heard as the *sound* of words instead of the meaning conveyed by them. Words, however, need not be used at all: a Happening might consist of a swarm of locusts being dropped in and around the performance space. This element of chance with respect to the medium itself is not to be expected from the ordinary theater.

Indeed, the involvement in chance, which is the third and most problematical quality found in Happenings, rarely occurs in the conventional theater. When it does, it is usually a marginal benefit of interpretation. In the present work, chance (in conjunction with improvisation) is a deliberately employed mode of operating that penetrates the whole composition and its character. It is the vehicle of the spontaneous. And it is the clue to understanding how control (the setting up of chance techniques) can effectively produce the opposite quality of the unplanned and apparently uncontrolled.

I think it can be demonstrated that much contemporary art, which counts upon inspiration to yield that admittedly desirable verve or sense of the unselfconscious, is by now getting results that appear planned and academic. A loaded brush and a mighty swing always seem to hit the ball to the same spot.

Chance then, rather than spontaneity, is a key term, for it implies risk and fear (thus reestablishing that fine nervousness so pleasant when something is about to occur). It also better names a method that becomes manifestly unmethodical if one considers the pudding more a proof than the recipe.

Traditional art has always tried to make it good every time, believing that this was a truer truth than life. Artists who directly utilize chance hazard failure, the "failure" of being less artistic and more lifelike. The "Art" they produce might surprisingly turn out to be an affair that has all the inevitability of a well-ordered middle-class Thanksgiving dinner (I have seen a few remarkable Happenings that were "bores" in this sense). But it could be like slipping on a banana peel, or going to heaven.

If a flexible framework with the barest limits is established by selecting, for example, only five elements out of an infinity of possibilities, almost anything can happen. And something always does, even things that are unpleasant. Visitors to a Happening are now and then not sure what has taken place, when it has ended, even when things have gone "wrong." For when something goes "wrong," something far more "right," more revelatory, has many times emerged. This sort of sudden near-miracle presently seems to be made more likely by chance procedures.

If artists grasp the import of that word *chance* and accept it (no easy achievement in our culture), then its methods needn't invariably cause their work to reduce to either chaos or a bland indifference, lacking in concreteness and intensity, as in a table of random numbers. On the contrary, the identities of those artists who employ such techniques are very clear. It is odd that when artists give up certain hitherto privileged aspects of the self, so that they cannot always "correct" something according to their taste, the work and the artist frequently come out on top. And when they come out on the bottom, it is a very concrete bottom!

The final point I should like to make about Happenings as against plays is implicit in all the discussion—their impermanence. Composed so that a premium is placed on the unforeseen, a Happening cannot be reproduced. The few performances given of each work differ considerably from one another; and the work is over before habits begin to set in. The physical materials used to create the environment of Happenings are the most perishable kind: newspapers, junk, rags, old wooden crates knocked together, cardboard cartons cut up, real trees, food, borrowed machines, etc. They cannot last for long in whatever arrangement they are put. A Happening is thus fresh, while it lasts, for better or worse.

Here we need not go into the considerable history behind such values embodied in the Happenings. Suffice it to say that the passing, the changing, the natural, even the willingness to fail are familiar. They reveal a spirit that is at once passive in its acceptance of what may be and affirmative in its disregard of security. One is also left exposed to the quite marvelous experience of being surprised. This is, in essence, a continuation of the tradition of Realism.

The significance of the Happening is not to be found simply in the fresh creative wind now blowing. Happenings are not just another new style. Instead, like American art of the late 1940s, they are a moral act, a human stand of great urgency, whose professional status as art is less a criterion than their certainty as an ultimate existential commitment.

It has always seemed to me that American creative energy only becomes charged by such a sense of crisis. The real weakness of much vanguard art since 1951 is its complacent assumption that art exists and can be recognized and practiced. I am not so sure whether what we do now is art or something not quite art. If I call it art, it is because I wish to avoid the endless arguments some other name would bring forth. Paradoxically, if it turns out to be art after all, it will be so in spite of (or because of) this larger question.

But this explosive atmosphere has been absent from our arts for ten years, and one by one our major figures have dropped by the wayside, laden with glory. If tense excitement has returned with the Happenings, one can only suspect that the pattern will be repeated. These are our greenest days. Some of us will become famous, and we will have proven once again that the only success occurred when there was a lack of it.

Such worries have been voiced before in more discouraging times, but today is hardly such a time, when so many are rich and desire a befitting culture. I may seem therefore to throw water on a kindly spark when I touch on this note, for we customarily prefer to celebrate victories without ever questioning whether they are victories indeed. But I think it is necessary to question the whole state of American success, because to do so is not only to touch on what is characteristically American and what is crucial about Happenings but also partly to explain America's special strength. And this strength has nothing to do with success.

Particularly in New York, where success is most evident, we have not yet looked clearly at it and what it may imply—something that, until recently, a European who had earned it did quite naturally. We are unable to accept rewards for being artists, because it has been sensed deeply that to be one means to live and work in isolation and pride. Now that a new haut monde is demanding of us art and more art, we find ourselves running away or running to it, shocked and guilty, either way. I must be emphatic: the glaring truth, to anyone who cares to examine it calmly, is that nearly all artists, working in any medium from words to paint, who have made their mark as innovators, as radicals in the best sense of that word, have, once they have been recognized and paid handsomely, capitulated to the interests of good taste.

There is no overt pressure anywhere. The patrons of art are the nicest people in the world. They neither wish to corrupt nor actually do so. The whole situation is corrosive, for neither patrons nor artists comprehend their role; both are always a little edgy, however abundantly smiles are exchanged. Out of this hidden discomfort there comes a stillborn art, tight or merely repetitive at best and at worst, chic. The old daring and the charged atmosphere of precarious discovery that marked every hour of the lives of modern artists, even when they were not working at art, vanishes. Strangely, no one seems to know this except, perhaps, the "unsuccessful" artists waiting for their day . . .

To us, who are already answering the increasing telephone calls from entrepreneurs, this is more than disturbing. We are, at this writing, still free to do what we wish, and are watching ourselves as we become caught up in an irreversible process. Our Happenings, like all the other art produced in the last decade and a half by those who, for a few brief moments, were also free, are in no small part the expression of this liberty. In our beginning some of us, reading the signs all too clearly, are facing our end.

If this is close to the truth, it is surely melodrama as well, and I intend the tone of my words to suggest that quality. Anyone moved by the spirit of tough-guyism would answer that all of this is a pseudo-problem of the artists' own making. They have the alternative of rejecting fame if they do not want its responsibilities. Artists have made their sauce; now they must stew in it. It is not the patrons' and the publicists' moral obligation to protect the artists' freedom.

But such an objection, while sounding healthy and realistic, is in fact European and old-fashioned; it sees the creator as an indomitable hero who exists on a plane above any living context. It fails to appreciate the special character of our mores in America, and this matrix, I would maintain, is the only reality within which any question about the arts may be asked.

The tough answer fails to appreciate our taste for fads and "movements," each one increasingly equivalent to the last in value and complexion, making for that vast ennui, that anxiety lying so close to the surface of our comfortable existence. It does not account for our need to "love" everybody (our democracy) that must give every dog his bone and compels everyone known by no one to want to be addressed by a nickname. This relentless craving loves everything destructively, for it actually hates love. What can anyone's interest in this kind of art or that marvelous painter possibly mean then? Is it a meaning lost on the artist?

Where else can we see the unbelievable but frequent phenomenon of successful radicals becoming "fast friends" with successful academicians, united only by a common success and deliberately insensitive to the fundamental issues their different values imply? I wonder where else but here can be found that shutting of the eyes to the question of purpose. Perhaps in the United States such a question could not ever before exist, so pervasive has been the amoral mush.

This everyday world affects the way art is created as much as it conditions its response—a response the critic articulates for the patron, who in turn acts upon it. Melodrama, I think, is central to all of this.

Apart from those in our recent history who have achieved something primarily in the spirit of European art, much of the positive character of America can be understood by the word *melodrama:* the saga of the Pioneer is true melodrama, the Cowboy and the Indian; the Rent Collector, Stella Dallas, Charlie Chaplin, the Organization Man, Mike Todd are melodrama. And now the American Artist is a melodramatic figure. Probably without trying, we have been able to see profoundly what we are all about through these archetypal personages. This is the quality of our temperament that a classically trained mind would invariably mistake for sentimentality.

But I do not want to suggest that avant-garde artists produce even remotely sentimental works; I am referring more to the hard and silly melodrama of their lives and almost farcical social position, known as well as the story of George Washington and the Cherry Tree, which infuses what they do with a powerful yet fragile fever. The idea is partly that they will be famous only after they die, a myth we have taken to heart far more than the Europeans, and far more than we care to admit. Half-consciously, though, there is the more indigenous dream that the adventure is everything; the tangible goal is not important. The Pacific coast is farther away than we thought, Ponce de Leon's Fountain of Youth lies beyond the next everglade, and the next, and the next . . . meanwhile let's battle the alligators.

What is not melodramatic, in the sense I am using the word, but is disappointing and tragic, is that today vanguard artists are given their prizes very quickly instead of being left to their adventure. Furthermore, they are led to believe, by no one in particular, that this was the thing they wanted all the while. But in some obscure recess of their mind, they assume they must now die, at least spiritually, to keep the myth intact. Hence, the creative aspect of their art ceases. To all intents and purposes, they are dead and they are famous.

In this context of achievement-and-death, artists who make Happenings are living out the purest melodrama. Their activity embodies the myth of nonsuccess, for Happenings cannot be sold and taken home; they can only be supported. And because of their intimate and fleeting nature, only a few people can experience them. They remain isolated and proud. The creators of such events are adventurers too, because much of what they do is unforeseen. They stack the deck that way.

By some reasonable but unplanned process, Happenings, we may suspect, have emerged as an art that can function precisely as long as the mechanics of our present rush for cultural maturity continue. This situation will no doubt change eventually and thus will change the issues I address here.

But for now there is this to consider, the point I raised earlier: some of us will probably become famous. It will be an ironic fame fashioned largely by those who have never seen our work. The attention and pressure of such

a position will probably destroy most of us, as they have nearly all the others. We know no better than anyone else how to handle the metaphysics and practice of worldly power. We know even less, since we have not been in the slightest involved with it. That I feel it necessary, in the interests of the truth, to write this article, which may hasten the conclusion, is even more fatefully ironic. But this is the chance we take; it is part of the picture . . .

Yet I cannot help wondering if there isn't a positive side, too, a side also subject to the throw of the dice. To the extent that a Happening is not a commodity but a brief event, from the standpoint of any publicity it may receive, it may become a state of mind. Who will have been there at that event? It may become like the sea monsters of the past or the flying saucers of yesterday. I shouldn't really mind, for as the new myth grows on its own, without reference to anything in particular, the artist may achieve a beautiful privacy, famed for something purely imaginary while free to explore something nobody will notice.

Robert Rauschenberg
The Artist Speaks (Interview with Dorothy Gees Seckler) (1966)

In the early 1950s Rauschenberg reacted against the internal subjective musings of the Abstract Expressionists by asserting his own sensitivity to the images, objects, and sensations of his immediate environment. When Rauschenberg experienced the New York City of the early 1950s, he found a city of stark physical contrasts, a city heaving with the materiality of economic expansion. There seems to be a mixture of both optimism and weight in Rauschenberg's combinations of fabric, wood, rubber, stuffed animals, cardboard, pillows, found images, and paint. The optimism stems from his dynamic openness to the creative process, but this is tempered by the physical and visual density of his images. By the time he gave this interview, Rauschenberg had been on the cutting edge of American art for more than ten years. In this interview, "The Artist Speaks," Rauschenberg clearly articulates his position with regard to Abstract Expressionism and also touches on his range of creative activities. Originally published in the May–June 1966 issue of *Art in America*, this interview with Dorothy Gees Seckler was cosponsored by *Art in America* and the Archives of American Art.

In 1953 Rauschenberg had returned broke to New York after a year spent in North Africa, Spain and Italy. Although he had been given a one-man show at the Betty Parsons gallery two years earlier, his work was taken seriously by only a few. His main encouragement came not from painters but from a group of musicians, Morton Feldman, John Cage and Earle Brown, and the dancers associated with them. He was

Originally published in **ART IN AMERICA**, May–June 1966, Brant Publications, Inc.

spending fifteen cents a day for food and fifteen dollars a month for rent on a loft near the Fulton Fish Market in Lower Manhattan. To save carfare he walked uptown to Greenwich Village to sit in on the heated discussions about action painting then taking place at the Eighth Street Club and at the Cedar Bar.

"Affluence was very foreign to me in the period we are talking about but if you don't have trouble paying the rent, you have trouble doing something else. One needs a certain amount of trouble to operate, some need more, some less. The creative process somehow has to include adjusting realistically to the situation. I felt very rich being able to pick up Con Edison lumber from the street for combines and stretchers, taking advantage of whatever the day would lay out for me to use in my work—so much so that I am sometimes embarrassed that I seem to live on New York as if she were an unpaid maidservant.

"I felt new in New York. I thought the painting that was going on was unbelievable. Bill de Kooning is a great painter. I liked Jack Tworkov himself and his work, and also Franz Kline but I found a lot of the artists at the Cedar Bar were hard to talk to. There was something about the self-confession and self-confusion of abstract expressionism—as though the man and the work were the same—that personally always put me off because at that time my focus was in the opposite direction. I was busy trying to find ways where the imagery, the material and the meaning of the painting would be, not in an illustration of my will, but more like an unbiased documentation of what I observed, letting the area of feeling and meaning take care of itself [Rauschenberg is speaking here of his *Combines*]. I mean that literally: I felt an excitement at being in a city where you have on one lot a forty-story building and right next to it, you have a little shack. There is this constant irrational juxtaposition of things that one doesn't find in the countryside. I had traveled quite a lot in Europe just previously and had not found it there either: instead there's a kind of architectural harmony; everything is so much more cohesive than I have found in New York."

While some abstract expressionists were nailing boards over their windows to shut out the distractions of the city, Rauschenberg was drawing stimulation from the dramatic contrasts of the waterfront neighborhood: the animals in the largest pet store in New York, the wholesale plant stores on the same block as the Washington Market, and in the next block, hardware stores galore.

"During the day the streets would be so full of people that it looked like an ant hill that had been kicked over; then, bang—at six o'clock you could hear footsteps three blocks away. The buildings were the tallest there and I always like being near the water if I have the choice. So I think that this is a very rich part of town, but I don't find the rest of the city lacking in this quality. Every time I've moved, my work has changed radically and I think that if it didn't change naturally, that I'd do something about it to make it change. In this place [his studio at 809 Broadway] the light is so white that it's not to be believed. In other places where the ceilings may not be so high, the windows

may be bigger; there you'd get the light bouncing off the floor—it would be warmed up. It is the job of the artist to move with these things, using them as additional qualities. Some artists move into a new place and force on it a working attitude they remember as one they like. That attitude makes a kind of painting different from mine. My work was never a protest against what was going on, it was all expression of my own involvement."

A principal difference between the outlook of Rauschenberg and the abstract expressionists is seen in their very opposite estimates of the significance of the unconscious in art. Rauschenberg told me that, as far as he was aware of it, the unconscious was not an important source of imagery or content in his work. Pollock had said: "I think the unconscious is a very important side of modern art." Rauschenberg, in his wish to exclude unconscious fantasy, also rejects much of the associational aura read into some of his paintings. This came out in a discussion of his black paintings (with collage) of 1951.

"Lots of critics shared with the public a certain reaction: they couldn't see black as pigment. They moved immediately into association with 'burned-out,' 'tearing,' 'nihilism' and 'destruction.' That began to bother me. I'm never sure what the impulse is psychologically; I don't mess around with my subconscious. I try to keep wide-awake. If I see any superficial subconscious relationships that I'm familiar with—clichés of association—I change the picture. I always have a good reason for taking something out but never have one for putting something in. I don't want to—because that means that the picture is being painted predigested.

"There was a whole language (used in discussions of the abstract expressionists) that I could never make function for myself: it revolved around words like, 'tortured,' 'struggle,' 'pain.' I don't know whether it was my Albers training or my personal 'hang-up' but I could never see those qualities in paint—I could see them in life and in art that illustrates life. But I could not see such conflict in the materials and I knew that it had to be in the attitude of the painter, his interpretation of an attitude that existed separately. In the future, if one were to lose contact with this idea it would be possible to have a completely different attitude about the painting.

"In the black paintings I might have—with my subconscious having me—used black with newspapers because of the burned-out look but I certainly did not like the idea of 'tortured,' 'tarred' and 'torn.' A newspaper that you are not reading can be used for anything. These same people didn't think there was anything immoral in wrapping their garbage in newspaper—a very positive use."

He investigated these possible associative qualities of materials in several experiments.

"I did a painting in toilet-paper, then duplicated it in gold-leaf. I studied both very carefully and found no advantage in either; whatever one was

saying, the other seemed to be just as articulate. I know then that it was somebody else's problem—not mine."

An artist who uses black because of established associations with death, and gold for its implications of elegance, is trading on known qualities in a way that Rauschenberg regards as dangerous for the life of the picture.

"When someone close to you has been away it's only in about the first fifteen minutes that you're back together that you notice how he has changed from the idea you have of the way he looks. The same thing happens to a painting: when it becomes so familiar that one recognizes it without looking at it, the work has turned into a facsimile of itself. If you do work with known quantities—making puns or dealing symbolically with your material—you are shortening the life of the work. It is already leading someone else's life instead of its own."

In recent years he has designed sets and costumes for the Merce Cunningham and Paul Taylor Dance Companies and while on tour has taken part in dance performances. He has also choreographed, directed and acted in a series of performances with dancers. Although these involve objects, the main motivation comes from dance.

"I don't call these performances 'happenings'—happenings have to do with the animation of objects. Since they come out of my really quite traditional appreciation for dance, I would rather call them 'dance-theater.' I begin by just having an idea and if that idea isn't enough, have another idea and then a third and a fourth; composition could be described as an attempt to mass all these things in such a way that they don't interfere with each other. I never set up cause and effect sequences or action contrasts that are extreme: calmly or less calmly, episodes just happen to exist at the same time. One of my main problems is how to get a piece started and how to get it stopped without breaking into the sense of the continuation of the whole unit. I work very much the same way—composing in non-sequential relationships—that I do in painting.

"I like the necessity of working with people to put on a piece, and one of the reasons I have been preoccupied with theater is because of the extreme discipline necessarily demanded in working with other people."

In December 1965 he staged several performances at the Film-Maker's Cinematheque in New York (on a program with presentations by Claes Oldenburg and Robert Whitman) of "Map Room II," a development of a sketch he had initially designed and carried out at Goddard College as "Map Room I." In a final sequence he got into a pair of shoes embedded in glass-like blocks that reflected light from the floor.

"I used my body as a conductor of electricity by holding a live coil in one hand; with the contact with neon tubes, they lit up (with different colors). I consider this more successful than some of my other pieces—maybe I've

done enough to build a collective vocabulary. If one's body can be a conductor of electricity, there are all kinds of materials one could activate by hand. It's like moving the controls out onto the stage. I like the technicians to be visible and, if something has to be moved onto the stage, one does it in the most direct, simple fashion: you just walk over and put it there. I would rather not have the proscenium hiding everything. I nearly never choreograph expressions for people that I work with; they should not look as though they were doing something easily if it is necessarily difficult."

In his work he exploits certain effects that appear accidental but this does not imply that he is motivated by an aesthetic based on chance (as is his friend, composer John Cage).

"I have certainly made use of the fact that paint will run. This is just a friendly relationship with materials—you want them for what they are rather than for what you can make out of them. One of my preoccupations was rather an intellectual idea. I tried to imply by the different ways that paint went on that even though I might know only seventeen ways, that there were actually thousands.

"I was interested in many of John Cage's chance operations and I liked the sense of experimentation he is involved in, but painting is just a different ground for activities. I could never figure out an interesting way to use any kind of programmed activity—and even though chance deals with the unexpected and unplanned, it still has to be organized.

"Working with chance, I would end up with something that was quite geometric; I felt as though I were carrying out an idea rather than witnessing an unknown idea taking shape.

"I did a twenty-foot print, and John Cage was involved because he was the only person with a car who would be willing to do this. I glued together fifty sheets of paper—the largest I had—and stretched it out on the street. He drove his A–Model Ford through the paint and onto the paper. The only directions he had were to try to stay on the paper. He did a beautiful job but I consider it my print."

Persisting through a number of changes in color and materials are certain ways of composing that are the opposite of conventional design.

"For years I've been concerned with the idea of a relaxed symmetry. I think of symmetry as a neutral shape as opposed to a form of design. If you are dealing with multiplicity, variation and inclusion as your content, then any feeling of complete consistency or sameness is a violation of that attitude. I had to try consciously to do a work that would imply the kind of richness and complexity I saw around me.

"One of my painter friends once said that I'm awfully good at the edges. This was intended as a joke but I think that it may be true: there's been a conscious attempt to avoid giving a dramatic preference to any area

whether dead center or at a point where I have only half an inch before I hit the wall. I have ignored simpleminded ideas of formal composition by just putting something of no consequence at dead center."

While critics have habitually credited Rauschenberg (along with Jasper Johns) with having launched many of the ideas and techniques that have become staples of pop art, some have failed to distinguish between his own attitudes and those of the artistic offspring. He was asked to clarify his own position vis-a-vis pop art.

"The word 'pop' is more Hollywoodian than historian. Pop art decontaminated our art of stream-of-consciousness. We have a frontier country—the means have to be direct. Today in New York we have masters and matters of all sorts. Their voluntary cooperation indicates a certain amount of communication, tolerance and pleasure in each others' ideas. At the same time, I think that one of the aspects of my work that I criticize myself for the most is that so many people recognized it as a way of working, as an end in itself, so that the influence that the work has had on other artists who work in what they would call the same direction, is really a weakness of my concept. The reason: even the socially interesting misleads directly to the embalming of the work.

"I think that in the last twenty years there has been a new kind of honesty in painting where painters have been very proud of paint, let it behave openly though used for different reasons—just as many reasons as there are artists. For a long time one could see a brushload of paint almost as though the artist had just put it on the canvas and walked away (but now there's a new kind of paint that hides it because some artists were looking for, and then finding, a new medium—plastics).

"This was opposed to the older way of using paint only to build an illusion about something else or wanting only the color aspect. All of these things—elements of painting, such as line and color—are now being separated out, taken out of traditional relationships so that they function independently. Each one becomes a whole rather than a detail. And these elements will never fit back together to make anything we have seen. I think that it's a great time.

"In this new give and take, when an artist sees something exciting that another artist has done he is likely to say, as Larry Poons has: 'Well, now I don't have to do that.'"

In contrast to the abstract expressionists who have generally preferred to stay within variations on major themes established in their maturity, Rauschenberg has moved restlessly from one style and material to another.

"As far as style is concerned, I've run through a good many and it is always a pleasure to give them up. . . . Yet I am not so facile that I can accomplish what I want to explore in one or two paintings. Sometimes a period, such as the all-red paintings or the ones I call I 'pedestrian colors,' encompassed about fifteen paintings or it may go up to thirty. When I reach a stage where working in

a certain way is more apt to be successful than unsuccessful—and it's not just a lucky streak—when I definitely see that this is the case, I start something else. Usually while I'm working one way there's another attitude that's growing up, a reaction to what I'm doing that almost may be the reverse of it.

"The problem when I started the Dante illustrations [thirty-four illustrations for "The Inferno," 1959] was to see if I was working abstractly because I couldn't work any other way or whether I was doing it by choice. So I insisted on the challenge of being restricted by a particular subject where it meant that I'd have to be involved in symbolism. An illustration has to be read; it has to relate to something already in existence and, well, I spent two-and-a-half years deciding that, yes, I could do that. All these statements can sound rather school-roomish—insisting that you force yourself to do something—but it's against my nature to be disciplined anyway; I have to strain a little to keep sanely free."

When Life *magazine commissioned him to do a new series of illustrations for Dante's "Inferno" (December 17, 1965) Rauschenberg had hoped to use lithography as the means of transferring images culled from the press but was prevented from doing so by legal and technical difficulties and had to return to the silk-screen technique he had used earlier. He found that working with twenty-five photographs (reduced to magazine scale on one screen) was "like having many palettes—instead of having colors laid out, there were all these images.* Life *readers saw in Rauschenberg's new "Inferno" illustrations, a series of juxtaposed images with recognizably specific references to concentration camps, the Bomb and episodes connected with the civil rights movement. Since these more readily identifiable elements represented a definite departure from the more ambiguous imagery of the earlier Dante series, I asked him if his point of view had changed.*

"Someone asked me yesterday: 'Do you really see modern life as all made up of hell?' Of course not. But if one is illustrating hell one usually uses the properties of hell. I've never thought that problems were so simple politically that they could be tackled directly in art works, not by me anyway, although in my personal life I do take stands on atrocities of all kinds. But every day, by doing consistently what you do with the attitude you have, if you have strong feelings, these thing are expressed over a period of time as opposed to, say, one *Guernica*. That's just a different attitude. When I was doing Dante, the first series, it was election year and a historian would be able to read that this was when it was done. When you just illustrate your feeling about something self-consciously—that is for me almost a commercial attitude. If you feel strongly, it's going to show. That's the only way the political scene can come into my work—and I believe it's there. Consistently there has been an attempt to use the very last minute in my life and the particular location as a source of energy and inspiration rather than retiring into some other time or dream or idealism. I think that cultivated protest is just as dreamlike as idealism."

The free-standing metal forms wired for radio transmission that made up his 1965 exhibition at Leo Castelli called "Oracle" seemed a startling departure from his paintings. These sculptures followed (after a needed interlude of painting) a strenuous sculptural project he had carried out under great pressure in Amsterdam's Stedelijk Museum. His interest in radio-equipped forms had began with Broadcast, a painting with two knobs on the surface that enabled people to tune in different channels of its concealed radios.

"I objected [in *Broadcast*] to the fact that one had to be standing so close to the picture that the sound didn't seem to be using the space the way the images were reacting to each other; I wanted to do one with remote control but I saw that the problem would be the one of weight and the depth that was needed to house the equipment.

"Painting was the wrong form. I became interested in sculpture after I returned from a dance tour with the Merce Cunningham Company and made two additional pieces besides the one I had begun before [incorporating radios]. In these pieces the sound was literally important in shifting the focus of the audience; from the sound you had a sense of distance that, as often as not, was distorted. It had the feeling of knowing where you were but where you were was lost! Friends pointed out that I could have obtained similar sound effects in a far simpler way by recording and playing back radio sounds from a tape and I do not doubt that technically this could be done, but to me it was important to have the live sounds actually being broadcast at that moment in time. To have used a tape would have been like commercial art in the sense that it would be a rendering of the idea. I'd like for the sound to be as fresh as the daily fall of dust and rust that accumulates—that doesn't mean that from time to time one doesn't clean it off. This insistence of the piece operating in the time situation it was observed in, is another one of the ways of trying to put off the death of the work."

Since Rauschenberg "likes very much this mixture of technology and esthetics," he thinks he is likely to pursue this direction after he moves to his new building on Lafayette Street.

"I'd like to work with wind and water and plants. I have been thinking about a group of independent sculptural units that will form a single unit when combined. They will be sensitive to the proximity of the spectator—responding even to his body temperature—and they will be so delicately controlled by circumstance that two people viewing these forms will see something different from what is seen by either a crowd or one person. They will be responsive also to forces outside the jurisdiction of the viewer—to weather and passing traffic. Viewing of the work will not be completely dependent on seeing and the attention and desires of the viewer will be modified by circumstance. Constructed and viewed in the ground of darkness, (this work) will explore the nuances of not seeing and nearly not seeing. In darkness images can, literally, come and go."

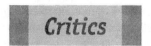

Alan Solomon
The New Art (1963)

As director of the Jewish Museum in New York City from 1963 to 1965, Alan Solomon was responsible for orchestrating the first museum exhibitions of the work of Robert Rauschenberg and Jasper Johns, which were held in 1963 and 1964, respectively. In 1964 Solomon was in charge of the American exhibition at the Venice Biennial, which featured the work of Rauschenberg and Johns as well as of Claes Oldenburg and Jim Dine. At the biennial Rauschenberg received widespread recognition by winning the International Prize in Painting. Solomon's essay "The New Art" first appeared in the exhibition catalog *The Popular Image*, which was published in conjunction with a show at the Gallery of Modern Art in Washington, DC, in 1963.

As the foundational avant-garde movement in America, Abstract Expressionism was the benchmark by which many artists and critics of the next generation defined their creative methodologies. The art of Jackson Pollock most directly set the tone for this next generation. Pollock's best paintings exhibited a purity and inseparability of process and finished product that seemed to close a major chapter in the development of abstract painting. For some people—such as Allan Kaprow—this sense of closure was liberating. Nevertheless, many artists were left wondering how they could find a way back to the objects of our everyday world without being nostalgic for the latent humanist notions of past figurative art. In Solomon's view a new generation of artists, which included Rauschenberg, Johns, and Oldenburg, was answering this question by commenting on the ubiquity and status of mass-produced objects and images in 1960s American culture. By appropriating objects of commercial culture, these artists challenged the age-old hierarchies in the art world between high art and kitsch, thereby forging a new attitude with regard to the status of objects in a work of art.

From the moment when it became plain in the late forties that the first significant American style had crystallized in abstract expressionism, a certain unhappy majority began to look forward to the day when its discomfort at the absence from art of references to external reality would be mollified by a return to figuration in painting and sculpture. For this group the abandonment of the human figure and its environment reflected a failure with respect to "humanism," and they were unwilling to acknowledge the opportunity presented by the new attitude for the artist to create a new world of

This article originally appeared in the exhibition catalog *The Popular Image* (Washington, DC: Gallery of Modern Art, 1963).

form and space, existing apart from all previous experience of the tangible external world, and creating its own special logic as well as its own unique excitement.

The appeal to humanism had built into it an implied moral hierarchy of ideas deriving from the whole classical tradition which has been a model for our society and which takes as its point of departure the anthropomorphism of the Greeks.

From time to time, those who take comfort in the presence of humans in art have found momentary hope in the prospect of the emergence of new images of man. However, contemporary man sees himself in his art not as an idealized godlike figure, in the manner of the classical tradition, but as a disrupted, contorted victim of the modern cataclysm, torn by forces of a magnitude beyond his comprehension, a grim figure, full of despair and anguish, entirely without hope. The "new image" is a monster, the product of irradiated aesthetic genes. The basis of classical humanism was the spirit of man and its accommodation to the world, not the simple physical presence of his "human" person; figuration alone has not succeeded in restoring to art a meaningful sense of the value of man's existence and of his unique personality. Those of us who have looked for a way out of what we have regarded as the dilemma of abstraction through a new figurative art have therefore been faced with frustration heaped upon frustration.

Those of us for whom abstract art had not presented a dilemma, but for whom abstract expressionism seemed to have run its course, now find ourselves confronted by an ironic turn of events. In the first place, a vigorous new kind of geometric abstraction has quietly gathered force during the past few years. In the second place, and much less quietly, a new figurative art has come to public attention during the past few months. Unfortunately, the new art offers no solace at all to the advocates of figuration, who had something quite different in mind. While the public has received the new abstraction with relative indifference so far, the new figurative art, or, as it is called, new realism, pop art, neo-dada, etc., etc., has provoked a response of extraordinary intensity, stimulating extremes of unabashed delight or renewed anguish. Like all vital new movements in the modern period (impressionism, cubism, fauvism) it has quickly been assigned a pejorative title—or string of titles, in this case—by the unsympathetic critics, who add to the confusion by emphasizing the wrong attributes of the style. On the other hand, among the "advanced" observers and collectors of contemporary art, the new artists have enjoyed a spectacular success in a relatively short period of time, and their work has been sought out even before it reached the up-town galleries during the last two seasons.

The new art stirs such polar responses because it seems to make an active frontal assault on all of our established aesthetic conventions at every level of form and subject matter. Yet the problem is really ours and not the artists'; they have no aggressive or doctrinaire intention and, in fact, they

present their new faces to us with a certain blandness and indirection. At the same time, their work is pitched at a high emotive level (for reasons which will be explained later) without any accretion of reference to complex abstract ideas; they appeal directly to the senses in which one might describe as a visceral rather than an intellectual way. In other words, these artists speak to our feelings rather than to our minds and they have no *programmatic* philosophical intent. Still, they speak so clearly from the contemporary spirit that their art, as much as it varies from individual to individual, shows a remarkable degree of philosophical consistency.

It is not difficult to understand the extremes of feeling stirred by the new art. In the past, with few exceptions we have attached a special importance to art, separating it clearly from the rest of the world and the rest of experience, viewing it as an activity of man comparable in importance to his most highly regarded institutions, in a distinct moral sense.

This habit of separating one kind of activity *and its attributes* from others which are demeaned by the wear and tear of the practical details of human existence had brought us to a position in which we attached "moral value" to objects depending on their uses as well as their properties. For a long time (until the sixteenth century) objects of utility or common familiarity did not enjoy sufficient moral value to justify their use as subjects for art by themselves, and it was really not until the nineteenth century that artists actually enjoyed the freedom to make such choices without reference to external consideration of hierarchy (an historical painting was "better" than a portrait which was "better" than a landscape, which was "better" than a still life, etc.). Even so, as free as the artist may have seemed in such matters even up to the mid-twentieth century, his repertory of objects included, for example, food and culinary implements, but not tools or plumbing, books and musical instruments, but not comic strips and radios. Even within acceptable categories like food, definite distinctions were made, so that bread, meat, game, fruit, vegetables, fish or wine as they come from the market might be used, but not hamburgers, hot dogs, candy bars, pies or Seven-Up. It does not suffice to answer that the latter were not available fifty years ago or that their contemporary equivalents appeared in art. In 1913 the cubists exercised a precise, self-conscious restraint in their choice of still life objects not only in continuing acknowledgment of the traditional attitude toward such choices, but also because they wished to avoid the introduction into the cubist still life of associations which would detract from the emphasis on formal issues. They chose objects from the studio-cafe environment, but only those which connote pleasurable, unexacting activities like eating, drinking, smoking, playing cards, music, painting, and so on. The Bass bottle or the bunch of grapes in a Braque still life have a very different function from the Coke bottle or chocolate cream pie in the work of the new artists when the latter have become highly charged emotive devices. The cubists selected things which

were familiar, intimate and comfortable, so that they could set a diffuse iconographical tone for the painting. The new artists select things which are familiar, public and often disquieting.

Why is this so? To put it as simply as possible, because the new artists have brought their own sensibilities and their deepest feelings to bear on a range of distasteful, stupid, vulgar, assertive and ugly manifestations of the worst side of our society. Instead of rejecting the deplorable and grotesque products of the modern commercial industrial world—the world of the hard sell and all it implies, the world of bright color and loud noise too brash for nuance, of cheap and tawdry sentiment aimed at fourteen-year-old intelligences, of images so generalized for the mass audience of millions that they have lost all real human identity—instead of rejecting the incredible proliferation of kitsch which provides the visual environment and probably most of the aesthetic experience for 99 percent of Americans, these new artists have turned with relish and excitement to what those of us who know better regard as the wasteland of television commercials, comic strips, hot dog stands, billboards, junk yards, hamburger joints, used car lots, juke boxes, slot machines and supermarkets. They have done so not in a spirit of contempt or social criticism or self-conscious snobbery, but out of an affirmative and unqualified commitment to the present circumstance and to a fantastic new wonderland, or, more properly, Disneyland, which asserts the conscious triumph of man's inner resources of feeling over the material rational world, to a degree perhaps not possible since the middle ages.

We cannot help but be anxious or cynical about the activities of these artists in the face of what we know to be "true" about Disneyland as a source of aesthetic meaning. We suspect them of deliberate provocation in the manner of the dadaists, that is to say of political intention, so that they might seem to be nihilists at the very least, or subversives at best, or even worse, we fear that they might be "putting us on," asking us to take seriously activities which we know to be frivolous and valueless. Yet in retrospect the way in which the present group emerged has not only an air of undeniable consistency but also a distinct flavor of historical inevitability. This new style could neither have been encouraged nor prevented, nor could it have been contrived; it has followed an organic course which makes it an absolute product of its time. Perhaps the most remarkable features of the new art are the rapidity and the spontaneity with which it developed from the assumptions of several artists at the same moment in a variety of different places. Almost all of the key figures in the group gravitated to New York, where their styles were established and they had become conscious of one another long before even the informed art public was significantly aware of their activities.

Writing history always becomes a process of oversimplification, and it is extremely difficult in this case to pinpoint the precise way in which the new group arrived at its own position. We can speak of a certain prevailing

climate, refer to the fact that most of these artists were too young to serve in the war, grew up in the time of The Bomb, have inherited a set of aesthetic predilections, and so on. We can certainly make a number of accurate observations about them, as artists and as the younger generation. For example, they have matured in an environment in which the path of the artist has been made smoother than it was for the generation which suffered through the depression and the war decades. They have enjoyed not only a sympathetic milieu in which art has flourished, but they have also arrived at financial security with extraordinary speed; the importance of this cannot be denied; it has spared them much of the bitterness of their predecessors.

For whatever historical reasons, the new artists are detached politically (they have not shared the political experience of the older generation), and indeed they are disengaged from all institutional associations. At the same time that they are withdrawn from causes (social manifestations), they are deeply committed to the individual experience and one's identity with the environment (by contrast with the dada group, whose sense of estrangement led them away from participation). This involvement has an unquestionably optimistic and affirmative basis as well as a distinctly existential cast, and it has a good deal to do with the tone set in their work, as we shall see. At the same time, the new artists are not intellectuals, by and large, and they have no interest in enunciated philosophical or aesthetic tendencies.

They share, then, an intense passion for direct experience, for unqualified participation in the richness of our immediate world, whatever it may have become, for better or worse. For them this means a kind of total acceptance; they reject nothing except all of our previous aesthetic canons. Since we regard our institutions as rationally derived and morally valid, this makes the artist seem antirational and reprehensible. It should be understood, of course, that the issue of morality raised here is an aesthetic issue and not personal or social. Despite whatever impressions their work may stimulate, these artists are not bohemians or "beatniks"; they have not rebelled against conventional social standards or modes of behavior.

The non-sense of their work results from the unfamiliarity of their juxtapositions of ideas, which depend on intuitions and associations somewhat removed from customary habits of looking and feeling. In much the same way, the new theater, which searches for a deeper psychological reality and which shares a good deal in common with the new artists, had been called "absurd"; its absurdity lies simply in its rejection of the familiar modes of reality which have governed the theater much longer than they have the plastic arts. In referring to the unfamiliarity of the artists' associations, I come back to what is perhaps their essential quality, their unwillingness to accept anything (any object, say) at face value, in the light of its possibility for enrichment and elaboration. Such an attitude is not unique in the contemporary world; it might be regarded both as a product of modern scientific skepticism and at the same time as a reaction to the modern scientific habit

of precise determination of phenomena. It may well be that the new artists could best be described as "hip" in the sense that they are incapable of outrage, in the sense that they cannot generate conventional responses to established virtues, and in this sense that they are sharply attuned to the bizarre, the grotesque and, for that matter, the splendor contained in the contemporary American scene.

I have said that these artists are not bohemians; most of them are familiar middle-class types, but their detachment from their own society becomes a necessary condition to their work. As outsiders they see us with a clarity that throws our appurtenances into proper focus. Like Vladimir Nabokov, they are tourists from another country, with resources and a spirit of curiosity which permit them to observe Disneyland with delight and amazement.

The point of view of the new artists depends on two basic ideas which were transmitted to them by a pair of older (in a stylistic sense) members of the group, Robert Rauschenberg and Jasper Johns. A statement by Rauschenberg which has by now become quite familiar implicitly contains the first of these ideas: "Painting relates to both art and life. Neither can be made. (I try to act in the gap between the two.)" Rauschenberg, along with the sculptor Richard Stankiewicz, was one of the first artists of this generation to take up again ideas which had originated fifty years earlier in the objects made or "found" by Picasso, Duchamp and various members of the dada group. Rauschenberg's statement, however, suggested much more acute consciousness of the possibility of breaking down the distinction between the artist and his life on the one hand, and the thing made on the other. Earlier I discussed the philosophical issues involved here in some detail. In Rauschenberg's view, the work of art has stopped being an illusory world, or a fragment of such a world, surrounded by a frame which cuts it off irrevocably from the real world. Now, the entrance into the picture of objects from outside—not as intruders but as integral components—breaks down the distinction between a shirt collar, say, as an article of clothing and the same thing as an emotive pictorial device. In other words, we begin to operate here in an indeterminate area somewhat between art and life, in such a way that the potential of enrichment of life as art merges inseparably with the possibility of making the work of art an experience to be enormously more directly felt than the previous nature of paintings and sculpture had ever permitted. Rauschenberg wants the work of art to be *life*, not an aesthetic encounter depending in part on an intellectual process.

Without a doubt, this is an exciting and suggestive idea, one of those concepts which may not be startlingly new, but which, stated positively in appropriate circumstances, can trigger activity in other artists.

Allan Kaprow, as much as any one, helped to elaborate this idea. An art historian as well as an artist, Kaprow has brought to the new art a sense of its

historical and philosophical contexts. It seems to me that an article written by Kaprow, ostensibly an homage to Jackson Pollock, should be regarded as the manifesto of the new art. ("The Legacy of Jackson Pollock," *ARTnews*, October 1958.)

Kaprow says in it that

> Pollock . . . left us at the point where we must become preoccupied with and even dazzled by the space and objects of our everyday life. . . . Not satisfied with the *suggestion* through paint of our other senses, we shall utilize the specific substances of sight, sound, movement, people, odors, touch. Objects of every sort are materials for the new art: paint, chairs, food, electric and neon lights, smoke, water, old socks, a dog, movies, a thousand other things which will be discovered by the present generation of artists. Not only will these bold creators show us, as if for the first time, the world we have always had about us but ignored, but they will disclose entirely unheard of happenings and events, found in garbage cans, police files, hotel lobbies, seen in store windows and on the streets, and sensed in dreams and horrible accidents.
>
> The young artist of today need no longer say "I am a painter. . . ." He is simply an "artist." All of life will be open to him. . . . Out of nothing he will devise the extraordinary. . . . People will be delighted or horrified, critics will be confused or amused, but these, I am sure, will be the alchemies of the 1960s.

Elaboration of the idea of interpenetration of art and the external world brought Kaprow from painting to the construction of "environments" in which he experimented with the articulation and complication of space in various ways, with lights, with three-dimensional sound, etc. Kaprow's interest in such possibilities had also been stimulated in another way. John Cage, whom Rauschenberg had met in the early fifties, was already deeply committed to the whole of formal innovations and unprecedented mixtures of sights and sounds, especially in his collaborations with Rauschenberg and Merce Cunningham, which have continued to the present. Cage's freshness of vision, his delight in the accidental and unpredictable and his total avoidance of qualitative judgments have more than a little to do with Zen, and his interest in all of these questions has carried over into the new movement. His friendship with both Rauschenberg and Johns has resulted in a high degree of interaction among the three, and one cannot really separate these factors clearly from the rest of the process.

Cage's "performances" were presented to assembled audiences, as Kaprow's environments were not. The new artists' desire to communicate more directly suggests closer participation with the audience; as a result, Kaprow and several other artists—more notably Red Grooms, Dine, Oldenburg and Lucas Samaras—spontaneously began to elaborate a new kind of theater unlike any seen before, but perhaps recalling certain dada performances. The formal freedom, the fluid spatial situation, the direct involvement of the audience (who got wet, fed, hit, over-heated, caressed, fanned, berated,

gassed, spangled, deafened, kicked, moved, blinded, splattered and entangled) and the spontaneity of the situation were so remote from conventional theater that a new name was required for these performances. They were called "happenings," a name which conveys the immediacy, the intensity of the present moment, the sense of individual participation and the unpredictable accidents which keep the audience at a high pitch of involvement. These events, which usually last five or ten minutes, happen *now*. Unlike ordinary theater, where every moment is predetermined, the happenings depend for their intensity on the audience's awareness that the conditions of the performance approach those of life, heightened in a special way by the creativity of the artist, but experienced without the sense of outcome which can be anticipated within the rigid forms of comedy or tragedy. The happenings differ from theater in another important respect; they depend not on the interplay of personalities, not on human conflict or even dialogue, but on "conversations" between people and objects, or between objects alone. The actors are only participants, and the objects often surpass them in scale, importance, variety of traits and violence of behavior.

If the happenings seem preoccupied with objects, it is no accident; the artists who have been involved have worked interchangeably between making objects and devising happenings. Some, like Dine, have not abandoned the performances, which appear to have been a necessary interlude in the whole process of exploration of the relation between people and things.

The contemporary absorption in the identity of objects and their emotive potential originated not only in the work of Rauschenberg but also in the paintings of Jasper Johns. Earlier I spoke of two basic considerations in the new art, the first being the new awareness of the mutuality of art and life. The second brings us back to the object and its new "personality." Without a doubt, Johns's flags and targets from the mid-fifties reopened the whole issue as much as anything else, since the subsequent preoccupation with popular images and sub-aesthetic objects in one way or another refers to his initial assumptions (or nonassumptions).

When Johns made an American flag the subject of a painting, he invited a substantial list of questions about both the image and the way he painted it. The flag is the kind of image so frequently exposed that we have literally become blind to it. In the context of the painting, we ask ourselves whether we have really ever looked at it; a moment of hesitation follows about whether the artist is really serious or not (the banality of the new images always raises this question). We might then wonder whether it is even legal to paint a flag. Short of obscenity, it is hard to think of a situation which could be more unsettling to us than the conflicts presented by this image.

Furthermore, when we really *look* at the flag, it becomes a curious obtuse image, apart from its emotive impact. A strong, simple design of rectangles and stars produces no recessive effects, so that its flatness puts us off at

the same time that the strong contrasts and vibrations make such distinct visual demands. The repetitive character of the design verges on monotony, but we simply cannot isolate such factors from our compelling identification with the image, which means so many different things to each of us.

In the face of the flatness and purity of the rectangles and stars, without any modulation of tone or softening of edge, when Johns imposes on the image his own painterly handing, a new tension results, bringing us back to the basic problem of the relation between the picture and the real object. As I have said, Johns raises quite a number of questions.

Once one has looked at the flag this way (there are few more familiar images), one has to look anew at everything, including the Father of Our Country, the *Mona Lisa,* Coke bottles, money, stamps, comic strips and billboards. However, simply putting these objects in the painting is not the whole story for these artists, and Johns's tension between the anonymity of the execution of the real object and his own performance suggests to them exploration of the style of billboards, advertising art, comic strips, etc. Upon examination, these two reveal unimagined mysteries of form, eccentricities of style, and a strange accumulation of images lurking where we never think to look for them. We discover that we are indeed blind and that we can be taught a new way to see.

Despite the differences in their styles, these artists share a common desire to intensify our perception of the image and to alter it in some way which complicates its effect. They may do this by augmenting the scale (Lichtenstein, Warhol) or by exaggerating or complicating the form, color or texture of objects (Oldenburg, Dine). Since the objects chosen in one sense *must* be banal, the new artists have been accused of nostalgia for childish things, an effect which is enhanced by the simple-minded blandness with which they present their objects to us. But they purposefully appeal to our tastes for the simple things, recalling the spirit but not the facts of the child's appetite, for very much the same reasons that an earlier generation of painters turned to child art in search of the directness and intensity of the child's perceptions. The ways in which these artists have made objects function ambiguously and indeterminately recall an earlier time in man's history when spirits hid in every pot, bedeviling objects, making them move or break, even killing and curing. We are reminded here of Picasso's (from whom much of this comes) willingness to believe that paintings might one day again perform miracles. For the new artists, objects do indeed possess mysterious powers and attributes, strange new kinds of beauty, sexuality even.

The grounds on which these new artists come to us could not be simpler, stronger or offered in better faith. They want us to share with them their pleasure and excitement at feeling and being, in an unquestioning and optimistic way. Their concern for the quality of experience and for the human

condition reflects an optimism absolutely at odds with that distrust which any appeal to our intuition and to our deeped currents of feeling seems always to provoke in us. Are we perhaps afraid to let down our guard, to let life become art? The problem seems to touch upon the security of our most cherished values. The contemporary artist is leading us through an aesthetic revolution with enormous ramifications in the post-Freudian world in which our fundamental ideas of art, beauty, the nature of experience, and the function of objects all must be reconsidered on substantially new terms. This is not a minor aberration, an interlude which will pass with a change in taste. These new artists may only be pointing the way to us, but we are entering a new world where the old art can no longer function any more than the old technology can. The new art may not provide the answers, but it is surely asking questions the consequences of which we cannot evade.

Context

Allen Ginsberg
Howl (1955–1956)

The Beats were a group of writers that included William S. Burroughs, Jack Kerouac, and Allen Ginsberg. The common bond of this diverse group was an attitude of rebellion against the conformity that was prevalent in 1950s American culture. Repulsed by rampant consumerism and frightened by the technocratic structuring of everyday life, they looked for solace in discarded materials and for liberation in metaphysical as well as physical travel. The Beats found inspiration in a range of things from jazz to Zen and challenged social taboos by championing openness, spontaneity, and experimentation in life as well as in art.

Allen Ginsberg's first public reading of "Howl" was in 1955 at the Six Gallery in San Francisco. "Howl" became the most celebrated Beat poem. In many ways the Beat attitude set the tone for much of the progressive art of the late 1950s and early 1960s. Ginsberg's gritty vernacular recalls the use of detritus in the work of many of the artists discussed in this chapter; the level to which the Beats engaged people by "performing" their work in the bookstores, cafés, and artist-run galleries is akin to the activities of Happenings and of Fluxus. "Howl" was first published in 1956 by the San Francisco–based City Lights Books.

for
Carl Solomon

I

I saw the best minds of my generation destroyed by madness, starving
 hysterical naked,
dragging themselves through the negro streets at dawn looking for an
 angry fix,
angelheaded hipsters burning for the ancient heavenly connection to the
 starry dynamo in the machinery of night,
who poverty and tatters and hollow-eyed and high sat up smoking in the
 supernatural darkness of cold-water flats floating across the tops of
 cities contemplating jazz,
who bared their brains to Heaven under the El and saw Mohammedan
 angels staggering on tenement roofs illuminated,
who passed through universities with radiant cool eyes hallucinating
 Arkansas and Blake-light tragedy among the scholars of war,
who were expelled from the academies for crazy & publishing obscene odes
 on the windows of the skull,
who cowered in unshaven rooms in underwear, burning their money in
 wastebaskets and listening to the Terror through the wall,
who got busted in their pubic beards returning through Laredo with a belt
 of marijuana for New York,
who ate fire in paint hotels or drank turpentine in Paradise Alley, death, or
 purgatoried their torsos night after night
with dreams, with drugs, with waking nightmares, alcohol and cock and
 endless balls,
incomparable blind streets of shuddering cloud and lightning in the mind
 leaping toward poles of Canada & Paterson, illuminating all the
 motionless world of Time between,
Peyote solidities of halls, backyard green tree cemetery dawns, wine drunk-
 enness over the rooftops, storefront boroughs of teahead joyride neon
 blinking traffic light, sun and moon and tree vibrations in the roaring
 winter dusks of Brooklyn, ashcan rantings and kind king light of mind,
who chained themselves to subways for the endless ride from Battery to
 holy Bronx on benzedrine until the noise of wheels and children
 brought them down shuddering mouth-wracked and battered bleak
 of brain all drained of brilliance in the drear light of Zoo,
who sank all night in submarine light of Bickford's floated out and sat
 through the stale beer afternoon in desolate Fugazzi's, listening to the
 crack of doom on the hydrogen jukebox,
who talked continuously seventy hours from park to pad to bar to Bellevue
 to museum to the Brooklyn Bridge,

a lost battalion of platonic conversationalists jumping down the stoops off
 fire escapes off windowsills off Empire State out of the moon,
yacketayakking screaming vomiting whispering facts and memories and
 anecdotes and eyeball kicks and shocks of hospitals and jails and
 wars,
whole intellects disgorged in total recall for seven days and nights with
 brilliant eyes, meat for the Synagogue cast on the pavement,
who vanished into nowhere Zen New Jersey leaving a trail of ambiguous
 picture postcards of Atlantic City Hall,
suffering Eastern sweats and Tangerian bone-grindings and migraines of
 China under junk-withdrawal in Newark's bleak furnished room,
who wandered around and around at midnight in the railroad yard
 wondering where to go, and went, leaving no broken hearts,
who lit cigarettes in boxcars boxcars boxcars racketing through snow
 toward lonesome farms in grandfather night,
who studied Plotinus Poe St. John of the Cross telepathy and bop kaballa
 because the cosmos instinctively vibrated at their feet in Kansas,
who loned it through the streets of Idaho seeking visionary indian angels
 who were visionary indian angels,
who thought they were only mad when Baltimore gleamed in supernatural
 ecstasy,
who jumped in limousines with the Chinaman of Oklahoma on the impulse
 of winter midnight streetlight smalltown rain,
who lounged hungry and lonesome through Houston seeking jazz or sex or
 soup, and followed the brilliant Spaniard to converse about America
 and Eternity, a hopeless task, and so took ship to Africa,
who disappeared into the volcanoes of Mexico leaving behind nothing but
 the shadow of dungarees and the lava and ash of poetry scattered in
 fireplace Chicago,
who reappeared on the West Coast investigating the F.B.I. in beards and
 shorts with big pacifist eyes sexy in their dark skin passing out
 incomprehensible leaflets,
who burned cigarette holes in their arms protesting the narcotic tobacco
 haze of Capitalism,
who distributed Supercommunist pamphlets in Union Square weeping and
 undressing while the sirens of Los Alamos wailed them down, and
 wailed down Wall, and the Staten Island ferry also wailed,
who broke down crying in white gymnasiums naked and trembling before
 the machinery of other skeletons,
who bit detectives in the neck and shrieked with delight in policecars for
 committing no crime but their own wild cooking pederasty and
 intoxication,
who howled on their knees in the subway and were dragged off the roof
 waving genitals and manuscripts,

who let themselves be fucked in the ass by saintly motorcyclists, and
 screamed with joy,

who blew and were blown by those human seraphim, the sailors, caresses
 of Atlantic and Caribbean love,

who balled in the morning in the evenings in rosegardens and the grass of
 public parks and cemeteries scattering their semen freely to
 whomever come who may,

who hiccupped endlessly trying to giggle but wound up with a sob behind
 a partition in a Turkish Bath when the blonde & naked angel came to
 pierce them with a sword,

who lost their loveboys to the three old shrews of fate the one eyed shrew
 of the heterosexual dollar the one eyed shrew that winks out of the
 womb and the one eyed shrew that does nothing but sit on her ass
 and snip the intellectual golden threads of the craftsman's loom,

who copulated ecstatic and insatiate with a bottle of beer a sweetheart a pack-
 age of cigarettes a candle and fell off the bed, and continued along the
 floor and down the hall and ended fainting on the wall with a vision of
 ultimate cunt and come eluding the last gyzym of consciousness,

who sweetened the snatches of a million girls trembling in the sunset, and
 were red eyed in the morning but prepared to sweeten the snatch of
 the sunrise, flashing buttocks under barns and naked in the lake,

who went out whoring through Colorado in myriad stolen night-cars, N.C.,
 secret hero of these poems, cocksman and Adonis of Denver—joy to
 the memory of his innumerable lays of girls in empty lots & diner
 backyards, moviehouses' rickety rows, on mountaintops in caves
 or with gaunt waitresses in familiar roadside lonely petticoat
 upliftings & especially secret gas-station solipisisms of johns, &
 hometown alleys too,

who faded out in vast sordid movies, were shifted in dreams, woke on a
 sudden Manhattan, and picked themselves up out of basements
 hungover with heartless Tokay and horrors of Third Avenue iron
 dreams & stumbled to unemployment offices,

who walked all night with their shoes full of blood on the snowbank docks
 waiting for a door in the East River to open to a room full of
 steamheat and opium,

who created great suicidal dramas on the apartment cliff-banks of the
 Hudson under the wartime blue floodlight of the moon & their heads
 shall be crowned with laurel in oblivion,

who ate the lamb stew of the imagination or digested the crab at the muddy
 bottom of the rivers of Bowery,

who wept at the romance of the streets with their pushcarts full of onions
 and bad music,

who sat in boxes breathing in the darkness under the bridge, and rose up to
 build harpsichords in their lofts,

who coughed on the sixth floor of Harlem crowned with flame under the
tubercular sky surrounded by orange crates of theology,

who scribbled all night rocking and rolling over lofty incantations which in
the yellow morning were stanzas of gibberish,

who cooked rotten animals lung heart feet tail borsht & tortillas dreaming
of the pure vegetable kingdom,

who plunged themselves under meat trucks looking for an egg,

who threw their watches off the roof to cast their ballot for Eternity outside
of Time, & alarm clocks fell on their heads every day for the next
decade,

who cut their wrists three times successively unsuccessfully, gave up and
were forced to open antique stores where they thought they were
growing old and cried,

who were burned alive in their innocent flannel suits on Madison Avenue
amid blasts of leaden verse & the tanked-up clatter of the iron
regiments of fashion & the nitroglycerine shrieks of the fairies of
advertising & the mustard gas of sinister intelligent editors, or were
run down by the drunken taxicabs of Absolute Reality,

who jumped off the Brooklyn Bridge this actually happened and walked
away unknown and forgotten into the ghostly daze of Chinatown
soup alleyways & firetrucks, not even one free beer,

who sang out of their windows in despair, fell out of the subway window,
jumped in the filthy Passaic, leaped on negroes, cried all over the
street, danced on broken wineglasses barefoot smashed phonograph
records of nostalgic European 1930's German jazz finished the
whiskey and threw up groaning into the bloody toilet, moans in their
ears and the blast of colossal steamwhistles,

who barreled down the highways of the past journeying to each other's
hotrod-Golgotha jail-solitude watch or Birmingham jazz incarnation,

who drove crosscountry seventytwo hours to find out if I had a vision or
you had a vision or he had a vision to find out Eternity,

who journeyed to Denver, who died in Denver, who came back to Denver
& waited in vain, who watched over Denver & brooded & loned in
Denver and finally went away to find out the Time, & now Denver is
lonesome for her heroes,

who fell on their knees in hopeless cathedrals praying for each other's
salvation and light and breasts, until the soul illuminated its hair for
a second,

who crashed through their minds in jail waiting for impossible criminals
with golden heads and the charm of reality in their hearts who sang
sweet blues to Alcatraz,

who retired to Mexico to cultivate a habit, or Rocky Mount to tender
Buddha or Tangiers to boys or Southern Pacific to the black locomotive
or Harvard to Narcissus to Woodlawn to the daisychain or grave,

who demanded sanity trials accusing the radio of hypnotism & were left
 with their insanity & their hands & a hung jury,

who threw potato salad at CCNY lecturers on Dadaism and subsequently
 presented themselves on the granite steps of the madhouse
 with shaven heads and harlequin speech of suicide, demanding
 instantaneous lobotomy,

and who were given instead the concrete void of insulin metrasol electricity
 hydrotherapy psychotherapy occupational therapy pingpong &
 amnesia,

who in humorless protest overturned only one symbolic pingpong table,
 resting briefly in catatonia,

returning years later truly bald except for a wig of blood, and tears and
 fingers, to the visible madman doom of the wards of the madtowns
 of the East,

Pilgrim State's Rockland's and Greystone's foetid halls, bickering with the
 echoes of the soul, rocking and rolling in the midnight solitude-bench
 dolmen-realms of love, dream of life a nightmare, bodies turned to
 stone as heavy as the moon,

with mother finally ******, and the last fantastic book flung out of the tene-
 ment window, and the last door closed at 4 AM, and the last telephone
 slammed at the wall in reply and the last furnished room emptied
 down to the last piece of mental furniture, a yellow paper rose twisted
 on a wire hanger in the closet, and even that imaginary, nothing but a
 hopeful little bit of hallucination—

ah, Carl, while you are not safe I am not safe, and now you're really in the
 total animal soup of time—

and who therefore ran through the icy streets obsessed with a sudden flash
 of the alchemy of the use of the ellipse the catalog the meter & the
 vibrating plane,

who dreamt and made incarnate gaps in Time & Space through images
 juxtaposed, and trapped the archangel of the soul between 2 visual
 images and joined the elemental verbs and set the noun and dash of
 consciousness together jumping with sensation of Pater Omnipotens
 Aeterna Deus

to recreate the syntax and measure of poor human prose and stand
 before you speechless and intelligent and shaking with shame,
 rejected yet confessing out the soul to conform to the rhythm of
 thought in his naked and endless head,

the madman bum and angel beat in Time, unknown, yet putting down here
 what might be left to say in time come after death,

and rose reincarnate in the ghostly clothes of jazz in the goldhorn shadow
 of the band and blew the suffering of America's naked mind for love
 into an eli eli lamma lamma sabacthani saxophone cry that shivered
 the cities down to the last radio

with the absolute heart of the poem of life butchered out of their own
bodies good to eat a thousand years.

II

What sphinx of cement and aluminum bashed open their skulls and ate up
their brains and imagination?
Moloch! Solitude! Filth! Ugliness! Ashcans and unobtainable dollars!
Children screaming under the stairways! Boys sobbing in armies!
Old men weeping in the parks!
Moloch! Moloch! Nightmare of Moloch! Moloch the loveless! Mental
Moloch! Moloch the heavy judger of men!
Moloch the incomprehensible prison! Moloch the crossbone soulless
jailhouse and Congress of sorrows! Moloch whose buildings are
judgement! Moloch the vast stone of war! Moloch the stunned
governments!
Moloch whose mind is pure machinery! Moloch whose blood is running
money! Moloch whose fingers are ten armies! Moloch whose breast is
a cannibal dynamo! Moloch whose car is a smoking tomb!
Moloch whose eyes are a thousand blind windows! Moloch whose
skyscrapers stand in the long streets like endless Jehovahs! Moloch
whose factories dream and croak in the fog! Moloch whose smoke-
stacks and antennae crown the cities!
Moloch whose love is endless oil and stone! Moloch whose soul is
electricity and banks! Moloch whose poverty is the specter of genius!
Moloch whose fate is a cloud of sexless hydrogen! Moloch whose
name is the Mind!
Moloch in whom I sit lonely! Moloch in whom I dream Angels! Crazy in
Moloch! Cocksucker in Moloch! Lacklove and manless in Moloch!
Moloch who entered my soul early! Moloch in whom I am a consciousness
without a body! Moloch who frightened me out of my natural ecstasy!
Moloch whom I abandon! Wake up in Moloch! Light streaming out of
the sky!
Moloch! Moloch! Robot apartments! invisible suburbs! skeleton treasuries!
blind capitals! demonic industries! spectral nations! invincible
madhouses! granite cocks! monstrous bombs!
They broke their backs lifting Moloch to Heaven! Pavements, trees, radios,
tons! lifting the city to Heaven which exists and is everywhere about us!
Visions! omens! hallucinations! miracles! ecstasies! gone down the
American river!
Dreams! adorations! illuminations! religions! the whole boatload of
sensitive bullshit!

Breakthroughs! over the river! flips and crucifixions! gone down the flood!
 Highs! Epiphanies! Despairs! Ten years' animal screams and suicides!
 Minds! New loves! Mad generation! down on the rocks of Time!
Real holy laughter in the river! They saw it all! the wild eyes! the holy yells!
 They bade farewell! They jumped off the roof! to solitude! waving!
 carrying flowers! Down to the river! into the street!

III

Carl Solomon! I'm with you in Rockland
 where you're madder than I am
I'm with you in Rockland
 where you must feel very strange
I'm with you in Rockland
 where you imitate the shade of my mother
I'm with you in Rockland
 where you've murdered your twelve secretaries
I'm with you in Rockland
 where you laugh at this invisible humor
I'm with you in Rockland
 where we are great writers on the same dreadful typewriter
I'm with you in Rockland
 where your condition has become serious and is reported on the radio
I'm with you in Rockland
 where the faculties of the skull no longer admit the worms of the
 senses
I'm with you in Rockland
 where you drink the tea of the breasts of the spinsters of Utica
I'm with you in Rockland
 where you pun on the bodies of your nurses the harpies of the Bronx
I'm with you in Rockland
 where you scream in a straightjacket that you're losing the game of
 the actual pingpong of the abyss
I'm with you in Rockland
 where you bang on the catatonic piano the soul is innocent and
 immortal it should never die ungodly in an armed madhouse
I'm with you in Rockland
 where fifty more shocks will never return your soul to its body again
 from its pilgrimage to a cross in the void
I'm with you in Rockland
 where you accuse your doctors of insanity and plot the Hebrew socialist
 revolution against the fascist national Golgotha

I'm with you in Rockland
> where you will split the heavens of Long Island and resurrect your
> living human Jesus from the superhuman tomb

I'm with you in Rockland
> where there are twentyfive-thousand mad comrades all together
> singing the final stanzas of the Internationale

I'm with you in Rockland
> where we hug and kiss the United States under our bedsheets the
> United States that coughs all night and won't let us sleep

I'm with you in Rockland
> where we wake up electrified out of the coma by our own souls'
> airplanes roaring over the roof they've come to drop angelic bombs
> the hospital illuminates itself imaginary walls collapse O skinny
> legions run outside O starry-spangled shock of mercy the eternal
> war is here O victory forget your underwear we're free

I'm with you in Rockland
> in my dreams you walk dripping from a
> sea-journey on the highway across America in tears to the door of
> my cottage in the Western night

San Francisco 1955–56

FOOTNOTE TO HOWL

Holy! Holy! Holy! Holy! Holy! Holy! Holy! Holy! Holy! Holy! Holy! Holy!
> Holy! Holy! Holy!

The world is holy! The soul is holy! The skin is holy! The nose is holy!
> The tongue and cock and hand and asshole holy!

Everything is holy! everybody's holy! everywhere is holy! everyday is in
> eternity! Everyman's an angel!

The bum's as holy as the seraphim! the madman is holy as you my soul
> are holy!

The typewriter is holy the poem is holy the voice is holy the hearers are
> holy the ecstasy is holy!

Holy Peter holy Allen holy Solomon holy Lucien holy Kerouac holy
> Huncke holy Burroughs holy Cassady holy the unknown buggered
> and suffering beggars holy the hideous human angels!

Holy my mother in the insane asylum! Holy the cocks of the grandfathers
> of Kansas!

Holy the groaning saxophone! Holy the bop apocalypse! Holy the
> jazzbands marijuana hipsters peace & junk & drums!

Holy the solitudes of skyscrapers and pavements! Holy the cafeterias
> filled with the millions! Holy the mysterious rivers of tears under
> the streets!

Holy the lone juggernaut! Holy the vast lamb of the middle-class! Holy the
crazy shepherds of rebellion! Who digs Los Angeles IS Los Angeles!
Holy New York Holy San Francisco Holy Peoria & Seattle Holy Paris Holy
Tangiers Holy Moscow Holy Istanbul!
Holy time in eternity holy eternity in time holy the clocks in space holy the
fourth dimension holy the fifth International holy the Angel in
Moloch!
Holy the sea holy the desert holy the railroad holy the locomotive holy the
visions holy the hallucinations holy the miracles holy the eyeball holy
the abyss!
Holy forgiveness! mercy! charity! faith! Holy! Ours! bodies! suffering!
magnanimity!
Holy the supernatural extra brilliant intelligent kindness of the soul!

Lawrence Ferlinghetti
Dog (1955)

Lawrence Ferlinghetti was a member of the group of writers known as the San Fran-
cisco Renaissance who flourished in the cafés and bookstores of San Francisco in
the 1940s and 1950s. This group of writers also included Gary Snyder, Michael
McClure, and others who were closely associated both socially and philosophically
with the Beat writers. The poem "Dog," from Ferlinghetti's book of poems *A Coney
Island of the Mind,* is a call to experience the sensations of the everyday world in a
way that parallels the work of many of the visual artists at this time. One can al-
most imagine the dog of the poem as Rauschenberg sniffing around New York City
looking for "reality" in sensations and discarded materials of this highly animated
street. "Dog" was published in 1955 by New Directions.

 The dog trots freely in the street
 and sees reality
 and the things he sees
 are bigger than himself
 and the things he sees
 are his reality
 Drunks in doorways
 Moons on trees

The dog trots freely thru the street
and the things he sees
are smaller than himself
Fish on newsprint
Ants in holes
Chickens in Chinatown windows
their heads a block away
The dog trots freely in the street
and the things he smells
smell something like himself
The dog trots freely in the street
past puddles and babies
cats and cigars
poolrooms and policemen
He doesn't hate cops
He merely has no use for them
and he goes past them
and past the dead cows hung up whole
in front of the San Francisco Meat Market
He would rather eat a tender cow
than a tough policeman
though either might do
And he goes past the Romeo Ravioli Factory
and past Coit's Tower
and past Congressman Doyle
He's afraid of Coit's Tower
but he's not afraid of Congressman Doyle
although what he hears is very discouraging
very depressing
very absurd
to a sad young dog like himself
to a serious dog like himself
But he has his own free world to live in
His own fleas to eat
He will not be muzzled
Congressman Doyle is just another
fire hydrant
to him
The dog trots freely in the street
and has his own dog's life to live
and to think about
and to reflect upon
touching and tasting and testing everything
investigating everything
without benefit of perjury
a real realist
with a real tale to tell

John Cage
Experimental Music (1957)

John Cage premiered his groundbreaking musical composition *4'33"* at Black Mountain College in 1952. The piece consisted of four minutes and thirty-three seconds of silence. This gesture attempted to blur the lines between art and life by making the listener more aware of everyday sounds. His challenge to the traditional structures of musical composition brought him into contact with many of the most important visual and performance artists of the 1950s and 1960s, the culmination of which includes his now-famous collaborations with the choreographer and dancer Merce Cunningham.

"Experimental Music" was given as an address to the Music Teachers National Association convention in Chicago in 1957. "Experimental Music" reflects Cage's desire to find ways of leaving his ego behind during the creation of a composition. Through experiments with chance operations as well as with consciously allowing the sounds of the environment enter into the work, Cage relinquishes control over the piece and allows nature to take its place in the creative act. These ideas influenced a number of the artists in this chapter, including Robert Rauschenberg, whose use of found materials reflected the world in which he lived more than his own artistic personality. When Cage says that writing music is "simply a way of waking up to the very life we're living, which is so excellent once one gets one's mind and desires out of the way and lets it act of its own accord," it is hard not to think of this quote from Rauschenberg: "I was busy trying to find ways where the imagery, the material and the meaning of the painting would be, not an illustration of my will, but more like an unbiased documentation of what I observed."

Formerly, whenever anyone said the music I presented was experimental, I objected. It seemed to me that composers knew what they were doing, and that the experiments that had been made had taken place prior to the finished works, just as sketches are made before paintings and rehearsals precede performances. But, giving the matter further thought, I realized that there is ordinarily an essential difference between making a piece of music and hearing one. A composer knows his work as a woodsman knows a path he has traced and retraced, while a listener is confronted by the same work as one is in the woods by a plant he has never seen before.

Now, on the other hand, times have changed; music has changed; and I no longer object to the word "experimental." I use it in fact to describe all the music that especially interests me and to which I am devoted, whether someone else wrote it or I myself did. What has happened is that I have become a

John Cage, "Experimental Music" from *Silence*. © 1973 by John Cage, Wesleyan University Press by permission of University Press of New England.

listener and the music has become something to hear. Many people, of course, have given up saying "experimental" about this new music. Instead, they either move to a halfway point and say "controversial" or depart to a greater distance and question whether this "music" is music at all.

For in this new music nothing takes place but sounds: those that are notated and those that are not. Those that are not notated appear in the written music as silences, opening the doors of the music to the sounds that happen to be in the environment. This openness exists in the fields of modern sculpture and architecture. The glass houses of Mies van der Rohe reflect their environment, presenting to the eye images of clouds, trees, or grass, according to the situation. And while looking at the constructions in wire of the sculptor Richard Lippold, it is inevitable that one will see other things, and people too, if they happen to be there at the same time, through the network of wires. There is no such thing as an empty space or an empty time. There is always something to see, something to hear. In fact, try as we may to make a silence, we cannot. For certain engineering purposes, it is desirable to have as silent a situation as possible. Such a room is called an anechoic chamber, its six walls made of special material, a room without echoes. I entered one at Harvard University several years ago and heard two sounds, one high and one low. When I described them to the engineer in charge, he informed me that the high one was my nervous system in operation, the low one my blood in circulation. Until I die there will be sounds. And they will continue following my death. One need not fear about the future of music.

But this fearlessness only follows if, at the parting of the ways, where it is realized that sounds occur whether intended or not, one turns in the direction of those he does not intend. This turning is psychological and seems at first to be a giving up of everything that belongs to humanity—for a musician, the giving up of music. This psychological turning leads to the world of nature, where, gradually or suddenly, one sees that humanity and nature, not separate, are in this world together; that nothing was lost when everything was given away. In fact, everything is gained. In musical terms, any sounds may occur in any combination and in any continuity.

And it is a striking coincidence that just now the technical means to produce such a free-ranging music are available. When the Allies entered Germany towards the end of World War II, it was discovered that improvements had been made in recording sounds magnetically such that tape had become suitable for the high-fidelity recording of music. First in France with the work of Pierre Schaeffer, later here, in Germany, in Italy, in Japan, and perhaps, without my knowing it, in other places, magnetic tape was used not simply to record performances of music but to make a new music that was possible only because of it. Given a minimum of two tape recorders and a disk recorder, the following processes are possible: (1) a single recording of any sound may be made; (2) a rerecording may be made, in the course of which, by means of filters and circuits, any or all of the physical characteristics of a

given recorded sound may be altered; (3) electronic mixing (combining on a third machine sounds issuing from two others) permits the presentation of any number of sounds in combination; (4) ordinary splicing permits the juxtaposition of any sounds, and when it includes unconventional cuts, it, like rerecording, brings about alterations of any or all of the original physical characteristics. The situation made available by these means is essentially a total sound-space, the limits of which are ear-determined only, the position of a particular sound in this space being the result of five determinants: frequency or pitch, amplitude or loudness, overtone structure or timbre, duration, and morphology (how the sound begins, goes on, and dies away). By the alteration of any one of these determinants, the position of the sound in sound-space changes. Any sound at any point in this total sound-space can move to become a sound at any other point. But advantage can be taken of these possibilities only if one is willing to change one's musical habits radically. That is, one may take advantage of the appearance of images without visible transition in distant places, which is a way of saying "television," if one is willing to stay at home instead of going to a theater. Or one may fly if one is willing to give up walking.

Musical habits include scales, modes, theories of counterpoint and harmony, and the study of the timbres, singly and in combination of a limited number of sound-producing mechanisms. In mathematical terms these all concern discrete steps. They resemble walking—in the case of pitches, on steppingstones twelve in number. This cautious stepping is not characteristic of the possibilities of magnetic tape, which is revealing to us that musical action or existence can occur at any point or along any line or curve or what have you in total sound-space; that we are, in fact, technically equipped to transform our contemporary awareness of nature's manner of operation into art.

Again there is a parting of the ways. One has a choice. If he does not wish to give up his attempts to control sound, he may complicate his musical technique towards an approximation of the new possibilities and awareness. (I use the word "approximation" because a measuring mind can never finally measure nature.) Or, as before, one may give up the desire to control sound, clear his mind of music, and set about discovering means to let sounds be themselves rather than vehicles for man-made theories or expressions of human sentiments.

This project will seem fearsome to many, but on examination it gives no cause for alarm. Hearing sounds which are just sounds immediately sets the theorizing mind to theorizing, and the emotions of human beings are continually aroused by encounters with nature. Does not a mountain unintentionally evoke in us a sense of wonder? otters along a stream a sense of mirth? night in the woods a sense of fear? Do not rain falling and mists rising up suggest the love binding heaven and earth? Is not decaying flesh loathsome?

Does not the death of someone we love bring sorrow? And is there a greater hero than the least plant that grows? What is more angry than the flash of lightning and the sound of thunder? These responses to nature are mine and will not necessarily correspond with another's. Emotion takes place in the person who has it. And sounds, when allowed to be themselves, do not require that those who hear them do so unfeelingly. The opposite is what is meant by response ability.

New music: new listening. Not an attempt to understand something that is being said, for, if something were being said, the sounds would be given the shapes of words. Just an attention to the activity of sounds.

Those involved with the composition of experimental music find ways and means to remove themselves from the activities of the sounds they make. Some employ chance operations, derived from sources as ancient as the Chinese *Book of Changes,* or as modern as the tables of random numbers used also by physicists in research. Or, analogous to the Rorschach tests of psychology, the interpretation of imperfections in the paper upon which one is writing may provide a music free from one's memory and imagination. Geometrical means employing spatial superimpositions at variance with the ultimate performance in time may be used. The total field of possibilities may be roughly divided and the actual sounds within these divisions may be indicated as to number but left to the performer or to the splicer to choose. In this latter case, the composer resembles the maker of a camera who allows someone else to take the picture.

Whether one uses tape or writes for conventional instruments, the present musical situation has changed from what it was before tape came into being. This also need not arouse alarm, for the coming into being of something new does not by that fact deprive what was of its proper place. Each thing has its own place, never takes the place of something else; and the more things there are, as is said, the merrier.

But several effects of tape on experimental music may be mentioned. Since so many inches of tape equal so many seconds of time, it has become more and more usual that notation is in space rather than in symbols of quarter, half, and sixteenth notes and so on. Thus where on a page a note appears will correspond to when in a time it is to occur. A stop watch is used to facilitate a performance; and a rhythm results which is a far cry from horse's hoofs and other regular beats.

Also it has been impossible with the playing of several separate tapes at once to achieve perfect synchronization. This fact has led some towards the manufacture of multiple-tracked tapes and machines with a corresponding number of heads; while others—those who have accepted the sounds they do not intend—now realize that the score, the requiring that many parts be played in a particular togetherness, is not an accurate representation of how things are. These now compose parts but not scores, and the parts may

be combined in any unthought ways. This means that each performance of such a piece of music is unique, as interesting to its composer as to others listening. It is easy to see again the parallel with nature, for even with leaves of the same tree, no two are exactly alike. The parallel in art is the sculpture with moving parts, the mobile.

It goes without saying that dissonances and noises are welcome in this new music. But so is the dominant seventh chord if it happens to put in an appearance.

Rehearsals have shown that this new music, whether for tape or for instruments, is more clearly heard when the several loud-speakers or performers are separated in space rather than grouped closely together. For this music is not concerned with harmoniousness as generally understood, where the quality of harmony results from a blending of several elements. Here we are concerned with the coexistence of dissimilars, and the central points where fusion occurs are many: the ears of the listeners wherever they are. This disharmony, to paraphrase Bergson's statement about disorder, is simply a harmony to which many are unaccustomed.

Where do we go from here? Towards theater. That art more than music resembles nature. We have eyes as well as ears, and it is our business while we are alive to use them.

And what is the purpose of writing music? One is, of course, not dealing with purposes but dealing with sounds. Or the answer must take the form of paradox: a purposeful purposelessness or a purposeless play. This play, however, is an affirmation of life—not an attempt to bring order out of chaos nor to suggest improvements in creation, but simply a way of waking up to the very life we're living, which is so excellent once one gets one's mind and one's desires out of its way and lets it act of its own accord.

Mass Culture, Mass Media, Pop Art

James Rosenquist (American, b. 1933), *President Elect*. 1960–61. Oil on Masonite, 89 3/4 x 144 in. (228.0 x 365.8 cm). © James Rosenquist/Licensed by VAGA, New York, N.Y.

Roy Lichtenstein, Andy Warhol, Robert Indiana, James Rosenquist
What Is Pop Art? (Interviews with Gene Swenson) (1963 and 1964)

In the early 1960s the group of artists later to be codified under the term "Pop" began to make their presence felt in the art world. By imitating the look of mass-produced images—from comic books, newspapers, and packaging design—Pop artists began to blur the lines between commercial and avant-garde art. In America the precedent for using commercially manufactured objects and images as the starting point for works of art can be traced back at least to the 1920s with paintings such as *Lucky Strike* by Stuart Davis. The most recent artists to focus on the objects and images of consumer culture were Jasper Johns, Robert Rauschenberg, and others discussed in the last chapter. However, the Pop artists pushed this idea one step further by diminishing the visual record of the artist's hand, thereby downplaying the process by which the object was made. Warhol went so far as to mirror a machine aesthetic by silk-screening images onto his canvas. The directness and uncompromising mechanical look of Warhol's Campbell's Soup cans, Lichtenstein's comic books, and Indiana's signage was startling to critics and other artists who had come to believe that truth in art was to a large degree found in the artist's ability to reveal process.

The Abstract Expressionists had given America its first avant-garde movement by pushing the principles of European abstraction. Their heroic canvases and humanistic themes exalted the painting process as a struggle of the individual will. Within three years of the triumphant European tour of *The New American Painting* (the influential exhibition of Abstract Expressionist works), a strong case was being made for the second major movement in American art: Pop. The 1962 exhibition called *New Realists* at the Sidney Janis Gallery in New York helped to codify the ideas surrounding this burgeoning movement. In a two-part series called "What Is Pop Art?" published in *Art News* in November 1963 and February 1964, Gene Swenson interviews the major proponents of this new style.

ROY LICHTENSTEIN

What is pop art?

I don't know—the use of commercial art as subject matter in painting, I suppose. It was hard to get a painting that was despicable enough so that no one

would hang it—everybody was hanging everything. It was almost acceptable to hang a dripping paint rag, everybody was accustomed to this. The one thing everyone hated was commercial art; apparently they didn't hate that enough either.

Is pop art despicable?

That doesn't sound so good, does it? Well it *is* an involvement with what I think to be the most brazen and threatening characteristics of our culture, things we hate, but which are also powerful in their impingement on us. I think art since Cézanne has become extremely romantic and unrealistic, feeding on art; it is utopian. It has had less and less to do with the world, it looks inward—neo-Zen and all that. This is not so much a criticism as an obvious observation. Outside is the world; it's there. Pop art looks out into the world; it appears to accept its environment, which is not good or bad, but different—another state of mind.

"How can you like exploitation? How can you like the complete mechanization of work? How can you like bad art?" I have to answer that I accept it as being there, in the world.

Are you anti-experimental?

I think so, and anti-contemplative, anti-nuance, anti-getting-away-from-the-tyranny-of-the-rectangle, anti-movement-and-light, anti-mystery, anti-paint-quality, anti-Zen, and anti all of those brilliant ideas of preceding movements which everyone understands so thoroughly.

We like to think of industrialization as being despicable. I don't really know what to make of it. There's something terribly brittle about it. I suppose I would still prefer to sit under a tree with a picnic basket rather than under a gas pump, but signs and comic strips are interesting as subject matter. There are certain things that are usable, forceful and vital about commercial art. We're using those things—but we're not really advocating stupidity, international teenagerism and terrorism.

Where did your ideas about art begin?

The ideas of Professor Hoyt Sherman [at Ohio State University] on perception were my earliest important influence and still affect my ideas of visual unity.

Perception?

Yes. Organized perception is what art is all about.

He taught you "how to look"?

Yes. He taught me how to go about learning how to look.

At what?

At what, doesn't have anything to do with it. It is a process. It has nothing to do with any external form the painting takes, it has to do with a way of building a unified pattern of seeing. . . . In abstract-expressionism the paintings symbolize the idea of ground-directedness as opposed to object-directedness. You put something down, react to it, put something else down, and the painting itself becomes a symbol of this. The difference is that rather than symbolize this ground-directedness I do an object-directed appearing thing. There is humor here. The work is still ground-directed; the fact that it's an eyebrow or an almost direct copy of something is unimportant. The ground-directedness is in the painter's mind and not immediately apparent in the painting. Pop art makes the statement that ground-directedness is not a quality that the painting has because of what it looks like. . . . This tension between apparent object-directed products and actual ground-directed processes is an important strength of pop art.

Antagonistic critics say that pop art does not transform its models. Does it?

Transformation is a strange word to use. It implies that art transforms. It doesn't, it just plain forms. Artists have never worked with the model—just with the painting. What you're really saying is that an artist like Cézanne transforms what we think the painting ought to look like into something he thinks it ought to look like. He's working with paint, not nature; he's making a painting, he's forming. I think my work is different from comic strips—but I wouldn't call it transformation; I don't think that whatever is meant by it is important to art. What I do is form, whereas the comic strip is not formed in the sense I'm using the word; the comics have shapes but there has been no effort to make them intensely unified. The purpose is different, one intends to depict and I intend to unify. And my work is actually different from comic strips in that every mark is really in a different place, however slight the difference seems to some. The difference is often not great, but it is crucial. People also consider my work to be anti-art in the same way they consider it pure depiction, "not transformed." I don't feel it is anti-art.

There is no neat way of telling whether a work of art is composed or not; we're too comfortable with ideas that art is the battleground for interaction, that with more and more experience you become more able to compose.

It's true, everybody accepts that; it's just that the idea no longer has any power.

Abstract expressionism has had an almost universal influence on the arts. Will pop art?

I don't know. I doubt it. It seems too particular—too much the expression of a few personalities. Pop might be a difficult starting point for a painter. He would have great difficulty in making these brittle images yield to compositional purposes. . . . Interaction between painter and painting is not the total commitment of pop, but it is still a major concern—though concealed and strained.

Do you think that an idea in painting—whether it be "interaction" or the use of commercial art—gets progressively less powerful with time?

It seems to work that way. Cubist and action painting ideas, although originally formidable and still an influence, are less crucial to us now. Some individual artists, though—Stuart Davis, for example—seem to get better and better.

A curator at the Modern Museum has called pop art fascistic and militaristic.

The heroes depicted in comic books are fascist types, but I don't take them seriously in these paintings—maybe there is a point in not taking them seriously, a political point. I use them for purely formal reasons, and that's not what those heroes were invented for. . . . Pop art has very immediate and of-the-moment meanings which will vanish—that kind of thing is ephemeral—and pop takes advantage of this "meaning," which is not supposed to last, to divert you from its formal content. I think the formal statement in my work will become clearer in time. Superficially, pop seems to be all subject matter, whereas abstract expressionism, for example, seems to be all aesthetic. . . .

I paint directly—then it's said to be an exact copy, and not art, probably because there's no perspective or shading. It doesn't look like a painting *of* something, it looks like the thing itself. Instead of looking like a painting *of* a billboard—the way a Reginald Marsh would look—pop art seems to be the actual thing. It is an intensification, a stylistic intensification of the excitement which the subject matter has for me, but the style is, as you said, cool. One of the things a cartoon does is to express violent emotion and passion in a completely mechanical and removed style. To express this thing in a painterly style would dilute it; the techniques I use are not commercial, they only appear to be commercial—and the ways of seeing and composing and unifying are different and have different ends.

Is pop art American?

Everybody has called pop art "American" painting, but it's actually industrial painting. America was hit by industrialism and capitalism harder and sooner and its values seem more askew. . . . I think the meaning of my work is that it's industrial, it's what all the world will soon become. Europe will be the same way, soon, so it won't be American; it will be universal.

ANDY WARHOL

Someone said that Brecht wanted everybody to think alike. I want everybody to think alike. But Brecht wanted to do it through Communism, in a way. Russia is doing it under government. It's happening here all by itself without being under a strict government; so if it's working without trying, why can't it work without being Communist? Everybody looks alike and acts alike, and we're getting more and more that way.

I think everybody should be a machine.

I think everybody should like everybody.

Is that what pop art is all about?

Yes. It's liking things.

And liking things is like being a machine?

Yes, because you do the same thing every time. You do it over and over again.

And you approve of that?

Yes, because it's all fantasy. It's hard to be creative and it's also hard not to think what you do is creative or hard not to be called creative because everybody is always talking about that and individuality. Everybody's always being creative. And it's so funny when you say things aren't, like the shoe I would draw for an advertisement was called a "creation" but the drawing of it was not. But I guess I believe in both ways. All these people who aren't very good should be really good. Everybody is too good now, really. Like, how many actors are there? There are millions of actors. They're all pretty good. And how many painters are there? Millions of painters and all pretty good. How can you say one style is better than another? You ought to be able to be an abstract expressionist next week, or a pop artist, or a realist, without feeling you've given up something. I think the artists who aren't very good should become like everybody else so that people would like things that

aren't very good. It's already happening. All you have to do is read the magazines and the catalogues. It's this style or that style, this or that image of man—but that really doesn't make any difference. Some artists get left out that way, and why should they?

Is pop art a fad?
Yes, it's a fad, but I don't see what difference it makes. I just heard a rumor that G. quit working, that she's given up art altogether. And everyone is saying how awful it is that A. gave up his style and is doing it in a different way. I don't think so at all. If an artist can't do any more, then he should just quit; and an artist ought to be able to change his style without feeling bad. I heard that Lichtenstein said he might not be painting comic strips a year or two from now—I think that would be so great, to be able to change styles. And I think that's what's going to happen, that's going to be the whole new scene. That's probably one reason I'm using silk screens now. I think somebody should be able to do all my paintings for me. I haven't been able to make every image clear and simple and the same as the first one. I think it would be so great if more people took up silk screens so that no one would know whether my picture was mine or somebody else's.

It would turn art history upside down?
Yes.

Is that your aim?
No. The reason I'm painting this way is that I want to be a machine, and I feel that whatever I do and do machinelike is what I want to do.

Was commercial art more machinelike?
No, it wasn't. I was getting paid for it, and did anything they told me to do. If they told me to draw a shoe, I'd do it, and if they told me to correct it, I would—I'd do anything they told me to do, correct it and do it right. I'd have to invent and now I don't; after all that "correction," those commercial drawings would have feelings, they would have a style. The attitude of those who hired me had feeling or something to it; they knew what they wanted, they insisted; sometimes they got very emotional. The process of doing work in commercial art was machinelike, but the attitude had feeling to it.

Why did you start painting soup cans?
Because I used to drink it. I used to have the same lunch every day, for twenty years, I guess, the same thing over and over again. Someone said my life has dominated me; I liked that idea. I used to want to live at the Waldorf Towers and have soup and a sandwich, like that scene in the restaurant in *Naked Lunch.* . . .

We went to see *Dr. No* at Forty-Second Street. It's a fantastic movie, so cool. We walked outside and somebody threw a cherry bomb right in front of us, in this big crowd. And there was blood, I saw blood on people and all over. I felt like I was bleeding all over. I saw in the paper last week that there are more people throwing them—it's just part of the scene—and hurting people. My show in Paris is going to be called "Death in America." I'll show the electric-chair pictures and the dogs in Birmingham and car wrecks and some suicide pictures.

Why did you start these "Death" pictures?

I believe in it. Did you see the *Enquirer* this week? It had "The Wreck that Made Cops Cry"—a head cut in half, the arms and hands just lying there. It's sick, but I'm sure it happens all the time. I've met a lot of cops recently. They take pictures of everything, only it's almost impossible to get pictures from them.

When did you start with the "Death" series?

I guess it was the big plane crash picture, the front page of a newspaper: 129 DIE. I was also painting the *Marilyns*. I realized that everything I was doing must have been Death. It was Christmas or Labor Day—a holiday—and every time you turned on the radio they said something like, "Four million are going to die." That started it. But when you see a gruesome picture over and over again, it doesn't really have any effect.

But you're still doing "Elizabeth Taylor" pictures.

I started those a long time ago, when she was so sick and everybody said she was going to die. Now I'm doing them all over, putting bright colors on her lips and eyes.

My next series will be pornographic pictures. They will look blank; when you turn on the black lights, then you see them—big breasts and . . . If a cop came in, you could just flick out the lights or turn on the regular lights—how could you say that was pornography? But I'm still just practicing with these yet. Segal did a sculpture of two people making love, but he cut it all up, I guess because he thought it was too pornographic to be art. Actually it was very beautiful, perhaps a little too good, or he may feel a little protective about art. When you read Genêt you get all hot, and that makes some people say this is not art. The thing I like about it is that it makes you forget about style and that sort of thing; style isn't really important.

Is "pop" a bad name?

The name sounds so awful. Dada must have something to do with pop—it's so funny, the names are really synonyms. Does anyone know what they're supposed to mean or have to do with, those names? Johns and Rauschenberg—neo-dada for all these years, and everyone calling them derivative

and unable to transform the things they use—are now called progenitors of pop. It's funny the way things change. I think John Cage has been very influential, and Merce Cunningham, too, maybe. Did you see that article in the *Hudson Review* ["The End of the Renaissance?," Summer 1963]? It was about Cage and that whole crowd, but with a lot of big words like radical empiricism and teleology. Who knows? Maybe Jap and Bob were neo-dada and aren't anymore. History books are being rewritten all the time. It doesn't matter what you do. Everybody just goes on thinking the same thing, and every year it gets more and more alike. Those who talk about individuality the most are the ones who most object to deviation, and in a few years it may be the other way around. Someday everybody will think just what they want to think, and then everybody will probably be thinking alike; that seems to be what is happening.

ROBERT INDIANA

What is pop?

Pop is everything art hasn't been for the last two decades. It is basically a U-turn back to a representational visual communication, moving at a breakaway speed in several sharp late models. It is an abrupt return to Father after an abstract fifteen-year exploration of the Womb. Pop is a reenlistment in the world. It is shuck the Bomb. It is the American Dream, optimistic, generous and naïve. . . .

It springs newborn out of a boredom with the finality and oversaturation of abstract expressionism which, by its own aesthetic logic, *is* the END of art, the glorious pinnacle of the long pyramidal creative process. Stifled by this rarefied atmosphere, some young painters turn back to some less exalted things like Coca-Cola, ice-cream sodas, big hamburgers, supermarkets, and "EAT" signs. They are eye-hungry; they pop. . . .

Pure pop culls its techniques from all the present-day communicative processes: it is Wesselmann's TV set and food ad, Warhol's newspaper and silk screen, Lichtenstein's comics and benday, it is my road signs. It is straight-to-the-point, severely blunt, with as little "artistic" transformation and delectation as possible. The self-conscious brush stroke and the even more self-conscious drip are not central to its generation. Impasto is visual indigestion.

Are you pop?

Pop is either hard-core or hard-edge. I am hard-edge pop.

Will pop bury abstract expressionism?

No. If A-E dies, the abstractionists will bury themselves under the weight of their own success and acceptance; they are battlers and the battle is won; they are theoreticians and their theories are respected in the staidest institutions; they seem by nature to be teachers and inseminators and their students and followers are legion around the world; they are inundated by their own fecundity. They need birth control.

Will pop replace abstract expressionism?

In the eternal What-Is-New-in-American-Painting shows, yes; in the latest acquisitions of the avant-garde collectors, yes; in the American Home, no. Once the hurdle of its nonobjectivity is overcome, A-E is prone to be as decorative as French impressionism. There is a harshness and matter-of-factness to pop that doesn't exactly make it the interior decorator's Indispensable Right Hand.

Is pop here to stay?

Give it ten years perhaps; if it matches A-E's fifteen or twenty, it will be doing well in these accelerated days of mass-medium circulation. In twenty years it must face 1984.

Is pop aesthetic suicide?

Possibly for those popsters who were once believing A-E'ers, who abandoned the Temple for the street; since I was never an acolyte, no blood is lost. Obviously aesthetic *A* passes on and aesthetic *B* is born. Pity more that massive body of erudite criticism that falls prostrate in its verbiage.

Is pop death?

Yes, death to smuggery and the Preconceived-Notion-of-What-Art-Is diehards. More to the heart of the question, yes, pop does admit Death in inevitable dialogue as Art has not for some centuries; it is willing to face the reality of its own and life's mortality. Art is really alive only for its own time; that eternally-vital proposition is the bookman's delusion. Warhol's autodeath transfixes us; DIE is equal to EAT.

Is pop easy art?

Yes, as opposed to one eminent critic's dictum that great art must necessarily be *difficult* art. Pop is Instant Art. . . . Its comprehension can be as immediate as a Crucifixion. Its appeal may be as broad as its range; it is the wide-screen of the Late Show. It is not the Latin of the hierarchy, it is vulgar.

Is pop complacent?

Yes, to the extent that pop is not burdened with that self-consciousness of A-E, which writhes tortuously in its anxiety over whether or not it has fulfilled Monet's Water-Lily-Quest-for-Absolute/Ambiguous-Form-of-Tomorrow theory: it walks young for the moment without the weight of four thousand years of art history on its shoulders, though the grey brains in high places are well arrayed and hot for the Kill.

Is pop cynical?

Pop does tend to convey the artist's superb intuition that modern man, with his loss of identity, submersion in mass culture, beset by mass destruction, is man's greatest problem, and that Art, pop or otherwise, hardly provides the Solution—some optimistic, glowing, harmonious, humanitarian, plastically perfect Lost Chord of Life.

Is pop pre-sold?

Maybe so. It isn't the popster's fault that the A-E'ers fought and won the bloody Battle of the Public-Press-Pantheon; they did it superbly and now there *is* an art-accepting public and a body of collectors and institutions that are willing to take risks lest they make another Artistic-Oversight-of-the-Century. This situation is mutually advantageous and perilous alike to all painters, popsters and non-popsters. The new sign of the Art Scene is BEWARE—Thin Ice. Some sun-dazed Californians have already plunged recklessly through.

Is pop the new morality?

Probably. It is libertine, free and easy with the old forms, contemptuous of its elders' rigid rules.

Is pop love?

Pop IS love in that it accepts all . . . all the meaner aspects of life, which, for various aesthetic and moral considerations, other schools of painting have rejected or ignored. Everything is possible in pop. Pop is still pro-art, but surely not art for art's sake. Nor is it any neo-dada anti-art manifestation: its participants are not intellectual, social and artistic malcontents with furrowed brows and fur-lined skulls.

Is pop America?

Yes. America is very much at the core of every pop work. British Pop, the first-born, came about due to the influence of America. The generating issue is *Americasm* [sic], that phenomenon that is sweeping every continent. French pop is only slight Frenchified; Asiatic pop is sure to come (remember Hong

Kong). The pattern will not be far from the Coke, the Car, the Hamburger, the Jukebox. It is the American Myth. For this is the best of all possible worlds.

JAMES ROSENQUIST

I think critics are hot blooded. They don't take very much time to analyze what's in the painting. . . .

O.K., the critics can say [that pop artists accept the mechanization of the soul]. I think it's very enlightening that *if* we do, we realize it instead of protesting too much. It hasn't been my reason. I have some reasons for using commercial images that these people probably haven't thought about. If I use anonymous images—it's true my images have not been hot blooded images—they've been anonymous images of recent history. In 1960 and 1961 I painted the front of a 1950 Ford. I felt it was an anonymous image. I wasn't angry about that, and it wasn't a nostalgic image either. Just an image. I use images from old magazines—when I say old, I mean 1945 to 1955—a time we haven't started to ferret out as history yet. If it was the front end of a new car there would be people who would be passionate about it, and the front end of an old car might make some people nostalgic. The images are like no-images. There is a freedom there. If it were abstract, people might make it into something. If you paint Franco-American spaghetti, they won't make a crucifixion out of it, and also who could be nostalgic about canned spaghetti? They'll bring their reactions but, probably, they won't have as many irrelevant ones. . . .

The images are now, already, on the canvas and the time I painted it is on the canvas. That will always be seen. That time span, people will look at it and say, "why did he paint a '50 Ford in 1960, why didn't he paint a '60 Ford?" That relationship is one of the important things we have as painters. The immediacy may be lost in a hundred years, but don't forget that by that time it will be like collecting a stamp; this thing might have ivy growing around it. If it bothers to stand up—I don't know—it will belong to a stamp collector, it will have nostalgia then. But still that time reference will mean something. . . .

I have a feeling, as soon as I do something, or as I do something, nature comes along and lays some dust on it. There's a relationship between nature—nature's nature—and time, the day and the hour and the minute. If you do an iron sculpture, in time it becomes rusty, it gains a patina and that patina can only get to be beautiful. A painter searches for a brutality that hasn't been assimilated by nature. I believe there is a heavy hand of nature on the artist. My studio floor could be, some people would say that is part of

James Rosenquist, "What Is Pop Art?" © 1964 ARTnews LLC. Reprinted by permission of the publisher.

me and part of my painting because that is the way I arranged it, the way things are. But it's not, because it's an accidental arrangement: it *is* nature, like flowers or other things. . . .

[Paint and paint quality] are natural things before you touch them, before they're arranged. As time goes by the brutality of what art is, the idea of what art can be, changes; different feelings about things become at home, become accepted, natural. . . . [Brutality is] a new vision or method to express something, its value geared right to the present time. . . .

When I was a student, I explored paint quality. Then I started working, doing commercial painting and I got all of the paint quality I ever wanted. I had paint running down my armpits. I kept looking at everything I was doing—a wall, a gasoline tank, I kept looking to see what happened, looking at a rusty surface, at the nature, at changing color. I've seen a lot of different ways paint takes form and what it does, and what excited me and what didn't. After some abstract expressionist painting I did then, I felt I had to slice through all that, because I had a lot of residue, things I didn't want. I thought that I would be a stronger painter if I made most of my decisions before I approached the canvas; that way I hoped for a vision that would be more simple and direct. I don't know what the rules for abstract expressionism are, but I think one is that you make a connection with the canvas and then you discover; that's what you paint—and eliminate what you don't want. I felt my canvases were jammed with stuff I didn't want. . . .

I'm amazed and excited and fascinated about the way things are thrust at us, the way this invisible screen that's a couple of feet in front of our mind and our senses is attacked by radio and television and visual communications, through things larger than life, the impact of things thrown at us, at such a speed and with such a force that painting and the attitudes toward painting and communication through doing a painting now seem very old-fashioned. . . .

I think we have a free society, and the action that goes on in this free society allows encroachments, as a commercial society. So I geared myself, like an advertiser or a large company, to this visual inflation—in commercial advertising which is one of the foundations of our society. I'm living in it, and it has such impact and excitement in its means of imagery. Painting is probably more exciting than advertising—so why shouldn't it be done with that power and gusto, with that impact. I see very few paintings with the impact that I've felt, that I feel and try to do in my work. . . . My metaphor, if that is what you can call it, is my relations to the power of commercial advertising which is in turn related to our free society, the visual inflation which accompanies the money that produces box tops and space cadets. . . .

When I use a combination of fragments of things, the fragments or objects or real things are caustic to one another, and the title is also caustic to the fragments. . . . The images are expendable, and the images are in the painting and therefore the painting is also expendable. I only hope for a colorful shoe-horn to get the person off, to turn him on to his own feelings. . . .

The more we explore, the more we dig through, the more we learn, the more mystery there is. For instance, how can I justify myself, how can I make my mark, my X on the wall in my studio, or in my experience, when somebody is jumping in a rocket ship and exploring outer space? Like, he begins to explore space, the deeper he goes in space, the more there is of nature, the more mystery there is. You may make a discovery, but you get to a certain point and that point opens up a whole new area that's never even been touched. . . .

I treat the billboard image as it is, so apart from nature. I paint it as a reproduction of other things; I try to get as far away from nature as possible. . . .

An empty canvas is full, as Bob [Rauschenberg] said. Things are always gorgeous and juicy—an empty canvas is—so I put something in to dry it up. Just the canvas and paint—that would be nature. I see all this stuff [pointing to the texture of a canvas]—that's a whole other school of painting. All that very beautiful canvas can be wonderful, but it's another thing. The image— certainly it's juicy, too—but it throws your mind to something else, into art. From having an empty canvas, you have a painted canvas. It may have more action; but the action is like a confrontation, like a blow that cancels out a lot of other stuff, numbing your appreciation for a lot of juicy things. Then, too, somebody will ask, why do I want that image there? I don't want that image, but it's there. To put an image in, or a combination of images, is an attempt to make it at least not nature, cancel it from nature, wrest it away. Look at that fabric, there, the canvas, and the paint—those are like nature. . . .

I learned a lot more about painting paint when I painted signs. I painted things from photos and I had quite a bit of freedom in the interpretation, but still, after I did it, it felt cold to me, it felt like I hadn't done it, that it had been done by a machine. The photograph was a machine-produced image. I threw myself at it. I reproduced it as photographically and stark as I could. They're still done the same way; I like to paint them as stark as I can. . . .

I thought for a while I would like to use machine-made images, silk screens, maybe. But by the time I could get them—I have specifics in my mind—it would take longer or as long, and it would be in a limited size, than if I did them as detached as I could by hand, in the detached method I learned as a commercial painter. . . .

When I first started thinking like this, feeling like this, from my outdoor painting, painting commercial advertising, I would bring home colors that I liked, associations that I liked using in my abstract painting, and I would remember specifics by saying this was a dirty bacon tan, this was a yellow T-shirt yellow, this was a Man-Tan suntan orange. I remember these like I was remembering an alphabet, a specific color. So then I started painting Man-Tan orange and—I always remember Franco-American spaghetti orange, I can't forget it—so I felt it as a remembrance of things, like a color chart, like learning an alphabet. Other people talk about painting nothing. You just can't do it. I paint something as detached as I can and as well as I

can; then I have one image, that's it. But in a sense the image is expendable; I have to keep the image so that the thing doesn't become an attempt at a grand illusion, an elegance. . . .

If I use a lamp or a chair, that isn't the subject, it isn't the subject matter. The relationships may be the subject matter, the relationships of the fragments I do. The content will be something more, gained from the relationships. If I have three things, their relationship will be the subject matter; but the content will, hopefully, be fatter, balloon to more than the subject matter. One thing, though, the subject matter isn't popular images, it isn't that at all.

Lawrence Alloway
The Arts and the Mass Media (1958)

In his influential 1939 essay "Avant-Garde and Kitsch," Clement Greenberg delineates the differences between fine art, which is based on aesthetic quality and generally appeals to an elite audience, and mass-produced commercial art (kitsch), which is based on marketability and generally appeals to a less-educated audience. To a large degree "Avant-Garde and Kitsch" attempts to establish standards by which progressive fine art is judged, thereby keeping the fine arts on sure footing. Twenty years later critics such as Lawrence Alloway claimed that it was no longer possible or necessary to maintain these divisions, largely because of the explosion in both the population and the methods for the reproduction and distribution of images. Alloway argues in "The Arts and the Mass Media," which was published in the February 1958 issue of *Architectural Design*, that for too long critics had used criteria established in the arena of the fine arts to critique mass arts. He felt that a new vocabulary needed to be established that was more aware of the particulars of mass communication.

One of the strengths of mass art, in Alloway's view, is that it is inherently more open to change than is fine art. Further because it was able to be reproduced, it had the potential to be ubiquitous. Alloway recognized the unease that mass art created, stating "What worries intellectuals is the fact that the mass arts spread; they encroach on the high ground." Nevertheless, Alloway—who had worked at the Institute of Contemporary Art in London in the early 1950s and was aware of the early Pop tendencies of Eduardo Paolozzi and Richard Hamilton before moving to New York—was an early advocate of Pop art.

In *Architectural Design* last December there was a discussion of "the problem that faces the architect today—democracy face to face with hugeness—mass society, mass housing, universal mobility." The architect is not the only kind of person in this position; everybody who works for the public in a creative capacity is face to face with the many-headed monster. There are heads and to spare.

Before 1800 the population of Europe was an estimated 180 million; by 1900 this figure had risen to 460 million. The increase of population and the industrial revolution that paced it has, as everybody knows, changed the world. In the arts, however, traditional ideas have persisted, to limit the definition of later developments. As Ortega pointed out in *The Revolt of the Masses:* "the masses are today exercising functions in social life which coincide with those which hitherto seemed reserved to minorities." As a result the élite, accustomed to set aesthetic standards, has found that it no longer possesses the power to dominate all aspects of art. It is in this situation that we need to consider the arts of the mass media. It is impossible to see them clearly within a code of aesthetics associated with minorities with pastoral and upper-class ideas because mass art is urban and democratic.

It is no good giving a literary critic modern science fiction to review, no good sending the theater critic to the movies, and no good asking the music critic for an opinion on Elvis Presley. Here is an example of what happens to critics who approach mass art with minority assumptions. John Wain, after listing some of the spectacular characters in P. C. Wren's *Beau Geste* observes: "It sounds rich. But in fact—as the practiced reader could easily foresee . . . it is not rich. Books with this kind of subject matter seldom are. They are lifeless, petrified by the inert conventions of the adventure yarn." In fact, the practiced reader is the one who understands the conventions of the work he is reading. From outside all Wain can see are inert conventions; from inside the view is better and from inside the conventions appear as the containers of constantly shifting values and interests.

The Western movie, for example, often quoted as timeless and ritualistic, has since the end of World War II been highly flexible. There have been cycles of psychological Westerns (complicated characters, both the heroes and the villains), anthropological Westerns (attentive to Indian rights and rites), weapon Westerns (Colt revolvers and repeating Winchesters as analogues of the present armament race). The protagonist has changed greatly, too: the typical hero of the American depression who married the boss's daughter and so entered the bright archaic world of the gentleman has vanished. The ideal of the gentleman has expired, too, and with it evening dress which is no longer part of the typical hero-garb.

If justice is to be done to the mass arts which are, after all, one of the most remarkable and characteristic achievements of industrial society, some of the common objections to it need to be faced. A summary of the opposition

to mass popular art is in *Avant-Garde and Kitsch* (*Partisan Review*, 1939, *Horizon*, 1940), by Clement Greenberg, an art critic and a good one, but fatally prejudiced when he leaves modern fine art. By kitsch he means "popular, commercial art and literature, with their chromeotypes, magazine covers, illustrations, advertisements, slick and pulp fiction, comics, Tin Pan Alley music, tap dancing, Hollywood movies, etc." All these activities to Greenberg and the minority he speaks for are "ersatz culture . . . destined for those who are insensible to the value of *genuine* culture . . . Kitsch, using for raw material the debased and academic simulacra of *genuine* culture welcomes and cultivates this insensibility" (my italics). Greenberg insists that "all kitsch is academic," but only some of it is, such as Cecil B. DeMille–type historical epics which use nineteenth-century history-picture material. In fact, stylistically, technically, and iconographically the mass arts are anti-academic. Topicality and a rapid rate of change are not academic in any usual sense of the word, which means a system that is static, rigid, self-perpetuating. Sensitiveness to the variables of our life and economy enable the mass arts to accompany the changes in our life far more closely than the fine arts which are a repository of time-binding values.

The popular arts of our industrial civilization are geared to technical changes which occur, not gradually, but violently and experimentally. The rise of the electronics era in communications challenged the cinema. In reaction to the small TV screen, movie makers spread sideways (CinemaScope) and back into space (VistaVision). All the regular film critics opposed the new array of shapes, but all have been accepted by the audiences. Technical change as dramatized novelty (usually spurred by economic necessity) is characteristic not only of the cinema but of all the mass arts. Color TV, the improvements in color printing (particularly in American magazines), the new range of paper back books; all are part of the constant technical improvements in the channels of mass communication.

An important factor in communication in the mass arts is high redundancy. TV plays, radio serials, entertainers, tend to resemble each other (though there are important and clearly visible differences for the expert consumer). You can go into the movies at any point, leave your seat, eat an ice cream, and still follow the action on the screen pretty well. The repetitive and overlapping structure of modern entertainment works in two ways: (1) it permits marginal attention to suffice for those spectators who like to talk, neck, parade; (2) it satisfies, for the absorbed spectator, the desire for intense participation which leads to a careful discrimination of nuances in the action.

There is in popular art a continuum from data to fantasy. Fantasy resides in, to sample a few examples, film stars, perfume ads, beauty and the beast situations, terrible deaths, sexy women. This is the aspect of popular art which is most easily accepted by art minorities who see it as a vital substratum of the folk, as something primitive. This notion has a history since

Herder in the eighteenth century, who emphasized national folk arts in opposition to international classicism. Now, however, mass-produced folk art is international: Kim Novak, *Galaxy Science Fiction*, Mickey Spillane, are available wherever you go in the West.

However, fantasy is always given a keen topical edge; the sexy model is shaped by datable fashion as well as by timeless lust. Thus, the mass arts orient the consumer in current styles, even when they seem purely, timelessly erotic and fantastic. The mass media give perpetual lessons in assimilation, instruction in role-taking, the use of new objects, the definition of changing relationships, as David Riesman has pointed out. A clear example of this may be taken from science fiction. Cybernetics, a new word to many people until 1956, was made the basis of stories in *Astounding Science Fiction* in 1950.* SF aids the assimilation of the mounting technical facts of this century in which, as John W. Campbell, the editor of *Astounding*, put it. "A man learns a pattern of behavior—and in five years it doesn't work." Popular art, as a whole, offers imagery and plots to control the changes in the world; everything in our culture that changes is the material of the popular arts.

Critics of the mass media often complain of the hostility towards intellectuals and the lack of respect for art expressed there, but, as I have tried to show, the feeling is mutual. Why should the mass media turn the other cheek? What worries intellectuals is the fact that the mass arts spread; they encroach on the high ground. For example, into architecture itself as Edmund Burke Feldman wrote in *Arts and Architecture* last October: "Shelter, which began as a necessity, has become an industry and now, with its refinements, is a popular art." This, as Feldman points out, has been brought about by "a democratization of taste, a spread of knowledge about non-material developments, and a shift of authority about manners and morals from the few to the many." West Coast domestic architecture has become a symbol of a style of living as well as an example of architecture pure and simple; this has occurred not through the agency of architects but through the association of stylish interiors with leisure and the good life, mainly in mass circulation magazines for women and young marrieds.

The definition of culture is changing as a result of the pressure of the great audience, which is no longer new but experienced in the consumption of its arts. Therefore, it is no longer sufficient to define culture solely as something that a minority guards for the few and the future (though such art

*Although for purposes of this general article I have treated the mass arts as one thing, it is in fact highly specialized. *ASF* is for scientifically and technically minded readers, whereas *Galaxy SF* leans towards mainstream stories. SF editorials tend to see the unlikeness of the field to the rest of the mass media. There are, in fact, a multitude of audiences within the great audience (*Mademoiselle*, for example, is aimed at female readers from eighteen to thirty), but here I just want to separate the popular from the fine arts.

is uniquely valuable and as precious as ever). Our definition of culture is being stretched beyond the fine art limits imposed on it by Renaissance theory, and refers now, increasingly, to the whole complex of human activities. Within this definition, rejection of the mass produced arts is not, as critics think, a defense of culture but an attack on it. The new role for the academic is keeper of the flame; the new role for the fine arts is to be one of the possible forms of communication in an expanding framework that also includes the mass arts.

Peter Selz with Henry Geldzahler, Hilton Kramer, Dore Ashton, Leo Steinberg, Stanley Kunitz
A Symposium on Pop Art (1963)

The rise of Pop art to the forefront of American art was unnerving to some in the art world and refreshing to others. Never before in American cultural life had new art risen so fast and become so commercially successful. In 1962 the Museum of Modern Art in New York City organized a symposium on Pop art that brought together a prominent group of curators and art critics in an attempt to better understand this new phenomenon. Peter Selz, Curator of Painting and Sculpture at MoMA, moderated the discussion at the Modern on December 13, 1962. This panel included Henry Geldzahler, Assistant Curator at the Metropolitan Museum of Art, and the art critics Hilton Kramer, Dore Ashton, Leo Steinberg, and Stanley Kunitz. The transcript of this symposium was published in the April 1963 issue of *Arts Magazine*.

This balanced dialog presents both a healthy amount of skepticism as well as some convincing arguments for Pop art. What seems to be of greatest concern is the shifting terrain for judging the value of a work of art. The major question about Pop art is whether it is an honest commentary on the ubiquity of commercial images in American society or whether it simply adopts these images without adding the necessary amount of the artist transformative energy to make them legitimate works of art. Throughout the twentieth century the art world had come to expect an anti-establishment stance in much progressive art. So the ambivalence that Pop artists had to their subjects infuriated some critics, but this is precisely what made it compelling to others. One of the other major points of unease among some of the critics is the speed with which Pop art was accepted within the ever-growing mechanism of critics, museums, galleries, and collectors. With the ascent of Pop art there is a sense that the art market's systems of legitimization and reward were moving at a speed and according to a system that was replacing connoisseurship

Originally published in *Arts Magazine* in April 1963.

with reactions to fashion. Related to these issues, the panel debates some interesting questions as to the role of museums in the promotion of new art, an issue that continued to resonate throughout the rest of the twentieth century.

HENRY GELDZAHLER

It is always a simple matter to read inevitability back into events after they have happened, but from this vantage point it seems that the phenomenon of pop art was inevitable. The popular press, especially and most typically *Life* magazine, the movie close-up, black and white, technicolor and wide screen, the billboard extravaganzas, and finally the introduction, through television, of this blatant appeal to our eye into the home—all this has made available to our society, and thus to the artist, an imagery so pervasive, persistent and compulsive that it had to be noticed. After the heroic years of Abstract Expressionism a younger generation of artists is working in a new American regionalism, but this time, because of the mass media, the regionalism is nationwide, and even exportable to Europe, for we have carefully prepared and reconstructed Europe in our own image since 1945 so that two kinds of American imagery, Kline, Pollock, and De Kooning on the one hand, and the pop artists on the other, are becoming comprehensible abroad.

Both Clement Greenberg and Harold Rosenberg have written that increasingly in the twentieth century, art has carried on a dialogue with itself, art leads to art, and with internal sequence. This is true still, even with the external references pop art makes to the observed world. The best and most developed post–Abstract Expressionist painting is the big single-image painting, which comes in part out of Barney Newman's work—I am thinking of Ellsworth Kelly, Kenneth Noland, Ray Parker and Frank Stella, among others—and surely this painting is reflected in the work of Lichtenstein, Warhol and Rosenquist. Each of these painters inflates his compulsive image. The aesthetic permission to project their immense pop images derives in part from a keen awareness of the most advanced contemporary art. And thus pop art can be seen to make sense and have a place in the wider movement of recent art.

I have heard it said that pop art is not art, and this by a museum curator. My feeling is that it is the artist who defines the limit of art, not the critic or the curator. It is perhaps necessary for the art historian, who deals with closed issues, to have a definition of art. It is dangerous for the critic of contemporary art to have such a definition. Just so there is no unsuitable subject for art. Marcel Duchamp and Jasper Johns have taught us that it is the artist who decides what is art, and they have been convincing philosophically and aesthetically.

Pop art is a new two-dimensional landscape painting, the artist responding specifically to his visual environment. The artist is looking around again and painting what he sees. And it is interesting that this art does not look like the new humanism some critics were so eagerly hoping for. It points up again the fact that responsible critics should not predict, and they should not goad the artist into a direction that criticism would feel more comfortable with. The critic's highest goal must be to stay alert and sensitive to what the artist is doing, not to tell him what he should be doing.

We live in an urban society, ceaselessly exposed to mass media. Our primary visual data are for the most part secondhand. Is it not then logical that art be made out of what we see? Has it not been true in the past? There is an Ogden Nash quatrain that I feel is apposite:

> I think that I shall never see
> A billboard lovely as a tree
> Perhaps unless the billboards fall
> I'll never see a tree at all.

Well, the billboards haven't fallen, and we can no longer paint trees with great contemporary relevance. So we paint billboards.

A proof I have heard that pop art cannot be serious is that it has been accepted so readily. As everyone knows, the argument goes, great art is ignored for years. We must examine this prejudice. Why are we mistrustful of an art *because* it is readily acceptable? It is because we are still working with myths developed in the years of alienation.

The heroism of the New York School has been to break through and win acceptance for the high and serious purpose of American painting. There is now a community of collectors, critics, art dealers and museum people, a rather large community, that has been educated and rehearsed to the point that there is no longer any shock in art.

For the first time in this century there is a class of American collectors that patronizes its advanced artists. The American artist has an audience, and there exists a machinery, dealers, critics, museums, collectors, to keep things moving and keep people on their toes. Yet there persists a nostalgia for the good old days when the artist was alienated, misunderstood, unpatronized. The new situation is different. People *do* buy art. In this sense too there is no longer, or at least not at the moment, such a thing as an avant-garde. Avant-garde must be defined in terms of audience, and here we have an audience more than ready to stay with the artist. One even gets the idea that shock has become so ingrained that the dealer, critic and collector want and expect it.

The general public has not become appreciably more aware of good painting, but the audience for advanced art, partly because of the influence of the Museum of Modern Art, is considerably wider than it has ever been in this country.

Through our writers and art historians we have become very conscious of the sequence of movements, of action and reaction. The clichés and tools of art writing have become so familiar that we can recognize a movement literally before it fully happens. About a year and a half ago I saw the work of Wesselman, Warhol, Rosenquist and Lichtenstein in their studios. They were working independently, unaware of each other, but with a common source of imagery. Within a year and a half they have had shows, been dubbed a movement, and we are here discussing them at a symposium. This is instant art history, art history made so aware of itself that it leaps to get ahead of art.

The great body of imagery from which the pop artists draw may be said to be a common body, but the style and decisions of each are unmistakable. The choice of color, composition, the brush stroke, the hardness of edge, all these are personal no matter how close to anonymity the artist may aspire in his desire to emulate the material of his inspiration, the anonymous mass media. The pop artists remain individual, recognizable and separate. The new art draws on everyday objects and images. They are isolated from their ordinary context, and typified and intensified. What we are left with is a heightened awareness of the object and image, *and* of the context from which they have been ripped, that is, our environment. If we look for attitudes of approval or disapproval of our culture in this art, of satire or glorification of our society, we are oversimplifying. Surely there is more than satire in Hogarth, the Longhis, Daumier, Toulouse-Lautrec. There is a satirical aspect in much of this art, but it is only that, one aspect.

Pop art is immediately contemporary. We have not yet assimilated its new visual content and style. The question at hand is not whether it is great art; this question is not answerable, or even interesting, just now. I think the point is *not* to make an immediate ultimate evaluation, but to admit the possibility that this subject matter and these techniques are and can be the legitimate subject matter and technique of art. And the point is too to realize that pop art did not fall from the heavens fully developed. It is an expression of contemporary sensibility aware of contemporary environment and growing naturally out of the art of the recent past.

HILTON KRAMER

Perhaps I should begin my remarks on the phenomenon of pop art, neo-Dada, New Realism, or whatever we finally agree to call it, on a positive note (since there will be much to say in the negative) and admit straightaway

that I do believe it represents a significant historical breakthrough, as we say, in one—but only one—respect. It represents something new, not so much in the history of art as in the history of art criticism, for criticism, from its beginnings, has suffered from the humiliating predicament of having to deal with a class of objects—namely, works of art—which were far more interesting than anything that might be said about them. With the coming of pop art, this humiliation has at last been abated. It has, to all appearances, been triumphantly overcome. The relation of the critic to his material has been significantly reversed, and critics are now free to confront a class of objects, which, while still works of art more or less, are art only by default, only because they are nothing else, but about which almost anything critics say will engage the mind more fully and affect the emotions more subtly than the objects whose meaning they are ostensibly elucidating.

Pop art is, indeed, a kind of emancipation proclamation for the art critic, and while I hesitate to labor the point unduly, it may just conceivably be possible that *some*, though surely not all, of the interest this movement has generated among critics—and among museums, too, and museum symposia—is traceable to the sense they have of being placed by this new development in a more advantageous position vis-à-vis the work of art than they have heretofore enjoyed.

Why is it the case, as I emphatically believe it to be, that this work is interesting for what is said *about* it rather than for what it, intrinsically, is? Primarily, I think, because it is so preponderantly contextual in its mode of address and in its aesthetic existence; so crucially dependent upon cultural logistics outside itself for its main expressive force. It neither creates new forms nor gives us new ways of perceiving the visual materials out of which it is made; it takes the one from the precedents of abstract art and the other from the precedents of window display and advertising design. It adopts and adapts received ideas and received goods in both spheres—form and content—synthesizing nothing new, no new visual fact of aesthetic meaning, in the process. The critic Sidney Tillim, in writing about Oldenburg's last exhibition said: ". . . at no time in Oldenburg's work was there ever a possibility for form to have a destiny"; and to this correct observation I would myself add: There was neither the possibility of content having a destiny, for the brute visual facts of the popular culture all around us, and upon which Oldenburg was drawing, had already endowed this material with a destiny that only a formal and psychological and social imagination of the greatest power and magnitude could hope to compete with and render artistically meaningful.

Pop art derives its small, feeble victories from the juxtaposition of two clichés: a cliché of form superimposed on a cliché of image. And it is its failure to do anything more than this that makes it so beguiling to talk about and write about—that makes pop art the conversation piece *par excellence*—for it requires talk to complete itself. Only talk can effect the act of imaginative synthesis which the art itself fails to effect.

Why, then, are we so interested in it just now, so interested in the art and in the talk?

In answering this more general question, it seems to me imperative to grasp the relation of this development to the current popularity of abstract painting, and particularly abstract painting which has been so extreme (whatever its other achievements may be) in denuding art of complex visual incident. This poverty of visual incident in abstract painting has given rise to practically every new development of the last couple of years; happenings, pop art, figure painting, monster-making, kinetic art—all have in common, whatever their differences, the desire to restore to complex and recognizable experience its former hegemony over pure aestheticism. And it is as part of this desire that the taste for pop art must be understood—again, I emphasize, a contextual meaning rather than an intrinsic, creative one.

Pop art carries out a moderately successful charade—but a charade only—of the two kinds of significance we are particularly suckers for at the present moment: the Real and the Historical. Pop art seems to be about the real world, yet it appears to its audience to be sanctified by tradition, the tradition of Dada. Which is to say, it makes itself dependent upon something outside art for its expressive meaning, and at the same time makes itself dependent upon the myths of art history for its aesthetic integrity. In my opinion, both appeals are fraudulent.

But pop art does, of course, have its connections with art history. Behind its pretensions looms the legendary presence of the most overrated figure in modern art: Mr. Marcel Duchamp. It is Duchamp's celebrated silence, his disavowal, his abandonment of art, which has here—in pop art—been invaded, colonized and exploited. For this was never a real silence. Among the majority of men who produced no art, and experienced little or none, Duchamp's disavowal was devoid of all meaning. Only in a milieu in which art was still created, worried over, and found to be problematical as well as significant and necessary, could Duchamp's silence assume the status of a relevant myth. And just so, it is only in the context of a school of painting which has radically deprived art of significant visual events that pop art has a meaning. Place it in any other visual context and it fades into insignificance, as remote from our needs as the décor in last year's Fifth Avenue windows.

Duchamp's myth does carry a moral for pop art. If his silence means anything—and it surely means much less than has been made of it—its meaning is more biographical than historical. At a certain point in Duchamp's development as an artist, the experience and objects of modern life defeated his ability to cope with them. This is not an uncommon development in the life of an artist, but Duchamp was perhaps the first to turn his aesthetic impotence into a myth of superior powers. His ready-mades were simply the prologue to the silence that followed. It was *not* Duchamp, but artists like Mondrian (in his "Boogie-Woogie" paintings) and Stuart Davis

(in his paintings of New York) and David Smith (in the very way he used factory materials) who told us what it felt like to live in this particular civilization at this particular moment in history.

Pop art does not tell us what it feels like to be living through the present moment of civilization—it is merely part of the evidence of that civilization. Its social effect is simply to reconcile us to a world of commodities, banalities and vulgarities—which is to say, an effect indistinguishable from advertising art. This is a reconciliation that must—now more than ever—be refused, if art—and life itself—is to be defended against the dishonesties of contrived public symbols and pretentious commerce.

DORE ASHTON

When Lawrence Alloway first discussed pop art he explained that it was based "on the acceptance of mass-produced objects just because they are what is around." The throwaway materials of cities as they collect in drawers, closets and empty lots are used, he said, so that "their original identity is solidly kept." For Alloway it was essential that the "original status" of junk be maintained. He bared the naturalistic bias of pop art when he insisted that "assemblages of such material come at the spectator as bits of life, bits of the city."

The urgent quest for unadorned or common reality, which is the avowed basis of pop art, was again asserted by Alloway two years after. In an introduction to Jim Dine's catalogue he flatly poses pop art as an antidote to idealism: he suggests that aesthetic tradition tends to discount the reality of subject matter, stressing art's formality "which can be made a metaphor of an ideal order."

And here is the crux of the matter: the contemporary artist, weary and perplexed by the ambiguities of idealism (as in Abstract Expressionism, for instance) decides to banish metaphor. Metaphor is necessarily a complicating device, one which insists on the play of more than one element in order to effect an image. The pop artist wants no such elaborate and oblique obligation. He is engaged in an elementary game of naming things—one at a time.

Perhaps the movement can be seen as an exacerbated reaction to the Romantic movement, so long ascendant in modern art history, in which artists were prepared to endure an existence among things that have no name.

Or perhaps pop art is a defensive movement against overwhelming Romantic isolation. Baudelaire said that the exclusive passion of art is a canker which devours everything else. Perhaps this generation is fearful of being devoured—fearful of life itself.

The impatient longing to reduce reality to the solid simple object which resists everything—interpretation, incorporation, juxtaposition, transformation—appears again and again in modern art history. But it is always delusive. The artist who believes that he can maintain the "original status" of an object deludes himself. The character of the human imagination is expansive and allegorical. You cannot "think" an object for more than an instant without the mind's shifting. Objects have always been no more than cues to the vagabond imagination. Not an overcoat, not a bottle dryer, not a Coca-Cola bottle can resist the onslaught of the imagination. Metaphor is as natural to the imagination as saliva to the tongue.

The attitude of the pop artist is diffident. He doesn't aspire to interpret or re-present, but only to present. He very often cedes his authority to chance—either as he produces his object, or as it is exposed to the audience which is expected to complete his process. The recent pop artist is the first artist in history to let the world into his creative compound without protest.

A few brief history notes: Apollinaire said Picasso used authentic objects which were "impregnated with humanity"—in other words, he used them metaphorically. When Duchamp exhibited his urinal he was careful to insist that it was significant because he, Duchamp, had chosen it. Schwitters wrote that "every artist must be allowed to mold a picture with nothing but blotting paper, provided he is capable of molding a picture."

But by the time pop art appears, the artist as master image-maker is no longer assertive. He gladly allows Chance to mold his picture, and is praised for it, as when John Cage praises Rauschenberg because he makes no pretense at aesthetic selection. There is a ring of Surrealism and Lautréamont in Cage's observation that between Rauschenberg and what he picks up is the quality of an encounter—but not the metaphorical encounter of sewing machine and umbrella—only a chance encounter in the continuum of random sensation he calls life.

In the emphasis on randomness and chance, on the virtual object divested of associations, on the audience as participant, and in his rebellion against metaphor, the pop artist generally begs the question of reality. He refuses to take the responsibility of his choices. He is not the only one. Alain Robbe-Grillet, commenting on his filmscript *Last Year at Marienbad*, parallels him when he says that the spectator can do with it what he likes; he, the author, had nothing decisive in mind.

The contemporary aesthetic, as exemplified by many pop artists and certain literary and musical figures, implies a voluntary diminution of choices. The artist is expected to cede to the choice of vulgar reality; to present it in unmitigated form. Conventionally, choice and decision are the essence of a work of art, but the new tendency reduces the number and quality of decisions to a minimum. To the extent that interest in objects and their assemblage in non-metaphorical terms signifies a reduction of individual

choices, pop art is a significant sociological phenomenon, a mirror of our society. To the extent that it shuns metaphor, or any deep analysis of complex relations, it is an impoverished genre and an imperfect instrument of art.

Far from being an art of social protest, it is an art of capitulation. The nightmare of poet Henri Michaux, who imagines himself surrounded by hostile objects pressing in on him and seeking to displace his "I," to annihilate his individuality by "finding their center in his imagination," has become a reality for many would-be artists. The profusion of things is an overwhelming fact that they have unfortunately learned to live with.

I can see the movement as cathartic—art protecting itself from art. But catharsis is by no means an adequate response to the conundrum of contemporary life.

LEO STEINBERG

I have put down three questions: First: Is it art? Second: If it is—if pop art is a new way in art—what are its defining characteristics? And Third: Given its general characteristics (if definable), how in any particular case do you tell the good art from the bad? Since I have only seven minutes, if I can't answer these questions, I can at least complicate them.

The question "Is it art?" is regularly asked of pop art, and that's one of the best things about it, to be provoking this question. Because it's one that ought to be asked more or less constantly for the simple reason that it tends to be constantly repressed. We get used to a certain look, and before long we say, "Sure it's art; it looks like a De Kooning, doesn't it?" This is what we might have said five years ago, after growing accustomed to the New York School look. Whereas ten years earlier, an Abstract Expressionist painting, looking quite unlike anything that looked like art, provoked serious doubts as to what it was.

Now I think the point of reformulating this question time and again is to remind us that if there is a general principle involved in what makes a work of art, we have yet to establish it. And I mean specifically this: Do we decide that something is art because it exhibits certain general characteristics? Or because of the way we respond to it? In other words, exactly what is it that the artist creates?

Victor Hugo, after reading *Les Fleurs du Mal*, wrote to Baudelaire and in five words summed up a system of aesthetics: "You create a new shudder." This implies that what the artist creates is essentially a new kind of spectator response. The artist does not simply make a thing, an artifact, or in the case of Baudelaire, a poem with its own beat and structure of evocation and image. What he creates is a provocation, a particular, unique and perhaps novel relation with reader or viewer.

Does pop art then create anything new—a new shudder—or not? The criticism of pop art is that it fails to do it. We are told that much of it is prefigured in Dada, or in Surrealism, or worse still, that it simply arrests what advertisements and window displays throw at us every hour. In other words, there is not sufficient transformation or selection within pop art to constitute anything new.

This I cannot accept because I think there is nothing new under the sun except only man's focus of attention. Something that's always been around suddenly moves into the center of vision. What was peripheral becomes central, and that's what's new. And therefore it really doesn't help the discussion of any artistic experience to point out that you can find antecedents for every feature of it. And so I still think it justified to apply to pop art the remark that Victor Hugo applied to Baudelaire: it creates a new shudder.

Just what is it that's new about it? I will limit myself to my own experience; it involves Roy Lichtenstein, who paints what appear to be mere blow-ups of comic-book illustrations. When I first saw these paintings, I did not like them, and I don't like them now. But I saw in them a new approach to an old problem, that of relating the artist to the bourgeois, the square, the Philistine or pretentious hipster. We remember that twentieth-century art came in with the self-conscious slogan *Epater le bourgeois:* to outrage or needle the bourgeois, keep him as uncomfortable and worried as possible. This program lasted roughly through the 1930s, when it was pursued chiefly by the Surrealists. The heroic years of Abstract Expressionism in New York after the Second World War brought another approach, an approach so organic that it was hardly formulated; it simply ignored the bourgeois. The feeling was, "They don't want us, we don't want them." The artists developed a thoroughgoing camaraderie: "We know what we're doing, the rest of the world never will. We'll continue to paint for each other." This surely was a radically different phase in the relationship of artist and middle class.

And when I saw these pictures by Lichtenstein, I had the sensation of entering immediately upon a third phase in twentieth-century painting. The idea seemed to be to out-bourgeois the bourgeois, to move in on him, unseat him, play his role with a vengeance—as if Lichtenstein were saying, "You think you like the funnies. Wait till you see how I like the funnies!"

I think it has something to do with God and idolatry, God being understood as the object of man's absolute worship. (I know no other way of defining the word.) Wherever people worship respectably, there is rivalry among worshippers to show who worships the most. Where the object of worship is disreputable, we pretend that our respect for it is very casual or a matter of mere necessity. And now Lichtenstein and certain others treat mass-produced popular culture as Duccio would treat the Madonna, Turner the Sea, Picasso the Art of Painting—that is to say, like an absolute good. Something like this is now going on, I think; the artists are moving in, naïvely or mockingly, each in his way, an uninvited priesthood for an unacknowledged, long-practiced

cult. And this may be why, as Mr. Geldzahler was able to tell us, several pop artists were working along the same lines for years, though in ignorance of one another.

Whether their productions are works of art I am not prepared to say at this point. But that they are part of the history of art, of its social and psychological history, is beyond question. And if I say that I am not prepared to tell whether they are art or not, what I mean is that I cannot yet see the art for the subject. When I tell you, as I told Mr. Lichtenstein, that I don't like his paintings, I am merely confessing that in his work the subject matter exists for me so intensely that I have been unable to get through to whatever painterly qualities there may be.

This leads me to the second question I had wanted to touch upon. We have here one characteristic of pop art as a movement or style: to have pushed subject matter to such prominence that formal or aesthetic considerations are temporarily masked out. Our eyes will have to grow accustomed again to a new presence in art: the presence of subject matter absolutely at one with the form.

One thing I'm sure of: critics who attack pop art for discarding all synthetic considerations talk too fast. They forget that artists always play peekaboo. Sometimes—and I am now thinking of all the history of painting —sometimes they play with latent symbolism, at other times they disguise their concern with pure form. Today, for some reason, these pop artists want the awareness of form to recede behind the pretense of subject matter alone, and this creates a genuine difficulty. Why they assign this new role to subject matter, after almost a century of formalist indoctrination, is not easy to say.

I see that some critics of pop art denounce it as a case of insufferable condescension. Several writers regard it as ineffectual satire (I myself see almost nothing satirical in pop art). Others think it's simple conformity with middle-class values. And there is always the possibility that the choice of pop subjects is artistically determined; that the variegated ready-made, pictorial elements he now uses furnish the artist with new richness of incident both in surface and depth, while allowing him not to worry about "the integrity of the picture plane." For since the elements employed in the picture are known and seen to be flat (being posters, cartoons, ads, etc.), the overall flatness of the picture-as-object is taken care of, and the artist, confronting new problems galore, faces one old problem the fewer. But it is obviously impossible to declare whether pop art represents conformity with middle-class values, social satire, effective or otherwise, or again a completely asocial exploration of new, or newly intriguing, formal means. It is impossible to give one answer because we are not dealing with one artist. We are asked to deal with many. And so far, there has been no attempt around this table to differentiate between them. And the fact that there has been no such differentiation encourages me to say something here which, I hope, won't sound too pedagogical.

There are two ways of treating an exhibition experience, especially one like the recent pop-art show at Sidney Janis's. One way consists of the following steps: First: Walk around the show, noting the common features. Second: Describe these features in one or more generalizations. Third: Evaluate your abstracted generalizations and, if you find them wanting, condemn the whole movement.

The other way begins in the same manner. Walking around, you observe this and that, passing by all the works that do nothing to you. Then, if any one work seems at all effective, open up at once and explore it as far as you can. Lastly, ponder and evaluate your reaction to this single work; and this, strangely enough, also yields a first generalization: If this one work in the show produced a valid experience, e.g., a new shudder, then the whole movement is justified by its proven ability to produce a valid work. The generalization emerges from the more intense experience of the particular. This is another way of doing it, and I prefer it, not only because I enjoy thinking about one work at a time, but also because the artists we are discussing share no common intention.

I am sorry to see that my time is up, so that I cannot comment on my question 3.

STANLEY KUNITZ

Confronting this sudden and rather staggering proliferation of "pop art" in our midst, I am tempted to echo the exclamation of the French artist Paul Delaroche when in 1839 he saw a daguerreotype for the first time: "From today," he said, "painting is dead." If I resist the temptation—and I do—it is not because I am afraid of sticking my neck out, for fear I may be proven wrong, but simply because I have every confidence that art is too tough a bird to die of either shame or indigestion. It has outlived even worse disasters. Of course, M. Delaroche was not completely mistaken: something did die after the invention of photography, namely M. Delaroche, together with his brand of bad academicism. The more I reflect on the subject, the more I am convinced that if we are ever to get an ideal history of art, it will have to be written by a master of comedy.

How does one explain the overnight apotheosis not of a single lonely artist but of a whole regiment wearing the colors of pop art, for whom the galleries and the museums immediately open their doors, and the collectors their pocketbooks? The best analogy I can think of is a blitz campaign in advertising, the object of which is to saturate the market with the name and presence—even the subliminal presence—of a commodity. "Repetition is reputation," said one of the great tycoons of American industry. The real artists of this affair, I submit, are the promoters, who have made a new kind of assemblage out of the assorted and not necessarily related works of dozens of

painters and sculptors, to which they have given the collective title (substitute brand-name) "pop art," or the "new realism." I wish I had time to discuss the significance of style in art as the signature of a culture, but I must be content with merely noting that history has become subject to such an acceleration of tempo that the life span of a style, which used to be measured in centuries, has been reduced first to generations, and more recently to decades. Some of the vibration, I am sure, of American art has its source in the speed of our transit; but I am not persuaded that anything is to be gained by treating art as though it were almost exclusively a commodity, pliant to the whims of the market place and subject to the same principle of planned obsolescence as is inherent in the rest of our economy. I seriously doubt that we really need an annual change of model. And what of the role of the Museum in this development? Much as I love this place, I must confess that I wonder a bit about the ultimate consequences of such a rapacious historicity, such an indefatigable search for novelty. I find it disturbing that in concept and function a museum of art, traditionally a conservator of values, should grow closer and closer to an industrial museum, such as the one opened and operated by the Ford Motor Co., which was designed as a showcase for every model of a Ford car manufactured since the founding of the company. The art-establishment, as a whole, seems to be in such a hurry to get on the bandwagon these days that sometimes it gets there too soon and has to build the contraption before it can jump on it. Of course it is a peculiar kind of stupidity to regard any change of style as a form of subversion; but it is an equally peculiar kind of folly to greet every new twist of style as a revelation. We have in our time invented a new kind of tyranny, which is the tyranny of the avant-garde.

Anyone who has ever written on art must know that it is impossible to prove in words that a given work of art is either good or bad. In the end the art-object must stand as its own witness. Nevertheless I want to try to indicate, in a few paragraphs, why my response to pop art, or, let me say, to most of what passes as pop art, is largely negative. We have had the supreme fortune of a great art in this century, and a substantial part of that greatness originated and flowered here in this country. For the past dozen years in particular I have rejoiced in the companionship of an art that at its best, regardless of the modalities of style, I have felt to be notable for its courage and self-reliance; its self-awareness, sprung between psyche and medium; its rich spontaneity of nervous energy; the pitch and range of its sensibility; and the simultaneous sense that it has often given me of a wild act of assertion combined with a metaphysical entrapment in the infrangible web of space-time. An art of beginnings, misdirections, rejections, becomings, existences, solitudes, rages, transformations.

The archetypal pop artist, who is nobody apart from the brute reality of his milieu, will have nothing to do with the intense subjectivity of what he calls "a painterly aesthetic"—a phrase that is intended to ring like an abusive epithet. He has no interest whatsoever in converting existential feeling into

unique gesture. The world of pop art is a clean, well-lighted place where we can see a deliberately tidy arrangement of the most anonymous traces of collective man, presented to us as though they were things in themselves, now that they have been detached from our Western karma, the cycle of manufacture and consumption. The pop artist assiduously refrains from divulging his feelings while he is setting up his store. Perhaps he has a hard day at the supermarket which is our world, but he is as reticent about his private responses as a newscaster on a network station. Perhaps he is saying that it is futile to attempt a new creation, given the facts of our situation, but we can only guess at that. All that we know is that he has limited himself to a rearrangement of familiar counters. In so doing he unwittingly demonstrates what Coleridge defined as the difference between fancy and the imagination. This is an art not of transformation but of transposition.

If the pop artist is concerned with creating anything, it is with the creation of an effect. Consider, for example, the celebrated rows of Campbell's Soup labels. We can scarcely be expected to have any interest in the painting itself. Indeed, it is difficult to think of it as painting at all, since apparently, the serial image has been mechanically reproduced with the aid of a stencil. If I insist, however, on classifying it as a painting, I am constrained to describe it as a kind of literary painting, since the effect for which it was created depends entirely on my recognition of an implied pair of references: first, to the preexistent supermarket from which the labels are borrowed; and, second, to the pre-existent paintings from whose painterly aesthetic this composition departs.

There is no value and, to give modesty its due, no pretension of value in the painting, *per se,* unless we read the footnotes, as it were, and get the drift of the allusions.

Ever since the Enlightenment, the arts have been the vehicle for conveying much of the mystery and disorder, the transcendental yearnings, that the Church had been able to contain before it became rationalized. Consequently the modern arts have found their analogue in religious ritual and action, in the communion that predicates the sharing of a deeply felt experience. The enemy has been consistently identified as bourgeois society and bourgeois values. Pop art rejects the impulse towards communion; most of its signs and slogans and stratagems come straight out of the citadel of bourgeois society, the communications stronghold where the images and desires of mass man are produced, usually in plastic.

Condemning an aesthetic of process, the pop artist proposes to purify the muddied stream of art by displaying objects in isolation, the banal items of our day refurbished, made real, by their separation from the continuum. What a quixotic enterprise! Even a seventh-grade science textbook informs us that objects are the least solid of our certainties. Heisenberg, who demonstrated that the very act of observation changes the phenomenon to be observed, quietly asserts—without feeling the need for an exclamation point: "Modern physics, in the final analysis, has already discredited the concept of

the truly real." Probing the universe, man finds everywhere himself. In the words of another Nobel Prize physicist, Niels Bohr: "We are both spectators and actors in the great drama of existence." When Sartre brought the full weight of his philosophical intelligence to bear on this theme in an early novel, he significantly entitled his book *Nausea*. The theme is still being pursued by some of the best creative minds of France, notably by the writers and film-makers of the so-called *nouvelle vague*.

Pop art, in conclusion, seems to me to be neither serious nor funny enough to serve as more than a nine-days' wonder. It brings to mind a recent Stanford Research Institute study on the contemporary boom in American culture—a study that is as amazing as it is, unintentionally, depressing. No doubt some of you will be even more depressed than I at the disclosure that there are as many painters in this country as hunters. Altogether some fifty million Americans are currently being stimulated to "do it yourself" in the practice of the sundry arts. One major explanation of this tidal wave is the growing availability of "instant success" products, such as chord attachments for pianos and automatic light meters for cameras. "These devices," concludes the study, "come close to making a pro out of a dubber."

DISCUSSION

Selz: I have a number of questions here which I would like the panel to discuss, questions I had prepared before . . . but before doing so, or perhaps instead of doing so, I will just take the place of the moderator and open it right up to you people.

Geldzahler: I'd like to ask Mr. Kunitz a question. I'd like to ask Mr. Kunitz what he feels the role of the Museum of Modern Art, or the art magazines and so on is, if it's not to record and to present to the public what is going on in the contemporary art world. If pop art is being done in New York City, if the Museum of Modern Art is involved in the hurly-burly, in the course of twentieth-century art and its most current manifestations as it has been since 1929 when it was founded, how could it possibly ignore something like this?

Kunitz: I don't think for a moment that the Museum should ignore what's going on, especially a museum of *modern* art. But there are obviously principles of selectivity and of timing that enter into any active choice. I do have a feeling that in this terrible effort to get everything even *before it happens*, something strange happens to the landscape of art in our time.

Geldzahler: Then you feel modern art becomes modern in time but not right away?

Kunitz: Well, the old debate of the difference between contemporary and modern is, I think, an exhausted one, and I don't want to get into that at this moment, but obviously I do believe in a principle of value.

Kramer: May I ask Mr. Geldzahler a question on that? Do you then conceive the role of the Museum to be like that of a kind of three-dimensional tape recorder, giving us back what is currently being seen a few blocks away?

Geldzahler: I will agree that there has been some confusion in recent years between the galleries and the Museum of Modern Art. The Ad Reinhardt retrospective was given at the Section 11, the big Dickinson show was at the Graham Gallery, not at one of the museums where it should be, the "Sixteen Americans" was here, the "35 Painters under 35," or whatever it was—a lot of whom didn't have galleries—was at the Whitney, and as far as that goes, I would agree. But my feeling is that I pointed out the fact that this all happened terribly quickly (instant art history, etc.), but it is a fact that it has been considered and seen as a movement, and that the Museum of Modern Art with its dedication to contemporary art was made aware of it immediately, and couldn't ignore it. I just feel it was a compelling issue, and had to be engaged.

Kunitz: But if the motto becomes "Make it new," and not only "Make it new," but "Make it new fast," and if obviously the role of the Museum is, as you see it, to introduce the *new*, then the sure way of being admitted to the Museum is to make it new faster than anybody else. And this becomes, it seems to me, a merry-go-round.

Steinberg: There is no shortage in the world today of museums, even museums dedicated to modern art (I'm thinking, for instance, of the Tate Gallery in London), which make a practice of waiting until quality can be sifted. The Tate Gallery now is trying to raise I don't know how many hundreds of thousands of dollars to buy a Matisse. (They're very short on Matisse. They missed out on him.) And I would like to remind everybody here of a remark of Mr. Alfred Barr's, who is Director of Museum Collections, and I quoted it once before from this platform because I've always admired it for its straightforward intelligence and humility and understanding of the nature and difficulties of contemporary art. Mr. Barr apparently said that if one choice in ten that we make now turns out to be valid in retrospect, we will have done very well indeed. It is very difficult, if you think of art-buying in the last hundred years, to find anyone who would have scored that well, and perhaps the Museum is buying a thousand percent to get its eventual hundred. I think that the words that Mr. Kunitz used and *repeated*, that the Museum is trying to get there before it happens, I think these are amusing words, but I don't understand what they are supposed to mean. They are not getting there before the pictures are painted, and they are clearly reacting to paintings that have been made, so what are you trying to say when you say "before it happens"?

Kramer: May I make a comment on that, because I think, Leo, that you are completely ignoring the role that the Museum plays in *creating* history as well as *reflecting* it. It is its responsibility as a factor determining the course of what art is created, that people are objecting to.

Geldzahler: It is too late for the Museum of Modern Art to step out of history. It is very much involved in the action and reaction of contemporary history.

Steinberg: Hilton, in answer to this I would say that of course the Museum has a role to play in making history, but fortunately this is a pluralistic society, and there is a balance of power. The Museum is not alone. The Museum had very hard days when it was fighting against God knows everything, from artists picketing on the street to Senators in Congress. And now that the opposition from Congress is hardly to be expected any more, the Museum has very tough competition from other museums that have arisen in New York.

Kramer: Not really.

Steinberg: Well, it certainly is a competition that will grow, but if the competition is not tough enough, then it's because Mr. Selz, Mr. Seitz, Mr. Barr, Mr. D'Harnoncourt, and the others, are faster or more intuitive or more perceptive . . . [cut off]

Kunitz: But you really aren't answering the question.

Steinberg: No, I am answering the question because I think that *Art News* and ARTS, and other museums, and the Metropolitan, they all share, quite equally, or potentially equally, in power play.

Kramer: No. I don't think that's the case, and the difference is measurable.

Steinberg: You cannot simply accuse a man of exercising power because he buys a certain art and this has an effect upon the market.

Kramer: Oh yes you can! Of course you can!

Geldzahler: Mr. Kramer, how does he correct the situation? Does the Museum of Modern Art step out for five years and hold its breath? I don't understand.

Kramer: Yes, I see nothing wrong with that. Maybe even *ten* years.

Ashton: Hilton, why is this whole discussion focusing on the word "competition"? I always thought that art was beyond the notion of competition. If this is a discussion of a genre of art, why don't we keep it within that limit?

Selz: I think maybe we ought to get back to some of the more basic issues. There is one question that I'd like to ask. It has something to do with one of the things Dore raised, that I'd like to bring out. I think most of us always felt that one of the absolute necessities for anything to be a work of art, was the aesthetic distance between the art and the experience. Now, if an aesthetic distance is necessary for a work of art, is an aesthetic experience possible when we are confronted with something which is almost the object itself? Without any distance, or with a real minimum of distance, which is, I think, one of the problems we are confronted with in looking at this art. The old story of the person witnessing an accident on the highway not having an aesthetic experience comparable to tragedy. Where does the problem of the metaphor come in? There is a distinction to be drawn, I think, in the slides I showed, between some of the art, where the object is presented almost directly, say like in a comic strip by Lichtenstein, and in some of the others where there is a much greater transformation taking place. But what happens really where there is this minimum of transformation? Now Leo said that we don't know yet, that the form is hidden to some extent behind the subject, which is obviously apparent. Yet as critics, I think it is our absolute duty to know this difference and to be able to say yes or no. And my question to any one of you people is: Where is the aesthetic distance? Where does the problem of the metaphor come in with some of these objects?

Geldzahler: I would like to say that the means of contemporary art, the ways in which most contemporary art at any point is projecting and creating its magic, are mysterious, and the extent to which they are mysterious, incomprehensible, the extent of the difficulty we have in talking about it, is the extent to which the contemporary vibration, the immediacy, is felt. And when I said at the end of my talk, "I don't know if it is great art or not, we are not going to evaluate it ultimately tonight," and when Leo Steinberg said that the subject matter is so strong that the actual formal means seem to be disguised or behind, we are so confronted by the object, therefore not being used to it for so many years. I think that all this ties into

Peter's question that the exact aesthetic distance is difficult to measure at this point.

Steinberg: I think that aesthetic distance is in any case a nineteenth-century concept, and I do not unhesitatingly subscribe to it as an essential, as a *measurable* essential, of experience. One develops aesthetic distance from works that attain the *look* of art, the patina of art. The objection to an art like Caravaggio, like Courbet, any sort of real, raw, tough, realistic breakthrough in the history of art—the objection to it is always that it ceases to be art. Poussin would say, in the name of art, about Caravaggio, that he had been born to destroy painting. The whole of painting can be felt—after the initial blast of something like Caravaggism—can be felt to recoil, to defend art against the incursion of too much reality. It closes itself off the way a cell would against a foreign body. And what happens always is that aesthetic distance seems to have been destroyed. But not for us who look at it with the distance of time, because this aesthetic distance has been created. Just as aesthetic distance will exist for us for any kind of fashion the moment it is more than twenty or thirty years old.

Selz: But when we look back does it become a work of art?

Steinberg: Well, this is exactly when I say that this is premature. When I said about Lichtenstein's paintings that I do not like them as *paintings,* what I meant to say was that I do not feel competent to judge them as paintings, because the pressure of subject matter is so intense. This was not intended as a negative judgment upon them, but as a confession of inability on my part. But as a rider to this, I would say I suspect anyone who claims to know, now, that it is not serious painting.

Kramer: I find a serious discrepancy in the discussion here. Dr. Selz asked a fairly sophisticated aesthetic question about pop art as art, and Mr. Steinberg, who avers that he doesn't *know* whether it is art or not, answers it in a very complicated way on the assumption that it *is.* Now. Do you think it's art, or not? And, are you in the habit of applying aesthetic criteria and aesthetic categories to a discussion of data or matter that you have not yet determined to have an aesthetic character?

Steinberg: I think the question is legitimate, and I am very glad it was raised. When I said before that the questions about the art status of a work that is presented to us, depend not merely on analysis of certain inherent characteristics, but may also depend on the nature of the spectator's response, this would imply that before I can answer the question "Is this a work of art or not?" I want to have all the data in. Now the picture itself is part of the data, obviously. The rest of the data will be my reaction to it, the full experience of it. And this means that I must be interested in the kind of reaction a work elicits. Not every work elicits a reaction from me, obviously. And I know for instance, in reading—I have a certain advantage here over Mr. Kramer because I have his article that he wrote in *The Nation.* And the article is, as everything Mr. Kramer writes, exceedingly intelligent. I disagree with about 90 percent of it. But I disagree with the method. And the method is evident, for instance, when he begins to describe the show at the Janis Gallery. He says: "It is full of things to talk about. There is a small refrigerator whose door opens to the sound of a fire siren. There is an old-fashioned lawn mower joined to a painting on canvas. There are collections of old sabers and discarded eyeglasses under glass. There are even paintings, like you know, with paint on canvas, of pies and sandwiches and canned soup . . ." and it goes on listing these things. Now, at no point

is there any indication that Mr. Kramer submitted to any one of these objects singly. Mr. Kramer is the person I have in mind who makes a general rapid survey and is interested in the generalization about the common features. This is a valid way of doing it. It is not the only way of doing it, and it is one that I suspect for my own purposes, because it will never yield an answer to the question whether an individual work is art or not. Now for myself, I feel pretty certain that a good many of the exhibits in the Janis show were not art.

Kramer: How do you know that?

Steinberg: This is entirely a matter of . . . [cut off]

Kramer: And if they aren't art, what are they?

Steinberg: Perhaps I should modify this. They are art in so far as things produced in the art classes in schools, from first grade up, are art, because they are art classes. In so far as work done in the art department of the layout department, where the art editor lays things out on a magazine—in so far as this is art, this is perhaps the kind of thing that some of the followers of pop art will also produce. Therefore, if I say, offhand, that I suspect that they are not art, they may be only that kind of thing.

Kramer: A *low* form of art.

Steinberg: A low form of art—yes, or I think for instance . . . [cut off]

Kramer: But not exactly *non*-art.

Steinberg: What is non-art?

Kramer: Well, that's what I'm asking you, because you are the only member of this panel who has declared himself as being uncertain as to whether these objects are art objects. And if they're not art objects, you must have another category that you place them in. Is it experience, or intellectualism?

Steinberg: Well, they could be attempts to create art objects, which misfire, couldn't they?

Kramer: Yes—*"failed"* art.

Steinberg: Yes.

Kramer: Still art.

Selz: May I bring up another point? A point that has been discussed comparatively little on this panel. We picked the term pop art. We might have called it New Realism as they did in the Sidney Janis Gallery, or New Dada. And this New Dada thing interests me. What is the relationship (I think this is something worth exploring) between this and Dadaism? Dada, as we know, was essentially a conscious movement by writers and artists against the spirit of conformity and the *bourgeoisie.* Now this neo-Dada is to some extent—well, we heard Mr. Geldzahler say that the alienation was over, that everything is nice now, and using very much of a Madison Avenue term, he says it's nice because it "keeps things moving." Now if this art is as closely related to advertising and the whole campaign of Madison Avenue that we are so familiar with, as some people say it is, what is its relation to Dada?

Geldzahler: The difference between the beginning and the end of the question was a little complicated.

Selz: Let's try to discuss for a minute its relationship to Dada.

Geldzahler: Leaving out Madison Avenue or bringing Madison Avenue in?

Kunitz: Briefly, obviously, one finds sources of pop art in Dada, and I think the term New Dada has a degree of relevance. Certainly if you think of Schwitters,

Merzbilder—there's a great relationship there. And then the *objets trouvés* and so forth. But it seems to me that the profound difference is that Dada was essentially a revolutionary movement. It was a movement that had great social passion behind it. It was a form of outrage. And it was launched against the very bourgeois society which the Dadaists felt were responsible for the First World War. It was launched as an *attack* upon them. Now the New Dada instead *embraces*, in a sense, the bourgeois symbols. And is without passion.

Steinberg: I want to use a technique of Professor Ernst Gombrich, who never gives a lecture without quoting a *New Yorker* cartoon. One of my favorite *New Yorker* cartoons, and one that I think was really prophetic in showing that a new pathway for our admiration was being grooved. This was a cartoon showing an exasperated wife who exclaims to her husband, "Why do you always have to be a non-conformist like everybody else?" Just about that time there was a show of nineteenth-century French drawings mounted in New York, and the artists who were not the well-known revolutionaries of French official art history were labeled as "non-dissenters." I was immensely impressed with this term—this is an invention of real genius—the non-dissenters. Because after being educated as we have been, all of us, in this century, to read the history of art is just one damn rebel after another, and that's all there is, see—the succession of Delacroix, and then it's Courbet, and then it's Monet, and then it's Cézanne, and then it's Picasso—suddenly we find that there is an alternative mode of conduct, the *non-dissenter*. This is terrific, you see, and this suddenly becomes an avenue of extraordinary novelty and originality. You don't always have to be a non-conformist like everybody else. So my answer to Mr. Kunitz is simply this: Sure, Dada was revolutionary. Every art movement we have known for a hundred years was revolutionary. And it may be that the extraordinary novelty and the shock and the dismay and the disdain that is felt over this movement is that it doesn't *seem revolutionary* like every other.

Geldzahler: The great excitement and so on of Dada was its anti-formal nature after the great formal revolutions of Cubism, etc., and the break of sequence with the First World War. Dada was an anti-formal excitement. Pop art is definitely a formal art. It's an art of decisions and choices of composition. And I think Mr. Selz has downgraded the extent to which, for instance, Roy Lichtenstein changes the comic strip he's working from and the painting that's finished. I've seen the comic strip, I've seen the painting, the colors . . . [cut off]

Ashton: What do you need, a magnifying glass? [laughter]

Geldzahler: You don't need a magnifying glass, Dore. All you need is a pair of eyes, and an open, willing spirit, and a soul, and a . . . [cut off by laughter]

Kramer: I think that the question of the relationship of pop art to Dada has really not been taken seriously. It should be. But I think if it's going to be taken seriously, Dada itself has to be looked at in a way that nobody has really been willing to look at it for a long time. And that is that Dada was revolutionary *only* in its ideology, not in its aesthetics. You cannot say that Schwitters broke with Cubism. That's an absurdity. Cubism provided the entire syntax for everything he did. And so, if you're going to compare pop art with Dada, you would have to be very clear about what you're talking about, whether its avowed social ideology or its actual plastic accomplishments. They do not coincide by any means.

Context

Norman Mailer
Perspective from the Biltmore Balcony (1960)

Like Andy Warhol, the writer Norman Mailer came to epitomize the 1960s. It was their public personae as much as their individual creative acts that made them archetypal characters. In 1960 *Esquire* magazine sent Mailer to cover the Democratic convention at the Biltmore Hotel in Los Angeles. The result was Mailer's extended essay "Superman Comes to the Supermarket." In the section reproduced here, "Perspective from the Biltmore Balcony," Mailer describes the arrival of John F. Kennedy (who would soon become the Democratic presidential nominee) at the convention in a manner that firmly roots Kennedy to the media-savvy decade of the 1960s. In this short but dense section Mailer paints a metaphorical picture of America's psychic life since World War II. In so doing he sets the stage for America's need to elect not just a pragmatic yet uninspiring president on the order of Truman or Eisenhower but someone who has the potential to tap into the "secret imagination" of his time, a hero who can project a facade that is as salient as the mythic images of Hollywood. The potential presidency of Kennedy represents for Mailer a sense that the oppressive conformity of the 1950s was about to explode into the free-wheeling optimism of the 1960s. "Superman Comes to the Supermarket" was originally published in *Esquire* in 1960.

> ... it can be said with a fair amount of certainty that the essence of his political attractiveness is his extraordinary political intelligence. He has a mind quite unlike that of any other Democrat of this century. It is not literary, metaphysical and moral, as Adlai Stevenson's is. Kennedy is articulate and often witty, but he does not seek verbal polish. No one can doubt the seriousness of his concern with the most serious political matters, but one feels that whereas Mr. Stevenson's political views derive from a view of life that holds politics to be a mere fraction of existence, Senator Kennedy's primary interest is in politics. The easy way in which he disposes of the question of Church and State—as if he felt that any reasonable man could quite easily resolve any possible conflict of loyalties—suggests that the organization of society is the one thing that really engages his interest.
>
> —Richard Rovere, *The New Yorker,* July 23, 1960

The afternoon he arrived at the convention from the airport, there was of course a large crowd on the street outside the Biltmore, and the best way to

get a view was to get up on an outdoor balcony of the Biltmore, two flights above the street, and look down on the event. One waited thirty minutes, and then a honking of horns as wild as the getaway after an Italian wedding sounded around the corner, and the Kennedy cortege came into sight, circled Pershing Square, the men in the open and leading convertibles sitting backwards to look at their leader, and finally came to a halt in a space cleared for them by the police in the crowd. The television cameras were out, and a Kennedy band was playing some circus music. One saw him immediately. He had the deep orange-brown suntan of a ski instructor, and when he smiled at the crowd his teeth were amazingly white and clearly visible at a distance of fifty yards. For one moment he saluted Pershing Square, and Pershing Square saluted him back, the prince and the beggars of glamour staring at one another across a city street, one of those very special moments in the underground history of the world, and then with a quick move he was out of the car and by choice headed into the crowd instead of the lane cleared for him into the hotel by the police, so that he made his way inside surrounded by a mob, and one expected at any moment to see him lifted to its shoulders like a matador being carried back to the city after a triumph in the plaza. All the while the band kept playing the campaign tunes, sashaying circus music, and one had a moment of clarity, intense as a *déjà vu*, for the scene which had taken place had been glimpsed before in a dozen musical comedies; it was the scene where the hero, the matinee idol, the movie star comes to the palace to claim the princess, or what is the same, and more to our soil, the football hero, the campus king, arrives at the dean's home surrounded by a court of open-singing students to plead with the dean for his daughter's kiss and permission to put on the big musical that night. And suddenly I saw the convention, it came into focus for me, and I understood the mood of depression which had lain over the convention, because finally it was simple: the Democrats were going to nominate a man who, no matter how serious his political dedication might be, was indisputably and willy-nilly going to be seen as a great box-office actor, and the consequences of that were staggering and not at all easy to calculate.

Since the First World War Americans have been leading a double life, and our history has moved on two rivers, one visible, the other underground; there has been the history of politics which is concrete, factual, practical and unbelievably dull if not for the consequences of the actions of some of these men; and there is a subterranean river of untapped, ferocious, lonely and romantic desires, that concentration of ecstasy and violence which is the dream life of the nation.

The twentieth century may yet be seen as that era when civilized man and underprivileged man were melted together into mass man, the iron and steel of the nineteenth century giving way to electronic circuits which communicated their messages into men, the unmistakable tendency of the new century seeming to be the creation of men as interchangeable as commodities,

their extremes of personality singed out of existence by the psychic fields of force the communicators would impose. This loss of personality was a catastrophe to the future of the imagination, but billions of people might first benefit from it by having enough to eat—one did not know—and there remained citadels of resistance in Europe where the culture was deep and roots were visible in the architecture of the past.

Nowhere, as in America, however, was this fall from individual man to mass man felt so acutely, for America was at once the first and most prolific creator of mass communications, and the most rootless of countries, since almost no American could lay claim to the line of a family which had not once at least severed its roots by migrating here. But, if rootless, it was then the most vulnerable of countries to its own homogenization. Yet America was also the country in which the dynamic myth of the Renaissance—that every man was potentially extraordinary—knew its most passionate persistence. Simply, America was the land where people still believed in heroes: George Washington; Billy the Kid; Lincoln, Jefferson; Mark Twain, Jack London, Hemingway; Joe Louis, Dempsey, Gentleman Jim; America believed in athletes, rum-runners, aviators; even lovers, by the time Valentino died. It was a country which had grown by the leap of one hero past another—is there a county in all of our ground which does not have its legendary figure? And when the West was filled, the expansion turned inward, became part of an agitated, overexcited, superheated dream life. The film studios threw up their searchlights as the frontier was finally sealed, and the romantic possibilities of the old conquest of land turned into a vertical myth, trapped within the skull, of a new kind of heroic life, each choosing his own archetype of a neo-renaissance man, be it Barrymore, Cagney, Flynn, Bogart, Brando or Sinatra, but it was almost as if there were no peace unless one could fight well, kill well (if always with honor), love well and love many, be cool, be daring, be dashing, be wild, be wily, be resourceful, be a brave gun. And this myth, that each of us was born to be free, to wander, to have adventure and to grow on the waves of the violent, the perfumed, and the unexpected, had a force which could not be tamed no matter how the nation's regulators—politicians, medicos, policemen, professors, priests, rabbis, ministers, *idéologues*, psychoanalysts, builders, executives and endless communicators—would brick-in the modern life with hygiene upon sanity, and middle-brow homily over platitude; the myth would not die. Indeed a quarter of the nation's business must have depended upon its existence. But it stayed alive for more than that—it was as if the message in the labyrinth of the genes would insist that violence was locked with creativity, and adventure was the secret of love.

Once, in the Second Word War and in the year or two which followed, the underground river returned to earth, and the life of the nation was intense, of the present, electric; as a lady said, "That was the time when we gave parties which changed people's lives." The Forties was a decade when the speed with which one's own events occurred seemed as rapid as the history

of the battlefields, and for the mass of people in America a forced march into a new jungle of emotion was the result. The surprises, the failures, and the dangers of that life must have terrified some nerve of awareness in the power and the mass, for, as if stricken by the orgiastic vistas the myth had carried up from underground, the retreat to a more conservative existence was disorderly, the fear of communism spread like an irrational hail of boils. To anyone who could see, the excessive hysteria of the Red wave was no preparation to face an enemy, but rather a terror of the national self: free-loving, lust-looting, atheistic, implacable—absurdity beyond absurdity to label communism so, for the moral products of Stalinism had been Victorian sex and a ponderous machine of material theology.

Forced underground again, deep beneath all *Reader's Digest* hospital dressings of Mental Health in Your Community, the myth continued to flow, fed by television and the film. The fissure in the national psyche widened to the danger point. The last large appearance of the myth was the vote which tricked the polls and gave Harry Truman his victory in '48. That was the last. Came the Korean War, the shadow of the H-bomb, and we were ready for the General. Uncle Harry gave way to Father, and security, regularity, order, and the life of no imagination were the command of the day. If one had any doubt of this, there was Joe McCarthy with his built-in treason detector, furnished by God, and the damage was done. In the totalitarian wind of those days, anyone who worked in Government formed the habit of being not too original. At the summit there was benevolence without leadership, regularity without vision, security without safety, rhetoric without life. The ship drifted on, that enormous warship of the United States, led by a Secretary of State whose cells were seceding to cancer, and as the world became more fantastic—Africa burning itself upside down, while some new kind of machine man was being made in China—two events occurred which stunned the confidence of America into a new night: the Russians put up their Sputnik, and Civil Rights—that reluctant gift to the American Negro, granted for its effect on foreign affairs—spewed into real life at Little Rock. The national Ego was in shock: the Russians were now in some ways our technological superiors, and we had an internal problem of subject populations equal conceivably in its difficulty to the Soviet and its satellites. The fatherly calm of the General began to seem like the uxorious mellifluences of the undertaker.

Underneath it all was a larger problem. The life of politics and the life of myth had diverged too far, and the energies of the people one knew everywhere had slowed down. Twenty years ago a post-Depression generation had gone to war and formed a lively, grousing, by times inefficient, carousing, pleasure-seeking, not altogether inadequate army. It did part of what it was supposed to do, and many, out of combat, picked up a kind of private life on the fly, and had their good time despite the yaws of the military system. But

today in America the generation which respected the code of the myth was Beat, a horde of half-begotten Christs with scraggly beards, heroes none, saints all, weak before the strong, empty conformisms of the authority. The sanction for finding one's growth was no longer one's flag, one's career, one's sex, one's adventure, not even one's booze. Among the best in this newest of the generations, the myth had found its voice in marijuana, and the joke of the underground was that when the Russians came over they could never dare to occupy us for long because America was too Hip. Gallows humor. The poorer truth might be that America was too Beat, the instinct of the nation so separated from its public mind that apathy, schizophrenia, and private beatitudes might be the pride of the welcoming committee any underground could offer.

Yes, the life of politics and the life of the myth had diverged too far. There was nothing to return them to one another, no common danger, no cause, no desire, and, most essentially, no hero. It was a hero America needed, a hero central to his time, a man whose personality might suggest contradictions and mysteries which could reach into the alienated circuits of the underground, because only a hero can capture the secret imagination of a people, and so be good for the vitality of his nation; a hero embodies the fantasy and so allows each private mind the liberty to consider its fantasy and find a way to grow. Each mind can become more conscious of its desire and waste less strength in hiding from itself. Roosevelt was such a hero, and Churchill, Lenin, and de Gaulle; even Hitler, to take the most odious example of this thesis, was a hero, the hero-as-monster, embodying what had become the monstrous fantasy of a people, but the horror upon which the radical mind and liberal temperament foundered was that he gave outlet to the energies of the Germans and so presented the twentieth century with an index of how horrible had become the secret heart of its desire. Roosevelt is of course a happier example of the hero; from his paralytic leg to the royal elegance of his geniality he seemed to contain the country within himself; everyone from the meanest starving cripple to an ambitious young man could expand into the optimism of an improving future because the man offered an unspoken promise of a future which would be rich. The sexual and the sex-starved, the poor, the hard-working and the imaginative well-to-do could see themselves in the President, could believe him to be like themselves. So a large part of the country was able to discover its energies because not as much was wasted in feeling that the country was a poisonous nutrient which stifled the day.

Too simple? No doubt. One tried to construct a simple model. The thesis is after all not so mysterious; it would merely nudge the notion that a hero embodies his time and is not so very much better than his time, but he is larger than life and so is capable of giving direction to the time, able to encourage a nation to discover the deepest colors of its character. At bottom the

concept of the hero is antagonistic to impersonal social progress, to the belief that social ills can be solved by social legislating, for it sees a country as all-but-trapped in its character until it has a hero who reveals the character of the country to itself. The implication is that without such a hero the nation turns sluggish. Truman for example was not such a hero, he was not sufficiently larger than life, he inspired familiarity without excitement, he was a character but his proportions came from soap opera: Uncle Harry, full of salty common-sense and small-minded certainty, a storekeeping uncle.

Whereas Eisenhower has been the anti-Hero, the regulator. Nations do not necessarily and inevitably seek for heroes. In periods of dull anxiety, one is more likely to look for security than a dramatic confrontation, and Eisenhower could stand as a hero only for that large number of Americans who were most proud of their lack of imagination. In American life, the unspoken war of the century has taken place between the city and the small town: the city which is dynamic, orgiastic, unsettling, explosive and accelerating to the psyche; the small town which is rooted, narrow, cautious and planted in the life-logic of the family. The need for the city is to accelerate growth; the pride of the small town is to retard it. But since America has been passing through a period of enormous expansion since the war, the double-four years of Dwight Eisenhower could not retard the expansion, it could only denude it of color, character, and the development of novelty. The small-town mind is rooted—it is rooted in the small town—and when it attempts to direct history the results are disastrously colorless because the instrument of world power which is used by the small-town mind is the committee. Committees do not create, they merely proliferate, and the incredible dullness wreaked upon the American landscape in Eisenhower's eight years has been the triumph of the corporation. A tasteless, sexless, odorless sanctity in architecture, manners, modes, styles has been the result. Eisenhower embodied half the needs of the nation, the needs of the timid, the petrified, the sanctimonious, and the sluggish. What was even worse, he did not divide the nation as a hero might (with a dramatic dialogue as the result); he merely excluded one part of the nation from the other. The result was an alienation of the best minds and bravest impulses from the faltering history which was made. America's need in those years was to take an existential turn, to walk into the nightmare, to face into that terrible logic of history which demanded that the country and its people must become more extraordinary and more adventurous, or else perish, since the only alternative was to offer a false security in the power and the panacea of organized religion, family, and the FBI, a totalitarianization of the psyche by the stultifying techniques of the mass media which would seep into everyone's most private associations and so leave the country powerless against the Russians even if the denouement were to take fifty years, for in a competition between totalitarianisms the first maxim of the prizefight manager would doubtless apply: "Hungry fighters win fights."

Marshall McLuhan
Television: The Timid Giant (1964)

By the mid-1960s the Canadian professor Marshall McLuhan had established himself as the most important and widely read writer on the impact of mass media on mainstream culture. In "Television: The Timid Giant," from his 1964 book *Understanding Media,* McLuhan discusses how television—which by the early 1960s had become the centerpiece of the American living room—was changing American culture and consciousness. The candidacy, presidency, and assassination of John F. Kennedy exemplifies some of the particular ways in which TV images affect the public's experience of events. As examples, McLuhan discusses how Kennedy's camera-friendly appearance and manner helped him defeat Richard Nixon in the first televised presidential debate in 1960 as well as the unprecedented way the Kennedy administration used TV images to create an intimate relationship between the American public and the White House. McLuhan's analysis gives us a sense of the level to which images projected through the television had the potential to create collective experiences of unique authority. This sense of the unifying power of images was no more profoundly displayed than the way the public experienced the televised events surrounding Kennedy's assassination. In McLuhan's opinion "the Kennedy funeral, in short, manifested the power of TV to involve an entire population in a ritualized process."

It is interesting to note that Andy Warhol used multiple images of Jackie Kennedy at the funeral of JFK in a series of obsessively repetitive silk screens in 1964. When viewed within the context of McLuhan's media studies, Warhol's use of the iconic images of mass culture seems to comment directly on the level to which mediated images had come to define the American experience. In this regard it is worth reconsidering the significance of the title of the first exhibition devoted to what was later called Pop art; the title of the 1962 show at the Sidney Janis Gallery was *New Realists.* If we are to take this title at its word, then what American culture faced in the 1960s was that "reality" was best exemplified by the projected images of television and the created symbols of advertising.

Perhaps the most familiar and pathetic effect of the TV image is the posture of children in the early grades. Since TV, children—regardless of eye condition—average about six and a half inches from the printed page. Our children are striving to carry over to the printed page the all-involving sensory mandate of the TV image. With perfect psycho-mimetic skill, they carry out the commands of the TV image. They pore, they probe, they slow down and involve themselves in depth. This is what they had learned to do in the cool iconography of the comic-book medium. TV carried the process much further. Suddenly they are transferred to the hot print medium with its uniform patterns

and fast lineal movement. Pointlessly they strive to read print in depth. They bring to print all their senses, and print rejects them. Print asks for the isolated and stripped-down visual faculty, not for the unified sensorium.

The Mackworth head-camera, when worn by children watching TV, has revealed that their eyes follow, not the actions, but the reactions. The eyes scarcely deviate from the faces of the actors, even during scenes of violence. This head-camera shows by projection both the scene and the eye movement simultaneously. Such extraordinary behavior is another indication of the very cool and involving character of this medium.

On the Jack Paar show for March 8, 1963, Richard Nixon was Paared down and remade into a suitable TV image. It turns out that Mr. Nixon is both a pianist and a composer. With sure tact for the character of the TV medium, Jack Paar brought out this *pianoforte* side of Mr. Nixon, with excellent effect. Instead of the slick, glib, legal Nixon, we saw the doggedly creative and modest performer. A few timely touches like this would have quite altered the result of the Kennedy-Nixon campaign. TV is a medium that rejects the sharp personality and favors the presentation of processes rather than of products.

The adaptation of TV to processes, rather than to the neatly packaged products, explains the frustration many people experience with this medium in its political uses. An article by Edith Efron in *TV Guide* (May 18–24, 1963) labeled TV "The Timid Giant," because it is unsuited to hot issues and sharply defined controversial topics: "Despite official freedom from censorship, a self-imposed silence renders network documentaries almost mute on many great issues of the day." As a cool medium TV has, some feel, introduced a kind of *rigor mortis* into the body politic. It is the extraordinary degree of audience participation in the TV medium that explains its failure to tackle hot issues. Howard K. Smith observed: "The networks are delighted if you go into a controversy in a country 14,000 miles away. They don't want real controversy, real dissent, at home." For people conditioned to the hot newspaper medium, which is concerned with the clash of *views*, rather than involvement in *depth* in a situation, the TV behavior is inexplicable.

Such a hot news item that concerns TV directly was headlined "It finally happened—a British film with English subtitles to explain the dialects." The film in question is the British comedy "Sparrows Don't Sing." A glossary of Yorkshire, Cockney, and other slang phrases has been printed for the customers so that they can figure out just what the subtitles mean. Sub subtitles are as handy an indicator of the depth effects of TV as the new "rugged" styles in feminine attire. One of the most extraordinary developments since TV in England has been the upsurge of regional dialects. A regional brogue or "burr" is the vocal equivalent of gaiter stockings. Such brogues undergo continual erosion from literacy. Their sudden prominence in England in areas in which previously one had heard only standard

English is one of the most significant cultural events of our time. Even in the classrooms of Oxford and Cambridge, the local dialects are heard again. The undergraduates of those universities no longer strive to achieve a uniform speech. Dialectal speech since TV has been found to provide a social bond in depth, not possible with the artificial "standard English" that began only a century ago.

An article on Perry Como bills him as "Low-pressure king of a high-pressure realm." The success of any TV performer depends on his achieving a low-pressure style of presentation, although getting his act on the air may require much high-pressure organization. Castro may be a case in point. According to Tad Szulc's story on "Cuban Television's One-man Show" (*The Eighth Art*), "in his seemingly improvised 'as-I-go-along' style he can evolve politics and govern his country—right on camera." Now, Tad Szulc is under the illusion that TV is a hot medium, and suggests that in the Congo "television might have helped Lumumba to incite the masses to even greater turmoil and bloodshed." But he is quite wrong. Radio is the medium for frenzy, and it has been the major means of hotting up the tribal blood of Africa, India, and China, alike. TV has cooled Cuba down, as it is cooling down America. What the Cubans are getting by TV is the experience of being directly engaged in the making of political decisions. Castro presents himself as a teacher, and as Szulc says, "manages to blend political guidance and education with propaganda so skillfully that it is often difficult to tell where one begins and the other ends." Exactly the same mix is used in entertainment in Europe and America alike. Seen outside the United States, any American movie looks like subtle political propaganda. Acceptable entertainment has to flatter and exploit the cultural and political assumptions of the land of its origin. These unspoken presuppositions also serve to blind people to the most obvious facts about a new medium like TV.

In a group of simulcasts of several media done in Toronto a few years back, TV did a strange flip. Four randomized groups of university students were given the same information at the same time about the structure of preliterate languages. One group received it via radio, one from TV, one by lecture, and one read it. For all but the reader group, the information was passed along in straight verbal flow by the same speaker without discussion or questions or use of blackboard. Each group had half an hour of exposure to the material. Each was asked to fill in the same quiz afterward. It was quite a surprise to the experimenters when the students performed better with TV-channeled information and with radio than they did with lecture and print—and the TV group stood *well* above the radio group. Since nothing had been done to give special stress to any of these four media, the experiment was repeated with other randomized groups. This time each medium was allowed full opportunity to do its stuff. For radio and TV, the material was dramatized with many auditory and visual features. The

lecturer took full advantage of the blackboard and class discussion. The printed form was embellished with an imaginative use of typography and page layout to stress each point in the lecture. All of these media had been stepped up to high intensity for this repeat of the original performance. Television and radio once again showed results high above lecture and print. Unexpectedly to the testers, however, radio now stood significantly above television. It was a long time before the obvious reason declared itself, namely that TV is a cool, participant medium. When hotted up by dramatization and stingers, it performs less well because there is less opportunity for participation. Radio is a hot medium. When given additional intensity, it performs better. It doesn't invite the same degree of participation in its users. Radio will serve as background-sound or as noise-level control, as when the ingenious teenager employs it as a means of privacy. TV will not work as background. It engages you. You have to be *with* it. (The phrase has gained acceptance since TV.)

A great many things will not work since the arrival of TV. Not only the movies, but the national magazines as well, have been hit very hard by this new medium. Even the comic books have declined greatly. Before TV, there had been much concern about why Johnny couldn't read. Since TV, Johnny has acquired an entirely new set of perceptions. He is not at all the same. Otto Preminger, director of *Anatomy of a Murder* and other hits, dates a great change in movie making and viewing from the very first year of general TV programming. "In 1951," he wrote, "I started a fight to get the release in motion-picture theaters of *The Moon Is Blue* after the production code approval was refused. It was a small fight and I won it." (*Toronto Daily Star,* October 19, 1963)

He went on to say, "The very fact that it was the word 'virgin' that was objected to in *The Moon Is Blue* is today laughable, almost incredible." Otto Preminger considers that American movies have advanced toward maturity owing to the influence of TV. The cool TV medium promotes depth structures in art and entertainment alike, and creates audience involvement in depth as well. Since nearly all our technologies and entertainment since Gutenberg have been not cool, but hot; and not deep, but fragmentary; not producer-oriented, but consumer-oriented, there is scarcely a single area of established relationships, from home and church to school and market, that has not been profoundly disturbed in its pattern and texture.

The psychic and social disturbance created by the TV image, and not the TV programming, occasions daily comment in the press. Raymond Burr, who plays Perry Mason, spoke to the National Association of Municipal Judges, reminding them that, "Without our laymen's understanding and acceptance, the laws which you apply and the courts in which you preside cannot continue to exist." What Mr. Burr omitted to observe was that the Perry Mason TV program, in which he plays the lead, is typical of that intensely

participational kind of TV experience that has altered our relation to the laws and the courts.

The mode of the TV image has nothing in common with film or photo, except that it offers also a nonverbal *gestalt* or posture of forms. With TV, the viewer is the screen. He is bombarded with light impulses that James Joyce called the "Charge of the Light Brigade" that imbues his "soulskin with subconscious inklings." The TV image is visually low in data. The TV image is not a *still* shot. It is not photo in any sense, but a ceaselessly forming contour of things limned by the scanning-finger. The resulting plastic contour appears by light *through*, not light *on*, and the image so formed has the quality of sculpture and icon, rather than of picture. The TV image offers some three million dots per second to the receiver. From these he accepts only a few dozen each instant, from which to make an image.

The film image offers many more millions of data per second, and the viewer does not have to make the same drastic reduction of items to form his impression. He tends instead to accept the full image as a package deal. In contrast, the viewer of the TV mosaic, with technical control of the image, unconsciously reconfigures the dots into an abstract work of art on the pattern of a Seurat or Rouault. If anybody were to ask whether all this would change if technology stepped up the character of the TV image to movie data level, one could only counter by inquiring, "Could we alter a cartoon by adding details of perspective and light and shade?" The answer is "Yes," only it would then no longer be a cartoon. Nor would "improved" TV be television. The TV image is *now* a mosaic mesh of light and dark spots which a movie shot never is, even when the quality of the movie image is very poor.

As in any other mosaic, the third dimension is alien to TV, but it can be superimposed. In TV the illusion of the third dimension is provided slightly by the stage sets in the studio; but the TV image itself is a flat two-dimensional mosaic. Most of the three-dimensional illusion is a carry-over of habitual viewing of film and photo. For the TV camera does not have a built-in angle of vision like the movie camera. Eastman Kodak now has a two-dimensional camera that can match the flat effects of the TV camera. Yet it is hard for literate people, with their habit of fixed points of view and three-dimensional vision, to understand the properties of two-dimensional vision. If it had been easy for them, they would have had no difficulties with abstract art, General Motors would not have made a mess of motorcar design, and the picture magazine would not be having difficulties now with the relationship between features and ads. The TV image requires each instant that we "close" the spaces in the mesh by a convulsive sensuous participation that is profoundly kinetic and tactile, because tactility is the interplay of the senses, rather than the isolated contact of skin and object.

To contrast it with the film shot, many directors refer to the TV image as one of "low definition," in the sense that it offers little detail and a low

degree of information, much like the cartoon. A TV close-up provides only as much information as a small section of a long-shot on the movie screen. For lack of observing so central an aspect of the TV image, the critics of program "content" have talked nonsense about "TV violence." The spokesmen of censorious views are typical semiliterate book-oriented individuals who have no competence in the grammars of newspaper, or radio, or of film, but who look askew and askance at all non-book media. The simplest question about any psychic aspect, even of the book medium, throws these people into a panic of uncertainty. Vehemence of projection of a single isolated attitude they mistake for moral vigilance. Once these censors became aware that in all cases "the medium is the message" or the basic source of effects, they would turn to suppression of media as such, instead of seeking "content" control. Their current assumption that content or programming is the factor that influences outlook and action is derived from the book medium, with its sharp cleavage between form and content.

Is it not strange that TV should have been as revolutionary a medium in America in the 1950s as radio in Europe in the 1930s? Radio, the medium that resuscitated the tribal and kinship webs of the European mind in the 1920s and 1930s, had no such effect in England or America. There, the erosion of tribal bonds by means of literacy and its industrial extensions had gone so far that our radio did not achieve any notable tribal reactions. Yet ten years of TV have Europeanized even the United States, as witness its changed feelings for space and personal relations. There is new sensitivity to the dance, plastic arts, and architecture, as well as the demand for the small car, the paperback, sculptural hairdos and molded dress effects—to say nothing of a new concern for complex effects in cuisine and in the use of wines. Notwithstanding, it would be misleading to say that TV will retribalize England and America. The action of radio on the world of resonant speech and memory was hysterical. But TV has certainly made England and America vulnerable to radio where previously they had immunity to a great degree. For good or ill, the TV image has exerted a unifying synesthetic force on the sense-life of these intensely literate populations, such as they have lacked for centuries. It is wise to withhold all value judgments when studying these media matters, since their effects are not capable of being isolated.

Synesthesia, or unified sense and imaginative life, had long seemed an unattainable dream to Western poets, painters, and artists in general. They had looked with sorrow and dismay on the fragmented and impoverished imaginative life of Western literate man in the eighteenth century and later. Such was the message of Blake and Pater, Yeats and D. H. Lawrence, and a host of other great figures. They were not prepared to have their dreams realized in everyday life by the aesthetic action of radio and television. Yet these massive extensions of our central nervous systems have enveloped Western man in a daily session of synesthesia. The Western way of life attained centuries since by the rigorous separation and specialization of the

senses, with the visual sense atop the hierarchy, is not able to withstand the radio and TV waves that wash about the great visual structure of abstract Individual Man. Those who, from political motives, would now add their force to the anti-individual action of our electric technology are puny subliminal automatons aping the patterns of the prevailing electric pressures. A century ago they would, with equal somnambulism, have faced in the opposite direction. German Romantic poets and philosophers had been chanting in tribal chorus for a return to the dark unconscious for over a century before radio and Hitler made such a return difficult to avoid. What is to be thought of people who wish such a return to preliterate ways, when they have no inkling of how the civilized visual way was ever substituted for tribal auditory magic?

At this hour, when Americans are discovering new passions for skin-diving and the wraparound space of small cars, thanks to the indomitable tactile promptings of the TV image, the same image is inspiring many English people with race feelings of tribal exclusiveness. Whereas highly literate Westerners have always idealized the condition of integration of races, it has been their literate culture that made impossible real uniformity among races. Literate man naturally dreams of visual solutions to the problems of human differences. At the end of the nineteenth century, this kind of dream suggested similar dress and education for both men and women. The failure of the sex-integration programs has provided the theme of much of the literature and psychoanalysis of the twentieth century. Race integration, undertaken on the basis of visual uniformity, is an extension of the same cultural strategy of literate man, for whom differences always seem to need eradication, both in sex and in race, and in space and in time. Electronic man, by becoming ever more deeply involved in the actualities of the human condition, cannot accept the literate cultural strategy. The Negro will reject a plan of visual uniformity as definitely as women did earlier, and for the same reasons. Women found that they had been robbed of their distinctive roles and turned into fragmented citizens in "a man's world." The entire approach to these problems in terms of uniformity and social homogenization is a final pressure of the mechanical and industrial technology. Without moralizing, it can be said that the electric age, by involving all men deeply in one another, will come to reject such mechanical solutions. It is more difficult to provide uniqueness and diversity than it is to impose the uniform patterns of mass education; but it is such uniqueness and diversity that can be fostered under electric conditions as never before.

Temporarily, all preliterate groups in the world have begun to feel the explosive and aggressive energies that are released by the onset of the new literacy and mechanization. These explosions come just at a time when the new electric technology combines to make us share them on a global scale.

The effect of TV, as the most recent and spectacular electric extension of our central nervous system, is hard to grasp for various reasons. Since it has

affected the totality of our lives, personal and social and political, it would be quite unrealistic to attempt a "systematic" or visual presentation of such influence. Instead, it is more feasible to "present" TV as a complex *gestalt* of data gathered almost at random.

The TV image is of low intensity or definition, and therefore, unlike film, it does not afford detailed information about objects. The difference is akin to that between the old manuscripts and the printed word. Print gave intensity and uniform precision, where before there had been a diffuse texture. Print brought in the taste for exact measurement and repeatability that we now associate with science and mathematics.

The TV producer will point out that speech on television must not have the careful precision necessary in the theater. The TV actor does not have to project either his voice or himself. Likewise, TV acting is so extremely intimate, because of the peculiar involvement of the viewer with the completion or "closing" of the TV image, that the actor must achieve a great degree of spontaneous casualness that would be irrelevant in movies and lost on stage. For the audience participates in the inner life of the TV actor as fully as in the outer life of the movie star. Technically, TV tends to be a close-up medium. The close-up that in the movie is used for shock is, on TV, a quite casual thing. And whereas a glossy photo the size of the TV screen would show a dozen faces in adequate detail, a dozen faces on the TV screen are only a blur.

The peculiar character of the TV image in its relation to the actor causes such familiar reactions as our not being able to recognize in real life a person whom we see every week on TV. Not many of us are as alert as the kindergartener who said to Garry Moore, "How did you get off TV?" Newscasters and actors alike report the frequency with which they are approached by people who feel they've met them before. Joanne Woodward in an interview was asked what was the difference between being a movie star and a TV actress. She replied: "When I was in the movies I heard people say, 'There goes Joanne Woodward.' Now they say, 'There goes somebody I think I know.'"

The owner of a Hollywood hotel in an area where many movie and TV actors reside reported that tourists had switched their allegiance to TV stars. Moreover, most TV stars are men, that is, "cool characters," while most movie stars are women, since they can be presented as "hot" characters. Men and women movie stars alike, along with the entire star system, have tended to dwindle into a more moderate status since TV. The movie is a hot, high-definition medium. Perhaps the most interesting observation of the hotel proprietor was that the tourists wanted to see Perry Mason and Wyatt Earp. They did not want to see Raymond Burr and Hugh O'Brian. The old movie-fan tourists had wanted to see their favorites as they were in *real* life, not as they were in their film roles. The fans of the cool TV medium want to see their star in *role*, whereas the movie fans want the *real thing*.

A similar reversal of attitudes occurred with the printed book. There was little interest in the private lives of authors under manuscript or scribal

culture. Today the comic strip is close to the preprint woodcut and manuscript form of expression. Walt Kelly's *Pogo* looks very much indeed like a gothic page. Yet in spite of great public interest in the comic-strip form, there is as little curiosity about the private lives of these artists as about the lives of popular-song writers. With print, the private life became of the utmost concern to readers. Print is a hot medium. It projects the author at the public as the movie did. The manuscript is a cool medium that does not project the author, so much as involve the reader. So with TV. The viewer is involved and participant. The *role* of the TV star, in this way, seems more fascinating than his private life. It is thus that the student of media, like the psychiatrist, gets more data from his informants than they themselves have perceived. Everybody experiences far more than he understands. Yet it is experience, rather than understanding, that influences behavior, especially in collective matters of media and technology, where the individual is almost inevitably unaware of their effect upon him.

Some may find it paradoxical that a cool medium like TV should be so much more compressed and condensed than a hot medium like film. But it is well known that a half minute of television is equal to three minutes of stage or vaudeville. The same is true of manuscript in contrast to print. The "cool" manuscript tended toward compressed forms of statement, aphoristic and allegorical. The "hot" print medium expanded expression in the direction of simplification and the "spelling-out" of meanings. Print speeded up and "exploded" the compressed script into simpler fragments.

A cool medium, whether the spoken word or the manuscript or TV, leaves much more for the listener or user to do than a hot medium. If the medium is of high definition, participation is low. If the medium is of low intensity, the participation is high. Perhaps this is why lovers mumble so.

Because the low definition of TV insures a high degree of audience involvement, the most effective programs are those that present situations which consist of some process to be completed. Thus, to use TV to teach poetry would permit the teacher to concentrate on the poetic process of actual *making*, as it pertained to a particular poem. The book form is quite unsuited to this type of involved presentation. The same salience of process of do-it-yourself-ness and depth involvement in the TV image extends to the art of the TV actor. Under TV conditions, he must be alert to improvise and to embellish every phrase and verbal resonance with details of gesture and posture, sustaining that intimacy with the viewer which is not possible on the massive movie screen or on the stage.

There is the alleged remark of the Nigerian who, after seeing a TV western, said delightedly, "I did not realize you valued human life so little in the West." Offsetting this remark is the behavior of our children in watching TV westerns. When equipped with the new experimental head-cameras that follow their eye movements while watching the image, children keep their eyes on the faces of the TV actors. Even during physical violence their eyes remain concentrated on the facial *reactions*, rather than on the eruptive *action*.

Guns, knives, fists, all are ignored in preference for the facial expression. TV is not so much an action, as a re-action, medium.

The yen of the TV medium for themes of process and complex reactions has enabled the documentary type of film to come to the fore. The movie *can* handle process superbly, but the movie viewer is more disposed to be a passive consumer of actions, rather than a participant in reactions. The movie western, like the movie documentary, has always been a lowly form. With TV, the western acquired new importance, since its theme is always: "Let's make a town." The audience participates in the shaping and processing of a community from meager and unpromising components. Moreover, the TV image takes kindly to the varied and rough textures of Western saddles, clothes, hides, and shoddy match-wood bars and hotel lobbies. The movie camera, by contrast, is at home in the slick chrome world of the nightclub and the luxury spots of a metropolis. Moreover, the contrasting camera preferences of the movies in the Twenties and Thirties, and of TV in the Fifties and Sixties, spread to the entire population. In ten years the new tastes of America in clothes, in food, in housing, in entertainment, and in vehicles express the new pattern of interrelation of forms and do-it-yourself involvement fostered by the TV image.

It is no accident that such major movie stars as Rita Hayworth, Liz Taylor, and Marilyn Monroe ran into troubled waters in the new TV age. They ran into an age that questions all the "hot" media values of the pre-TV consumer days. The TV image challenges the values of fame as much as the values of consumer goods. "Fame to me," said Marilyn Monroe, "certainly is only a temporary and a partial happiness. Fame is not really for a daily diet, that's not what fulfills you. . . . I think that when you are famous every weakness is exaggerated. This industry should behave to its stars like a mother whose child has just run out in front of a car. But instead of clasping the child to them they start punishing the child."

The movie community is now getting clobbered by TV, and lashes out at anybody in its bewildered petulance. These words of the great movie puppet who wed Mr. Baseball and Mr. Broadway are surely a portent. If many of the rich and successful figures in America were to question publicly the absolute value of money and success as means to happiness and human welfare, they would offer no more shattering a precedent than Marilyn Monroe. For nearly fifty years, Hollywood had offered "the fallen woman" a way to the top and a way to the hearts of all. Suddenly the love-goddess emits a horrible cry, screams that eating people is wrong, and utters denunciations of the whole way of life. This is exactly the mood of the suburban beatniks. They reject a fragmented and specialist consumer life for anything that offers humble involvement and deep commitment. It is the same mood that recently turned girls from specialist careers to early marriage and big families. They switch from jobs to roles.

The same new preference for depth participation has also prompted in the young a strong drive toward religious experience with rich liturgical

overtones. The liturgical revival of the radio and TV age affects even the most austere Protestant sects. Choral chant and rich vestments have appeared in every quarter. The ecumenical movement is synonymous with electric technology.

Just as TV, the mosaic mesh, does not foster perspective in art, it does not foster lineality in living. Since TV, the assembly line has disappeared from industry. Staff and line structures have dissolved in management. Gone are the stag line, the party line, the receiving line, and the pencil line from the backs of nylons.

With TV came the end of bloc voting in politics, a form of specialism and fragmentation that won't work since TV. Instead of the voting bloc, we have the icon, the inclusive image. Instead of a political viewpoint or platform, the inclusive political posture or stance. Instead of the product, the process. In periods of new and rapid growth there is a blurring of outlines. In the TV image we have the supremacy of the blurred outline, itself the maximal incentive to growth and new "closure" or completion, especially for a consumer culture long related to the sharp visual values that had become separated from the other senses. So great is the change in American lives, resulting from the loss of loyalty to the consumer package in entertainment and commerce, that every enterprise, from Madison Avenue and General Motors to Hollywood and General Foods, has been shaken thoroughly and forced to seek new strategies of action. What electric implosion or contraction has done inter-personally and inter-nationally, the TV image does intra-personally or intra-sensuously.

It is not hard to explain this sensuous revolution to painters and sculptors, for they have been striving, ever since Cézanne abandoned perspective illusion in favor of structure in painting, to bring about the very change that TV has now effected on a fantastic scale. TV is the Bauhaus program of design and living, or the Montessori educational strategy, given total technological extension and commercial sponsorship. The aggressive lunge of artistic strategy for the remaking of Western man has, *via* TV, become a vulgar sprawl and an overwhelming splurge in American life.

It would be impossible to exaggerate the degree to which this image has disposed America to European modes of sense and sensibility. America is now Europeanizing as furiously as Europe is Americanizing. Europe, during the Second War, developed much of the industrial technology needed for its first mass consumer phase. It was, on the other hand, the First War that had readied America for the same consumer "take-off." It took the electronic *implosion* to dissolve the nationalist diversity of a splintered Europe, and to do for it what the industrial *explosion* had done for America. The industrial explosion that accompanies the fragmenting expansion of literacy and industry was able to exert little unifying effect in the European world with its numerous tongues and cultures. The Napoleonic thrust had utilized the combined force of the new literacy and early industrialism. But Napoleon had had a less homogenized set of materials to work with than even the

Russians have today. The homogenizing power of the literate process had gone further in America by 1800 than anywhere in Europe. From the first, America took to heart the print technology for its educational, industrial, and political life; and it was rewarded by an unprecedented pool of standardized workers and consumers, such as no culture had ever had before. That our cultural historians have been oblivious of the homogenizing power of typography, and of the irresistible strength of homogenized populations, is no credit to them. Political scientists have been quite unaware of the effects of media anywhere at any time, simply because nobody has been willing to study the personal and social effects of media apart from their "content."

America long ago achieved its Common Market by mechanical and literate homogenization of social organization. Europe is now getting a unity under the electric auspices of compression and interrelation. Just how much homogenization via literacy is needed to make an effective producer-consumer group in the postmechanical age, in the age of automation, nobody has ever asked. For it has never been fully recognized that the role of literacy in shaping an industrial economy is basic and archetypal. Literacy is indispensable for habits of uniformity at all times and places. Above all, it is needed for the workability of price systems and markets. This factor has been ignored exactly as TV is now being ignored, for TV fosters many preferences that are quite at variance with literate uniformity and repeatability. It has sent Americans questing for every sort of oddment and quaintness in objects from out of their storied past. Many Americans will now spare no pains or expense to get to taste some new wine or food. The uniform and repeatable now must yield to the uniquely askew, a fact that is increasingly the despair and confusion of our entire standardized economy.

The power of the TV mosaic to transform American innocence into depth sophistication, independently of "content," is not mysterious if looked at directly. This mosaic TV image had already been adumbrated in the popular press that grew up with the telegraph. The commercial use of the telegraph began in 1844 in America, and earlier in England. The electric principle and its implications received much attention in Shelley's poetry. Artistic rule-of-thumb usually anticipates the science and technology in these matters by a full generation or more. The meaning of the telegraph mosaic in its *journalistic* manifestations was not lost to the mind of Edgar Allan Poe. He used it to establish two startlingly new inventions, the symbolist poem and the detective story. Both of these forms require do-it-yourself participation on the part of the reader. By offering an incomplete image or process, Poe *involved* his readers in the creative process in a way that Baudelaire, Valéry, T. S. Eliot, and many others have admired and followed. Poe had grasped at once the electric dynamic as one of public participation in creativity. Nevertheless, even today the homogenized consumer complains when asked to participate in creating or completing an abstract poem or painting or structure of any kind. Yet Poe knew even then that participation

in depth followed at once from the telegraph mosaic. The more lineal and literal-minded of the literary brahmins "just couldn't see it." They still can't see it. They prefer not to participate in the creative process. They have accommodated themselves to the completed package, in prose and verse and in the plastic arts. It is these people who must confront, in every classroom in the land, students who have accommodated themselves to the tactile and nonpictorial modes of symbolist and mythic structures, thanks to the TV image.

Life magazine for August 10, 1962, had a feature on how "Too Many Subteens Grow Up Too Soon and Too Fast." There was no observation of the fact that similar speed of growth and precociousness have always been the normal in tribal cultures and in nonliterate societies. England and America fostered the institution of prolonged adolescence by the negation of the tactile participation that is sex. In this, there was no conscious strategy, but rather a general acceptance of the consequences of prime stress on the printed word and visual values as a means of organizing personal and social life. This stress led to triumphs of industrial production and political conformity that were their own sufficient warrant.

Respectability, or the ability to sustain visual inspection of one's life, became dominant. No European country allowed print such precedence. Visually, Europe has always been shoddy in American eyes. American women, on the other hand, who have never been equaled in any culture for visual turnout, have always seemed abstract, mechanical dolls to Europeans. Tactility is a supreme value in European life. For that reason, on the Continent there is no adolescence, but only the leap from childhood to adult ways. Such is now the American state since TV, and this state of evasion of adolescence will continue. The introspective life of long, long thoughts and distant goals, to be pursued in lines of Siberian railroad kind, cannot coexist with the mosaic form of the TV image that commands immediate participation in *depth* and admits of no delays. The mandates of that image are so various yet so consistent that even to mention them is to describe the revolution of the past decade.

The phenomenon of the paperback, the book in "cool" version, can head this list of TV mandates, because the TV transformation of book culture into something else is manifested at that point. Europeans have had paperbacks from the first. From the beginnings of the automobile, they have preferred the wraparound space of the small car. The pictorial value of "enclosed space" for book, car, or house has never appealed to them. The paperback, especially in its highbrow form, was tried in America in the 1920s and thirties and forties. It was not, however, until 1953 that it suddenly became acceptable. No publisher really knows why. Not only is the paperback a tactile, rather than a visual, package; it can be as readily concerned with profound matters as with froth. The American since TV has lost his inhibitions and his innocence about depth culture. The paperback reader has discovered that he can enjoy Aristotle or Confucius by simply slowing down. The old literate habit of racing ahead on

uniform lines of print yielded suddenly to depth reading. Reading in depth is, of course, not proper to the printed word as such. Depth probing of words and language is a normal feature of oral and manuscript cultures, rather than of print. Europeans have always felt that the English and Americans lacked depth in their culture. Since radio, and especially since TV, English and American literary critics have exceeded the performance of any European in depth and subtlety. The beatnik reaching out for Zen is only carrying the mandate of the TV mosaic out into the world of words and perception. The paperback itself has become a vast mosaic world in depth, expressive of the changed sense-life of Americans, for whom depth experience in words, as in physics, has become entirely acceptable, and even sought after.

Just where to begin to examine the transformation of American attitudes since TV is a most arbitrary affair, as can be seen in a change so great as the abrupt decline of baseball. The removal of the Brooklyn Dodgers to Los Angeles was a portent in itself. Baseball moved West in an attempt to retain an audience after TV struck. The characteristic mode of the baseball game is that it features one-thing-at-a-time. It is a lineal, expansive game which, like golf, is perfectly adapted to the outlook of an individualist and inner-directed society. Timing and waiting are of the essence, with the entire field in suspense waiting upon the performance of a single player. By contrast, football, basketball, and ice hockey are games in which many events occur simultaneously, with the entire team involved at the same time. With the advent of TV, such isolation of the individual performance as occurs in baseball became unacceptable. Interest in baseball declined, and its stars, quite as much as movie stars, found that fame had some very cramping dimensions. Baseball had been, like the movies, a hot medium featuring individual virtuosity and stellar performers. The real ball fan is a store of statistical information about previous explosions of batters and pitchers in numerous games. Nothing could indicate more clearly the peculiar satisfaction provided by a game that belonged to the industrial metropolis of ceaselessly exploding populations, stocks and bonds, and production and sales records. Baseball belonged to the age of the first onset of the hot press and the movie medium. It will always remain a symbol of the era of the hot mommas, jazz babies, of sheiks and shebas, of vamps and gold-diggers and the fast buck. Baseball, in a word, is a hot game that got cooled off in the new TV climate, as did most of the hot politicians and hot issues of the earlier decade.

There is no cooler medium or hotter issue at present than the small car. It is like a badly wired woofer in a hi-fi circuit that produces a tremendous flutter in the bottom. The small European car, like the European paperback and the European belle, for that matter, was no visual package job. Visually, the entire batch of European cars are so poor an affair that it is obvious their makers never thought of them as something to look at. They are something to put on, like pants or a pullover. Theirs is the kind of space sought by the skin-diver, the water-skier, and the dinghy sailor. In an immediate tactile

sense, this new space is akin to that to which the picture-window fad had catered. In terms of "view," the picture window never made any sense. In terms of an attempt to discover a new dimension in the out-of-doors by pretending to be a goldfish, the picture window does make sense. So do the frantic efforts to roughen up the indoor walls and textures as if they were the outside of the house. Exactly the same impulse sends the indoor spaces and furniture out into the patios in an attempt to experience the outside as inside. The TV viewer is in just that role at all times. He is submarine. He is bombarded by atoms that reveal the outside as inside in an endless adventure amidst blurred images and mysterious contours.

However, the American car has been fashioned in accordance with the *visual* mandates of the typographic and the movie images. The American car was an enclosed space, not a tactile space. And an enclosed space, as was shown in the chapter on Print, is one in which all spatial qualities have been reduced to visual terms. So in the American car, as the French observed decades ago, "one is not on the road, one is in the car." By contrast, the European car aims to drag you along the road and to provide a great deal of vibration for the bottom. Brigitte Bardot got into the news when it was discovered that she liked to drive barefoot in order to get the maximal vibration. Even English cars, weak on visual appearance as they are, have been guilty of advertising that "at sixty miles an hour all you can hear is the ticking of the clock." That would be a very poor ad, indeed, for a TV generation that has to be *with* everything and has to *dig* things in order to get at them. So avid is the TV viewer for rich tactile effects that he could be counted on to revert to skis. The wheel, so far as he is concerned, lacks the requisite abrasiveness.

Clothes in this first TV decade repeat the same story as vehicles. The revolution was heralded by bobby-soxers who dumped the whole cargo of visual effects for a set of tactile ones so extreme as to create a dead level of flat-footed deadpanism. Part of the cool dimension of TV is the cool, deadpan mug that came in with the teenager. Adolescence, in the age of hot media, of radio and movie, and of the ancient book, had been a time of fresh, eager, and expressive countenances. No elder statesman or senior executive of the 1940s would have ventured to wear so dead and sculptural a pan as the child of the TV age. The dances that came in with TV were to match— all the way to the Twist, which is merely a form of very unanimated dialogue, the gestures and grimaces of which indicate involvement in depth, but "nothing to say."

Clothing and styling in the past decade have gone so tactile and sculptural that they present a sort of exaggerated evidence of the new qualities of the TV mosaic. The TV extension of our nerves in hirsute pattern possesses the power to evoke a flood of related imagery in clothing, hairdo, walk, and gesture.

All this adds up to the compressional implosion—the return to nonspecialized forms of clothes and spaces, the seeking of multi-uses for rooms and things and objects, in a single word—the iconic. In music and poetry and

painting, the tactile implosion means the insistence on qualities that are close to casual speech. Thus Schönberg and Stravinsky and Carl Orff and Bartok, far from being advanced seekers of esoteric effects, seem now to have brought music very close to the condition of ordinary human speech. It is this colloquial rhythm that once seemed so unmelodious about their work. Anyone who listens to the medieval works of Perotinus or Dufay will find them very close to Stravinsky and Bartok. The great explosion of the Renaissance that split musical instruments off from song and speech and gave them specialist functions is now being played backward in our age of electronic implosion.

One of the most vivid examples of the tactile quality of the TV image occurs in medical experience. In closed-circuit instruction in surgery, medical students from the first reported a strange effect—that they seemed not to be watching an operation, but performing it. They felt that they were holding the scalpel. Thus the TV image, in fostering a passion for depth involvement in every aspect of experience, creates an obsession with bodily welfare. The sudden emergence of the TV medico and the hospital ward as a program to rival the western is perfectly natural. It would be possible to list a dozen untried kinds of programs that would prove immediately popular for the same reasons. Tom Dooley and his epic of Medicare for the backward society was a natural outgrowth of the first TV decade.

Now that we have considered the subliminal force of the TV image in a redundant scattering of samples, the question would seem to arise: "What possible *immunity* can there be from the subliminal operation of a new medium like television?" People have long supposed that bulldog opacity, backed by firm disapproval, is adequate enough protection against any new experience. It is the theme of this book that not even the most lucid understanding of the peculiar force of a medium can head off the ordinary "closure" of the senses that causes us to conform to the pattern of experience presented. The utmost purity of mind is no defense against bacteria, though the confreres of Louis Pasteur tossed him out of the medical profession for his base allegations about the invisible operation of bacteria. To resist TV, therefore, one must acquire the antidote of related media like print.

It is an especially touchy area that presents itself with the question: "What has been the effect of TV on our political life?" Here, at least, great traditions of critical awareness and vigilance testify to the safeguards we have posted against the dastardly uses of power.

When Theodore White's *The Making of the President: 1960* is opened at the section on "The Television Debates," the TV student will experience dismay. White offers statistics on the number of sets in American homes and the number of hours of daily use of these sets, but not one clue as to the nature of the TV image or its effects on candidates or viewers. White considers the "content" of the debates and the deportment of the debaters, but it never occurs to him to ask why TV would inevitably be a disaster for a

sharp intense image like Nixon's, and a boon for the blurry, shaggy texture of Kennedy.

At the end of the debates, Philip Deane of the London *Observer* explained my idea of the coming TV impact on the election to the *Toronto Globe and Mail* under the headline of "The Sheriff and the Lawyer," October 15, 1960. It was that TV would prove so entirely in Kennedy's favor that he would win the election. Without TV, Nixon had it made. Deane, toward the end of his article, wrote

> Now the press has tended to say that Mr. Nixon has been gaining in the last two debates and that he was bad in the first. Professor McLuhan thinks that Mr. Nixon has been sounding progressively more definite; regardless of the value of the Vice-President's views and principles, he has been defending them with too much flourish for the TV medium. Mr. Kennedy's rather sharp responses have been a mistake, but he still presents an image closer to the TV hero, Professor McLuhan says—something like the shy young Sheriff—while Mr. Nixon with his very dark eyes that tend to stare, with his slicker circumlocution, has resembled more the railway lawyer who signs leases that are not in the interests of the folks in the little town.
>
> In fact, by counterattacking and by claiming for himself, as he does in the TV debates, the same goals as the Democrats have, Mr. Nixon may be helping his opponent by blurring the Kennedy image, by confusing what exactly it is that Mr. Kennedy wants to change.
>
> Mr. Kennedy is thus not handicapped by clear-cut issues; he is visually a less well-defined image, and appears more nonchalant. He seems less anxious to sell himself than does Mr. Nixon. So far, then, Professor McLuhan gives Mr. Kennedy the lead without underestimating Mr. Nixon's formidable appeal to the vast conservative forces of the United States.

Another way of explaining the acceptable, as opposed to the unacceptable, TV personality is to say that anybody whose *appearance* strongly declares his role and status in life is wrong for TV. Anybody who looks as if he might be a teacher, a doctor, a businessman, or any of a dozen other things all at the same time is right for TV. When the person presented *looks* classifiable, as Nixon did, the TV viewer has nothing to fill in. He feels uncomfortable with his TV image. He says uneasily, "There's something about the guy that isn't right." The viewer feels exactly the same about an exceedingly pretty girl on TV, or about any of the intense "high definition" images and messages from the sponsors. It is not accidental that advertising has become a vast new source of comic effects since the advent of TV. Mr. Khrushchev is a very filled-in or completed image that appears on TV as a comic cartoon. In wirephoto and on TV, Mr. Khrushchev is a jovial comic, an entirely disarming presence. Likewise, precisely the formula that recommends anybody for a movie role disqualifies the same person for TV acceptance. For the hot movie medium needs people who look very definitely a *type* of some kind.

The cool TV medium cannot abide the typical because it leaves the viewer frustrated of his job of "closure" or completion of image. President Kennedy did not look like a rich man or like a politician. He could have been anything from a grocer or a professor to a football coach. He was not too precise or too ready of speech in such a way as to spoil his pleasantly tweedy blur of countenance and outline. He went from palace to log cabin, from wealth to the White House, in a pattern of TV reversal and upset.

The same components will be found in any popular TV figure. Ed Sullivan, "the great stone face," as he was known from the first, has the much needed harshness of texture and general sculptural quality demanded for serious regard on TV. Jack Paar is quite otherwise—neither shaggy nor sculptural. But on the other hand, his presence is entirely acceptable on TV because of his utterly cool and casual verbal agility. The Jack Paar show revealed the inherent need of TV for spontaneous chat and dialogue. Jack discovered how to extend the TV mosaic image into the entire format of his show, seemingly snaffling up just anybody from anywhere at the drop of a hat. In fact, however, he understood very well how to create a mosaic from other media, from the world of journalism and politics, books, Broadway, and the arts in general, until he became a formidable rival to the press mosaic itself. As Amos and Andy had lowered church attendance on Sunday evenings in the old days of radio, so Jack Paar certainly cut night-club patronage with his late show.

How about Educational Television? When the three-year-old sits watching the President's press conference with Dad and Gradad, that illustrates the serious educational role of TV. If we ask what is the relation of TV to the learning process, the answer is surely that the TV image, by its stress on participation, dialogue, and depth, has brought to America new demand for crash-programming in education. Whether there ever will be TV in every classroom is a small matter. The revolution has already taken place at home. TV has changed our sense-lives and our mental processes. It has created a taste for all experience *in depth* that affects language teaching as much as car styles. Since TV, nobody is happy with a mere book knowledge of French or English poetry. The unanimous cry now is, "Let's *talk* French," and "Let the bard be *heard*." And oddly enough, with the demand for depth, goes the demand for crash-programming. Not only deeper, but further, into all knowledge has become the normal popular demand since TV. Perhaps enough has been said about the nature of the TV image to explain why this should be. How could it possibly pervade our lives any more than it does? Mere classroom use could not extend its influence. Of course, in the classroom its role compels a reshuffling of subjects, and approaches to subjects. Merely to put the present classroom on TV would be like putting movies on TV. The result would be a hybrid that is neither. The right approach is to ask, "What can TV do that the classroom cannot do for French, or for physics?" The answer is: "TV can illustrate the interplay of process and the growth of forms of all kinds as nothing else can."

The other side of the story concerns the fact that, in the visually organized educational and social world, the TV child is an underprivileged cripple. An oblique indication of this startling reversal has been given by William Golding's *Lord of the Flies.* On the one hand, it is very flattering for hordes of docile children to be told that, once out of the sight of their governesses, the seething savage passions within them would boil over and sweep away pram and playpen, alike. On the other hand, Mr. Golding's little pastoral parable does have some meaning in terms of the psychic changes in the TV child. This matter is so important for any future strategy of culture or politics that it demands a headline prominence, and capsulated summary:

WHY THE TV CHILD CANNOT SEE AHEAD

The plunge into depth experience via the TV image can only be explained in terms of the differences between visual and mosaic space. Ability to discriminate between these radically different forms is quite rare in our Western world. It has been pointed out that, in the country of the blind, the one-eyed man is not king. He is taken to be an hallucinated lunatic. In a highly visual culture, it is as difficult to communicate the nonvisual properties of spatial forms as to explain visuality to the blind. In *The ABC of Relativity* Bertrand Russell began by explaining that there is nothing difficult about Einstein's ideas, but that they do call for total reorganization of our imaginative lives. It is precisely this imaginative reorganization that has occurred via the TV image.

The ordinary inability to discriminate between the photographic and the TV image is not merely a crippling factor in the learning process today; it is symptomatic of an age-old failure in Western culture. The literate man, accustomed to an environment in which the visual sense is extended everywhere as a principle of organization, sometimes supposes that the mosaic world of primitive art, or even the world of Byzantine art, represents a mere difference in degree, a sort of failure to bring their visual portrayals up to the level of full visual effectiveness. Nothing could be further from the truth. This, in fact, is a misconception that has impaired understanding between East and West for many centuries. Today it impairs relations between colored and white societies.

Most technology produces an amplification that is quite explicit in its separation of the senses. Radio is an extension of the aural, high-fidelity photography of the visual. But TV is, above all, an extension of the sense of touch, which involves maximal interplay of all the senses. For Western man, however, the all-embracing extension had occurred by means of phonetic writing, which is a technology for extending the sense of sight. All nonphonetic forms of writing are, by contrast, artistic modes that retain much variety of sensuous orchestration. Phonetic writing, alone, has the power of

separating and fragmenting the senses and of sloughing off the semantic complexities. The TV image reverses this literate process of analytic fragmentation of sensory life.

The visual stress on continuity, uniformity, and connectedness, as it derives from literacy, confronts us with the great technological means of implementing continuity and lineality by fragmented repetition. The ancient world found this means in the brick, whether for wall or road. The repetitive, uniform brick, indispensable agent of road and wall, of cities and empires, is an extension, via letters, of the visual sense. *The brick wall is not a mosaic form,* and neither is the mosaic form a visual structure. The mosaic can be *seen* as dancing can, but is not *structured* visually; nor is it an extension of the visual power. For the mosaic is not uniform, continuous, or repetitive. It is discontinuous, skew, and nonlineal, like the tactual TV image. To the sense of touch, all things are sudden, counter, original, spare, strange. The "Pied Beauty" of G. M. Hopkins is a catalogue of the notes of the sense of touch. The poem is a manifesto of the nonvisual, and like Cézanne or Seurat or Rouault, it provides an indispensable approach to understanding TV. The nonvisual mosaic structures of modern art, like those of modern physics and electric-information patterns, permit little detachment. The mosaic form of the TV demands participation and involvement in depth of the whole being, as does the sense of touch. Literacy, in contrast, had, by extending the visual power to the uniform organization of time and space, psychically and socially, conferred the power of detachment and noninvolvement.

The visual sense when extended by phonetic literacy fosters the analytic habit of perceiving the single facet in the life of forms. The visual power enables us to isolate the single incident in time and space, as in representational art. In visual representation of a person or an object, a single phase or moment or aspect is separated from the multitude of known and felt phases, moments and aspects of the person or object. By contrast, iconographic art uses the eye as we use our hand in seeking to create an inclusive image, made up of many moments, phases, and aspects of the person or thing. Thus the iconic mode is not visual representation, nor the specialization of visual stress as defined by viewing from a single position. The tactual mode of perceiving is sudden but not specialist. It is total, synesthetic, involving all the senses. Pervaded by the mosaic TV image, the TV child encounters the world in a spirit antithetic to literacy.

The TV image, that is to say, even more than the icon, is an extension of the sense of touch. Where it encounters a literate culture, it necessarily thickens the sense-mix, transforming fragmented and specialist extensions into a seamless web of experience. Such transformation is, of course, a "disaster" for a literate, specialist culture. It blurs many cherished attitudes and procedures. It dims the efficacy of the basic pedagogic techniques, and the relevance of the curriculum. If for no other reason, it would be well to understand the

dynamic life of these forms as they intrude upon us and upon one another. TV makes for myopia.

The young people who have experienced a decade of TV have naturally imbibed an urge toward involvement in depth that makes all the remote visualized goals of usual culture seem not only unreal but irrelevant, and not only irrelevant but anemic. It is the total involvement in all-inclusive *nowness* that occurs in young lives via TV's mosaic image. This change of attitude has nothing to do with programming in any way, and would be the same if the programs consisted entirely of the highest cultural content. The change in attitude by means of relating themselves to the mosaic TV image would occur in any event. It is, of course, our job not only to understand this change but to exploit it for its pedagogical richness. The TV child expects involvement and doesn't want a specialist *job* in the future. He does want a *role* and a deep commitment to his society. Unbridled and misunderstood, this richly human need can manifest itself in the distorted forms portrayed in *West Side Story*.

The TV child cannot see ahead because he wants involvement, and he cannot accept a fragmentary and merely visual goal or destiny in learning or in life.

MURDER BY TELEVISION

Jack Ruby shot Lee Oswald while tightly surrounded by guards who were paralyzed by television cameras. The fascinating and involving power of television scarcely needed this additional proof of its peculiar operation upon human perceptions. The Kennedy assassination gave people an immediate sense of the television power to create depth involvement, on the one hand, and a numbing effect as deep as grief, itself, on the other hand. Most people were amazed at the depth of meaning which the event communicated to them. Many more were surprised by the coolness and calm of the mass reaction. The same event, handled by press or radio (in the absence of television), would have provided a totally different experience. The national "lid" would have "blown off." Excitement would have been enormously greater and depth participation in a common awareness very much less.

As explained earlier, Kennedy was an excellent TV image. He had used the medium with the same effectiveness that Roosevelt had learned to achieve by radio. With TV, Kennedy found it natural to involve the nation in the office of the Presidency, both as an operation and as an image. TV reaches out for the corporate attributes of office. Potentially, it can transform the Presidency into a monarchic dynasty. A merely elective Presidency scarcely affords the depth of dedication and commitment demanded by the TV form. Even teachers on TV seem to be endowed by the student audiences with a

charismatic or mystic character that much exceeds the feelings developed in the classroom or lecture hall. In the course of many studies of audience reactions to TV teaching, there recurs this puzzling fact. The viewers feel that the teacher has a dimension almost of sacredness. This feeling does not have its basis in concepts or ideas, but seems to creep in uninvited and unexplained. It baffles both the students and the analysts of their reactions. Surely, there could be no more telling touch to tip us off to the character of TV. This is not so much a visual as a tactual-auditory medium that involves all of our senses in depth interplay. For people long accustomed to the merely visual experience of the typographic and photographic varieties, it would seem to be the *synesthesia*, or tactual depth of TV experience, that dislocates them from their usual attitudes of passivity and detachment.

The banal and ritual remark of the conventionally literate, that TV presents an experience for passive viewers, is wide of the mark. TV is above all a medium that demands a creatively participant response. The guards who failed to protect Lee Oswald were not passive. They were so involved by the mere sight of the TV cameras that they lost their sense of their merely practical and specialist task.

Perhaps it was the Kennedy funeral that most strongly impressed the audience with the power of TV to invest an occasion with the character of corporate participation. No national event except in sports has ever had such coverage or such an audience. It revealed the unrivaled power of TV to achieve the involvement of the audience in a complex *process*. The funeral as a corporate process caused even the image of sport to pale and dwindle into puny proportions. The Kennedy funeral, in short, manifested the power of TV to involve an entire population in a ritual process. By comparison, press, movie, and even radio are mere packaging devices for consumers.

Most of all, the Kennedy event provides an opportunity for noting a paradoxical feature of the "cool" TV medium. It involves us in moving depth, but it does not excite, agitate or arouse. Presumably, this is a feature of all depth experience.

F O U R

Objectivity, Reduction, and Formalism

Frank Stella (American, b. 1936). *The Marriage of Reason and Squalor.* 1959.
Oil on canvas, 90 1/2 x 131 1/2 in. Collection Saint Louis Art Museum. Purchase
and funds given by Mr. and Mrs. Joseph Helman, Mr. and Mrs. Ronald K. Greenberg.
© 2000 Frank Stella/Artists Rights Society (ARS), New York.

Artists

Frank Stella
Excerpts from Painters Painting (1970)

At the same time as Pop artists were challenging the authority of the process-orientated introspective work of the Abstract Expressionists with slick renderings of the images of mass culture, other artists were challenging Abstract Expressionism by developing further possibilities within the language of abstraction. In the late 1950s the artist Frank Stella was trying to find a way to push the implications of the work of Pollock and de Kooning beyond their reliance on the expressive gesture and into paintings that exhibited a rigorously controlled literalness. The first of these works were Stella's now-famous "black paintings," done in 1959. By using pattern and repetition, and by denying the painterly touch, Stella forced the viewer to read these paintings in objective terms. The "black paintings" that were included in the exhibition *Sixteen Americans* at the Museum of Modern Art are an early example of the style that later came to be called Minimalism.

By the early 1960s Stella was using shaped canvases to further emphasize the objective presence of his work. Although Stella's geometric "objects" seemed a far cry from Pop art, they were similar in the sense that they employed a cleanly delineated, almost mechanical application of the paint. This precluded the possibility of reading the paintings in relation to the personality of the artist. But whereas Pop art was legitimized through its embrace of the dynamic transformations that the material images of mass culture were bringing to American consciousness, Stella's art was legitimized in relation to the formal issues defined within the art establishment. Some critics were turned off to the cool, intellectual approach of Stella's work. For others, Stella had pushed the fundamental issue of objectivity in abstract painting to its logical conclusion. In 1970, at the age of thirty-three, Stella had a major retrospective at the Museum of Modern Art. These statements are from the transcript of the 1970 film *Painters Painting* by Emile De Antonio, which was published in a book by the same name in 1984.

I knew enough about early de Kooning and some of Gorky. You could see that they were worried about Picasso and Matisse in some way, particularly Cubism. But the thing about Picasso being such a big figure was something that I just sort of passed around. That was their problem, Gorky's problem and de Kooning's, a whole complicated identity situation and struggle, and I passed by that, I suppose, largely owing to the example of Pollock.

Both Pollock and Hofmann seemed to me to have solved the problem, at least they solved it in a sense for me. They came to terms in some concrete and accomplished way with what had happened with twentieth-century

modernism in European painting. They established American painting as a kind of real thing for me, as something I had confidence in, something I didn't have to go all the way back and worry again about where I stood in relation to Matisse and Picasso. I could worry about where I stood in relation to Hofmann and Pollock. That seemed to me like more than enough of a struggle. That seemed to me almost as difficult to overcome—and it still seems that way somehow today. They were both strong and monumental enough to represent that kind of example, that kind of level of accomplishment and seriousness.

Having some idea of what painting is about in general doesn't bear much relation to what you actually do and the way you actually think and look at things when you're trying to make paintings yourself. And so while I had a lot of slightly abstract and theoretical ideas about Pollock, which were expressed in the things I wrote, Pollock wasn't exactly the kind of thing that influenced my painting at the time, except in a general way. In other words, I was actually more influenced by what was in the magazines and around and talked about at the time: people like the second generation, like Al Leslie and Grace Hartigan and Mike Goldberg and Helen Frankenthaler. They were the ones that were most active, were getting the most publicity in general, or were the most known at the time. Those were the people I was most influenced by. Motherwell also was active and well known. Barnett Newman was probably just as active as any of those people at the time, but for some reason he just wasn't in the forefront.

Basically the Action Painters and particularly the second-generation Action Painters adopted an attitude toward painting that was based on an idea of allover attack. But they were inconsistent. They didn't really carry it out. In other words, it seemed to me that they were in a slightly compromised or slightly academic situation. They would start out with an attack, which in one way they couldn't sustain, and then they fell back on more conventional ways of paint manipulation and particularly special divisions to make the painting work. It was supposed to be an allover painting, but it ended up working with too much conventional push-pull of value-modeled space, where you have basically too many depth situations with one thing in front of or behind another.

The other big thing as far as I was concerned was that they all seemed to get in trouble in the corners. They started out with a big, expansive gesture, and then they ended up fiddling around or trying to make that one explosive gesture work on the canvas in some way. It seemed finally compromised by all the fixing up that went around the supposedly loose and free, explosive images.

If I criticize that or criticize the basic romance of Abstract Expressionism, the idea of alloverness and explosive energy and all the things that were supposed to be in it but weren't necessarily always there, it's a little misleading. I wanted to be able to have what I think were some of the virtues of Abstract Expressionism but still have them under control. It's partly involved with having pictorial strength and controlled identity as a painter, too. But I still wanted to have energy in the paintings.

The use of the regulated pattern in the whole question of flatness is slightly problematic. I mean, it's a relative question. What I felt at the time— and I don't feel this now—I felt very strongly that Morris Louis, for example, and Ken Noland and particularly Helen Frankenthaler, in their use of the stain- ing technique, there was identification with the facture and weave and all that, but it still seemed to me basically those stains read quite illusionistically. I felt I could make my paintings flat—and I wanted to make them flat—through the use of a kind of regulated pattern. The switch from the black enamel and softer bleed edge of the black paintings into the metallic paints and consequent shap- ing seized the surface more strongly than their paintings did and had a kind of aggressive flatness that I liked. It seemed to me to be right in that way. I'm not saying that they were better paintings, because that flatness doesn't assure quality, as Clem is always one to point out—and I certainly agree with him.

I got very involved with the black paintings with pattern. I began mak- ing little drawings and sketches, and in some of the sketches I got involved with patterns that travel; they would move and make a jog. They built up a kind of thing that Carl Andre later called a kind of force-field situation. It seemed to be a kind of generative pattern. It moved out, and it seemed to hold the surface in a nice way. I mean, I liked the way the pattern worked. I made a number of drawings, small drawings, and I was getting ready to build the stretchers and start the painting. I already had an idea of the kind of paint I wanted to use. I was interested in this metallic paint, particularly aluminum paint, and I was sure that that would be right in the sense that it was the kind of surface that I wanted, and I felt that this kind of pattern worked pretty well with this kind of surface. I'd have a real aggressive kind of controlling surface, something that would sort of seize the surface in a good way. I also felt, maybe in a slightly perverse way, that it would proba- bly also be fairly repellent. I liked the idea, thinking about flatness and depth, that these would be very hard paintings to penetrate. All of the action would be on the surface, and that metallic surface would be, in effect, kind of resistant. You couldn't penetrate it, both literally and, I suppose, visually. It would appear slightly reflective and slightly hard and metallic.

At this time [1960] I was talking to Darby Bannard down in Prince- ton—he was working at the Little Gallery—and showed him the drawings, and I just said, "You know, this seems pretty good. I mean, I really like this, but this part bothers me," and I showed him some corners, some little squares where the pattern ended in a small block. And I said, "I really don't like that. I don't like the way that anchors the corner in. It doesn't seem in the right kind of scale relationship. It just doesn't seem right."

He said, "Well, if you don't like it, why don't you take it away? Get rid of it?"

It was a kind of simpleminded thing, and I said, "You know, that's a good idea. I'll just take it out."

In the drawing it was very easy: I just erased a block in the corner, and I had this kind of slightly shaped or notched format. The more I looked at it, the more I liked it, and that's the way I built the stretchers and painted the series.

That was the beginning, at least for me, of shaping the outside edge. Once I started on that, once I started thinking about it, then it just sort of ran away with itself for a while. It led through the copper paintings. I guess maybe in some ways I turned back after the copper paintings.

The copper paintings [1961] cut the most space out of the rectangle, and they started to seem to me to raise a lot of problematic questions, one, about their being objects, and, two, about their being wall plaques or sculpture. It seemed to me they set a kind of limit or at least made me very aware of the limit of what you can do with shape. I made the decision then that I wanted my work to remain paintings and not get into relief or sculpture or that particular kind of literal object.

The idea of repetition appealed to me, and there were certain literary things that were in the air that corresponded to it. At the time I was going to school, for example, Samuel Beckett was very popular. Beckett is pretty lean, you might say, but he is also slightly repetitive to me in the sense that certain very simple situations in which not much happened are a lot like repetition. I don't know why it struck me that bands, repeated bands, would be somewhat more like a Beckett-like situation than, say, a big, blank canvas. You could say that might be equally Beckett-like, but it doesn't seem like that to me. There was something about Beckett that seemed kind of insistent about what little was there. It also seemed to fit me.

The whole thing about pattern, regulated pattern, was to keep the viewer from reading a painting. In other words, it had to do with an idea that seemed to me to be, if not new, at least somehow necessary to the time. It seemed to me that you had to have some kind of way of addressing yourself to the viewer which wasn't so much an invitation as it was a presentation. In other words, I made something and it was available for people to look at, but it wasn't an invitation for them to explore, and it wasn't an invitation to them to read a record of what I had done exactly. In fact, I think one of the things you could say about my paintings, which I think is probably a good thing, is that it's not immediately apparent how they're done. You can say finally it's brushed or it's sprayed or this, that, and the other, but the first thing you do is see it, I think, and not how it was done.

It's not a particular record of anything, and that may explain in some kind of way its unpopularity with the critics. I make it hard for the critics. There's not that much for them to describe. First of all, basically it's a simple situation visually, and the painting doesn't do that much in conventional terms. They can't explain how one part relates to another. There's nothing in descriptive terms for them to say or for them to point out that you, the viewer, might have missed if you were slightly untrained or not so used to

looking at paintings. That critical function is subverted. I don't think that's a big accomplishment, but I think that on the positive side, and this, again, becomes very subjective but has to do finally with both the value and the quality of the painting, if this presents a kind of visual experience to you that's really convincing, I think it can also be a moving experience. In other words, that apprehension-confrontation with the picture, that kind of visual impact, that kind of stamping out of an image, and that kind of sense of painted surface being really its own surface, I think, was a kind of attempt to give the painting a life of its own in relationship to the viewer. All good paintings have a life of their own, but this had its own kind of life. I hoped that it would be immediately apparent to the viewer (although it doesn't necessarily have to be). Maybe some people, and I think a lot of people, could miss it because you can go right by it: you can have just the impact and dismiss that impact and forget about it.

The business about my work being unfeeling and cold and intellectual, I can't quite explain it. The only explanation I can make is a biographical one. Certainly no one would see the black paintings now as cold and calculating or very logical, but they seemed to seem that way in the context of 1959 and 1960. They were lean compared with some paintings, but the general look of them, if you really looked, seemed to me to have an awful lot to do with somebody like Rothko in feeling—and no one accused Rothko of being cold and intellectual.

I don't want to say I suffered from it, but certainly my biography seemed to stick in the minds of these people, certain literary types: the fact that I went to Princeton and was supported by people who seemed to be at that time at the fringe of the art world—art historians. That little support that I got seemed to drive them to fairly hysterical positions. Hilton Kramer doesn't write much about the painting: he gives you a lot of "it's cold and intellectual" and says I went to Princeton. He is interested more in the sociology of my success than anything else.

I don't know how to get at it, and I'm not sure I want to say it . . . I guess I don't mind saying it: for critics who are not first-rate, there is a tremendous assumption of artistic humility, which I didn't seem to have: too much success and being too smug about it. There is no suffering. There is no feeling. There is no questioning. I just keep doing it, and I don't have troubled periods, I don't have crises and anxieties and all that that are documented on the canvas. Basically what they're after is that it's too easy for me, so, therefore, it couldn't be any good.

Actually Clem feels that way, too. He finds, only on a much more sophisticated level, when he looks at the paintings that they're too easy for him. He gets the idea too quickly, whereas the others get no idea at all.

I can't help it; again, this gets sort of personal and, I guess, gets to be vanity in a certain way, and it gets to be a kind of perceptual psychology problem: What is it that people remember about your paintings? What image do they carry with them? What kind of impact does it actually have

on them? I can only go by my own reaction—and, of course, I spend a lot more time with them—but there are certain things that do stay with me. I don't know how other painters remember their paintings, but I have two impressions of my own paintings. One has to do, I guess, with the conception of them, which is essentially diagrammatic: I suppose I have a diagrammatic file in my head of my paintings—but not all of them. But I also have a real impression of some of the paintings as paintings, as they were actually realized. I guess that it's hard to describe what the importance of that is, but it's very important for continuing the enterprise of being a painter, because I find that when that memory or that kind of memory or involvement fades, I get very discouraged about painting and continuing painting.

Donald Judd
Specific Objects (1965)

Donald Judd contributed to the dialog of American art both as an artist and critic. "Specific Objects," published in 1965 in *Arts Yearbook,* is an early critical document of the reductivist tendencies in the art of the 1960s. This essay is important for its claim that the representative art of this time is neither painting nor sculpture, but something in between. Judd also discusses the tendency of the best of recent painting to challenge conventional notions of format, space, and materials in a way that denies any notion of illusion, thereby making the painting read as a unified object.

For Judd, painting from earlier times had used the canvas as a surface on which marks were made that often did not refer in any way to the shape of the canvas; the very use of oil paint belied an assumption that format and materials should be neutral so as to make room for some kind of referential mark-making. By contrast, Judd argues that the power in works such as those being done by Frank Stella—in which format, application, and materials come together to create a "specific object"—is that "painting isn't an image. The shapes, unity, projection, order and color are specific, aggressive and powerful." It is no wonder that by the time Judd had his first exhibition at the Green Gallery in 1964 he had stopped painting and was working almost exclusively on cleanly delineated geometric forms that were either fastened to the wall or placed on the floor. Less than a year after the publication of this essay, Judd's work was featured in the spring 1966 exhibition *Primary Structures* at the Jewish Museum. Organized by Kynaston McShine, *Primary Structures* was the first major museum exhibition that helped define the Minimalist aesthetic.

Half or more of the best new work in the last few years has been neither painting nor sculpture. Usually it has been related, closely or distantly, to one or the other. The work is diverse, and much in it that is not in painting and sculpture is also diverse. But there are some things that occur nearly in common.

The new three-dimensional work doesn't constitute a movement, school or style. The common aspects are too general and too little common to define a movement. The differences are greater than the similarities. The similarities are selected from the work; they aren't a movement's first principles or delimiting rules. Three-dimensionality is not as near being simply a container as painting and sculpture have seemed to be, but it tends to that. But now painting and sculpture are less neutral, less containers, more defined, not undeniable and unavoidable. They are particular forms circumscribed after all, producing fairly definite qualities. Much of the motivation in the new work is to get clear of these forms. The use of three dimensions is an obvious alternative. It opens to anything. Many of the reasons for this use are negative, points against painting and sculpture, and since both are common sources, the negative reasons are those nearest commonage. "The motive to change is always some uneasiness: nothing setting us upon the change of state, or upon any new action, but some uneasiness." The positive reasons are more particular. Another reason for listing the insufficiencies of painting and sculpture first is that both are familiar and their elements and qualities more easily located.

The objections to painting and sculpture are going to sound more intolerant than they are. There are qualifications. The disinterest in painting and sculpture is a disinterest in doing it again, not in it as it is being done by those who developed the last advanced versions. New work always involves objections to the old, but these objections are really relevant only to the new. They are part of it. If the earlier work is first-rate it is complete. New inconsistencies and limitations aren't retroactive; they concern only work that is being developed. Obviously, three-dimensional work will not cleanly succeed painting and sculpture. It's not like a movement; anyway, movements no longer work; also, linear history has unraveled somewhat. The new work exceeds painting in plain power, but power isn't the only consideration, though the difference between it and expression can't be too great either. There are other ways than power and form in which one kind of art can be more or less than another. Finally, a flat and rectangular surface is too handy to give up. Some things can be done only on a flat surface. Lichtenstein's representation of a representation is a good instance. But this work which is neither painting nor sculpture challenges both. It will have to be taken into account by new artists. It will probably change painting and sculpture.

The main thing wrong with painting is that it is a rectangular plane placed flat against the wall. A rectangle is a shape itself; it is obviously the whole shape; it determines and limits the arrangement of whatever is on or inside of it. In work before 1946 the edges of the rectangle are a boundary, the end of the picture. The composition must react to the edges and the rectangle must be unified, but the shape of the rectangle is not stressed; the parts are more important, and the relationships of color and form occur among them. In the paintings of Pollock, Rothko, Still and Newman, and more recently of Reinhardt and Noland, the rectangle is emphasized. The elements inside the

rectangle are broad and simple and correspond closely to the rectangle. The shapes and surface are only those which can occur plausibly within and on a rectangular plane. The parts are few and so subordinate to the unity as not to be parts in an ordinary sense. A painting is nearly an entity, one thing, and not the indefinable sum of a group of entities and references. The one thing overpowers the earlier painting. It also establishes the rectangle as a definite form; it is no longer a fairly neutral limit. A form can be used only in so many ways. The rectangular plane is given a life span. The simplicity required to emphasize the rectangle limits the arrangements possible within it. The sense of singleness also has a duration, but it is only beginning and has a better future outside of painting. Its occurrence in painting now looks like a beginning, in which new forms are often made from earlier schemes and materials.

The plane is also emphasized and nearly single. It is clearly a plane one or two inches in front of another plane, the wall, and parallel to it. The relationship of the two planes is specific; it is a form. Everything on or slightly in the plane of the painting must be arranged laterally.

Almost all paintings are spatial in one way or another. Yves Klein's blue paintings are the only ones that are unspatial, and there is little that is nearly unspatial, mainly Stella's work. It's possible that not much can be done with both an upright rectangular plane and an absence of space. Anything on a surface has space behind it. Two colors on the same surface almost always lie on different depths. An even color, especially in oil paint, covering all or much of a painting is almost always both flat and infinitely spatial. The space is shallow in all of the work in which the rectangular plane is stressed. Rothko's space is shallow and the soft rectangles are parallel to the plane, but the space is almost traditionally illusionistic. In Reinhardt's paintings, just back from the plane of the canvas, there is a flat plane and this seems in turn indefinitely deep. Pollock's paint is obviously on the canvas, and the space is mainly that made by any marks on a surface, so that it is not very descriptive and illusionistic. Noland's concentric bands are not as specifically paint-on-a-surface as Pollock's paint, but the bands flatten the literal space more. As flat and unillusionistic as Noland's paintings are, the bands do advance and recede. Even a single circle will warp the surface to it, will have a little space behind it.

Except for a complete and unvaried field of color or marks, anything spaced in a rectangle and on a plane suggests something in and on something else, something in its surround, which suggests an object or figure in its space, in which these are clearer instances of a similar world—that's the main purpose of painting. The recent paintings aren't completely single. There are a few dominant areas, Rothko's rectangles or Noland's circles, and there is the area around them. There is a gap between the main forms, the most expressive parts, and the rest of the canvas, the plane and the rectangle. The central forms still occur in a wider and indefinite context, although the singleness of the paintings abridges the general and solipsistic quality of earlier work. Fields are also usually not limited, and they give the appearance of sections cut from something indefinitely larger.

Oil paint and canvas aren't as strong as commercial paints and as the colors and surfaces of materials, especially if the materials are used in three dimensions. Oil and canvas are familiar and, like the rectangular plane, have a certain quality and have limits. The quality is especially identified with art.

The new work obviously resembles sculpture more than it does painting, but it is nearer to painting. Most sculpture is like the painting which preceded Pollock, Rothko, Still and Newman. The newest thing about it is its broad scale. Its materials are somewhat more emphasized than before. The imagery involves a couple of salient resemblances to other visible things and a number of more oblique references, everything generalized to compatibility. The parts and the space are allusive, descriptive and somewhat naturalistic. Higgins's sculpture is an example, and, dissimilarly, Di Suvero's. Higgins's sculpture mainly suggests machines and truncated bodies. Its combination of plaster and metal is more specific. Di Suvero uses beams as if they were brush strokes, imitating movement, as Kline did. The material never has its own movement. A beam thrusts, a piece of iron follows a gesture; together they form a naturalistic and anthropomorphic image. The space corresponds.

Most sculpture is made part by part, by addition, composed. The main parts remain fairly discrete. They and the small parts are a collection of variations, slight through great. There are hierarchies of clarity and strength and of proximity to one or two main ideas. Wood and metal are the usual materials, either alone or together, and if together it is without much of a contrast. There is seldom any color. The middling contrast and the natural monochrome are general and help to unify the parts.

There is little of any of this in the new three-dimensional work. So far the most obvious difference within this diverse work is between that which is something of an object, a single thing, and that which is open and extended, more or less environmental. There isn't as great a difference in their nature as in their appearance, though. Oldenburg and others have done both. There are precedents for some of the characteristics of the new work. The parts are usually subordinate and not separate in Arp's sculpture and often in Brancusi's. Duchamp's ready-mades and other Dada objects are also seen at once and not part by part. Cornell's boxes have too many parts to seem at first to be structured. Part-by-part structure can't be too simple or too complicated. It has to seem orderly. The degree of Arp's abstraction, the moderate extent of his reference to the human body, neither imitative nor very oblique, is unlike the imagery of most of the new three-dimensional work. Duchamp's bottle-drying rack is close to some of it. The work of Johns and Rauschenberg and assemblage and low-relief generally, Ortman's reliefs for example, are preliminaries. Johns's few cast objects and a few of Rauschenberg's works, such as the goat with the tire, are beginnings.

Some European paintings are related to objects, Klein's for instance, and Castellani's, which have unvaried fields of low-relief elements. Arman and a few others work in three dimensions. Dick Smith did some large pieces in London with canvas stretched over cockeyed parallelepiped frames and with

the surfaces painted as if the pieces were paintings. Philip King, also in London, seems to be making objects. Some of the work on the West Coast seems to be along this line, that of Larry Bell, Kenneth Price, Tony Delap, Sven Lukin, Bruce Conner, Kienholz of course, and others. Some of the work in New York having some or most of the characteristics is that by George Brecht, Ronald Bladen, John Willenbecher, Ralph Ortiz, Anne Truitt, Paul Harris, Barry McDowell, John Chamberlain, Robert Tanner, Aaron Kuriloff, Robert Morris, Nathan Raisen, Tony Smith, Richard Navin, Claes Oldenburg, Robert Watts, Yoshimura, John Anderson, Harry Soviak, Yayoi Kusama, Frank Stella, Salvatore Scarpitta, Neil Williams, George Segal, Michael Snow, Richard Artschwager, Arakawa, Lucas Samaras, Lee Bontecou, Dan Flavin and Robert Whitman. H. C. Westermann works in Connecticut. Some of these artists do both three-dimensional work and paintings. A small amount of the work of others, Warhol and Rosenquist for instance, is three-dimensional.

The composition and imagery of Chamberlain's work is primarily the same as that of earlier painting, but these are secondary to an appearance of disorder and are at first concealed by the material. The crumpled tin tends to stay that way. It is neutral at first, not artistic, and later seems objective. When the structure and imagery become apparent, there seems to be too much tin and space, more chance and casualness than order. The aspects of neutrality, redundancy and form and imagery could not be coextensive without three dimensions and without the particular material. The color is also both neutral and sensitive and, unlike oil colors, has a wide range. Most color that is integral, other than in painting, has been used in three-dimensional work. Color is never unimportant, as it usually is in sculpture.

Stella's shaped paintings involve several important characteristics of three-dimensional work. The periphery of a piece and the lines inside correspond. The stripes are nowhere near being discrete parts. The surface is farther from the wall than usual, though it remains parallel to it. Since the surface is exceptionally unified and involves little or no space, the parallel plane is unusually distinct. The order is not rationalistic and underlying but is simply order, like that of continuity, one thing after another. A painting isn't an image. The shapes, the unity, projection, order and color are specific, aggressive and powerful.

Painting and sculpture have become set forms. A fair amount of their meaning isn't credible. The use of three dimensions isn't the use of a given form. There hasn't been enough time and work to see limits. So far, considered most widely, three dimensions are mostly a space to move into. The characteristics of three dimensions are those of only a small amount of work, little compared to painting and sculpture. A few of the more general aspects may persist, such as the work's being like an object or being specific, but other characteristics are bound to develop. Since its range is so wide, three-dimensional work will probably divide into a number of forms. At any rate, it will be larger than painting and much larger than sculpture, which, compared to painting, is fairly particular, much nearer to what is usually called a

form, having a certain kind of form. Because the nature of three dimensions isn't set, given beforehand, something credible can be made, almost anything. Of course something can be done within a given form, such as painting, but with some narrowness and less strength and variation. Since sculpture isn't so general a form, it can probably be only what it is now—which means that if it changes a great deal it will be something else; so it is finished.

Three dimensions are real space. That gets rid of the problem of illusionism and of literal space, space in and around marks and colors—which is riddance of one of the salient and most objectionable relics of European art. The several limits of painting are no longer present. A work can be as powerful as it can be thought to be. Actual space is intrinsically more powerful and specific than paint on a flat surface. Obviously, anything in three dimensions can be any shape, regular or irregular, and can have any relation to the wall, floor, ceiling, room, rooms or exterior or none at all. Any material can be used, as is or painted.

A work needs only to be interesting. Most works finally have one quality. In earlier art the complexity was displayed and built the quality. In recent painting the complexity was in the format and the few main shapes, which had been made according to various interests and problems. A painting by Newman is finally no simpler than one by Cézanne. In the three-dimensional work the whole thing is made according to complex purposes, and these are not scattered but asserted by one form. It isn't necessary for a work to have a lot of things to look at, to compare, to analyze one by one, to contemplate. The thing as a whole, its quality as a whole, is what is interesting. The main things are alone and are more intense, clear and powerful. They are not diluted by an inherited format, variations of a form, mild contrasts and connecting parts and areas. European art had to represent a space and its contents as well as have sufficient unity and aesthetic interest. Abstract painting before 1946 and most subsequent painting kept the representational subordination of the whole to its parts. Sculpture still does. In the new work the shape, image, color and surface are single and not partial and scattered. There aren't any neutral or moderate areas or parts, any connections or transitional areas. The difference between the new work and earlier painting and present sculpture is like that between one of Brunelleschi's windows in the Badia di Fiesole and the façade of the Palazzo Rucellai, which is only an undeveloped rectangle as a whole and is mainly a collection of highly ordered parts.

The use of three dimensions makes it possible to use all sorts of materials and colors. Most of the work involves new materials, either recent inventions or things not used before in art. Little was done until lately with the wide range of industrial products. Almost nothing has been done with industrial techniques and, because of the cost, probably won't be for some time. Art could be mass-produced, and possibilities otherwise unavailable, such as stamping, could be used. Dan Flavin, who uses fluorescent lights, has appropriated the results of industrial production. Materials vary greatly and are simply materials—formica, aluminum, cold-rolled steel, plexiglas,

red and common brass, and so forth. They are specific. If they are used directly, they are more specific. Also, they are usually aggressive. There is an objectivity to the obdurate identity of a material. Also, of course, the qualities of materials—hard mass, soft mass, thickness of 1/32, 1/16, 1/8 inch, pliability, slickness, translucency, dullness—have unobjective uses. The vinyl of Oldenburg's soft objects looks the same as ever, slick, flaccid and a little disagreeable, and is objective, but it is pliable and can be sewn and stuffed with air and kapok and hung or set down, sagging or collapsing. Most of the new materials are not as accessible as oil on canvas and are hard to relate to one another. They aren't obviously art. The form of a work and its materials are closely related. In earlier work the structure and the imagery were executed in some neutral and homogeneous material. Since not many things are lumps, there are problems in combining the different surfaces and colors and in relating the parts so as not to weaken the unity.

Three-dimensional work usually doesn't involve ordinary anthropomorphic imagery. If there is a reference it is single and explicit. In any case the chief interests are obvious. Each of Bontecou's reliefs is an image. The image, all of the parts and the whole shape are coextensive. The parts are either part of the hole or part of the mound which forms the hole. The hole and the mound are only two things, which, after all, are the same thing. The parts and divisions are either radial or concentric in regard to the hole, leading in and out and enclosing. The radial and concentric parts meet more or less at right angles and in detail are structure in the old sense, but collectively are subordinate to the single form. Most of the new work has no structure in the usual sense, especially the work of Oldenburg and Stella. Chamberlain's work does involve composition. The nature of Bontecou's single image is not so different from that of images which occurred in a small way in semiabstract painting. The image is primarily a single emotive one, which alone wouldn't resemble the old imagery so much, but to which internal and external references, such as violence and war, have been added. The additions are somewhat pictorial, but the image is essentially new and surprising; an image has never before been the whole work, been so large, been so explicit and aggressive. The abatised orifice is like a strange and dangerous object. The quality is intense and narrow and obsessive. The boat and the furniture that Kusama covered with white protuberances have a related intensity and obsessiveness and are also strange objects. Kusama is interested in obsessive repetition, which is a single interest. Yves Klein's blue paintings are also narrow and intense.

The trees, figures, food or furniture in a painting have a shape or contain shapes that are emotive. Oldenburg has taken this anthropomorphism to an extreme and made the emotive form, with him basic and biopsychological, the same as the shape of an object, and by blatancy subverted the idea of the natural presence of human qualities in all things. And further, Oldenburg avoids trees and people. All of Oldenburg's grossly anthropomorphized objects are manmade—which right away is an empirical matter. Someone or many made these things and incorporated their preferences. As practical as an ice-cream

cone is, a lot of people made a choice, and more agreed, as to its appearance and existence. This interest shows more in the recent appliances and fixtures from the home and especially in the bedroom suite, where the choice is flagrant. Oldenburg exaggerates the accepted or chosen form and turns it into one of his own. Nothing made is completely objective, purely practical or merely present. Oldenburg gets along very well without anything that would ordinarily be called structure. The ball and cone of the large ice-cream cone are enough. The whole thing is a profound form, such as sometimes occurs in primitive art. Three fat layers with a small one on top are enough. So is a flaccid, flamingo switch draped from two points. Simple form and one or two colors are considered less by old standards. If changes in art are compared backwards, there always seems to be a reduction, since only old attributes are counted and these are always fewer. But obviously new things are more, such as Oldenburg's techniques and materials. Oldenburg needs three dimensions in order to simulate and enlarge a real object and to equate it and an emotive form. If a hamburger were painted it would retain something of the traditional anthropomorphism. George Brecht and Robert Morris use real objects and depend on the viewer's knowledge of these objects.

Sol LeWitt
Paragraphs on Conceptual Art (1967)

The six-foot-high modular cube sculpture called *Open Modular Cube* (1966) that Sol LeWitt exhibited in the 1966 Jewish Museum exhibition *Primary Structures* has certain visual affinities to the reductivist tendencies in much abstract art of the 1960s—most specifically in its use of pared-down geometric forms and in its refined, machinelike finish. Like Frank Stella and Donald Judd, LeWitt wanted to move abstract art beyond the expressionist clichés that had prevailed since the 1940s. However, in "Paragraphs on Conceptual Art," which was published in the June 1967 issue of *Artforum*, LeWitt departs theoretically from other artists who were working in a reductivist manner by placing emphasis on the ideas from which the work derives instead of on the work's physical presence. For LeWitt, the concept itself drives the work to the extent that "the idea itself, even if not made visual, is as much a work of art as any finished product." LeWitt's goal as defined in this article was to make the physical work of art a manifestation of a clearly defined set of mental procedures so that the concept stands above the work's materiality. This emphasis on the conceptual processes in the work of art leads to an engagement of the viewer's mind, not his eyes or emotions. The positions articulated in this article also connect LeWitt to artists such as Hans Haacke, who uses language and concepts to engage the viewer in a dialectical process that totally sidesteps any traditional notion of the art object.

The editor has written me that he is in favor of avoiding "the notion that the artist is a kind of ape that has to be explained by the civilized critic." This should be good news to both artists and apes. With this assurance I hope to justify his confidence. To continue a baseball metaphor (one artist wanted to hit the ball out of the park, another to stay loose at the plate and hit the ball where it was pitched), I am grateful for the opportunity to strike out for myself.

I will refer to the kind of art in which I am involved as conceptual art. In conceptual art the idea of concept is the most important aspect of the work. When an artist uses a conceptual form of art, it means that all of the planning and decisions are made beforehand and the execution is a perfunctory affair. The idea becomes a machine that makes the art. This kind of art is not theoretical or illustrative of theories; it is intuitive, it is involved with all types of mental processes and it is purposeless. It is usually free from the dependence on the skill of the artist as a craftsman. It is the objective of the artist who is concerned with conceptual art to make his work mentally interesting to the spectator, and therefore usually he would want it to become emotionally dry. There is no reason to suppose however, that the conceptual artist is out to bore the viewer. It is only the expectation of an emotional kick, to which one conditioned to expressionist art is accustomed, that would deter the viewer from perceiving this art.

Conceptual art is not necessarily logical. The logic of a piece or series of pieces is a device that is used at times only to be ruined. Logic may be used to camouflage the real intent of the artist, to lull the viewer into the belief that he understands the work, or to infer a paradoxical situation (such as logic vs. illogic). The ideas need not be complex. Most ideas that are successful are ludicrously simple. Successful ideas generally have the appearance of simplicity because they seem inevitable. In terms of idea the artist is free to even surprise himself. Ideas are discovered by intuition.

What the work of art looks like isn't too important. It has to look like something if it has physical form. No matter what form it may finally have it must begin with an idea. It is the process of conception and realization with which the artist is concerned. Once given physical reality by the artist the work is open to the perception of all, including the artist. (I use the word "perception" to mean the apprehension of the sense data, the objective understanding of the idea and simultaneously a subjective interpretation of both.) The work of art can only be perceived after it is completed.

Art that is meant for the sensation of the eye primarily would be called perceptual rather than conceptual. This would include most optical, kinetic, light and color art.

Since the functions of conception and perception are contradictory (one pre-, the other postfact) the artist would mitigate his idea by applying subjective judgment to it. If the artist wishes to explore his idea thoroughly, then arbitrary or chance decisions would be kept to a minimum, while caprice, taste

and other whimsies would be eliminated from the making of the art. The work does not necessarily have to be rejected if it does not look well. Sometimes what is initially thought to be awkward will eventually be visually pleasing.

To work with a plan that is pre-set is one way of avoiding subjectivity. It also obviates the necessity of designing each work in turn. The plan would design the work. Some plans would require millions of variations, and some a limited number, but both are finite. Other plans imply infinity. In each case however, the artist would select the basic form and rules that would govern the solution of the problem. After that the fewer decisions made in the course of completing the work, the better. This eliminates the arbitrary, the capricious, and the subjective as much as possible. That is the reason for using this method.

When an artist uses a multiple modular method he usually chooses a simple and readily available form. The form itself is of very limited importance; it becomes the grammar for the total work. In fact it is best that the basic unit be deliberately uninteresting so that it may more easily become an instrinsic part of the entire work. Using complex basic forms only disrupts the unity of the whole. Using a simple form repeatedly narrows the field of the work and concentrates the intensity to the arrangement of the form. This arrangement becomes the end while the form becomes the means.

Conceptual art doesn't really have much to do with mathematics, philosophy or any other mental discipline. The mathematics used by most artists is simple arithmetic or simple number systems. The philosophy of the work is implicit in the work and is not an illustration of any system of philosophy.

It doesn't really matter if the viewer understands the concepts of the artist by seeing the art. Once out of his hand the artist has no control over the way a viewer will perceive the work. Different people will understand the same thing in a different way.

Recently there has been much written about minimal art, but I have not discovered anyone who admits to doing this kind of thing. There are other art forms around called primary structures, reductive, rejective, cool, and mini-art. No artist I know will own up to any of these either. Therefore I conclude that it is part of a secret language that art critics use when communicating with each other through the medium of art magazines. Mini-art is best because it reminds one of mini-skirts and long-legged girls. It must refer to very small works of art. This is a very good idea. Perhaps mini-art shows could be sent around the country in matchboxes. Or maybe the mini-artist is a very small person, say under five feet tall. If so, much good work will be found in the primary schools (primary school primary structures).

If the artist carries through his idea and makes it into visible form, then all the steps in the process are of importance. The idea itself, even if not made visual, is as much a work of art as any finished product. All intervening steps—scribbles, sketches, drawings, failed work, models, studies, thoughts, conversations—are of interest. Those that show the thought process of the artist are sometimes more interesting than the final product.

Determining what size a piece should be is difficult. If an idea requires three dimensions then it would seem any size would do. The question would be what size is best. If the thing were made gigantic then the size alone would be impressive and the idea may be lost entirely. Again, if it is too small, it may become inconsequential. The height of the viewer may have some bearing on the work and also the size of the space into which it will be placed. The artist may wish to place objects higher than the eye level of the viewer, or lower. I think the piece must be large enough to give the viewer whatever information he needs to understand the work and placed in such a way that will facilitate this understanding. (Unless the idea is of impediment and requires difficulty of vision or access.)

Space can be thought of as the cubic area occupied by a three-dimensional volume. Any volume would occupy space. It is air and cannot be seen. It is the interval between things that can be measured. The intervals and measurements can be important to a work of art. If certain distances are important they will be made obvious in the piece. If space is relatively unimportant it can be regularized and made equal (things placed equal distances apart), to mitigate any interest in interval. Regular space might also become a metric time element, a kind of regular beat or pulse. When the interval is kept regular whatever is irregular gains more importance.

Architecture and three-dimensional art are of completely opposite natures. The former is concerned with making an area with a specific function. Architecture, whether it is a work of art or not, must be utilitarian or else fail completely. Art is not utilitarian. When three-dimensional art starts to take on some of the characteristics of architecture such as forming utilitarian areas, it weakens its function as art. When the viewer is dwarfed by the large size of a piece, this domination emphasizes the physical and emotive power of the form at the expense of losing the idea of the piece.

New materials are one of the great afflictions of contemporary art. Some artists confuse new materials with new ideas. There is nothing worse than seeing art that wallows in gaudy baubles. By and large most artists who are attracted to these materials are the ones that lack the stringency of mind that would enable them to use the materials well. It takes a good artist to use new materials and make them into a work of art. The danger is, I think, in making the physicality of the materials so important that it becomes the idea of the work (another kind of expressionism).

Three-dimensional art of any kind is a physical fact. This physicality is its most obvious and expressive content. Conceptual art is made to engage the mind of the viewer rather than his eye or emotions. The physicality of a three-dimensional object then becomes a contradiction to its non-emotive intent. Color, surface, texture, and shape only emphasize the physical aspects of the work. Anything that calls attention to and interests the viewer in this physicality is a deterrent to our understanding of the idea and is used as an expressive device. The conceptual artist would want to ameliorate this emphasis on materiality as much as possible or to use it in a paradoxical way. (To

convert it into an idea.) This kind of art then, should be stated with the most economy of means. Any idea that is better stated in two dimensions should not be in three dimensions. Ideas may also be stated with numbers, photographs, or words or any way the artist chooses, the form being unimportant.

These paragraphs are not intended as categorical imperatives but the ideas stated are as close as possible to my thinking at this time. These ideas are the result of my work as an artist and are subject to change as my experience changes. I have tried to state them with as much clarity as possible. If the statements I make are unclear it may mean the thinking is unclear. Even while writing these ideas there seemed to be obvious inconsistencies (which I have tried to correct, but others will probably slip by). I do not advocate a conceptual form of art for all artists. I have found that it has worked well for me while other ways have not. It is one way of making art: other ways suit other artists. Nor do I think all conceptual art merits the viewer's attention. Conceptual art is only good when the idea is good.

Agnes Martin
Reflections (1973)

Unlike much of the reductivist art that was being made during the 1960s and 1970s, the austere grid paintings that Agnes Martin began developing in the late 1950s have a handmade quality that brings a sense of the artist's touch to the use of fundamental geometry. Because of this, Martin's work has the potential to elicit the kind of subjective readings that were consciously avoided by other artists who were using a reductivist vocabulary. The contemplative and personal tone of the statement "Reflections," which was first published in *Artforum* in April 1973, seems quite removed from the art-world language prevalent in the words of Stella, Judd, and LeWitt. Martin is less interested in justifying her work in relation to other art or in giving the reader a systematic account of the work's theoretical tenets than she is in opening up a metaphysical dialog that speaks not about an objective external reality but of the possible expression of an internal state.

I'd like to talk about the perfection underlying life
when the mind is covered over with perfection
and the heart is filled with delight
but I wish not to deny the rest.
In our minds, there is awareness of perfection;
when we look with our eyes we see it,
and how it functions is mysterious to us and unavailable.

When we live our lives it's something like a race—our minds become
　　concerned and covered over and we get depressed and have to
　　get away for a holiday.
And then sometimes there are moments of perfection
and in these moments we wonder why we ever thought life was difficult.
We think that at last our feet are on the right path and that we will not falter
　　or fail.
We're absolutely convinced we have the solution and then the moment
　　is over.
Moments of awareness are not complete awareness,
just as moments of blindness are not completely blind.
In moments of blindness when you meet someone you know well,
they seem hardly recognizable,
and one seems even a stranger to oneself.
These experiences of the mind are too quickly passed over and forgotten,
although startling moments of awareness are never forgotten.
Seeking awareness of perfection in the mind is called living the inner life.
It is not necessary for artists to live the inner life.
It is only necessary for them to recognize inspiration or to represent it.
Our representations of inspiration are far from perfect for perfection
　　is unobtainable and unattainable.
Moments of awareness of perfection and of inspiration are alike except that
　　inspirations are often directives to action.
Many people think that if they are attuned to fate, all their inspirations will
　　lead them toward what they want and need.
But inspiration is really just the guide to the next thing and may be what we
　　call success or failure.
The bad paintings have to be painted
and to the artist these are more valuable than those paintings later brought
　　before the public.
A work of art is successful when there is a hint of perfection present—
at the slightest hint . . . the work is alive.
The life of the work depends upon the observer, according to his own
　　awareness of perfection and inspiration.
The responsibility of the response to art is not with the artist.
To feel confident and successful is not natural to the artist.
To feel insufficient,
to experience disappointment and defeat in waiting for inspiration
is the natural state of mind of an artist.
As a result praise to most artists is a little embarrassing.
They cannot take credit for inspiration,
for we can see perfectly, but we cannot do perfectly.
Many artists live socially without disturbance to mind,
but others must live the inner experiences of mind, a solitary way of living.

Barbara Rose
A B C Art (1965)

In the article "A B C Art," which was first published in the October–November 1965 issue of *Art in America*, critic and historian Barbara Rose traces the mechanical impersonality of the work of artists such as Donald Judd, Dan Flavin, and Robert Morris back to the iconoclastic work of early twentieth-century artists Kasimir Malevich and Marcel Duchamp, both of whom rejected many of what she calls the "cherished premises of Western art." Specifically Malevich renounced the need for art to be complex and Duchamp directly challenged the notion of the uniqueness of a work of art. The creative premises that the Minimalists themselves were most directly rejecting were the notions of self-conscious individuality and "unbridled subjectivity" that were cultivated by the Abstract Expressionists. By contrast, the elemental forms used by Minimalist artists do not reference the emotional state of the artist.

Rose resists interpreting this new sensibility and instead attempts to see the pure, repetitive, and concrete forms of Minimalism as part of a tendency that was reflected in a range of creative activities, including dance, music, philosophy, and literature. Rose discusses the limitations of the formalist criticism of both Clement Greenberg and Michael Fried with regard to Minimalism, which she dismisses because their approach precludes an evaluation of the impulses of Minimalism in relation to other disciplines. Nevertheless, Rose stops short of directly connecting the reductivist tendencies in so much of the art of the 1960s to any larger societal issues. Only near the end of the essay does she comment that Pop art was a reflection of the "screeching, blaring, spangled carnival of American life," whereas the calm factual purity of Minimalism might be viewed as its antidote.

I am curious to know what would happen if art were suddenly seen for what it is, namely, exact information of how to rearrange one's psyche in order to anticipate the next blow from our own extended faculties. . . . At any rate, in experimental art, men are given the exact specifications of coming violence to their own psyches from their own counterirritant or technology. . . . But the counterirritant usually proves a greater plague than the initial irritant, like a drug habit.

—Marshall McLuhan, *Understanding Media*, 1964

How do you like what you have. This is a question that anybody can ask anybody. Ask it.

—Gertrude Stein, *Lectures in America*, 1935

Originally published in **ART IN AMERICA,** October–November 1965, Brant Publications, Inc.

On the eve of the First World War, two artists, one in Moscow, the other in Paris, made decisions that radically altered the course of art history. Today we are feeling the impact of their decisions in an art whose blank, neutral, mechanical impersonality contrasts so violently with the romantic, biographical Abstract-Expressionist style which preceded it that spectators are chilled by its apparent lack of feeling or content. Critics, attempting to describe this new sensibility, call it Cool Art or Idiot Art or Know-Nothing Nihilism.

That a new sensibility has announced itself is clear, although just what it consists of is not. This is what I hope to establish here. But before taking up specific examples of the new art, not only in painting and sculpture, but in other arts as well, I would like briefly to trace its genealogy.

In 1913, Kasimir Malevich, placing a black square on a white ground that he identified as the "void," created the first suprematist composition. A year later, Marcel Duchamp exhibited as an original work of art a standard metal bottle-rack, which he called a "ready-made." For half a century, these two works marked the limits of visual art. Now, however, it appears that a new generation of artists, who seem not so much inspired as impressed by Malevich and Duchamp (to the extent that they venerate them), are examining in a new context the implications of their radical decisions. Often, the results are a curious synthesis of the two men's work. That such a synthesis should be not only possible but likely is clear in retrospect. For, although superficially Malevich and Duchamp may appear to represent the polarities of twentieth-century art—that is, on one hand, the search for the transcendent, universal, absolute, and on the other, the blanket denial of the existence of absolute values—the two have more in common than one might suppose at first.

To begin with, both men were precocious geniuses who appreciated the revolutionary element in Post-Impressionist art, particularly Cézanne's, and both were urban modernists who rejected the possibility of turning back to a naïve primitivism in disgusted reaction to the excesses of civilization. Alike, too, was their immediate adoption and equally rapid disenchantment with the mainstream modern style, Cubism. Turning from figurative manners, by 1911 both were doing Cubist paintings, although the provincial Malevich's were less advanced and "analytic" than Duchamp's; by 1913 both had exhausted Cubism's possibilities as far as their art was concerned. Moreover, both were unwilling to resolve some of the ambiguities and contradictions inherent in Analytic Cubism in terms of the more ordered and logical framework of Synthetic Cubism, the next mainstream style. I say unwilling rather than unable, because I do not agree with critic Michael Fried's view that Duchamp, at any rate, was a failed Cubist. Rather, the inevitability of a logical evolution toward a reductive art was obvious to them already. For Malevich, the poetic Slav, this realization forced a turning inward toward an inspirational mysticism, whereas for Duchamp, the rational Frenchman, it meant a fatigue so ennervating that finally the wish to paint at all was killed. Both the yearnings of Malevich's Slavic soul and the deductions of

Duchamp's rationalist mind led both men ultimately to reject and exclude from their work many of the most cherished premises of Western art in favor of an art stripped to its bare, irreducible minimum.

It is important to keep in mind that both Duchamp's and Malevich's decisions were renunciations—on Duchamp's part, of the notion of the uniqueness of the art object and its differentiation from common objects, and on Malevich's part, a renunciation of the notion that art must be complex. That the art of our youngest artists resembles theirs in its severe, reduced simplicity, or in its frequent kinship to the world of things, must be taken as some sort of validation of the Russian's and the Frenchman's prophetic reactions.

MORE IS LESS

The concept of "Minimal Art," which is surely applicable to the empty, repetitious, uninflected art of many young painters, sculptors, dancers, and composers working now, was recently discussed as an aesthetic problem by Richard Wollheim (*Arts*, January 1965). It is Professor Wollheim's contention that the art content of such works as Duchamp's found-objects (that is, the "unassisted ready-mades" to which nothing is done) or Ad Reinhardt's nearly invisible "black" paintings is intentionally low, and that resistance to this kind of art comes mainly from the spectator's sense that the artist has not worked hard enough or put enough effort into his art. But, as Professor Wollheim points out, a decision can represent work. Considering as "Minimal Art" either art made from common objects that are not unique but massproduced or art that is not much differentiated from ordinary things, he says that Western artists have aided us to focus on specific objects by setting them apart as the "unique possessors of certain general characteristics." Although they are increasingly being abandoned, working it a lot, making it hard to do, and differentiating it as much as possible from the world of common objects, formerly were ways of insuring the uniqueness and identity of an art object.

Similarly, critic John Ashbery has asked if art can be excellent if anybody can do it. He concludes that "what matters is the artist's will to discover, rather than the manual skills he may share with hundreds of other artists. Anybody could have discovered America, but only Columbus *did*." Such a downgrading of talent, facility, virtuosity, and technique, with its concomitant elevation of conceptual power, coincides precisely with the attitude of the artists I am discussing (although it could also apply to the "conceptual" paintings of Kenneth Noland, Ellsworth Kelly, and others).

Now I should make it clear that the works I have singled out to discuss here have only one common characteristic: they may be described as Minimal Art. Some of the artists, such as Darby Bannard, Larry Zox, Robert Huot, Lyman Kipp, Richard Tuttle, Jan Evans, Ronald Bladen, and Anne Truitt,

obviously are closer to Malevich than they are to Duchamp, whereas others, such as Richard Artschwager and Andy Warhol, are clearly the reverse. The dancers and composers are all, to a greater or lesser degree, indebted to John Cage, who is himself an admirer of Duchamp. Several of the artists—Robert Morris, Donald Judd, Carl Andre, and Dan Flavin—occupy to my eye some kind of intermediate position. One of the issues these artists are attacking is the applicability of generalizations to specific cases. In fact, they are opposed to the very notion that the general and the universal are related. Thus, I want to reserve exceptions to all of the following remarks about their work; in other words, *some of the things I will say apply only in some cases and not in others.*

Though Duchamp and Malevich jumped the gun, so to speak, the avenue toward what Clement Greenberg has called the "modernist reduction," that is, toward an art that is simple, clear, direct, and immediate, was traveled at a steadier pace by others. Michael Fried (in the catalogue "Three American Painters," Fogg Art Museum, 1965) points out that there is "a superficial similarity between modernist painting and Dada in one important respect: namely that just as modernist painting has enabled one to see a blank canvas, a sequence of random spatters, or a length of colored fabric as a picture, Dada and Neo-Dada have equipped one to treat virtually any object as a work of art." The result is that "there is an apparent expansion of the realm of the *artistic* corresponding—ironically, as it were—to the expansion of the pictorial achieved by modernist painting." I quote this formulation because it demonstrates not only how Yves Klein's monochrome blue paintings are art, but because it ought finally to make clear the difference in the manner and kind of reductions and simplifications he effected from those made by Noland and Jules Olitski, thus dispelling permanently any notions that Noland's and Olitski's art are in any way, either in spirit or in intention, linked to the Dada outlook.

Although the work of the painters I am discussing is more blatant, less lyrical and more resistant—in terms of surface, at any rate, insofar as the canvas is not stained or is left with unpainted areas—it has something important in common with that of Noland, Olitski, and others who work with simple shapes and large color areas. Like their work, this work is critical of Abstract-Expressionist paint-handling and rejects the brushed record of gesture and drawing along with loose painterliness. Similarly, the sculpture I am talking about appears critical of open, welded sculpture.

That the artist is critic not only of his own work but of art in general and specifically of art of the immediate past is one of the basic tenets of formalist criticism, the context in which Michael Fried and Clement Greenberg have considered reductive tendencies in modern art. But in this strict sense, to be critical means to be critical only of the formal premises of a style, in this case Abstract Expressionism. Such an explanation of a critical reaction in the purely formal terms of color, composition, scale, format and execution seems to me adequate to explain the evolution of Noland's and Olitski's work, but

it does not fully suffice to describe the reaction of the younger people I am considering, just as an explanation of the rise of Neo-Classicism which considered only that the forms of the Rococo were worn out would hardly give one much of a basis for understanding the complexity of David's style.

It seems clear that the group of young artists I am speaking of were reacting to more than merely formal chaos when they opted not to fulfill Ad Reinhardt's prescription for "divine madness" in "third generation Abstract Expressionists." In another light, one might as easily construe the new, reserved impersonality and self-effacing anonymity as a reaction against the self-indulgence of an unbridled subjectivity, as much as one might see it in terms of a formal reaction to the excesses of painterliness. One has the sense that the question of whether or not an emotional state can be communicated (particularly in an abstract work) or worse still, to what degree it can be simulated or staged, must have struck some serious-minded young artists as disturbing. That the spontaneous splashes and drips could be manufactured was demonstrated by Robert Rauschenberg in his identical action paintings, *Factum I* and *Factum II*. It was almost as if, toward the *Götterdämmerung* of the late fifties, the trumpets blared with such an apocalypytic and Wagnerian intensity that each moment was a crisis and each "act" a climax. Obviously, such a crisis climate could hardly be sustained; just to be able to hear at all again, the volume had to be turned down, and the pitch, if not the instrument, changed.

Choreographer Merce Cunningham, whose work has been of the utmost importance to young choreographers, may have been the first to put this reaction into words (in an article in *trans/formation*, No. 1, 1952): "Now I can't see that crisis any longer means a climax, unless we are willing to grant that every breath of wind has a climax (which I am), but then that obliterates climax, being a surfeit of such. And since our lives, both by nature and by the newspapers, are so full of crisis that one is no longer aware of it, then it is clear that life goes on regardless, and further that each thing can be and is separate from each and every other, viz: the continuity of the newspaper headlines. Climax is for those who are swept by New Year's Eve." In a dance called "Crises" Cunningham eliminated any fixed focus or climax in much the way the young artists I am discussing here have banished them from their works as well. Thus Cunningham's activity, too, must be considered as having helped to shape the new sensibility of the post-Abstract-Expressionist generation.

It goes without saying that sensibility is not transformed overnight. At this point I want to talk about sensibility rather than style, because the artists I'm discussing, who are all roughly just under or just over thirty, are more related in terms of a common sensibility than in terms of a common style. Also, their attitudes, interests, experiences, and stance are much like those of their contemporaries, the Pop artists, although stylistically the work is not very similar.

Mainly this shift toward a new sensibility came, as I've suggested, in the fifties, a time of convulsive transition not only for the art world, but for

society at large as well. In these years, for some reasons I've touched on, many young artists found action painting unconvincing. Instead they turned to the static emptiness of Barnett Newman's eloquent chromatic abstractions or to the sharp visual punning of Jasper Johns's objectlike flags and targets.

Obviously, the new sensibility that preferred Newman and Johns to Willem de Kooning or his epigoni was going to produce art that was different, not only in form but in content as well, from the art that it spurned, because it rejected not only the premises, but the emotional content of Abstract Expressionism.

The problem of the subversive content of these works is complicated, though it has to be approached, even if only to define why it is peculiar or corrosive. Often, because they appear to belong to the category of ordinary objects rather than art objects, these works look altogether devoid of art content. This, as it has been pointed out in criticism of the so-called contentless novels of Alain Robbe-Grillet, is quite impossible for a work of art to achieve. The simple denial of content can in itself constitute the content of such a work. That these young artists attempt to suppress or withdraw content from their works is undeniable. That they wish to make art that is as bland, neutral, and as redundant as possible also seems clear. The content, then, if we are to take the work at face value, should be nothing more than the total of the series of assertions that it is this or that shape and takes up so much space and is painted such a color and made of such a material. Statements from the artists involved are frequently couched in these equally factual, matter-of-fact descriptive terms; the work is described but not interpreted and statements with regard to content or meaning or intention are prominent only by their omission.

For the spectator, this is often all very bewildering. In the face of so much nothing, he is still experiencing something, and usually a rather unhappy something at that. I have often thought one had a sense of loss looking at these big, blank, empty things, so anxious to cloak their art identity that they were masquerading as objects. Perhaps, what one senses is that, as opposed to the florid baroque fullness of the *Angst*-ridden older generation, the hollow, barrenness of the void has a certain poignant, if strangled, expressiveness.

For the present, however, I prefer to confine myself mostly to describing the new sensibility rather than attempting to interpret an art that, by the terms of its own definition, resists interpretation. However, that there *is* a collective new sensibility among the young by now is self-evident. Looking around for examples, I was struck by the number of coincidences I discovered. For example, I found five painters who quite independently arrived at the identical composition of a large white or light-colored rectangle in a colored border. True, in some ways these were recapitulations of Malevich's *Black Square on White* (or to get closer to home, of Ellsworth Kelly's 1952 pair of a white square on black and black square on white); but there was an element in each example that finally frustrated a purist reading. In some cases

(Ralph Humphrey's, for example) a Magritte-like sense of space behind a window-frame was what came across; other times there seemed to be a play on picture (blank) and frame (colored), though again, it was nearly impossible to pin down a specific image or sensation, except for the reaction that they weren't quite what they seemed to be. In the same way, three of the sculptors I'm considering (Carl Andre, Robert Morris, and Dan Flavin) have all used standard units interchangeably. Again, the reference is back to the Russians—particularly to Rodchenko in Andre's case—but still, another element has insinuated itself, preventing any real equations with Constructivist sculpture.

Rather than guess at intentions or look for meanings I prefer to try to surround the new sensibility, not to pinpoint it. As T. E. Hulme put it, the problem is to keep from discussing the new art with a vocabulary derived from the old position. Though my end is simply the isolation of the old-fashioned *Zeitgeist*, I want to go about it impressionistically rather than methodically. I will take up notions now in the air that strike me as relevant to the work. As often as possible I will quote directly from texts that I feel have helped to shape the new sensibility. But I do not want to give the impression that everything I mention applies indiscriminately to all the artists under consideration. Where I do feel a specific cause and effect relationship exists between influences of the past and these artists' work, I will illustrate with examples.

MEANING IN THE VISUAL ARTS

> Let us, then, try to define the distinction between *subject matter* or *meaning* on the one hand, and *form* on the other.
>
> When an acquaintance greets me on the street by removing his hat, what I see from a formal point of view is nothing but the change of certain details within a configuration that forms part of the general pattern of color, lines and volumes which constitutes my world of vision. When I identify, as I automatically do, this as an *event* (hat-removing), I have already overstepped the limits of purely *formal* perception and entered a first sphere of *subject matter* or *meaning* . . . we shall call . . . the factual meaning.
>
> —Erwin Panofsky, *Studies in Iconology*, 1939

The above text and some of the subsequent passages in which Professor Panofsky further differentiates among levels of meaning in art was read by Robert Morris in a work (I hesitate to call it a dance although it was presented in a dance concert at the Surplus Theatre in New York) titled *21.3*. Morris is the most overtly didactic of all the artists I am considering; his dances, or more precisely his events, seem to represent a running commentary on his sculpture as well as a running criticism of art interpretation. At the Surplus Theatre concert he stood before a lectern and mouthed the Panofsky text, which was broadcast from a tape simultaneously. From time

to time he interrupted himself to pour water from a pitcher into a glass. Each time he poured out water, the tape, timed to coincide with his action, produced the sound of water gurgling.

Until recently, in his glass and lead pieces, Morris was fairly explicit about putting subject matter (mostly Duchampesque speculations on process and sex or illustrations of Cartesian dualism) into his art. But now that he is making only bloated plywood constructions, which serve mostly to destroy the contour and space of a room by butting off the floor onto the wall, floating from the ceiling, or appearing as pointless obstacles to circulation, he seems to be concentrating on meaning. This victory for modernism has coincided with his retirement from the performing arts in order to concentrate on his role as theoretician. That he chose the passage from Panofsky, which deals with slight changes of detail and the difference between factual and expressive meaning, is significant for the purpose of isolating the kind of matters that preoccupy many of these artists. For the painters and sculptors whom I am discussing here are aware not only of the cycle of styles but of levels of meaning, of influences, of movements, and of critical judgments. If the art they make is vacant or vacuous, it is intentionally so. In other words, the apparent simplicity of these artists' work was arrived at through a series of complicated, highly informed decisions, each involving the elimination of whatever was felt to be nonessential.

ART FOR AD'S SAKE

Nowhere in world art has it been clearer than in Asia that anything irrational, momentary, spontaneous, unconscious, primitive, expressionistic, accidental, or informal, cannot be called serious art. Only blankness, complete awareness, disinterestedness; the "artist as artist" only, of one and rational mind, "vacant and spiritual, empty and marvelous," in symmetries and regularities only; the changeless "human content" the timeless "supreme principle," the ageless "universal formula" of art, nothing else . . .

The forms of art are always preformed and premeditated. The creative process is always an academic routine and sacred procedure. Everything is prescribed and proscribed. Only in this way is there no grasping or clinging to anything. Only a standard form can be imageless, only a stereotyped image can be formless, only a formulaized art can be formulaless.

—Ad Reinhardt, "Timeless in Asia," *Art News,* January 1960

Fine art can only be defined as exclusive, negative, absolute, and timeless.

—Ad Reinhardt, "Twelve Rules for a New Academy," *Art News,* May 1957

No one, in the mid-fifties, seemed less likely to spawn artistic progeny and admirers than Ad Reinhardt. An abstract painter since the thirties, and a voluble propagandist for abstract art, Reinhardt was always one of the liveliest spirits in the art world, though from time to time he would be

chided as the heretical black monk of Abstract Expressionism, or the legendary Mr. Pure, who finally created an art so pure it consisted of injecting a clear fluid into foam rubber. His dicta, as arcane as they may have sounded when first handed down from the scriptorium, have become nearly canonical for the young artists. Suddenly, his wry irony, aloofness, independence, and ideas about the proper use and role of art, which he has stubbornly held to be noncommercial and nonutilitarian, are precisely the qualities the young admire. It is hard to say how much Reinhardt's constant theorizing, dogmatizing, and propagandizing actually helped to change the climate and to shift the focus from an overtly romantic style to a covertly romantic style.

Of course Reinhardt's "purity" is a relative matter, too. The loftiness is ultimately only part of the statement; and as he made of impersonality one of the most easily recognized styles in New York, so the new blandness is likely to result in similarly easy identification, despite all the use of standard units and programmatic suppression of individuality. In some ways, it might be interesting to compare Reinhardt with the younger artists. To begin with, in Reinhardt's case, there is no doubt that his is classic art (with mystical overtones, perhaps), and there is no doubt that it is abstract, or more precisely that it is abstract painting. Both the concepts of a classical style, toward which an art based on geometry would naturally tend, and that of a genuinely abstract style, are called into question frequently by the ambiguous art of the younger artists. First of all, many use a quirky asymmetry and deliberately bizarre scale to subvert any purist or classical interpretations, whereas others tend to make both paintings and sculptures look so much like plaques or boxes that there is always the possibility that they will be mistaken for something other than art. Their leaving open this possibility is, I think, frequently deliberate.

A ROSE IS A ROSE IS A ROSE: REPETITION AS RHYTHMIC STRUCTURING

> . . . the kind of invention that is necessary to make a general scheme is limited in everybody's experience, every time one of the hundreds of times a newspaper man makes fun of my writing and of my repetition he always has the same theme, that is, if you like, repetition, that is if you like the repeating that is the same thing, but once started expressing this thing, expressing any thing there can be no repetition because the essence of that expression is insistence, and if you insist you must each time use emphasis and if you use emphasis it is not possible while anybody is alive that they should use exactly the same emphasis.
>
> —Gertrude Stein, "Portraits and Repetition" in *Lectures in America*, 1935

Form ceases to be an ordering in time like ABA and reduces to a single, brief image, an instantaneous whole both fixed and moving. Satie's form can be extended only by reiteration or "endurance." Satie frequently scrutinizes a very simple musical object; a short unchanging ostinato accompaniment plus a fragmentary melody. Out of this sameness comes subtle variety.

—Roger Shattuck, *The Banquet Years*, 1955

In painting the repetition of a single motif (such as Larry Poons's dots or Gene Davis's stripes) over a surface usually means an involvement with Jackson Pollock's all-over paintings. In sculpture, the repetition of standard units may derive partly from practical considerations. But in the case of Judd's, Morris's, Andre's, and Flavin's pieces it seems to have more to do with setting up a measured, rhythmic beat in the work. Judd's latest sculptures, for example, are wall reliefs made of a transverse metal rod from which are suspended, at even intervals, identical bar or box units. For some artists—for example, the West Coast painter Billy Al Bengston, who puts sergeants' stripes in all his paintings—a repeated motif may take on the character of a personal insignia. Morris's four identical mirrored boxes, which were so elusive that they appeared literally transparent, and his recent *L*-shape plywood pieces were demonstrations of both variability and interchangeability in the use of standard units. To find variety in repetition where only the nuance alters seems more and more to interest artists, perhaps in reaction to the increasing uniformity of the environment and repetitiveness of a circumscribed experience. Andy Warhol's Brillo boxes, silk-screen paintings of the same image repeated countless times, and films in which people or things hardly move are illustrations of the kind of life situations many ordinary people will face or face already. In their insistence on repetition both Satie and Gertrude Stein have influenced the young dancers who perform at the Judson Memorial Church Dance Theatre in New York. Yvonne Rainer, the most gifted choreographer of the group (which formed as a result of a course in dance composition taught by the composer, Robert Dunn, at Merce Cunningham's New York dance studio) has said that repetition was her first idea of form:

> I remember thinking that dance was at a disadvantage in relation to sculpture in that the spectator could spend as much time as he required to examine a sculpture, walk around it, and so forth—but a dance movement—because it happened in time—vanished as soon as it was executed. So in a solo called *The Bells* [performed at the Living Theatre in 1961] I repeated the same seven movements for eight minutes. It was not exact repetition, as the sequence of the movements kept changing. They also underwent changes through being repeated in different parts of the space and faced in different directions—in a sense allowing the spectator to "walk around it."

For these dancers, and for composers like La Monte Young (who conceives of time as an endless continuum in which the performance of his

Dream Music is a single, continuous experience interrupted by intervals during which it is not being performed), durations of time much longer than those we are accustomed to are acceptable. Thus, for example, an ordinary movement like walking across a stage may be performed in slow motion, and concerts of the *Dream Music* have lasted several days, just as Andy Warhol's first film, *Sleep*, was an eight-hour-long movie of a man sleeping. Again, Satie is at least a partial source. It is not surprising that the only performance of his piano piece *Vexations*, in which the same fragment is ritualistically repeated 840 times, took place two years ago in New York. The performance lasted 18 hours, 40 minutes and required the participation in shifts of a dozen or so pianists, of whom John Cage was one. Shattuck's statement that "Satie seems to combine experiment and inertia" seems applicable to a certain amount of avant-garde activity of the moment.

ART AS A DEMONSTRATION:
THE FACTUAL, THE CONCRETE, THE SELF-EVIDENT

> But what does it mean to say that we cannot define (that is, describe) these elements, but only name them? This might mean, for instance, that when in a limiting case a complex consists of only *one* square, its description is simply the name of the colored square.
>
> There are, of course, what can be called "characteristic experiences" of pointing to (e.g.) the shape. For example, following the outline with one's finger or with one's eyes as one points.—But *this* does not happen in all cases in which I "mean the shape," and no more does any other one characteristic process occur in all these cases.
>
> —Ludwig Wittgenstein, *Philosophical Investigations*, 1953

If Jasper Johns's notebooks seem a parody of Wittgenstein, then Judd's and Morris's sculptures often look like illustrations of that philosopher's propositions. Both sculptors use elementary, geometrical forms that depend for their art quality on some sort of presence or concrete thereness, which in turn often seems no more than a literal and emphatic assertion of their existence. There is no wish to transcend the physical for either the metaphysical or the metaphoric. The thing, thus, is presumably not supposed to "mean" other than what it is; that is, it is not supposed to be suggestive of anything other than itself. Morris's early plywood pieces are all of elementary structures: a door, a window-frame, a platform. He even did a wheel, the most rudimentary structure of all. In a dance he made called *Site,* he mimed what were obviously basic concepts about structure. Dressed as a construction worker, he manipulated flat plywood sheets ("planes," one assumes) until finally he pulled the last one away to reveal behind it a nude girl posed as Manet's *Olympia*. As I've intimated, Morris's dances seem to function more as *explications du texte* of his sculptures than as independent dances or theatrical

events. Even their deliberately enigmatic tone is like his sculpture, although he denies that they are related. Rauschenberg, too, has done dances that, not surprisingly, are like three-dimensional, moving equivalents of his combine constructions and are equally littered with objects. But his dance trio called *Pelican* for two men on roller-skates and a girl in toe shoes has that degree of surprise that characterizes his best paintings.

ART AS CONCRETE OBJECT

Now the world is neither meaningful nor absurd. It simply *is.*

In place of this universe of "meanings" (psychological, social, functional), one should try to construct a more solid, more immediate world. So that first of all it will be through their presence that objects and gestures will impose themselves, and so that this presence continues thereafter to dominate, beyond any theory of explication that might attempt to enclose them in any sort of a sentimental, sociological, Freudian, metaphysical, or any other system of reference.

—Alain Robbe-Grillet, "Une voie pour le roman futur," 1956, from *Pour un Nouveau Roman*

Curiously, it is perhaps in the theory of the French objective novel that one most closely approaches the attitude of many of the artists I've been talking about. I am convinced that this is sheer coincidence, since I have no reason to believe there has been any specific point of contact. This is quite the contrary to their knowledge of Wittgenstein, whom I know a number of them have read. But nonetheless the rejection of the personal, the subjective, the tragic, and the narrative in favor of the world of things seems remarkable, even if or even because it is coincidental.

But neither in the new novels nor in the new art is the repudiation of content convincing. The elimination of the narrative element in dance (or at least its suppression to an absolute minimum) has been one of Merce Cunningham's most extraordinary achievements, and in this the best of the young choreographers have followed his lead. Although now, having made dance more abstract than it has ever been, they all (including Cunningham in *Story*) appear to be reintroducing the narrative element precisely in the form of objects, which they carry, pass around, manipulate, and so forth.

ART AS FACT, DOCUMENT, OR CATALOGUE

Researchers measured heart beat, respiration, and other intimate body responses during every stage of the sexual excitation cycle. In addition, motion-picture cameras captured on color film not only surface reactions (down to the most fleeting change of skin color) but internal reactions, through a technique of medical photography.

—Recent newspaper ad for *The Sexually Responsive Woman*

I could have picked any number of statistical quotations about the population explosion, or the number of college graduates in Wilmington, Delaware, but the above quotation illustrates better how we can now treat all matters statistically, factually, scientifically, and objectively. One could bring up in this context not only the flood of art with sexual themes and explicit images, but Warhol's *Kiss* and *Couch* movies as well. Morris's *I* box, in which he exposes himself behind an *L*-shaped flesh-colored door, or his nude dance might also be brought up here. Mainly the point is what we are seeing everywhere is the inversion of the personal and the public. What was once private (nudity, sex) is now public and what was once the public face of art at least (emotions, opinions, intentions) is now private. And as the catalogue, of things again mainly, has become part of poetry and literature, so the document is part of art. As an example I might use Lucas Samaras's documentation of his years in a tiny cell-like bedroom in West New York, New Jersey, transplanted in its entirety to the Green Gallery, or George Segal's quite literal plaster replicas of real people in familiar situations. In a similar inversion, whereas the unusual and the exotic used to interest artists, now they tend to seek out the banal, the common, and the everyday. This seems a consequence of the attitude that, among young artists today, nothing is more suspect than "artiness," self-consciousness, or posturing. To paraphrase Oscar Wilde, being natural hence is not just a pose, it is being natural. Not only do painters paint common objects, and sculptors enshrine them, but poets seek the ordinary word. (Carl Andre has said that in his poetry he avoids obscene language because it calls attention to itself too much, and because it is not yet sufficiently common.) Along these same lines, one of the most interesting things the young dancers are doing is incorporating non-dance movements into their work.

BLACK HUMOR, IRONY, AND THE *MEMENTO MORI*

> I could die today, if I wished, merely by making a little effort, if I could wish, if I could make an effort.
>
> —Samuel Beckett, *Malone Dies*

> Il n'y a pas de solution parce qu'il n'y a pas de problème.
>
> —Marcel Duchamp

It is part of the irony of the works I'm discussing—and irony plays a large part in them—that they blatantly assert their unsaleability and functionlessness. Some, like Artschwager's pseudofurniture or Warhol's Brillo boxes, are not too unwieldy to be sold, but since they approximate real objects with actual uses, they begin to raise questions about the utility of art, and its ambiguous role in our culture. On the one hand art as a form of free expression is seen as a weapon in the Cold War, yet on the other there appears no hope for

any organic role for art in the life of the country. The artists, scarcely unaware of the provisional nature of their status, are responding in innumerable peculiar ways, some of which I've mentioned. Now, besides making difficult, hostile, awkward, and oversize art, an increasing number of artists seem involved in making monumental art, too large to fit into existing museums. This is quite amusing, as there is no conceivable use in our society as it exists for such work, although it may endure as a monumental *j'accuse* in the case of any future rapprochement. Thus, part of what the new art is about is a subversion of the existing value structure through simple erosion. Usually these acts of subversion are personal rather than social, since it seems to be the person rather than the society that is in danger of extinction at this point.

Using irony as a means, the artists are calling bluffs right and left. For example, when Yvonne Rainer, using dramatic speeches in her dances as she has been, says one thing while she is doing another, she is making a statement about how people behave as well as performing a dance. In fact, the use of taped narratives that either do not correspond with or contradict the action is becoming more frequent among the dancers. The morbidity of the text Rainer chose as "musical accompaniment" for *Parts of Some Sextets,* with its endless deaths and illnesses and poxes and plagues (it was the diary of an eighteenth-century New England minister) provided an ironic contrast to the banality of the dance action, which consisted in part of transporting, one by one, a stack of mattresses from one place to another. Such a setting up of equations between totally dissimilar phenomena (death and play, for example) can be seen in a number of cases. Dan Flavin describes several commemorative sculptures he made this way: "*Icon IV. The Pure Land* is entirely white. The surmounting light is 'daylight' that has a slight blue tint. I built the structure in 1962, finishing it late in the fall. I believe that the conception dates from the previous year. *The Pure Land* is dedicated to my twin brother, David, who died October 8, 1962. The face of the structure is forty-five inches square. It was made of a prefabricated acrylic plastic sheeting that John Anderson cut to size for me." The factual tone does not alter when he describes (in a lecture given in Columbus, Ohio) his marriage: "After I left *Juan Gris in Paris* unfinished in 1960, there was a pause of many months when I made no work. During this period I married Sonia Severdija, who happens to be a strong carpenter."

Or consider Carl Andre's solution for war: "Let them eat what they kill." Andy Warhol, whose morbid interest in death scenes has led him to paint innumerable Marilyn Monroes, electric chairs, and car crashes, claims that "when you see a gruesome picture over and over again, it doesn't really have any effect." Dan Flavin, in a journal entry of August 18, 1962, makes it clear that sentimental notions of immortality are to be ignored as motivations: "I can take the ordinary lamp out of use and into a magic that touches ancient mysteries. And yet it is still a lamp that burns to death like any other of its kind. In time the whole electrical system will pass into inactive history.

My lamps will no longer be operative; but it must be remembered that they once gave light."

As a final example, I cite Robert Morris's project for his own mausoleum. It is to consist of a sealed aluminum tube three miles long, inside which he wishes to be put, housed in an iron coffin suspended from pulleys. Every three months, the position of the coffin is to be changed by an attendant who will move along the outside of the tube holding a magnet. On a gravel walk leading to the entrance are swooning maidens, carved in marble in the style of Canova. (This opposition, of the sentimental to the icecold, is similar to the effect he produced in a dance in which two nude figures inch solemnly across the stage on a track to the accompaniment of a particularly lush aria from *Simon Boccanegra*.)

THE INFINITE: NEGATION AND VOID

I have broken the blue boundary of color limits, come out into the white, beside me comrade—pilots swim in this infinity. I have established the semaphore of Suprematism. I have beaten the lining of the colored sky, torn it away and in the sack that formed itself, I have put color and knotted it. Swim! The free white sea, infinity, lies before you.

—Kasimir Malevich, *Suprematism*, 1919

The art I have been talking about is obviously a negative art of denial and renunciation. Such protracted asceticism is normally the activity of contemplatives or mystics. Speaking of the state of blankness and stagnation preceding illumination, usually known (after St. John of the Cross) as the mystic's Dark Night, Evelyn Underhill says that the Dark Night is an example of the operation of the law of reaction from stress. It is a period of fatigue and lassitude following a period of sustained mystical activity. How better to describe the inertia most of these works convey, or their sense of passivity, which seems nonetheless resistant rather than yielding. Like the mystic, in their work these artists deny the ego and the individual personality, seeking to evoke, it would seem, that semihypnotic state of blank consciousness, of meaningless tranquility and anonymity that both Eastern monks and yogis and Western mystics, such as Meister Eckhart and Miguel de Molinos, sought. The equilibrium of a passionless nirvana, or the negative perfection of the mystical silence of Quietism, require precisely the kind of detachment, renunciation, and annihilation of ego and personality we have been observing. Certain specific correlations may be pointed out to substantiate such allusions. The "continuum" of La Monte Young's *Dream Music* is analogous in its endlessness to the Maya of Hindu cosmology; titles of many of Flavin's works are explicitly religious (*William of Ockham*, *Via Crucis*). In fact, Flavin calls his

works "icons," and it is not surprising to learn that he left a Catholic seminary on the verge of being ordained.

Of course, it is not novel to have mystical abstract art. Mondrian was certainly as much a mystic as Malevich. But it does seem unusual in America, where our art has always been so levelheaded and purposeful. That all this new art is so low-key, and so often concerned with little more than nuances of differentiation and executed in the *pianissimo* we associate with, for example, Morton Feldman's music, makes it rather out of step with the screeching, blaring, spangled carnival of American life. But, if Pop Art is the reflection of our environment, perhaps the art I have been describing is its antidote, even if it is a hard one to swallow. In its oversized, awkward, uncompromising, sometimes brutal directness, and in its refusal to participate, either as entertainment or as whimsical, ingratiating commodity (being simply too big or too graceless or too empty or too boring to appeal), this new art is surely hard to assimilate with ease. And it is almost as hard to talk about as it is to have around, because of the art that is being made now, it is clearly the most ambivalent and the most elusive. For the moment one has made a statement, or more hopeless still, attempted a generality, the precise opposite then appears to be true, sometimes simultaneously with the original thought one had. As Roger Shattuck says of Satie's music, "The simplest pieces, some of the humoristic works, and children's pieces built out of a handful of notes and rhythms are the most enigmatic for this very reason: they have no beginning middle and end. They exist simultaneously." So with the multiple levels of an art not so simple as it looks.

Clement Greenberg
Modernist Painting (1965)

"Modernist Painting," which was published in *Art and Literature* in Spring 1965, is arguably the most influential essay of Greenberg's prodigious output. It establishes a firm position with regard to the characteristics that define modernism in the visual arts. When he uses the term *Modernism,* Greenberg is referring to the necessity of a discipline (in this case painting) to be self-critical so as to find those elements that are essential to that particular discipline. For Greenberg the fundamental characteristic that separates painting from the other arts—such as sculpture and theater—is that painting is fundamentally flat. The logical conclusion of this line of reasoning is that when painters attempt to create an illusionistic world through the manipulation of spatial effects, they are moving away from painting's very essence as a two-dimensional art.

Developments in modern art are for Greenberg positioned more or less linearly toward ever more purified forms of abstraction. By sticking solely to the use of pictorial conventions to define what it means to be modern, Greenberg makes the definition of modernism inextricable from the formal analysis of a work of art. At the time that he wrote this essay, Greenberg was directly involved with the promotion of the Color Field artists Morris Louis and Kenneth Noland, whom he championed in part because they denied the painterliness embodied by the work of the Abstract Expressionists and maintained the unprecedented position that the picture plane should be flat. The formalist approach that Greenberg establishes in this and other essays was developed further by a number of other critics. His most ardent follower was Michael Fried.

Modernism includes more than just art and literature. By now it includes almost the whole of what is truly alive in our culture. It happens, also, to be very much of a historical novelty. Western civilization is not the first to turn around and question its own foundations, but it is the civilization that has gone furthest in doing so. I identify Modernism with the intensification, almost the exacerbation, of this self-critical tendency that began with the philosopher Kant. Because he was the first to criticize the means itself of criticism, I conceive of Kant as the first real Modernist.

The essence of Modernism lies, as I see it, in the use of the characteristic methods of a discipline to criticize the discipline itself—not in order to subvert it, but to entrench it more firmly in its area of competence. Kant used logic to establish the limits of logic, and while he withdrew much from its old jurisdiction, logic was left in all the more secure possession of what remained to it.

The self-criticism of Modernism grows out of but is not the same thing as the criticism of the Enlightenment. The Enlightenment criticized from the outside, the way criticism in its more accepted sense does; Modernism criticizes from the inside, through the procedures themselves of that which is being criticized. It seems natural that this new kind of criticism should have appeared first in philosophy, which is critical by definition, but as the nineteenth century wore on it made itself felt in many other fields. A more rational justification had begun to be demanded of every formal social activity, and Kantian self-criticism was called on eventually to meet and interpret this demand in areas that lay far from philosophy.

We know what has happened to an activity like religion that has not been able to avail itself of "Kantian" immanent criticism in order to justify itself. At first glance the arts might seem to have been in a situation like religion's. Having been denied by the Enlightenment all tasks they could take seriously, they looked as though they were going to be assimilated to entertainment pure and simple, and entertainment itself looked as though it was going to be assimilated, like religion, to therapy. The arts could save themselves from this leveling down only by demonstrating that the kind of experience they provided was valuable in its own right and not to be obtained from any other kind of activity.

Each art, it turned out, had to effect this demonstration on its own account. What had to be exhibited and made explicit was that which was unique and irreducible not only in art in general, but also in each particular art. Each art had to determine, through the operations peculiar to itself, the effects peculiar and exclusive to itself. By doing this each art would, to be sure, narrow its area of competence, but at the same time it would make its possession of this area all the more secure.

It quickly emerged that the unique and proper area of competence of each art coincided with all that was unique to the nature of its medium. The task of self-criticism became to eliminate from the effects of each art any and every effect that might conceivably be borrowed from or by the medium of any other art. Thereby each art would be rendered "pure," and in its "purity" find the guarantee of its standards of quality as well as of its independence. "Purity" meant self-definition, and the enterprise of self-criticism in the arts became one of self-definition with a vengeance.

Realistic, illusionist art had dissembled the medium, using art to conceal art. Modernism used art to call attention to art. The limitations that constitute the medium of painting—the flat surface, the shape of the support, the properties of pigment—were treated by the Old Masters as negative factors that could be acknowledged only implicitly or indirectly. Modernist painting has come to regard these same limitations as positive factors that are to be acknowledged openly. Manet's paintings became the first Modernist ones by virtue of the frankness with which they declared the surfaces on which they were painted. The Impressionists, in Manet's wake, abjured underpainting and glazing, to leave the eye under no doubt as to the fact that the colors used were made of real paint that came from pots or tubes. Cézanne sacrificed verisimilitude, or correctness, in order to fit drawing and design more explicitly to the rectangular shape of the canvas.

It was the stressing, however, of the ineluctable flatness of the support that remained most fundamental in the processes by which pictorial art criticized and defined itself under Modernism. Flatness alone was unique and exclusive to that art. The enclosing shape of the support was a limiting condition, or norm, that was shared with the art of the theater; color was a norm or means shared with sculpture as well as the theater. Flatness, two-dimensionality, was the only condition painting shared with no other art, and so Modernist painting oriented itself to flatness as it did to nothing else.

The Old Masters had sensed that it was necessary to preserve what is called the integrity of the picture plane: that is, to signify the enduring presence of flatness under the most vivid illusion of three-dimensional space. The apparent contradiction involved—the dialectical tension, to use a fashionable but apt phrase—was essential to the success of their art, as it is indeed to the success of all pictorial art. The Modernists have neither avoided nor resolved this contradiction; rather, they have reversed its terms. One is made aware of the flatness of their pictures before, instead of after, being made

aware of what the flatness contains. Whereas one tends to see what is *in* an Old Master before seeing it as a picture, one sees a Modernist painting as a picture first. This is, of course, the best way of seeing any kind of picture, Old Master or Modernist, but Modernism imposes it as the only and necessary way, and Modernism's success in doing so is a success of self-criticism.

It is not in principle that Modernist painting in its latest phase has abandoned the representation of recognizable objects. What it has abandoned in principle is the representation of the kind of space that recognizable, three-dimensional objects can inhabit. Abstractness, or the non-figurative, has in itself still not proved to be an altogether necessary moment in the self-criticism of pictorial art, even though artists as eminent as Kandinsky and Mondrian have thought so. Representation, or illustration, as such does not abate the uniqueness of pictorial art; what does do so are the associations of the things represented. All recognizable entities (including pictures themselves) exist in three-dimensional space, and the barest suggestion of a recognizable entity suffices to call up associations of that kind of space. The fragmentary silhouette of a human figure, or of a teacup, will do so, and by doing so alienate pictorial space from the two-dimensionality which is the guarantee of painting's independence as an art. Three-dimensionality is the province of sculpture, and for the sake of its own autonomy painting has had above all to divest itself of everything it might share with sculpture. And it is in the course of its effort to do this, and not so much—I repeat—to exclude the representational or the "literary," that painting has made itself abstract.

At the same time Modernist painting demonstrates, precisely in its resistance to the sculptural, that it continues tradition and the themes of tradition, despite all appearances to the contrary. For the resistance to the sculptural begins long before the advent of Modernism. Western painting, insofar as it strives for realistic illusion, owes an enormous debt to sculpture, which taught it in the beginning how to shade and model towards an illusion of relief, and even how to dispose that illusion in a complementary illusion of deep space. Yet some of the greatest feats of Western painting came as part of the effort it has made in the last four centuries to suppress and dispel the sculptural. Starting in Venice in the sixteenth century and continuing in Spain, Belgium, and Holland in the seventeenth, that effort was carried on at first in the name of color. When David, in the eighteenth century, sought to revive sculptural painting, it was in part to save pictorial art from the decorative flattening-out that the emphasis on color seemed to induce. Nevertheless, the strength of David's own best pictures (which are predominantly portraits) often lies as much in their color as in anything else. And Ingres, his pupil, though subordinating color far more consistently, executed pictures that were among the flattest, least sculptural done in the West by a sophisticated artist since the fourteenth century. Thus by the middle of the nineteenth century all ambitious tendencies in painting were converging (beneath their differences) in an anti-sculptural direction.

Modernism, in continuing this direction, made it more conscious of itself. With Manet and the Impressionists, the question ceased to be defined as one of color versus drawing, and became instead a question of purely optical experience as against optical experience modified or revised by tactile associations. It was in the name of the purely and literally optical, not in that of color, that the Impressionists set themselves to undermining shading and modeling and everything else that seemed to connote the sculptural. And in a way like that in which David had reacted against Fragonard in the name of the sculptural, Cézanne, and the Cubists after him, reacted against Impressionism. But once again, just as David's and Ingres's reaction had culminated in a kind of painting even less sculptural than before, so the Cubist counter-revolution eventuated in a kind of painting flatter than anything Western art had seen since before Cimabue—so flat indeed that it could hardly contain recognizable images.

In the meantime the other cardinal norms of the art of painting were undergoing an equally searching inquiry, though the results may not have been equally conspicuous. It would take me more space than is at my disposal to tell how the norm of the picture's enclosing shape or frame was loosened, then tightened, then loosened once again, and then isolated and tightened once more by successive generations of Modernist painters; or how the norms of finish, of paint texture, and of value and color contrast, were tested and retested. Risks have been taken with all these, not only for the sake of new expression, but also in order to exhibit them more clearly as norms. By being exhibited and made explicit they are tested for their indispensability. This testing is by no means finished, and the fact that it becomes more searching as it proceeds accounts for the radical simplifications, as well as radical complications, in which the very latest abstract art abounds.

Neither the simplifications nor the complications are matters of license. On the contrary, the more closely and essentially the norms of a discipline become defined the less apt they are to permit liberties ("liberation" has become a much abused word in connection with avant-garde and Modernist art). The essential norms or conventions of painting are also the limiting conditions with which a marked-up surface must comply in order to be experienced as a picture. Modernism has found that these limiting conditions can be pushed back indefinitely before a picture stops being a picture and turns into an arbitrary object; but it has also found that the further back these limits are pushed the more explicitly they have to be observed. The intersecting black lines and colored rectangles of a Mondrian may seem hardly enough to make a picture out of, yet by echoing the picture's enclosing shape so self-evidently they impose that shape as a regulating norm with a new force and a new completeness. Far from incurring the danger of arbitrariness in the absence of a model in nature, Mondrian's art proves, with the passing of time, almost too disciplined, too convention-bound in certain respects; once we have become used to its utter abstractness we realize that it is more traditional in its color, as well as in its subservience to the frame, than the last paintings of Monet are.

It is understood, I hope, that in plotting the rationale of Modernist art I have had to simplify and exaggerate. The flatness towards which Modernist painting orients itself can never be an utter flatness. The heightened sensitivity of the picture plane may no longer permit sculptural illusion, or *trompe-l'oeil*, but it does and must permit optical illusion. The first mark made on a surface destroys its virtual flatness, and the configurations of a Mondrian still suggest a kind of illusion of a kind of third dimension. Only now it is a strictly pictorial, strictly optical third dimension. Where the Old Masters created an illusion of space into which one could imagine oneself walking, the illusion created by a Modernist is one into which one can only look, can travel through only with the eye.

One begins to realize that the Neo-Impressionists were not altogether misguided when they flirted with science. Kantian self-criticism finds its perfect expression in science rather than in philosophy, and when this kind of self-criticism was applied in art the latter was brought closer in spirit to scientific method than ever before—closer than in the early Renaissance. That visual art should confine itself exclusively to what is given in visual experience, and make no reference to anything given in other orders of experience, is a notion whose only justification lies, notionally, in scientific consistency. Scientific method alone asks that a situation be resolved in exactly the same kind of terms as that in which it is presented—a problem in physiology is solved in terms of physiology, not in those of psychology; to be solved in terms of psychology, it has to be presented in, or translated into, these terms first. Analogously, Modernist painting asks that a literary theme be translated into strictly optical, two-dimensional terms before becoming the subject of pictorial art—which means its being translated in such a way that it entirely loses its literary character. Actually, such consistency promises nothing in the way of aesthetic quality or aesthetic results, and the fact that the best art of the past seventy or eighty years increasingly approaches such consistency does not change this; now as before, the only consistency which counts in art is aesthetic consistency, which shows itself only in results and never in methods or means. From the point of view of art itself its convergence of spirit with science happens to be a mere accident, and neither art nor science gives or assures the other of anything more than it ever did. What their convergence does show, however, is the degree to which Modernist art belongs to the same historical and cultural tendency as modern science.

It should also be understood that the self-criticism of Modernist art has never been carried on in any but a spontaneous and subliminal way. It has been altogether a question of practice, immanent to practice and never a topic of theory. Much has been heard about programs in connection with Modernist art, but there has really been far less of the programmatic in Modernist art than in Renaissance or Academic art. With a few untypical exceptions, the masters of Modernism have betrayed no more of an appetite for fixed ideas about art than Corot did. Certain inclinations and emphases, certain refusals

and abstinences seem to become necessary simply because the way to stronger, more expressive art seems to lie through them. The immediate aims of Modernist artists remain individual before anything else, and the truth and success of their work is individual before it is anything else. To the extent that it succeeds as art Modernist art partakes in no way of the character of a demonstration. It has needed the accumulation over decades of a good deal of individual achievement to reveal the self-critical tendency of Modernist painting. No one artist was, or is yet, consciously aware of this tendency, nor could any artist work successfully in conscious awareness of it. To this extent—which is by far the largest—art gets carried on under Modernism in the same way as before.

And I cannot insist enough that Modernism has never meant anything like a break with the past. It may mean a devolution, an unraveling of anterior tradition, but it also means its continuation. Modernist art develops out of the past without gap or break, and wherever it ends up it will never stop being intelligible in terms of the continuity of art. The making of pictures has been governed, since pictures first began to be made, by all the norms I have mentioned. The Paleolithic painter or engraver could disregard the norm of the frame and treat the surface in both a literally and a virtually sculptural way because he made images rather than pictures, and worked on a support whose limits could be disregarded because (except in the case of small objects like a bone or horn) nature gave them to the artist in an unmanageable way. But the making of pictures, as against images in the flat, means the deliberate choice and creation of limits. This deliberateness is what Modernism harps on: that is, it spells out the fact that the limiting conditions of art have to be made altogether human limits.

I repeat that Modernist art does not offer theoretical demonstrations. It could be said, rather, that it converts all theoretical possibilities into empirical ones, and in doing so tests, inadvertently, all theories about art for their relevance to the actual practice and experience of art. Modernism is subversive in this respect alone. Ever so many factors thought to be essential to the making and experiencing of art have been shown not to be so by the fact that Modernist art has been able to dispense with them and yet continue to provide the experience of art in all its essentials. That this "demonstration" has left most of our old *value* judgments intact only makes it the more conclusive. Modernism may have had something to do with the revival of the reputations of Uccello, Piero, El Greco, Georges de la Tour, and even Vermeer, and it certainly confirmed if it did not start other revivals like that of Giotto; but Modernism has not lowered thereby the standing of Leonardo, Raphael, Titian, Rubens, Rembrandt or Watteau. What Modernism has made clear is that, though the past did appreciate masters like these justly, it often gave wrong or irrelevant reasons for doing so.

Still, in some ways this situation has hardly changed. Art criticism lags behind Modernist as it lagged behind pre-Modernist art. Most of the things

that get written about contemporary art belong to journalism rather than criticism properly speaking. It belongs to journalism—and to the millennial complex from which so many journalists suffer in our day—that each new phase of Modernism should be hailed as the start of a whole new epoch of art making a decisive break with all the customs and conventions of the past. Each time, a kind of art is expected that will be so unlike previous kinds of art and so "liberated" from norms of practice or taste, that everybody, regardless of how informed or uninformed, will be able to have his say about it. And each time, this expectation is disappointed, as the phase of Modernism in question takes its place, finally, in the intelligible continuity of taste and tradition, and as it becomes clear that the same demands as before are made on artist and spectator.

Nothing could be further from the authentic art of our time than the idea of a rupture of continuity. Art is, among many other things, continuity. Without the past of art, and without the need and compulsion to maintain past standards of excellence, such a thing as Modernist art would be impossible.

Context

Alain Robbe-Grillet
A Future for the Novel (1965)

French writer and filmmaker Alain Robbe-Grillet was the leading theoretician of the *Nouveau Roman* (New Novel), the French literary movement of the 1950s. Robbe-Grillet attempts to strip his writing down to descriptions of objective reality by paying particular attention to the objects, gestures, and details of the environment of a given narrative scene without interpreting these elements through an ideological or psychological lens. In her essay "A B C Art," Barbara Rose draws a parallel between Robbe-Grillet's focus on the physical presence of objects with the matter-of-fact quality of Minimalist art. Just as artists such as Frank Stella and Donald Judd suppress the handmade quality of their art in an attempt to deny the viewer the space for subjective musings, Robbe-Grillet hopes to position fiction within an experiential framework that challenges constructed notions concerning fiction's reliance on psychological interpretation.

Robbe-Grillet describes his intentions as follows: "Let it be first of all by their *presence* that objects and gestures establish themselves, and let this presence continue to prevail over whatever explanatory theory that may try to enclose them in a system of reference, whether emotional, sociological, Freudian or metaphysical." His work includes the novels *Jealousy* (1957) and *In the Labyrinth* (1959) as well as the film *Last Year at Marienbad* (1961). "A Future for the Novel" was first published in English in 1965 in the book *For a New Novel: Essays on Fiction*.

It seems hardly reasonable at first glance to suppose that an entirely *new* literature might one day—now, for instance—be possible. The many attempts made these last thirty years to drag fiction out of its ruts have resulted, at best, in no more than isolated works. And—we are often told—none of these works, whatever its interest, has gained the adherence of a public comparable to that of the bourgeois novel. The only conception of the novel to have currency today is, in fact, that of Balzac.

Or that of Mme. de La Fayette. Already sacrosanct in her day, psychological analysis constituted the basis of all prose: it governed the conception of the book, the description of its characters, the development of its plot. A "good" novel, ever since, has remained the study of a passion—or of a conflict of passions, or of an absence of passion—in a given milieu. Most of our contemporary novelists of the traditional sort—those, that is, who manage to gain the approval of their readers—could insert long passages from *The Princess of Clèves* or *Père Goriot* into their own books without awakening the suspicions of the enormous public which devours whatever they turn out. They would merely need to change a phrase here and there, simplify certain constructions, afford an occasional glimpse of their own "manner" by means of a word, a daring image, the rhythm of a sentence. . . . But all acknowledge, without seeing anything peculiar about it, that their preoccupations as writers date back several centuries.

What is so surprising about this, after all? The raw material—the French language—has undergone only very slight modifications for three hundred years; and if society has been gradually transformed, if industrial techniques have made considerable progress, our intellectual civilization has remained much the same. We live by essentially the same habits and the same prohibitions—moral, alimentary, religious, sexual, hygienic, etc. And of course there is always the human "heart," which as everyone knows is eternal. There's nothing new under the sun, it's all been said before, we've come on the scene too late, etc., etc.

The risk of such rebuffs is merely increased if one dares claim that this new literature is not only possible in the future, but is already being written, and that it will represent—in its fulfillment—a revolution more complete than those which in the past produced such movements as romanticism or naturalism.

There is, of course, something ridiculous about such a promise as "Now things are going to be different!" How will they be different? In what

direction will they change? And, especially, why are they going to change now?

The art of the novel, however, has fallen into such a state of stagnation— a lassitude acknowledged and discussed by the whole of critical opinion— that it is hard to imagine such an art can survive for long without some radical change. To many, the solution seems simple enough: such a change being impossible, the art of the novel is dying. This is far from certain. History will reveal, in a few decades, whether the various fits and starts which have been recorded are signs of a death agony or of a rebirth.

In any case, we must make no mistake as to the difficulties such a revolution will encounter. They are considerable. The entire caste system of our literary life (from publisher to the humblest reader, including bookseller and critic) has no choice but to oppose the unknown form which is attempting to establish itself. The minds best disposed to the idea of a necessary transformation, those most willing to countenance and even to welcome the values of experiment, remain, nonetheless, the heirs of a tradition. A new form will always seem more or less an absence of any form at all, since it is unconsciously judged by reference to the consecrated forms. In one of the most celebrated French reference works, we may read in the article on Schoenberg: "Author of audacious works, written without regard for any rules whatever!" This brief judgment is to be found under the heading *Music*, evidently written by a specialist.

The stammering newborn work will always be regarded as a monster, even by those who find experiment fascinating. There will be some curiosity, of course, some gestures of interest, always some provision for the future. And some praise; though what is sincere will always be addressed to the vestiges of the familiar, to all those bonds from which the new work has not yet broken free and which desperately seek to imprison it in the past.

For if the norms of the past serve to measure the present, they also serve to construct it. The writer himself, despite his desire for independence, is situated within an intellectual culture and a literature which can only be those of the past. It is impossible for him to escape altogether from this tradition of which he is the product. Sometimes the very elements he has tried hardest to oppose seem, on the contrary, to flourish more vigorously than ever in the very work by which he hoped to destroy them; and he will be congratulated, of course, with relief for having cultivated them so zealously.

Hence it will be the specialists in the novel (novelists or critics, or overassiduous readers) who have the hardest time dragging themselves out of its rut.

Even the least conditioned observer is unable to see the world around him through entirely unprejudiced eyes. Not, of course, that I have in mind the naive concern for objectivity which the analysts of the (subjective) soul

find it so easy to smile at. Objectivity in the ordinary sense of the word—total impersonality of observation—is all too obviously an illusion. But *freedom* of observation should be possible, and yet it is not. At every moment, a continuous fringe of culture (psychology, ethics, metaphysics, etc.) is added to things, giving them a less alien aspect, one that is more comprehensible, more reassuring. Sometimes the camouflage is complete: a gesture vanishes from our mind, supplanted by the emotions which supposedly produced it, and we remember a landscape as *austere* or *calm* without being able to evoke a single outline, a single determining element. Even if we immediately think, "That's literary," we don't try to react against the thought. We accept the fact that what is *literary* (the word has become pejorative) functions like a grid or screen set with bits of different colored glass that fracture our field of vision into tiny assimilable facets.

And if something resists this systematic appropriation of the visual, if an element of the world breaks the glass, without finding any place in the interpretative screen, we can always make use of our convenient category of "the absurd" in order to absorb this awkward residue.

But the world is neither significant nor absurd. It *is*, quite simply. That, in any case, is the most remarkable thing about it. And suddenly the obviousness of this strikes us with irresistible force. All at once the whole splendid construction collapses; opening our eyes unexpectedly, we have experienced, once too often, the shock of this stubborn reality we were pretending to have mastered. Around us, defying the noisy pack of our animistic or protective adjectives, things *are there*. Their surfaces are distinct and smooth, *intact*, neither suspiciously brilliant nor transparent. All our literature has not yet succeeded in eroding their smallest corner, in flattening their slightest curve.

The countless movie versions of novels that encumber our screens provide an occasion for repeating this curious experiment as often as we like. The cinema, another heir of the psychological and naturalistic tradition, generally has as its sole purpose the transposition of a story into images: it aims exclusively at imposing on the spectator, through the intermediary of some well-chosen scenes, the same meaning the written sentences communicated in their own fashion to the reader. But at any given moment the filmed narrative can drag us out of our interior comfort and into this proffered world with a violence not to be found in the corresponding text, whether novel or scenario.

Anyone can perceive the nature of the change that has occurred. In the initial novel, the objects and gestures forming the very fabric of the plot disappeared completely, leaving behind only their *significations:* the empty chair became only absence or expectation, the hand placed on a shoulder became a sign of friendliness, the bars on the window became only the impossibility of leaving. . . . But in the cinema, one *sees* the chair, the movement of the hand, the shape of the bars. What they signify remains obvious, but instead

of monopolizing our attention, it becomes something added, even something in excess, because what affects us, what persists in our memory, what appears as essential and irreducible to vague intellectual concepts are the gestures themselves, the objects, the movements, and the outlines, to which the image has suddenly (and unintentionally) restored their *reality*.

It may seem peculiar that such fragments of crude reality, which the filmed narrative cannot help presenting, strike us so vividly, whereas identical scenes in real life do not suffice to free us of our blindness. As a matter of fact, it is as if the very conventions of the photographic medium (the two dimensions, the black-and-white images, the frame of the screen, the difference of scale between scenes) help free us from our own conventions. The slightly "unaccustomed" aspect of this reproduced world reveals, at the same time, the unaccustomed character of the world that surrounds us: it, too, is unaccustomed insofar as it refuses to conform to our habits of apprehension and to our classification.

Instead of this universe of "signification" (psychological, social, functional), we must try, then, to construct a world both more solid and more immediate. Let it be first of all by their *presence* that objects and gestures establish themselves, and let this presence continue to prevail over whatever explanatory theory that may try to enclose them in a system of references, whether emotional, sociological, Freudian or metaphysical.

In this future universe of the novel, gestures and objects will be *there* before being *something*; and they will still be there afterwards, hard, unalterable, eternally present, mocking their own "meaning," that meaning which vainly tries to reduce them to the role of precarious tools, of a temporary and shameful fabric woven exclusively—and deliberately—by the superior human truth expressed in it, only to cast out this awkward auxiliary into immediate oblivion and darkness.

Henceforth, on the contrary, objects will gradually lose their instability and their secrets, will renounce their pseudo-mystery, that suspect interiority which Roland Barthes has called "the romantic heart of things." No longer will objects be merely the vague reflection of the hero's vague soul, the image of his torments, the shadow of his desires. Or rather, if objects still afford a momentary prop to human passions, they will do so only provisionally, and will accept the tyranny of significations only in appearance—derisively, one might say—the better to show how alien they remain to man.

As for the novel's characters, they may themselves suggest many possible interpretations; they may, according to the preoccupations of each reader, accommodate all kinds of comment—psychological, psychiatric, religious, or political—yet their indifference to these "potentialities" will soon be apparent. Whereas the traditional hero is constantly solicited, caught up, destroyed by these interpretations of the author's, ceaselessly projected into an immaterial and unstable *elsewhere*, always more remote and blurred, the

future hero will remain, on the contrary, *there*. It is the commentaries that will be left elsewhere; in the face of his irrefutable presence, they will seem useless, superfluous, even improper.

Exhibit X in any detective story gives us, paradoxically, a clear image of this situation. The evidence gathered by the inspectors—an object left at the scene of the crime, a movement captured in a photograph, a sentence overheard by a witness—seem chiefly, at first, to require an explanation, to exist only in relation to their role in a context which overpowers them. And already the theories begin to take shape: the presiding magistrate attempts to establish a logical and necessary link between things; it appears that everything will be resolved in a banal bundle of causes and consequences, intentions and coincidences. . . .

But the story begins to proliferate in a disturbing way: the witnesses contradict one another, the defendant offers several alibis, new evidence appears that had not been taken into account. . . . And we keep going back to the recorded evidence: the exact position of a piece of furniture, the shape and frequency of a fingerprint, the word scribbled in a message. We have the mounting sense that nothing else is *true*. Though they may conceal a mystery, or betray it, these elements which make a mockery of systems have only one serious, obvious quality, which is to *be there*.

The same is true of the world around us. We had thought to control it by assigning it a meaning, and the entire art of the novel, in particular, seemed dedicated to this enterprise. But this was merely an illusory simplification; and far from becoming clearer and closer because of it, the world has only, little by little, lost all its life. Since it is chiefly in its presence that the world's reality resides, our task is now to create a literature which takes that presence into account.

All this might seem very theoretical, very illusory, if something were not actually changing—changing totally, definitively—in our relations with the universe. Which is why we glimpse an answer to the old ironic question, "Why now?" There is today, in fact, a new element that separates us radically this time from Balzac as from Gide or from Mme. de La Fayette: it is the destitution of the old myths of "depth."

We know that the whole literature of the novel was based on these myths, and on them alone. The writer's traditional role consisted in excavating Nature, in burrowing deeper and deeper to reach some ever more intimate strata, in finally unearthing some fragment of a disconcerting secret. Having descended into the abyss of human passions, he would send to the seemingly tranquil world (the world on the surface) triumphant messages describing the mysteries he had actually touched with his own hands. And the sacred vertigo the reader suffered then, far from causing him anguish or nausea, reassured him as to his power of domination over the world. There

were chasms, certainly, but thanks to such valiant speleologists, their depths could be sounded.

It is not surprising, given these conditions, that the literary phenomenon par excellence should have resided in the total and unique adjective, which attempted to unite all the inner qualities, the entire hidden soul of things. Thus the word functioned as a trap in which the writer captured the universe in order to hand it over to society.

The revolution which has occurred is in kind: not only do we no longer consider the world as our own, our private property, designed according to our needs and readily domesticated, but we no longer even believe in its "depth." While essentialist conceptions of man met their destruction, the notion of "condition" henceforth replacing that of "nature," the *surface* of things has ceased to be for us the mask of their heart, a sentiment that led to every kind of metaphysical transcendence.

Thus it is the entire literary language that must change, that is changing already. From day to day, we witness the growing repugnance felt by people of greater awareness for words of a visceral, analogical, or incantatory character. On the other hand, the visual or descriptive adjective, the word that contents itself with measuring, locating, limiting, defining, indicates a difficult but most likely direction for a new art of the novel.

F I V E

Process and Materials

Richard Serra (American, b. 1939), throwing lead. 1969. Castelli warehouse. © 2000. Richard Serra/Artists Rights Society (ARS), New York. Photo by Gianfranco Gorgone.

Richard Serra, *Splashing*. 1968. Lead, 18 x 312 in., installed Castelli warehouse 1968. Piece destroyed. © 2000 Richard Serra/Artists Rights Society (ARS), New York. Photo by Peter Moore.

Artists

Robert Morris
Anti Form (1968)

Associated with Minimalism in the early 1960s, the artist Robert Morris started formulating a new set of concerns by the end of that decade. Using the inseparability of process and form in the work of Jackson Pollock as a starting point, Morris began to reinvestigate the nature of materials. He held on to some of the literalness of Minimalism, but shifted from using ridged to using flexible materials. The result was an art that was less concerned with a completed, well-built form than with process.

By integrating process with an investigation into the nature of materials, Morris wanted to move beyond what he called the European tradition of aestheticizing general forms. Morris's critique of constructed forms, "Anti Form," which was published in

Artforum in April 1968, builds on the Minimalist challenge to conventional notions of relational composition. In works such as "Untitled, 1968"—in which Morris seemingly randomly scattered thread waste, mirrors, asphalt, aluminum, lead, felt, copper, and steel onto the floor—gravity appears to play a larger role than construction. In addition to making sculpture, Robert Morris also created and performed in dances with the experimental Judson Dance Theater troupe.

In recent object-type art the invention of new forms is not an issue. A morphology of geometric, predominantly rectangular forms has been accepted as a given premise. The engagement of the work becomes focused on the particularization of these general forms by means of varying scale, material, proportion, placement. Because of the flexibility as well as the passive, unemphasized nature of object-type shape it is a useful means. The use of the rectangular has a long history. The right angle has been in use since the first post and lintel constructions. Its efficiency is unparalleled in building with rigid materials, stretching a piece of canvas, etc. This generalized usefulness has moved the rectangle through architecture, painting, sculpture, objects. But only in the case of object-type art have the forms of the cubic and the rectangular been brought so far forward into the final definition of the work. That is, it stands as a self-sufficient whole shape rather than as a relational element. To achieve a cubic or rectangular form is to build in the simplest, most reasonable way, but it is also to build well.

This imperative for the well-built thing solved certain problems. It got rid of asymmetrical placing and composition, for one thing. The solution also threw out all non-rigid materials. This is not the whole story of so-called Minimal or Object art. Obviously it does not account for the use of purely decorative schemes of repetitive and progressive ordering of multiple unit work. But the broad rationality of such schemes is related to the reasonableness of the well-built. What remains problematic about these schemes is the fact that any order for multiple units is an imposed one which has no inherent relation to the physicality of the existing units. Permuted, progressive, symmetrical organizations have a dualistic character in relation to the matter they distribute. This is not to imply that these simple orderings do not work. They simply separate, more or less, from what is physical by making relationships themselves another order of facts. The relationships such schemes establish are not critical from point to point as in European art. The duality is established by the fact that an order, any order, is operating beyond the physical things. Probably no art can completely resolve this. Some art, such as Pollock's, comes close.

The process of "making itself" has hardly been examined. It has only received attention in terms of some kind of mythical, romanticized polarity: the so-called action of the Abstract Expressionists and the so-called conceptualizations of the Minimalists. This does not locate any differences between the two types of work. The actual work particularizes general assumptions about forms in both cases. There are some exceptions. Both

ways of working continue the European tradition of aestheticizing general forms that has gone on for half a century. European art since Cubism has been a history of permuting relationships around the general premise that relationships should remain critical. American art has developed by uncovering successive alternative premises for making itself.

Of the Abstract Expressionists only Pollock was able to recover process and hold on to it as part of the end form of the work. Pollock's recovery of process involved a profound re-thinking of the role of both material and tools in making. The stick which drips paint is a tool which acknowledges the nature of the fluidity of paint. Like any other tool it is still one that controls and transforms matter. But unlike the brush it is in far greater sympathy with matter because it acknowledges the inherent tendencies and properties of that matter. In some ways Louis was even closer to matter in his use of the container itself to pour the fluid.

To think that painting has some inherent optical nature is ridiculous. It is equally silly to define its "thingness" as acts of logic that acknowledge the edges of the support. The optical and the physical are both there. Both Pollock and Louis were aware of both. Both used directly the physical, fluid properties of paint. Their "optical" forms resulted from dealing with the properties of fluidity and the conditions of a more or less absorptive ground. The forms and the order of their work were not *a priori* to the means.

The visibility of process in art occurred with the saving of sketches and unfinished work in the High Renaissance. In the nineteenth century both Rodin and Rosso left traces of touch in finished work. Like the Abstract Expressionists after them, they registered the plasticity of material in autobiographical terms. It remained for Pollock and Louis to go beyond the personalism of the hand to the more direct revelation of matter itself. How Pollock broke the domination of Cubist form is tied to his investigation of means: tools, methods of making, nature of material. Form is not perpetuated by means but by preservation of separable idealized ends. This is an anti-entropic and conservative enterprise. It accounts for Greek architecture changing from wood to marble and looking the same, or for the look of Cubist bronzes with their fragmented, faceted planes. The perpetuation of form is functioning Idealism.

In object-type art process is not visible. Materials often are. When they are, their reasonableness is usually apparent. Rigid industrial materials go together at right angles with great ease. But it is the *a priori* valuation of the well-built that dictates the materials. The well-built form of objects preceded any consideration of means. Materials themselves have been limited to those which efficiently make the general object form.

Recently, materials other than rigid industrial ones have begun to show up. Oldenburg was one of the first to use such materials. A direct investigation of the properties of these materials is in progress. This involves a reconsideration of the use of tools in relation to material. In some cases these investigations move from the making of things to the making of material itself. Sometimes a direct manipulation of a given material without the use of

any tool is made. In these cases considerations of gravity become as important as those of space. The focus on matter and gravity as means results in forms which were not projected in advance. Considerations of ordering are necessarily casual and imprecise and unemphasized. Random piling, loose stacking, hanging, give passing form to the material. Chance is accepted and indeterminacy is implied since replacing will result in another configuration. Disengagement with preconceived enduring forms and orders for things is a positive assertion. It is part of the work's refusal to continue aestheticizing form by dealing with it as a prescribed end.

Eva Hesse
An Interview with Eva Hesse (by Cindy Nemser)
(1970)

Eva Hesse exhibited in three of the defining post-Minimalist exhibitions of the 1960s: *Eccentric Abstraction* at the Fischbach Gallery (1966); *9 at Castelli* at the warehouse of the art dealer Leo Castelli (1968); and *Anti-Illusion: Procedures/Materials* at the Whitney Museum of American Art (1969). Like Robert Morris and Richard Serra, Hesse was engaged by the creative possibilities inherent in certain materials. For Hesse, translucent and luminous materials such as latex and fiberglass connected with the psychological and often very personal nature of what she was communicating in her work. Like Morris, Hesse was interested in moving beyond the formal rigor of Minimalism, but she was less concerned with theorizing her way into an antiformalist position than with grappling with how to make sculptural form embody deeply felt personal struggles. When asked about how it would be possible to ignore the formal aspects of art, Hesse answered, "So I am stuck with aesthetic problems. But I want to reach out past . . . I want to give greater significance to my art. I want to extend my art perhaps into something that doesn't exist yet. . . ." This interview, conducted by the critic Cindy Nemser, was published in *Artforum* in 1970, the same year as Hesse's death at the age of thirty-four.

Do you identify with any particular school of painting?

I don't think I ever did any traditional paintings—except what you call Abstract Expressionism. I most loved de Kooning and Gorky, but that was personal—not for what I could take from them. But I know the importance of Kline and Pollock and now I would say Pollock before anyone, but I didn't feel that way when I was growing up. Oldenburg is an artist that I really believe in. I respect his writings, his person, his energy, his art, the whole thing. He has humor, and he has his own use of materials. But I don't think I've taken or used those materials in any way. I don't think I've ever done that with anybody's work. To me, Oldenburg is wholly abstract. The same with Andy Warhol. He too is high on my favorite list . . . He is the most as an artist

that you could be. His art and his statements and his person are so equivalent. He and his work are the same. It is what I want to be, the most Eva can be as an artist and as a person . . . I feel very close to Carl Andre. I feel, let's say, emotionally connected to his work. It does something to my insides. His metal plates were the concentration camp for me.

If Carl knew your response to his work what would be his reaction?

I don't know! Maybe it would be repellent to him that I would say such a thing about his art. He says you can't confuse life and art. But I think art is a total thing. A total person giving a contribution. It is an essence, a soul, and that's what it's about . . . In my inner soul art and life are inseparable. It becomes more absurd and less absurd to isolate a basically intuitive idea and then work up some calculated system and follow it through—that supposedly being the more intellectual approach—than giving precedence to soul or presence or whatever you want to call it . . . I am interested in solving an unknown factor of art and an unknown factor of life. For me it's a total image that has to do with me and life. It can't be divorced as an idea or composition or form. I don't believe art can be based on that. In fact my idea now is to counteract everything I've ever learned or been taught about those things—to find something that is inevitable that is my life, my feeling, my thoughts. This year, not knowing whether I would survive or not was connected with not knowing whether I would ever do art again. One of my first visions when I woke up from my operation was that I didn't have to be an artist to justify my existence, that I had a right to live without being one.

How do you feel about craftsmanship in the process of your work?

I do think there is a state of quality that is necessary, but it is not based on correctness. It has to do with the quality of the piece itself and nothing to do with neatness or edges. It's not the artisan quality of the work, but the integrity of the piece . . . I'm not conscious of materials as a beautiful essence . . . For me the great involvement is for a purpose—to arrive at an end—not that much of a thing in itself . . . I am interested in finding out through working on the piece some of the potential and not the preconceived . . . As you work, the piece itself can define or redefine the next step, or the next step combined with some vague idea . . . I want to allow myself to get involved in what is happening and what can happen and be completely free to let that go and change . . . I do, however, have a very strong feeling about honesty—and in the process, I like to be, it sounds corny, true to whatever I use, and use it in the least pretentious and most direct way . . . If the material is liquid, I don't just leave it or pour it. I can control it, but I don't really want to change it. I don't want to add color or make it thicker or thinner. There isn't a rule. I don't want to keep any rules. That's why my art might be so good, because I have no fear. I could take risks . . . My attitude toward art is most open. It is totally unconservative—just freedom and willingness to work. I really walk on the edge . . .

How do the materials relate to the content of your work?

It's not a simple question for me . . . First, when I work it's only the abstract qualities that I'm working with, which is the material, the form it's going to take, the size, the scale, the positioning, where it comes from, the ceiling, the floor . . . However I don't value the totality of the image on these abstract or aesthetic points. For me, as I said before, art and life are inseparable. If I can name the content, then maybe on that level, it's the total absurdity of life. If I am related to certain artists it is not so much from having studied their works or writings, but from feeling the total absurdity in their work.

Which artists?

Marcel Duchamp, Yvonne Rainer, Jasper Johns, Carl Andre, Sartre, Samuel Beckett . . .

Absurdity?

It's so personal . . . Art and work and art and life are very connected and my whole life has been absurd. There isn't a thing in my life that has happened that hasn't been extreme—personal health, family, economic situations. My art, my school, my personal friends were the best things I ever had. And now back to extreme sickness—all extreme—all absurd. Now art being the most important thing for me, other than existing and staying alive, became connected to this, now closer meshed than ever, and absurdity is the key word . . . It has to do with contradictions and oppositions. In the forms I use in my work the contradictions are certainly there. I was always aware that I should take order versus chaos, stringy versus mass, huge versus small, and I would try to find the most absurd opposites or extreme opposites . . . I was always aware of their absurdity and also their formal contradictions and it was always more interesting than making something average, normal, right size, right proportion . . .

How about motifs, the circle for instance? You used it quite frequently in your early work.

I think that there is a time element in my use of the circle. It was a sequence of change and maturation. I think I am less involved in it now . . . In the last works I did, just about a year ago, I was less interested in a specific form like the circle or square or rectangle . . . I was really working to get to a non-anthropomorphic, non-geometric, non-non . . .

When I came back from Europe, about 1965–1966, I did a piece called *Hangup*. It was the most important early statement I made. It was the first time my idea of absurdity or extreme feeling came through. It was a huge piece, six feet by seven feet. The construction is really very naive. If I now were to make it, I'd construct it differently. It is a frame, ostensibly, and it sits on the wall with a very thin, strong but easily bent rod that comes out of it. The frame is all cord and rope. It's all tied up like a hospital bandage—as if

someone broke an arm. The whole thing is absolutely rigid, neat cord around the entire thing . . . It is extreme and that is why I like it and don't like it. It's so absurd to have that long thin metal rod coming out of that structure. And it comes out a lot, about ten or eleven feet out, and what is it coming out of? It is coming out of this frame, something and yet nothing and—oh, more absurdity!—is very, very finely done. The colors on the frame were carefully gradated from light to dark—the whole thing is ludicrous. It is the most ridiculous structure that I ever made and that is why it is really good. It has a kind of depth I don't always achieve and that is the kind of depth or soul or absurdity or life or meaning or feeling or intellect that I want to get . . . I know there is nothing unconnected in this world, but if art can stand by itself, these really were alone. And there was no one doing anything like this at the time. I mean it was totally absurd to everybody. That was the height of Minimal and Pop—not that I care—all I wanted was to find my own scene—my own world—inner peace or inner turmoil, but I wanted it to be mine.

You did a piece called Ennead *in 1965 that starts out symmetrical and ends up in a chaotic tangle.*

Yes. It started out perfectly symmetrical at the top and everything was perfectly planned. The strings were gradated in color as well as the board from which they came. Yet it ended up in a jumble of string . . . The strings were very soft and each came from one of the circles. Although I wove the string equally in the back (in the back of the piece you can see how equal they are) and it could be *arranged* to be perfect, since they are all the same length, as soon as they started falling down, they went different ways and as they got further toward the ground the more chaotic they got . . . I've always opposed content to form or just form to form. There is always divergency . . . That huge box I did in 1967, I called it *Accession*. I did it first in metal, then in fiberglass. On the outside it takes the form of a square, a perfect square, and the outside is very, very clear. The inside, however, looks amazingly chaotic, although it's the same pieces of hose going through. It's the same thing, but as different as it could possibly be . . . But it is a little too precious from where I stand now. It's too beautiful, like a gem, and too right. I'd like to do a little more wrong at this point . . .

Why do you repeat a form over and over again?

Because it exaggerates. If something is meaningful, maybe it's more meaningful said ten times. It's not just an aesthetic choice. If something is absurd, it's much more exaggerated, more absurd if it's repeated . . . I don't think I always do it, but repetition does enlarge or increase or exaggerate an idea or purpose in a statement . . . At times I thought, "The more thought the greater the art," but now I wonder about that . . . I think there is a lot that I'll just let happen and maybe it will come out the better for it . . . Maybe if I really believe in me, trust me, without any calculated plan, who knows what will happen . . .

You mentioned Duchamp before as an artist you felt close to. Perhaps you are also involved with the element of chance, say in a work like Sequel?

Yes, it's all loose. It's at random. The circles can be manipulated at random. The only limitation is the mat and these shapes could roll off the mat because they're basically cylindrical . . . The piece is made of half spheres that are rigid. They were cast from half balls and then they were put together again but not completely. They were put together with an opening so that the whole thing was "squooshy." It was a solid ball but it wasn't a solid ball, it's collapsible and it's not collapsible because it's rubber, and then it's cylindrical, but yet it's not, but the balls could still be moved. The whole thing is ordered but again there's that duplicity. But this is an old piece and it interests me less of course as a problem. Again that duplicity—before I said I was not interested in formal problems, but *Sequel* obviously represented a formal problem to me.

Is there another work that particularly embodies your impulses towards contradictions?

There is a piece called *Area* which I did in 1968 that I made out of the mold of another piece which was *Repetition 19*. I took the bottoms of the containers and rubberized the forms, attached them, and sewed them together. It's twenty feet long and I have a personal attachment to the piece. The pieces are totally disconnected. *Repetition 19* was made of empty containers and there was that sexual connotation—it is anthropomorphic. *Area* isn't, or is in a totally different way. It is used as a flat piece with a suggestive three-dimensionality. *Area* is so ugly, I mean the color, *Repetition 19* is clear fiberglass.

Your most recent work seems more free and daring than ever.

I would like to do that now—well, why not? I used to plan a lot and do everything myself. Then I started to take the chance—no, I needed the help. It was a little difficult at first. I worked with two people, but we got to know each other well enough, and I got confident enough, and just prior to when I was sick I would not state the problem or plan the day. I would let more happen and let myself be used in a freer way and they also—their participation was more their own, more flexible. I wanted to see within a day's work or within three days' work what we would do together with a general focus but not anything specified. I really would like, when I start working again, to go further into this whole process. It doesn't mean total chance, but more freedom and openness.

Has the new openness changed your work?

I can think of one thing that it changed. Prior to that time, the process of my work used to take a long time. First because I did most of it myself, and then when I planned the larger pieces and worked with someone, they were more formalistic. Then, when we started working less formalistically or with greater chance the whole process became speeded up. When we did one of the pieces at the Whitney that I love the most, the ladderlike piece, *Vinculum I*, it took a

very short time. It was a very complex piece, but the whole attitude was different, and that is more the attitude that I want to work with now, in fact, even increased, even more exaggerated . . . That was one of the last pieces I did before I got so ill. It was one of the pieces we started working on with less plan. I just described the vague idea to two people I worked with, and we went and just started doing it. There were a few things that I said to one of the people that I worked with. I said I wanted to make a pole. He made a perfect pole—it wasn't what I meant at all. So we started again and then he understood . . .

Vinculum II *also seems involved with chance elements, particularly in its potential for movement.*

Vinculum II is connected to the ladder piece in that it is made with the same rubber hosing. But *Vinculum I* is solid and staid and inflexible except for the hose, while *Vinculum II*, though very similar, is totally flexible. There isn't anything that can be staid or put. All these parts can be moved, every connection is movable. So it has a very fragile, tenuous quality. It is very, very taut as it is attached from two angles. There is lots of tension, yet the whole thing is flexible and moves. It's made of wire mesh with fiberglass and the parts are just stapled so they can really go up and down; they are positioned but they can be moved. And then through the wire and fiberglass is a hole and these irregular rubber hoses go through them. They're all different lengths. Everything is tenuous because the hoses are not really knotted very tight and they can change and I don't mind it, within reason.

You said you weren't interested in environmental pieces, yet Expanded Expansion, *with its size and presence has an environmental quality.*

I guess this is the closest thing I've done to an environment. It is leaning against the wall like a curtain and the scale might make it superficially environmental but that's not enough . . . I thought I would make more of it, but sickness prevented that—then it could actually be extended to a length one would really feel would be environmental. This piece does have an option . . . I think that what confuses people in a piece like this is that it's so silly and yet it is made fairly well. Its ridiculous quality is contradicted by its definite concern about its presentation . . .

What about Right After?

I want to tell you about the background of that work. I have to go back a bit, because it's relative. I started the initial idea a year ago. The idea totalled before I was sick. The piece was strung in my studio for a whole year. So I wasn't in connectiveness with it when I went back to it, but I visually remembered it. I remembered what I wanted to do with the piece and at that point I should have left it, because it was really daring. It was very, very simple and very extreme because it looked like a really big nothing which was one of the things that I so much wanted to be able to achieve. I wanted to totally throw myself into a vision that I would have to adjust to and learn to

understand . . . But coming back to it after a summer of not having seen it, I felt it needed more work, more completion and that was my mistake. It left the ugly zone and went to the beauty zone. I didn't mean it to do that.

You found it too decorative?

I don't want to even use this word because I don't want it to be used in any interview of mine, connected with my work. To me that word, or the way I use it or feel about it, is the only art sin. I can't stand gushy movies, pretty pictures and pretty sculptures, decorations on the walls, pretty colors, red, yellow, and blue, nice parallel lines make me sick . . .

Getting back to Right After . . .

My original statement was so simple and there wasn't that much there, just irregular wires and very little material. It was really absurd and totally strange and I lost it. So now I am attempting to do it in another material, in rope, and I think I'll get much better results with this one.

How can you ignore the formal aspects of art?

So I am stuck with aesthetic problems. But I want to reach out past . . . I want to give greater significance to my art. I want to extend my art perhaps into something that doesn't exist yet . . .

Like falling off the edge?

That's a nice way of saying it. Yes, I would like to do that.

Bruce Nauman
Nauman Interview (by Willoughby Sharp) (1970)

By the end of the 1960s Bruce Nauman had made a unique and diverse body of work using a variety of materials—including fiberglass, neon, and rubber—as well as created performance pieces, photographs, and videos. The main point of convergence for Nauman's art from the 1960s is the use of his own body as the starting point for the work, as with the descriptively titled *Neon Templates of the Left Half of My Body, Taken at Ten-Inch Intervals* from 1966. Other works from the mid-1960s are films he made of himself engaged in physical activities like pacing around his studio.

In this interview by the critic Willoughby Sharp, which was published in *Arts Magazine* in March 1970, Nauman describes his creative process as follows: "I think of it as going into the studio and being involved in some activity. Sometimes it works out that the activity involves making something and sometimes that the activity is the piece." Whether or not the end result of the scaled-down, focused

deeds that constitute Nauman's art are objects, his work reads as an exposure of the creative process. Nauman's art is more like the residue of a purposeful action than an embodiment of theoretical principles or the search for metaphorically evocative forms. In this sense Nauman's art challenges the conventional notion that art-making transforms relatively neutral materials into transcendent objects.

Within the last five years, Bruce Nauman has produced a highly complex body of work which retains strong affinities with the new sculpture but is quite independent from its dominant modes of expression. He began making sculpture in 1965 as a graduate student at the University of California—narrow fiberglass strips cast in a sketchy manner from plywood molds so that each work has a rough and ragged look resembling what is now referred to as Poor Art. Later that year, he did a series of latex mats backed with cloth, which hung from the wall or were heaped on the floor; but by the time of his first one-man show at Nicholas Wilder's Los Angeles gallery early in 1966, Nauman had outgrown these kinds of sculptural concerns and began to explore a wider range of media. He started filming physical activities like bouncing balls and pacing around the studio so that these everyday events were also incorporated into his oeuvre. That year he made about twenty pieces of sculpture using unusual materials like aluminum foil, foam rubber, felt, grease, galvanized iron, cardboard, lead and vinyl in which lengthy explicit titles play a crucial role in the conception and understanding of the artistic enterprise. A work such as *Collection of Various Flexible Materials Separated by Layers of Grease with Holes the Size of My Waist and Wrists* would be unintelligible without reference to its mildly ironic title. Aside from an isolated outdoor work, *Lead Tree Plaque,* bearing the inscription "A ROSE HAS NO TEETH"; most of the sculptural objects from late 1966 are concerned with seeing the human body in new ways. The subject and scale of these works is often a direct ratio of unusual measurements taken from sections of the body. To realize the punning piece, *From Hand to Mouth* (1967), Nauman cast that part of his own body in plaster and pea green wax, an introspective and detached statement of a self-mocking sensibility. After moving to New York for his one-man exhibition at the Leo Castelli Gallery in January 1968, he started producing videotapes, one of which shows him saying "lip sync" as it gradually goes out of sync.

The presentation of the body in straightforward physical movements is a recurring theme of Nauman's recent work as seen in several of his latest one-man exhibitions. He showed *Six Sound Problems*—"Walking and bouncing balls," "Violin sounds in the gallery," etc.—in July 1968 at Konrad Fischer's Düsseldorf gallery; the *Making Faces* holograms at Ileana Sonnabend's Paris gallery in December 1969; and a video performance piece at the Nicholas Wilder Gallery in March 1970.

W.S.: What are you doing for your one-man show at the Nicholas Wilder Gallery this month?

B.N.: The piece I want to do will have a set of walls running the whole length of the forty-foot-long gallery. The distance between the walls will vary from about three

feet to about two or three inches, forming corridors, some of which can be entered and some of which can't. Within the wider corridors, some television cameras will be set up with monitors so that you can see yourself. Body parts of me or someone else going in and out of those corridors will also be shown on videotape. Sometimes you'll see yourself and sometimes you'll see a videotape of someone else. The cameras will be set upside down or at some distance from the monitor so that you will only be able to see your back. I have tried to make the situation sufficiently limiting, so that spectators can't display themselves very easily.

W.S.: Isn't that rather perverse?

B.N.: Well, it has more to do with my not allowing people to make their own performance out of my art. Another problem that I worked out was using a single wall, say twenty feet long, that you can walk around. If you put a television camera at one end and the monitor around the corner, when you walk down the wall you can see yourself just as you turn the corner, but only then. You can make a square with the same function—as you turn each corner, you can just see your back going around the corner. It's another way of limiting the situation so that someone else can be a performer, but he can do only what I want him to do. I mistrust audience participation. That's why I try to make these works as limiting as possible.

W.S.: This work seems like an extension of your *Performance Corridor*.

B.N.: Yes, that work consisted of two parallel walls twenty inches apart. Originally, it was just a prop for a videotape I was making in my Southampton studio of me walking up and down the corridor.

W.S.: I don't think many people realized they were supposed to enter it.

B.N.: Well, that was difficult. I didn't want to write it down, or have an arrow, so it was left open. That piece is important because it gave me the idea that you could make a participation piece without the participants being able to alter your work.

W.S.: Was it only possible to get in from one end?

B.N.: Yes, it ran directly into the wall, like a channel. It was much rougher in the studio, because you could only see down the corridor on the videotape. I walked very slowly toward and away from the camera, one step at a time. My hands were clasped behind my neck, and I used a very exaggerated contraposto motion.

W.S.: How did the videotape read?

B.N.: The way you saw it, the camera was placed so that the walls came in at either side of the screen. You couldn't see the rest of the studio, and my head was cut off most of the time. The light was shining down the length of the corridor and made shadows on the walls at each side of me.

W.S.: It is significant that your head couldn't be seen?

B.N.: In most of the pieces I made last year, you could see only the back of my head, pictures from the back or from the top. A lot of people asked why I did that.

W.S.: There is a similar attitude in some of your objects, like *Henry Moore Bound to Fail (back view)*.

B.N.: Someone said that it made the pieces more about using a body than autobiographical.

W.S.: Do you ever let others carry out your works?

B.N.: I always prefer to do them myself, although I've given instructions to someone else from time to time. It's a bit more difficult than doing it myself; I have to make the instructions really explicit, because I trust myself as a performer more than I do others. What I try to do is to make the situation sufficiently specific, so that the dancer can't interpret his position too much.

W.S.: Could you say something about your relation to the California scene, because the contribution of West Coast artists is often overlooked.

B.N.: The artists that I knew in San Francisco were a little older than I am and had lived there a long time. They were connected to a hiding-out tradition. I think that had something to do with the confusion about my work. When people first saw it, they thought it was Funk Art. In my mind it had nothing to do with that, it just wasn't in my background at Wisconsin. It looked like it in a way but really I was just trying to present things in a straightforward way without bothering to shine them and clean them up.

W.S.: What works were you doing then?

B.N.: Plastic pieces and rubber pieces, the 1965 fiberglass things on the floor. I was still in school then, and I don't know that they're particularly strong works. I still like some of the rubber pieces and a couple of the fiberglass ones.

W.S.: In what ways are you critical of them now?

B.N.: I don't think they were really clear. A little later, in 1966, I started to feel that they were like doing things with sculpture, and that I wasn't doing work based on my thinking. I didn't know what to do with those thoughts. So I stopped making that kind of work and then I did the first pieces with neon and with wax.

W.S.: How were the early pieces unclear?

B.N.: It is difficult to think about them. They involved simple things like making a mold, taking the two halves and putting them together to make a hollow shape and turning it inside out. I tried to create a confusion between the inside and outside of a piece. One side is smooth so that it looks like the outside, and the other is rough because that's the way the fiberglass is cast, but you can see it as well.

W.S.: So there were formal considerations and technical problems.

B.N.: But I wanted to get beyond those problems. So when I made the rubber pieces, I used the same kinds of molds but on soft materials. Then I made the neon piece of my name exaggerated fourteen times.

W.S.: The latex rubber floor piece which you did in 1965–1966 seems to be a prototype of your late work. How was that made?

B.N.: Well, that work consists of four or five pieces of latex rubber which were all cast in the same shape, fastened together painted slightly different colors and just dropped on the floor. There were others. I think the one Walter Hopps has is one of the best, it is about seven or eight feet long and ten inches wide, with slits cut down the length of it. It's hung by one strip so that it drops open.

W.S.: What led you to start cutting into materials?

B.N.: It was a specific formal problem. I was making those pieces when I was still at graduate school at Davis in California. The first real change came after that when I had a studio. I was working very little, teaching a class one night a week, and I didn't know what to do with all that time. I think that's when I did the first casts of my body and the name parts and things like that. There was nothing in the studio because I didn't have much money for materials. So I was forced to examine myself, and what I was doing there. I was drinking a lot of coffee, that's what I was doing.

W.S.: Have your feelings about using your own body in your work changed since then?

B.N.: No, not really. It's getting a little clearer to me now. At that time it took the form of acting out puns, like in *From Hand to Mouth*. Now I can make dance pieces and I can go back to something like *Performances Corridor* for a very simple problem.

W.S.: Doesn't *From Hand to Mouth*, which is a wax impression of a part of your body, have different concerns from a performance or a videotape?

B.N.: Well, it does. But the only things that I could think of doing at that time were presenting these objects as extensions of what I was thinking about in the studio.

W.S.: What were you thinking about when you made *From Hand to Mouth?*

B.N.: Well, things like language games and making objects and how I could put those together.

W.S.: You almost had to make an object. That's what an artist did, so you did that. But a pun became a way of going beyond just making an object.

B.N.: That's more or less it. I was very involved with making objects. But also at about that time I did *Flour Arrangements*. I did those to see what would happen in an unfamiliar situation. I took everything out of my studio so that *Flour Arrangements* became an activity which I could do every day, and it was all I would allow myself to do for about a month. Sometimes it got pretty hard to think of different things to do every day.

W.S.: You forced yourself to do flour arranging rather than make something?

B.N.: Yes, and a lot of the work after that deals with the same problem, like the films of bouncing two balls in the studio and pacing in the studio. Playing the violin was a more arbitrary situation, because I didn't know how to play the violin. Some were very logical, like pacing, because that's just what I was doing around the studio. My activities were reasonably straightforward.

W.S.: There seems to be a great diversity in your work, from *Flour Arrangements* to the films.

B.N.: I've always had overlapping ways of going about my work. I've never been able to stick to one thing.

W.S.: Would you say that *Flour Arrangements* was a test of your strength?

B.N.: Yes, I suppose it was a way of testing yourself to find out if you are really a professional artist. That's something I was thinking about at the time.

W.S.: Is that still a problem?

B.N.: No. Last year I was reading *Dark is the Grave wherein my Friend is Laid*, Malcolm Lowry's last book . . . it's a complicated situation. The main character, an alcoholic writer, has problems finishing his book and with his publishers. He is sure that other writers know when their books are finished and how to deal with publishers and with their own lives. I suppose it's the normal artist's paranoia and that was more or less the way I felt at the time, kind of cut off, just not knowing how to proceed at being an artist.

W.S.: You often use words in your work, but you mistrust them a lot, don't you.

B.N.: My work relies on words less and less. It has become really difficult to explain the pieces. Although it's easier to describe them now, it's almost impossible to explain what they do when you're there. Take *Performance Corridor* which I've already talked about. It's very easy to describe how the piece looks, but the experience of walking inside it is something else altogether which can't be described. And the pieces increasingly have to do with physical or physiological responses.

W.S.: Could you describe some of the word pieces?

B.N.: Well, a couple of years ago I made a piece called *Dark*. It's just a steel plate with the word "Dark" written on the bottom. I don't know how good it is but it seemed to be a germinal piece to me.

W.S.: In what way?

B.N.: The feeling of the weight of the piece. I thought I made a good job of getting the word with the piece, having the word "Dark" underneath so that you can't see it.

W.S.: Could you have used other words?

B.N.: I did think of the word "Silent," but that was the only other word I really considered.

W.S.: Is it absolutely necessary to have the word there?

B.N.: If I did the piece now I probably wouldn't put the word there. But it seems that having the word there helps you think about that bottom side and what it might be like under there.

W.S.: What is your attitude to making outdoor works now?

B.N.: Well, last fall I designed a couple of other pieces for outdoors. One is simply to drill a hole into the heart of a large tree and put a microphone in it. The amplifier and speaker are put in an empty room so that you can hear whatever sound might come out of the center of the tree. Another one had to do with placing odd-shaped steel plates and mirrors over a large shrub garden—that was the only work in which I tried to put objects outside, and even in that case it's not really a natural situation because it was supposed to be in a garden rather than out in nature. But neither of them has been done.

W.S.: One of your most striking works is *Portrait of the Artist as a Fountain*. Is that one of your first photographic works?

B.N.: Yes.

W.S.: How did you come to do that?

B.N.: I don't know.

W.S.: Did you take several photographs of that piece?

B.N.: Yes. There was also a black and white photograph taken in a garden.

W.S.: To present a photograph as a work in 1966 was pretty advanced. There weren't very many sculptors, I can't think of any, who were presenting photographs as the work at that time. Can you say anything about what made you decide to do it?

B.N.: Well, I've always been interested in graphics, prints, drawings and paintings and I was a painter before I started making sculpture. I guess I first started using photographs to record *Flour Arrangements*. Then I started thinking about the *Fountain* and similar things. I didn't know how to present them. I suppose I might have made them as paintings if I had been able to make paintings at that time. In fact, I think I did get some canvas and paint but I had no idea of how to go about making a painting anymore. I didn't know what to do. Perhaps if I had been a good enough painter I could have made realistic paintings. I don't know, it just seemed easier to make the works as photographs.

W.S.: In *Flour Arrangements*, the photographs documented a work, whereas in *Portrait of the Artist as a Fountain* the photo documented you as a work. Does that mean that you see yourself as an object in the context of the piece?

B.N.: I use the figure as an object. More recently that's roughly the way I've been thinking, but I didn't always. And when I did those works, I don't think such differences or similarities were clear to me. It's still confusing. As I said before, the problems involving figures are about the figure as an object, or at least the figure as a person and the things that happen to a person in various situations—to most people rather than just to me or one particular person.

W.S.: What kind of performance pieces did you do in 1965?

B.N.: I did a piece at Davis which involved standing with my back to the wall for about forty-five seconds or a minute, leaning out from the wall, then bending at

the waist, squatting, sitting and finally lying down. There were seven different positions in relation to the wall and floor. Then I did the whole sequence again standing away from the wall, facing the wall, then facing left and facing right. There were twenty-eight positions and the whole presentation lasted for about half an hour.

W.S.: Did it relate to sculptural problems that you were thinking about then?

B.N.: Yes, that was when I was doing the fiberglass pieces that were inside and outside, in which two parts of the same mold were put together.

W.S.: Did you identify your body with those fiberglass pieces?

B.N.: Yes. In a way I was using my body as a piece of material and manipulating it.

W.S.: Then there is a body-matter exchange which plays a very strong part in your thinking?

B.N.: Yes. I had another performance piece in 1965; I manipulated an eight-foot fluorescent light fixture. I was using my body as one element and the light as another, treating them as equivalent and just making shapes.

W.S.: I see that there is a close correlation between the performances and the sculptural objects such as the fiberglass works.

B.N.: I think of it as going into the studio and being involved in some activity. Sometimes it works out that the activity involves making something, and sometimes that the activity is the piece.

W.S.: Could you talk more specifically about a performance piece and a sculptural object that are based on similar ideas?

B.N.: Well, take the twenty-eight positions piece and the fiberglass pieces. I vaguely remember making lists of things you could do to a straight bar: bend it, fold it, twist it; and I think that's how the performance piece finally came about, because it was just that progression of actions, standing, leaning, etc. which I carried out. I don't know whether it was that clear.

W.S.: How did you come to use videotape in the first instance?

B.N.: When I was living in San Francisco, I had several performance pieces which no museum or gallery was interested in presenting. I could have rented a hall, but I didn't want to do it that way. So I made films of the pieces, the bouncing balls and others. Then we moved to New York, and it was harder to get film equipment. So I got the videotape equipment which is a lot more straightforward to work with.

W.S.: How did the change from film to videotape affect the pieces?

B.N.: Mainly they got longer. My idea was to run the films as loops, because they have to do with ongoing activities. The first film I made, *Fishing for Asian Carp*, began when a given process started and continued until it was over. Then that became too much like making movies, which I wanted to avoid, so I decided to record an on-going process and make a loop that could continue all day or all week. The videotapes can run for an hour—long enough to know what's going on.

W.S.: Are you working only with videotapes at the moment?

B.N.: No, I've been working with film again. The reason they are films again is because they're in super-slow motion; I've been able to rent a special industrial camera. You really can't do it with the available videotape equipment for amateurs. I'm getting about four thousand frames per second. I've made four films so far. One is called *Bouncing Balls*, only this time it's testicles instead of rubber balls. Another one is called *Black Balls*. It's putting black makeup on testicles. The others are *Making a Face*, and in the last one I start out with about five or six yards of gauze in my mouth, which I then pull out and let fall to the floor. These are all shot extremely close up.

W.S.: You could call that body sculpture.

B.N.: Yes, I suppose.

W.S.: Are there any precedents for this in your early work?

B.N.: The works of this kind that I did were the holograms, *Making Faces* (1968), which came up in a very formal way when I was thinking about arrangements.

W.S.: What kind of facial arrangements did you do?

B.N.: They were usually contortions, stretching or pulling my face. I guess I was interested in doing a really extreme thing. It's almost as though if I'd decided to do a smile, I wouldn't have had to take a picture of it. I could just have written down that I'd done it or made a list of things that one could do. There was also the problem with the holograms, of making the subject-matter sufficiently strong so that you wouldn't think about the technical side so much.

W.S.: Mitigating the media is a real concern then?

B.N.: It was particularly difficult with the holograms, because of their novelty.

W.S.: Are you still working with holograms?

B.N.: There is one more set that I want to do, using double exposures. That piece would involve my body in a much more passive way than the others.

W.S.: It seems that one could almost divide your work into two categories: the pieces that are directly related to your body, and the ones that aren't.

B.N.: Well, in the works I've tried to describe to you, the one with the television cameras and the walls, and others I have in the studio using acoustic materials, I have tried to break down this division in some way, by using spectator response. These pieces act as a sort of bridge.

W.S.: Like the work with a tape recorder, *Steel Channel*, that you showed in *9 at Castelli*. What sound did you use?

B.N.: It was a loud whisper. Let's see, how did it go . . . "Steel channel, lean snatch, lean channel, steel snatch." "Lean snatch" is a cheating anagram of "Steel channel." It's not one of my favorite pieces.

W.S.: What other audio works have you done?

B.N.: There are two different groups of tapes: one was in *Theodoron Foundation: Nine Young Artists* at the Guggenheim in August 1969, of rubbing the violin on the studio floor, the violin tuned *D,E,A,D,* and one other. Then I did a piece at Ileana Sonnabend in December. It was a large L-shaped wall covering two walls of her Paris gallery. It was flush with the wall with very thin speakers in it. For that there were two difference tapes: one was of exhaling sounds, and the other of pounding and laughing alternately. You couldn't locate the sound. That was quite a threatening piece, especially the exhaling sounds.

W.S.: What are the sources of the punning in your work?

B.N.: I don't know. I just do it.

W.S.: Duchamp?

B.N.: Yes, I can't argue with that, but I don't think he's a very important influence. He leads to everybody and nobody.

W.S.: Well, one source that you have mentioned is Dada and Surrealism.

B.N.: I would like to back out of that too. Those questions were brought up by other people rather than by me. I really don't give these things that much thought.

W.S.: Is there an affinity in some of your work with Duchamp's body casts?

B.N.: Yes, there's no question about that. On the other hand, when I made a lot of that work, it had more to do with Wittgensteins's *Philosophical Investigations* which I was reading at that time. That work had a lot to do with the word-game thing.

W.S.: What particularly impressed you in *Philosophical Investigations*?

B.N.: Just the way Wittgenstein proceeds in thinking about things, his awareness of how to think about things. I don't think you can point to any specific piece that's the result of reading Wittgenstein, but it has to do with some sort of process of how to go about thinking about things.

W.S.: In 1966 you exhibited *Shelf Sinking* at the Nicholas Wilder Gallery. It seemed to me to be the most complicated piece you had done up to that point.

B.N.: It was one of my first pieces with a complicated title, a sort of functional title. I like the piece quite a bit. I took a mold and made plaster casts of the spaces underneath the shelf. I suppose the elaborate title enables you to show a mold with its casts without presenting the work as such.

W.S.: How important is the title to a work like *Henry Moore Bound to Fail (back view)*?

B.N.: I don't know. There's a certain amount of perverseness involved, because the piece could probably just have been left the way it was. I mean, it could have just stood without any kind of descriptive title. It could have been just "bound to fail." When I made the piece a lot of young English sculptors who were getting publicity were putting down Henry Moore, and I thought they shouldn't be so hard on him, because they're going to need him. That's about all the explanation I can give about adding Moore to the title.

W.S.: How did you make that work?

B.N.: Well, a photograph of my back was taken, then I modeled it in wax. It's not a cast of anyone.

W.S.: That's one of the very few figures or parts of a figure that you've actually modeled.

B.N.: Yes.

W.S.: This perverseness is of course something that a lot of people have mentioned. Do you think you are deliberately perverse?

B.N.: It's an attitude I adopt sometimes to find things out—like turning things inside out to see what they look like. It had to do with doing things that you don't particularly want to do, with putting yourself in unfamiliar situations, following resistances to find out why you're resisting, like therapy.

W.S.: So you try to go against your own nature, and to go against what people expect: exhibiting things from the back or that you can't see.

B.N.: Yes. But I tend to look at those things in a positive way and I've often been surprised when people take them in the opposite way and think I'm being perverse. It's like the John Coltrane mirror piece. To talk about perversion because you're hiding the mirror . . . That wasn't what I had intended at all. To me it seemed that hiding the mirror was a positive thing, because it made for an entirely different kind of experience—the mirror reflecting and yet not being able to reflect the floor.

W.S.: That piece is so private . . .

B.N.: Yes. I remember talking to someone about public art and private art. My art tends to fall in the private category.

W.S.: Would you say that the works are more about you than they are about art itself?

B.N.: Well, I wouldn't say it, no.

Richard Serra
Verb List (1972)

In 1968 artist Richard Serra made his piece titled *Splashing* by throwing molten lead in the corner where the floor meets the wall in the warehouse of the art dealer Leo Castelli. This work was part of the exhibition *9 at Castelli* in 1968. In a later version, called *Casting*, Serra used a greater amount of lead—so the forms created by subsequent executions of this activity could be removed from the wall and placed in a row on the floor. *Casting* was exhibited at the Whitney Museum of American Art in the exhibition *Anti-Illusion: Processes and Materials* in 1969. At about this same time Serra wrote his now-famous "Verb List," which comprises more than one hundred different processes that could be done to or with a given material. "Verb List" was published in 1972 in the book *The New Avant-Garde: Issues for the Art of the Seventies*.

If a part of speech were to be ascribed to mechanically clean and whole forms of Minimalists sculpture such as those described by Donald Judd in his essay "Specific Objects," we might refer to those objects as "nouns" because of their strong objectivity and suppression of any visible process. With this in mind, it is apropos of the process-orientated work of Serra that verbs would be the impetus for his sculptures from the late 1960s and into the 1970s. Certainly the notion that sculpture could be the residue of a particular activity is connected to the work of both Robert Morris and Bruce Nauman, but Serra's work is directed more specifically toward exposing the physical properties of industrial materials.

TO ROLL	TO DIFFER	TO SUPPORT
TO CREASE	TO DISARRANGE	TO HOOK
TO FOLD	TO OPEN	TO SUSPEND
TO STORE	TO MIX	TO SPREAD
TO BEND	TO SPLASH	TO HANG
TO SHORTEN	TO KNOT	TO COLLECT
TO TWIST	TO SPILL	OF TENSION
TO DAPPLE	TO DROOP	OF GRAVITY
TO CRUMPLE	TO FLOW	OF ENTROPY
TO SHAVE	TO CURVE	OF NATURE
TO TEAR	TO LIFT	OF GROUPING
TO CHIP	TO INLAY	OF LAYERING
TO SPLIT	TO IMPRESS	OF FELTING
TO CUT	TO FIRE	TO GRASP
TO SEVER	TO FLOOD	TO TIGHTEN
TO DROP	TO SMEAR	TO BUNDLE
TO REMOVE	TO ROTATE	TO HEAP
TO SIMPLIFY	TO SWIRL	TO GATHER

TO SCATTER	TO JOIN	OF TIDES
TO ARRANGE	TO MATCH	OF REFLECTION
TO REPAIR	TO LAMINATE	OF EQUILIBRIUM
TO DISCARD	TO BOND	OF SYMMETRY
TO PAIR	TO HINGE	OF FRICTION
TO DISTRIBUTE	TO MARK	TO STRETCH
TO SURFEIT	TO EXPAND	TO BOUNCE
TO COMPLEMENT	TO DILUTE	TO ERASE
TO ENCLOSE	TO LIGHT	TO SPRAY
TO SURROUND	TO MODULATE	TO SYSTEMATIZE
TO ENCIRCLE	TO DISTILL	TO REFER
TO HIDE	OF WAVES	TO FORCE
TO COVER	OF ELECTROMAGNETIC	OF MAPPING
TO WRAP	OF INERTIA	OF LOCATION
TO DIG	OF IONIZATION	OF CONTEXT
TO TIE	OF POLARIZATION	OF TIME
TO BIND	OF REFRACTION	OF CARBONIZATION
TO WEAVE	OF SIMULTANEITY	TO CONTINUE

Critics

Marcia Tucker
Anti-Illusion: Procedures/Materials (1969)

Anti-Illusion: Procedures and Materials was the first museum exhibition dedicated to post-Minimalist artistic sensibilities. Organized by James Monte and Marcia Tucker, the exhibition at the Whitney Museum of American Art featured the work of Eva Hesse, Richard Serra, Robert Morris, Keith Sonnier, Alan Saret, and Bruce Nauman, among others. The essay "Anti-Illusion: Procedures/Materials," which was written by Tucker, was published in the 1969 catalog that corresponded with the exhibition.

In Tucker's view one of the characteristics that ties together the work of this diverse group of artists is the rejection of the assumption that artists create order out of chaos by giving form to particular materials. The work of these artists challenges this notion by prioritizing process and materials over the creation of conventionally self-contained sculptures, which had been done in the past. Flinging

lead into the space where the floor meets the wall or distributing felt, sand, ball-bearings, and oil in a room in a seemingly random manner replaces welding, carving, and casting. Tucker describes it this way: "If a work of art offers us various components, arranged and assembled into a coherent whole, there is the assumption that such order is meaningful, either in terms of the work itself or in the terms of our experience of the world. Much of the work in this exhibition denies this premise and disorients us by making chaos its structure." One of the by-products of a working method that focuses on process is that the work becomes integrally connected to the site of its execution. A lot of the work featured in this exhibition was made in the museum itself and was only in existence for the duration of the show. This tactic further erodes the traditionally portable sculptural form and opens the way for a fundamental expansion of sculpture into a concern with site specificity.

There must, it seems to me, be some human activity which serves to break up orientations, to weaken and frustrate the tyrannous drive to order, to prepare the individual to observe what the orientation tells him is irrelevant but what may very well be relevant. That activity, I believe, is the activity of artistic perception.
—Morse Peckham, *Man's Rage for Chaos*

Our approach to works of art has been based on certain assumptions about the nature of art. One of these assumptions has been that art creates order from the chaos of experience; it is presumed that our understanding of a work of art is equivalent to our grasp of the formal or conceptual order inherent in it.

The present exhibition challenges this supposition. We are offered an art that presents itself as disordered, chaotic, or anarchic. Such an art deprives us of the fulfillment of our aesthetic expectations and offers, instead, an experience which cannot be anticipated nor immediately understood. By negating prior orientations, our personal aesthetic values are also challenged. If, then, no preconceived order reveals itself to our scrutiny, we must ask if there are other ways in which a work of art can be meaningful.

It has been assumed until recently that sculpture is, by its very nature, three-dimensional, self-contained, and fashioned from relatively durable materials, such as stone, metals, plastics or wood. The methods traditionally employed in the making of sculpture have been those of welding, carving, molding or joining, and the resultant works have focused on a harmonious balance of parts to the whole. Certain pieces in the exhibition appear disordered and unharmonious.

This does not mean that the elements employed have *no* relationship to each other but rather that such relationships are of a new kind. They do not evolve from a preconception of order which the artist is trying to express, but from the activity of making a work and from the dictates of the materials used. A relational logic has been replaced by a functional one. By divorcing art from an established value system in which order is inherent, new concerns with time, gesture, materials and attitudes take precedence.

Painting, which has been dependent on illusion, whether optical or representational, has been even more rigorously subject to specific criteria.

According to Clement Greenberg, "authentic" painting is determined by the extent to which a picture upholds the integrity of the picture plane, stresses the surface upon which it is painted, adheres to the rectilinear shape of the canvas and makes its two-dimensionality explicit. Greenberg's definition of painting is, then, an empirical reductive analysis based on the physical properties of a painting. This reduction of a painting to its physical properties (frame, canvas and paint) is challenged by certain artists who have denied the material and analytical basis of this judgment, not by ideology, but by materiality itself. Such paintings do not lend themselves to this kind of physical analysis of the object, but to a gestural analysis of the art activity *per se.*

Lynda Benglis's paintings are poured onto the floor, with no boundaries or format other than that established by the colored liquid rubber she uses—they are neither stretched nor hung. Her primary interest in color relationships is expressed in terms of the process of pouring, eliminating any *a priori* theoretic framework.

Robert Ryman purifies painting to a further extreme by eliminating color as a formal element and concentrating on the act of putting paint on a surface. He uses white paint only, allowing the application of pigment to become the subject of the work. Each brushstroke affords a raw, immediate and spontaneous gesture whose intimations have nothing to do with narrative nor formal configuration. Moreover, he uses plain or corrugated paper, rejecting even the use of stretched canvas as a pictorial convention.

Even the least stringent definition would indicate that to qualify as a painting, a surface must at the very least be *painted.* Tuttle's *Octagons* (1968) are dyed. Unstretched, cut canvas shapes are hung on the wall or placed on the floor, their wrinkled surfaces unequivocally denying illusion.

If all traces of representation or illusion are eliminated from painting, it would seem that formal relationships of line, color and shape would remain crucial. However, these works suggest that if analytical relationships, as well as any dependence upon a geometric support, are eliminated, it is still possible to make a painting.

If a work of art offers us various components, arranged and assembled into a coherent whole, there is the assumption that such order is meaningful, either in terms of the work itself or in terms of our experience of the world. Much of the work in this exhibition denies this premise and disorients us by making chaos its structure. The pieces shown cannot, therefore, be precisely understood in terms of our previous experience of "art." They are *not* attempts to use new materials to express old ideas or evoke old emotional associations, but to express a new content that is totally integrated with material.

Eva Hesse, for example, has found that because she is concerned with creating personal forms, she must use only materials that she can make herself. The plastic, fiberglass, rubberized cheesecloth and gauze from which her pieces are modelled are neither cast nor molded. They are made by putting

the raw material on the floor and shaping it, adding layers until the proper substance is attained. The result of using only colors and shapes intrinsic to the materials is that the work has both a strong presence and a provocative, other-worldly quality. Her pieces are draped, hung, extended or propped, but look unlike anything "real."

Keith Sonnier's flock and neon pieces also depend upon a new idea of materiality that has little to do with the substance of past sculptural forms. To a similar end, Robert Morris, Barry Le Va and Alan Saret have used scale and figure-ground relationships which are imprecise and alterable. Neil Jenney employs tin foil, plaster, peanuts and fungus in his work, subverting traditional ideas of volume and substantiality in sculpture. His work not only appears fragile, but can actually rot away.

Some of the earliest pieces to exhibit this involvement with materials were Claes Oldenburg's giant soft structures, but they always refer directly to real objects. The artists in this exhibition express a similar interest in materials, but disregard any obvious links with actual things.

There is, in the exhibition, no illusionism that is relevant to the past tradition of art. We are presented with a non-symbolic, non-ordered approach, one which does not depend upon a conceptual framework to be understood. The work is realistic in the fullest sense, because it does not rely on descriptive, poetic or psychological referents. The approach is phenomenological in nature, dealing with the appearances and gestural modes by means of which physical things are presented to our consciousness.

Still another possible function of this kind of art is, as Robbe-Grillet has indicated, "not to illustrate a truth—or even an interrogation—known in advance, but to bring into the world certain interrogations (and also, perhaps, in time, certain answers) not yet known as such to themselves." (*Notes for a New Novel*, 1965.) The work is, therefore, open-ended and difficult to discuss without the framework of a historical perspective. It is possible, however, to discuss the works individually by speaking of them in terms of intention, which differs for each artist.

Here, the intention which prompts the artistic endeavor is one of exploration, an attempt to discover and to make something which has not been made before. For some artists, like Jenney and Duff, expressive intent remains crucial; for others, like Serra or Andre, such romantic factors are deliberately eliminated.

If the nature of the artistic endeavor is a questioning one, then the artists' methods will accord with the endeavor. Richard Serra continually asks questions about his own work: what is it? how does it look? what does it mean? how is it used? Serra's mode of sculpture is *active*, that is, he is involved with the physical properties of things, and the traces that result from a manipulation of the materials. Serra is concerned with various activities and processes—propping, bending, leaning, rolling, sawing, splattering.

He avoids illusion, representation and especially construction in order to concentrate on *what is being done*. Since the emphasis is on the activity, the piece must be analyzed in terms of the kind of work that has gone into its making. Serra avoids permanently joining anything; thus, his lead pieces deal with a functional rather than formal relationship of parts. His concern with what he calls "arrested moments," that is, fixing a piece at its point of maximum potential change, incorporates an element of actual time into a sculptural mode.

Music, film, theater and dance have been considered separate from the plastic arts because they involve time as well as space. They are therefore impermanent, temporal manifestations whose duration is dependent upon the artist rather than the observer. However, the plastic arts have begun to share with the performing arts the mobile relational character of single notes to series, individuated actions to the fabric of a narrative sequence, or single steps to a total configuration of movement.

It has been thought that music creates its own suspended temporality, dependent upon the elements of rhythm and silence. Musical time has thus been considered different from "real" time. For Philip Glass and Steve Reich, actual time is a crucial factor in their music; it offers no illusion of temporality other than that which exists in the performance of their pieces. They have no beginning, middle or end—only the sense of an isolated present. This constant present exists because of a deliberate and unrelenting use of repetition which destroys the illusion of musical time and focuses attention instead on the material of the sounds and on their performance. Both composers are personally involved in the temporal evolution of their work since they play their own music, accompanied by a limited number of other musicians.

Carl Andre, in a recent symposium (March, 1969), discussed the question of time in his sculpture:

> Nothing is timeless, but it's an idea that haunts us . . . something that exists in my own work. In one way, all we know is *now* . . . The work must be experienced in terms of its material presence.
>
> The tense of memory is the present, and the tense of prophesy is *now*. Time is an illusion. The *now* is inescapable.

Andre has also used repetition to create an isolated present in his sculpture. He uses uniform parts which are placed in identical relationships to each other, without welding, joining or construction of any kind (except for an occasional use of magnets). These parts, or "sections," become the units in the creation of scale. Scale then becomes the focus of the piece; it acquires temporality because it cannot be visually or physically encompassed by the viewer in a single glance or motion.

In Bruce Nauman's extended-time pieces, the repetition of an isolated physical gesture—bouncing from a corner, walking through a wallboard

channel, bouncing a ball—is problematic; that is, it questions the nature of time itself.

In a recent exhibition, Robert Morris altered a piece daily, allowing the materials to dictate the addition and subtraction of elements in the piece. Rafael Ferrer has made anonymous, but highly personal gestures that are dependent upon split-second timing for their impact: several tons of leaves appeared suddenly in locations (stairs, elevators, etc.) around the city, totally altering an environment from one minute to the next. No fastening, arranging nor ordering of any sort was involved.

For many of these artists, the implications of time indicate a new attitude toward the creation of non-precious objects. Some works come into being at the moment of their execution in a specific location and cease to exist when they are removed from that environment. The relationship of work to location becomes one in which the artist also dictates the temporal duration of the piece.

Michael Snow makes films, for example, in which actual duration eliminates the illusion of a duration created by narrative exposition. The films are simple and direct; he is sparing in his use of technical manipulations to further an illusion and concentrates instead on a single focus: a single note, a single action (such as that of the zoom in *Wavelenth,* 1967). A mysterious, subjective quality results from the intensity of presenting what is *seen.* "I'm interested," he says, "in doing something that can't be explained."

Robert Fiore's documentary footage is equally non-illusionistic. With a minimum of editing or montage, he concentrates instead upon making the process of shooting become the structure of the film. Film time thus becomes the actual time involved in the recording of the action.

The use of time in each case becomes paradoxically disorienting. In the plastic and performing arts, we are used to an artificial time that entertains us, since it suspends reality. The force of real time, when presented in the context of a work of art, is bewildering and even annoying. Ironically, we are asked to re-orient ourselves to what we already know.

Robert Morris, in his remarks on "Anti Form" (*Artforum,* April 1968), stated that "disengagement with preconceived enduring forms and orders for things is a positive assertion. It is part of the work's refusal to continue aestheticizing form by dealing with it as a prescribed end." This assertion is, at the very least, disarming when translated into physical terms by the work itself.

Most materials used are commonplace and do not have the durability nor inherent value of materials usually associated with sculpture. String, hay, rubber, lead, cloth or dirt give the objects an unpretentious, active quality, whose focus is often on a relationship to the surrounding space rather than to the objects themselves. The choice of material is allowed to dictate the final form of the object.

For Alan Saret, the scattering, hanging, piling or bunching of material becomes an expressive gesture. The "triumph of mind over matter" is not a crucial issue since the observer is no longer awed at a mystery of creation which is foreign to him; rather, he is drawn into the very process of the work being made. In Saret's pieces, gesture is communicative and remains succinct even in the final product.

A young West Coast sculptor, Michael Asher, uses material which deliberately subverts sculptural definitions. Just as "painting" appeared to be a necessary condition of painting, visibility would seem to be a necessary condition of sculpture. Asher's pieces are *non-visible;* they are made of columns of air. The forms are perceivable by means of physical participation only.

If aesthetic priority is given to neither form *nor* object, the results are even more disruptive. In Neil Jenney's "environments," all elements are either totally unaesthetic or in a constant process of change. All elements are so commonplace that their juxtaposition prompts a radical disorientation. Jenney does not alter these objects, but, unlike the Dadaists, he has little interest in making an aesthetic experience of them. Instead, they promote a *physical* experience which is not dependent upon artifice. Some of his pieces, however, are so materially insubstantial that they even question the nature of that physical experience.

Joel Shapiro makes things that have no independent existence apart from the wall to which they are stapled. Dyed nylon mono-filament is fixed in an enormous, dark rectangle to eliminate references to real objects. He is interested in physical decision-making processes that have no functional necessity; he does not try to make his work accord with a prior conception of what it should look like.

In some instances, the nature of the material selected by the artist makes the analytical categories of painting and sculpture irrelevant. Bollinger's graphite pieces, sprayed on the wall or sprinkled on the floor (Bykert Gallery, January 1969), are neither painting nor sculpture—or they are both. Robert Rohm's string sculpture has its origins in the minimal aluminum extrusions with which he has been working simultaneously, but by hanging string and rope grids and collapsing portions of them, his pieces challenge their own geometry. They can be read as three-dimensional "drawings" or two-dimensional, hanging "sculptures."

From 1966 to 1968, Barry La Va's "distributions" combined felt and ball-bearings which he scattered on the floor. The floor became a ground upon which particles of potential change, flow and mobility were deployed. Fluid elements, such as sand and oil, have been added in his recent work, making the figure-ground relationships usually found in painting relevant for sculpture as well. Because of the enormous scale of the works and their indeterminate format, they require the spatial participation of the viewer in a similar way to Andre's pieces. Thus, they make certain physical demands which we have come to associate with sculpture.

A different kind of physical concern can be seen in the work of Robert Lobe and John Duff, who are interested in the act of assembling. Lobe's visual system is direct and non-conceptual; "You can't make art," he says, "out of other people's literature." His structures, made of mats (which serve to locate each piece), wood, springs and rope reveal ways of making common things uncommon. Their internal relationships are mobile and non-practical. Duff makes poetic objects which are symmetrical and balanced. They consist of man-made materials—window-screen, fiberglass rope and wood strapping— yet draw attention to non-literal, indefinable gestures. Although every physical process and material is presented in a matter-of-fact way, a complex, mysteriously non-referential image results.

Certain works in the exhibition, then, are about time, distribution, process and materials. It is also possible, within these means, to express a quality of existence or an attitude toward one's experience of the world.

Eva Hesse, as early as 1965, created chaos in her pieces from the premise of a perfect system. More recently, in her fiberglass buckets, rubber wrappings and translucent curtains, she has been concerned with "making something which is nothing, yet becomes something." This kind of existential decision eliminates work which has organic or associative referents. Her pieces are complex objects which connect to our lives, yet have no meaning outside themselves.

Bruce Nauman's *Performance Area*, while not a "sculpture," is not a found object either. Rather, it is entirely *specific*, forcing the observer to accept the work the way it is given. Its use is also specific, unlike a found object, since anyone who enters the work becomes a performer. No interpretation is available; therefore, no ambiguity occurs. A one-hour videotape of Nauman walking back and forth in this wall-board channel (a separate work, not shown in the exhibition) indicates his attitude toward his own experience of the world. His pieces are about himself without being autobiographical, highly personal without being psychological, peverse without being sadistic.

Keith Sonnier's configurations are more formal than Nauman's, but also have an element of aesthetic eroticism. As a sculptor, his interest in linear drawing and surface incident is expressed with materials that avoid a "high-art" content. The flock and neon wall pieces are suggestive because they are sensually appealing and contain an active, painterly spatial fluctuation. When working with neon, the results are non-iconic; by wrapping one light source (a bulb) with another (neon tubing), each plays against and transforms the other without direct manipulation of the lights themselves.

For some artists in this exhibition, meaning results from the activity of making the work; for others, meaning resides in the configuration dictated by the choice of materials; for still others, meaning can be found in an expressed intention. In all cases, meaning and material cannot be separated.

When our aesthetic norms are challenged, the factor of negation may appear more obvious to us at first than the significance of the challenge. In time, the most severely criticized characteristics of these new works may ultimately prove to be their strength.

Context

Steve Reich
Music As a Gradual Process (1968)

Parallel to the work of visual artists such as Richard Serra and Robert Morris, the music of the composer Steve Reich uses process as its grounding force. Just as the work of these visual artists highlights the properties of certain materials, Reich's music does the same with sound. In discussing his music, Reich says, "What I'm interested in is a compositional process and a sounding music that are one and the same." Steve Reich performed his music as part of the 1969 exhibition *Anti-Illusion: Procedures/Materials*. In the catalog to this exhibition he describes the particulars of his now-legendary piece called "Pendulum Music." This work consists of two, three, four, or more microphones that are suspended from the ceiling and plugged into separate amplifiers. Each microphone is then taken by a performer, pulled back, and then released in unison. As the microphones swing like pendulums in front of the amplifiers, they create feedback, which constitutes the music. The piece is over when the microphones stop swinging. In some of Reich's other, more structured compositions, such as "Music for 18 Musicians," the fundamental auditory arrangements are slowly revealed to the listener through gradual and perceptible shifts in the music. The statement "Music As a Gradual Process" was first published in *Studio International* in 1974.

I do not mean the process of composition, but rather pieces of music that are, literally, processes.

The distinctive thing about musical processes is that they determine all the note-to-note (sound-to-sound) details and the overall form simultaneously. (Think of a round or infinite canon.)

I am interested in perceptible processes. I want to be able to hear the process happening throughout the sounding music.

To facilitate closely detailed listening, a musical process should happen extremely gradually.

Performing and listening to a gradual musical process resembles:

pulling back a swing, releasing it, and observing it gradually come to rest;

turning over an hourglass and watching the sand slowly run through to the bottom;

placing your feet in the sand by the ocean's edge and watching, feeling, and listening to the waves gradually bury them.

Though I may have the pleasure of discovering musical processes and composing the musical material to run through them, once the process is set up and loaded, it runs by itself.

Material may suggest what sort of process it should be run through (content suggests form), and processes may suggest what sort of material should be run through them (form suggests content). If the shoe fits, wear it.

As to whether a musical process is realized through live human performance or through some electromechanical means is not finally the main issue. One of the most beautiful concerts I ever heard consisted of four composers playing their tapes in a dark hall. (A tape is interesting when it's an interesting tape.)

It is quite natural to think about musical processes if one is frequently working with electromechanical sound equipment. All music turns out to be ethnic music.

Musical processes can give one a direct contact with the impersonal and also a kind of complete control, and one doesn't always think of the impersonal and complete control as going together. By "a kind" of complete control I mean that by running this material through this process, I completely control all that results, but also that I accept all that results, without changes.

John Cage has used processes and has certainly accepted their results, but the processes he used were compositional ones that could not be heard when the piece was performed. The process of using the *I Ching* or imperfections in a sheet of paper to determine musical parameters can't be heard when listening to music composed that way. The compositional processes and the sounding music have no audible connection. Similarly, in serial music the series itself is seldom audible. (This is a basic difference between serial [basically European] music and serial [basically American] art, where the perceived series is usually the focal point of the work.)

What I'm interested in is a compositional process and a sounding music that are one and the same thing.

James Tenney said in conversation, "then the composer isn't privy to anything." I don't know any secrets of structure that you can't hear. We all listen to the process together since it's quite audible, and one of the reasons it's quite audible is it's happening extremely gradually.

The use of hidden structural devices in music never appealed to me. Even when all the cards are on the table and everyone hears what is gradually happening in a musical process, there are still enough mysteries to satisfy all. These mysteries are the impersonal, unintended, psychoacoustic by-products of the intended process. These might include submelodies heard within repeated melodic patterns, stereophonic effects due to listener location, slight irregularities in performance, harmonics, difference tones, etc.

Listening to an extremely gradual musical process opens my ears to *it*, but *it* always extends farther than I can hear, and that makes it interesting to listen to that musical process again. That area of every gradual (completely controlled) musical process, where one hears the details of the sound moving out away from intentions, occurring for their own acoustic reasons, is *it*.

I begin to perceive these minute details when I can sustain close attention and a gradual process invites my sustained attention. By "gradual" I mean extremely gradual; a process happening so slowly and gradually that listening to it resembles watching a minute hand on a watch—you can perceive it moving after you stay with it a little while.

Several currently popular modal musics like Indian classical and drug-oriented rock-and-roll may make us aware of minute sound details because in being modal (constant key center, hypnotically droning, and repetitious) they naturally focus on these details rather than on key modulation, counterpoint, and other peculiarly Western devices. Nevertheless, these modal musics remain more or less strict frameworks for improvisation. They are not processes.

The distinctive thing about musical processes is that they determine all the note-to-note details and the overall form simultaneously. One can't improvise in a musical process—the concepts are mutually exclusive.

While performing and listening to gradual musical processes, one can participate in a particular liberating and impersonal kind of ritual. Focusing in on the musical process makes possible that shift of attention away from *he* and *she* and *you* and *me* outward toward *it*.

SIX

Sculpture in the Environment

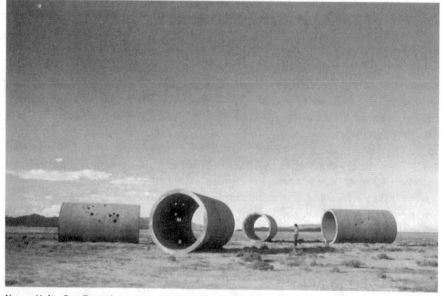

Nancy Holt, *Sun Tunnels*. 1973–1976. Concrete; tunnels 16 ft, total length 66 ft; aligned with sunrise and sunset on solstices; Great Basin Desert, northwestern Utah. © Nancy Holt/Licensed by VAGA, New York, N.Y.

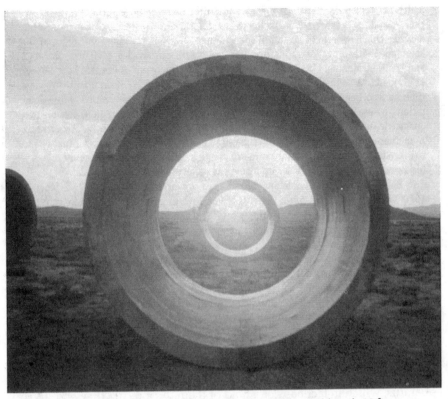

Nancy Holt, *Sun Tunnels.* 1973–1976. Concrete; tunnels 16 ft, total length 66 ft. Detail showing sunset at summer solstice. Great Basin Desert, northwestern Utah. © Nancy Holt/Licensed by VAGA, New York, N.Y.

Artists

Robert Smithson
Cultural Confinement (1972)

The process-oriented work of Robert Morris, Richard Serra, and others had disintegrated the notion of sculpture as a static whole object and in so doing had opened up new possibilities for the exploration of the concepts of both time and location in a work of art. Toward the end of the 1960s, a group of artists that included Robert

Smithson, Nancy Holt, Michael Heizer, and Walter De Maria pushed these notions further by making art directly in the landscape. Smithson used the term "Earthworks" to describe this new form of art. Smithson's interest in geological time, entropy, and the abandoned sites of industry led him to write a series of articles, including "Entropy and the New Monuments" (1966), "A Tour of the Monuments of Passaic, New Jersey" (1967), and "A Sedimentation of the Mind: Earth Projects" (1968). At about this same time he also began a series of works that he called "Non-Sites," which were explorations/assessments of abandoned industrial sites in New Jersey. Smithson created geometric metal bins, reminiscent of Minimalist sculpture, in which he placed rocks from these sites. He enhanced this physical material with photographs, maps, and written descriptions. Smithson wanted to create a dialectic between this portable material, which he was able to set up inside the gallery, and the actual sites.

By the end of the decade Smithson began to work directly in the landscape. In 1970 Smithson created *Spiral Jetty*, a 1,500-foot-long and 15-foot-wide spiral of earth and stone that curled into the Great Salt Lake in Utah. In the essay "Cultural Confinement," which was published in the October 1972 issue of *Artforum*, Smithson speaks passionately about the need to create works of art outside of the gallery and museum systems. He feels that the galleries and museums sanitize art to the point where it becomes nothing more than a portable object ready for consumption. In "Cultural Confinement" he states it this way: "I am talking about a dialectic of nature that interacts with the physical contradictions inherent in natural forces as they are—nature as both sunny and stormy."

Cultural confinement takes place when a curator imposes his own limits on an art exhibition, rather than asking an artist to set his limits. Artists are expected to fit into fraudulent categories. Some artists imagine they've got a hold on this apparatus, which in fact has got a hold of them. As a result, they end up supporting a cultural prison that is out of their control. Artists themselves are not confined, but their output is. Museums, like asylums and jails, have wards and cells—in other words, neutral rooms called "galleries." A work of art when placed in a gallery loses its charge, and becomes a portable object or surface disengaged from the outside world. A vacant white room with lights is still a submission to the neutral. Works of art seen in such spaces seem to be going through a kind of aesthetic convalescence. They are looked upon as so many inanimate invalids, waiting for critics to pronounce them curable or incurable. The function of the warden-curator is to separate art from the rest of society. Next comes integration. Once the work of art is totally neutralized, ineffective, abstracted, safe, and politically lobotomized it is ready to be consumed by society. All is reduced to visual fodder and transportable merchandise. Innovations are allowed only if they support this kind of confinement.

Occult notions of "concept" are in retreat from the physical world. Heaps of private information reduce art to hermeticism and fatuous metaphysics. Language should find itself in the physical world, and not end up locked in an idea in somebody's head. Language should be an ever-developing procedure and not an isolated occurrence. Art shows that have beginnings and ends are confined by unnecessary modes of *representation* both "abstract" and "realistic." A face or a grid on a canvas is still a representation. Reducing representation to

writing does not bring one closer to the physical world. Writing should generate ideas into matter, and not the other way around. Art's development should be dialectical and not metaphysical.

I am speaking of a dialectic that seeks a world outside of cultural confinement. Also, I am not interested in the works that suggest "process" within the metaphysical limits of the neutral room. There is no freedom in that kind of behavioral game playing. The artist acting like a B. F. Skinner rat doing his "tough" little tricks is something to be avoided. Confined process is no process at all. It would be better to disclose the confinement rather than make illusions of freedom.

I am for an art that takes into account the direct effect of the elements as they exist from day to day apart from representation. The parks that surround some museums isolate art into objects of formal delectation. Objects in a park suggest static repose rather than any ongoing dialectic. Parks are finished landscapes for finished art. A park carries the values of the final, the absolute, and the sacred. Dialectics have nothing to do with such things. I am talking about a dialectic of nature that interacts with the physical contradictions inherent in natural forces as they are—nature as both sunny and stormy. Parks are idealizations of nature, but nature in fact is not a condition of the ideal. Nature does not proceed in a straight line, it is rather a sprawling development. Nature is never finished. When a finished work of twentieth-century sculpture is placed in an eighteenth-century garden, it is absorbed by the ideal representation of the past, thus reinforcing political and social values that are no longer with us. Many parks and gardens are re-creations of the lost paradise or Eden, and not the dialectical sites of the present. Parks and gardens are pictorial in their origin—landscapes created with natural materials rather than paint. The scenic ideals that surround even our national parks are carriers of a nostalgia for heavenly bliss and eternal calmness.

Apart from the ideal gardens of the past, and their modern counterparts—national and large urban parks—there are the more infernal regions—slag heaps, strip mines, and polluted rivers. Because of the great tendency toward idealism, both pure and abstract, society is confused as to what to do with such places. Nobody wants to go on a vacation to a garbage dump. Our land ethic, especially in that never-never land called the "art world," has become clouded with abstractions and concepts.

Could it be that certain art exhibitions have become metaphysical junkyards? Categorical miasmas? Intellectual rubbish? Specific intervals of visual desolation? The warden-curators still depend on the wreckage of metaphysical principles and structures because they don't know any better. The wasted remains of ontology, cosmology, and epistemology still offer a ground for art. Although metaphysics is outmoded and blighted, it is presented as tough principles and solid reasons for installations of art. The museums and parks are graveyards above the ground—congealed memories of the past that act as a pretext for reality. This causes acute anxiety among artists, in so far as they challenge, compete, and fight for the spoiled ideals of lost situations.

Nancy Holt
Sun Tunnels (1977)

In the article "Sun Tunnels," which was originally published in the April 1977 issue of *Artforum,* artist Nancy Holt describes in detail her Earthwork *Sun Tunnels,* created in the Great Basin Desert in Utah between 1973 and 1976. In addition to detailing the complex logistics involved with creating a site-specific work of this magnitude, Holt clarifies that the meaning of *Sun Tunnels* is to be found in the specific relationship between the created forms and the particulars of the location itself. *Sun Tunnels* consists of four eighteen-foot-long concrete tunnels that Holt positioned so that they align with the angles of the rising and setting sun on the days of the Summer and Winter solstices. By connecting to the cyclical essence of the solar year as well as by being a marker that brings this vast and ancient landscape into human scale, *Sun Tunnels* becomes a meditation on time. Holt describes her reaction to the timelessness of the Great Basin Desert this way: "'Time' is not just a mental concept or a mathematical abstraction in the desert. The rocks in the distance are ageless; they have been deposited in layers over hundreds of thousands of years. 'Time' takes on a physical presence." Works such as *Sun Tunnels,* whose meanings are inextricable from their surroundings, create the dialectic that Smithson was calling for in his article "Cultural Confinement." Yet the irony is that due to the extreme isolation of *Sun Tunnels* (as well as many other Earthworks, including Smithson's *Spiral Jetty*), most people experience this work through photographs or other forms of documentation.

Sun Tunnels (1973–1976) is built on forty acres which I bought in 1974 specifically as a site for the work. The land is in the Great Basin Desert in northwestern Utah, about four miles southeast of Lucin (pop. 10) and nine miles east of the Nevada border.

Sun Tunnels marks the yearly extreme positions of the sun on the horizon—the tunnels being aligned with the angles of the rising and the setting of the sun on the days of the solstices, around June 21st and December 21st. On those days the sun is centered through the tunnels, and is nearly centered for about ten days before and after the solstices.

The four concrete tunnels are laid out on the desert in an open X configuration 86 ft. long on the diagonal. Each tunnel is 18 ft. long, and has an outside diameter of 9 ft. 2-1/2 in. and an inside diameter of 8 ft., with a wall thickness of 7-1/4 in. A rectangle drawn around the outside of the tunnels would measure 68-1/2 ft. × 53 ft.

Cut through the wall in the upper half of each tunnel are holes of four different sizes—7, 8, 9, and 10 in. in diameter. Each tunnel has a different configuration of holes corresponding to stars in four different constellations—Draco, Perseus, Columba, and Capricorn. The sizes of the holes vary relative to the magnitude of the stars to which they correspond. During the

day, the sun shines through the holes, casting a changing pattern of pointed ellipses and circles of light on the bottom half of each tunnel. On nights when the moon is more than a quarter full, moonlight shines through the holes casting its own paler pattern. The shapes and positions of the cast light differ from hour to hour, day to day, and season to season, relative to the positions of the sun and moon in the sky.

Each tunnel weighs 22 tons and rests on a buried concrete foundation. Due to the density, shape, and thickness of the concrete, the temperature is 15 to 20 degrees cooler inside the tunnels in the heat of day. There is also a considerable echo inside the tunnels.

In 1974 I looked for the right site for *Sun Tunnels* in New Mexico, Arizona, and Utah. What I needed was flat desert ringed by low mountains. It was hard finding land which was both for sale and easy to get to by car. The state and federal governments own about two-thirds of the land, the rest is owned mainly by railroads and large ranches, and is usually sold in one-square-mile sections. Fortunately, the part of the valley I finally chose for *Sun Tunnels* had been divided up into smaller sections, and several of these were for sale. I bought forty acres, a quarter of a mile square.

My land is in a large, flat valley with very little vegetation—it's land worn down by Lake Bonneville, an ancient lake that gradually receded over thousands of years. The Great Salt Lake is what remains of the original lake now, but it is just a puddle by comparison. From my site you can see mountains with lines on them where the old lake bit into the rock as it was going down. The mirages are extraordinary; you can see whole mountains hovering over the earth reflected upside down in the heat. The feeling of timelessness is overwhelming.

> An interminable string of warped, arid mountains with broad valleys swung between them; a few waterholes, a few springs, a few oasis towns and a few dry towns dependent for water on barrels and horsepower; a few little valleys, where irrigation is possible . . . a desert more vegetationless, more indubitably hot and dry, and more terrible than any desert in North America except possibly Death Valley. Even the Mormons could do little with it. They settled its few watered valleys and let the rest of it alone.
>
> —Wallace Stegner in
> *Mormon Country: The Land Nobody Wanted*

In the surrounding area are old trails, crystal caves, disused turquoise, copper, and tungsten mines, old oil wells and windmills, hidden springs, and ancient caves. A nearby cave, coated with centuries of charcoal and grease, is filled with at least ten feet of residue—mostly dirt, bones, and artifacts. Out there a lifetime seems very minute. After camping alone in the desert awhile, I had a strong sense that I was linked through thousands of years of human

time with the people who had lived in the caves around there for so long. I was sharing the same landscape with them. From the site, they would have seen the sun rising and setting over the same mountains and ridges.

The closest settlement is four miles away in Lucin, Utah. It is a village of ten people; nine are retired and one works for the railroad. Until the demise of the railroad, Lucin and Tacoma (ten miles west) were thriving towns of a few hundred people, with hotels, cafes, barber shops, saloons. Tacoma is completely leveled now. Except for a sign, there is no way of telling that a town had once been there. Lucin has only one of its old buildings left standing. The next closest town, Montello, Nevada (pop. 60), twenty-two miles west, went through a similar process, but is more intact: even a few of the original sheds, made of interlocking railroad ties covered with sod roots, still exist.

> Dawn points and another day
> Prepares for heat and silence
> > T. S. Eliot
> > *The Waste Land*

The idea for *Sun Tunnels* came to me while I was in Amarillo, Texas, in 1973, but it wasn't until the next year that I bought land for the work. Then in August of 1975 I went back to Utah and began working. I didn't know anyone there, and was totally outside any art-world structure. I was one individual contacting other individuals. But by the time *Sun Tunnels* was finished, I had spent one year in Utah and had worked with two engineers, one astrophysicist, one astronomer, one surveyor and his assistant, one road grader, two dump truck operators, one carpenter, three ditch diggers, one concrete mixing truck operator, one concrete foreman, ten concrete pipe company workers, two core-drillers, four truck drivers, one crane operator, one rigger, two cameramen, two soundmen, one helicopter pilot, and four photography lab workers.

In making the arrangements and contracting out the work, I became more extended into the world than I've ever been before. It was hard involving so many people in making my art. Since my two grants covered only one-third the total cost, and I was financing the other two-thirds with my own money, I had to hustle quite a bit to keep down the cost and get special consideration. Making business deals doesn't come easy to me; it was often very exasperating. I don't have any romantic notions about testing the edges of the world that way. It's just a necessity. It doesn't lead to anything except the work.

I went out West for the first time in 1968 with Robert Smithson and Michael Heizer.[1] As soon as I got to the desert, I connected with the place. Before that, the only other place that I had felt in touch with in the same way was the Pine Barrens in southern New Jersey,[2] which only begins to approach that kind of Western spaciousness.

I went back West for a few months every year. In 1969 I began a series of "Buried Poems,"[3] using some desert sites. Then in 1972 I made *Missoula Ranch Locators*[4] in Montana in a very different kind of Western landscape—very expansive, but greener and more "scenic" than the desert. The site is right for the work; different things can be seen through each of the eight *Locators*—a mountain, a tree, a flat plain, a ranch house, etc. Through the work, the place is seen in a different way. The work becomes a human focal point, and in that respect it brings the vast landscape back to human proportion and makes the viewer the center of things. In both works I used a natural ordering; *Missoula Ranch Locators* is positioned on the points of the compass. *Sun Tunnels* on the angles of the solstices at the latitude of the site.

When I was making projected light works in New York, the idea of working with the actual projected light of the sun began to intrigue me. I put cut-outs in my window and models on my roof in New York, so I could watch the light and shadow change hour by hour, day by day. In Utah I made drawings and worked with scale models and large hoops, in the desert, trying out different lengths, diameters, and placements, and doing photographic studies of the changes in light and shadow. I consulted with an astrophysicist[5] at the University of Utah about the angles of the solstices at the latitude of my land. Because the land had irregular contours, and the earth was not a perfect sphere, we had to calculate the height of the distant mountains and ridges and, using a computer, readjust the solstice angles from this data. The angles we arrived at formed an "X," which worked as a configuration for the tunnels. Using a helioscope set for the latitude of the site, it was possible to study the changes in light and shadow in my model for every hour during every day of the year.

"Time" is not just a mental concept or a mathematical abstraction in the desert. The rocks in the distance are ageless; they have been deposited in layers over hundreds of thousands of years. "Time" takes on a physical presence. Only ten miles south of *Sun Tunnels* are the Bonneville Salt Flats, one of the few areas in the world where you can actually see the curvature of the earth. Being part of that kind of landscape, and walking on earth that has surely never been walked on before, evokes a sense of being on this planet, rotating in space, in universal time.

By marking the yearly extreme positions of the sun, *Sun Tunnels* indicates the "cyclical time" of the solar year. The center of the work becomes the center of the world. The changing pattern of light from our "sun-star" marks the days and hours as it passes through the tunnel's "star-holes." The positioning of the work is also based on star-study: the surveyor and I were only able to find True North by taking our bearings on the North Star—Polaris—as it ovals around the North Pole because of the Earth's movement.

I wanted to bring the vast space of the desert back to human scale. I had no desire to make a megalithic monument. The panoramic view of the landscape is too overwhelming to take in without visual reference points. The view blurs out rather than sharpens. Through the tunnels, parts of the landscape are framed and come into focus. I chose the diameter, length, and distance between the tunnels based on the proportions of what could be seen of the sky and land, and how long the sun could be seen rising and setting on the solstices.

In the desert, scale is hard to discern from a distance. Mountains that are five or ten miles away look deceptively close. When *Sun Tunnels* is seen from four miles away, it seems very large. Closer in, a mile or so away, the relational balance changes and is hard to read. The work is seen from several angles on the road in: at times two of the tunnels line up exactly head on and seem to disappear. Seen from a side angle, the two tunnels in front can totally overlap and cancel out the ones in the back.

From the center of the work, the tunnels extend the viewer visually into the landscape, opening up the perceived space. But once inside the tunnels, the work encloses—surrounds—and there is a framing of the landscape through the ends of the tunnels and through the holes.

The color and substance of the tunnels is the same as the land that they are a part of, and the inner matter of the concrete—the solidified sand and stone—can be seen on the insides of the holes, where the "core-drill" cut through and exposed it. In that kind of space the work had to have a substantial thickness and weight, which was only possible with concrete. The rims are wide enough to frame the space from long distances, and the weight (22 tons per tunnel) gives the work a feeling of permanence.

Only the sunlight holds things together. Noon is the crucial hour; the desert reveals itself nakedly and cruelly, with no meaning but its own existence.

Edward Abbey
Desert Solitaire

In the glare of the desert sunlight, I want to turn away from the sun, rather than contemplate it. When the sunlight is all around me like that, I only become conscious of it when it is edged by shadow. The sunlight pours in wherever there are holes in the tunnels. Because of the 7-1/4–inch thickness of the holes, the shape of the light that reaches the bottom of the tunnels is usually a pointed ellipse, but there are times when the sun is directly over a hole and a perfect circle is cast. Day is turned into night, and an inversion of the sky takes place: stars are cast down to Earth, spot of warmth in cool tunnels.

Moonlike crescents of light form inside the rims of the tunnels. They elongate in the early and late hours of the day, and disappear altogether when the tunnels are in full shadow inside, which occurs at a different time on one

diagonal of the "X" than it does on the other. (Around the summer solstice this happens about 12:30 and 3:30.) On days when the clouds come and go, there is a dimming, a darkening, and then a brightening of the areas of light.

When the sun beats down on the site, the heat waves seem to make the earth dissolve, and the tunnels appear to lose their substance—they float like the mirages in the distance. Around the time of the solstices, when the sun rises and sets through the tunnels, it glows bright orange on the tunnel walls.

> When the white-hot sun was sinking
> To the blue edge of the mountain,
> The watchers saw the whiteness turn
> To red along the rim.
> Saw the redness deepen, till the sun
> Like a huge bowl filled with fire
> Red and glowing, seemed to rest upon the world.
>
> <div align="right">Navajo Indian Poem
trans. Eugenia Faunce Wetherill</div>

The sun is nothing out of the ordinary in the universal scheme of things; merely one star among thousands of millions, and not even a particularly large or bright one.

<div align="right">J. B. Sidgwick
<i>Introducing Astronomy</i></div>

At night, even a quarter moon can cast a pattern of light. The moonlight shines through the holes in different positions and with a different intensity than the sunlight does. In the moonlight the tunnels seem to glow from within their own substance, the rims of the tunnels forming crescents in the night. As you move through the tunnels, the moon and stars and planets can be lined up and framed through each hole. Looking up through the holes on a bright night is like seeing the circles of light during the day, only inverted.

The Moon was formed billions of years ago. But no one is sure just how. Space was full of dust and rocks in those days, and these came together to form the Earth. Perhaps when the Earth was first formed, part of it broke loose and became the Moon.

<div align="right">Isaac Asimov
<i>The Moon</i></div>

> Thus he conceived his voyaging to be
> An up and down between two elements,
> A fluctuating between sun and moon,
> A sally into gold and crimson forms.
>
> <div align="right">Wallace Stevens
"The Comedian as the Letter C"</div>

In choosing the constellations for the holes, I wanted only those with stars of several different magnitudes, so that I could have holes of different diameters. Depending on which of the twelve astronomical charts I consulted, the number and positions of the stars in the constellations varied, increasing my options considerably. Each constellation had also to have enough stars, and to encompass the top half of a tunnel with some holes at eye level on each side, so that the viewer could look through the eye-level holes from the outside and see through the holes on the other side of the tunnel. With those criteria there were only a few constellations that I could use, and from them I chose Draco, Perseus, Columba, and Capricorn. Together, they encompass the globe—Columba is a Southern Hemisphere constellation which slips over the edge of the horizon for a short time each year, but can't be seen because of the dense atmosphere near the Earth. Capricorn is visible in the fall and early winter, and is entered by the sun at the winter solstice. Draco and Perseus are always visible in the sky.

The work was constructed in several stages. From True North in the center of the site, the surveyor and I staked out the solstice angles that the astrophysicist had calculated. But before digging the first hole for the foundations, I wanted actually to "see" a solstice. Delaying the work until the end of December meant delaying the work until the spring, because the ground would be frozen. In the interim before the winter solstice, I hired a road gravelling crew and I gravelled a 3/4-mile road out to the site. On December 22nd we watched the sunrise and sunset and the data checked out.

I worked with the engineers in designing the foundations, and began getting estimates from contractors. It was difficult to find good workers who would go 200 miles from Salt Lake City into the middle of the desert to work. But by spring I had found some, and the holes were dug and the foundations poured. It took two weeks finally to convince the owner of the road construction company, 50 miles away in Oasis, Nevada, to send a concrete-mixing truck to my site. A few local people volunteered their help with this work and with the final installation.

I was in the pipe yard every day while the tunnels were being constructed.[6] I made templates to mark the hole positions on the inner and outer pipe forms, so that the steel that goes into the wall of the pipe—the re-bar cage—could be cut wherever there was going to be a hole. Steel rings were welded around the areas where the holes would be cut to increase the strength. The pipe form had to be blocked on one end to make the ends of the tunnels smooth, not recessed.

The core drilling was done with hollow, cylindrical drill heads ringed with diamonds. As a hole was cut, the edge of the drill head would slice through the wall, taking the core of concrete out with it as the drill was removed. When the core drilling was finished, I hired four large low-boy trucks to haul the tunnels, and a 60-ton crane, which went the 200 miles out to the site at 25 m.p.h., to lift them onto the foundations.

The local people and I differ on one point: if the land isn't too good for grazing, or if it doesn't have water, or minerals, or shade, or interesting vegetation, then they think it's not much good. They think it's very strange when I camp out at my site, although they say they're glad I found a use for that land. Many of the local people who came to my summer solstice camp-out had never been out in that valley before. So by putting *Sun Tunnels* in the middle of the desert, I have not put it in the middle of their regular surroundings. The work paradoxically makes available, or focuses on, a part of the environment that many local people wouldn't normally have seen.

The idea for *Sun Tunnels* became clear to me while I was in the desert watching the sun rising and setting, keeping the time of the Earth. *Sun Tunnels* can exist only in that particular place—the work evolved out of its site.

Words and photographs of the work are memory traces, not art. At best, they are inducements for people to go and see the actual work.

NOTES

1. On that first trip West, Smithson and I collected rocks for his *Non-Sites*, while Heizer was making his initial works in the dry lakes near Las Vegas. Together, the three of us made a film at Mono Lake, a salt lake in the California desert, and I did some still photography of the land.

2. In 1975 I made a 32-minute, 16mm, color and sound film, *Pine Barrens*, about that area.

3. Each "Buried Poem" was made for a specific person, who received a booklet containing maps, descriptions and/or history of the site, and detailed directions for retrieving the poem, which was buried in a vacuum container.

4. *Missoula Ranch Locators*, 1972, is 22 miles north of Missoula, Montana, on Route 10A-93 on the Waddell Ranch. Eight *Locators*, made of 2-inch diameter, galvanized steel pipe, welded in a T shape, their ends embedded in the ground, are placed on the points of the compass in a 40 ft. diameter circle. A viewer, looking through a pipe toward the center of the circle, sees the opposing *Locator* within the diameter of the circle of vision. Looking outward through the *Locators*, various aspects of the landscape are seen.

5. Les Fishbone, the astrophysicist, calculated the solstice angles to be 31.98° north and south of east and west. Robert Bliss, Dean of the School of Architecture at the University of Utah, allowed me to use their helioscope. Harold Stiles, a surveyor and engineer, did the readings of the sunrises and sunsets, and laid out the solstice angles at the site.

6. By spring the estimated cost of my pipes had doubled, because the pipe forms that I needed had to be shipped in from Los Angeles. So I decided to go to Los Angeles and meet with Jack McGill, the president of the U. S. Pipe Co., to see if I could interest him in subsidizing a work of art. The outcome was disappointing—they saw no value in getting involved with art; they did however reduce the cost of the pipes about five percent and their engineer approved

the stability and strength of my design. I met with executives of two other large concrete pipe companies in the Los Angeles area with the same results, but only U. S. Pipe had a plant in Utah.

Christo and Jeanne-Claude
Interview by Barbaralee Diamonstein (1979)

Unlike the works of Robert Smithson and Nancy Holt (which were generally in remote locations), the large-scale outdoor works that the Bulgarian-born artist Christo began creating in the late 1960s were designed to engage people in their everyday environment. This engagement began with a public relations campaign, which Christo and his artistic partner and wife, Jeanne-Claude, waged in order to get the proper support for projects such as *Running Fence*, 1972–1976. *Running Fence* was an eighteen-foot-high "fence" of fabric that ran for twenty-four and a half miles through Sonoma and Marin counties in northern California for two weeks in September 1976. It traversed private ranches, roads, a highway, and a town and went into the ocean at Bodega Bay. The realization of *Running Fence* took years of negotiations—including a 450-page environmental impact statement and several public hearings. The total cost of *Running Fence*—including labor, materials, and permits—was $3.2 million. This entire sum was paid by Christo through the sale of his drawings, collages, and small sculptures.

Christo and Jeanne-Claude believe that for a work of art to be truly contemporary it must engage with the economic, political, and the legal systems within our society. They view the social mechanisms that their large-scale projects set in motion as integral to the work itself. They hope that the public debates that surround their essentially irrational proposals create a reference point for understanding a range of social values. This interview, conducted in 1979 by Barbaralee Diamonstein, was originally published in the book *Inside New York's Art World*. The *Reichstag* project that is discussed toward the end of the interview was completed in June 1995.

BLDD: Two persons who produced some of the most monumental pieces of art in recent times, in scale as well as in importance, are Christo and Jeanne-Claude.

Christo is your given name. You were born Christo Javacheff, a native of Bulgaria, and you left there twenty years ago. Can you tell us when and why you chose to leave that country?

C: I was born in Bulgaria but I am also Czech. I lived in both countries—in Bulgaria and Czechoslovakia—until late 1956.

The last time I was in Czechoslovakia was in 1956, and I crossed the border in January 1957 to Austria and to Vienna. Why I left Bulgaria and the East? For many reasons, and of course I was very young, I was twenty-one, and this type of decision was most easily done. I studied at the Art Academy in Sofia in the mid-fifties, and was involved with architecture, movies, and propaganda art during the Cold War. During that time I learned about Russian-Soviet art of the twenties through some older artists.

BLDD: Tell us your views about propaganda art.

C: That was during the Cold War, and all the students were obliged to give their Saturday or Sunday to the Party or to the proletarian revolution, and there was a lot of activity, basically activity in cooperative farms and factories. During that time the only Western people passing through Bulgaria were on the Orient Express going from Paris to Constantinople, and the Party was very eager that all the landscape and all the view for 400 kilometers along the Orient Express line, from the Serbian border to the Turkish border, should be proper-looking, dynamic, prosperous and full of work. The art students were sent to give advice to factory workers, ranchers, farmers, on how to stack their machinery, how to put things around the railroad tracks, so that they would not look disorderly and clumsy.

Perhaps that was a very significant part, because during those weekends I developed a taste for working with different people outside of the academic world of scholars, people who were not doing art but who were managing space in a different way.

But early in 1956, during the Khrushchev era of the Party, it was really through the de-Stalinization in that period that I started to learn about the underground.

There was the Hungarian revolution during that time. It started in late September. The Soviet army was on the border, but there was a way of crossing the frontier.

BLDD: What was your way?

C: Well, that's a long story. I crossed the border with sixteen people, mostly a Czechoslovakian family, and on January 10, 1957, at four o'clock in the afternoon, I found myself in Vienna.

When I arrived in Paris in 1958, one of the first people I met was the French writer and critic Pierre Restany. I spent both the summer of 1958 and the summer of 1959 in Germany, and I met John Cage at that time, and Mary Baumeister and Karlheinz Stockhausen.

BLDD: What about the new realist group?

C: I was not part of the new realist group. An important concept in that group was that they would do work with objects or with space but with extremely low interference of the artist. The artist's interference with the objects and the situation would be minimal.

My interest (especially the packages I was doing at that time) was not considered pure enough by Pierre Restany for me to be in the group. This is why I was not one of its founders. I showed with them twice, in 1962 and in 1963.

BLDD: You started as a painter of portraiture. Whatever happened to that work and how did it evolve to wrapping those first small objects?

C: I really did not start in portraiture, no. It's just the same if you ask if Jasper Johns was doing show windows.

BLDD: He was.

C: Yes, he was doing show windows but he was not a show window artist. I was doing portraits, and all my portraits were signed with my family name, in the way Kandinsky was doing flower paintings in Paris and here, you know. And I was doing portrait and landscape and I was also washing dishes in restaurants and doing garage work, anything available and fast to produce enough money to do my work, and this is why the portrait is something I have no predilection for.

BLDD: When did you first begin to wrap objects?

C: The first wrapped group, in 1958, was called *Inventory*. *Inventory* was like you were moving from your house, and you have chairs, and you have cases all covered with cloth and fabric, and there was a group freely put together, and there

were cans and bottles and all sorts of materials, sometimes very small—about twenty—sometimes large—about forty, fifty pieces—and they were all home objects, you know, objects you can manipulate yourself alone, some large—perhaps the chair and table were large—and some small ones.

BLDD: What was the first object? A bottle?

C: I don't know exactly. There was a group of objects, not one object. There were a number of elements in my studio: certainly chairs and bottles.

BLDD: Well, you have always known the effectiveness of size. Obviously that was one of the things you learned early on from your propaganda art. But what of the scale of your initial work?

C: It was small because you know, I was in France, I was speaking French very poorly, I had no means, I was living in a very small place, and I had a seventh floor studio, a little room in a Paris house, and of course the only material that was around me was very humble, small things I could manipulate at that time, or use for my work. But that was a very short time. I should tell you that in 1961, at my first show in Cologne, I did a project inside the gallery, but we did a very large one outside, a dockside project on the Rhine, in the harbor in Cologne.

BLDD: Was that the first large-scale project, the oil drums in the Cologne harbor?

C: There was a huge amount of material on the dock, like paper, rolls of industrial paper, eighteen to twenty feet high. Now the gallery was just in front of the harbor, so it was very easy to do a piece inside the gallery and, outside, do pieces using the harbor sights and some ruins from the war.

BLDD: The two of you represent one of the more successful art mergers in history. When did you first become interested in Christo's art, Jeanne-Claude?

JCC: The moment I fell in love with him. I've known Christo since 1958.

C: In 1961, I was doing the exhibition in Cologne, and at that moment they built a wall in Berlin, and there was a very tense moment in Germany and in Europe. It was almost the outbreak of a world war. I came back to Paris. During that time Paris was in an incredible political uproar because of the end of the Algerian conflict. It was very exciting.

We proposed, in September 1961, to build a Wall of Oil Drums, an iron curtain, in a small street on the Left Bank in the Quartier Latin, Rue Visconti. I did the photomontage, I did some drawings, and we started to ask for the permits from the prefect and the government in Paris. That process was very long, almost a year; we had to go to court and to the police and never got the permission. But we did the project anyway, in June of 1962.

BLDD: Jeanne-Claude, you are almost uniquely known for your managerial skills, and it certainly is, if I may use the word, a unique collaboration that the two of you have. When did you first become so deeply involved in Christo's projects?

JCC: Ask Christo. It's for him to say when I started to be useful.

C: I think already in 1961 or 1962.

BLDD: All your projects have not only been monumental in scale, but with costs to match. How did you go about raising the funds for something like *Valley Curtain*?

JCC: The *Valley Curtain* cost $850,000, and we never use the word raise because that is not the word that artists use when they sell their drawings and works of art. They never say they are raising money, they call it a sale, and this is what Christo and I do: we sell his works of art, which are either recent—a recent project—or future projects, or old projects or early packages, and we sell them through the corporation of which

I am president. The works of art are sold to museums, to art dealers and to private collectors, and the money is used to build the projects.

BLDD: There are so many concerns—economic, technological, political, social. How much do these matters impinge on the making of your projects? I am thinking of some of the projects that you tried to do, Christo, that met with opposition: wrapping the trees on the Champs-Elysées, wrapping the Reichstag and other monumental projects. How do you deal with that?

C: I hope you understand that the final object is the end of the work of art. The work of art is the dynamic stage of several months or years. The lifetime of the work is the work, and the physical object is the end of the work, and of course that is the essence of that project. They are conceived subversively and they are never commissioned, you know, and they involve unpredictable futures. They have a basic suicidal character. And of course that is a very important part of these projects, because the projects are larger than our imagination, than the imagination of anybody, and they build their own identity in a complex life or world where this has happened. In the case of the *Running Fence*, it involved directly half a million people, and in the case of the *Reichstag* it involves complex national and international relations.

A project grows like a child and is like a giant monster. We hire a lot of specialists who give us advice, but there is no way to know where the project is going because nobody did a *Running Fence* before and nobody did *Valley Curtain*. And we will never do another fence or another *Valley Curtain*. This is the basic importance of these projects. It is like experience which is lived and after that cannot be repeated, and there is no routine, no precedent. And of course that is the challenge of the work. There is no reference in the courts to building permits, no reference when you go to the public hearings and trials in the different courts, and that of course really makes the project build itself and be its own invention.

BLDD: Your work remains such a personal gesture on the one hand, and on the other, involves a vast army of people that collaborate, or at least have roles assigned to them. Why do you object to the choice of the term, collaboration? How does the final expression, after three or four years of work, becomes a seamless, personal expression of Christo and Jeanne-Claude's work?

JCC: When you talk of collaboration with half a million people, I will not correct it—that is absolutely right. But we never collaborate with other artists.

BLDD: How do you communicate your philosophy, the idea behind your projects for your volunteer "army"?

C: We have no volunteers—everyone is paid. It's very important to be simple because that is the way the projects become understandable. Often the idea for a project is very simple, almost stupid, often very stupid. The *Valley Curtain* is a curtain in a valley—I mean it looks like a curtain in a valley—the *Running Fence* is a fence that's running, and it's very basically like a fence. They are not titles with dubious meanings. They are very descriptive. A very complex reality.

BLDD: Perhaps you might tell us how you select first the geography, and then the specific site for a particular project. Why California?

C: I think I'd like to talk about a specific project. For a long time we were interested in doing a project in California. For us California was a huge fascination. Perhaps this is the most American state in the way of living. You know, the people live horizontally, in a very complex relation between urban, suburban, and rural life, and

of course through all that sort of living they have a huge, acute notion about the land, the use of the land, driving to the land. And now they have the most highly advanced laws restricting land use and working on the land, and this is why—the project should be rooted in a community with a fantastically acute and very nervous relation to the land.

BLDD: Do you like that edge of anxiety?

C: This is why the project was horizontal, and the 24.5 miles are dealing with these urban, suburban and rural situations. The axis is basically east-west. The fence is related from a very rural situation around the coast going inland to suburbia and a small-town situation around Freeway 101. The fence crossed a very typical element of California life, the freeway, that very busy eight-lane highway.

Now there were many, many considerations why we chose California, just as there were when we were doing the *Valley Curtain* in Colorado. We felt these projects should be done in a society or community where the people have very strong relations with their street, or their houses, or their mountains. Colorado people are most strongly attached to their mountains. They refused to have the Olympic games there, the winter Olympics, because they like to keep their mountains clean, and the mountains are used in a very complex way between farming and ranching and sports.

Well, all this answers the question why we were doing the project in California and not near Capetown in South Africa.

And when we chose to do a project in Berlin in the city, we were not choosing just a type of city, like Tokyo or London or New York. We were very interested in doing a project in a city extremely affected by our twentieth-century life. There is no other city in the world like Berlin, a metropolis of five million people who are divided physically by the Wall, living closely, completely together, within a few hundred yards of each other. This is why we did the *Reichstag*.

BLDD: You selected the very symbol of German unification.

C: This is the only strip in Berlin which is in the jurisdiction of the Soviets and the Western powers.

And of course, to do that project we needed permission from the Soviets, and from the British, the Americans, the French, and the German Bundestag. From there evolved a huge relationship between the East and the West, and we put together the Soviet generals and the British and the German Bundestag to let us do it.

BLDD: So then the political and social contexts are as significant or perhaps more significant than the topographical context.

C: They are all bound together. We cannot avoid it. In California we chose exactly a typical specific situation. Same thing in Berlin—the *Reichstag*.

But we cannot qualify one part as more important and another less important. The most important part is really the driving energy for the physical object. If the physical object is not the ultimate end, we never arrive at this fantastic power of the project.

JCC: You mean if you did not really intend to build it.

C: Yes. You know, it's very easy for the conceptual artist in the conventional way. The conceptual artist can stop his projects after a few weeks, saying that he has gathered enough political material.

BLDD: Then you reject the association with the now-traditional conceptual artist?

JCC: We reject it.

C: Absolutely. I don't think we are conceptual artists. Because the final object is the ultimate end of the work. It's like the goal set, and that is the energy. The work created a fantastic energy for and against the project, the true energy, and that is energy that we have only because we pledge and we swear that in the end we will go through with the work.

Of course the buildup, the antagonism, the forces, the committee to stop the *Running Fence,* the opposition of some Christian Democrats in Germany—that created a fantastic rolling machine against each of the projects. But that is the force of the project, because they know that if the project is not arrived at the final object will be a failure, and we have many failures. And of course the failures are very important because the failures are like a cold shower, and very good for our egos, and also very refreshing. They make you see and consider and revise things, and it is very important, I think.

BLDD: Does it lend an existential aspect to the work?

C: Perhaps.

JCC: Yes, but it keeps a true, real suspense constantly, not a fake suspense.

BLDD: There are some people who would describe your work, and admiringly, as a theatrical experience. There is an art critic who says, "We call it art because we do not have an alternate word to describe it." You just said, "I do not think of myself as an artist." How *would* you describe yourself and your work?

C: No, no, no, we think of ourselves as artists 100 percent.

JCC: He meant conceptually.

C: There are really two questions to answer. It's very important to understand that all those projects have not one single element of make-believe.

BLDD: Not one?

C: Not one. It is the contrary to any theater, including very advanced theater. All these projects are outside of the art system. This is very important. Actually all the art activity, including avant-garde activity, is manipulated by an art system at all levels, through the gallery, councils of the arts—the New York State Council of the Arts—public grounds reserved for art activity, pledged to art activity. . . . All that makes art into a make-believe reality. What is important with the *Running Fence* or the *Reichstag* or the *Valley Curtain*—they are outside of that art system, and they are thrown directly into the everyday life of the country, of the community, of politicians, of the army, of circulation on streets and highways. And of course that is like teasing the system, you know, and the system responds very seriously, and that becomes the humor of the project, because when the system responds very seriously, we go to court and have these three judges discussing the fence in court. Before the fence was built.

BLDD: You were still negotiating permissions because of some of the opposition to the project?

JCC: Three serious judges are discussing something that doesn't exist yet.

C: Yes. In the same way the system is teased and the government of California, Governor Jerry Brown, all the county, different departments, will all hold public hearings open to radio and television and newspapers, and the people attend, the people talk against, the people talk for. Now that is how this work is done. And of course that is the reality. The project draws energy from that reality.

BLDD: Is that dynamic energy a component of the project?

C: Yes, but that is the true reality. It is not orchestrated by us or invited by the gallery or things like that. Not at all. We would be glad to have less problems. But it is like an enormous machine—that's the exciting thing.

Now when we work on the *Reichstag* project, the project is much beyond any possible control, so that we could not do anything. If Mr. Springer is against the project, or *Pravda* writes editorials against it . . .

BLDD: The publisher Axel Springer?

C: Yes. And *Pravda* just wrote editorials against the project. Now this is a story that is beyond any valid situation in the art criteria system.

JCC: And has nothing to do with theater.

C: And that's why it perhaps looks like a political campaign. When people were building the fence it looked very much like they were installing electricity poles. Anyway, many of our workers on the fence were specialists in television and high-wire installations.

But the ultimate goal—and that is extremely important—is the irrational purpose of the project.

BLDD: Irrational?

C: Irrational, totally irrational, totally. Now this huge amount of energy, hundreds of people coming to the hearings—court trials—the only purpose of the *Running Fence*—it's not a windbreaker, it's not an agricultural fence, it's a work of art for a few days, and of course the logic to be injected in the mind of these people, this half a million people . . . this is a slow process. It does not happen right away. It's an extremely slow melting process, welding process, it's almost like a generative thing, and that is why the politicians and others were very upset. They cannot understand how two hundred and fifty ranchers, who are such pragmatic people, can be involved with a project completely without purpose. But of course that is the magnetic power of these projects, because they have this incredible swinging around, and it is electrifying.

The point is, that energy can, by simple momentum, create forces for and against the project.

BLDD: Do you think of the fence as a real fence, or as a barrier, or as a work of art? What do you want from the people involved in a project, the people who live there? Do you want them involved in every aspect of the process? What do you really want them to do? You say you are 100 percent artists. I assume there is something about their perception and something about their vision that you care about.

C: We start from a very simple story and we try to elaborate our language, but we never try to tell what the fence really means. But there was a Swiss journalist in the home of one of our ranchers, long before the fence was up, a typical California rancher, not very poor, not very rich, he had a plastic home with plastic furniture and carpets, and on the wall a reproduction of an oil painting of the sunset in plastic, mass reproduction. And through his window he was seeing the fence and we later got the fence through for almost one mile. Now that rancher, who later became one of the greatest supporters of the project, was trying to explain the fence, what it meant to him, to the Swiss journalist.

BLDD: And how did he describe it?

C: He looked at the landscape in the reproduction and he said, "You see, the sunset in the landscape is make-believe art. The fence is the real art, not make-believe."

There was an enormous build-up of imagination in these three and a half years, because the ultimate object was the fence, and throughout these hearings and the court trials the only things we could show was some sketches, some drawings and some photomontage, to really try to visualize the fence. But the ranchers and the people who supported the project, and the people who were against the project also, built some high-level imagery of how the project would look—that really was a dynamic situation because the fence did not exist. And because so many people were fighting against it and so many for it, they started to build a vision of how the fence would look on the hill. And of course that is one of the most important facts of these projects, this type of perception of art, the enormous anticipation. No graph can develop this kind of dynamic understanding of art, you know, when the people of an entire community have that type of communion, when there is something that will become the ultimate work of art.

I remember when the fence was going up—the process was slow—and over twenty-four miles it was impossible to take care of the huge number of friends and people and some of the media, so we simply asked the ranchers to become our PR people, and the ranchers invited TV people and journalists to their homes and were holding press conferences—they were telling what the fence is and how they were fighting for it. For them, the fence became their own project. They were doing that for three and a half years.

BLDD: What was the opposition about? Please describe the process of going to each of the sixty ranchers who were involved, and how you turned opinion around.

JCC: We knew, we thought the most difficult would be to convince the ranchers to rent us the land.

BLDD: Was this in Petaluma, in northern California?

JCC: Yes, sixty miles north of San Francisco. I told Christo that there shouldn't be any problems at all with the permits, but the ranchers would not sign, so we thought we must concentrate on getting the permission from the ranchers because it is all private land—except for the last parcel; because it is the frontier of the United States, being the coast and the ocean and navigable waters et cetera, this belongs to the state and to the military.

And we thought, we are only two, with a few helpers; we cannot start talking to everybody, and the most important persons are the land owners. So we devoted most of our time to them, which afterwards made us realize that maybe we should also have devoted some time to some other people, but this you always learn afterwards.

At first we thought we would nicely and gently explain to the ranchers' wives how interesting our work is and to please tell their husband to let us do it. After a few weeks—three or four visits to sixty ranches—we understood that this was not at all the right approach, because those people had no reason at all to be interested in us if we were not interested in them.

So we started learning about them. I know everything now about making butter and milk and artificial insemination, everything. And we were genuinely interested, because they would have felt the make-believe and it wouldn't work—they are very genuine people. We became friends, and once you are friends then it's easy because from a friend you can ask anything, even to put up a *Running Fence* on his land.

Of course there were details. It's a five-page contract of agreement, written by lawyers, which means it's in Chinese, and we had to talk with their lawyers and our lawyers, but those were details—once we were friends everything was all right.

Now it took almost one year to convince fifty-nine families. It was not a few weeks' work, and we learned very much about them. Unfortunately now in retrospect we understand that politically we were naive in not taking care of some supervisors or some congressional persons.

We were keeping a very low profile, trying not to let the press know that we were doing the project, because we didn't want to upset the ranchers by having it become public before they agreed entirely on the land. But by September or October 1974, when all the ranchers had signed, even if you have rights of private owners in the United States—at least in California—you cannot do anything without a fantastic battery of governmental permits. There were about fifteen governmental agencies to go through for that project, from county level to a very complex federal investigation. We were thinking that that could be done in a few months. Actually the governmental permits took us more than a year and a half. We started in late 1974.

Meanwhile, coming inland to the east, which becomes more and more suburban and urban, the fence was going through several subdivisions, behind kitchen windows and all kinds of gates. Some of the subdivision people—about a quarter of a mile of the fence—were opposed to the project, and they started to write letters to the counties. We really were not aware how powerful the opposition was.

In the first public hearing we lost, but not entirely because of the opposition. We lost because the supervisor was not quite sure that he should let us do the project. And on January 29, 1975, we understood that we were facing a terrible amount of very complex opinions.

BLDD: Did you think at that point the project would not be realized?

C: I never thought that, but there were some very low periods in that time of exhaustion. You know, some of these public hearings took seven or eight hours.

BLDD: The *Running Fence* was up for two weeks. What happened to it after that?

C: When we were renting the land there were all kinds of agreements. The agreement on the project was that the fence would remain in full view for two weeks maximum, and after that it would be removed entirely before the rainy season started. This is why all the real physical work on the project was done in the entirely dry season of California. We must remove everything—that was the condition of the government agency—the holes would be filled with earth and seeded so that the grass would grow, and the cable, the fabric and the poles were given to the ranchers. That was our payment to the ranchers as friends—that each rancher have the material, and they use the material for gates, for fences, for cattle guards for barns, for covering the tractors and other machinery during the rainy season, and things like that. I know some of the ranchers were selling the fabrics and one used it for a wedding dress and things like that.

BLDD: What do you think your work has done to the credibility and the status of monumental works, traditional, conventional ones?

C: Our perception of art is basically Victorian. The object, the commodity as a work of art is a completely recent perception, and of course this became more and more evident—perhaps I now talk like a Marxist—with the advance of capitalist society and industrial society, when you have the family, the molecules of husband, wife

and children, an apartment, and have the commodity, transportation, goods that you can move out fast with yourself.

And of course relating the value of art in terms of a commodity object is an extremely recent perception. It's very sad to see, but in the postindustrial epoch we are still living with objects that are physical elements and we venerate them like the Christians venerate the shirt of St. Peter in Rome.

Before, art was a much more fluid communion—I always think that art in the tenth century was much more democratic than it is today. In that time nobody was involved with owning art because the people owned the kings and the gods, and there was a complete link, like for them the kings and gods were the same thing, and they were the direct link with art that was real, existing.

But when art became a commodity and we started to own it and to have it only for ourselves, that is when our monumentality started to be broken into small pieces. We cannot have monumentality when we are involved with a commodity, with transportation of goods and all these things, and it's very sad to see that we are claiming that we are doing public art when actually we do only garden objects and things of that kind around the city. I don't know how long it'll take until our society understands that it's capable of mobilizing energy, if you call it that, or wealth or money or power, so that that power can be used for irrational purposes. That's very important.

BLDD: Did you originally start to wrap objects to protect them from people, from pollution? What is the idea? Is it symbolic?

C: You touch on another important question, the fabric. The fabric is a very important part of our work. Friedrich Engels said that fabric made man different from primitive man. The process of weaving is the oldest and one of the most important processes of the evolution of man. In the same way fabric is almost like an extension of our skin, and you see that very well in the nomads, and in the tribes in the Sahara and Tibet, where they can build large structures of fabric in a very short time, pitch their tents, move them away, and nothing remains. But also fabric can be used in large dimensions. This is why using it in the late fifties and early sixties to wrap objects with was the most simple way to do something, and these objects were always compared: there was a wrapped bottle with a not-wrapped bottle, a wrapped chair with a not-wrapped chair. There was always this comparison.

BLDD: The fabric becomes less and less opaque as your work evolves. Is that significant as well?

C: In the early sixties I used plastic because of the "passing through" activity. Actually all these projects were about passing through. It's a dynamic situation when the light passes through. Often what is in the package is not important. But actually that activity of passing through should be very, very acute. You cannot have that passing through if there is obstruction, if it's steel or wood or concrete and it never can go through.

But the fabric is extremely fragile, and the fragility is essential for the project. It can break and it breaks, it can tear and it tears. Of course the fabric is dialectically the only material that can be used in temporary projects. It would be completely idiotic to build a fence with some kind of incredible steel material when the fence is intended to last for fourteen days.

All these projects are thought of as temporary. This is why it is so completely funny and extremely ironical to see all these great artists doing huge steel structures

for a short time and move them away, and it's stupid. There is no logic in it. It's like some people dropping things for an imperial power because they have the right to drop them and then they drop something very big.

All these projects, from the bottom to the end, they work in a completely dialectical relation. In the way a thing is done, in the way a life is lived, in the way people live their life, in the way people fight for their life in their streets, in their neighborhoods, in the way the wind affects and everything—those very, very simple things.

BLDD: What is the status of the *Reichstag* project?

C: Very, very ambiguous. We are now involved up to here with international and national problems. We have never before been involved with a project which involves millions and millions of people—including the President in Washington. And of course we don't know how to do that. With the ranchers in California there was a one-to-one relation—finally we could go to the ranchers, to the congressmen, and talk. But when you involve a large number of politicians and generals in different states and nations, then it's very difficult to know who is really the decision-maker of that project. And we tried to enlist advice of many people, and we tried to explain the project to many people. Last July I was in Berlin and we had a long talk with the new mayor of Berlin—and he advised that we give the project more international attention to make it more flexible.

BLDD: And what did you do about this?

C: The *Reichstag* is a very critical thing. Anyway, we tried to explain the project to the politicians in London, in France, in the United States, and to the media.

I'll tell you, if that project happens it will only be because some friend or professor or art historian tried to help me. I cannot do it alone. And of course that will be the first work of art that can be experienced and lived and seen from both sides, east and west, simultaneously. But of course a good number of East German people and Poles and some Russians think the project is going to happen.

BLDD: Jeanne-Claude, how do *you* plan to pursue the *Reichstag* project?

JCC: The same way as other projects. It's always different people, different countries, different customs, different levels of society, and each time we don't know anything, and we have to learn. Now that we are specialists about ranching, we have to learn about international politics, but we can learn, it's all right.

BLDD: Christo, you may talk like a Marxist, but you don't think like a Marxist. That *Running Fence* cost an almost unbelievable $2 million.

JCC: Three.

C: But you know, if we succeeded in that it's because we used the system fully. I learned that from my studies in my country.

When I was in Washington at a meeting for the National Endowment to make some possible efforts to better relations between artists and business people and the big corporations, in the end I was so furious that I told them, why should we not talk in decent terms? The business community and the government always try to see artists as the orphans and the blind, on a charity level. Why not talk on the ego level? Artists have a great ego and you, the company, have a great ego. There is nothing wrong with that. In the great period of the Renaissance, in the great period of Christianity, the pope or the king recognized their identity.

JCC: During the Renaissance the business community knew that helping the arts is good business, while today helping the arts is charity.

Robert Irwin
On the Periphery of Knowing
(Interview by Jan Butterfield) (1976)

After creating paintings in the mode of Abstract Expressionism and Minimalism in the late 1950s and early 1960s, Robert Irwin stopped making objects altogether and began to think about ways in which he could make the viewer aware of the fundamental links between experience, perception, and consciousness. In the early 1970s Irwin began to alter pre-existing built environments by painting specific areas within the space and/or setting up walls out of semitranslucent scrim. By subtly altering the conditions of space and light in a given environment, Irwin accentuates the viewer's awareness of that space. Irwin views perception as directly connected to consciousness. So if the viewer is placed in a situation in which his perceptual faculties are challenged, then there is potential for the viewer's consciousness to be altered as well.

Irwin is interested in ways in which artists can make people aware of how they construct their own realities. In the interview "On the Periphery of Knowing," which was published in *Arts Magazine* in February 1976, Irwin talks about the need for art to expand beyond the current cultural dialog. Artists must be aware of the limitations of a given system. This is best achieved by pushing art to what he calls "the periphery of knowing"; it is here that art is involved with inquiry and not with conclusions.

"We are given to organizing and structuring," Irwin wrote in an unpublished manuscript in 1973. "We physically organize ourselves and our environments but more critically, we organize our perceptions of the physical world into abstract structures—our minds directing our sensory apparatus as much as our sensory apparatus informs our minds. Our reality is confined to our ideas about reality."

All too often those structures which are created for practice are so defined as to exclude experimental, erratic, or even innovative information. Long interested in Irwin's inquiry into the nature of things, and in what way it could, or *if* it could affect existing structures, I have followed the progression of his ideas and activities with interest, and sometimes with difficulty; his route is far from linear.

Toward the end of the 1960s, as his theoretical position was honed and shaped, the artist maintained a low public profile, producing no "tangible" works. Then, beginning with an untitled and unlabeled piece or "situation" executed at The Museum of Modern Art in 1970, there has been a gradual proliferation of scrim pieces and other environmental works executed as "responses," always at the instigation of the institution.

The most recent public works deal with a range of very different perceptual concerns; executed as "responses," they vary with each situation. In November and December in California three works were available: at Long Beach

State College, at Mizuno Gallery in Los Angeles, and at the La Jolla Museum of Art. At Long Beach, a large-scale white "window" was created outside, filling the entire breezeway between two buildings. Clearly a frame, it set up a situation in which the viewer found it necessary to shift his sense of focus from real to pictorial to real space in such a way as to become acutely conscious of the activities which took place "within" it. The work was very much about questioning of our systems of focus, an integral part of Irwin's inquiry.

At Mizuno Gallery, a work of great power obliterated the space, becoming instead the space itself. Alternately a void and a volume, it was at once empty—and loaded with information. In it, Irwin's now-familiar scrim, stretched tight from the ceiling, had an almost blue tonality. Held taut by a black metal bar/band, its "real" physical presence ended somewhere below the participant's eye level. A mirror image of that black band appeared on the floor beneath it, extending up the walls to the edge of the scrim, forming a clear, clean rectangle. Volumetrically, the piece reversed itself out as the space above the black bar came into shape perceptually as a solid, and then suddenly slipped out of focus, causing the void below to take on the real "reality." Taut, powerful, the sensibility of the piece changed several times through the day as the light paled and yellowed, and the work took on a rounded, softened sensibility with yet another kind of perceptual hum than that created by its early "blueness."

At the La Jolla Museum, Irwin created perhaps the simplest and most "gentle" of his scrim pieces to date. In a low-ceilinged gallery room, the walls of which appeared to be cream, the piece began softly up from the nubby carpet and encased the entire end of the room—track lights, molding, corners and all, in a soft, muted cocoon.

JB: What is your definition of what "Art" consists of?

RI: I have certain reservations about the "outside" in terms of holding or making some clarification or definition for what art is specifically. First of all, there is no way that a definition can be anything more than a cultural agreement, a matter of placing our collective attention or a certain amount of our energies towards an activity for gaining an aesthetic awareness. But this art is not an inevitable thing, since art has no *actual* physical attributes other than the ones that we give to it as a kind of statement (temporary) about the condition of our understanding of art at that moment in our culture. There *is* no "Art" until we make an agreement and a cultural definition. This is reflective of the cultural state of mind at that point in time concerning its own ideas about its own aesthetic consciousness. Now we have an "Art," but not an art per se. The first thing you have to recognize is that "Art" is a cultural dialogue, and remains solely that until you take it to the periphery of that dialogue.

That dialogue makes a great deal of sense when you take up the boundaries for the idea of a cultural identification and assume art to operate in relation to those boundaries or those ideas or those givens about what art is, and through performance gain historical precedents, philosophical assumptions, and intellectual concepts as such. These are all the context boundaries of what art operates *in*, and *with*,

and *against*. Take that and put it right in the middle of a cultural space like a city or a room, a cultural environment, one that has already been bounded, cut up, divided, systematized, ordered, or organized by any system or logic, attitude, aesthetic, or historical precedent. Then, *that* art is immediately operative in *that* world. For example, that each mark in the arena of painting can be immediately measured with and against the whole history of painting and of knowns, is a marvelous expediency, and it most likely makes good sense in that world, but the minute you take it out of that world, and really put it in the world of the complexity of nature—in the world of atoms or light, mind, or consciousness—it can become very arbitrary. And, if there are some things we do not yet know, you have to *begin* examining the assumption "Art." This "Art" is as much an act of identification of our effect on the nature of things, leaving our record and acquiring control and function of aesthetics, as having to do with aesthetics per se.

JB: Do you, then, think you *can* define "Art"?

RI: The closest I have come to one is to say that art is *the placing of your attention on the periphery of knowing*. It is a state of mind, ultimately. If there ever could be such a thing as a total or "cosmic" consciousness, then there would *be* no periphery of knowing, because we would be *all*-knowing. There would also be no "Art"—but simply "being." However, we do not have that consciousness; our awareness of art or aesthetics is in direct proportion to the kind and degree of investments we make in them. That art, that state of mind, that attention is what is meant by a "state of real." As Ad Reinhardt said, "Art is art, as art and everything else is everything else." Taking that definition, there is no difference based on methodology or language or discipline. The critical distinction for art lies in the *intention* art. Those aesthetic games we play are simply cultural practice. This "Art," as I am defining it now, could be held to be the same in every discipline. There are those interested in placing their attention on the periphery of knowing and act of inquiry, those who are interested in placing it in that state of mind necessary for practice, and still others who are concerned with the history of cultural successes. The distinctions could be held exactly the same for every discipline. We may hold *more* in common across disciplinary lines by *intention*, than we do by common methodology. What confuses things is that each of us begins as a practitioner, develops and understands the system by coming up through the ranks and the confusion begins.

JB: I like that statement you made before to the effect that "My art may be obscure, but it is not elite."

RI: This is the reasoning behind some of the practices I am now engaged in . . . which is part of how I have been defining my activities. I see the principal difference between elitism and obscurity as *availability*. Even though the concept may remain obscure for some time, and few understand what you are saying, *if* it is totally available for as much as anybody can, or is willing to deal with it, then it is not elite.

JB: That begins to clarify much of your recent activity—your reasons for going anywhere and everywhere whenever anyone has asked you to lecture.

RI: There are two parts to that; one was the simple availability without conditions, and the second was that if ideas *begin* obscure, they may also be eccentric to our existing structures, and then it becomes absolutely necessary that you then begin to examine the processes and systems of assimilation that are already operative.

I've begun by circumventing the normal channels for this communication which are too limiting by taking on a very old concept: that new ideas are best considered *live*, in a dialectic.

JB: We have not been able to allow within the art structure difference of attitude and activity. *Your* life is very different from *my* life; you function one way, I function another way, but there is no "right" or "wrong" to either of those methods of procedure.

RI: Why confine the questions simply to art? There are no social systems conceived to encourage diversity of opinion either. Perception is ultimately a question of individual responsibility. It is to gain that diversity that modern art brought us to individually question the processes and limitations of an organized collective consciousness as form. Much/most of what is viewed as "Art" is not in any way a development or an extension of the human consciousness or knowledge of the dialogue per se. It is instead the development of a larger segment of the culture's consciousness of what we commonly refer to as communications towards the assimilation of an idea which has already existed for some time in art as inquiry. In line with this, it is interesting to note that the Cubists were unable to live directly with the consequences of their ideas, which is a way of saying how deeply those ideas could come to affect our lives.

JB: Give me an example of art as innovation.

RI: The germane ideas in Cubism. The shorting of that system of values that structured prevalent thought, followed by the social adjustments of Dada and Surrealism, carried to their appropriate conclusions in painting by the generating of Abstract-Expressionist ideas such as Reinhardt's "I'm simply painting the last painting that anyone can ever paint." The idea of a less structured view of the world—the flatness of figure and ground in Cubism—was culturally applied by the Pop artists, and is being further acted out by Andy Warhol. This is an amoral view of the world from a traditional perspective.

Cultural innovation usually consists of the new idea couched in an old form, in this case, a less structured perspective carved in figurative painting. This is the crux of innovation: context. New Realism is the same process now carried a step further culturally, a broader figuration, one that everyone can see, and a corresponding modification of the germane ideas. Cultures do not assimilate ideas whole, nor do they assimilate them *immediately* as causal connecting social activities would like to believe.

JB: Within that context, how do you see art's dilemma at this point in time?

RI: As sophisticated as we think we are, our systems of measure and innovation have uncovered no real way to deal with data at its inception. Only in the hands of the individual does the system participate in the early recognition of art culturally, and only in myth do we hold a place for art per se. What we measure, and this is the concern of historians, are the cultural overlaps and consistencies of our cultural contexts conceded to be answers. The artist, on the other hand, begins seeking the *inconsistencies* and his inquiry is process related first to his questions, and only in time is carried to performance. As performance closes in on itself, as it becomes resolution, its definitions/boundaries raise new questions about those potentials eccentric to the conclusion.

We are both Structuralists and phenomenologists, capable of feeling and thinking. There is an inquirer, a practitioner and a traditionalist in all of us. The root

question is "What do you want, or need to know?" This is the economics of our investment/intention in life, that we can't know everything, and while we may have accepted the idea that things must be orderly, the paradoxes for our perception are simply not resolvable as we live them. I don't know where we got that limited idea of order in the first place.

Any useful concept in time is carried to underwrite some act or physical existence in the world. That existence in time can come to be seen as some form of precedence. Any precedent can in time come to be seen as some form of truth and truth in time can be held to be moral. A precedent is a truth rooted in history. The abstraction of our concepts is never totally static and is constantly compounding, independent of its original election in the world and takes on a life of its own.

JB: If people are to learn to recognize the limitations within a given system and to attempt to learn to work with it or within it, but not see it as a "universal," how do they begin?

RI: You have to learn to recognize that you are philosopher, innovator, practitioner, traditionalist, historian, and participant. You are all those things, and you are capable of determining the differences in context and form which those perspectives bring to things. All of them *are* you, and they are all true, reflecting only your complexity and potential in the world. We seem to do a lot of unreasonable things in the guise of order simply to avoid the real complexity. It is in this idea of conclusions that we lose sight of our potential.

JB: How is the cognizance of all of this reflected in your own work?

RI: There are five areas of involvement for me right now. One level is my own writing, which aspires to participate at the root of Structuralist thought, the presentation and concepts argued in the form of ideas. Next are my involvements with projects like Josh Young's Market Street Program, a system of innovation/selection which operates without an opinion (i.e., bias of expertise), my work with Dr. Wortz on habitability, and the series of "Responses" I will continue to execute at the Fort Worth Art Museum over a year-and-a-half period of time. Concerning the questions for context, they represent my inquiry into systems building or reordering by building new tools, and expanding the context by which information is organized. Social interaction with students and artists also plays an important role in my activity right now, which goes back again to that thing of availability.

The fourth area of activity is one which overlaps the existing structures in a very real way. Exhibitions of new works such as those in my recent exhibitions at the Chicago Museum of Contemporary Art, the pieces at the La Jolla Museum, Mizuno Gallery, and Cal State Long Beach, etc., all acknowledge the disciplinary dialogue that constitutes what we term "Art" in the cultural sense. The fifth area of activity is personal and probably the closest to where my interest is right now: the pieces I have done in the desert and in cityscapes which no one has seen, which are my own root inquiry.

JB: Have you mapped or marked those pieces in any way, or is their purpose strictly one of inquiry?

RI: They are a means of inquiry. I don't want to simply convert them to systems like maps and markings and photographs and so forth. They represent good questions and I arrived at them reasonably and I want to *leave* them there. I want them to stay in the air as questions.

Gordon Matta-Clark
Gordon Matta-Clark's Building Dissections (Interview by Donald Wall) (1976)

Informed by the critical climate of the late 1960s and early 1970s, Gordon Matta-Clark's work critiqued architecture. In his most celebrated work, called *Splitting*, Matta-Clark used a chain saw to cut vertically through a two-story house in Englewood, New Jersey. He then cut off all four corners from the top of the house. This gesture was meant to expose both the physical and social structures of architecture. The site-specific nature of Matta-Clark's work connects it to the land art projects of Robert Smithson, Nancy Holt, and others, but its focus on urban environments was in opposition to the isolated locations of many of the Earthworks.

By creating works *in situ* Matta-Clark faced some of the same issues Smithson and Holt had concerning the relationship of the work to the gallery and museum world. Matta-Clark admits there is an incongruity between his desire to work outside of the traditional art system and the fact that the cut-away pieces from the buildings end up being a substantial "sculptural" reference to the site and therefore have the potential of becoming portable commodities within that system. When Donald Wall asked Matta-Clark—in "Gordon Matta-Clark's Building Dissections," which was published in the May 1976 issue of *Arts Magazine*—how he feels about the residue from his "cuts" potentially ending up in a sculpture garden at a museum, Matta-Clark simply replied that "if someone in the museum was truly interested in my work they would let me cut open the building."

A wry paradox surrounds Gordon Matta-Clark's art: On the one hand, his building removals and dissections represent the furthest advance yet made in American behavioral architecture. On the other hand, most people, including many accomplished art/architecture critics, are not even aware that a new architecture has been among us for the last decade—an architecture which has just rendered culturally obsolete European-derived Modernist architecture as effectively as did that architecture once render obsolete the older beaux-arts tradition. It's time to catch up; time to begin placing the new architecture into its own genealogical framework, much like Corbusier once did with Purism. A good place to start might be with certain comments made by Clement Greenberg in 1948. The mid-century does, undeniably, constitute a crucial germination period in American artistic thinking.

Greenberg, writing on David Smith, made the following observation: "Painting continues as the most leading and the most adventuresome as well as the most expressive of the visual arts. In point of recent achievement architecture alone seems comparable with it." The comments were well taken. American architecture, under direct insemination by the presence of

such imports as Mies Van Der Rohe, Gropius, Moholy-Nagy, Breuer, Neutra, Chermiayeff, and others, did exhibit much the same progressive excellence characteristic of its overseas origins as had painting. But American painting under the hands of Motherwell, Still, Pollock, Newman, de Kooning, soon broke out of the European mold. Architecture never did, then. Increasingly, architecture failed to command attention: by 1960, architecture all but disappeared from the pages of the art magazines. Its absence was easily overlooked in a decade where, as Peter Schjeldahl so aptly observed, "extreme avant-garde ideas proliferated like flies." Schjeldahl's words prompt no architecture imagery comparable to the heady list that even the most casually informed reader could compile for painting, sculpture, conceptual, linguistic, or other art forms. At no time did architecture stir intense critical debate. Nor can such a lacuna be attributed to a lack of vocabulary on the part of the art critics: given Weiner, Kosuth, Acconci, individuals like Lippard, Perreault, Burnham soon manufactured a properly responsive lexicon. Architecture was not integral to that lexicon. In contrast with their 1910–1920 prototypes, the sixties architect did not personally participate in the various burgeoning controversies and ideological disputes. Whatever controversy there was in architecture—I am thinking particularly of the supergraphic and Pop episodes—it looked like pale versions of harder core attitudes already firmly established by far tougher intellects. And what little that did emerge remained virtually unexplored from exponent to exponent. One exception might be Louis Kahn's innovative use of structural/constructional emblematics (a type of heraldic art with strong affinities with the work of Stella and Held). But not even Kahn could legitimize the stasis of an entire discipline. Indeed, architecture so rarely qualified as serious art, it did not and could not participate in that process of interdisciplinary autocriticism which Greenberg and others deemed mandatory for regenerative growth. For all intents and purposes, traditional architecture became irrelevant to well over a generation of creative thinkers. Amusing, in a way; while the art and language boys were running around trying to talk painting and sculpture to death, functionalist architecture assumed the culturally mortuistic without sponsorship, and without fanfare.

But not architecture itself. By the mid-sixties, radically new precepts of architecture were in the process of formation in America, almost all of it of non-European derivation. Most of the activity took place among artists, not the professional practicing architect. And for good reason: ambitious art exists only by breaking with fixed notions concerning what is possible and what is not. So when the artists did focus attention on the built environment, two mainstays of conventional architectural thinking (functionalism and patronage) quickly became rejected. Rather than depending on use specified by others, the artist substituted himself as locus of development—and all that this implicates in terms of years of enriched autocriticism.

The following interview with Matta-Clark will illustrate the new origins. Matta-Clark traces his genealogy not to the Bauhaus, nor to Corbusier, but to the Greene Street establishment. Predominate are influences from his childhood, especially that of voyeurism, dollhouses, and silent comedy. An irreverence for today's architecture is notably apparent. And always there exists concern over what constitutes allowable limits.

Matta-Clark's work should not, however, be understood as that of an outsider. Similar to others who have begun to redefine our postures to architecture (Insley and Saret), Matta-Clark received a formal architectural education. Typically, he also abandoned customary architectural notions to favor the strictly ideational. Therefore, whether referring to his early diggings under 112 Greene Street, or to the compost heaps under stairways, or in the use of dumpster garbage containers as "found" architecture, Matta-Clark's work accepts architecture first as information before all else: to be more specific, information that is itself undergoing a feedback process (metamorphic) from other sources, whether ecological (his garbage works) or manmade (the removals and dissections). Due to this decided process and performance base, Matta-Clark's architecture is absolutely antithetical to the "object"-oriented architecture characteristic of European sources. If one had to classify Matta-Clark's work, it obviously does not belong to the conventionalists like Moore, Venturi, Roche, Meier. Rather, his art belongs to that ever-growing body of work stemming from people like Acconci, Morris, Nauman, Smithson, Levine, Asher, Bochner, and others who have explored the behavioral and definitional aspects of place. These individuals originate from a potpourri of influences—art-as-idea-as-idea, developmental psychology, happenings, etc.—or whichever factors one wishes to cite for the emergence of "performance constancy" as a concept distinct from "object constancy."

The impact of all this was the pulverization of architecture into discrete pieces of subject matter, with each artist usually addressing himself to a specific circumstance. For Vito Acconci, this meant behavioral-spatial topology derived, perhaps, from Lewis's psychology. For Matta-Clark, this meant a metamorphic cutting into a building's specific semiology.

Such a pulverization was guaranteed, for within the autocritical attitude (which most artists, even now, subconsciously carry around) lay the reductivist mentality. "The growing specialization in the arts is due," augeristically wrote Greenberg again in 1948, "to our increasing faith in and taste for the immediate, the concrete, the irreducible [and] in principle, to avoid dependence upon any order of experience not given in the most essentially construed nature of the medium." The impact of reductivism cannot be sufficiently underscored where hybrid art is concerned. All hybrid art, to which architecture certainly belongs, faces instant disintegration as soon as the components are differentiated into the autonomous. In its geometric abstractness, for instance, decorative Greek pottery was replaced by architecture; in its depicted imagery, the pot succumbed to the invention of

the easel painting. A similar case can be seen in architecture. Prior to 1900 architecture held virtual sway over geometric abstraction in the fine arts. If geometry existed in painting, it existed either covertly as underlying compositional structure, or overtly in the renderings of interiors or exteriors of buildings, in fabric patterns, on the sleeves of garments, etc., where it predominately served as a foil for biomorphic human form. With the rise of nonobjective painting and sculpture, architecture slowly lost dominion over the geometrically abstract, not only in terms of flexibility of enterprise, but also in purity of results. No longer need a spectator depend on the Gothic cathedral in order to experience horizontal/vertical equilibration: there were now the Mondrians. (Granted, the comparison is overly simplistic.)

Similar comments could be made about other so-called "prerogatives" of architecture. Scale, geophysicality, projective viewpoint, location, etc., eventually became subject matter in themselves. This seems to suggest that the irrelevance of modernist architecture cannot be attributed to architecture as architecture, but to the means traditionally employed to sustain architectural thought. It is too early, however, for an accounting of what precisely are these newer means. Today's behavioral architecture is still at a yeasty stage of development, and should be left that way.

GMC: By undoing a building there are many aspects of the social conditions against which I am gesturing: first, to open a state of enclosure which had been preconditioned not only by physical necessity but by the industry that profligates suburban and urban boxes as a context for insuring a passive, isolated consumer—a virtually captive audience. The fact that some of the buildings I have dealt with are in Black ghettos reinforces some of this thinking, although I would not make a total distinction between the imprisonment of the poor and the remarkably subtle self-containerization of higher socio-economic neighborhoods. The question is a reaction to an ever less viable state of privacy, private property, and isolation.

I see in the formal aspect of past building works a constant concern with the center of each structure. Even before the *Splitting, Bin.go.ne,* and *Pier 52* Projects, which were direct exercises in centering and recentering, I would usually go to what I saw as the heart of the spatial-structural constant that could be called the Hermetic aspect of my work, because it relates to an inner-personal gesture, by which the microcosmic self is related to the whole. In fact, one of my earlier works dramatized this when I hung myself upside down at the center of one of my openings. More recently I have enjoyed a term used in reference to Walter Benjamin, "Marxist Hermeneutics." This phrase helps me think about my activities which combine the inwardly removed sphere of Hermetics and interpretation with the material dialectics of a real environment. The activity takes the form of a theatrical gesture that cleaves structural space.

The dialectics involve my dualistic habit of centering and removal (cutting away at the core of a structure); another socially relevant aspect of the activity then becomes clearer. Here I am directing my attention to the central void, to the gap which, among other things, could be between the self and the American

Capitalist system. What I am talking about is a very real, carefully sustained, mass schizophrenia in which our individual perceptions are constantly being subverted by industrially controlled media, markets, and corporate interests. The average individual is exposed to this barrage of half truths and monstrous untruths which all revolve around "who runs his life" and how it is accomplished. This conspiracy goes on every day, everywhere, while the citizen commutes to and from his shoe-box home with its air of peace and calm, while he is being precisely maintained in a state of mass insanity.

DW: Would the following be a fair description of how you proceed? First, you find an abandoned building, one that has outlived its usefulness, go in with chain-saws, sheet-metal cutters, and what have you, then section out various portions of the building; when it's all done, the building is re-abandoned. For the layman as well as for the practicing architect, wouldn't this be regarded as not only useless but almost inane behavior? And don't you find something perverse in this form of expression?

GMC: No, that would be an oversimplification. One of my favorite definitions of the difference between architecture and sculpture is whether there is plumbing or not. So, although it is an incomplete definition, it puts the functionalist aspect of past due Machine Age Moralists where it belongs—down some well-executed drain. Without getting too carried away, what I mean is that the very nature of my work with buildings takes issue with a functionalist attitude to the extent that this kind of self-righteous vocational responsibility has failed to question, or reexamine, the quality of life being serviced. I know that this may sound like an artistic rationalization (and to some extent it is), but it is exactly here that I defend Art against Architecture—or at least that aspect of Architecture that is a janitor to civilization. I don't mean to belittle the janitor's role as people, only as policy. My best (wo)man-in-the-street reaction to the Paris work came from a seventy-year-old concierge who said, "Oh, I see the purpose for that hole—it is an experiment in bringing light and air into spaces that never had enough of either." As far as being perverse, I am sure of it. Especially to the extent that anyone is, who enjoys breaking the rules while being convinced that he is right some of the time.

DW: In view of this, how does your life as a professional artist function in the gallery system? Especially since your work deals with specific sites?

GMC: The whole question of gallery space and the exhibition convention is a profound dilemma for me. I don't like the way most art needs to be looked at in galleries any more than the way empty halls make people look or high-rise city plazas create lifeless environments. And even though my work has always stressed an involvement with spaces outside the studio-gallery context, I have put objects and documentation on display in gallery spaces. All too often there is a price to pay due to exhibition conditions; my kind of work pays more than most just because the installation materials end up making a confusing reference to what was not there. . . . But for me, what was outside the display became more and more the essential experience.

DW: Yet the Humphrey House residue might end up in the Hirshhorn sculpture court.

GMC: There is always that danger. I am more interested in making the Hirshhorn a piece. I mean, if someone in the museum was truly interested in my work they would let me cut open the building. The desire for exhibiting the leftover pieces

hopefully will diminish as time goes by. This may be useful for people whose mentality is orientated toward possession. Amazing, the way people steal stones from the Acropolis. Even if they are good stones, they are not the Acropolis.

DW: What criteria do you use in selecting a building?

GMC: The best building I can find.

DW: Best in what sense: Picturesque? Structural? Compositional?

GMC: I seek typical structures which have certain kinds of historical and cultural identities. But the kind of identity for which I am looking has to have a recognizable social form. One of my concerns here is with the Non.u.mental, that is, an expression of the commonplace that might counter the grandeur and pomp of architectural structures and their self-glorifying clients. In Paris, I was incredibly lucky in finding just such a situation. The work was done on two seventeenth-century town houses. Typical, but with remarkable identities, almost to the point of having anthropomorphic qualities. This old couple, as I called them, were literally the last of a vast neighborhood of buildings destroyed to "improve" the Les Halles-Plateaux-Beaubourg areas. And they were surviving in the web of an immense modern structure which—in the traditionally monumental French approach—is to house all the Fine Art Agencies of Parisian Culture.

The determining factor is the degree to which my intervention can transform the structure into an act of communication. It is undesirable to have a situation where the fabric of the space is too run down for it to be identified as ever having been changed, or a situation where I would be competing with factual disintegration.

DW: This brings up the placement of your work historically. Does it lie more within Dadaist or Land Art concerns?

GMC: I'll answer the last part first because Land Art is more recent and my break with it is clearer. First, the choice of dealing with either the urban environment in general, and building structures specifically, alters my whole realm of reference and shifts it away from the grand theme of vast natural emptiness which, for the Earth artists, was literally like drawing on a blank canvas. But more important, I have chosen not isolation from the social conditions, but to deal directly with social conditions whether by physical implication, as in most of my building works, or through more direct community involvement, which is how I want to see the work develop in the future. I think that differences in context is my primary concern—and a major separation from Earth art. In fact, it is the attention paid to specific occupied areas of the community.

At this point I should mention my feelings about Dada since its influence has been a great source of energy. Its challenge to the rigidity of language both formal and popular, as well as our perception of things, is now a basic part of art. Dada's devotion to the imaginative disruption of convention is an essential liberating force. I can't imagine how Dada relates stylistically to my work, but in spirit it is fundamental.

DW: Are you solely interested in the social implications of the "cuttings"?

GMC: The act of cutting through from one space to another produces a certain complexity involving depth perception. Aspects of stratification probably interest me more than the unexpected views which are generated by the removals—not the surface, but the thin edge, the severed surface that reveals the autobiographical process of its making. There is a kind of complexity which comes from taking an

otherwise completely normal, conventional, albeit anonymous situation and re-defining it, retranslating it into overlapping and multiple readings of conditions past and present. Each building generates its own unique situation.

The *Datum Cuts,* for example, took place in an engineers' drafting rooms and offices. I couldn't deal with the outside because there wasn't enough exterior en-closure to really penetrate anything. What fascinated me was the interior central plan. The engineers took a small, square, primitive hut shape and divided it in half to make one big drafting room. They divided the other half into a quarter which became the office, and divided the remaining quarter in half again for the coatroom and bathroom. And then divided that again to make a shower or some-thing. Everything was progressively divided so that the remaining last piece was 1/32 of the whole. I used the idea of division around the center. Therefore, I re-moved a square section out of the roof apex, then projected that cut from the roof down into the building and spread it out laterally through the walls and doors. The walls in Italy are fascinating because they hold a good fine chisel line without failing apart.

The *Niagara Falls* was quite different. It involved a subtraction game. Each of the removed pieces is one-ninth of the total facade, randomly taken out. I would have preferred a sequential removal. As it turned out, the problem of just getting it done physically was so great that it couldn't be ideally choreographed. I crated all the removed pieces and debated for a while whether to reconstruct the crated facade in immediate proximity to the house. In the crates the removed sections had this incredible anonymity which was also an identity—a masked identity. If you looked really hard you could detect differences. For awhile I thought of show-ing them in their crates in New York, at John Gibson's. Instead, I left six of the nine extractions, still in their crates, out in the countryside. They were dumped—thrown off the back of my truck and left pretty much as they fell.

DW: Are they still there?

GMC: I have no idea.

DW: Do you feel any apprehension in occupying an ideological position diametri-cally opposed to the practicing architect, and to all that the profession implicates regarding solving humanity's problems?

GMC: I don't think most practitioners are solving anything except how to make a liv-ing. Architecture is a big business. It's an enormously costly undertaking and, therefore, like government, comes equipped with its entire panoply of propaganda.

I must clarify several issues. First, I think it is a mistake to place what I have done, with its very specific and, especially, local emphasis into so grand a histori-cal context, as the whole issue of Modernity, proliferated by the International Style, must be seen in the development of postwar American Imperialism. The state of that architecture reflects the iconography of the Western Corporate Axis. It is first the abuse of Bauhaus and early Purist ideals that I take issue with. Then I must clarify how Monolithic Idealist problem-solving has not only failed to solve the problems but created a dehumanized condition at both a domestic and institu-tional level. So what I am reacting to is the deformation of values (ethics) in the disguise of Modernity, Renewal, Urban Planning, call it what you will.

DW: Are there other artists or architects who interest you?

GMC: Yes, anyone who challenges the preconceptions of limits.

DW: The limits of what? Perception? Or just limits?

GMC: Artistic, ethical, and moral limits. I don't know too many artists who are concerned solely with perception. It's more a mixture. There's Sonnier's transmission piece which pushes our conceptions about local space to an extreme: it's very hard to grasp locality at the speed of light, in motion, from one side of the continent to the other. Then there is Vito Acconci; he deals in an entirely different spatial context, which is a type of space we all, all of us, have stored in memory: spaces that are detailed and precise, fragments generally, at all levels of reminiscence. And of course, once you get into reminiscence, an infinite number of associations emerge. Memory seems to create a unique kind of space setting up an about-to-be-disintegrated level.

DW: How sympathetic are you to performance art?

GMC: I feel my work intimately linked with the process as a form of theater in which both the working activity and the structural changes to and within the building are the performance. I also include a free interpretation of movement as gesture, both metaphoric, sculptural, and social into my sense of theater, with only the most incidental audience—an ongoing act for the passer-by just as the construction site provides a stage for busy pedestrians in transit. So my working has a similar effect. People are fascinated by space-giving activity. I am sure that it is a fascination with the underground that most captures the imagination of the random audience; people can't resist contemplating the foundations of a new construction site. So in a reverse manner, the openings I have made stop the viewer with their careful revealings.

Moreover, I see the work as a special stage in perpetual metamorphosis, a model for peoples' constant action on space as much as in the space that surrounds them. Buildings are fixed entities in the minds of most—the notion of mutable space is virtually taboo—even in one's own house. People live in their space with a temerity that is frightening. Home owners generally do little more than maintain their property. It's baffling how rarely the people get involved in fundamentally changing their place by simply undoing it.

DW: To interject for a moment. Duchamp once said that a major artist makes maybe one or two major statements in his lifetime, and the rest is infill, something to be done merely to occupy time; in effect, garbage. How close are you to those statements?

GMC: Duchamp was a master strategist. Being a perfectly tutored rational human being, he could define his problem in terms of a few discrete, well maneuvered gestures. I see the process of my own work as being much more diffuse. Generally, I don't know what the next piece will be. I work similarly to the way gourmets hunt for truffles. I mean, a truffle is a fantastic thing buried somewhere in the ground. Very fleshy, esteemed as a prize food. So what I try to find is the subterranean kernel. Sometimes I find it. Sometimes I don't.

In fact, the next area that interests me is an expedition into the underground: a search for the forgotten spaces left buried under the city either as historical reserve or as surviving reminders of lost projects and fantasies, such as the famed Phantom Railroad. This activity would include mapping and breaking or digging into these lost foundations; working back into society from beneath. Although the original idea involved possible subversive acts, I am now more interested in the act of search and discovery. This activity should bring art out of the gallery and into the sewers.

DW: What were your first works like?

GMC: I believe that was the pipe piece at the Boston Museum of Art in 1971. I extended one of the gas lines from behind a wall out into the exhibition space and then returned it back into the wall, accompanied by a photographic documentation of the pipe's journey from the street into and through the building. The pipe led two lives: it had both physical as well as photographic extension, and dealt with the building as a mechanical system rather than as a series of discrete spaces. Well, no, I guess that wasn't the first. A year previously I dug a deep hole in the basement of 112 Greene Street. What I wanted to do I didn't accomplish at all, which was digging deep enough so that a person could see the actual foundations, the "removed" space under the foundation, and liberate the building's enormous compressive, confining forces simply by making a hole. To be able to pass freely under an area once so dominated by gravitational constraint—that would have been something!

Another installation I had for Greene Street, which I was a bit reluctant about since it might have jeopardized the people in the building, was to have cut each column at midpoint and insert a small steel cube. Where digging a hole liberated compression, this one would have done the opposite: concentrated the entire building's forces onto those little cubes. The cubes then would have balanced the building: an identity transference. The sheer compressive energy being invoked would have made, I think, the physical reality of confronting those cubes a fairly threatening experience.

DW: Hadn't other artists become deeply involved with the environment by 1970, either using the environment as explicit subject matter or using the environment tangentially on their way to other concerns? Where do you fit into all this? Obviously a proving into place, whether through information interdiction or perceptual modifications, had been firmly established by the end of the sixties. Yet your reliance on the existing architecture's infra-system points to unique, somewhat divergent sources.

GMC: One of the prevailing tendencies was—and I think Greene Street was typical of widespread sensibilities—the idea of working with a very specific, particular space. The generalized was downplayed. So most everyone's work at that time involved doing art in a space as well as for a space. I wanted to alter the whole space to its very roots, which meant a recognition of the building's total (semiotic) system, not in any idealized form, but using the actual ingredients of a place. So physically penetrating the surface seemed the logical next step.

Let me qualify this. While my preoccupations involve creating deep metamorphic incisions into space/place, I do not want to create a totally new supportive field of vision, of cognition. I want to reuse the old one, the existing framework of thought and sight. So, on the one hand, I am altering the existing units of perception normally employed to discern the wholeness of a thing. On the other hand, much of my life's energies are simply about being denied. There's so much in our society that purposely intends denial: deny entry, deny passage, deny participation, etc. We would all still be living in towers and castles, if we hadn't broken down some of the social and economic barriers, inhibitions, and restraints. My work directly reflects this.

I would like to end with an idea of the direction in which I can see my work evolving. One of the greatest influences on me in terms of new attitudes was a recent experience in Milan. When searching for a factory to "cut-up," I found an expansive long-abandoned factory complex that was being exuberantly occupied by

a large group of radical Communist youths. They had been taking turns holding down a section of the plant for over a month. Their program was to resist the intervention of "laissez-faire" real estate developers from exploiting the property. Their proposal was that the area be used for a much needed community services center. My exposure to this confrontation was my first awakening to doing my work, not in artistic isolation, but through an active exchange with peoples' concern for their own neighborhood. My goal is to extend the Milan experience to the U.S., especially to neglected areas of New York such as the South Bronx where the city is just waiting for the social and physical condition to deteriorate to such a point that the borough can redevelop the whole area into the industrial park they really want. A specific project might be to work with an existing neighborhood youth group and to involve them in converting the all too plentiful abandoned buildings into a social space. In this way, the young could get both practical information about how buildings are made and, more essentially, some first-hand experience with one aspect of the very real possibility of transforming their space. In this way, I could adapt my work to still another level of the given situation. It would no longer be concerned with just personal or metaphoric treatment of the site, but finally responsive to the express will of its occupants.*

Critics

Rosalind E. Krauss
Sculpture in the Expanded Field (1979)

In the essay "Sculpture in the Expanded Field," which was originally published in *October* in the spring of 1979, the critic and historian Rosalind Krauss traces the genealogy of sculpture from its classical function as a monument that symbolically marks a particular location to its modernist role as a largely self-referential object that is often not linked to any singular place. She then creates a conceptual model for the understanding of the wide range of artistic practices that had developed since the 1960s that were being called sculpture, including the work of Robert Smithson, Richard Serra, Bruce Nauman, Christo, Robert Irwin, and many others. Because Krauss feels that these artists had moved beyond the modernist preoccupation with purity of form and separateness of medium, she wants to situate their work outside of the Modernist paradigm. Krauss argues that the once-portable and autonomous work of Modernist sculpture has expanded into an array of activities

*Certain ideas put forth in this interview evolved out of discussions with such friends as Joseph Kosuth, Marlis Grueterich, and Betsy Sussler.

that can be situated on various plains between architecture and landscape. Krauss uses the term "Postmodern" to describe this activity and in so doing views recent sculptural activities as marking a specific rupture with the past.

Toward the center of the field there is a slight mound, a swelling in the earth, which is the only warning given for the presence of the work. Closer to it, the large square face of the pit can be seen, as can the ends of the ladder that is needed to descend into the excavation. The work itself is thus entirely below grade: half atrium, half tunnel, the boundary between outside and in, a delicate structure of wooden posts and beams. The work, *Perimeters/Pavilions/Decoys*, 1978, by Mary Miss, is of course a sculpture or, more precisely, an earthwork.

Over the last ten years rather surprising things have come to be called sculpture: narrow corridors with TV monitors at the ends; large photographs documenting country hikes; mirrors placed at strange angles in ordinary rooms; temporary lines cut into the floor of the desert. Nothing, it would seem, could possibly give to such a motley of effort the right to lay claim to whatever one might mean by the category of sculpture. Unless, that is, the category can be made to become almost infinitely malleable.

The critical operations that have accompanied postwar American art have largely worked in the service of this manipulation. In the hands of this criticism categories like sculpture and painting have been kneaded and stretched and twisted in an extraordinary demonstration of elasticity, a display of the way a cultural term can be extended to include just about anything. And though this pulling and stretching of a term such as sculpture is overtly performed in the name of vanguard aesthetics—the ideology of the new—its covert message is that of historicism. The new is made comfortable by being made familiar, since it is seen as having gradually evolved from the forms of the past. Historicism works on the new and different to diminish newness and mitigate difference. It makes a place for change in our experience by evoking the model of evolution, so that the man who now is can be accepted as being different from the child he once was, by simultaneously being seen—through the unseeable action of the telos—as the same. And we are comforted by this perception of sameness, this strategy for reducing anything foreign in either time or space, to what we already know and are.

No sooner had minimal sculpture appeared on the horizon of the aesthetic experience of the 1960s than criticism began to construct a paternity for this work, a set of constructivist fathers who could legitimize and thereby authenticate the strangeness of these objects. Plastic? inert geometries? factory production?—none of this was *really* strange, as the ghosts of Gabo and Tatlin and Lissitzky could be called in to testify. Never mind that the content, of the one had nothing to do with, was in fact the exact opposite of, the content of the other. Never mind that Gabo's celluloid was the sign of lucidity and intellection, while Judd's plastic-tinged-with-dayglo spoke the hip patois of California. It did not matter that constructivist forms were intended as

visual proof of the immutable logic and coherence of universal geometries, while their seeming counterparts in minimalism were demonstrably contingent—denoting a universe held together not by Mind but by guy wires, or glue, or the accidents of gravity. The rage to historicize simply swept these differences aside.

Of course, with the passing of time these sweeping operations got a little harder to perform. As the 1960s began to lengthen into the 1970s and "sculpture" began to be piles of thread waste on the floor, or sawed redwood timbers rolled into the gallery, or tons of earth excavated from the desert, or stockades of logs surrounded by firepits, the word *sculpture* became harder to pronounce—but not really that much harder. The historian/critic simply performed a more extended sleight-of-hand and began to construct his genealogies out of the data of millennia rather than decades. Stonehenge, the Nazca lines, the Toltec ballcourts, Indian burial mounds—anything at all could be hauled into court to bear witness to this work's connection to history and thereby to legitimize its status as sculpture. Of course Stonehenge and the Toltec ballcourts were just exactly *not* sculpture, and so their role as historicist precedent becomes somewhat suspect in this particular demonstration. But never mind. The trick can still be done by calling upon a variety of primitivizing work from the earlier part of the century—Brancusi's *Endless Column* will do—to mediate between extreme past and present.

But in doing all of this, the very term we had thought we were saving—*sculpture*—has begun to be somewhat obscured. We had thought to use a universal category to authenticate a group of particulars, but the category has now been forced to cover such a heterogeneity that it is, itself, in danger of collapsing. And so we stare at the pit in the earth and think we both do and don't know what sculpture is.

Yet I would submit that we know very well what sculpture is. And one of the things we know is that it is a historically bounded category and not a universal one. As is true of any other convention, sculpture has its own internal logic, its own set of rules, which, though they can be applied to a variety of situations, are not themselves open to very much change. The logic of sculpture, it would seem, is inseparable from the logic of the monument. By virtue of this logic a sculpture is a commemorative representation. It sits in a particular place and speaks in a symbolical tongue about the meaning or use of that place. The equestrian statue of Marcus Aurelius is such a monument, set in the center of the Campidoglio to represent by its symbolical presence the relationship between ancient, Imperial Rome and the seat of government of modern, Renaissance Rome. Bernini's statue of the *Conversion of Constantine,* placed at the foot of the Vatican stairway connecting the Basilica of St. Peter to the heart of the papacy, is another such monument, a marker at a particular place for a specific meaning/event. Because they thus function in relation to the logic of representation and marking, sculptures are normally figurative and vertical, their pedestals an important part of the sculpture since they mediate between actual site and representational sign. There is

nothing very mysterious about this logic; understood and inhabited, it was the source of a tremendous production of sculpture during centuries of Western art.

But the convention is not immutable and there came a time when the logic began to fail. Late in the nineteenth century we witnessed the fading of the logic of the monument. It happened rather gradually. But two cases come to mind, both bearing the marks of their own transitional status. Rodin's *Gates of Hell* and his statue of *Balzac* were both conceived as monuments. The first were commissioned in 1880 as the doors to a projected museum of decorative arts; the second was commissioned in 1891 as a memorial to literary genius to be set up at a specific site in Paris. The failure of these two works as monuments is signaled not only by the fact that multiple versions can be found in a variety of museums in various countries, while no version exists on the original sites—both commissions having eventually collapsed. Their failure is also encoded onto the very surfaces of these works: the doors having been gouged away and anti-structurally encrusted to the point where they bear their inoperative condition on their face; the *Balzac* executed with such a degree of subjectivity that not even Rodin believed (as letters by him attest) that the work would ever be accepted.

With these two sculptural projects, I would say, one crosses the threshold of the logic of the monument, entering the space of what could be called its negative condition—a kind of sitelessness, or homelessness, an absolute loss of place. Which is to say one enters modernism, since it is the modernist period of sculptural production that operates in relation to this loss of site, producing the monument as abstraction, the monument as pure marker or base, functionally placeless and largely self-referential.

It is these two characteristics of modernist sculpture that declare its status, and therefore its meaning and function, as essentially nomadic. Through its fetishization of the base, the sculpture reaches downward to absorb the pedestal into itself and away from actual place; and through the representation of its own materials or the process of its construction, the sculpture depicts its own autonomy. Brancusi's art is an extraordinary instance of the way this happens. The base becomes, in a work like the *Cock*, the morphological generator of the figurative part of the object; in the *Caryatids* and *Endless Column*, the sculpture is all base; while in *Adam and Eve*, the sculpture is in a reciprocal relation to its base. The base is thus defined as essentially transportable, the marker of the work's homelessness integrated into the very fiber of the sculpture. And Brancusi's interest in expressing parts of the body as fragments that tend toward radical abstractness also testifies to a loss of site, in this case the site of the rest of the body, the skeletal support that would give to one of the bronze or marble heads a home.

In being the negative condition of the monument, modernist sculpture had a kind of idealist space to explore, a domain cut off from the project of temporal and spatial representation, a vein that was rich and new and could for a while be profitably mined. But it was a limited vein and, having been

opened in the early part of the century, it began by about 1950 to be exhausted. It began, that is, to be experienced more and more as pure negativity. At this point modernist sculpture appeared as a kind of black hole in the space of consciousness, something whose positive content was increasingly difficult to define, something that was possible to locate only in terms of what it was not. "Sculpture is what you bump into when you back up to see a painting," Barnett Newman said in the '50s. But it would probably be more accurate to say of the work that one found in the early '60s that sculpture had entered a categorical no-man's-land: it was what was on or in front of a building that was not a building, or what was in the landscape that was not the landscape.

The purest examples that come to mind from the early 1960s are both by Robert Morris. One is the work exhibited in 1964 in the Green Gallery—quasi-architectural integers whose status as sculpture reduces almost completely to the simple determination that it is what is in the room that is not really the room; the other is the outdoor exhibition of the mirrored boxes—forms which are distinct from the setting only because, though visually continuous with grass and trees, they are not in fact part of the landscape.

In this sense sculpture had entered the full condition of its inverse logic and had become pure negativity: the combination of exclusions. Sculpture, it could be said, had ceased being a positivity, and was now the category that resulted from the addition of the *not-landscape* to the *not-architecture*. Diagrammatically expressed, the limit of modernist sculpture, the addition of the neither/nor, looks like this:

Now, if sculpture itself had become a kind of ontological absence, the combination of exclusions, the sum of the neither/nor, that does not mean that the terms themselves from which it was built—the *not-landscape* and the *not-architecture*—did not have a certain interest. This is because these terms express a strict opposition between the built and the not-built, the cultural and the natural, between which the production of sculptural art appeared to be suspended. And what began to happen in the career of one sculptor after another, beginning at the end of the 1960s, is that attention began to focus on the outer limits of those terms of exclusion. For, if those terms are the expression of a logical opposition stated as a pair of negatives, they can be transformed by a simple inversion into the same polar opposites but expressed positively. That is, the *not-architecture* is, according to the logic of a certain kind of expansion, just another way of expressing the term *landscape,* and the *not-landscape* is, simply, *architecture.* The expansion to which I am referring is

called a Klein group when employed mathematically and has various other designations, among them the Piaget group, when used by structuralists involved in mapping operations within the human sciences. By means of this logical expansion a set of binaries is transformed into a quaternary field which both mirrors the original opposition and at the same time opens it. It becomes a logically expanded field which looks like this:

The dimensions of this structure may be analyzed as follows: (1) there are two relationships of pure contradiction which are termed *axes* (and further differentiated into the *complex axis* and the *neuter axis*) and are designated by the solid arrows (see diagram); (2) there are two relationships of contradiction, expressed as involution, which are called *schemas* and are designated by the double arrows; and (3) there are two relationships of implication which are called *deixes* and are designated by the broken arrows.[1]

Another way of saying this is that even though *sculpture* may be reduced to what is in the Klein group the neuter term of the *not-landscape* plus the *not-architecture,* there is no reason not to imagine an opposite term—one that would be both *landscape* and *architecture*—which within this schema is called the *complex.* But to think the complex is to admit into the realm of art two terms that had formerly been prohibited from it: *landscape* and *architecture*—terms that could function to define the sculptural (as they had begun to do in modernism) only in their negative or neuter condition. Because it was ideologically prohibited, the complex had remained excluded from what might be called the closure of post-Renaissance art. Our culture had not before been able to think the complex, although other cultures have thought this term with great ease. Labyrinths and mazes are *both* landscape and architecture; Japanese gardens are *both* landscape and architecture; the ritual playing fields and processionals of ancient civilizations were all in this sense the unquestioned occupants of the complex. Which is *not* to say that they were an early, or a degenerate, or a variant form of sculpture. They were part of a universe or cultural space in which sculpture was simply

another part—not somehow, as our historicist minds would have it, the same. Their purpose and pleasure is exactly that they are opposite and different.

The expanded field is thus generated by problematizing the set of oppositions between which the modernist category *sculpture* is suspended. And once this has happened, once one is able to think one's way into this expansion, there are—logically—three other categories that one can envision, all of them a condition of the field itself, and none of them assimilable to *sculpture*. Because as we can see, *sculpture* is no longer the privileged middle term between two things that it isn't. *Sculpture* is rather only one term on the periphery of a field in which there are other, differently structured possibilities. And one has thereby gained the "permission" to think these other forms. So our diagram is filled in as follows:

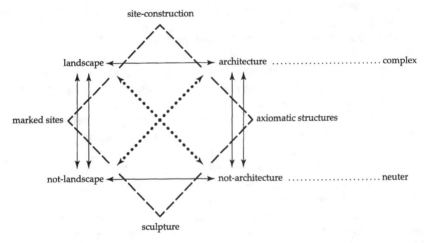

It seems fairly clear that this permission (or pressure) to think the expanded field was felt by a number of artists at about the same time, roughly between the years 1968 and 1970. For one after another Robert Morris, Robert Smithson, Michael Heizer, Richard Serra, Walter De Maria, Robert Irwin, Sol LeWitt, Bruce Nauman . . . had entered a situation the logical conditions of which can no longer be described as modernist. In order to name this historical rupture and the structural transformation of the cultural field that characterizes it, one must have recourse to another term. The one already in use in other areas of criticism is postmodernism. There seems no reason not to use it.

But whatever term one uses, the evidence is already in. By 1970, with the *Partially Buried Woodshed* at Kent State University, in Ohio, Robert Smithson had begun to occupy the complex axis, which for ease of reference I am calling *site construction*. In 1971 with the observatory he built in wood and sod in Holland, Robert Morris had joined him. Since that time, many other artists—Robert Irwin, Alice Aycock, John Mason, Michael Heizer, Mary Miss, Charles Simonds—have operated within this new set of possibilities.

Similarly, the possible combination of *landscape* and *not-landscape* began to be explored in the late 1960s. The term *marked sites* is used to identify work like Smithson's *Spiral Jetty (1970)* and Heizer's *Double Negative* (1969), as it also describes some of the work in the '70s by Serra, Morris, Carl Andre, Dennis Oppenheim, Nancy Holt, George Trakis, and many others. But in addition to actual physical manipulations of sites, this term also refers to other forms of marking. These might operate through the application of impermanent marks—Heizer's *Depressions,* Oppenheim's *Time Lines,* or De Maria's *Mile Long Drawing,* for example—or through the use of photography. Smithson's *Mirror Displacements in the Yucatan* were probably the first widely known instances of this, but since then the work of Richard Long and Hamish Fulton has focused on the photographic experience of marking. Christo's *Running Fence* might be said to be an impermanent, photographic, and political instance of marking a site.

The first artists to explore the possibilities of *architecture* plus *not-architecture* were Robert Irwin, Sol LeWitt, Bruce Nauman, Richard Serra, and Christo. In every case of these *axiomatic structures,* there is some kind of intervention into the real space of architecture, sometimes through partial reconstruction, sometimes through drawing, or as in the recent works of Morris, through the use of mirrors. As was true of the category of the *marked site,* photography can be used for this purpose; I am thinking here of the video corridors by Nauman. But whatever the medium employed, the possibility explored in this category is a process of mapping the axiomatic features of the architectural experience—the abstract conditions of openness and closure—onto the reality of a given space.

The expanded field which characterizes this domain of postmodernism possesses two features that are already implicit in the above description. One of these concerns the practice of individual artists; the other has to do with the question of medium. At both these points the bounded conditions of modernism have suffered a logically determined rupture.

With regard to individual practice, it is easy to see that many of the artists in question have found themselves occupying, successively, different places within the expanded field. And though the experience of the field suggests that this continual relocation of one's energies is entirely logical, an art criticism still in the thrall of a modernist ethos has been largely suspicious of such movement, calling it eclectic. This suspicion of a career that moves continually and erratically beyond the domain of sculpture obviously derives from the modernist demand for the purity and separateness of the various mediums (and thus the necessary specialization of a practitioner within a given medium). But what appears as eclectic from one point of view can be seen as rigorously logical from another. For, within the situation of postmodernism, practice is not defined in relation to a given medium—sculpture—but rather in relation to the logical operations on a set of cultural terms, for which any medium—photography, books, lines on walls, mirrors, or sculpture itself—might be used.

Thus the field provides both for an expanded but finite set of related positions for a given artist to occupy and explore, and for an organization of work that is not dictated by the conditions of a particular medium. From the structure laid out above, it is obvious that the logic of the space of postmodernist practice is no longer organized around the definition of a given medium on the grounds of material, or, for that matter, the perception of material. It is organized instead through the universe of terms that are felt to be in opposition within a cultural situation. (The postmodernist space of painting would obviously involve a similar expansion around a different set of terms from the pair *architecture/landscape*—a set that would probably turn on the opposition *uniqueness/reproducibility.*) It follows, then, that within any one of the positions generated by the given logical space, many different mediums might be employed. It follows as well that any single artist might occupy, successively, any one of the positions. And it also seems the case that within the limited position of sculpture itself the organization and content of much of the strongest work will reflect the condition of the logical space. I am thinking here of the sculpture of Joel Shapiro, which, though it positions itself in the neuter term, is involved in the setting of images of architecture within relatively vast fields (landscapes) of space. (These considerations apply, obviously, to other work as well—Charles Simonds, for example, or Ann and Patrick Poirier.)

I have been insisting that the expanded field of postmodernism occurs at a specific moment in the recent history of art. It is a historical event with a determinant structure. It seems to me extremely important to map that structure and that is what I have begun to do here. But clearly, since this is a matter of history, it is also important to explore a deeper set of questions which pertain to something more than mapping and involve instead the problem of explanation. These address the root cause—the conditions of possibility—that brought about the shift into postmodernism, as they also address the cultural determinants of the opposition through which a given field is structured. This is obviously a different approach to thinking about the history of form from that of historicist criticism's constructions of elaborate genealogical trees. It presupposes the acceptance of definitive ruptures and the possibility of looking at historical process from the point of view of logical structure.

NOTE

1. For a discussion of the Klein group, see Marc Barbut, "On the Meaning of the Word 'Structure' in Mathematics," in Michael Lane, ed., *Introduction to Structuralism*, (New York, Basic Books, 1970); for an application of the Piaget group, see A.-J. Greimas and F. Rastier, "The Interaction of Semiotic Constraints," *Yale French Studies*, no. 41 (1968), 86–105.

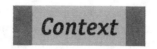

Maurice Merleau-Ponty
The Primacy of Perception
and Its Philosophical Consequences (1964)

Maurice Merleau-Ponty was one of the foremost French philosophers of the postwar period. By identifying perception as a key element in understanding consciousness, Merleau-Ponty further developed the concepts of phenomenology that had been first presented by Edmund Husserl. For Merleau-Ponty, the shifting spatial and psychological dynamic of bodily experience is the basis for understanding the nature of perception, and it is through this understanding that individuals are able to grasp the essence of consciousness. These notions parallel the concerns of much of the experiential-based art covered in this chapter, especially the work of Robert Irwin. The following speech, delivered in 1946 to the Société Français de Philosophie, is a summary of the ideas in Merleau-Ponty's major work, *The Phenomenology of Perception.* "The Primacy of Perception and Its Philosophical Consequences" was first published in English in *The Primacy of Perception and Other Essays* in 1964.

PRELIMINARY SUMMARY OF THE ARGUMENT[1]

1. *Perception as an original modality of consciousness*

The unprejudiced study of perception by psychologists has finally revealed that the perceived world is not a sum of objects (in the sense in which the sciences use this word), that our relation to the world is not that of a thinker to an object of thought, and finally that the unity of the perceived thing, as perceived by several consciousnesses, is not comparable to the unity of a proposition [*théorème*], as understood by several thinkers, any more than perceived existence is comparable to ideal existence.

Merleau-Ponty, Maurice. "The Primacy of Perception and Its Philosophical Consequences," from *The Primacy of Perception and Other Essays*, pp. 121–27. Evanston, IL: Northwestern University Press, 1964. Translation © 1964 by Northwestern University Press. Reprinted by permission of the publisher.

 1. This address to the Société Française de Philosophie was given shortly after the publication of Merleau-Ponty's major work, the *Phenomenology of Perception,* and it represents his attempt to summarize and defend the central thesis of that work. The following translation gives the complete text of Merleau-Ponty's address. The address took place on November 23, 1946, and was published in the *Bulletin de la Société Française de Philosophie,* vol. 49 (December, 1947), pp. 119–153.—*Trans.*

As a result we cannot apply the classical distinction of form and matter to perception, nor can we conceive the perceiving subject as a consciousness which "interprets," "deciphers," or "orders" a sensible matter according to an ideal law which it possesses. Matter is "pregnant" with its form, which is to say that in the final analysis every perception takes place within a certain horizon and ultimately in the "world." We experience a perception and its horizon "in action" [*pratiquement*] rather than by "posing" them or explicitly "knowing" them. Finally the quasi-organic relation of the perceiving subject and the world involves, in principle, the contradiction of immanence and transcendence.

2. The generalization of these results

Do these results have any value beyond that of psychological description? They would not if we could superimpose on the perceived world a world of ideas. But in reality the ideas to which we recur are valid only for a period of our lives or for a period in the history of our culture. Evidence is never apodictic, nor is thought timeless, though there is some progress in objectification and thought is always valid for more than an instant. The certainty of ideas is not the foundation of the certainty of perception but is, rather, based on it—in that it is perceptual experience which gives us the passage from one moment to the next and thus realizes the unity of time. In this sense all consciousness is perceptual, even the consciousness of ourselves.

3. Conclusions

The perceived world is the always presupposed foundation of all rationality, all value and all existence. This thesis does not destroy either rationality or the absolute. It only tries to bring them down to earth.

REPORT OF THE SESSION

The point of departure for these remarks is that the perceived world comprises relations and, in a general way, a type of organization which has not been recognized by classical psychology and philosophy.

If we consider an object which we perceive but one of whose sides we do not see, or if we consider objects which are not within our visual field at this moment—i.e., what is happening behind our back or what is happening in America or at the South Pole—how should we describe the existence of these absent objects or the nonvisible parts of present objects?

Should we say, as psychologists have often done, that I *represent* to myself the sides of this lamp which are not seen? If I say these sides are representations, I imply that they are not grasped as actually existing; because

what is represented is not here before us, I do not actually perceive it. It is only a possible. But since the unseen sides of this lamp are not imaginary, but only hidden from view (to see them it suffices to move the lamp a little bit), I cannot say that they are representations.

Should I say that the unseen sides are somehow anticipated by me, as perceptions which would be produced necessarily if I moved, given the structure of the object? If, for example, I look at a cube, knowing the structure of the cube as it is defined in geometry, I can anticipate the perceptions which this cube will give me while I move around it. Under this hypothesis I would know the unseen side as the necessary consequence of a certain law of the development of my perception. But if I turn to perception itself, I cannot interpret it in this way because this analysis can be formulated as follows: It is *true* that the lamp has a back, that the cube has another side. But this formula, "It is true," does not correspond to what is given to me in perception. Perception does not give me truths like geometry but presences.

I grasp the unseen side as present, and I do not affirm that the back of the lamp exists in the same sense that I say the solution of a problem exists. The hidden side is present in its own way. It is in my vicinity.

Thus I should not say that the unseen sides of objects are simply possible perceptions, nor that they are the necessary conclusions of a kind of analysis or geometrical reasoning. It is not through an intellectual synthesis which would freely posit the total object that I am led from what is given to what is not actually given; that I am given, together with the visible sides of the object, the nonvisible sides as well. It is, rather, a kind of practical synthesis: I can touch the lamp, and not only the side turned toward me but also the other side; I have only to extend my hand to hold it.

The classical analysis of perception reduces all our experience to the single level of what, for good reasons, is judged to be true. But when, on the contrary, I consider the whole setting [*l'entourage*] of my perception, it reveals another modality which is neither the ideal and necessary being of geometry nor the simple sensory event, the *"percipi,"* and this is precisely what remains to be studied now.

But these remarks on the setting [*entourage*] of what is perceived enable us better to see the perceived itself. I perceive before me a road or a house, and I perceive them as having a certain dimension: the road may be a country road or a national highway; the house may be a shanty or a manor. These identifications presuppose that I recognize the true size of the object, quite different from that which appears to me from the point at which I am standing. It is frequently said that I restore the true size on the basis of the apparent size by analysis and conjecture. This is inexact for the very convincing reason that the apparent size of which we are speaking is not perceived by me. It is a remarkable fact that the uninstructed have no awareness of perspective and that it took a long time and much reflection for men to become aware of a perspectival deformation of objects. Thus there is no deciphering,

no mediate inference from the sign to what is signified, because the alleged signs are not given to me separately from what they signify.

In the same way it is not true that I deduce the true color of an object on the basis of the color of the setting or of the lighting, which most of the time is not perceived. At this hour, since daylight is still coming through the windows, we perceive the yellowness of the artificial light, and it alters the color of objects. But when daylight disappears this yellowish color will no longer be perceived, and we will see the objects more or less in their true colors. The true color thus is not deduced, taking account of the lighting, because it appears precisely when daylight disappears.

If these remarks are true, what is the result? And how should we understand this "I perceive" which we are attempting to grasp?

We observe at once that it is impossible, as has often been said, to decompose a perception, to make it into a collection of sensations, because in it the whole is prior to the parts—and this whole is not an ideal whole. The meaning which I ultimately discover is not of the conceptual order. If it were a concept, the question would be how I can recognize it in the sense data, and it would be necessary for me to interpose between the concept and the sense data certain intermediaries, and then other intermediaries between these intermediaries, and so on. It is necessary that meaning and signs, the form and matter of perception, be related from the beginning and that, as we say, the matter of perception be "pregnant with its form."

In other words, the synthesis which constitutes the unity of the perceived objects and which gives meaning to the perceptual data is not an intellectual synthesis. Let us say with Husserl that it is a "synthesis of transition" [*synthèse de transition*][2]—I anticipate the unseen side of the lamp because I can touch it—or a "horizonal synthesis" [*synthèse d'horizon*]—the unseen side is given to me as "visible from another standpoint," at once given but only immanently. What prohibits me from treating my perception as an intellectual act is that an intellectual act would grasp the object either as possible or as necessary. But in perception it is "real"; it is given as the infinite sum of an indefinite series of perspectival views in each of which the object is given but in none of which is it given exhaustively. It is not accidental for the object to be given to me in a "deformed" way, from the point of view [*place*] which I occupy. That is the price of its being "real." The perceptual synthesis thus must be accomplished by the subject, which can both delimit certain perspectival aspects in the object, the only ones actually given, and at the same time go beyond them. This subject, which takes a point of view, is my body as the field of perception and action [*pratique*]—in so far as my gestures have a certain reach and circumscribe as my domain the whole group of objects

2. The more usual term in Husserl is "passive synthesis," which designates the "syntheses" of perceptual consciousness as opposed to the "active syntheses" of imagination and categorical thought.—*Trans.*

familiar to me. Perception is here understood as a reference to a whole which can be grasped, in principle, only through certain of its parts or aspects. The perceived thing is not an ideal unity in the possession of the intellect, like a geometrical notion, for example; it is rather a totality open to a horizon of an indefinite number of perspectival views which blend with one another according to a given style, which defines the object in question.

Perception is thus paradoxical. The perceived thing itself is paradoxical; it exists only in so far as someone can perceive it. I cannot even for an instant imagine an object in itself. As Berkeley said, if I attempt to imagine some place in the world which has never been seen, the very fact that I imagine it makes me present at that place. I thus cannot conceive a perceptible place in which I am not myself present. But even the places in which I find myself are never completely given to me; the things which I see are things for me only under the condition that they always recede beyond their immediately given aspects. Thus there is a paradox of immanence and transcendence in perception. Immanence, because the perceived object cannot be foreign to him who perceives; transcendence, because it always contains something more than what is actually given. And these two elements of perception are not, properly speaking, contradictory. For if we reflect on this notion of perspective, if we reproduce the perceptual experience in our thought, we see that the kind of evidence proper to the perceived, the appearance of "something," requires both this presence and this absence.

Finally, the world itself, which (to give a first, rough definition) is the totality of perceptible things and the thing of all things, must be understood not as an object in the sense the mathematician or the physicist give to this word—that is, a kind of unified law which would cover all the partial phenomena or as a fundamental relation verifiable in all—but as the universal style of all possible perceptions. We must make this notion of the world, which guides the whole transcendental deduction of Kant, though Kant does not tell us its provenance, more explicit. "If a world is to be possible," he says sometimes, as if he were thinking before the origin of the world, as if he were assisting at its genesis and could pose its *a priori* conditions. In fact, as Kant himself said profoundly, we can only think the world because we have already experienced it; it is through this experience that we have the idea of being, and it is through this experience that the words "rational" and "real" receive a meaning simultaneously.

If I now consider not the problem of knowing how it is that there are things for me or how it is that I have a unified, unique, and developing perceptual experience of them, but rather the problem of knowing how my experience is related to the experience which others have of the same objects, perception will again appear as the paradoxical phenomenon which renders being accessible to us.

If I consider my perceptions as simple sensations, they are private; they are mine alone. If I treat them as acts of the intellect, if perception is an inspection of the mind, and the perceived object an idea, then you and I are

talking about the same world, and we have *the right* to communicate among ourselves because the world has become an ideal existence and is the same for all of us—just like the Pythagorean theorem. But neither of these two formulas accounts for our experience. If a friend and I are standing before a landscape, and if I attempt to show my friend something which I see and which he does not yet see, we cannot account for the situation by saying that I see something in my own world and that I attempt, by sending verbal messages, to give rise to an analogous perception in the world of my friend. There are not two numerically distinct worlds plus a mediating language which alone would bring us together. There is—and I know it very well if I become impatient with him—a kind of demand that what I see be seen by him also. And at the same time this communication is required by the very thing which I am looking at, by the reflections of sunlight upon it, by its color, by its sensible evidence. The thing imposes itself not as true for every intellect, but as real for every subject who is standing where I am.

I will never know how you see red, and you will never know how I see it; but this separation of consciousnesses is recognized only after a failure of communication, and our first movement is to believe in an undivided being between us. There is no reason to treat this primordial communication as an illusion, as the sensationalists do, because even then it would become inexplicable. And there is no reason to base it on our common participation in the same intellectual consciousness because this would suppress the undeniable plurality of consciousnesses. It is thus necessary that, in the perception of another, I find myself in relation with another "myself," who is, in principle, open to the same truths as I am, in relation to the same being that I am. And this perception is realized. From the depths of my subjectivity I see another subjectivity invested with equal rights appear, because the behavior of the other takes place within my perceptual field. I understand this behavior, the words of another; I espouse his thought because this other, born in the midst of my phenomena, appropriates them and treats them in accord with typical behaviors which I myself have experienced. Just as my body, as the system of all my holds on the world, founds the unity of the objects which I perceive, in the same way the body of the other—as the bearer of symbolic behaviors and of the behavior of true reality—tears itself away from being one of my phenomena, offers me the task of a true communication, and confers on my objects the new dimension of intersubjective being or, in other words, of objectivity. Such are, in a quick résumé, the elements of a description of the perceived world.

Some of our colleagues who were so kind as to send me their observations in writing grant me that all this is valid as a psychological inventory. But, they add, there remains the world of which we say "It is true"—that is to say, the world of knowledge, the verified world, the world of science. Psychological description concerns only a small section of our experience, and there is no reason, according to them, to give such descriptions any universal value. They do not touch being itself but only the psychological peculiarities

of perception. These descriptions, they add, are all the less admissible as being in any way definitive because they are contradicted by the perceived world. How can we admit ultimate contradictions? Perceptual experience is contradictory because it is confused. It is necessary to think it. When we think it, its contradictions disappear under the light of the intellect. Finally, one correspondent tells me that we are invited to return to the perceived world as we experience it. That is to say that there is no need to reflect or to think and that perception knows better than we what it is doing. How can this disavowal of reflection be philosophy?

It is true that we arrive at contradictions when we describe the perceived world. And it is also true that if there were such a thing as a non-contradictory thought, it would exclude the world of perception as a simple appearance. But the question is precisely to know whether there is such a thing as logically coherent thought or thought in the pure state. This is the question Kant asked himself and the objection which I have just sketched is a pre-Kantian objection. One of Kant's discoveries, whose consequences we have not yet fully grasped, is that all our experience of the world is throughout a tissue of concepts which lead to irreducible contradictions if we attempt to take them in an absolute sense or transfer them into pure being, and that they nevertheless found the structure of all our phenomena, of everything which *is* for us. It would take too long to show (and besides it is well known) that Kantian philosophy itself failed to utilize this principle fully and that both its investigation of experience and its critique of dogmatism remained incomplete. I wish only to point out that the accusation of contradiction is not decisive, *if the acknowledged contradiction appears as the very condition of consciousness.* It is in this sense that Plato and Kant, to mention only them, accepted the contradiction of which Zeno and Hume wanted no part. There is a vain form of contradiction which consists in affirming two theses which exclude one another at the same time and under the same aspect. And there are philosophies which show contradictions present at the very heart of time and of all relationships. There is the sterile non-contradiction of formal logic and the justified contradictions of transcendental logic. The objection with which we are concerned would be admissible only if we could put a system of eternal truths in the place of the perceived world, freed from its contradictions.

We willingly admit that we cannot rest satisfied with the description of the perceived world as we have sketched it up to now and that it appears as a psychological curiosity if we leave aside the idea of the true world, the world as thought by the understanding. This leads us, therefore, to the second point which I propose to examine: what is the relation between intellectual consciousness and perceptual consciousness?

Before taking this up, let us say a word about the other objection which was addressed to us: you go back to the unreflected [*irréfléchi*]; therefore you renounce reflection. It is true that we discover the unreflected. But the

unreflected we go back to is not that which is prior to philosophy or prior to reflection. It is the unreflected which is understood and conquered by reflection. Left to itself, perception forgets itself and is ignorant of its own accomplishments. Far from thinking that philosophy is a useless repetition of life I think, on the contrary, that without reflection life would probably dissipate itself in ignorance of itself or in chaos. But this does not mean that reflection should be carried away with itself or pretend to be ignorant of its origins. By fleeing difficulties it would only fail in its task.

Should we now generalize and say that what is true of perception is also true in the order of the intellect and that in a general way all our experience, all our knowledge, has the same fundamental structures, the same synthesis of transition, the same kind of horizons which we have found in perceptual experience?

No doubt the absolute truth or evidence of scientific knowledge would be opposed to this idea. But it seems to me that the acquisitions of the philosophy of the sciences confirm the primacy of perception. Does not the work of the French school at the beginning of this century, and the work of Brunschvicg, show that scientific knowledge cannot be closed in on itself, that it is always an approximate knowledge, and that it consists in clarifying a prescientific world the analysis of which will never be finished? Physicomathematical relations take on a physical sense only to the extent that we at the same time represent to ourselves the sensible things to which these relations ultimately apply. Brunschvicg reproached positivism for its dogmatic illusion that the law is truer than the fact. The law, he adds, is conceived exclusively to make the fact intelligible. The perceived happening can never be reabsorbed in the complex of transparent relations which the intellect constructs because of the happening. But if this is the case, philosophy is not only consciousness of these relations; it is also consciousness of the obscure element and of the "non-relational foundation" on which these relations are based. Otherwise it would shirk its task of universal clarification. When I think the Pythagorean theorem and recognize it as true, it is clear that this truth is not for this moment only. Nevertheless later progress in knowledge will show that it is not yet a final, unconditioned evidence and that, if the Pythagorean theorem and the Euclidean system once appeared as final, unconditioned evidences, that is itself the mark of a certain cultural epoch. Later developments would not annul the Pythagorean theorem but would put it back in its place as a partial, and also an abstract, truth. Thus here also we do not have a timeless truth but rather the recovery of one time by another time, just as, on the level of perception, our certainty about perceiving a given thing does not guarantee that our experience will not be contradicted, or dispense us from a fuller experience of that thing. Naturally it is necessary to establish here a difference between ideal truth and perceived truth. I do not propose to undertake this immense task just now. I am only trying to show the organic tie, so to speak, between perception and intellection. Now it is

incontestable that I dominate the stream of my conscious states and even that I am unaware of their temporal succession. At the moment when I am thinking or considering an idea, I am not divided into the instants of my life. But it is also incontestable that this domination of time, which is the work of thought, is always somewhat deceiving. Can I seriously say that I will always hold the ideas I do at present—and mean it? Do I not know that in six months, in a year, even if I use more or less the same formulas to express my thoughts, they will have changed their meaning slightly? Do I not know that there is a life of ideas, as there is a meaning of everything I experience, and that every one of my most convincing thoughts will need additions and then will be, not destroyed, but at least integrated into a new unity? This is the only conception of knowledge that is scientific and not mythological.

Thus perception and thought have this much in common—that both of them have a future horizon and a past horizon and that they appear to themselves as temporal, even though they do not move at the same speed nor in the same time. We must say that at each moment our ideas express not only the truth but also our capacity to attain it at that given moment. Skepticism begins if we conclude from this that our ideas are always false. But this can only happen with reference to some idol of absolute knowledge. We must say, on the contrary, that our ideas, however limited they may be at a given moment—since they always express our contact with being and with culture—are capable of being true provided we keep them open to the field of nature and culture which they must express. And this possibility is always open to us, just because we are temporal. The idea of going straight to the essence of things is an inconsistent idea if one thinks about it. What is given is a route, an experience which gradually clarifies itself, which gradually rectifies itself and proceeds by dialogue with itself and with others. Thus what we tear away from the dispersion of instants is not an already-made reason; it is, as has always been said, a natural light, our openness to *something*. What saves us is the possibility of a new development, and our power of making even what is false, true—by thinking through our errors and replacing them within the domain of truth.

But finally, it will be objected that I grasp myself in pure reflection, completely outside perception, and that I grasp myself not now as a perceiving subject, tied by its body to a system of things, but as a thinking subject, radically free with respect to things and with respect to the body. How is such an experience of self, of the *cogito*, possible in our perspective, and what meaning does it have?

There is a first way of understanding the *cogito:* it consists in saying that when I grasp myself I am limited to noting, so to speak, a psychic fact, "I think." This is an instantaneous constatation, and under the condition that the experience has no duration I adhere immediately to what I think and consequently cannot doubt it. This is the *cogito* of the psychologists. It is of this instantaneous *cogito* that Descartes was thinking when he said that I am

certain that I exist during the whole time that I am thinking of it. Such certitude is limited to my existence and to my pure and completely naked thought. As soon as I make it specific with any particular thought, I fail, because, as Descartes explains, every particular thought uses premises not actually given. Thus the first truth, understood in this way, is the only truth. Or rather it cannot even be formulated as truth; it is experienced in the instant and in silence. The *cogito* understood in this way—in the skeptical way— does not account for our idea of truth.

There is a second way of understanding the *cogito:* as the grasping not only of the fact that I think but also of the objects which this thought intends, and as evidence not only of a private existence but also of the things which it thinks, at least as it thinks them. In this perspective the *cogito* is neither more certain than the *cogitatum,* nor does it have a different kind of certainty. Both are possessed of ideal evidence. Descartes sometimes presented the *cogito* in this way—as, for example, in the *Regulae* when he placed one's own existence *(se esse)* among the most simple evidences. This supposes that the subject is perfectly transparent for itself, like an essence, and is incompatible with the idea of the hyperbolic doubt which even reaches to essences.

But there is a third meaning of the *cogito,* the only solid one: the act of doubting in which I put in question all possible objects of my experience. This act grasps itself in its own operation [*à l'oeuvre*] and thus cannot doubt itself. The very fact of doubting obturates doubt. The certitude I have of myself is here a veritable perception: I grasp myself, not as a constituting subject which is transparent to itself, and which constitutes the totality of every possible object of thought and experience, but as a particular thought, as a thought engaged with certain objects, as a thought in act; and it is in this sense that I am certain of myself. Thought is given to itself; I somehow find myself thinking and I become aware of it. In this sense I am certain that I am thinking this or that as well as being certain that I am simply thinking. Thus I can get outside the psychological *cogito*—without, however, taking myself to be a universal thinker. I am not simply a constituted happening; I am not a universal thinker [*naturant*].[3] I am a thought which recaptures itself as already possessing an ideal of truth (which it cannot at each moment wholly account for) and which is the horizon of its operations. This thought, which *feels* itself rather than *sees* itself, which searches after clarity rather than possesses it, and which creates truth rather than finds it, is described in a formerly celebrated text of Lagneau. Should we submit to life or create it, he asked. And he answered: "Once again this question does not pertain to the domain of the intellect; we are free and, in this sense, skepticism is true. But to answer negatively is to make the world and the self unintelligible; it is to decree chaos and above all to establish it in the self. But chaos is nothing. To

3. The reference is to Spinoza's *natura naturans.—Trans.*

be or not to be, the self and everything else, we must choose" *(Cours sur l'existence de dieu).* I find here, in an author who spent his whole life reflecting on Descartes, Spinoza, and Kant, the idea—sometimes considered barbarous—of a thought which remembers it began in time and then sovereignly recaptures itself and in which fact, reason, and freedom coincide.

Finally, let us ask what happens, from such a point of view, to rationality and experience, whether there can be any absolute affirmation already implied in experience.

The fact that my experiences hold together and that I experience the concordance of my own experiences with those of others is in no way compromised by what we have just said. On the contrary, this fact is put in relief, against skepticism. Something appears to me, as to anyone else, and these phenomena, which set the boundaries of everything thinkable or conceivable for us, are certain as phenomena. There is meaning. But rationality is neither a total nor an immediate guarantee. It is somehow open, which is to say that it is menaced.

Doubtless this thesis is open to two types of criticism, one from the psychological side and the other from the philosophical side.

The very psychologists who have described the perceived world as I did above, the Gestalt psychologists, have never drawn the philosophical conclusions of their description. In that respect they remain within the classical framework. Ultimately they consider the structures of the perceived world as the simple result of certain physical and physiological processes which take place in the nervous system and completely determine the *gestalten* and the experience of the *gestalten.* The organism and consciousness itself are only functions of external physical variables. Ultimately the real world is the physical world as science conceives it, and it engenders our consciousness itself.

But the question is whether Gestalt theory, after the work it has done in calling attention to the phenomena of the perceived world, can fall back on the classical notion of reality and objectivity and incorporate the world of the *gestalten* within this classical conception of reality. Without doubt one of the most important acquisitions of this theory has been its overcoming of the classical alternatives between objective psychology and introspective psychology. Gestalt psychology went beyond this alternative by showing that the object of psychology is the structure of behavior, accessible both from within and from without. In his book on the chimpanzees, Köhler applied this idea and showed that in order to describe the behavior of a chimpanzee it is necessary, in characterizing this behavior, to bring in notions such as the "melodic line" of behavior. These are anthropomorphic notions, but they can be utilized objectively because it is possible to agree on interpreting "melodic" and "non-melodic" behaviors in terms of "good solutions" and "bad solutions." The science of psychology thus is not something constructed outside the human world; it is, in fact, a property of the human

world to make the distinction between the true and the false, the objective and the fictional. When, later on, Gestalt psychology tried to explain itself—in spite of its own discoveries—in terms of a scientistic or positivistic ontology, it was at the price of an internal contradiction which we have to reject.

Coming back to the perceived world as we have described it above, and basing our conception of reality on the phenomena, we do not in any way sacrifice objectivity to the interior life, as Bergson has been accused of doing. As Gestalt psychology has shown, structure, *Gestalt,* meaning are no less visible in objectively observable behavior than in the experience of ourselves—provided, of course, that objectivity is not confused with what is measurable. Is one truly objective with respect to man when he thinks he can take him as an object which can be explained as an intersection of processes and causalities? Is it not more objective to attempt to constitute a true science of human life based on the description of typical behaviors? Is it objective to apply tests to man which deal only with abstract aptitudes, or to attempt to grasp the situation of man as he is present to the world and to others by means of still more tests?

Psychology as a science has nothing to fear from a return to the perceived world, nor from a philosophy which draws out the consequences of this return. Far from hurting psychology, this attitude, on the contrary, clarifies the philosophical meaning of its discoveries. For there are not two truths; there is not an inductive psychology and an intuitive philosophy. Psychological induction is never more than the methodological means of bringing to light a certain typical behavior, and if induction includes intuition, conversely intuition does not occur in empty space. It exercises itself on the facts, on the material, on the phenomena brought to light by scientific research. There are not two kinds of knowledge, but two different degrees of clarification of the same knowledge. Psychology and philosophy are nourished by the same phenomena; it is only that the problems become more formalized at the philosophical level.

But the philosophers might say here that we are giving psychology too big a place, that we are compromising rationality by founding it on the texture of experience, as it is manifested in perceptual experience. But either the demand for an absolute rationality is only a wish, a personal preference which should not be confused with philosophy, or this point of view, to the extent that it is well-founded, satisfies it as well as, or even better than, any other. When philosophers wish to place reason above the vicissitudes of history they cannot purely and simply forget what psychology, sociology, ethnography, history, and psychiatry have taught us about the conditioning of human behavior. It would be a very romantic way of showing one's love for reason to base its reign on the disavowal of acquired knowledge. What can be validly demanded is that man never be submitted to the fate of an external nature or history and stripped of his consciousness. Now my philosophy satisfies this

demand. In speaking of the primacy of perception, I have never, of course, meant to say (this would be a return to the theses of empiricism) that science, reflection, and philosophy are only transformed sensations or that values are deferred and calculated pleasures. By these words, the "primacy of perception," we mean that the experience of perception is our presence at the moment when things, truths, values are constituted for us; that perception is a nascent *logos*; that it teaches us, outside all dogmatism, the true conditions of objectivity itself; that it summons us to the tasks of knowledge and action. It is not a question of reducing human knowledge to sensation, but of assisting at the birth of this knowledge, to make it as sensible as the sensible, to recover the consciousness of rationality. This experience of rationality is lost when we take it for granted as self-evident, but is, on the contrary, rediscovered when it is made to appear against the background of non-human nature.

The work[4] which was the occasion for this paper is still, in this respect, only a preliminary study, since it hardly speaks of culture or of history. On the basis of perception—taken as a privileged realm of experience, since the perceived object is by definition present and living—this book attempts to define a method for getting closer to present and living reality, and which must then be applied to the relation of man to man in language, in knowledge, in society and religion, as it was applied in this work to man's relation to perceptible reality and with respect to man's relation to others on the level of perceptual experience. We call this level of experience "primordial"—not to assert that everything else derives from it by transformations and evolution (we have expressly said that man perceives in a way different from any animal) but rather that it reveals to us the permanent data of the problem which culture attempts to resolve. If we have not tied the subject to the determinism of an external nature and have only replaced it in the bed of the perceptible, which it transforms without ever quitting it, much less will we submit the subject to some impersonal history. History is other people; it is the interrelationships we establish with them, outside of which the realm of the ideal appears as an alibi.

This leads us . . . to draw certain conclusions from what has preceded as concerns the realm of the practical. If we admit that our life is inherent to the perceived world and the human world, even while it re-creates it and contributes to its making, then morality cannot consist in the private adherence to a system of values. Principles are mystifications unless they are put into practice; it is necessary that they animate our relations with others. Thus we cannot remain indifferent to the aspect in which our acts appear to others, and the question is posed whether intention suffices as moral justification. It is clear that the approval of such or such a group proves nothing,

4. The *Phenomenology of Perception.—Trans.*

since, in looking for it, we choose our own judges—which comes down to saying that we are not yet thinking for ourselves. It is the very demand of rationality which imposes on us the need to act in such a way that our action cannot be considered by others as an act of aggression but, on the contrary, as generously meeting the other in the very particularity of a given situation. Now from the very moment when we start bringing the consequences of our actions for others into morality (and how can we avoid doing so if the universality of the act is to be anything more than a word?), it appears possible that our relations with others are involved in immorality, if perchance our perspectives are irreconcilable—if, for instance, the legitimate interests of one nation are incompatible with those of another. Nothing guarantees us that morality is possible, as Kant said in a passage which has not yet been fully understood. But even less is there any fatal assurance that morality is impossible. We observe it in an experience which is the perception of others, and, by sketching here the dangerous consequences which this position entails, we are very much aware of its difficulties—some of which we might wish to avoid. Just as the perception of a thing opens me up to being, by realizing the paradoxical synthesis of an infinity of perceptual aspects, in the same way the perception of the other founds morality by realizing the paradox of an *alter ego*, of a common situation, by placing my perspectives and my incommunicable solitude in the visual field of another and of all the others. Here as everywhere else the primacy of perception—the realization, at the very heart of our most personal experience, of a fecund contradiction which submits this experience to the regard of others—is the remedy to skepticism and pessimism. If we admit that sensibility is enclosed within itself, and if we do not seek communication with the truth and with others except on the level of a disembodied reason, then there is not much to hope for. Nothing is more pessimistic or skeptical than the famous text in which Pascal, asking himself what it is to love, remarks that one does not love a woman for her beauty, which is perishable, or for her mind, which she can lose, and then suddenly concludes: "One never loves anybody; one loves only qualities." Pascal is proceeding like the skeptic who asks *if* the world exists, remarks that the table is only a sum of sensations, the chair another sum of sensations, and finally concludes: one never sees anything; one sees only sensations.

If, on the contrary, as the primacy of perception requires, we call what we perceive "the world," and what we love "the person," there is a type of doubt concerning man, and a type of spite, which become impossible. Certainly, the world which we thus find is not absolutely reassuring. We weigh the hardihood of the love which promises beyond what it knows, which claims to be eternal when a sickness, perhaps an accident, will destroy it . . . But it is *true*, at the moment of this promise, that our love extends beyond *qualities*, beyond the body, beyond time, even though we could not

love without qualities, bodies, and time. In order to safeguard the ideal unity of love, Pascal breaks human life into fragments at will and reduces the person to a discontinuous series of states. The absolute which he looks for beyond our experience is implied in it. Just as I grasp time through my present and by being present, I perceive others through my individual life, in the tension of an experience which transcends itself.

There is thus no destruction of the absolute or of rationality here, only of the absolute and the rationality separated from experience. To tell the truth, Christianity consists in replacing the separated absolute by the absolute in men. Nietzsche's idea that God is dead is already contained in the Christian idea of the death of God. God ceases to be an external object in order to mingle in human life, and this life is not simply a return to a non-temporal conclusion. God needs human history. As Malebranche said, the world is unfinished. My viewpoint differs from the Christian viewpoint to the extent that the Christian believes in another side of things where the *"renversement du pour au contre"* takes place. In my view this "reversal" takes place before our eyes. And perhaps some Christians would agree that the other side of things must already be visible in the environment in which we live. By advancing this thesis of the primacy of perception, I have less the feeling that I am proposing something completely new than the feeling of drawing out the conclusions of the work of my predecessors.

Theory, Politics, and Performance

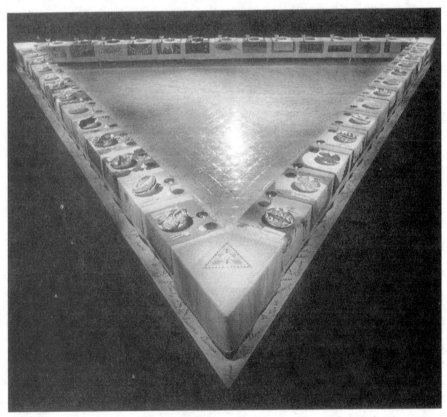

Judy Chicago (American, b. 1939), *The Dinner Party*. Mixed media, 48 ft x 42 ft 3 in.
© 1979 Judy Chicago. Photo © Donald Woodman.

Artists

Hans Haacke
Interview with Hans Haacke (by Robert C. Morgan)
(1979)

Hans Haacke began in the late 1960s to use language (along with photography) as a way to expand the role of art so that it could function in the political arena. Specifically, Haacke was intent on exposing the political underpinnings of social systems. One of Haacke's pieces was included in the now-famous exhibition *Information* at the Museum of Modern Art in 1970. His work in this show consisted of a poll that asked the following question: "Would the fact that Governor Rockefeller had not denounced President Nixon's Indo-China policy be a reason for you not to vote for him in November?" Museum attendees were asked to deposit their admission tickets in one of two boxes—one of which was marked "yes" and one of which was marked "no."

Nelson Rockefeller was the Republican governor of New York. He had also been a member of the board of trustees of the museum since 1932. Throughout the 1970s Haacke's work continued to expose the connections among economics, politics, and the arts in works that documented a range of facts, including the real-estate holdings of wealthy landlords in New York and sponsorship of art by specific corporations. This interview with Robert C. Morgan was conducted in 1979 and was first published in *Real Life Magazine* in 1984.

Robert Morgan: *Is it possible to hold a non-ideological position and work within the context of political art?*

Hans Haacke: Before we talk about that I think it is necessary to clarify the term "ideological." I personally don't use it in the normal Marxist sense, where ideology is a set of beliefs and practices that covers up the real situation and constitutes "false consciousness," although, no doubt, this is indeed what ideology often does. When I use the term I merely mean—without judgment—that system of beliefs, goals, assumptions, aspirations that determine how society and we ourselves shape our lives. I do not assume that there is such a thing as "correct consciousness." For that to exist would require an ability to view the world from the outside, unconstrained by historical contingencies. It would be a bit like playing God. Back to your question, obviously, there is no non-ideological position.

Non-ideological art is therefore an impossibility.

It is impossible, because we are all working with what we have learned and what we have internalized as unquestioned assumptions about the world. There is no objective position.

I guess I was thinking in terms of the institutional use of the term today. The fact that experience is subjugated to an institutional framework which neutralizes personal experience.

Of course, I also mean the experience one has with and through institutions; the family, school, religion, the press, government, the art world, etc., unavoidably they are all ideological agents. The personal is to a considerable degree affected by what is believed by the group one happens to belong to. It is not really that personal at all.

So would a non-ideological position be the same as an apolitical position?

There is no non-ideological position! Those who would like to exempt themselves from politics, or who in normal parlance are apolitical, nevertheless act politically. Abstentions also affect the outcome of a vote or, for that matter, leave a power vacuum that is filled immediately by the bully on the block.

There are simply those who are more aware of their political maneuvers. Perhaps we can say that some artists are more tuned in to ideology in terms of their work.

That is true. Some deliberately work with it. Others are not aware of it. However, unwillingly or not, their ideology also transpires in their work and affects the ideological climate of the consciousness industry.

"Conceptual Art" was a popular term back in the late sixties, do you in any sense consider yourself a Conceptual artist now, in the eighties, or would you prefer not to carry that with you now?

"Conceptual Art" is a heavily burdened term. It has so many interpretations. I never presented myself as a Conceptual artist. For that matter, I didn't present myself as anything. It is other people who sometimes call me a Conceptual artist or pin all sorts of other labels on my work. And I resent this because it often associates me with things with which I don't have much in common. It can distract from viewing my work on its own terms.

I may happen to use language more than artists who are not likely to be called Conceptual, but I don't think this is such a significant feature. What might be significant is a sense of rationality—for example, I detect a rational approach in Sol LeWitt's work. I like that a lot—no mystification. But Sol's work, even though he coined the term "Conceptual Art," is not typical of the artists who are usually grouped under that label.

I see. Greenberg talks about rational self-criticism as the basis for Modernism. That seems to be quite different from the kind of rational approach that you're involved in.

I don't really know what he means when he uses the term "rational." Generally I find his theories very irrational. I have no patience with the mystification of purported disinterestedness. Art making is just another part of the consciousness industry that reflects the time in which it occurs, and the ideological persuasions and mundane constraints put on the work force.

Often the economic and political concerns that you're involved with don't enter into art critical discourse. Some artists willfully deny this kind of reflective activity as part of the aesthetic process in which they're involved. But you're using economic and political systems as a basis for the content in your work. And because of your position as an artist, you're seeing these systems quite differently from those who are actually embedded within the corporation hierarchies.

Obviously I'm not so much interested in the bottom line that the corporation reports to its shareholders. I'm more interested in how the corporation functions in contemporary society and what consequences this has for all of us. Multinationals in particular shape, to a great extent, the way we live and perceive the world. They are quite successful in their campaign of persuasion.

The explicit use of language—do you feel that it is necessary in the identification of political art?

I don't know if it is necessary, but for me it has been quite handy because I found that complex social situations are very difficult to lay bare in purely visual terms—through imagery alone.

By explicit use of language, what I'm getting at is the literal use of language as opposed to maybe something metaphorical. I don't believe that your work deals with metaphorical language so much.

No, not much. But I hope it is thereby strengthened in terms of accessibility and clarity. Metaphoric language can be so ambiguous that it interferes with communication. When that occurs the text becomes a playground for interpretation. Of course, this is a favorite ploy for the building of myths and the laundering of crypto-fascist ideas.

Does the language become more formal in such instances?

No. It allows you to wallow in the language and to forget about its implications. However that does not mean that I'm proposing a dry, annual report type of thing. That would be boring as hell. I also don't want to be understood as saying that metaphor is an absolute no-no, or that ambiguity is in all cases to be avoided.

You have said that the earlier works, such as the condensation pieces and the aerodynamics pieces, were not involved with formal problems, but were rather concerned with natural cause and effect relationships. Has that position changed since those earlier years?

No, I don't think it has changed. The form I choose is derived directly from the job it is supposed to perform. So, if I deal with corporate policy, for instance, I try to emulate the corporate look. I do not only quote the words of corporations, I also quote the visual presentation with which they approach the public. I appropriate styles, I don't create them. And I hope that that also helps to reveal the mechanics of appropriated styles.

The formality is implicit to the actual structure that you're dealing with. You're not imposing anything from the art world upon it.

I'm not interested in discussions about the edge of a painting, or if it should be a floor piece, a hanging piece, or this or that. I choose what is appropriate for a particular job. It was the same with physical and biological things I was working with before. It had to come out of the peculiar characteristics of the phenomena.

In the art world right now there are very different points of view about the use of photography. There is Ansel Adams who had a big retrospective at MoMA, and then there are people like Victor Burgin or Conrad Atkinson, who use the photograph in a much different way. What is your relationship to photography? I know you've used photographs.

Wherever the medium of photography is useful for a particular task, I use it. If another medium is more suitable, I use that. For instance, I would not exclude painting with brush and paint, if that seemed the best means for getting a certain message across. I believe very much that materials and the modes of representation—photography, painting, print processes, etc.—can all act as signifiers.

In the Aesthetic Dimension, a book that came out shortly before his death, Herbert Marcuse argues that the mere existence of art in a society is evidence that a dialectic is in progress between the individual and the state. This further implies that the ideological content of art is a more implicit undertaking than it is an explicit form of production. Marcuse is interested in establishing the viability of the creative arts within the context of society. But apparently he forgot about the way in which art can be used in advertising, for example, or stored away in warehouses for investment purposes.

He probably forgot about tax shelters also.

Probably. What do you think, can art change the ideology of the state?

When it comes to art Marcuse is an idealist like Marx. The arts as such are seen as something good, like motherhood, and therefore deserve to be

sponsored, no matter by whom. If you are really interested in changing the way people look at society, and how they organize their relations, I think art as such needs to be questioned. One has to examine carefully whose interests are promoted, implicitly or explicitly, by particular kinds of art. I'm a little wary of any kind of general love of art.

So you would not agree that the mere existence of art is capable of inciting praxis at some point?

It certainly doesn't do that. Art can solidify the *status quo* in a given society, or it can help shake it up. Wherever art is controlled by governmental or other institutions like the church or business, it serves to bolster the powers that be. I cannot believe that Marcuse thought that the mere existence of, say, the blood and earth art under Hitler promoted the kind of social change that Marcuse was looking for.

Things become more clouded when we talk about non-dictatorial circumstances. In this country, for instance, we generally do not feel any censorship, any direction from above. But it is quite clear that certain products of the consciousness industry are promoted and get big exposure, while others are not. This occurs without any well planned conspiracy, or a minister of propaganda setting switches. One should inquire though, whose ideas about social relations are boosted and whose are left out, and what reasons lie behind this selection. Increasingly the need of art institutions to receive corporate funds in order to stay afloat will set limits of a particular kind. Irving Kristol, the neo-conservative Godfather, and his followers, are getting through to their friends in big business that they better get busy to shape the public's perception of the world. Mobil's culture campaign is a prototypical example.

Ideological control in a non-dictatorial society has to be subtle. Punishment for deviant behavior is relatively mild, that is, it is restricted to economic sanctions and difficulty reaching audiences, but nevertheless it seems to guarantee a high degree of conformity within a given range. People adjust more out of instinct than under pressure. Nobody wants to be a loser.

What do you think of the term "Postmodernism" as it applies to the visual arts? What do you think it represents?

I really don't know. Labels like this mean so little. I have a hard time understanding what distinguishes Modernism, so I really don't know what Postmodernism means. I don't care either. Labels are good for packaging but absolutely unsuitable for an intelligent analysis of the works under discussion.

Then what is the criteria for political art given its non-aesthetic base?

That's a hard one. When all is said and done, it probably boils down to intelligence, like with purportedly non-political art.

It would seem to me that a relationship with the academic structure is very important to somebody involved with political art.

For me it's extremely useful. My type of work obviously doesn't sell well. Right from the beginning, before I even got into political things, I determined that I should never strive to live off the sale of my work. That would make me dependent upon the market. So there had to be another source of income. Teaching seems to be the most convenient, and I do enjoy it, it's not a burden.

I do too. I can sympathize with that. Where do you see the audience for political art?

My audience is predominantly the same audience as that for supposedly non-political art.

Is that effective in terms of your goals, what you're trying to achieve?

Well, there's a sort of division of labor. Some people address other audiences, say union members, minority groups, straphangers on the subway, or whatever it may be. That is fine, I don't quarrel with that. I personally feel more comfortable in the established art world. I grew up there, I know the people, I know how it functions, I know its sore points. I believe the public of the art world—sociologically speaking—is to a considerable degree identical with the segment of society that makes the decisions today, that determines what we think. If one has a bit of influence there, it might be of some importance.

People that are attracted to art are obviously involved in these other concerns. Art becomes a vehicle to get the point across, if I'm understanding you correctly.

Yes, absolutely. In a way my opponents in this game have understood this for some time. The funding of cultural programs by big corporations is done with this express understanding. Political problems for big business do not come from the left in this country, for here the left is nonexistent as far as political effectiveness goes. Trouble comes primarily from the liberal end of the political spectrum. So business has to convince these troublesome liberals that corporations are not out to exploit, but that they, in fact, stand for a clean environment, for health, good citizenship, peace in the world, etc. One way of doing that is by associating the company name with cultural programs. I'm dealing with the same public the corporation is trying to reach. My assessment of the situation is pretty similar to theirs. It's just that we have opposite points of view.

A curious phenomenon occurred as a result of the recession of the seventies. Around 1973 several galleries began closing in New York, Los Angeles and San Francisco,

because they couldn't sustain themselves. People weren't buying art. This happened during the first oil crisis, when oil doubled in price. In any case people weren't buying art like they had in the sixties, and this put a lot of Conceptual artists in real trouble. In response some of them began to make more elaborate documents, relics and other artifacts for sale. Objects and images were produced with a much stronger visual appeal. Is it possible that a highly experimental art form like Conceptual Art needs a certain economic climate in order to survive? After all, if this proves to be the case, we are faced with a contradiction—an art form that emphasizes a political position by being against the commodity fetish approach to the art work that can only thrive during an upswing in the capitalist cycle?

I don't quite subscribe to your description of the history. I think the material artifacts coming from Conceptual artists preceded the recession by a number of years. You could buy Joseph Kosuth's definitions quite early on.

No question about that. But at the outset there was a movement away from the material object towards a more reduced, ephemeral statement. Photographs by artists appeared everywhere, photographs which documented performances and installations that very few people had actually witnessed. These were relatively inexpensive, throwaway things that took on an importance by being referential signifiers of a sort. Then all of a sudden the documents became more objectified, more decorative, more visually appealing, and more concerned with material. I began to see this shift of thinking around 1972. I felt there was a parallel between what was happening in the economic sphere and how economics was affecting galleries and how galleries, in turn, had a certain impact upon artists in terms of the kind of work they chose.

I don't believe it had such a close relationship to the economy of the country. I think it had more to do with the economic situation of the individual artist. Obviously, if you produce art it costs some money, and you also have to live. If you don't have an independent income, you are always looking for some way to make money. So these artists, like everybody else, irrespective of the prosperity or decline of the national economy, had an interest in eventually selling work.

I can agree with that, but wouldn't you also agree that part of the effectiveness of Conceptualism back in the late sixties was that it rejected the necessity of the material object as a support system for the concept of art?

It rejected the material object, yes. But I think the claims made for non-collectibility were not always genuine. It certainly had an exotic appeal among followers of the art world, because it contradicted the way people normally act. But then the market in relics blossomed.

Let's talk more specifically about presentation. How do you feel about your own work in terms of presentation? The Good Will Umbrella, shown at the John Weber

Gallery in 1977, struck me as being incredibly visual. I remember walking into the space and just getting this visual flash of Mobil logos running down the wall. I felt it was very effective, just as an installation, like a piece of good advertising. I felt the flash before I got into the content of the piece. I didn't feel you were trying to disregard the visual apparatus, or to downplay its impact.

No, I'm not against visual appeal at all. I'm very fond of Bertolt Brecht, who said, in 1932, in an essay about the radio, that one has to represent interests in an interesting way. People should enjoy going to the theater or looking at visual art. Otherwise one loses the audience. I'm not an asensual person myself. I also like to get pleasure out of it, I'm part of the audience.

Your work appears to have very little division between the interior and the exterior components. Simply looking at the Mobil piece or the more recent Tiffany piece was a real lead-in to the substance of the work.

Since reading the entire text could have been very tedious I did not adopt the standard "conceptual" mannerism, typewritten pages on the wall. That would have been absolutely devastating. For me, like other people, it is quite painful to read off a wall, particularly if it is in small print. So I deliberately printed the panels very large. The form was inviting, and it alluded to Mobil gas station signs—therefore, the printing on plastic, the round corners, the quoting of the Mobil logo.

Obviously, I work within a contradiction. Part of my message is that art should have a use-value rather than be seen as the commodity produced by an entrepreneur. But in order to publicize this as well as other ideas for mental use in the most appropriate way, one must be able, financially, to produce the work. And then one has to get it out of the studio to the art public, which, for reasons that I explained, is the primary audience. So one needs the commercial channels of the established art world—the galleries, museums, magazines, etc. If the work stayed outside this network nobody would get to see it. The issues it raises would not be talked about, and for all practical purposes it would not exist. It would be cut off from the communications network that I'm trying to influence. So, by necessity, I'm in the contradictory position of playing the game while criticizing it.

I have always felt that the gallery was a necessary component. It's not that the gallery presents a contradiction to your intentions, but that you're establishing that art can only really function in that context.

Obviously the context in which my works are seen is an integral part of the material I work with. Outside of the intended context one reads them differently and some even become meaningless.

There are artists who change the function of objects by bringing them into the gallery. Then there are those who take objects out of the gallery in order to change their

function in the world. I think you do both. Duchamp, of course, was one of the first— if not the first—artists to make this kind of transition explicit in his ready-mades. He drew attention to the fact that everyday objects could operate as signs in their own right just as words can be elevated to this kind of question. Octavio Paz once said that an early indication of social transition is the investigation of language by artists and writers. Language doesn't have to have direct political connotations, but the fact that its function is being reconsidered, this becomes political. Do you feel the current investigations of language by artists has any kind of relationship to political praxis, and if so, is there a cause and effect relationship that we can identify?

I strongly believe that all unmasking of language, whether it's verbal or visual, would help a great deal. All these fantastic buzz words—"free enterprise," "deregulation," the "marketplace of ideas," "individualism," "deterrence," and so forth. They usually mean something totally different from what a naïve listener might think. In effect they serve to disguise the forces at work in the political arena.

Indeed they do. It would seem that the art world has its own peculiar set of buzz words too. That being the case, who checks the significance of political art?

It's just the same as with any other type of art, a general consensus of all those who are called culturally powerful—critics, artists, gallery people, museum people, to some extent even art students and art schools. If somebody who is perceived as producing so-called political art gets a grant and is invited to prestigious exhibitions, that legitimizes the work. But as I said, that holds for other types of art is well.

I wonder if a critic like Hilton Kramer could deal objectively with your art?

There are no universally accepted qualifications.

It gets back to the problem of criteria, doesn't it?

Yes, Kramer has revealed his ideological bias quite blatantly. He has never reviewed a show of mine. Nor have any other critics of *The New York Times* written reviews while he has been editor of the arts section. I must have had about half a dozen shows since he's been at *The Times*. On at least one occasion this blackout was obviously deliberate. That was when I had a show at John Weber's together with Nancy Holt.

Is that when you showed the Tiffany piece?

Yes, and that is a piece, of course, which made fun of supply-side economics, which Kramer, as a card carrying neo-conservative, fervently supports. Kramer wrote a very favorable review of Nancy Holt's work, but did not even mention my show in the large room in the gallery. That must have been a deliberate omission. Given his New Right bias he must loathe my stuff.

Criticizing it in public, though, would give it status, and that is something he obviously does not want to give me.

Yes, indeed. So the creation of a negative social space can be a very powerful weapon.

Yes. It is probably not accidental that since my problem with the Guggenheim, not a single New York museum has invited me to show.

Is that true? What about museums in Europe?

It varies from place to place. I had a problem in Cologne. You might have heard about it—the Manet story.

What happened?

I was asked by the Wallraf-Richartz-Museum to produce a new work for an invitational group show, called *PROJEKT 74*, in celebration of the museum's centennial. I chose to present the history of ownership of a still life that played a prominent role in the museum's collection. Towards the end of the provenance I listed the biography of Herman Josef Abs, the head of the Deutsche Bank and chairman of the museum's Friend's Committee, which had donated the major part of the funds to acquire the painting for the museum. He is a very powerful person in post-war Germany—and happened to have a fantastic career during the Nazi period. Although he was not a Nazi party member he became the chief of the foreign division of the Deutsche Bank, and towards the end of the war he was on the board of over fifty companies. With only a brief interruption shortly after the war, he continued his career in banking, and began a new one in the political world of post-war Germany. He is obviously a very intelligent man. Anyhow, I listed his biography along with the biographies of the other owners of the painting. The museum couldn't stomach it, and censored the piece.

So then I showed it, at the same time as the museum show, at Paul Maenz's gallery in Cologne. We opened the same day as *PROJEKT 74*. Alongside the piece, I also made my correspondence with the museum people public. One of the nuggets from this was a statement by the director that said, "The museum knows nothing about economic power, however, it knows about spiritual power." Daniel Buren, who had also been invited to take part in the big show, asked me if I could give him a photo facsimile of the original piece, and during the opening he pasted the facsimile over his own stripes. So in effect it became a collage of his work and my photocopy.

I've wondered about that. I've seen that photograph of the installation many times and I've always thought it was the original piece, a collaboration or something.

No, that's not the original. The next morning the museum director came around and had my offensive stuff pasted over. Two layers of typewriter paper were pasted over it.

Daniel had produced something that, in art historical terms, one would call a collage. Part of that collage was destroyed by the museum—an act of vandalism. Quite a scandal. Several artists pulled out of the show in protest. Daniel put up a poster next to it that read, "Art Remains Politics," which was a paraphrase of the official subtitle of the show which was, "Art Remains Art."

I had no problems with other things that I produced in Europe that referred to specific local situations. Last January I did a show in Eindhoven at the van Abbemuseum. I presented two works dealing with the Philips company. Philips is the fifth largest multinational in the world, outside of the American multinationals. Their world headquarters is in Eindhoven. They are the largest private employer of the Netherlands and the main employer in Eindhoven. Almost every family has at least one member working for Philips. Both of my works were very critical of Philips's policies in South Africa and the Shah's Iran, yet there was never any hint that the museum would reject these pieces. The van Abbemuseum is a municipal museum and the show was widely covered in the press—all favorable. I also did something in Britain on British Leyland and its operations in South Africa, also in a publicly funded museum, this time in Oxford, and again, there was no problem. The difficulty I see here in the U.S. is structural. The boards of trustees of most museums in this country are predominantly composed of the segment of society that I criticize, primarily people in big business and finance. And then curators in the U.S. don't have tenure, often they don't even have a contract. They can be fired from one day to the next. The same is true for the directors—we have seen two go from the Museum of Modern Art. So naturally curators wouldn't dream of proposing shows of extremely critical works to their board, they would be putting their job in jeopardy. So we see few challenging shows in American museums.

Judy Chicago
Excerpts from The Dinner Party: A Symbol of Our Heritage (1979)

With the publication of her autobiographical book *Through the Flower* in 1975 and the completion of her monumental sculpture *The Dinner Party* in 1979, Judy Chicago was instrumental in creating a climate for serious discussion about the discrimination faced by women artists. *The Dinner Party* is a triangular banquet table with custom-designed place settings for thirty-nine women, who include both historical and mythological figures chosen by Chicago because of their contributions to Western culture. The table stands on a tiled floor, upon which the names of ninety-nine other important women are inscribed.

Chicago's goal for *The Dinner Party* was to celebrate women's achievements and to call into question the marginalization of these achievements throughout history in a symbolically powerful way. To create this piece Chicago collaborated with a number of women who painted china and embroidered cloth, two art forms historically associated with women. The conceptual sophistication of *The Dinner Party* is matched by an intense focus on artistic craft. In this excerpt from her book *The Dinner Party: A Symbol of Our Heritage,* which was published in 1979, Chicago clearly states that she "firmly believes that if art speaks clearly about something relevant to people's lives, it can change the way people perceive reality."

During a trip up the northwest coast in the summer of 1971, I stumbled onto a small antique shop in Oregon and went in. There, in a locked cabinet, sitting on velvet, was a beautiful hand-painted plate. The shopkeeper took it out of the case, and I stared at the gentle color fades and soft hues of the roses, which seemed to be part of the porcelain on which they were painted. I became enormously curious as to how it had been done. The next year I went to Europe for the first time and found myself almost more interested in cases of painted porcelain than in the endless rows of paintings hanging on musty museum walls.

Classically trained as a fine artist, I felt somewhat uneasy with my interest in decorative arts. But I was sufficiently fascinated by the china-painting I had seen in Europe to enroll in a class given at a small shop in Los Angeles in the fall of 1972. The first class consisted of learning to mix pigments with what seemed like very exotic oils and then practicing to make dots, dashes, and commas, which, I was told, were the basic components of china-painting brushwork. We also learned how to thin down our paint so it would flow through a crow-quill pen point for line work. We then traced some forget-me-nots onto gleaming white porcelain plates and proceeded to do the pen work we had learned.

I soon realized that this hobbyist approach was not what I had in mind. I wanted to learn the basic components of the china-painting medium and use it for a new work—a series of painted plates that related to the series of paintings I had been doing, entitled "Great Ladies." These abstract portraits of women of the past were part of my personal search for a historical context for my art. After having worked on plexiglass for a number of years, I was now spraying paint on canvas. But I was dissatisfied with the way the color sat on top of the canvas surface instead of merging with it, as it had done on the plastic. I also wanted to use a brush again, thus allowing a contact with the paint surface that cannot be achieved by spraying.

The rose plate I had seen in Oregon suggested not only another painting technique, but also another format for my "Great Ladies." Since plates are associated with eating, I thought images on plates would convey the fact that the women I planned to represent had been swallowed up and obscured by history instead of being recognized and honored. I originally conceived of one hundred plates, which would hang on the wall as paintings normally do; the idea of setting the plates on a table came later.

Although the china-painting class left much to be desired, something else was beginning to unfold. I had been a "serious" art student from the time I was young, and later I became deeply involved in the art world. The women in this class were primarily housewives interested in filling their spare time. However, they also genuinely wanted to find a way to create something of value, and, as I learned more about the china-painting world, I realized that a number of these women were dedicated professionals as well. Shortly after I left the class, a sculptor friend of mine, Bruria, introduced me to Miriam Halpern, a china-painter who was sophisticated about art. Mim agreed to teach me, with the understanding that I didn't want to learn to paint forget-me-nots, but rather to develop an overall knowledge of china-painting techniques.

Under Mim's supervision, I undertook a series of test plates that allowed me to explore the various aspects of the medium. She also introduced me to the world of the china-painter—the magazines, the organizations, and the exhibitions. The first time I attended a china-painting exhibition I was flabbergasted both by the quality of some of the work and by the size of the crowds. I was used to small art-world audiences, not to hundreds—and, at the international show, thousands—of viewers.

At these exhibitions, the painters worked at booths and demonstrated their techniques in classes. Hundreds of women watched attentively, made notes, bought supplies, and exchanged information. I was struck by everyone's seriousness and was somewhat puzzled that the painters, seemingly oblivious to the people around them, could work even while they were being asked questions. I, in contrast, could work only if I were alone, had gone through my morning ritual (which required at least an hour of quiet), and had an entirely uninterrupted day.

During the year and a half I studied china-painting. I attended exhibitions, met painters, visited their houses, and asked questions about the history of china-painting. I learned that for the last thirty or forty years, china-painting had been entirely in the hands of these women and they had been responsible for preserving this historic technique. In the 1950s, a number of china-painters began to organize classes, shows, and publications. Before that, one could only learn the technique through one's mother or grandmother. Many women worked full-time in their home studios—painting, teaching, and showing. Despite the fact that some of them had been painting for as long as forty years, they didn't know how, nor did they have the resources, to present their work properly; it was poorly exhibited, improperly installed, and inadequately lighted, and it sold for outrageously low prices. Many china-painters had gone to art school when they were young and had soon married and had children. They later looked for a way to express themselves that did not require—as it did for so many professional artists—a choice between their family life and their work.

I remember one particularly poignant experience of visiting a china-painter's house and seeing, as Virginia Woolf once said, that the very bricks

were permeated with her creative energy. All the chairs had needlepoint cushions; all the beds were covered with quilts; all the pillowcases were hand-embroidered; all the walls were covered with oil paintings; all the plates were painted with flowers; and the garden was planted with the kinds of flowers that were painted on the plates. This woman had done all that work, trying as best she could to fit her creative drive—which could probably have expanded into mural-size paintings or monumental sculptures—into the confined space of her house, which could hardly have held another piece of work.

The china-painting world, and the household objects the women painted, seemed to be a perfect metaphor for women's domesticated and trivialized circumstances. It was an excruciating experience to watch enormously gifted women squander their creative talents on teacups. I wanted to honor the women who had preserved this technique, and, by making china-painting visible through my work, I hoped to stimulate interest in theirs.

I finished my studies by 1974, and by that time my plan had changed. I had discarded the idea of painting a hundred abstract portraits on plates, each paying tribute to a different historic female figure. Instead, I was thinking about a series called "Twenty-five Women Who Were Eaten Alive." In my research I realized over and over again that women's achievements had been left out of history and the records of their lives had apparently disappeared. My new idea was to try to symbolize this. I had seen a traditional dinnerware set that had taken its creator, Ellie Stern, three years to paint. It made me think about putting the plates on a table with silver, glasses, napkins, and tablecloths, and over the next year and a half the concept of *The Dinner Party* slowly evolved. I began to think about the piece as a reinterpretation of the Last Supper from the point of view of women, who, throughout history, had prepared the meals and set the table. In my "Last Supper," however, the women would be the honored guests. Their representation in the form of plates set on the table would express the way women had been confined, and the piece would thus reflect both women's achievements and their oppression.

There were thirteen men present at the Last Supper. There were also thirteen members in a witches' coven, and witches were always associated with feminine evil. The fact that the same number had both a positive and a negative connotation seemed perfect for the dual meaning of the piece; the idea of twenty-five plates therefore gave way to thirteen.

But the Last Supper existed within the context of the Bible, which was a history of a people. So my *Dinner Party* would also be a people's history—the history of women in Western civilization. As I explained in my autobiography, *Through the Flower,* I had been personally strengthened by discovering my rich heritage as a woman and the enormous amount of information that existed about women's contributions to society. This information, however, was totally outside the mainstream of historical thought and was certainly unknown to most people. And as long as women's achievements were excluded from

our understanding of the past, we would continue to feel as if we had *never* done anything worthwhile. This absence of any sense of our tradition as women seemed to cripple us psychologically. I wanted to change that, and I wanted to do it through art.

My goal with *The Dinner Party* was consistent with all my efforts in the previous decade. I had been trying to establish a respect for women and women's art; to forge a new kind of art expressing women's experience; and to find a way to make that art accessible to a large audience. I firmly believed that if art speaks clearly about something relevant to people's lives, it can change the way they perceive reality. In a similar way medieval art had been used to teach the Bible to illiterate people. Since most of the world is illiterate in terms of women's history and contributions to culture, it seemed appropriate to relate our history through art, particularly through techniques traditionally associated with women—china-painting and needlework.

I was planning thirteen place settings, with the name of each woman embroidered on the tablecloth along with a phrase indicating what she had achieved. It became evident, however, that thirteen plates were not enough to represent the various stages of Western civilization, and therefore the number tripled. I arrived at the idea of an open triangular table, equilateral in structure, which would reflect the goal of feminism—an equalized world. (Also, the triangle was one of the earliest symbols of the feminine.) But there was something wrong with the image of this large table without a context: The concept of an isolated woman "pulling herself up by her bootstraps" simply did not stand up to the evidence of history. Rather, women's achievements took place against a background of societies in which women either had equal rights or were predominant to begin with or, later, enjoyed expanded opportunities, agitated for their rights, or built support networks among themselves.

To convey this idea, I decided to place the triangular table on a floor inscribed with the names of additional women of achievement besides those represented by place settings. This would suggest that the women at the table had risen from a foundation provided by other women's accomplishments, and each plate would then symbolize not only a particular woman but also the tradition from which she emerged. The floor would be porcelain, like the plates, and the women's names would be painted on triangular tiles in gold china-paint with a luster overglaze. This would make the names appear and disappear as the viewer walked around the table—a fitting metaphor for women's history.

By March 1975, the conceptual work on the piece was completed. The only changes that would take place later would be the decision to make the goblets and flatware out of clay and the decision to put the women's names on individual runners rather than on the tablecloth itself. I planned to embroider the name and a phrase around the plate in a circle as a way of making the identity of the woman clear. I had obtained a sewing machine, and I now began trying to learn how to embroider the names. At this point I

believed that I could do the china-painting in the morning, the needlework in the afternoon, and the research in the evenings!

I had begun work on the plates for the piece the preceding summer. As I was familiar with porcelain imported from Japan, which is used by many contemporary china-painters, I naturally started out using Japanese plates in my first test series. The exact composition of this porcelain is a highly guarded secret, but one of its attributes is that it doesn't break, no matter how many times it's fired. Some china-painters build up color very slowly, and I've heard of a piece being fired as many as forty-two times.

I chose fourteen-inch plates because everything was going to be slightly oversized in order to emphasize that this was not a normal dinner party table. With thirteen place settings on each of three wings of the table, shaped in a triangle, it seemed that the outside dimension of the piece would be about thirty feet on a side and would fit in a standard museum gallery, which is where I wanted to exhibit it. In order to reach a large audience, I thought *The Dinner Party* should travel to a number of museums, but I was worried about the difficulty of getting them to show feminist art.

The plates were going well and a number were completed, most of them incorporating a butterfly image, which I had used in my work for some time. In *The Dinner Party*, I intended to make the butterfly a symbol of liberation and create the impression through the imagery that the butterfly became increasingly active in her efforts to escape from the plate. I soon found myself thinking about having the forms literally rise, which meant making the plates dimensional. Although I had worked in clay in college and exhibited painted clay sculptures in my graduate show, I had never studied ceramics. Deciding that I would have to develop ceramic skills in order to make certain images, in the fall of 1975 I took a bus to UCLA and—eighteen years after I started undergraduate school there—walked onto the campus to take a ceramics class. But to create the plates I envisioned would mean two years of study; I decided to try to find a technical assistant instead. Leonard Skuro, a graduate student with eight years' experience in porcelain, agreed to work with me for the few months he thought would be required to make the remaining plates.

At about the same time I received a letter from a woman named Susan Hill, who had read *Through the Flower*, had heard me lecture, and wanted to work with me. I didn't know what her abilities were, but I happily accepted her assistance and asked her to do some historical research. Shortly thereafter, I ran into Diane Gelon, an art history graduate I had met several years before when she purchased one of my drawings. I discovered that she had some free time and asked if she'd like to help with the research also. Diane agreed, and soon the Project had four workers.

One day Susan mentioned that she came from a family of needleworkers. I asked her if she'd be interested in doing some needlework investigation, as I'd been having trouble solving the problems of embroidering the names. She spent the next six months doing research on embroidery and

needlework history. She also enrolled in an ecclesiastical embroidery class at the Episcopal Diocesan Altar Guild of Los Angeles; this class was taught by a woman named Marjorie Biggs, who eventually made a major contribution to the needlework of *The Dinner Party.*

Susan had been showing me the information she was uncovering in her research, and this made me see the richness of yet another neglected area of women's work. She took me to her class, where the women were working on church needlework, and later we went to a show of ecclesiastical embroidery, which both excited and depressed us. Like china-painters, needleworkers receive very little recognition. During the Middle Ages needlework was considered a high art, and the garments women embroidered were worn as emblems of power by church officials and rulers. By the time of the Industrial Revolution, however, needlework had declined and become a domestic art: Women were taught patience and "ladylike" behavior through the discipline of stitchery.

Susan and I thought it would be fitting to turn all this around and use embroidery to aggrandize women, relating our history through the varieties of needlework women have traditionally used. Giving needlework a more significant role in *The Dinner Party* would expand the piece and honor yet another female tradition. Susan had by now informed me that my idea of embroidering circular phrases on the tablecloths was impossible; thirty feet of fabric could not be manipulated through a sewing machine in circles, nor could it be put onto a hoop to do hand-embroidery. She suggested, as an alternative, the idea of individual runners modeled on the "fair linen" that covers the plate during the Eucharist. The runner concept gradually developed from there: We decided to embroider each woman's name on the front of her runner, which would drop over the viewers' side of the table. Instead of using a phrase to describe the woman's achievements, we would design needlework to visually express something about her and the time in which she lived. We also decided to let the runner extend over the back of the table and repeat or expand the imagery on the plate. Specific needlework techniques common to the woman's lifetime would be used, and, additionally, we would illuminate the first letter of her name. Neither of us knew much about embroidery, so we had no idea of the amount of work we were about to undertake.

Since I'd never embroidered and could barely sew, I approached designing for needlework entirely in terms of a visual medium. A number of skilled needleworkers had joined the Project, intrigued by the prospect of using their techniques in new ways. (They were very patient with me, never mentioning that one or another of my runner designs could take as long as a year to complete.) The first time I saw the painted mockup runners translated into stitching, I was ecstatic. The color fades and surface quality achieved with silk thread were even more dazzling than those on the china-painted plates. After we had designed the first third of the runners, Susan and I made a trip east

to study historic needlework; we returned with the realization that our first designs had only scratched the surface of the potential of embroidery.

In order to accommodate all the needlework we planned, the size of the piece had to expand. Each side of the floor would now be forty-eight feet long and each wing of the table forty-six feet, six inches. The runners were to be thirty inches wide and the table twenty-six inches deep. We decided to cover the corners of the tables with three sumptuous runners embellished with triangular patterns that I designed. The triangle, which symbolizes the feminine, is also the Goddess's sign, and the patterns on these altar cloths are intended to honor the female principle embodied in the concept of the Goddess. Each cloth was done in a different needlework technique. The first, embroidered in white silk by Marjorie Biggs, demonstrates many different stitch patterns. The second was crocheted by Stephanie Martin and Pauline Schwartz, and the last—incorporating shadow-work, needlepoint, and French knots—was a cooperative work supervised by L. A. Olson. All three cloths commemorate the endless hours women have spent to create something beautiful by crocheting, making lace, or doing other intricate needlework—labor that has been used for decorations on clothing or in the home and has gone largely unnoticed, never seen or appreciated as art.

Meanwhile, Leonard had been developing the ceramic technology for the plates and, working with a designer friend of his, Ken Gilliam, had produced a jigger machine for us to use in the plate-making process. Leonard and I had decided to make the goblets and flatware in clay. Ken began by designing the flatware and eventually designed the entire installation of *The Dinner Party*, along with the numerous objects, tools, and machines the piece required. The plate-making process, which ultimately took three years, was slowly developed by Leonard. It involved making the plaster molds that formed the interior shape of the plate—as well as the plates themselves—on the jigger machine (a converted potter's wheel). The clay was placed on the mold and compressed by the arm of the machine, which contained a metal template fashioned to cut the exterior of the plate. The plate was left to dry in specially designed drying racks, then trimmed and carved. Later we began to build up the surface of the plate in order to emphasize the rising of the image.

It required three years to produce the plates, as the ceramic problems we encountered were incredibly difficult. First, there is no porcelain body in America which is comparable to that used for the Japanese plates. Second, the stress placed on a plate that has different thicknesses is enormous and makes it subject to cracking. Carving into the plate or adding onto it creates great variation in thickness, and firing the plate repeatedly puts additional strain on it. In order to achieve a painted surface comparable to the surface of the already finished Japanese plates, the dimensional plates had to be fired at least five times. We had difficulty even making a perfect *flat* fourteen-inch plate and matching the beautiful glaze quality of the plates from Japan. For

months Leonard lost every plate he made, and he made hundreds. But these struggles are best described in the journal entries and plate descriptions that appear later in the book.

From the time Gelon joined the Project, my own workload was greatly eased. My initial idea of doing this piece alone was rapidly changing, and I felt staggered by what needed to be done. In addition to carving plates, painting, and designing runners, I was raising money by lecturing and by selling my art. The influx of more people into the *Dinner Party* crew meant integrating them into the studio and, if they came from out of town, helping them get settled as well. Diane began by doing research, then became my personal assistant, and eventually took over all the administrative work of the Project.

The research, like everything else, grew far beyond my original conception. Gelon and I had listed all the women we thought should be on the floor, and it totaled about three hundred. I had determined that there should be nine hundred and ninety-nine—a nice Biblical number, I thought. I had already done a good deal of research for the women on the table, which Gelon completed; she then began the research for the floor. I had previously discovered that there were a great many books dealing with women's history, but the information they provided was fragmented and needed to be unified. We thought we should collect enough research on women of the past so that we could make choices based on an overall historic view. We therefore formed a team—headed by a painter, Ann Isolde—to carry out this work. With no research skills and little scholarly background, team members plundered the libraries for books about women. They learned to cut through the biases of history which usually described, not the woman's achievements, but her physical attributes and the men in her life.

Every Friday afternoon, Ann and the team met at her house to discuss the information they were uncovering and to exchange ideas. Slowly the files grew. Cataloging the material alphabetically and by country, century, and profession, we began to assemble the fractured pieces of our heritage which would eventually appear on the 2,300 twelve-inch, triangular porcelain tiles that make up the Heritage Floor. The research team gradually developed its skills, and new people joined who had sophisticated historical and academic backgrounds. I watched them all undergo a process very similar to my own: As they learned about their history as women, their sense of themselves changed. Their initial lack of confidence was replaced by an understanding of their historic circumstances and a determination to share the information they were finding with other women.

I was already planning a book documenting the creation of *The Dinner Party*, and I decided to expand the section on the Heritage Floor to include short biographies of all the women represented. The book, like everything else in the Project, evolved. This first volume will be followed by a second, which will deal with the needlework in the piece.

As the Project grew and expanded, my isolation as an artist slowly gave way to a studio environment in which many people worked together. At first working with others was extremely difficult for me, and it sometimes still is. But "opening" my studio actually led me to the fulfillment of some earlier goals. I had taught women in Fresno and Los Angeles and encouraged them to work together, openly using their own subject matter, but then I had gone back to my studio and worked alone, making veiled art. I had helped establish alternative exhibition spaces for women and rarely showed in them myself. I had co-founded the Woman's Building and the Feminist Studio Workshop—an alternative educational program—and left within a year because I had not been able to integrate my own art-making life with my need for a support community. When I began working on *The Dinner Party*, I had no idea that it would take five years and so many people to realize my conception. By the time the Project was completed, some of those people had been working for two or three years. The struggle to bring this piece into fruition has given birth to a community—one which is centered on creating art that can affect the world and help change its values. . . .

The women represented at the *Dinner Party* table are either historical or mythological figures. I chose them for their actual accomplishments and/or their spiritual or legendary powers. I have brought these women together—invited them to dinner, so to speak—in order that we might hear what they have to say and see the range and beauty of our heritage, a heritage we have not yet had an opportunity to know.

These guests, whether they are real women or goddess figures, have all been transformed in *The Dinner Party* into symbolic images—images that stand for the whole range of women's achievements and yet also embody women's containment. Each woman is herself, but through her can be seen the lives of thousands of other women—some famous, some anonymous, but all struggling, as the women on the table struggled, to have some sense of their own worth through five thousand years of a civilization dominated by men. The images on the plates are not literal, but rather a blending of historical facts, iconographical sources, symbolic meanings, and imagination. I fashioned them from my sense of the woman (or, if a goddess, what she represented); the artistic style of the time (when it interested me or seemed to have a potential to express something about the figure I was portraying); and my own imagery.

When I began working on the *Dinner Party* plates, I developed an iconography using the butterfly to symbolize liberation and the yearning to be free. The butterfly form undergoes various stages of metamorphosis as the piece unfolds. Sometimes she is pinned down; sometimes she is trying to move from a larva to an adult state; sometimes she is nearly unrecognizable as a butterfly; and sometimes she is almost transformed into an unconstrained being. During the earlier stages of the work, I imagined that all the plates would be flat and only the imagery would change. I painted half the plates on imported Japanese

porcelain and then decided to alter the dimension of the plates. The ceramic difficulties I describe in the first part of the book were a result of trying to match the quality of the industrially made, imported plates with studio technology. Additionally, the images I had in mind required new ceramic methods and the blending of many people's skills. By the time the plates were completed, the ceramic team included seven people, all of whom brought different technical experience to bear on the problems of creating the highly dimensional plates. It took three years and enormous frustration to finish the plates, but the introduction of dimension on the surface allowed me to symbolize another aspect of women's history—the rise and fall of opportunities, and the efforts women have made in the last two hundred years to change their destiny.

There is a strong narrative aspect to the piece that grew out of the history uncovered in our research and underlying the entire conception of *The Dinner Party*. This historical narrative is divided into three parts, corresponding to the three wings of the table. The first table begins with prehistory and ends with the point in time when Greco-Roman culture was diminishing. The second wing stretches from the beginning of Christianity to the Reformation, and the third table includes the seventeenth to the twentieth centuries. Beginning with prepatriarchal society, *The Dinner Party* demonstrates the development of goddess worship, which represents a time when women had social and political control (clearly reflected in the goddess imagery common to the early stages of almost every society in the world). The piece then suggests the gradual destruction of these female-oriented societies and the eventual domination of women by men, tracing the institutionalizing of that oppression and women's response to it.

During the Renaissance, the male-dominated Church—built in large part with the help of women—and the newly emerged, male-controlled State joined hands. They began to eliminate all who resisted their power— the heretics who held onto pre-Christian, generally female-oriented religions; the lay healers who continued to practice medicine in the face of increasing restrictions by the emerging medical profession; the political dissenters who challenged the corruption of the Church; the women who refused to submit to their husbands, to their fathers, and to the priests; those who insisted on administering the drug ergot to relieve the suffering of women in labor; those who helped women abort themselves; those who wished to practice sexual freedom; those who wanted to continue preaching or healing or leading social groups and religious groups; and all who resented and resisted the steady but inevitable destruction of what was left of female power. These women were harassed, intimidated, and—worst of all—burned, in a persecution whose real meaning has completely evaded the history taught to us today.

By the time of the Reformation, when the convents were dissolved, women's education—formerly available through the Church—was ended. Women were barred from the universities, the guilds, and the professions; women's property and inheritance rights, slowly eroded over centuries,

were totally eliminated; and women's role was restricted to domestic duties. Opportunities were more severely limited than in pre-Renaissance society. The progress we have all been educated to associate with the Renaissance took place for men at the expense of women. By the time of the Industrial Revolution women's lives were so narrow, their options so few, there is little wonder that a new revolution began—a revolution that has remained hidden by a society that has not heard the voices raised in protest by women (as well as by some men) throughout the centuries.

The women represented in *The Dinner Party* tried to make themselves heard, fought to retain their influence, attempted to implement or extend the power that was theirs, and endeavored to do what they wanted. They wanted to exercise the rights to which they were entitled by virtue of their birth, their talent, their genius, and their desire, but they were prohibited from doing so—were ridiculed, ignored, and maligned by historians for attempting to do so—because they were women.

Each plate stands for one or more aspects of women's experience. I chose Caroline Herschel, the eighteenth-century astronomer, for example, to represent the appearance and achievement of women in science in the late seventeenth and early eighteenth centuries. Selecting Herschel also allowed me to denote those women who could gain access to scientific education, equipment, and employment only through a brother, a father, or a husband. (In Herschel's case, it is debatable whether she would have elected to be an astronomer had she not been the unmarried sister of an ambitious man.) Moreover, her life clearly demonstrates the way a woman was both exploited and denied recognition even if she was able to make a place for herself in her chosen field. I tried to consider each of the women who seemed sufficiently accomplished to qualify for the table from this point of view.

If I'd already picked a person of one discipline or period, I would try to find another who reflected a different set of life conditions. There were more women than I could accommodate. There were women whose achievements were greater than those I chose, but whom I rejected because I already had too many writers, or because I had another important woman from Germany, or because it seemed essential to represent this or that period in Western civilization. Sometimes I did not choose someone because I did not feel I could adequately represent her, either because her life did not offer me information I could use in an image or because she had been represented by history in too negative a way (like Lucrezia Borgia, whom I really wanted to include, feeling there was an untold and important story in her life). It seemed impossible in these situations to create an image that could challenge our previous perceptions of that woman.

Conversely, I sometimes chose someone specifically because—after she had met the basic criteria for the table—something about her or her life experience suggested a visual conception that interested me. This was the case with Isabella d'Este, who not only represented the achievement of female scholars

during the Renaissance, the importance of female patronage of the arts, and the political position of Italian women of her century, but also offered me the opportunity of trying to simulate, with china paint, one of my favorite ceramic styles—Urbino majolica, a lusterware produced in a factory patronized by D'Este. Majolica had intrigued me from the moment I first saw it in European museums. The possibility of recreating it for my own purposes, combined with the significance of D'Este's own achievements, supported her candidacy for the table over that of Victoria Colonna or Margaret Roper, two other highly distinguished Renaissance women.

Each plate is set on a sewn runner in a place setting that provides a context for the woman or goddess represented. The plate is aggrandized by and contained within that place setting, which includes a goblet, flatware, and a napkin. The runner in many instances incorporates the needlework of the time in which the woman lived and illuminates another level of women's heritage. The place settings are placed on three long tables—which form an equilateral triangle—covered with linen tablecloths. On the corners of the tables are embroidered altar cloths carrying the triangular sign of the Goddess. The tables rest on a porcelain floor composed of over 2,300 hand-cast tiles, upon which are written the names of 999 women. According to their achievements, their life situations, their places of origin, or their experiences, the women on the Heritage Floor are grouped around one of the women on the table. The plates are the symbols of the long tradition that is shared by all the women in *The Dinner Party*. The floor is the foundation of the piece, a re-creation of the fragmented parts of our heritage, and, like the place settings themselves, a statement about the condition of women. The women we have uncovered, however, still represent merely a part of the heritage we have been denied. If we have found so much information on women in Western civilization during the duration of this project, how much more is there still? Moreover, what about all the other civilizations on Earth?

Adrian Piper
Catalysis: An Interview with Adrian Piper (by Lucy Lippard) (1972)

The artist Adrian Piper was one of a number of women artists in the late 1960s and 1970s (including Carolee Schneeman and Yoko Ono) who used performance as a method of probing aspects of identity. After working for a while with images that used maps, graphs, and charts in a mode closer to the analytical conceptualism

Reprinted from *The Drama Review*, 16, No. 1 (March 1972). Reprinted with permission of *TDR*.

of Sol LeWitt, Piper decided to create works that were not supported by art world conventions and that engaged people in the "real world." In this interview with the critic Lucy Lippard, which was published in the March 1972 issue of *The Drama Review*, Piper discusses a series of performances she did in New York City in 1971 called "Catalysis." For *Catalysis I* Piper soaked her clothes in vinegar, eggs, milk, and cod-liver oil and then wore them while riding the subway. For *Catalysis IV* she shoved one end of a towel into her mouth so that her cheeks bulged out dramatically and then walked through public spaces, interacting with people. By confronting people in public with exaggerated "masks" of otherness, which she felt turned her into an "object," Piper hoped to provoke the people on the street into assessing their own responses to difference.

Last year, Adrian Piper did a series of pieces called Catalysis. *They included* Catalysis I, *"in which I saturated a set of clothing in a mixture of vinegar, eggs, milk, and cod-liver oil for a week, then wore them on the D train during evening rush hour, then while browsing in the Marboro bookstore on Saturday night";* Catalysis VIII, *a recorded talk inducing hypnosis;* Catalysis IV, *in which "I dressed very conservatively but stuffed a large red bath towel in the side of my mouth until my cheeks bulged to about twice their normal size, letting the rest of it hang down my front, and riding the bus, subway, and Empire State Building elevator";* Catalysis VI, *"in which I attached helium-filled Mickey Mouse balloons from each of my ears, under my nose, to my two front teeth, and from thin strands of my hair, then walked through Central Park, the lobby of the Plaza Hotel, and rode the subway during morning rush hours";* Catalysis III, *"in which I painted some clothing with sticky white paint with a sign attached saying 'WET PAINT,' then went shopping at Macy's for some gloves and sunglasses";* Catalysis V, *"in which I recorded loud belches made at five-minute intervals, then concealed the tape recorder on myself and replayed it all full volume while reading, doing research, and taking out some books and records at the Donnell Library";* Catalysis VII, *"in which I went to The Metropolitan Museum's 'Before Cortes' show, while chewing large wads of bubble gum, blowing large bubbles, and allowing the gum to adhere to my face . . . (and) filling a leather purse with catsup, then adding wallet, comb, keys, etc.; opening and digging out change for bus or subway, a comb for my hair in the ladies' room at Macy's, a mirror to check my face on the bus, etc.; coating my hands with rubber cement, then browsing at a newspaper stand . . ." And so on.*

I hold monologues with myself, and whenever anyone passes near me, within hearing distance, I try to direct the monologue toward them without changing the presentation or the content of what I'm saying. Usually, when I know that someone is approaching me, I find that I'm psychologically preparing myself for their approach. I'm turning around to meet them, and I have a whole presentation for their benefit, because they are there, and I'm aware of them. I'm trying *not* to do that. I'm not sure whether or not I'm involving myself in a contradiction. On the one hand, I want to register my awareness of someone else's existence, of someone approaching me and

intruding into my sense of self, but I don't want to present myself artificially in any way. I want to try to incorporate them into my own consciousness.

Do you look at them?

Yes. That's another thing I've been trying to work with. When I started doing this kind of work I found I was really having trouble looking people in the eye while I was doing it; it was very hairy. I looked odd and grotesque, and somehow just confronting them head on was very difficult. It makes me cringe every time I do it, but I'm trying to approach them in a different way.

This is much subtler than the things you were doing last year. Are you still in that context?

Yes. These came out of them. Not formally, but through the kinds of experiences that I was having when I was doing these things. I feel that I went through some really heavy personality changes as a result of them.

Just to be able to do them at all, in the first place . . .

Well, a lot of things happened. I seem to have gotten more aware of the boundaries of my personality, and how much I intrude myself upon other people's realities by introducing this kind of image, this facade, and a lot of things happen to me psychologically. Initially, it was really hard to look people in the eye. I simply couldn't overcome the sense that if I was going to keep my own composure and maintain my own identity, it was just impossible. I would have to pretend that they weren't there, even though I needed them. Then something really weird happened; it doesn't happen all the time. Something I really like. It is almost as if I manage to make contact in spite of how I look, in spite of what I'm doing. There was a piece I did last summer that was part of the work I was doing before. I had on very large knit clothes and I got a lot of Mickey Mouse balloons, which have three shapes, with the two ears. I stuffed them into the clothes, so I was not only very obese, but I was also bulging out all over; it was very strange. I was on the subway and the balloons were breaking and people were getting very hostile because I was taking up a lot of space, and it just occurred to me to ask someone what time it was. So I did, and they answered me in a perfectly normal voice. This was very enlightening. I decided that was a worthwhile thing to go after. Somehow transcending the differences I was presenting to them by making that kind of contact . . .

How often do you do it?

Maybe two or three times a week in different kinds of situations; wherever I find myself. I haven't started cataloguing the kinds of reactions I have gotten . . . The scary thing about it for me is that there is something about doing this that involves you in a kind of universal solipsism. When you start realizing that you can do things like that, that you are capable of incorporating all

those different things into your realm of experience, there comes a point where you can't be sure whether what you are seeing is of your own making, or whether it is objectively true.

Because you begin to have almost too much power over the situation?

Yes. You know you are in control, that you are a force acting on things, and it distorts your perception. The question is whether there is *anything* left to external devices or chance. How are people when you're not there? It gets into a whole philosophical question. I found that at times it's exhilarating, too. It is a heady thing, which has to do with power, obviously . . .

What do you think it has to do with being a woman? Or being Black? It's a very aggressive thing. Do you think you're getting out some of your aggressions about how women are treated? Is it related to that at all?

Well, not in terms of intention. As far as the work goes, I feel it is completely apolitical. But I do think that the work is a product of me as an individual, and the fact that I am a woman surely has a lot to do with it. You know, here I am, or was, "violating my body"; I was making it public. I was turning myself into an object.

But an object that wasn't attractive, the way it was supposed to be; instead it was repellent, as if you were fighting back.

In retrospect, all these things seem valid, even though they weren't considerations when I did the pieces.

One thing I don't do, is say: "I'm doing a piece," because somehow that puts me back into the situation I am trying to avoid. It immediately establishes an audience separation period—"Now we will perform"—that destroys the whole thing. As soon as you say, this is a piece, or an experiment, or guerrilla theater—that makes everything all right, just as set up and expected as if you were sitting in front of a stage. The audience situation and the whole art context makes it impossible to do anything.

Don't you feel that this is kind of infinite? That you have to cut it off someplace so that it is a piece, and not life? If you're making art, you have to have a limit.

I really don't know. For quite a while I felt absolutely unanchored in terms of what I was doing. I'm not sure I can describe that. Now I feel certain of what I'm doing because it is necessary for me to do it, but I do not feel terribly certain as to what my frame of reference is. It seems that since I've stopped using gallery space, and stopped announcing the pieces, I've stopped using art frameworks. There is very little that separates what I'm doing from quirky personal activity. Except I've been thinking a lot about the fact that I relate what I'm doing to people. Occasionally, I meet somebody I know while I'm doing a piece, and it seems OK to me, because it affirms what I'm doing as art.

That gives me some kind of anchor. But when I just tell people what I'm doing, I don't think it has the same effect. What it does is reaffirm my own identity as an artist to me. If you ask me what I'm doing, I'll tell you I'm doing this, rather than saying, well, you know, I'm not doing any work lately, but I've been doing some really weird things in the street. I subscribe to the idea that art reflects the society to a certain extent, and I feel as though a lot of the work I'm doing is being done because I am a paradigm of what the society is.

Chris Burden
Untitled Statements (1975)

In the 1970s a diverse group of artists—which included Adrian Piper, Bruce Nauman, Vito Acconci, and Chris Burden—developed performance-based art beyond the ideas that had been articulated in the Happenings of the 1950s. The appeal of performance is twofold: This work was not bound by the constraints of object-making, and at the same time it offers the artist the possibility of having direct contact with the viewer. In addition, the potentially confrontational nature of performance fit with the anti-establishment energy of the early 1970s.

The Los Angeles–based artist Chris Burden gained a wide reputation for a group of performances he executed in the early 1970s. Unlike the clandestine "street" works of Adrian Piper or the banal tasks executed in the early performance work of Bruce Nauman, Burden's performances involved putting himself in seemingly dangerous or physically and mentally challenging situations. For *Through the Night Softly*, Burden crawled bare-chested over fifty feet of broken glass with his hands behind his back. For *Bed Piece*, Burden stayed in bed in a gallery for twenty-one days. Although violence and danger charge much of his early performances, Burden insists that the work has more to do with the process of anticipating the act than actually doing it; so in that sense the process is as much mental as physical. Burden says: "The hardest time is when I am deciding whether to do a piece or not, because once I make a decision to do it, then I have decided—that's the real turning point. It's a commitment. That's the crux of it right then."

My art is an examination of reality. By setting up aberrant situations, my art functions on a higher reality, in a different state. I live for those times.

I don't think I am trying to commit suicide. I think my art is an *inquiry*, which is what *all* art is about.

—Chris Burden, 1974

Art doesn't have a purpose. It's a free spot in society, where you can do anything. I don't think my pieces provide answers, they just ask questions, they don't have an end in themselves. But they certainly raise questions.

—Chris Burden

Five-Day Locker Piece (University of California, Irvine, April 26–30, 1971). "I was locked in Locker 5 for five consecutive days and did not leave the locker during this time. The locker measured 2 feet high, 2 feet wide, and 3 feet deep. I stopped eating several days prior to entry. The locker directly above me contained five gallons of bottled water; the locker below me contained an empty five-gallon bottle.

"It was kind of weird really. The students were all kind of defending me and Conlon was sort of trying to knock me down, and there I was shut up in there, and they were arguing with the art. It was kind of nice really. It was one of the nicer moments.

"About 10:30 P.M. the doors were locked and people could no longer come in the building. That was the most frightening period. I had this fantasy, though, that I could always kick the door out. Some nights my wife would sleep on the floor outside in case I really flipped out or something. It was pretty strange. One night the janitor came by and he couldn't figure out what she was doing there.

"The important part to remember was that I *had* set it up. I could foresee the end too (it was not an open-ended situation, which is partially what creates fear). It was not something that was thrust upon me, but rather something I imposed upon myself like a task. I think a part of it is . . . you just keep telling yourself that you just have to wait, because time will ultimately take care of it, that it is inevitable, and that this moment is no more fearful than those that went on before. The first part of the pieces is always the hardest. Once I have passed the halfway point, then I am already there and I know I can certainly make it through the next half. The beginning is pretty shocking. That's when I begin to have all the doubts and stuff, but once I am really into it and halfway through it, it's easy.

"To be right, the pieces have to have a kind of crisp quality to them. For example, I think a lot of them are physically very frontal. Also, it is more than just a physical thing. I think of them, sense them that way too. When I think of them, I try to make them sort of clean, so that they are not formless, with a lot of separate parts. They are pretty crisp and you can read them pretty quickly, even the ones that take place over a long period of time. It's not like a Joan Jonas dance piece where you have a lot of intricate parts that make a whole. With my pieces there is one thing and that's it. "

Prelude to 220, or 110 (F-Space, September 10–12, 1971). "I was strapped to the floor with copper bands bolted into the concrete. Two buckets of water with

110 lines submerged in them were placed near me. The piece was performed from 8:00 P.M. to 10:00 P.M. for three nights.

"People were angry at me for the *Shout Piece,* so in *110* I presented them with an opportunity in a sacrificial situation—to atone for the earlier piece. Not really literally, I wasn't hoping that somebody was going to kick the buckets over, but just by putting myself in that position, it was kind of like a way of absolving myself from the last piece, which was aggressive and hostile. It was also a way of getting recruits for a piece called *220*—to show them that I could do it and not be electrocuted, so that I could get others to participate in a piece with me. There was no actual danger, no taunting; if anything, people were apprehensive about getting near me. It was almost as if the buckets were repulsive magnets. Most people stayed very far away. I would talk to people and they would sort of come up gingerly, but they all stayed really very far away as if the floor were littered with banana peels and they might at any point slip and kick the buckets over.

"I never feel like I'm taking risks. What the pieces are about is what is going to happen. Danger and pain are catalysts—to hype things up. That's important. The object is to see how I can deal with them. The fear is a lot worse than the actual deed.

"Dealing with it psychologically, I have fear, but once I have set it up, as far as I am concerned, it is inevitable. It is something that is going to happen anyway. Time ticks by and it is going to happen at a certain hour, whatever it is. Sometimes I can feel myself getting really knotted up about it, and I just have to relax because I know it is inevitable. The hardest time is when I am deciding whether to do a piece or not, because once I make a decision to do it, then I have decided—that's the real turning point. It's a commitment. That's the crux of it right then.

"The thought comes before the conception. The satisfaction is trying to figure out something I feel right about, something that seems strong and correct. That part is always a struggle. That part is really hard and I get nervous about it. Once I have figured out all of the parts and how I want it to go together, and I have a conception of it (when the piece is actually finished in my head), then it is a matter of actually executing it. That is the fairly mechanical part of it. The hardest part really is trying to conceive something and struggling with it. Then the rest is, well, the rest is really the good part."

220 (F-Space, October 9, 1971). "The gallery was flooded with twelve inches of water. Three other people and I waded through the water and climbed onto fourteen-foot ladders, one ladder per person. After everyone was positioned, I dropped a 220 electric line into the water. The piece lasted from midnight until dawn, about six hours. There was no audience except for the participants.

"The piece was an experiment in what would happen. It was a kind of artificial 'men in a life raft' situation. The thing I was attempting to set up

was a hyped-up situation with high danger, which would keep them awake, confessing, and talking, but it didn't, really. After about two and a half hours everybody got really sleepy. They would kind of lean on their ladders by hooking their arms around, and go to sleep. It was surprising that anyone could sleep, but we all did intermittently. There was a circuit breaker outside the building and my wife came in at six in the morning and turned it off and opened the door. I think everyone enjoyed it in a weird sort of way. I think they had some of the feelings that I had had, you know? They felt kind of elated, like they had really done something."

Bed Piece (Market Street, Venice, California, February 18–March 10, 1972). "Josh Young asked me to do a piece for the Market Street Program from February 18 to March 10. I told him I would need a single bed in the gallery. At noon on February 18, I took off my clothes and got into bed. I had given no other instructions and did not speak to anyone during the piece.

"I started to *like* it there. It was really seductive. That's why I considered just staying there—because it was so much nicer than the outside world. I *really* started to like it, and then that's when I started thinking that I'd better be pretty sure that when the end of the exhibition came—I got up.

"About the death thing—I don't think so, no. It's just that the piece was very relaxing. It is very relaxing to do that and all the anxiety about everything, about what is going to happen, goes because there is nothing I can do to change it. And when that happens it is like a tremendous relief.

"I had started liking it there and seriously considered staying there, but I didn't because I knew I just couldn't. People were really getting upset toward the end. Stanley and Elyse Grinstein were afraid I had flipped out. Bob Irwin came in and asked me not to do anything crazy, not to let the whole thing come down on my head. I could feel this whole tension kind of building up outside. There was no outside communication and everyone thought I had gone over the edge. As the end came near, I had a sort of nostalgia about it. In the same sense that it was boring in the beginning, but I had no control over it because it was inevitable, at the end I had this nostalgia, this deep regret at having to return to normal. But it *was* inevitable, and I couldn't do anything to prolong or shorten it. On a certain day I had to get up and it would be over, and it would be gone."

Dos Equis (October 16, 1972). "On the evening of October 16, I placed two XXs constructed of sixteen-foot beams in an upright position blocking both lanes of the Laguna Canyon Road. The timber had been soaked in gasoline for several days. I set the XXs on fire and left the area.

Dos Equis was just for one person. I do not know who he is or anything. He was the first one to come upon those big XXs burning in the road. In the classical or traditional sense of going to a museum or gallery to view

something maybe it was not art, not by that definition, but to me it was. For whoever saw it, it was a kind of really unforgettable experience. Those fiery crosses must really have burned into that guy's mind. Sometimes I choose to limit the number of people who see a piece because I want those people to have a really strong experience. I did this with the *Icarus* piece in my studio as well. It is always a toss-up whether or not it is better for a hundred people to see it casually or two people to receive it really strong."

Icarus (April 13, 1973). "At 6:00 P.M. three invited spectators came to my studio. The room was fifteen feet by twenty-five feet and well lit by natural light. Wearing no clothes, I entered the space from a small room at the back. Two assistants lifted onto each shoulder one end of six-foot sheets of plate glass. The sheets sloped onto the floor at right angles from my body. The assistants poured gasoline down the sheets of glass. Stepping back they threw matches to ignite the gasoline. After a few seconds I jumped up, sending the burning glass crashing to the floor. I walked back into the room."

Through the Night Softly (Main Street, Los Angeles, September 12, 1973). "Holding my hands behind my back, I crawled through fifty feet of broken glass. There were very few spectators, most of them passersby. This piece was documented with a 16mm film."

Doorway to Heaven (November 15, 1973). "At 6:00 P.M. I stood in the doorway of my studio facing the Venice Boardwalk, a few spectators watched as I pushed two live electric wires into my chest. The wires crossed and exploded, burning me but saving me from electrocution.

"That [danger] is something I have been thinking a great deal about. I don't know—I guess there was a lot more danger in that piece than I would admit to myself at the time. That's one of those things, you know? I started fooling around with the wires and I really liked the way they exploded and I wanted to do something, to relate it to me. For a long time I thought about pushing them into me and stuff, but there was the very real problem that I could get electrocuted. And then, finally, I had this idea that just as the wires went together they would pop and then they would go into me, and maybe I would get shocked, but the pain from the burst and the explosion would jerk my hands away and save me."

Trans-Fixed (Venice, California, April 23, 1974). "Inside a small garage on Speedway Avenue, I stood on the rear bumper of a Volkswagen. I lay on my back over the rear section of the car, stretching my arms onto the roof. Nails were driven through my palms onto the roof of the car. The garage door was opened and the car was pushed halfway out into the speedway. Screaming for me, the engine was run at full speed for two minutes. After two minutes

the engine was turned off and the car pushed back into the garage. The door was closed."

Sculpture in Three Parts (Hansen-Fuller Gallery, September 10–21, 1974). "I sat on a small metal stool placed on a sculpture stand directly in front of the gallery entrance, and elevator door. A sign on the stand read 'Sculpture in Three Parts. I will sit on this chair from 10:30 A.M. 9/10/74 until I fall off.' About ten feet away, a camera was constantly attended by changing photographers waiting to take a photograph as I fell. I sat in the chair for forty-three hours. When I fell, a chalk outline was drawn on the floor around my body. I wrote 'forever' inside the outline. I placed another sign on the stand, which read 'I sat on this chair from 10:30 A.M. 9/10/74 until I fell off at 5:25 A.M. 9/12/74.' The chair, stand, and outline remained an exhibit until September 21."

Oh, Dracula (Utah Museum of Fine Arts, Salt Lake City, October 7, 1974). "I was invited to do a piece in the foyer of the Utah Museum by the director, E. F. Sanguinetti. The room was filled with Renaissance paintings of religious subjects. Using strips of adhesive tape, I made a large chrysalis for my body. I was mounted on the wall replacing one of the paintings. A lighted candle was placed on the floor beneath my head, and another at my feet. An engraved plaque, similar to those identifying the paintings, giving my name, title of the piece, and the date was placed on the wall. I remained in the chrysalis during museum hours, 9:00 A.M. to 5:00 P.M. on October 7."

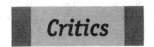

Critics

Lucy R. Lippard
Sexual Politics, Art Style (1971)

The political upheaval that characterized much of the late 1960s and 1970s created an environment that was conducive for many disenfranchised groups to voice their opposition to the status quo. Among the most significant developments of this period was the intense momentum gained by the feminist movement in the United

Originally published in **ART IN AMERICA**, September–October 1971, Brant Publications, Inc.

States. This movement spurred on dialogs related to many aspects of American culture. In this brief discussion, "Sexual Politics, Art, and Style," which was originally published in the September/October 1971 issue of *Art in America*, Lippard exposes the prevailing sexist attitudes in the art world and how these attitudes are reinforced by the male-dominated worlds of museums, galleries, critics, and institutions of criticism and education.

At the time that Lippard wrote this article, a number of organized protests were being waged against many art museums in an attempt to expose their exclusionary practices. For instance, the Ad Hoc Women's Committee (which was an offshoot of the Art Workers' Coalition) picketed the Whitney Museum in 1970 in order to highlight the lack of women who had been represented in their past biennial exhibitions; as a direct result of this protest, the biennial of 1971 included substantially more women artists than had previous biennials. In addition, during the early 1970s a number of collective and co-op galleries devoted to women's art were formed, as was the first women's art program (which was set up by Judy Chicago and Miriam Schapiro at the California Institute of the Arts). Concurrent with Lippard's article, the historian Linda Nochlin wrote her now-famous essay "Why Have There Been No Great Women Artists?" which became a catalyst for rethinking the role women have played in the history of art as well as for reassessing the attitudes that led to women being excluded from this history.

For the last three New York seasons, and particularly during the past winter, women artists have begun to protest discrimination against their sex in the art world. Active protest began in 1969 with WAR, burgeoned in 1970 with the Ad Hoc Women's Committee, which first addressed itself solely and successfully to raising the number of women in the Whitney Annual; now there are at least two other organizations in New York as well as smaller artists' consciousness-raising groups. On the West Coast, at Cal Arts, Judy Chicago and Miriam Schapiro have set up the first women's art program, and Marcia Tucker will direct one similar course at the School of Visual Arts in New York. An international liaison network called WEB (West-East Bag) was recently created to inform women's art groups of each other's activities. In June, the new Los Angeles Council of Women Artists threatened a civil-rights suit against the Los Angeles County Museum with statistics that reflect the national situation: 29 of 713 artists whose works appeared in museum group shows in a decade were women; of 53 one-artist shows, one was by a woman—the same record, incidentally, as New York's Museum of Modern Art, and both of these women were photographers.

Yet, in spite of all this activity, the art world has been slow in coming to grips with the question of sexist discrimination. Real change probably won't come about until the society we live in and its basic woman-man relationships are fundamentally altered. In the meantime, however, discrimination against women in the art world consists of (1) disregarding women and stripping them of their self-confidence from art school on; (2) refusing to consider

a married woman or mother a serious artist no matter how hard she works or what she produces; (3) labeling women unfeminine and abnormally assertive if they persist in maintaining the value of their art and protest their treatment; (4) treating women as sex objects and using this as an excuse not to visit their studios or show their work ("Sure, her work looked terrific, but she's such a good-looking chick if I went to her studio I wouldn't know if I liked the work or her," one male dealer told me earnestly, "so, I never went"); (5) using fear of social or professional rejection to turn successful women against unsuccessful women, and vice versa; (6) ripping off women if they participate in the unfortunately influential social life of the art world (if she comes to the bar with a man she's a sexual appendage and is ignored as such; if she comes with a woman she's gay; if she comes alone she's on the make); (7) identifying women artists with their men ("That's so-and-so's wife; I think she paints too"); (8) exploiting women's inherent sensitivity and upbringing as nonviolent creatures by resorting to personal insults, shouting down, art-world clout, in order to avoid confrontation or to subdue and discourage women who may be more articulate and intelligent, or better artists than their male company; (9) galleries turning an artist away without looking at her slides, saying, "Sorry, we already have a woman," or refusing to have any women in their stable because women are "too difficult" (a direct quote— though since the Movement, people are more careful about saying these things). And so forth.

The roots of this discrimination can probably be traced to the fact that making art is considered a primary function, like running a business or a government, and women are conventionally relegated to the secondary, housekeeping activities such as writing about, exhibiting or caring for the art made by men. Art-making in America has a particularly virile tradition, the ideal of large scale, "tough," uncompromising work being implicitly a masculine prerogative. Men are somehow "professional" artists even if they must teach a twenty-hour week or work forty hours as carpenter, museum guard or designer. Women, on the other hand, especially if they are married and have children, are supposed to be wholly consumed by menial labors. If a single female artist supports herself by teaching or working as a "gallery girl" or whatever, she is called a dilettante. If she is a mother, she may work forty hours a week in her studio and she will be taken seriously by other artists only after she has become so thoroughly paranoid about her position that she can be called an "aggressive bitch," an opportunist, "pushy" and so on. It doesn't seem to occur to people that women who can manage all this and still be serious artists may be *more* serious than their male counterparts.

Sadly enough, most of the few women who have made it into the public eye have been so absorbed by the male world that they resist association with other less successful women artists, for fear of being forced into a "woman's ghetto" and having their work thereby taken less seriously. They

tend to think of themselves as one of an extraordinary elite who are strong enough and good enough to make it, not realizing that they denigrate and isolate their own work by being ashamed of their own sex, that if their art is good it cannot be changed by pride in being a woman.

The worst source not only of discrimination but of the tragic feelings of inferiority so common among women artists is the art schools and college art departments (especially women's colleges), most of which have little or no female faculty despite a plethora of unknown male names. Women comprise a majority of art students, at least for the early years; after that they begin to drop out as a result of having no women teachers after whom to model themselves, seeing few women shown in museums and galleries, lack of encouragement from male professors who tell them that they'll just get married anyway, that the only women artists who make it are dykes, that they'll get along fine if they screw the instructor, or that pale colors, weak design and fine line are "feminine" (i.e., bad) but less so when perpetrated by men. Small wonder that there are far fewer women in the graduate schools, that survivors of this system are afraid to take their slides to galleries or invite criticism, that they find it difficult to work in isolation if their husbands move them to the sticks, that they may marry an artist instead of continuing to be one, or become the despised "lady painter" in between children, without studio space or materials money.

When a woman does show, the same attitudes prevail in regard to journalistic coverage. The one art magazine that has had any feature coverage of the "woman problem" (two articles, which enabled the editors to announce their "women's issue") now feels it need never mention the subject again. The Whitney Annual was chosen for sustained public protest last year because survey shows are the most obvious examples of discrimination, focused as they are on no single taste, but simply on "what is being done in such and such an area." But why is it that so few women's studios are visited when survey shows are being organized? Connections in the art world are made through friends and galleries, and aside from the problem of competition with men (which makes it unlikely that many women will be recommended to begin with) few women artists are represented by the big galleries to which curators refer when doing a show.

What applies to group shows applies equally to foundation grants, which again purport to concentrate on no single style, gallery affiliation, or institutional support. The statistics here are even worse. The usual defense is that not many women applied or that they weren't "good enough." It is important to remember that so-called "quality" on a list of, say, twenty-five younger artists given grants or shown in a museum, will not be agreed upon by any five "experts." If "quality" is admittedly elusive, why is it that foundations ignore women with *qualifications* (one-artist shows, prestigious

group exhibitions, specialized press coverage, even age and length of career) far exceeding those of male colleagues who do receive grants? A Women's Art Registry (138 Prince St., N.Y.C., 10012), now including slides of about a thousand women, makes it clear that a large number of female artists are working on a par with men. Last spring it was possible to put together, in good conscience, an exhibition of twenty-six women who had never had one-artist shows. I could never have organized an exhibition of that strength (*all* this being regulated by my own taste, of course) of unshown male artists; by the time they are that mature, most men have had a show somewhere. All grant lists, all art school faculties and all group shows include a certain percentage that is totally inexplicable to anybody. Why aren't these, *at least*, replaced with women whose work is as good as the best men accepted? The John Simon Guggenheim Foundation and the National Endowment for the Arts, among others, have lousy records. In fact, there isn't any art-world institution so far that hasn't.

Henri Ghent
Black Creativity in Quest of an Audience (1970)

By the end of the 1960s the national fight for equal rights that had galvanized so many black Americans had entered into the arts. Although both the Studio Museum in Harlem and the Dance Theater of Harlem were founded in the late 1960s, African Americans were still vastly underrepresented in the mainstream art establishments. In the article "Black Creativity in Quest of an Audience," which was published in the May–June 1970 issue of *Art in America*, Henri Ghent voices his frustration over racial discrimination in the art world. Ghent (who was the director of the Brooklyn Museum's New Community Gallery at that time) discusses specific instances of racial prejudice displayed by both critics and museums. Ghent is particularly incensed by the lack of African American artists in the landmark exhibition *New York Painting and Sculpture: 1940–1970*, which was held at the Metropolitan Museum of Art in 1970. In a statement that epitomizes his frustrations and aspirations, Ghent says, "If the art establishment is sincerely interested in reaffirming the depth and quality and variety in American art, it must reverse its racist practices and cull talent from all segments of society."

A basic understanding of modern art, in its entirety, necessarily includes an appreciation of African art. It is common knowledge that African art was instrumental in helping to shape the course of modern art. How can one appreciate Picasso and Modigliani without understanding the derivation of their forms? One would naturally assume that art historians in particular—as well

Originally published in **ART IN AMERICA,** May–June 1970, Brant Publications, Inc.

as art connoisseurs—would curiously look to Afro-American artists, as direct descendants of this African heritage, for an extension of this *vitality* in art.

In trying to discover a possible link between African art and art created by Afro-Americans, one should *not* look to find these artists repeating traditional African art forms simply because of their ancestral bond. The very lack of contact with Africa—together with centuries of forced acculturation—has indeed served to weaken the Afro-American's knowledge of and freedom to exercise those skills requisite to creative continuity of traditional African art. What *should* be discerned is the marriage of this *African spirit* and a temperament that has been shaped out of the *blacks' "unique" experience in America.*

Contrary to the uncritical myth that blacks are of a unilife style, they are very much a diverse people. A careful examination of blacks representing various socio-economic, educational and political strata will reveal that this diversity of life style does not alter the basic existence of their common consciousness. Black artist are as diverse as the black populace in general. Their creativity clearly reflects the difference in the conditions and circumstances out of which it grew.

One divergent aspect of black creativity is the current black "nationalist" art movement. The principal objective of the "nationalists," they claim, is to elevate the status of "Negritude." What particularly distresses this writer is the fact that their credo is based on a policy of reverse racism. Their non-thinking attitude reveals that they are willing to perpetuate an ideology as venomous as the one that has victimized them over the centuries! Aside from displaying their vulnerability as human beings, they, as artists, suffer doubly when they abandon an essential concern for aesthetic criteria for the sake of politicizing. What results are feeble works of art that fall far short of communicating their message, thereby rendering a gross disservice to their cause. In other words, black artists who are "nationalist"-inclined are much too preoccupied with *what* they have to say rather than how *well* it should be said.

On the other hand, there are many black artists who are very concerned with organizing their personal statements, regardless of subject matter or stylistic preference, in accord with the best-known and agreed-upon aesthetic criteria. It is to these black artists, who adhere to flexible *universal* artistic standards, that the writer addresses himself. Even so, these artists, along with their radical counterparts, are unceremoniously relegated to obscurity by the white "art establishment."

The art establishment is primarily to blame for the black artist's "invisible" status in this country. The directors of these public and private institutions continue to operate as the "artistic tastemakers of America." They have excluded black creativity from public exposure because it is the establishment's belief that black artists are creatively bankrupt. Black artists are judged by double standards.

A *classic* example of an exercise of this double standard is evidenced in the review by John Canaday (*The New York Times*, October 8, 1969) of the "New Black Artists" exhibit at the Brooklyn Museum (under the aegis of the Urban Center of Columbia University, and organized by the American Federation of Arts and Ed Taylor of the Harlem Cultural Council). Mr. Canaday's so-called review was downright perverse. For one of New York's leading art critics to falsely praise work that was obviously inferior is proof positive that, in his mind, a double art standard was operative; to gush out gratuitous statements for poor work that was exhibited on a "professional" plane (for which he apologized in each subsequent sentence) was nothing more than a hypocritical expression of a kind of racist-condescension on Mr. Canaday's part. The exhibit in question was, in the opinion of many knowledgeable people (and in the opinion of this gallery director of color), one of the most horrendous and embarrassing showings of painting and sculpture that ever purported to embrace the "black spirit," a criterion which *quality* black artists hold so dear!

The black artist is further maligned by virtue of his repeated exclusion from significant surveys of American art. Although black artists began to emerge in appreciable numbers in the thirties, not one was included in the Whitney Museum's 1969 survey of American art of that period. Still another case in point is the Metropolitan Museum's recent centennial exhibition "New York Painting and Sculpture: 1940–1970." This show was the brainchild of Henry Geldzahler, that hallowed crypt's curator of contemporary art. As is his wont, Geldzahler went to great lengths to pay homage to his coterie of intimates, while flagrantly ignoring the towering contributions of such "deflectors," black and white, as Louise Nevelson, Larry Rivers, Marisol, Romare Bearden, Eldzier Cortor, Felrath Hines—to name only a few. His highly questionable taste, integrity and intellectual capacity, as a curator, were never more in doubt than when he unveiled his choices. Black artists, radical and moderate alike, were overwhelmed by the fact that Geldzahler's manner of selection for the show eliminated so many really strong talents. They were, understandably, most critical of the *total* exclusion of the many significant works created by blacks. Such blatant racism causes *all* black artists to distrust the integrity of the white art establishment. Geldzahler's imprudent omission of art created by blacks merely adds fuel to the black separatists' call for a complete separation of the races; after such an insult, they ask why they should acknowledge white art standards, white institutions, white creativity. One certainly cannot expect a reversal in racist practices at the Metropolitan as long as a curator such as Mr. Geldzahler continues to operate on a policy of anointing his circle of friends with celebrity. Mr. Geldzahler will definitely not be able to echo the "liberal's" refrain, "One of my best friends is a Negro artist"!

What all this points to is the fact that black artists of quality lack an appreciative audience for their unique manner of creative expression. The art

establishment must bear its share of the criticism for the existing attitude that, in essence, implies that the blacks' potential for enriching the American cultural scene is nil. If the art establishment is sincerely interested in re-affirming the depth and quality and variety in American art, it must reverse its racist practices and cull talent from all segments of society. Until this ideal is achieved, it is incumbent upon the black community—particularly its af-fluent members—to lend support to its innovators. Most important, black artists themselves must utilize their inherited vitality to sustain their posi-tive orientation during the bleak hours and, at the same time, dedicate them-selves to creating the finest possible art.

Jack Burnham
Hans Haacke's Cancelled Show at the Guggenheim (1971)

One of the more tangible manifestations of the cultural climate of the late 1960s and early 1970s were critiques of powerful institutions. The organizations most suscepti-ble to protest from artists were museums. Organizations such as the Art Workers' Coalition (AWC) and the Gorilla Art Action Group (GAAG) fought for artists' rights through protests and sit-ins at the Museum of Modern Art and the Metropolitan Mu-seum of Art. One of the most notorious clashes between an individual artist and a museum resulted from the Guggenheim Museum's cancellation of a scheduled exhibi-tion of the work of Hans Haacke in 1970, which is discussed in Jack Burnham's June 1971 *Artforum* article, "Hans Haacke's Cancelled Show at the Guggenheim."

The Guggenheim director, Thomas Messer, canceled the show because Haacke was unwilling to remove his "social systems" pieces, which dealt with real-estate holdings in New York. This work consisted of photographs of the facades of a number of build-ings along with pertinent ownership and financial information about the buildings that Haacke had gathered from the county clerk's office. Haacke's work specifically connected a few elite families and real-estate partnerships with a number of slum properties. This exposure of questionable real-estate practices made the director at the Guggenheim uncomfortable. In a letter to Haacke that is quoted in the following essay, Messer says, "We [the trustees at the Guggenheim] have held consistently that under our Charter we are pursuing aesthetic and educational objectives that are self-sufficient and without ulterior motive. On those grounds, the trustees have estab-lished policies that exclude active engagement toward social and political ends." Haacke, of course, wanted to challenge the notion that the museum is an unbiased repository of culturally significant objects. In his view it is impossible for a museum to be politically neutral. The cancellation of this exhibition underscores the line being drawn between politics and aesthetics in the art world of the 1970s.

© *Artforum*, June 1971, "Hans Haacke's Cancelled Show at the Guggenheim," Jack Burnham.

Section 1. The purposes of The Solomon R. Guggenheim Foundation (referred to in these By-Laws as the "corporation") are set forth in its charter, and are as follows:

To provide for the promotion of art and for the mental or moral improvements of men and women by furthering their education, enlightenment and aesthetic taste, and by developing the understanding and appreciation of art by the public; to establish, maintain and operate, or contribute to the establishment, maintenance and operation of, a museum or museums, or other proper place or places for the public exhibition of art . . .

—Beginning of Article I of the By-Laws
of The Solomon R. Guggenheim Foundation

Underlying Hans Haacke's art is the interconnectedness of all systems regardless of size or complexity. In the early '60s his systems consisted of various weather boxes: "drippers," "waves," gravity tubes, and condensation cubes. Gradually his thinking expanded towards air-blown ribbons and sails, ice constructions, hydraulic systems, steam generators, plant growths, and animal ecologies. There was never any attempt to solve the usual formal problems of art, rather *he wanted to reveal the way the world functions on its most essential levels.*

From all appearances, Haacke's phenomenology of Nature would seem to be an elegant foil for the Guggenheim's nautilus-like spaces. Yet last April 1st he received a letter from the Director of the Museum, Thomas Messer, notifying him that a scheduled April 30th one-man show was off. The exhibition proposed consisted of a three-part investigation into physical, biological, and social systems. The first two categories held no problems, but by March Messer began to have reservations about the "social systems."

Two of the three social pieces consisted of photographs of the facades of large Manhattan real estate holdings. These included pertinent business information collected from the public records of the County Clerk's office. According to the artist: "The works contain no evaluative comment. One set of holdings are mainly slum-located properties owned by a group of people related by family and business ties. The other system is the extensive real estate interests, largely in commercial properties, held by two partners."[1] One example of a caption for a photograph reads:

292 E 3 St. Block 373 Lot 56
5 story walk-up old law tenement
owned by Broweir Realty Corp., . . . E 11 St., NYC
Sidney Winter, President
acquired 10-22 '65 from Apponaug Properties,
. . . Riverside Drive, NYC
mtg. on 292 E 3 St. and 312 E 3 St., totaling $55,000.
— at 5% interest, 10-6 '65, held by The Ministers and
Missionaries Benefit Board of The American Baptist
Convention . . . Riverside Drive N.Y.C., from Apponaug Properties

After examining cards such as the one above, Messer asserted in a letter to Haacke dated March 19th that "... a muckraking venture ... raises serious questions." The Director went on to write that "We have held consistently that under our Charter we are pursuing aesthetic and educational objectives that are self-sufficient and without ulterior motive. On those grounds, the trustees have established policies that exclude active engagement toward social and political ends. It is well understood, in this connection, that art may have social and political *consequences* but these, we believe, are furthered by indirection and by the generalized, exemplary force that works of art may exert upon the environment, not, as you propose, by using political means to achieve political ends, no matter how desirable these may appear to be in themselves."[2]

Initially, Messer's position was that the photographs and captions placed the Museum in a position where a libel suit could be filed against the Foundation. He asserted that Haacke's intention was to "... name, and thereby publicly expose, individuals and companies whom you consider to be at fault," whereas, "... Verification of your charge would be beyond our capacity ..."[3]

Haacke, in a press release of April 3rd, replied that he had modified the two works in question by substituting fictitious names for all family names (maintaining their initials), and obscured their addresses, while retaining all the names of corporations and addresses of the properties themselves. In his cancellation letter Messer insisted that Haacke's modifications would be transparent subterfuges, still leaving the Museum in a vulnerable position. It would seem that on emotional, aesthetic, legal, *and* perhaps political grounds, Messer and his Board of Trustees wanted to have nothing to do with the projects.

The Director also had strong doubts about a third "social system" when he read questions to be asked at the exhibition. This third work consisted of ten demographic questions (age, sex, education, etc.) and ten socio-political queries, with examples such as

Is the use of the American flag for the expression of political beliefs, e.g., on hard-hats and in dissident art exhibitions, a legitimate exercise of free speech?

yes	no

Should the use of marijuana be legalized, lightly or severely punished?

legalized	lightly punished	severely punished

Would you mind busing your children to integrated schools?

yes	no

Do you think the interests of profit-oriented business usually are compatible with the common good of the world?

yes	no

Haacke insists that such polls were an integral part of his art in past museum shows, and that he "tried to frame the questions so that they do not assert a political stance, are not inflammatory and do not prejudge the answers."[4] The artist continues by quoting from an announcement of his last New York gallery show:

> The working premise is to think in terms of systems; the production of systems, the interference with and the exposure of existing systems.
>
> Such an approach is concerned with the operational structure of organizations, in which transfer of information, energy and/or material occurs. Systems can be physical, biological or social, they can be man-made, naturally existing or a combination of any of the above. In all cases verifiable processes are referred to.

Howard Wise, Haacke's friend and previously his dealer, followed the cancellation with a thoughtful letter to Messer. He reflects that

> It seems to me that in the two "real estate" works, Haacke's approach is in the classic tradition of art. He looks at the landscape (Manhattan) and seeks to bring order out of chaos by emphasizing certain aspects and minimizing others to treat a clearer picture and to afford the viewer new understanding and insights. I cannot comprehend what "ulterior motive" he might have had except the desire to create a "realistic" work; in other words, he is "telling it like it is."[5]

Wise ends his letter noting that the Museum has the option of either assisting the vitality of contemporary art or retarding it. *"Either way,"* he comments to Messer, *"you now become part of the work of art."* This last sentence is important because it reconfirms something that Haacke has been striving for: that is the complete integration of his art, leaving no essential dividing line between his professional life and his existence as a social and political creature. Messer's decision was, in effect, one *aesthetic* alternative to his proposals.

In a *Village Voice* article of April 15th John Perrault attacked the basic duplicity behind the Museum's decision by citing its policy in regard to political art: "The Guggenheim can show Russian Constructivist propaganda because it is 'history' (*i.e.*, digested), but not the work of a living artist whose sophistication, both political and artistically, has to be acknowledged."

Usually there are two ways an artist tries to reveal political concern through his work: either by defacing a patriotic icon or by inserting ideological propaganda into his art. Perrault points out that the elegance of Haacke's approach has nothing to do with either, since the artist discloses what is already public property through a process of selection.

However, in an artistic sense, it is no longer useful to maintain the fiction that Haacke is not a political animal and that his work has no extra aesthetic motivation. Superficially his art is perfectly reasonable and harmless. Since modernist art stems from a great tradition of political painting (David,

Géricault, Delacroix, Daumier, Courbet, Manet, Pissarro, and Meunier did explicitly political art on occasion, but many other artists used daring social themes), it seems unbelievably reactionary to be confronted by such censorship in the late twentieth century.

The history of European and American avant-garde art is in no small way born out of revolutionary politics and radicalism. American abstract art of the 1930s was synonymous with the political traditions of Cubism, Dadaism, Constructivism, and the Mexican muralists. Even after the Second World War there were politicians who continued to identify abstraction with communism, but on the whole—and even as Greenberg and Rosenberg realized at the time—the new art of Abstract Expressionism was incapable of even the faintest political motives. The Solomon R. Guggenheim Museum of Nonobjective Art was in part responsible for the "rites of purification," its *nihil obstat* which the New York upper middle classes required of the American innovations. Complete dominance of a content-free painting style left a few artists uneasy, but not many in the climate of the fifties. With the Vietnam War, collage techniques and Pop art made message painting viable again, though not particularly effective.

The late sixties became a time of political maturity for many artists—and accompanying this was an enormous sense of frustration, organization-joining, petition-signing, while making "beautiful" *au courant* art works. The essence of this was conveyed to me by Haacke in a letter dated April 10th, 1968:

> Last week's murder of Dr. King came as a great shock. Linda and I were gloomy for days and still have not quite recovered. This even pressed something into focus that I had known for a long time but never realized so bitterly and helplessly—namely, what we are doing: the production and the talk about sculpture has nothing to do with the urgent problems of our society. Whoever believes that art can make life more humane is utterly naive. Mondrian was one of those naive saints
> . . . Nothing, but absolutely nothing, is changed by whatever type of painting, or sculpture, or happening you produce. All the shows of Angry Arts will not prevent a single Napalm bomb from being dropped. We must face the fact that art is unsuited as a political tool.

Still, a truism of the museum world has it that directors survive and flourish in direct proportion to their ability to please, if not all their trustees, at least the most powerful ones. Considering the reviews that the Guggenheim International Exhibition received last winter (an instance preciously free of painting and where "sculpture" took the form of dirt, documents, and tape recorders), one can understand the Director's sensitivity to another potential hornet's nest. Gone are the days of Ipousteguy, Manzu, Wotruba, Moore, and Pomodoro, when sculpture on the Guggenheim's ramps looked

like jewelry in Cartier's! Quite possibly Process, Systems, and Conceptual art have become the final divorce decree between the avant-garde artist and the wealthy patron.

Nevertheless, the function of modernist art has traditionally been to make the tabooed socially acceptable. Though, according to George Devereux, the artist can fail in one of two ways:

> (1) Skating on ice so thin that it will break and cause the forbidden utterance to erupt from behind the stylistic alibi; and
>
> (2) Freezing his real utterance over a crust of ("artistic") ice so thick as to cause the elemental utterance, and the effect pertaining to it, to be lost . . . thereby turning the boiling lake into a refrigerated indoor rink, where figure skating—pattern-making on ice—becomes the real goal.[6]

Highly touted formalist art is preeminently the second type. Here the *frisson* is telegraphed far ahead of time for collectors with high blood pressure. If anything, Haacke might be faulted for unsuccessfully "skating on thin ice." His alibi is the revelation of all kinds of systems. But he is doing more than holding up a mirror, as when he writes

> Consequently, any work done with and in a given social situation cannot remain detached from its cultural and ideological context. It differs principally, therefore, from the functionally self-sufficient weather-box. In fact, it is precisely the exchange of necessarily biased information between the members of a social set that is the energy on which social relations evolve . . . As in dealing with "the real stuff" in physical and biological systems, perhaps more so, one therefore has to weigh carefully the prospective outcome of undertakings in the social field. One's responsibilities increase; however, this also gives the satisfaction of being taken as a bit more than a court-jester with the danger of not being forgiven everything.[7]

It was the French sociologist, Emile Durkheim, who suggested in his *The Elementary Forms of the Religious Life* that the dominant goal of primitive religion and art is the recognition of oppositions and contradictions. Whereas, because we are dominated by scientific thought, it is the principle of identity that defines our lifestyle—and perhaps our art as well. As I have indicated previously in my article on Duchamp,[8] sacred art is defined by the conjunction of the ambiguous and the hidden; a relatively harmless outer message is used to mask a more profound statement, usually one that poses irreconcilable opposites or contradictions about life.

Hence the ability to accept and welcome contradiction is a vital feature of primitive existence. This is brought out in a beautiful essay by the anthropologist Stanley Diamond, where he defines the mythic transition between kinship, or primitive organization, and civilized, or political, society.[9] Very

little raw and spontaneous "sacred art" exists in civilized cultures. Diamond stresses the sublimated one-dimensional quality of advanced societies. Using Plato's *Republic*, he focuses upon the philosopher's affinity for the class system, highly specialized divisions of labor, and the inherent divinity of rulers—all features alien to primitive cultures. Bound to the State, instead of a family group, the citizen is compelled to show his loyalty to the Republic. Here the conflict between kin and political principles is resolved by the "royal lie," a group impulse (call it patriotism) that there is something greater than the individual's own clan. What undermines this fiction is the poet, artist, and dramatist, and Plato knows this too well as he has Socrates give the following advice:

> When any one of these pantomimic gentlemen, who are so clever that they can imitate anything, come to us, and make a proposal to exhibit himself and his poetry, we will fall down and worship him as a sweet and holy and wonderful being; but we must also inform him that in our State such as he are not permitted to exist; the law will not allow them.[10]

In a fashion not at all dissimilar, Thomas Messer can inform the newspapers that "Artistic merit was never a question. We invited him [Haacke] in the first place because we admire his work. I think that while the exposure of social malfunction is a good thing, it is not the function of a museum."[11]

Plato knew that all art has an "ulterior motive" and is never "self-sufficient" (in spite of Messer's statement), rather "self-sufficient" art is without a message or with a message handed down from above for public edification. Not only did the great philosopher perceive that poets are corrupters of youth, impious portrayers of our superiors, but they "persuade our youth that the Gods are the authors of evil, and that heroes are no better than men." In other words, they tend to level a society based on principles of social hierarchy.

Diamond relates the authentic artist to the primitive Trickster, a creature devoid of normal values, knowing neither good nor evil, yet constantly revealing both:

> In his never-ending search for himself, Trickster changes shape, and experiments with a thousand identities. He has enormous power, is enormously stupid, is "creator and destroyer, giver and negator." Trickster is the personification of human ambiguity. He is the archetype of the comic spirit, the burlesque of the problem of identity, the ancestor of the clown, the fool of the ages.[12]

Plato would have Trickster tamed to "sing songs of the heroes," allowing the "royal lie" to assume a multitude of forms. In civilized society Trickster is constrained to produce art that harmonizes with the existing power structure. Rewards are based on tacit recognition of who is fit to judge and rule. Social myth insists that the divine right of money *is* power, and our

"sacred places" are a celebration of that fact. For advanced societies the greatest dangers are always within, because the greatest contradictions are found in our social mythologies.

Within primitive societies the role of Trickster is more fundamental for the reason that the most serious contradictions stem from outside the kinship unit. Accordingly, contradictions between life and death, sickness, sexuality, old age, war, and famine are the subjects of Trickster's ritual dramas. His purpose is to see that art and life converge:

> In the ritual drama . . . roles are symbolically acted out, dangers confronted and overcome, anxieties faced and resolved. Relations among the individual, society, and nature are defined, renewed, and reinterpreted. There is no theater containing these performances, ancestral to the civilized drama; the world is a stage and, at one time or another, all the people are players. . . .
> The ritual drama, then, focuses on ordinary human events and makes them, in a sense, sacramental.[13]

One might ask how the Guggenheim Foundation is able to dispense hundreds of thousands of dollars in grants every year, induce wealthy patrons to contribute, structure spectacular social events, involve itself in intricate financial affairs, and then insist that it is "not competent" to comment on social ills? In reality any public or semi-public institution is *a priori* a political symbol. The avowed function of this Museum is to say, "We possess the aesthetically superior objects of contemporary culture; we have chosen them."

But what if these turn out to be floor-sweeping compound and fluorescent lights? Beauty, at any rate, is not the issue. What is at stake is the convenient fiction that beauty and the Trickster's function are synonymous. Trickster is always on the side of the mob, although it may seem that he is playing the individual. His natural targets are the values at the apex of Plato's *Republic;* similarly in primitive ceremonials, "it is the thing which is regarded with the greatest respect which is ridiculed."[14] Trickster's clumsy inversions are responsible for his *psychic* effectiveness—just as "competency" remains in the hands of the ruling class. When the Museum specifies that *it* is "not competent" to analyze social problems, what it is saying in effect is that the artist (as one of the "ignorant multitude") has overstepped his bounds.

By connecting physical decay with specific financial transactions Haacke has attacked the holy institution of *private property* in a capitalist society. If the real estate systems were merely matter of exposing housing malpractices, they would, indeed, be tame works. But Haacke is introducing *sacred art* in the oldest sense of the word: *the revelation of unresolvable contradictions.* In essence, the hidden aesthetic of the real estate pieces proclaims that the "sacred place" (*i.e.,* the museum or receptacle of aesthetic truth) is also responsible for the oppressive ugliness of New York City.

The structural principle behind the photographs and their installation is that of *analogy*. Consequently the Guggenheim Museum is the rich and powerful receptacle for the *photographs,* just as the group of related business-men are the rich and powerful owners of the *buildings* in the photographs. In both instances the museological function of the Guggenheim and the financial documentation act as a collective background for the photographs and their contents.

Properties: Group of Owners
Photos of Properties: Guggenheim Museum

At this point Haacke forces each viewer to make an unconscious decision based on class sympathies and affiliations. Either a viewer mentally sides with the occupants of the slums (numerous, poverty-stricken, and oppressed) or with the owners of the slums (small number, affluent, and in control). One is given the choice of affirming solidarity and sympathy with the underprivileged, or with protecting legitimized power.

Art Viewer: Group of Owners
Art Viewer: Guggenheim Museum

The viewer must either unconsciously repudiate the Museum or desire to protect it by banishing the photographs. However a spectator decides, Haacke discloses a crucial relationship; this is the indirect and invisible way in which financial holdings define environmental aesthetics. At a gut level Haacke is asking this question: is there really any difference between the power of money to control the direction of art and the power of money to keep rotten slums in existence?

Haacke, being an artist, has not consciously set out to organize the relationships I have indicated. But it is obvious that his "Systems Art" has entered a new phase. In its semiotic structure it draws closer to the *ritual drama* (where the artist's premises are recapitulated in everyday life) and away from the plastic arts. Perhaps this is inevitable, since the drama is the confrontation between the archetypal artist and the "guardian" of the official myth.

NOTES

1. From a press release by the artist, dated April 3, 1971.
2. From a letter by Thomas Messer to the artist, dated March 19, 1971.
3. *Ibid.*

4. Haacke, *op. cit.*
5. From a letter by Howard Wise to Thomas Messer, dated April 8, 1971.
6. George Devereux, "Art and Mythology: A General Theory" in *Art and Esthetics in Primitive Societies* (edited by Carol F. Jopling), New York: E. P. Dutton & Co., Inc., pp. 219–220.
7. Hans Haacke, "Provisional Remarks" (an essay to be published).
8. Jack Burnham, "Unveiling the Consort: Part II" in *Artforum*, April 1971.
9. Stanley Diamond, "Plato and the Definition of the Primitive" in *Primitive Views of the World* (edited by Stanley Diamond). New York and London: Columbia University Press, pp. 170–193.
10. *Ibid.*, p. 180.
11. Doris Herzig, "Art show scrubbed as politically dirty" in *Newsday*, Friday, April 9, 1971, p. 15A.
12. Diamond, "Plato and the . . .", p. 182.
13. *Ibid.*, p. 187.
14. *Ibid.*, p. 190.

POSTSCRIPT

Possibly the most serious personal consequence of the Haacke affair is the firing of senior Associate Curator Edward F. Fry. Beginning last September Haacke and Ed Fry worked closely on the artist's exhibition. When Haacke learned of the cancellation of his show, Ed Fry fought the decision in the front office and backed Haacke in the press. While trying to be tactful, he stressed that the Director's decision produced grave implications for the Museum's future, and particularly in its role as a free institution supporting public expression. Shortly after, Ed Fry was summoned by Thomas Messer and asked if he fully understood the implications of his position. Fry responded that he did.

On Monday, April 26th, Ed Fry received a note discharging him from the staff of the Museum. In a single gesture the Guggenheim Museum not only lost a most capable scholar, but perhaps the only member of its curatorial staff with the guts to defend artists' integrity and the right to reasonable expression.

There is something profoundly pathetic in a great museum becoming a frightened, third-rate institution. Already the response from the art community has been decisive. A number of artists have categorically refused to have their work in the building. By next season the Museum may be reduced to exhibiting its permanent collections and the art of a few obscure contemporaries. With his need for personal and institutional safety, Thomas Messer may very well transform the Guggenheim into a relic of a bygone age.

Martin Luther King Jr.
I've Been to the Mountaintop (1968)

Martin Luther King Jr. was one of the most charismatic leaders of the civil rights movement from the mid-1950s until his death in 1968. King's passionate organization of nonviolent protests was a major catalyst that urged President Johnson to sign the Civil Rights Act in 1964. This act outlawed segregation and called for equal opportunity in employment and education among other things. Although the Civil Rights Act was the most far-reaching civil rights legislation passed since the aftermath of the Civil War, it was viewed as only one step along the path to racial equality in America. Throughout the 1960s racial tensions continued to escalate. In 1966 and 1967 African Americans' deep frustrations culminated in the eruption of race riots in a number of American cities, including Los Angeles, Chicago, New York, Cleveland, Baltimore, and Detroit. King addresses these tensions in his call for unity among African Americans as well as in his reaffirmation of the power of nonviolence.

"I've Been to the Mountaintop" was delivered to striking sanitation workers in Memphis, Tennessee, on April 3, 1968, the night before King was assassinated. It is possible to get a glimpse of how this tragic event resonated within the artistic community by referring back to Jack Burnham's article "Hans Haacke's Cancelled Show at the Guggenheim." In this essay Burnham quotes Haacke's response to the King assassination, which he said "pressed something into focus that I had known for a long time but never realized so bitterly and helplessly—namely, what we are doing: the production and the talk about sculpture has nothing to do with the urgent problems of our society." "I've Been to the Mountaintop" is among the most important documents of the civil rights movement—in large part because it encapsulates in broad, eloquent language both the progress and challenges of racial equality in America.

Thank you very kindly, my friends. As I listened to Ralph Abernathy and his eloquent and generous introduction, and then thought about myself, I wondered who he was talking about. [*Laughter*] It is always good to have your closest friend and associate to say something good about you. And Ralph Abernathy is the best friend that I have in the world.

I'm delighted to see each of you here tonight in spite of a storm warning. You reveal that you are determined. [*Voice says, "Come on, talk to us."*] I would go on even to the great heyday of the Roman Empire, and I would see

developments around there through various emperors and leaders, but I wouldn't stop there. [*Voice says, "Keep on."*] I would even come up to the day of the Renaissance, and get a quick picture of all that the Renaissance did for the cultural and aesthetic life of man, but I wouldn't stop there. I would even go by the way that the man for whom I'm named had his habitat, and I would watch Martin Luther as he tacks his 95 Theses on the door at the Church of Wittenberg, but I wouldn't stop there. I would come on up even to 1863, and watch a vacillating President by the name of Abraham Lincoln finally come to the conclusion that he had to sign the Emancipation Proclamation, but I wouldn't stop there. [*Applause*] I would even come up to early 'thirties, and see a man grappling with the problems of the bankruptcy of his nation, and come with an eloquent cry that "We have nothing to fear but fear itself," but I wouldn't stop there. Strangely enough I would turn to the Almighty and say, "If you allow me to live just a few years in the second half of the twentieth century, I will be happy." [*Applause*]

Now that's a strange statement to make because the world is all messed up, the nation is sick, trouble is in the land, confusion all around. That's a strange statement. But I know somehow that only when it is dark enough can you see the stars. And I see God working in this period of the twentieth century in a way that men in some strange way are responding. Something is happening in our world. The masses of people are rising up, and wherever they are assembled today, whether they are in Johannesburg, South Africa; Nairobi, Kenya; Accra, Ghana; New York City; Atlanta, Georgia; Jackson, Mississippi; or Memphis, Tennessee, the cry is always the same: "We want to be free!" [*Applause. Thunder sounds in the background*]

And another reason that I'm happy to live in this period is that we have been forced to a point where we are going to have to grapple with the problems that men have been trying to grapple with through history but the demands didn't force them to do it. Survival demands that we grapple with them. Men for years now have been talking about war and peace but now no longer can they just talk about it. It is no longer the choice between violence and nonviolence in this world, it's nonviolence or nonexistence. That is where we are today. [*Applause*] And also in the human rights revolution, if something isn't done and done in a hurry to bring the colored peoples of the world out of their long years of poverty, their long years of hurt and neglect, the whole world is doomed. [*Applause. Voice says, "All right."*] Now I'm just happy that God has allowed me to live in this period, to see what is unfolding, and I'm happy that He has allowed me to be in Memphis. [*Applause*]

I can remember . . . I can remember when Negroes were just going around as Ralph has said so often, scratching where they didn't itch and laughing when they were not tickled. [*Applause*] But that day is all over. [*Applause*] We mean business now, and we are determined to gain our rightful place in God's world. [*Applause*] And that's all this whole thing is about. We aren't engaged in any negative protests and in any negative arguments with

anybody. We are saying that "We are determined to be men, we are determined to be people." We are saying, [*Applause*] . . . we are saying that "We are God's children." And if we are God's children we don't have to live like we are forced to live.

Now what does all of this mean in this great period of history? It means that we've got to stay together. We've got to stay together and maintain unity. You know, whenever Pharaoh wanted to prolong the period of slavery in Egypt, he had a favorite, favorite formula for doing it. What was that? He kept the slaves fighting among themselves. [*Applause*] But whenever the slaves get together, something happens in Pharaoh's court and he cannot hold the slaves in slavery. When the slaves get together, that's the beginning of getting out of slavery. [*Applause*] Now let us maintain unity.

Secondly, let us keep the issues where they are. [*Voice says, "Right."*] The issue is injustice. The issue is the refusal of Memphis to be fair and honest in its dealings with its public servants who happen to be sanitation workers. [*Applause*] Now we've got to keep attention on that. That's always the problem with a little violence. You know what happened the other day, and the press dealt only with the window-breaking. I read the articles. They very seldom got around to mentioning the fact that one thousand three hundred sanitation workers are on strike, and that Memphis is not being fair to them, and that Mayor Loeb is in dire need of a doctor. [*Cheers and applause*] They didn't get around to that.

Now we're gonna march again and we've gotta march again in order to put the issue where it is supposed to be, and force everybody to see that there are thirteen hundred of God's children here suffering, sometimes goin' hungry, going through dark and dreary nights wondering how this thing is gonna come out. That's the issue. And we've got to say to the nation, "We know how it's coming out." For when people get caught up with that which is right and they are willing to sacrifice for it, there is no stopping point short of victory! [*Applause*]

We aren't going to let any mace stop us. We are masters in our nonviolent movement in disarming police forces. They don't know what to do. I've seen them so often. I remember, in Birmingham, Alabama, when we were in that majestic struggle there, we would move out of the 16th Street Baptist Church day after day. By the hundreds we would move out, and Bull Connor would tell them to send the dogs forth, and they did come. But we just went before the dogs singing, "Ain't gonna let nobody turn me around." [*Cheers*] Bull Connor next would say, "Turn the firehoses on." And I said to you the other night Bull Connor didn't know history. He knew a kind of physics that somehow didn't relate to the transphysics that we knew about, and that was the fact that there was a certain kind of fire that no water could put out. [*Applause. Voice says, "Tell it like it is."*] And we went before the firehoses. We had known water. If we were Baptist or some other denominations we had been immersed, if we were Methodists and some others we had

been sprinkled, but we knew water. That couldn't stop us. [*Applause*] And we just went on before the dogs and we would look at them, and we'd go on before the water hoses and we would look at it, and we'd just go on singing "Over my head I see freedom in the air." And then we would be thrown in the paddy wagons, and sometimes we were stacked in there like sardines in a can. And they would throw us in and old Bull would say, "Take 'em off," and they did. And we would just go on in the paddy wagons singin' "We Shall Overcome." And every now and then we'd get in jail and we'd see the jailers looking through the windows being moved by our prayers, and being moved by our words and our songs. And there was a power there which Bull Connor couldn't adjust to. And so we ended up transforming Bull into a steer, and we won our struggle in Birmingham. [*Applause*]

And we've got to go on in Memphis just like that. I call upon you to be with us when we go out Monday.

Now about injunctions—we have an injunction and we are going into court tomorrow morning to fight this illegal, unconstitutional injunction. All we say to America is, "Be true to what you said on paper." [*Applause*] If I lived in China or even Russia or any totalitarian country, maybe I could understand some of these illegal injunctions. Maybe I could understand the denial of certain basic first amendment privileges because they haven't committed themselves to that over there. But somewhere I read of the freedom of assembly. Somewhere I read of the freedom of speech. Somewhere I read of the freedom of the press. Somewhere I read that the greatness of America is the right to protest for right. And so just as I say, we aren't going to let any injunction turn us around. We are going on. We need all of you.

And you know, what's beautiful to me is to see all of these ministers of the gospel. It's a marvelous picture. Who is it that is supposed to articulate the longings and aspirations of the people more than the preacher? Somehow the preacher must have a kind of fire shut up in his bones, [*Voice says, "Yes, Sir."*] and whenever injustice is around he must tell it. [*Voices say, "Yeah."*] Somehow the preacher must be an Amos, who said, "When God speaks, who can but prophesy." Again with Amos, "Let justice roll down like waters, and righteousness like a mighty stream." Somehow the preacher must say with Jesus, "The spirit of the Lord is upon me because He has anointed me." And He's anointed me to deal with the problems of the poor. And I want to commend the preachers, under the leadership of these noble men: James Lawson, one who has been in this struggle for many years, he's been to jail for struggling, he's been kicked out of Vanderbilt University for this struggling, but he's still going on fighting for the rights of his people. [*Applause*] Reverend Ralph Jackson, Billy Kyles, I could just go right on down the list but time will not permit. But I want to thank all of 'em, and I want you to thank them, because so often preachers aren't concerned about anything but themselves. [*Voices of agreement*]

And I'm always happy to see a relevant ministry. It's all right to talk about long white robes over yonder in all of its symbolism, but ultimately

people want some suits and dresses and shoes to wear down here. [*Cheers and applause. Voice says, "Yes, yes, yes."*] It's all right to talk about streets flowing with milk and honey, but God has commanded us to be concerned about the slums down here and His children who can't eat three square meals a day. [*Applause*] It's all right to talk about the New Jerusalem, but one day God's preacher must talk about the New York, the New Atlanta, the New Philadelphia, the New Los Angeles, the New Memphis, Tennessee. [*Applause*] This is what we have to do.

Now the other thing we'll have to do is this: Always anchor our external direct action with the power of economic withdrawal. Now we are poor people. Individually, we are poor when you compare us with white society in America. We are poor. Never stop . . . forget that collectively, that means all of us together, collectively we are richer than all the nations in the world with the exception of nine. Did you ever think about that? [*Voice says, "Right on."*] After you leave the United States, Soviet Russia, Great Britain, West Germany, France—and I could name the others—the American Negro collectively is richer than most nations of the world. We have an annual income of more than thirty billion dollars a year, which is more than all of the exports of the United States, and more than the national budget of Canada. Did you know that? That's power right there if we know how to pool it. [*Applause*]

We don't have to argue with anybody. We don't have to curse and go around acting bad with our words. We don't need any bricks and bottles. We don't need any Molotov cocktails. We just need to go around to these stores, [*Voice says, "Yes sir."*] and to these massive industries in our country and say, "God sent us by here to say to you that you're not treating His children right. [*Voice says, "That's right."*] And we've come by here to ask you to make the first item on your agenda fair treatment where God's children are concerned. Now if you are not prepared to do that we do have an agenda that we must follow. And our agenda calls for withdrawing economic support from you." [*Applause*]

So as the result of this we are asking you tonight to go out and tell your neighbors not to buy Coca Cola in Memphis. [*Applause*] Go by and tell them not to buy Sealtest milk, [*Applause*] tell them not to buy—what is the other bread?—Wonder bread. What is the other bread, Jesse? Tell them not to buy Hart's bread. As Jesse Jackson has said, "Up to now only the garbage men have been feeling pain. Now we must kind of redistribute the pain." [*Applause*] We are choosing these companies because they haven't been fair in their hiring policies, and we are choosing them because they can begin the process of saying they are going to support the needs and the rights of these men who are on strike, and then they can move on downtown and tell Mayor Loeb to do what is right. [*Applause*]

And not only that. We've got to strengthen black institutions. I call upon you to take your money out of the banks downtown and deposit your money in Tri-State Bank. [*Applause*] We want a bank-in movement in Memphis. Go by the savings and loan associations. I'm not asking you something

we don't do ourselves in S.C.L.C. Judge Hooks and others will tell you that we have an account here in the savings and loan association from the Southern Christian Leadership Conference. We are telling you to follow what we are doing, put your money there. You have six or seven black insurance companies here in the city of Memphis. Take out your insurance there, we want to have an insurance-in. [*Applause*]

Now these are some practical things that we can do. We begin the process of building a greater economic base, and at the same time we are putting pressure where it really hurts. And I ask you to follow through here. [*Applause*]

Now let me say as I move to my conclusion that we've got to give ourselves to this struggle until the end. Nothing would be more tragic than to stop at this point in Memphis. We've got to see it through. [*Applause*] And when we have our march you need to be there. If it means leaving work, if it means leaving school, be there. [*Applause*] Be concerned about your brother. You may not be on strike, but either we go up together or we go down together. [*Applause*] Let us develop a kind of dangerous unselfishness.

One day a man came to Jesus and he wanted to raise some questions about some vital matters of life. At points he wanted to trick Jesus [*Voice says, "That's right."*] and show him that he knew a little more than Jesus knew, and throw him off base. Jesus showed him up because he was a lawyer and he was raising a question that any lawyer should know. And finally the man didn't want to give up and he said to Jesus, "Who is my neighbor?" Now that question could have easily ended up in a philosophical and theological debate. But Jesus immediately pulled that question from mid-air, and placed it on a dangerous curve between Jerusalem and Jericho. [*Chuckles of appreciation from crowd.*] And he talked about a certain man who fell among thieves. And you remember that a Levite [*Voices say, "Sure."*] and a priest passed by on the other side. They didn't stop to help him. And finally a man of another race came by. [*Voices say, "Sure."*] He got down from his beast, decided not to be compassionate by proxy, but he got down with him, administered first aid, and helped the man in need. Jesus ended up saying, this was the good man, this was the great man, because he had the capacity to project the "I" into the "thou," and to be concerned about his brother.

Now you know we use our imagination a great deal to try to determine why the priest and the Levite didn't stop. At times we say they were busy going to a church meeting, an ecclesiastical gatherin', and they had to get on down to Jerusalem so they wouldn't be late for their meeting. At other times we would speculate that there was a religious law that one who was engaged in religious ceremonials was not to touch a human body twenty-four hours before the ceremony. And every now and then we begin to wonder whether maybe they were not going down to Jerusalem—or down to Jericho rather—to organize a Jericho Road Improvement Association. [*Laughter*] That's a possibility. Maybe they felt that it was better to deal with the problem from the causal root rather than to get bogged down with an individual effect.

But I'm going to tell you what my imagination tells me. It's possible that those men were afraid. You see, the Jericho road is a dangerous road. [*Voice says, "That's right. That's right."*] I remember when Mrs. King and I were first in Jerusalem. We rented a car and drove from Jerusalem down to Jericho. And as soon as we got on that road I said to my wife, "I can see why Jesus used this as the setting for his parable." It's a winding, meandering road. [*Voice says, "Yeah, yeah."*] It's really conducive for ambushing. You start out in Jerusalem, which is about twelve hundred miles—or rather twelve hundred feet—above sea level, and by the time you get down to Jericho fifteen or twenty minutes later you are about twenty-two hundred feet below sea level. That's a dangerous road. In the days of Jesus it came to be known as the Bloody Pass. You know it's possible that the priest and the Levite looked over to that man on the ground and wondered if the robbers were still around. [*Voices agree, "Yeah."*] Or it's possible that they felt that the man on the ground was merely faking [*Voice says, "Uh-huh."*] and he was acting like he had been robbed and hurt in order to seize them over there, lull them there for quick and easy seizure. [*Voices agree, "Yeah."*] And so the first question that the priest asked, the first question that the Levite asked, was, "If I stop to help this man, what will happen to me?" But then the good Samaritan came by, and he reversed the question: "If I do not stop to help this man, what will happen to him?"

That's the question before you tonight. Not, "If I stop to help the sanitation workers, what will happen to my job?" Not, "If I stop to help the sanitation workers, what will happen to all of the hours that I usually spend in my office every day and every week as a pastor?" The question is not, "If I stop to help this man in need, what will happen to me?" The question is, "If I do *not* stop to help the sanitation workers, what will happen to them?" That's the question. [*Long applause*]

Let us rise up tonight with a greater readiness. Let us stand with a greater determination. And let us move on, in these powerful days, these days of challenge, to make America what it ought to be. We have an opportunity to make America a better nation, and I want to thank God once more for allowing me to be here with you. [*Voice says, "Yes sir."*]

You know, several years ago I was in New York City, autographing the first book that I had written. And while sitting there autographing books, a demented black woman came up, and the only question I heard from her was, "Are you Martin Luther King?" And I was looking down writing, and I said, "Yes." The next minute I felt something beating on my chest. Before I knew it, I had been stabbed by this demented woman. I was rushed to Harlem Hospital. It was a dark Saturday afternoon. And that blade had gone through, and the X-rays revealed that the tip of the blade was on the edge of my aorta, the main artery, and once that's punctured you drown in your own blood. That's the end of you. It came out in the *New York Times* the next morning that if I had merely sneezed, I would have died.

Well, about four days later they allowed me after the operation, after my chest had been opened and the blade had been taken out, to move around in the wheelchair in the hospital. They allowed me to read some of the mail that came in, and from all over the states and the world kind letters came in. I read a few but one of them I will never forget. I had received one from the President and the Vice-President. I've forgotten what those telegrams said. [*Voice says, "Go ahead, now. Go ahead."*] I had received a visit and a letter from the governor of New York but I've forgotten what that letter said. [*Voice says, "Yes sir."*] But there was another letter [*Voices say, "All right."*] that came from a little girl, a young girl, who was a student at the White Plains High School, and I looked at that letter and I'll never forget it. It said simply, "Dear Dr. King, I am a ninth grade student at the White Plains High School." She said, "While it should not matter, I would like to mention that I'm a white girl. I read in the paper of your misfortune and of your suffering, and I read that if you had sneezed you would have died. I'm simply writing you to say that I'm so happy that you didn't sneeze."

And I want to say tonight . . . [*Applause*] I want to say tonight that I too am happy that I didn't sneeze, because if I had sneezed [*Voice says, "All right."*] I wouldn't have been around here in 1960 when students all over the South started sitting in at lunch counters. And I knew that as they were sitting in they were really standing up for the best in the American dream and taking the whole nation back to those great wells of democracy which were dug deep by the founding fathers in the Declaration of Independence and the Constitution. If I had sneezed [*Crowd replies, "Yeah."*] I wouldn't have been around here in 1961 when we decided to take a ride for freedom and ended segregation in interstate travel. If I had sneezed [*Crowd says, "Yes."*] I wouldn't have been around here in 1962 when Negroes in Albany, Georgia, decided to straighten their backs up. And whenever men and women straighten their backs up they are going somewhere because a man can't ride your back unless it is bent. If I had sneezed [*Long applause*] . . . if I had sneezed I wouldn't have been here in 1963, when the black people of Birmingham, Alabama, aroused the conscience of this nation and brought into being the civil rights bill. If I had sneezed [*Applause*] I wouldn't have had a chance later in that year in August to try to tell America about a dream that I had had. If I had sneezed [*Applause*] I wouldn't have been down in Selma, Alabama, to see the great movement there. If I had sneezed, I wouldn't have been in Memphis to see a community rally around those brothers and sisters who are suffering. [*Voices say, "Yes sir."*] I'm so happy that I didn't sneeze.

And they were telling me . . . [*Applause*] Now it doesn't matter now. [*Voice says, "Go ahead."*] It really doesn't matter what happens now. I left Atlanta this morning, and as we got started on the plane—there were six of us—the pilot said over the public address system, "We are sorry for the delay, but we have Dr. Martin Luther King on the plane, and to be sure that all of the bags were checked and to be sure that nothing would be wrong on

the plane, we had to check out everything carefully, and we've had the plane protected and guarded all night."

And then I got into Memphis, and some began to say the threats, or talk about the threats that were out of what would happen to me from some of our sick white brothers. Well, I don't know what will happen now. We've got some difficult days ahead. But it really doesn't matter with me now because I've been to the mountaintop. [*Applause*] And I don't mind. Like anybody I would like to live a long life. Longevity has its place, but I'm not concerned about that now. I just want to do God's will, and He's allowed me to go up to the mountain, and I've looked over and I've seen the Promised Land. I may not get there with you, but I want you to know tonight that we as a people will get to the Promised Land. [*Applause*] So I'm happy tonight, I'm not worried about anything. I'm not fearing any man. Mine eyes have seen the glory of the coming of the Lord. [*Long applause, cheers.*]

Noam Chomsky
Linguistics and Politics (1969)

The war in Vietnam in many respects motivated people to become critical of the power of institutional structures. Whether protesting the educational policies of universities, the priorities of the military industrial complex, or the ingrained attitudes of a male-dominated society, voices of dissent were gathering around a need to understand and a desire to change structures of power. Noam Chomsky was one of the most passionate and articulate critics of "American imperialism," which he defined as the desire of the United States to create an integrated world system based on capitalism. In Chomsky's view American imperialist tendencies motivated both the Cold War and the war in Vietnam. By the time this interview was conducted in the late 1960s, Chomsky was also firmly established at the forefront of the study of linguistics. His most important early contribution to linguistics was his theory of transformative grammar, which essentially states that human beings have an innate capacity for understanding the underlying formal principles of grammar. In this interview, "Linguistics and Politics," which was conducted by Robin Blackburn, Gareth Stedman Jones, and Lucien Rey and was originally published in the *New Left Review* in 1969, Chomsky discusses a range of topics, including the antiwar movement, the government sponsorship of university research, and the relationship between language and politics.

It is clear from your writings that you were thinking deeply about politics long before the Vietnam war became a dominant issue in America. Could you tell us something about the background to your present political stand?

"Linguistics and Politics" by Noam Chomsky was originally published in *New Left Review*, September–October 1969. Reprinted with permission of the publisher.

I have been involved in politics, intellectually if not always actively, since early childhood. I grew up among the radical Jewish community in New York. This was during the Depression and many of my immediate relatives were active in various left-wing and working-class movements. The first "political" article I remember writing was in a school newspaper, an article about the fall of Barcelona. The Spanish Civil War, of course, was a major experience from childhood which stuck.

I was connected loosely with various types of groups, searching for something that was within the Marxist or at least revolutionary tradition, but which did not have the elitist aspects which seemed to me then and seem to me today to be disfiguring and destructive. In the forties, when I was a teenager, I would hang around left-wing bookshops and the offices of off-beat groups and periodicals, talking to people—often very perceptive and interesting people who were thinking hard about the problems of social change—and seeing what I could pick up. Then I was much interested in a Jewish organization which was opposed to the Jewish state in Palestine and worked for Arab-Jewish co-operation on a socialist basis. Out of all this, from my relatives and friends, I learned a great deal informally and acquired a certain framework within which my own way of thinking developed.

In fact, I more or less got into linguistics this way, through my connections with these political groups. I was very impressed by Zellig Harris, who was the head of the Linguistics Department at the University of Pennsylvania, and I found I had political interests in common with him. He had a kind of semianarchist strain to his thought. Then I withdrew during the fifties from political involvements, though of course I retained my intellectual interest. I signed petitions, over the Rosenberg case, for instance, and went on occasional demonstrations but it did not amount to much. Then, in the sixties, I began to become more active again. Like most people, I had something to do with the civil rights movement. But in retrospect I think I was very slow in getting involved. It was only when the Vietnam war began escalating that I began to take any really active political role. Much too late, I am afraid.

How effective do you think the anti-war movement in America has been? How effective do you think it can be in the future?

I think if the movement was able to consolidate and act it could probably end the war. I think it is a great tragedy that it has more or less collapsed in the last few months. In the past I think it had had a marginal effect. The major factor has been the National Liberation Front and the struggle in Vietnam itself. But I think there is some evidence that political action in America has limited and retarded American aggression. I think the will to prosecute the war has been weakened by the turmoil and dissidence in American society itself. The domestic cost began to become too high. Of course, without the Tet offensive, this would not have weighed so greatly but I think it has been an important factor nonetheless. Pressure for ending the war became

really quite substantial. The *Wall Street Journal* opposed the war, for instance. I think that if, after Nixon was elected, there had been sufficient disruption and turmoil and demonstrations, then it might have hastened the end of the war considerably. But, for various reasons, this did not take place.

Do you think that the chain of insurrections on the campuses is a form of solidarity with the Vietnamese, apart from the anti-war movement as such?

I am of two minds about that. These insurrections are not specifically directed against the war so it is not so obvious that they are part of the cost of the war. There was a shift in student politics between the Pentagon demonstration in October 1967 and the Columbia action in Spring 1968. My own feeling is that this shift did not do much to help the Vietnamese. If the student movement had focused its energy and its activism more directly against the war, it would have been a much more powerful force in cutting down the American military effort. Obviously, anyone rational has to recognize that student insurrections are part of the fall-out from the war in Vietnam. But it is not so clear that they would stop if the war stopped. So in this sense they are less effective tactically than unambiguous **anti-war actions.**

But it is hard to see how the student movement could avoid campus issues. There are real contradictions on the campus which affect the students and which the student movement could not ignore. A number of the insurrections seem to have arisen spontaneously out of the campus situation.

I am not so convinced that people active in the student movement should simply find the most lively issue and work on that. That is a bit unprincipled. They ought to be finding the issues which are the most important and trying to make those issues important to the people whom they are trying to reach. That is different from finding issues which seem to have some life and selecting them because they may be useful issues for building a movement. Now I do not think that is necessarily wrong: building a movement concerned with social change, perhaps **revolutionary change,** is important. But I think one has to be careful to avoid opportunism and to try always to find principled issues rather than issues which happen to be convenient at the moment. The necessity to end the Vietnam war seems to me so urgent that I would be perfectly willing to be enormously involved in a movement that would end when the Vietnam war ended, if that movement helped to end the war. I feel that ending the Vietnam war is the highest priority for any radical or revolutionary movement in America.

What do you think are the most effective forms of action the anti-war movement might take in the future?

Draft resistance has been effective and could be even more effective if it were to become a well-organized and cohesive movement. I also think that sabotage

is perfectly justified against the war and should be publicly supported. In Milwaukee, for instance, there were fourteen people who simply went in and took the draft files out and burned them all with napalm. That was an important act and it could have been even more important had it been the signal for large demonstrations and actions in support of what they did.

It is not simply a question of action limited to universities. For instance, in California there have been actions involving both students and workers. Don't you think this is an important step forward, given that the American working class have not yet played any significant part in the anti-war movement?

If the Vietnamese have to wait until we build a serious political movement against all forms of capitalist repression in the United States, then they are all going to be dead. It is true that active opposition to the war has been middle class or even upper middle class, but that is a politically very important part of the population. It is difficult to repress, in the sense that there is a high political cost to the repression of these classes and that gives a lever for protest against the war which should be exploited. I have nothing against using the inegalitarian aspects of American society as a weapon against its foreign policy. In any case, we cannot delay on the Vietnam issue in order to build a movement on more long-term issues. Even if these two goals were in conflict, I think we should give priority to the goal of ending the war. But I do not think they are in conflict. Principled opposition to the war will lead directly to principled opposition to imperialism and to the causes of imperialism and hence to the formation of a principled anti-capitalist movement.

You have made many very persuasive and moving indictments of American imperialism in Vietnam. Could you spell out the reasons why the United States went into Vietnam?

I think the United States went in for a lot of reasons and I think they have changed through time. At the moment, I think we are staying in largely because there is a big investment in error and it is very hard for people who have invested an enormous amount of prestige in their commitment to a policy simply to admit defeat. So they are looking for what they choose to call an honorable peace, which does not exist, in their sense. But if we look back further we find a different set of reasons. If you read the State Department propaganda in 1950/1951, you will find that their intention then was to give sufficient support to the French to enable them to re-constitute French colonial rule and to eradicate Communism there.

When the French proved incapable of carrying this out, then the United States simply took over. Dean Acheson made it clear that when China was "lost" the United States would not tolerate any further disturbance to the integrated world system it was attempting to construct and revolution in Vietnam was seen as an erosion of that system. Now it is perfectly true, as many

people point out, that the United States can survive without Vietnam as a colony, that the United States does not need Vietnamese rubber or anything like that. But I think the very fact that Vietnam is so unimportant in this respect shows how desperately necessary it is felt to be to maintain an integrated world system. They are willing to make this great commitment even to hold a marginal, peripheral piece of their empire.

If one looks into it even more deeply then one discerns other things going on. For example, the United States fought the Second World War, in the Pacific theater, primarily in order to prevent Japan from constructing its own independent, integrated imperial system which would be closed to America. That was the basic issue which lay behind the Japanese-American war. Well, the United States won. The result is that now it must develop a system in which Japan can function effectively as a junior partner. That means the United States has to grant Japan what it needs as a partner, namely markets and access to raw materials, which for Japan, unlike the United States, are desperate necessities. Now the United States can very well survive without South East Asia. But Japan cannot. So if the United States wants to keep Japan securely embedded within the American system, then it has to preserve South East Asia for Japan. Otherwise Japan has other alternatives. It would turn to China or to Siberia, but that would mean the United States had lost the Second World War, in its Pacific phase. Once again a substantial industrial power would be carving itself out an independent space which, taken to its logical conclusion, would be separate and partially scaled off from the American world system.

I think the United States recognized this danger immediately after the Second World War and accordingly began to reconstitute the imperial relations between Japan and its former colonies. People in the Philippines were upset and taken aback by this. They thought they had helped the United States win the war and they were puzzled to find the United States building up Japan as an industrial power again and ignoring the Philippines. But the reason for that is plain. Japan could not be ignored and the United States wanted it to play its allotted role in the American system, similar to that played by Britain in the Atlantic. The consequence of that is that sources of raw materials and a market for Japanese goods must be maintained in South East Asia. The United States does not have to sell motorcycles there for itself but Japan does have to and the United States has to ensure that it can, if the American system there is to remain stable.

Another factor that was very important and is extremely suggestive for the future is that the Vietnam war became an ideological instrument for the strategic theory of the Cold War intelligentsia that moved into power with Kennedy. This was to be the testing ground where they could show how by properly designed counter-insurgency programs they could control potential revolutionary movements anywhere on the globe. They put an enormous commitment into this. When the technical intelligentsia becomes involved in

the design of policy, this is a very different matter from when a corporate elite or an aristocracy becomes involved in policy-making. To put it in a nutshell, when someone like Averell Harriman happens to make a mistake, it does not seem to him he has lost his right to be running the world. His right to be running the world is based on the fact that his grandfather built railroads. But if Walt Rostow or McGeorge Bundy happen to make a mistake, when it turns out they got everything wrong, then they have lost their only claim to be at the center of power, which was that they had superior knowledge to other people. The consequence of this is that policies designed by this technical intelligentsia have a peculiar persistence. Other people's claim to power need not be diminished by failure in the same way, so they can be somewhat more pragmatic and opportunistic.

You do not think that power has been transferred in any substantial way from large capital to the intelligentsia? Would you agree that power still remains where it has always been, with large capital, and that the new prominence of the intelligentsia does not mean there is some new mode of production or some new, qualitatively different stage of capitalism in the United States?

The idea that power has shifted from capital to knowledge is pretty much a fantasy. But the technical intelligentsia is providing great service to the corporate elite that has been running America throughout this century and I think they do make their own contribution, a very dangerous contribution. The intellectual community used to be a kind of critical voice. That was its main function. Now it is losing that function and accepting the notion that its role is to carry out piecemeal social technology.

Don't you think American imperialism is right, within its own terms, to fear popular uprisings and revolutions wherever they occur, in however small or distant a country, simply because there is always the threat of contagion?

That is true. There is such a threat, and it is a serious one. The goal of designing an integrated world economy to be dominated by American capital is the highest priority for the corporate elite that manages the United States. This is not just a matter of having safe areas for American investment and markets and control of raw materials though, of course, these are important. There is also the need to maintain a high level of defense spending, war spending basically. This has been the main "Keynesian" mechanism for maintaining what they call the health of the economy. The United States was still in the Depression in 1939. There were nine million unemployed. The war ended that. American industrial production quadrupled during the Second World War. It was done by running a tightly managed economy with government intervention, largely in arms, but multiplying out to the rest of the economy.

Now this lesson in economics was taught to precisely the people who could benefit from it, namely the corporate managers who came to Washington

to manage the war-time economy. Arms production is ideal from their point of view. It keeps the economy running and it does not conflict with private interests. But of course the taxpayer has to be willing to foot the bill. Hence the Cold War paranoia which goes with this enormous arms production. Without this great fear of the Communists or the Third World or China, there is no particular reason why 50% of a tax dollar should be spent on a public subsidy to war-based industry. These things all tie in together.

Could you say something about the campaign you have been involved in against MIT participation in the United States military program?

I have simply been following the lead of the students who have done a very good job on this. MIT manages two laboratories financed largely by the Pentagon and NASA to the tune of something like $125 million a year. About 4,000 people are employed there largely on war-related projects. They are involved in designing the guidance system for the Poseidon MIRV system and in research on ABM systems and very many things of that kind. They are involved in counterinsurgency too, techniques for detecting tunnels and detecting people hidden in dense foliage, everything. Now there are a number of alternatives open to us in a campaign against participation in "defense" programs of this kind. We could try to sever the connection between the university and the laboratories where this work is done. This happened recently at Stanford. But the students have opposed this. They have insisted from the beginning that this would not be an acceptable way out. In effect, it would mean only a kind of terminological shift. The work would go on, but under a different name. The same university people would be involved in it, but as consultants maybe instead of as staff.

There is no particular point in trying to develop pure universities in a criminal society. I would rather have the laboratories right in the middle of the campus, where their presence could be used to politicize future engineers, for instance, rather than having them hidden away somewhere while the campus is perfectly clean and cloistered. I feel this way about chemical and bacteriological warfare too. I would prefer to have a building in the middle of the campus, called Department of Bacteriological Warfare, rather than have it right off the map at Fort Detrick or some place nobody knows of. It could be actually retrograde, in this sense, to try to cut all connections between the university and the Department of Defense.

So this means taking a second alternative. We aim to try to keep control over the laboratories but to try to control also what kind of research is done in them. Of course, this is difficult, because there are limited funds for anything except military research. It brings the problem of establishing a student/worker alliance to the forefront too. As things stand now, the workers in the laboratories—scientists, technicians, unskilled workers—are terrified of the idea that war research might stop. In fact, when we started picketing, the Union there, whose members are mostly machinists and so forth, entered a

suit to prevent MIT from dropping war research. You can see the logic behind their action. They do not see any alternatives to war research and development within the New England economy.

We have somehow to get people to see that there are other things technology could be used for, that there is no good reason why the public subsidy they are living on should be used simply for purposes of destruction. We have to keep the issue alive and open; we have to try to reconvert the laboratories. We have to try to build up social and political pressures for a socially useful technology. It means making ideas that sound Utopian at first seem real and possible. It is a big order and we do not expect to do it in a short time.

You seem to reject the liberal idea that there can be limited reforms in American society but, at the same time, you do not seem to see much immediate future for revolutionary action.

We should set up the germs of new institutions where we can. We should try to make people realize what is wrong with this society and give them a conscious vision of the new society. Then we can go on to a program of action for great masses of people. A democratic revolution would take place when it is supported by the great mass of the people, when they know what they are doing and they know why they are doing it and they know what they want to see come into existence. Maybe not in detail, but at least in some manner. A revolution is something that great masses of people have to understand and be personally committed to.

In order to broaden the social base of the student movement, do you see good prospects for work in high schools?

The potential there is very great. According to recent reports about 60% of the high schools in America have had fairly significant student protest, usually over a political issue. This offers the same sort of potential as common action with the Richmond Oil workers in California: there is a radicalization, a politicization of a part of the population hitherto uninvolved in politics. We can envisage a loose set of connections ranging throughout high schools and colleges which could serve as the base for a really substantial political movement.

If there is going to be severe repression of the student movement, as seems more than likely, this brings out the need for better organization and for more intellectual coherence. Do you think the time for relying on ad hoc modes of action and ad hoc slogans is past?

Without a revolutionary theory or a revolutionary consciousness there is not going to be a revolutionary movement. There is not going to be a serious

movement without a clear analysis and a theoretical point of view. Naturally the student movement has to be able to defend itself against repression. This has to be broadened out beyond the student movement. The Black Panthers are subjected to intensive repression and we should not allow this to be forgotten.

What do you envisage by revolutionary theory?

There are certain crises of capitalism that cannot be overcome internally. They can be overcome only by the total reconstruction of social relations. All economic and political institutions should be placed under democratic control through direct participation by workers and by those involved because they live in a particular geographical area, for instance, or on the basis of other forms of free association. To take an example, there is at the moment a serious crisis of capitalism with respect to the problem of how to use technological resources to serve human needs rather than the need to maintain a senseless, irrational and predatory economy. This problem cannot be solved within the framework of capitalist ideology or the capitalist system of production. Certain human needs can only be expressed collectively and that requires an entirely different system. I think issues like the extension of democracy, the satisfaction of human needs, the preservation of the environment, are of the first importance. A revolutionary theory ought to be concerned with developing points of this sort and translating them into something that is immediately meaningful.

Do you not accept Leninism as the basis of the revolutionary theory you would like to see develop? Are you anti-Leninist as well as anti-Stalinist?

It would be a grotesque error to say that Stalin was simply the realization of Leninist principles or anything like that. Lenin himself insisted, quite correctly, that in a backward country like Russia the revolution could not succeed unless there was an international revolution. There are different strands in Lenin's theories. On the one hand, there is *State and Revolution,* which is basically fine, and on the other hand, there is the effective dismantling of the Soviets, there is Kronstadt and the suppression of the Workers' Opposition, which was under Lenin's aegis at least. We could go into the history of all this and we could criticize one thing and laud another. But I think there are really two competing tendencies. There is a model which stresses the leadership role of the vanguard party of committed intellectuals, which controls and determines the course of the movement. That is an aspect of the Leninist tradition which laid the groundwork for Stalin. Then, contrasted to this, there is a model which sees the revolutionary movement as based on voluntary mass associations which have control themselves and which are encouraged to exercise it, politicizing themselves in the process. This is a tendency associated more with Rosa Luxemburg and her criticisms of Lenin's concept of the

party, though, of course, we should not forget there is also the Lenin of the *April Theses* and of *State and Revolution*.

Do you not think that the Leninist tradition should be held responsible for the Chinese and Vietnamese revolutions if it is going to be held responsible for Stalinism?

Frankly I think the Chinese overestimate their dependence on the Bolshevik model and they underestimate the populist element that exists in Maoism. Without this they might not have had the success they did in involving masses of people in a way which was not characteristic of the Russian revolution.

Lenin stressed the need to involve the masses.

Yes, that is the side of Lenin which shows up in the *April Theses* and *State and Revolution*. But after the Bolsheviks took power, they followed a very different course.

What kind of explanation would you give for the Cold War? Do you accept some version of the convergence theory?

I think there is a kind of convergence in the sphere of the involvement of the technical intelligentsia at the center of power. There is an old anarchist critique of the role of the intelligentsia in bureaucracies which rings very true. There is also convergence in the evolution of large centralized economic units. But, of course, the Cold War took place without respect to any convergence of this kind. I think the main reason for the Cold War was that the Soviet Union constructed a closed order in Eastern Europe. One can see this by reading statements of the American ruling elite, like the study entitled *The Political Economy of American Foreign Policy* published in the mid-50s which identifies the primary threat of Communism as the refusal to continue to complement the industrial economies of the West. Any society which is closed is a threat to the United States. This applies both to the Soviet Union and to pre-war Japan. Of course, the Soviet threat involved socialized production and the Japanese threat did not. But basically they were threats of a very similar sort. They closed off significant areas of the world and made them inaccessible to American capital. The United States had to combat this threat. In one case, by the Pacific phase of the Second World War and, in the other case, by the Cold War.

You do not think it was also because the Soviet Union offered an alternative model of society?

An alternative model of development. If you compare the areas of the Soviet Union which are directly north of Turkey and Iran with the areas directly south of the border, there is a very striking difference in development. But the same was true of pre-war Japan and its New Order. I think the threat of

independent development is probably more important than the threat of so-
cialized production. It is a threat to the aim of constructing an international
system, dominated by the United States, in which there will be a free flow of
capital and goods and raw materials.

*But although the American economic penetration of the Soviet Union is still
relatively small, there has been a very marked shift in attitude towards a detente.
Why is China seen as so much more of a threat than the Soviet Union?*

The Soviet Union has already been given up. And it has been a long-
standing element of American belief that the China trade is going to be a
very great significance for the economic development of the United States.
That goes back to the 1780s, back to the time when the west coast of America
was settled by merchants interested in the China trade. One of the main rea-
sons why the United States took the Philippines in the late nineteenth cen-
tury was as a coaling station for the China trade. Of course, there is an
element of mythology in this, but in the formation of policy, it is what people
believe that counts, not what is true.

*All the same, that seems a very economistic line of argument. Surely both the Bolshevik
and Chinese revolutions were a threat because of force, for example, because of
the political ideological repercussions? Japan is a quite different case. The Japanese,
like the United States, tried to crush the revolution in China. That is not really true of
the Soviet Union.*

The Japanese did not set out to crush the Chinese revolution. For example,
there was no Chinese revolution in Manchuria in 1931 or North China in
1937. They set out to dominate China, and crushing the Chinese revolution
was a by-product. I think if China happened at that moment to be fascist
rather than communist, but also excluded from the present American world
system, then it would be perceived as a threat to the United States. But per-
haps I have been underestimating the ideological threat. It is true to say that
the success of a popular mass revolution, as in China, does give people else-
where ideas. It teaches people that property is not holy and that we can
make a revolution too. If China were fascist, it would not have this ideologi-
cal impact on other parts of the world, but it would still be perceived as a
danger if it were separated from the American world system and engaged on
an independent path of development.

*We would like to ask you something about your work in linguistics. Do you think
there is any connection between your specialized work there and your political
views, which you have been talking about?*

Scientific ideas and political ideas can converge and, if they converge inde-
pendently because they have each developed in the same direction, that is

fine. But they should not be made to converge at the cost of distortion and suppression, or anything like that.

For instance, in your work in linguistics, you use concepts like "freedom," "spontaneity," "creativity," "innovation" and so on. Is that connected in any way with your political views? Or is it just accidental?

A little of each. It is accidental in that the way these concepts arise in the study of **language** and the theses they sustain are appropriate or inappropriate, true or false, quite independently of politics. In that sense, it is independent. And similarly, in my opinion, **a Marxist-anarchist perspective** is justified quite apart from anything that may happen in linguistics. So that in that sense they are logically independent. But I still feel myself that there is a kind of tenuous connection. I would not want to overstate it but I think it means something to me at least. I think that anyone's political ideas or their ideas of social organization must be rooted ultimately in some concept of human nature and human needs. Now my own feeling is that the fundamental human capacity is the capacity and the need for creative self-expression, for free control of all aspects of one's life and thought. One particularly crucial realization of this capacity is the creative use of language as a free instrument of thought and expression. Now having this view of human nature and human needs, one tries to think about the modes of social organization that would permit the freest and fullest development of the individual, of each individual's potentialities in whatever direction they might take, that would permit him to be fully human in the sense of having the greatest possible scope for his freedom and initiative.

Moving along in this direction, one might actually develop a social science in which a concept of social organization is related to a concept of human nature which is empirically well-founded and which in some fashion leads even to value judgments about what form society should take, how it should change and how it should be reconstructed. I want to emphasize again that fundamentally the two are logically independent, but one can draw a sort of loose connection. This connection has been made occasionally. Von Humboldt, for example, who interests me particularly, combined a deep interest in human creativity and the creative aspect of language with what were, in the context of his time, libertarian politics.

Another concept which is crucial to your work in linguistics is that of "rules." How does that fit in with the stress on freedom?

I think that true creativity means free action within the framework of a system of rules. In art, for instance, if a person just throws cans of paint randomly at a wall, with no rules at all, no structure, that is not artistic creativity, whatever else it may be. It is a commonplace of aesthetic theory that creativity involves action that takes place within a framework of rules, but is not

narrowly determined either by the rules or by external stimuli. It is only when you have the combination of freedom and constraint that the question of creativity arises.

I would like to assume on the basis of fact and hope on the basis of confidence in the human species that there are innate structures of mind. If there are not, if humans are just plastic and random organisms, then they are fit subjects for the shaping of behavior. If humans only become as they are by random changes, then why not control that randomness by the state authority or the behaviorist technologist or anything else? Naturally I hope that it will turn out that there are intrinsic structures determining human need and fulfillment of human need.

What is the role of human history? Surely human needs and their fulfillment are historically determined. What kind of scope do you give to historical determinations?

I think we have to be very cautious about this until we have a much broader understanding of the range and extent of possible variations in human behavior. Things that seem to us great variations in language, for instance, would seem to some super-intelligence as minor modifications. As human beings, as living human beings, we are primarily interested in the differences among ourselves and that is perfectly proper. As a human being, living in the contemporary world, I am very much interested in the difference between English and Japanese because I cannot understand Japanese and it would be useful to be able to. But as a linguist I am interested in the fact that English and Japanese are rather minor modifications of a basic pattern and that other linguistic systems could be imagined which violate that basic pattern, but that they do not in fact anywhere exist. Now it is possible to carry out this study as a linguist because we can move up to a level of abstractness from which we can survey a vast class of possible systems and ask how the existing human linguistic systems fit into this class. And I think we will discover that they fit into a very narrow part of it.

A serious study of morals or of social systems would attempt the same thing. It would ask itself what kinds of social systems are conceivable. Then it would ask itself what kinds have actually been realized in history and it would ask how these came into existence, given the range of possibilities that exist at some moment of economic and cultural development. Then, having reached that point, the next question is whether the range of social systems that human beings have constructed is broad or narrow, what is its scope, what are its potentialities, are there kinds of social systems human beings could not possibly construct and so on. We have not really begun this kind of investigation. Hence it is only a guess when I say that the range of possible social systems may turn out to be very narrow. Of course, there is an enormous human significance in living in one social system rather than another, in capitalism rather than feudalism, for example. Whereas there is no

human significance, other than accidental, in speaking one language rather than another. But that is a different question from asking which kinds of system of social organization are possible for human beings and which kinds are not.

You have spoken about a possible convergence of your work in linguistics with your political ideas. Did your political ideas have any influence in the work you have done in linguistics up till now? Did they suggest hypotheses, for instance?

I do not think so. I worked for quite a few years trying to carry out a behaviorist program. As a student, I was very much convinced that it would be possible to construct simple inductive principles that would explain how language is acquired. I thought that there should be simple inductive principles which would lead directly from a corpus of data to the organization of that data and that such an organization is what language would, in fact, consist of. But at the same time I was also, on the side, trying to write generative grammars. I assumed that generative grammars were just for fun and my own private hobby. I thought the attempt to build up analytic procedures was the real stuff. It was only much later, a long time later, maybe four years of really hard work, that I finally managed to convince myself that the attempt to build up analytic procedures was nonsense and that generative grammar was the real thing.

How did you get interested in generative grammar?

It had been around a long time. As I understand Humboldt, for instance, he had a concept similar to generative grammar. In any event, whether Humboldt did or did not, one thing at least is clear. If he did have a concept of generative grammar he could not do anything with it, because he did not have the techniques for using it. There was no way to take his insights and turn them into a rich, explanatory theory. That required new notions which eventually grew out of work on the foundations of mathematics. The notion of recursive systems of rules, for example. This work only came to fruition in the 1930s. But by then most people had completely forgotten about Humboldt and his kind of insights. I happened to be very lucky since I began to study the foundations of mathematics, not thinking it had any bearing on linguistics. Of course, it turned out to be just what was needed.

I think the ideal situation would have been to have someone in 1940 who was steeped in **rationalist and romantic literary and aesthetic theory** and also happened to know **modern mathematics.** Such a person would have seen very quickly what to do. As far as I was concerned, it was pure accident. It just happened I grew up having some knowledge of historical linguistics largely because my father, who was a Hebrew scholar, was working on medieval grammatical texts and the history of the language. In historical

linguistics it is taken for granted that there are underlying processes and that you can explain things by looking at how these processes interrelate. Of course, this is usually done in a very atomistic fashion and there is not much theory or system to it, but at least the concept of explanation is there. And then, as I said, I had also done some work in modern mathematics and logic, so I was able to combine these two interests. At first, I thought it was just a hobby. It took years and years before any of it was published. Even after I was convinced myself, I still could not get it published. Very few people saw any value in this work.

Do you now think that your work on generative grammar looks forward to further scientific advances?

I think that among the biological characteristics that determine the nature of the human organism there are some that relate to intellectual development, some that relate to moral development, some that relate to development as a member of human society, some that relate to aesthetic development. I suspect that they are restrictive and that we shall find that all of these constraints can be said to constitute human nature. To a large extent, they are immutable. That is to say, they are just part of being human the same way as having legs and arms is part of being human.

Are you saying you think there is a generative grammar for social relations?

Not necessarily. That is, I do not think our capacities for having decent social relations, relations that would lead to some new form of society, would necessarily have the same structure as a generative grammar. I simply think that they must be constrained by some set of principles. But, of course, I cannot specify the principles.

You think there is some intrinsic disposition towards order in human beings which would spontaneously emerge if it was not repressed in some way?

I presume so. The only justification for any repressive institution is economic or cultural backwardness. In time, we should move to the gradual elimination of all repressive institutions without limit, as far as I can see. Just looking at the epoch that we are in now, it seems to me that our present level of technology permits enormous possibilities for eliminating repressive institutions. Automation makes it unnecessary for people to carry out the kind of imbecile labor that may have been necessary in the past. It is often said that advanced technology makes it imperative to vest control of institutions in the hands of a small managerial group. That is perfect nonsense. What automation can do first of all is to relieve people of an enormous amount of stupid labor, thus freeing them for other things. Computers also make possible a very rapid information flow. Everybody could be put in possession of vastly more information and more relevant information than they have now. Democratic decisions could be made immediately by everybody concerned.

Computers also make simulation possible, you can run simulation experiments, so that you can test decisions without bearing the cost of failure.

Of course, that is not how this technology is actually used. It is used for destructive purposes. You get a situation where, even if the Vietnam war was ended, resources would simply be redistributed to something like ABM systems. The electronics industry has not got a decent cut out of the budget since the Vietnam war got going. So they want an ABM system. The percentage of government expenditure on advanced technology has been reduced since the Vietnam war escalated, for the simple reason that you have to supply all the soldiers with uniforms and bullets and shoes and so on. But the end of the war would not divert any money to meeting collective needs on extending democratic practice. It would go back into aerospace and telecommunications, for the Defense Department or the Space Agency. Within a capitalist framework it could hardly be otherwise.

The Return of Painting

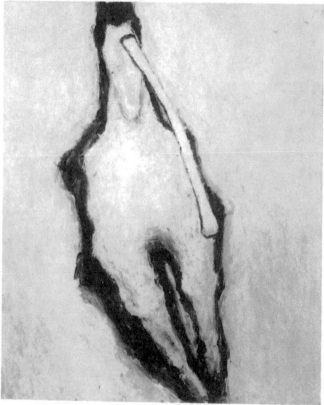

Susan Rothenberg (American, b. 1945), *For the Light*. 1978–1979.
Acrylic and flashe on canvas, 105 x 87 in. (266.7 x 221 cm).
Collection of the Whitney Museum of American Art, New York.
Purchase, with funds from Peggy and Richard Danziger. 79.23.
© 2001 Susan Rothenberg/Artists Rights Society (ARS), New York.
Photo by Geoffrey Clements.

Artists

Elizabeth Murray
Statement (1980)

The challenges posed by conceptual art practices as well as the end of Greenberg-ian formalism seemed to leave painting all but dead. However, beginning in the mid-1970s and continuing well into the 1980s, painting reasserted a strong presence in American art. Elizabeth Murray was one of a number of painters who reinvigorated painting by combining rigorous, expressive brushwork with recognizable imagery. Drawing on the tradition of past painting, Murray developed a powerful personal vocabulary of whimsical biomorphic forms that were rooted in the common objects of her everyday existence. Like other painters of her generation, Murray was uninterested in the old divisions between abstraction and representation. This strong and concise statement—which was published in the catalog that corresponded with the exhibition *American Painting: The Eighties, A Critical Interpretation* at the Grey Art Gallery in 1980—epitomizes the belief that the meaning of painting comes from the forms that emerge out of the act of painting itself. Murray's call for the autonomy of art—in particular as a discipline distinctly separate from fashion, politics, and economics—is in direct opposition to some of the radical art of the 1960s and 1970s.

I do not see a linear progression in art, nor do I feel that I should be refuting one phase in order to create the next. The most important issue in art today is to continue doing it with integrity. We are living in a critical time, and art is being threatened. Art is an important part of life and to confuse it with fashion, politics or economics can be very dangerous. Painting is an affirmation of life. The "issues" that surround painting have little relevance to my work. Discussions concerning conceptual art vs. minimal art, for example, create a false fog around the act of making art. It is stultifying.

I love looking at painting, and my work has evolved from the whole tradition of painting. As a young painter, Cézanne and Picasso influenced me the most—I learned the most from them.

I never start a painting from a clear, rational plan or from a complete drawing. I work more impulsively. Often, though, the motivation comes from the desire to make a shape or to get a certain color. The idea is to enact what happens. Although I have been working with shaped canvases lately, that doesn't mean that I won't go back to painting on canvases that are rectangular. There are shapes and figures in my paintings which refer to forms

in nature and to the human body. It is a figurative space. But the shapes are not identifiable with a specific thing. They feel like transformations. Since they are organic shapes, associations created by the viewer become inevitable. But the shape painted actually belongs to itself. The act of painting, which is a solitary one, ultimately teaches the artist about the complexity of painting.

Eric Fischl, Leon Golub, Susan Rothenberg, and Julian Schnabel
Expressionism Today: An Artist Symposium (Interviews by Carter Ratcliff and Hayden Herrera)
(1982)

By the beginning of the 1980s the term "Neo-Expressionists" came to be used for a large group of American and European painters that included Eric Fischl, Leon Golub, Susan Rothenberg, Julian Schnabel, Sigmar Polke, Anslem Kiefer, and Francesco Clemente. Although the paintings of the Neo-Expressionists addressed many different specific concerns, ranging from the psychologically charged figurative paintings of Eric Fischl to the messy mixture of representational and abstract elements in the operatic canvases of Julian Schnabel, some general characteristics tie the work together. These artists often painted on a large scale and paid a great amount of attention to the expressive qualities of the physically painted surface. They also shared a renewed interest in the process of painting as the locus of meaning for the work, but at the same time this expressive handling of the paint did not replace recognizable imagery—rather, the two elements often came together to create dense, emotionally charged works.

These statements are from "Expressionism Today: An Artist Symposium," which was published in *Art in America* in December 1982. Many people—critics as well as collectors—were energized by the fact that the theoretical posturing and the insular turf wars that seemed to epitomize the art world since the mid-1960s had given way to an unbridled expressiveness reminiscent of Modernism's romantic roots. In his statement Julian Schnabel reiterates this transcendent sentiment by saying that he is "aiming at an emotional state, a state that people can literally walk into and let themselves be engulfed by." A request for emotional resonance is evident again in Susan Rothenberg's statement when she says that her painting "alludes to some kind of power." Although this art enjoyed critical success and was highly collected, some critics were concerned that this return to the historically loaded trappings of expressive painting had parallels in the calls being made in many sectors of society for a return to traditional values.

Originally published in **ART IN AMERICA,** December 1982, Brant Publications, Inc.

ERIC FISCHL

I don't think Expressionism is the issue. I think what's going on in painting now is coming out of national identities. People have withdrawn into their own histories to try to find meanings. So you have art that seems like it can only be made out of a sensibility identified as Italian. England is enjoying a kind of rebirth. France, as well. And Germany. When Italians and Germans go back into their history, they're going back to their strengths. A lot of American art is going back to sources, too—the '50s, Pop Art—which I don't think is going back far enough. As you go back farther than that, you get to a time when America was more isolated—when its strengths are not easy to find, because American artists were very influenced by Europeans. It's almost like a denial of American strength to go back into American history— say, sixty years. One thing I love about people like Dove and O'Keeffe and Hartley is that there is this kind of dumbness to their work, a directness—the difference between Dove's abstractions and Kandinsky's is so great. Dove's are so literal and nudgy. But I respond to that. I understand it. I find that those qualities are in my own work, that there is an awkwardness to the forms or to the narrative moment.

Expressionism has been important to me, though, especially the paintings of Max Beckmann. When I was an abstract painter, I found Beckmann's *The Departure* interesting, exciting, but I thought, forget it. I can't deal with this. Then one day I stopped in front of it and said, I'll just repeat back to myself what I'm seeing, and see if it makes sense. What I discovered was that I could grasp the intention of the picture exactly, without understanding the allegory, without knowing this or that figure was a particular mythical character. I could see it simply as a complete narrative, and the discovery of narrative painting was much more important to me than Expressionism as a style.

The Departure made me feel how bankrupt abstraction had become, that it had somehow gotten to the point where I didn't trust what I was seeing in an abstract painting. The image always seemed to mean something hidden, so that I had to know outside references in order to know the particular meaning of that painting. And there was Beckmann's *Departure*, a work of art whose meanings were all inside it. Its references weren't art references. They were cultural, so I could hook up certain parts of the image to political violence or historical moments or religious values—all those things that belong to the general culture. And I thought that was great. It made sense. I find Beckmann's mythical characters fascinating, but I don't find references to them in American culture or in my own education. I think about achieving that level of myth in my own work, somehow tapping that source, but it doesn't happen, for what I think are cultural reasons. America just doesn't have that wellspring of iconography.

The most interesting quality of Beckmann's story-telling is the psychological one—the relationships of men and women, and how those relationships expand, usually in a painting's outside panels. So personal matters have broad implications. They refer to social and political issues. And the range of Beckmann's pictorial language is so great. There'll be parts simply delineated with a black line, then filled in with a single flesh color, and other areas of the painting where he is psychologically investing a lot into an arm, a breast, a leg, a detail of a varicose vein on the back of a calf. This is where you can feel his obsession. I find that experientially rich, and I miss it in artists like Kirchner or Nolde, who give a flatter presentation of the whole event. The psychology of Beckmann's art is to possess the subject. It's unique.

The direct approach of the other Expressionists—not Beckmann— where the painter tries to put everything into one gesture, is unsubtle. I find that I need, now, to get quieter, to have parts of a painting be very quiet. So I'm becoming much tighter as I paint, which I wonder about, except that—I think about Degas, and how you can always tell what area of a canvas he was interested in. You know from a distance that a certain image is a vase, and on close inspection it turns out to be just a set of brushstrokes. Beckmann did that on psychological terms. His way of painting says that this character is less important than that one, or this part of the body is less important than that one.

Art is like theater. In theater, if you want to whisper, you have to whisper loudly enough so that the audience hears you, and the audience also has to know it's a whisper. So the artist has to be able to blow the subtleties up proportionately, and at the same time have them be recognized as subtle. It's what marks a good artist, even if he is painting badly. He has to tip his hand, to let you know he's a good artist painting badly. Ultimately, painting is a craft. There are better craftsmen and worse. After an Abstract Expressionist smears the canvas for twenty years, it's ridiculous for him to pretend he doesn't know what he's doing. He knows exactly what he's doing. By then, his craft has developed as far as it's going to develop, and it's a question of being a mature artist who works with the world in a certain way, who continues to work with it. It's important for a painter to have the formal means to deal with his vision of the world, but it also helps if that vision is an interesting one.

LEON GOLUB

The claim of Expressionism, which is partially justified, is that feeling will burst out, that you can't repress feeling. And with it will come a style that's appropriate. Brushy paint, fast paint, which permits more emotion. What

happens in Expressionism is that some things come out intentionally, and other things may appear at the edges—certain recognitions, certain who-knows-what? The Neo-Expressionists are a secondary extrapolation of the primary Expressionists, so their painting has to have more opacity. On one level, these artists are very hip, they are very aware. On another level, they don't have the directness that the originals had, the early German Expressionists, who didn't have all that time to layer the image in quite the same way.

I've always had an Expressionist bias as against, let's say, a totally realist bias, which says that the totality of visual facts, put together, equals the viewing of the world. My basic early sources were outside of Western culture—Northwest coast Indian art, Pre-Columbian art. Then I jumped into late Greek and Roman stuff, in an attempt to objectify some of this primitivism. So I have never paid a tremendous amount of attention to the Expressionists, although I was very fond, at a certain point, of the early, crazy etchings and drawings of George Grosz—those semi-Futuristic things where you could see through a building and someone was scratching his armpit, and others were getting ready to fuck—you could see through their clothing. I liked Grosz's edginess. And I liked his attempt to take on the styles, the manner, of the Expressionists, who in their own way were quite detached, and then to focus all those stylistic developments in an image that was not contemplative, that could not be assimilated to a comfortable point of view. I liked his disruptiveness, his attempt to present an obdurate image, a report—some bad news, perhaps—but so ferocious in style that it couldn't be brushed away, dismissed as mere art. And of course I like that because it's what I try to do in my own painting.

SUSAN ROTHENBERG

When asked if I'm an Expressionist, I've always said, "I suppose so." To me "Expressionism" means expressing a personal view point about reality, but the word also means "juicy." I guess I'm a semi-Expressionist in terms of the visuals and surfaces of my paintings. That I've been placed in the new wave of Neo-Expressionism I find more confusing than the new painting itself. There is some awfully good painting going on, and it's a good time for painting—I like the energy and the heat that's around. But I find some of the rationalizations that some of the practitioners use awfully banal and young, and I'm also saturated with the untamed self-indulgence, the "young man addressing the world-body of knowledge" and the marketing aspects of the art world right now. It's all changed so much, even since 1978.

I think Expressionism just zipped in to fill the vacuum of Minimalism. Things rush into empty places and Minimal art had become an empty place. I'm interested in essences too, which Minimalism was certainly about, taking

things from the particular rather than the general. A lot of these younger people address general aspects of contemporary life. But sometimes it seems as if a lot of their information is not well digested or thought through. A little bit of heart and depth are missing. Those things are sacrificed for the sake of something else and it's that something else that I don't know about. Technically, some of the work is very good. I like what Julian is doing, what Cindy Sherman is doing.

I'm not a great museum goer or church hopper. Sometimes I find things I love—I just got knocked out by the great tall Bartholomew in the El Greco show, and the *View of Toledo*—it's so great to build up levels like that, to make a visionary landscape—but it's rare for me to have an awesome experience with art. I would rather go to the movies than to a museum. I've got some mis-match names that I relate to a lot—Giotto, Johns, Goya, Velázquez, Mondrian, Borofsky—some old, some new. My work comes right out of Jasper Johns's targets. In terms of goals, I'd like to be like Mondrian in the control I'd exert.

The way the horse image appeared in my paintings was not an intellectual procedure. Most of my work is not run through a rational part of my brain. It comes from a place in me that I don't choose to examine. I just let it come. I don't have any special affection for horses. A terrific cypress will do it for me too. But I knew that the horse is a powerful, recognizable thing, and that it would take care of my need for an image. For years I didn't give much thought to why I was using a horse. I just thought about wholes and parts, figures and space.

Then I did the human heads and hands. I started with nine-inch studies—mesmerizing at that size, and I suppose I connected to it because that's what I work with, a head and a hand, and I thought, why not paint it. Then I blew them up to ten by ten feet and they became very confrontational.

After the year of doing those enormous heads and hands, I felt I had finished with that problem. There were no variations that I was interested in exploring, and I thought I'd move to oil paints. When I taught myself oil painting, I was living on a creek in Long Island and there were boats parked out front. There were swans in the water. I started painting boats to learn how to use oils after a dozen years of acrylic.

What I think the work was starting to talk about is growing, taking journeys. The boat became a symbol to me—about the freedom I was feeling. Sailboats are beautiful—they're light and they depend on wind. They suggest qualities of light and atmospheric conditions. They started to lead me down a different avenue of painting. There is some kind of space now. Shadow and movement. Depth and resonance. At first I was horrified. "Christ—what is this, Neo-Impressionism?" But if I have to put black behind the swan so it will sit right there and look right, I do it. There need not be so strict an image and ground. Instead I had a figure and a sense of location.

In *10 Men*, I pared the idea of a group down so much that all that was left was a figure and a shadow. That figure has the quality of a Giacometti man in a big place. This has been remarked on. I can remember a time when I would have gotten ruffled at the thought of being compared to Giacometti, because I thought he was old-fashioned and stylized, but certainly I now have enough sense of the problem and respect for a great artist to appreciate that if you are going to mess with the human body you're likely to run into him.

My paintings are still really visceral. It comes back to trying to invent new forms to stand in for the body since I don't want to make a realist painting. I wanted to get that body down in paint, free it from its anatomical confines. I'm very aware of my body in space—shoulders, frontal positions. I have a body language that is difficult to explain. A lot of my work is about body orientation, both in the making of the work and in the sensing of space, comparing it to my own physical orientation.

I'm also teasing myself with some other problems. If I could paint a painting about New York City, how would I do it? If I wanted to paint a landscape, would I choose a panorama or a blade of grass? I'd like to do portraits. The paintings wouldn't be realistic. I'd probably do something weird. I'll need to make the human figure more specific, rather than addressing myself to the body orientation and gut-felt thing, which has been the raft on which I've floated for a long time.

JULIAN SCHNABEL

I don't know why "Expressionism" has emerged today. I hate generalities. A few artists do something, they paint in a certain way because it is their way of mediating the world. They put their finger on the pulse of their time and open up a set of possibilities. Then others jump into that space and fill it up, like protoplasm. One notion about the function of painting was exhausted, and painters were looking for a possible way of continuing to paint. Artists of the Greenbergian school were extracting the meaning out of what they were doing. Finally they were just messing around with color and paint in a very monastic way. It didn't have a hell of a lot that was essential about it. For me it didn't seem plausible or pertinent. It wasn't the kind of sensory and psychological experience that I thought one could get through art.

Then the works of the so-called "Expressionist" artists came along; they were noticeably different in appearance, and there was a noticeable difference in the artists' intentions—what they wanted these objects to mean in the world. The art was less elitist, less hermetic. Its subject matter was more overtly related to life.

My painting comes out of the continuum of art that has been. It's not antiart in any way. It's just an art that can get up and stick its head out of the window and do things that were maybe impossible before. Different artists from the past have touched me, and I have looked to their paintings. I went to the Dahlem Museum in Berlin and the paintings that stuck in my mind were by van Eyck and Dürer. Also a Masaccio tondo. There was a Vermeer of a girl with pearls looking in the mirror that just broke my heart. Vermeer makes you resee life.

We have to look at all the Mexican muralists. There were some great things—Orozco, Siqueiros, Diego Rivera. It might have been nice to see some Orozco paintings in that "Zeitgeist" show in Berlin. I like Frida Kahlo's work a lot. She's an unsung hero. I think she's really important if you think about Expressionism or art with a purpose. There's a painting I made called *Painting Without Mercy* which had a figure that looked like it came right out of Max Beckmann. But it didn't. You internalize all that information; then you make something that is in concert with the experience of it.

Something radiates out of paintings, a feeling, whether it be of time or place or the light at a certain moment in the day. It is all about clear recognition of something. I could see Vermeer's thought. I could see his acuity and understanding. Vermeer expressed his understanding of light and time in a way that is indelible. If that's Expressionism, then I guess I'm an Expressionist. If not, I would say I'm not an Expressionist; my work is just expressive.

I'm not distorting things in my paintings. I'm selecting things that have already been distorted in life, and painting them pretty true to their contour. It's not interpretive. My brushstrokes are not emotional. It's the way they configure together that becomes emotional. Some paintings are brushy and I don't think they're emotional at all. Also, maybe the work isn't designed to illustrate how I do or don't feel about something. My painting is more about what I think the world is like than what I think I'm like. I'm aiming at an emotional state, a state that people can literally walk into and let themselves be engulfed by. Some people might think my paintings are ugly. I think the feeling that you get from them is a feeling of beauty. They're very morose, also—like Beethoven. There's something heartbroken about Beethoven. In my last show the paintings were all parts of one state of consciousness. It had a chapellike feeling. I wanted to have a feeling of God in it. Now I don't know if there's a God up there or anywhere. I'm talking about everything that's outside of you and everything that's inside of you. Maybe I make paintings larger than I am so that I can step into them and they can massage me into a state of unspeakableness.

The paintings in my last show are the view from the bridge, the bridge between life and death. I think about death all the time. The painting called *Rest* is about after a bullfight. During the bullfight there's one moment just before the end when the bull has been stuck by the picador and is breathing heavily. There's blood coming out of his back. Everybody is waiting. There

is the glare of the sun and this adrenaline quality to the event, a compression of time.

My work, like all art, is formal as well as subjective. The way color functions is part of the subject. Color colors the meaning. I don't always choose a color beforehand. As you work on a painting, a color may have nothing to do with anything except that you like green next to violet or gray next to cadmium red. Some of my paintings are very thin; some of the velvet paintings are gossamer. Some are very heavy. It's like screaming sometimes and whispering other times.

The thing that interests me about primitive art is its directness and primariness, something carved out of wood with an incredible economy. Also, I'm interested in it in a sociological way. I think my paintings do something besides hang on the wall in back of people's couches. All my paintings have a function, so they're real things in the way that primitive objects might have been real, usable or magical things to the Indians in Mexico. My paintings allude to some kind of power. But they're really not primitive at all. They're pretty sophisticated. They are solar-powered energy generators. They seem to be alive in some way.

The thing that is most important is the direct connection between the artist and the work, and the viewer and the work. My presumption is that if the viewer becomes conscious of these realizations about life and death in my paintings, the world might be a better place. It's as fundamental as that.

Critics

Barbara Rose
American Painting: The Eighties (1980)

Curated by Barbara Rose, *American Painting: The Eighties* was one of the first large exhibitions to signal a shift away from the radical avant-garde practices of 1960s and 1970s. This essay was published in the catalog to the exhibition, which was held at the Grey Art Gallery in New York City in 1980. Conceptual art's pronouncement of the death of painting was being challenged by a new generation of artists. Painting was again seen as a vital form of artistic expression. Many critics invigorated by the energy being breathed into painting by artists like Elizabeth Murray, Susan Rothenberg, and Sam Gilliam. In Rose's view the paintings of these and other artists had moved beyond Minimalism's and Conceptualism's assertion of the actual and the political to a newfound faith in the power of painted forms to communicate

transcendent ideas. In addition, these artists did not view painting in Greenbergian terms as being on a linear procession toward purity of form and the suppression of content. By reconnecting with the tradition of painting, as a guide to the future, not as a nostalgic return, the painting of the 1980s reclaimed imagery without ignoring the modernist resistance to illusion. The use of recognizable images was digested through the imagination, not depicted in reality. This new generation of artists had, in Rose's view, reanimated painting by concentrating on the "sensuous, tactile qualities of surface, as well as the metaphorical and metaphysical aspects of imagery that is the unique capacity of painting to deliver."

You know exactly what I think about photography. I would like to see it make people despise painting until something else will make photography unbearable.

> —Marcel Duchamp (Beinecke Library, Yale)
> Letter to Alfred Stieglitz, May 17, 1922

To hold that one kind of art must be invariably superior or inferior to another kind means to judge before experiencing; and the whole history of art is there to demonstrate the futility of rules of preference laid down beforehand: the impossibility, that is, of anticipating the outcome of aesthetic experience . . . connoisseurs of the future may be able, in their discourse, to distinguish and name more aspects of quality in the Old Masters, as well as in abstract art, than we can. And in doing these things they may find much more common ground between the Old Masters and abstract art than we ourselves can yet recognize.

> —Clement Greenberg,
> "Abstract, Representational and so forth," 1954

Ten years ago, the question, "Is painting dead?" was seriously being raised as artist after artist deserted the illusory world of the canvas for the "real" world of three-dimensional objects, performances in actual time and space, or the secondhand duplication of reality in mechanically reproduced images of video, film and photography. The traditional activity of painting, especially hand painting with brush on canvas, as it had been practiced in the West since oil painting replaced manuscript illumination and frescoed murals, seemed to offer no possibility for innovation, no potential for novelty so startling it could compete with the popular culture for attention, with the capacity of the factory for mass production, or the power of political movements to make history and change men's minds. In the context of the psychedelic sixties and the post–Viet Nam seventies, painting seemed dwarfed and diminished compared with what was going on outside the studio. In the past, of course, the painter would never have compared his activity with the practical side of life; but by the time Senator Javits presented President Kennedy with an American flag painted by Jasper Johns, the idea that art was an activity parallel in some way with politics, business, technology and entertainment was on the way to becoming a mass delusion.

Once Andy Warhol not only painted the headlines, but appeared in them as well, the potential parity of the artist with the pop star or the sports hero was stimulating the drive to compete instilled in every American by our educational system. In the past, a painter might compete with the best of his peers, or in the case of the really ambitious and gifted, with the Old Masters themselves; but now, the celebrated dissolution of the boundary between art and life compelled the artist to compete with the politician for power, with the factory for productivity, and with pop culture for sensation and novelty.

Perhaps most pernicious, the drive toward novelty, which began to seem impossible to attain within the strictly delimitative conventions of easel painting, was further encouraged by the two dominant critical concepts of the sixties and seventies: the first was the idea that quality was in some way inextricably linked to or even a by-product of innovation; the second was that since quality was not definable, art only needed to be interesting instead of good. These two crudely positivistic formulations of critical criteria did more to discourage serious art and its appreciation than any amount of indifference in the preceding decades. The definition of quality as something that required verification to give criticism its authority contributed to the identification of quality with innovation. For if quality judgments had any claim to objectivity they had to be based on the idea that an artist did something *first*—a historical fact that could be verified through documentation. The further erosion of critical authority was accomplished in other quarters by the denial that quality was in any way a transcendent characteristic of the art work; for if a work validated its existence primarily by being "interesting" (i.e., novel), then qualitative distinctions were no longer necessary. Far more aligned than they might appear at first, these two materialist critical positions conspired to make painting less than it had ever been, to narrow its horizons to the vanishing point.

Thus, in the sixties and seventies, criticism militated on two fronts against styles that were based on continuity instead of rupture with an existing tradition. The term "radical" vied with "advanced" as the greatest accolade in the critic's vocabulary. Slow-moving, painstaking tortoises were outdistanced by swift hares, hopping over one another to reach the finish line where painting disappeared into nothingness. Such an eschatological interpretation of art history was the inevitable result of the pressure to make one's mark through innovation; for those who could not be first, at least there was the possibility of being the first to be last.

I. REDUCING RECIPES

This drive toward reductivism, encouraged and supported by a rigorously positivist criticism that outlawed any discussions of content and metaphor

as belonging to the unspeakable realm of the ineffable, was a surprising fi-
nale to Abstract Expressionism, which had begun with an idealistic Utopian
program for preserving not only the Western tradition of painting, but also
the entire Greco-Roman system of moral and cultural values. Of course this
was to ask of art more than art could deliver; the revulsion against such rhet-
oric was a primary reason for the rejection of Abstract Expressionist aesthet-
ics by pop and minimal artists beginning around 1960.

To be accurate, however, one must recall that the subversion of Ab-
stract Expressionism began within the ranks of the movement itself. A pop-
ular art world joke described the demise of "action painting" as follows:
Newman closed the window, Rothko pulled down the shade, and Rein-
hardt turned out the lights. A gross oversimplification of the critique of ges-
tural styles by these three absolutist artists, this pithy epithet indicates the
superficial manner in which the works of Newman, Rothko and Reinhardt
were interpreted by art students throughout America, anxious to take their
places in the limelight and the art market, without traveling the full dis-
tance of the arduous route that transformed late Abstract Expressionism
into simplified styles subsuming elements from earlier modern movements
into a synthesis that, while reductive, was still a synthesis. What lay behind
Abstract Expressionism was forgotten ancient history in the art schools,
where recipes for instant styles (two tablespoons Reinhardt, one half-cup
Newman, a dash of Rothko with Jasper Johns frosting was a favorite)
pressed immature artists into claiming superficial trademarks. These styles
in turn were authenticated by art historians trained only in modern art his-
tory, and quickly exported to Europe, where World War II and its aftermath
had created an actual historical rupture and an anxiety to catch up and
overtake American art by starting out with the *dernier cri*. Soon the minimal,
monochromatic styles that imitated Newman, Rothko and Reinhardt in a
way no less shameless than the manner de Kooning's Tenth Street admirers
copied the look of his works, gave a bad name to good painting on both
sides of the Atlantic.

Yet more disastrous in its implications was the haste to find a recipe for
instant innovation in Pollock's complex abstractions. Not well represented
in New York museums, rarely seen in the provinces at all, these daring
works were essentially known through reproduction and in the widely dif-
fused photographs and films Hans Namuth made of Pollock at work. The
focus on Pollock as a performer in action rather than as a contemplative critic
of his own work and student of the Old Masters—which was closer to the
truth—meshed perfectly with the American proclivity to act first, think later.
With little or no idea of what had gone into the making of Pollock's so-called
"drip" paintings, which vaulted him into international celebrity as the last
artist to genuinely *épater le bourgeois*, young artists turned to Happenings, the
"theater of action," and other forms of public performance. Later, Namuth's
photographs, which made the liquid paint look solid, promoted a series of

random "distributional" pieces of materials poured, dropped or dumped on the floor of museums and galleries. These ephemera signaled the end of minimal art in a misguided attempt to literalize Pollock's "drip" paintings in actual space.

This is not to say that all the artists of the sixties and seventies who interpreted Abstract Expressionism literally—seizing on those aspects of the works of the New York School that seemed most unlike European art—were cynical or meretricious. But they were hopelessly provincial. And it is as provincial that most of the art of the last two decades is likely to be viewed when the twentieth century is seen in historical perspective. By provincial, I mean art that is determined predominantly by topical references in reaction to local concerns, to the degree that it lacks the capacity to transcend inbred national habits of mind to express a universal truth. In the sixties and seventies, the assertion of a specifically American consciousness was an objective to be pursued instead of avoided. The Abstract Expressionist by and large had European or immigrant backgrounds; they rejected the strictly "American" expression as an impediment to universality. Beginning around 1960, however, the pursuit of a distinctively American art by native-born artists provided the rationale for the variety of puritanically precise and literalist styles that have dominated American art since Abstract Expressionism. A reductive literalism became the aesthetic credo; the characteristics of painting as mute objects were elevated over those of painting as illusion or allusion.

II. TECHNIQUE AS CONTENT

Even those artists who maintained closer contact with the European tradition, like Bannard and Olitski, avoiding the provincial American look, were unable to find more in painting than leftovers from the last banquet of the School of Paris, *art informel*. However, *tachiste* art, with its emphasis on materials, was nearly as literal as the local American styles. The absence of imagery in Yves Klein's monochrome "blue" paintings, the ultimate *informel* works, identifies content not with imagery or pictorial structure, but with technique and materials. In identifying image and content with materials, *informel* styles coincided with the objective literalist direction of American painting after Abstract Expressionism.

The identification of content with technique and materials rather than image, however, also had its roots in Abstract Expressionism. In seeking an alternative to Cubism, the Abstract Expressionist, influenced by the Surrealist, came to believe that formal invention was primarily to be achieved through technical innovation. To some extent, this was true; automatic procedures contributed in large measure to freeing the New York School from Cubist structure, space and facture. But once these automatic processes were divorced from their image-creating function, in styles that disavowed

drawing as a remnant of the dead European past to be purged, the absence of imagery threw the entire burden of pictorial expression on the intrinsic properties of materials. The result was an imageless, or virtually imageless, abstract painting as fundamentally materially oriented as the literal "object art" it purported to oppose.

The radicality of object art consisted of converting the plastic elements of illusion in painting—i.e., light, space and scale—into actual properties lacking any imaginative, subjective or transcendental dimension. No intercession by the imagination was required to infer them as realities because they were *a priori* "real." This conversion of what was illusory in painting into literal realties corresponds specifically to the process of reification. As the fundamental characteristic of recent American art, anti-illusionism reveals the extent to which art, in the service of proclaiming its "reality," has ironically been further alienated from the life of the imagination. The *reductio ad absurdem* of this tendency to make actual what in the past had been a function of the imagination was so-called "process art," which illustrated the procedure of gestural painting, without committing itself to creating images of any permanence that would permit future judgment. In conceptual art, the further reification of criticism was undertaken by minds too impotent to create art, too terrified to be judged, and too ambitious to settle for less than the status of the artist.

Thus it was in the course of the past two decades that first the criticism, and then the art that reduced it to formula and impotent theory, became so detached from sensuous experience that the work of art itself could ultimately be conceived as superfluous to the art activity—which by now epitomized precisely that alienation and reification it nominally criticized. Such were the possibilities of historical contradiction in the "revolutionary" climate of the sixties and seventies. In painting, or what remained of it, a similar process of reification of the illusory was undertaken. Edge had to be literal and not drawn so as not to suggest illusion; shape and structure had to coincide with one another to proclaim themselves as sufficiently "real" for painting to satisfy the requirements of radicality. In reducing painting to nothing other or more than its material components, rejecting all forms of illusionism as *retardataire* and European, radical art was forced to renounce any kind of illusive or allusive imagery simply to remain radical. And it was as *radical* that the ambitious artist felt compelled to identify himself. In its own terms, the pursuit of radicality was a triumph of positivism; the rectangular colored surface inevitably became an object as literal as the box in the room. Even vestigial allusions of landscape in the loaded surface style that evolved from stained painting in gelled, cracked or coagulated pigment—reminiscent of Ernst's experiments with decalcomania—express a nostalgia for meaning, rather than any convincing metaphor. For radicality demanded that imagery, presumably dependent on the outmoded conventions of representational art, was to be avoided at all costs. The result of

such a wholesale rejection of imagery, which cut across the lines from minimal to color-field painting in recent years, was to create a great hunger for images. This appetite was gratified by the art market with photography and Photo-Realism.

III. AGAINST PHOTOGRAPHY

Photography and the slick painting styles related to it answered the appetite for images; but they did so at the enormous price of sacrificing all the sensuous, tactile qualities of surface, as well as the metaphorical and metaphysical aspects of imagery that it is the unique capacity of painting to deliver. Pop art, which is based on reproduced images, had self-consciously mimicked the impersonal surfaces of photography, but Photo-Realism rejected this ironic distance and aped the documentary image without embarrassment. In a brilliant analysis of the limitations of photography ("What's All This About Photography?" *Artforum*, Vol. 17, No. 9, May 1979), painter Richard Hennessy defines the crucial differences between photographic and pictorial imagery. A devastating argument against photography ever being other than a minor art because of its intrinsic inability to transcend reality, no matter what its degree of abstraction, the article makes a compelling case for the necessity of painting, not only as an expressive human activity, but also as our only present hope for preserving major art, since the subjugation of sculpture and architecture to economic concerns leaves only painting genuinely "liberal" in the sense of free.

According to Hennessy, photography, and by inference painting styles derived from it, lacks surface qualities, alienating it from sensuous experience. More than any of the so-called optical painting styles, photography truly addresses itself to eyesight alone. Upon close inspection, the detail of photography breaks down into a uniform chemical film—that is, into something other than the image it records—in a way that painterly detail, whether an autonomous abstract stroke, or a particle of legible representation as in the Old Masters, does not. Thus it is the visible record of the activity of the human hand, as it builds surfaces experienced as tactile, that differentiates painting from mechanically reproduced imagery. (Conversely, the call for styles that are exclusively *optical* may indicate a critical taste unconsciously influenced in its preference by daily commerce with the opticality of reproduced images.)

The absence of the marks of the human hand that characterizes the detached automatic techniques of paint application with spraygun, sponge, spilling, mopping and screening typical of recent American painting, relates it to graphic art as well as to mechanical reproductions that are stamped and printed.

IV. EXAMPLE OF HOFMANN

Among the first painters to insist on a "maximal" art that is sensuous, tactile, imagistic, metaphorical and subjective, Hennessy himself painted in a variety of styles, examining the means and methods of the artists he most admired—Picasso, Matisse, Klee, Miró, and above all Hans Hofmann. The latter has come to symbolize for many younger painters the courage to experiment with different styles, to mature late, after a long career of assimilating elements from the modern movements in a synthesis that is inclusive and not reductive. Indeed, Hofmann's commitment to preserving all that remained alive in the Western tradition of painting, while rejecting all that was worn out by convention or superseded by more complex formulation, has become the goal of the courageous and ambitious painters today.

Who could have predicted in 1966, when Hofmann, teacher of the Abstract Expressionists, who brought Matisse's and Kandinsky's principles to New York, died in his eighties, that the late-blooming artist would become the model for those ready to stake their lives on the idea that painting had not died with him? Hofmann's example was important in many ways, for he had remained throughout his life an easel painter, untempted by the architectural aspirations of the "big picture" that dwarfed the viewer in its awesome environmental expanse. Conscious of allover design, Hofmann nevertheless chose to orient his paintings in one direction, almost always vertically, the position that parallels that of the viewer. The vertical orientation, which implies confrontation, rather than the domination of the viewer by the painting, is also typical of many of the artists of the eighties, who accept the conventions of easel painting as a discipline worthy of preservation. Moreover, Hofmann had also turned his back on pure automatism, after early experiments with dripping. Like Hofmann, with few exceptions, the artists who follow his example maintain that painting is a matter of an image that is frontal and based on human scale relationships. They paint on the wall, on stretched canvases that are roughly life-size, working often from preliminary drawings, using brushes or palette knives that record the marks of personal involvement and hand craft, balancing out spatial tensions by carefully revising, as Hofmann did.

Of course, not all the artists I am speaking of have a specific debt to Hofmann. In fact, the serious painters of the eighties are an extremely heterogeneous group—some abstract, some representational. But they are united on a sufficient number of critical issues that it is possible to isolate them as a group. They are, in the first place, dedicated to the preservation of painting as a transcendental high art, a major art, and an art of universal as opposed to local or topical significance. Their aesthetic, which synthesizes tactile with optical qualities, defines itself in conscious opposition to photography and all forms of mechanical reproduction which seek to deprive the art work of its unique "aura." It is, in fact, the enhancement of this aura,

through a variety of means, that painting now self-consciously intends—either by emphasizing the involvement of the artist's hand, or by creating highly individual visionary images that cannot be confused either with reality itself or with one another. Such a commitment to unique images necessarily rejects seriality as well.

V. THE PAINTER AS IMAGE MAKER

These painters will probably find it odd, and perhaps even disagreeable, since they are individualists of the first order, to be spoken of as a group, especially since for the most part they are unknown to one another. However, all are equally committed to a distinctively humanistic art that defines itself in opposition to the *a priori* and the mechanical: A machine cannot do it, a computer cannot reproduce it, another artist cannot execute it. Nor does their painting in any way resemble prints, graphic art, advertising, billboards, etc. Highly and consciously structured in its final evolution (often after a long process of being refined in preliminary drawings and paper studies), these paintings are clearly the works of rational adult humans, not a monkey, a child, or a lunatic. Here it should be said that although there is a considerable amount of painting that continues Pop Art's mockery of reproduced images—some of it extremely well done—there is a level of cynicism, sarcasm and parody in such work that puts it outside the realm of high art, placing it more properly in the context of caricature and social satire.

The imagery of painters committed exclusively to a tradition of painting, an inner world of stored images ranging from Altamira to Pollock, is entirely invented; it is the product exclusively of the individual imagination rather than a mirror of the ephemeral external world of objective reality. Even when such images are strictly geometric, as in the case of artists like Susanna Tanger, Lenny Contino, Peter Pinchbeck, Elaine Cohen, Georges Noel and Robert Feero, they are quirky and sometimes eccentrically personal interpretations of geometry—always asymmetrical or skewed, implying a dynamic and precarious balance, the opposite of the static immobility of the centered icon, emblem or insignia. The rejection of symmetry and of literal interpretations of "allover" design, such as the repeated motifs of Pattern Painting, defines this art as exclusively *pictorial;* it is as unrelated to the repetitious motifs of the decorative arts and the static centeredness of ornament as it is to graphics and photography. For the rejection of the encroachments made on painting by the minor arts is another of the defining characteristics of the serious painting of the eighties.

Although these artists refuse to literalize any of the elements of painting, including that of "allover" design, some, like Howard Buchwald, Joan Thorne, Nancy Graves and Mark Schlesinger, are taking up the challenge of

Pollock's allover paintings in a variety of ways without imitating Pollock's image. Buchwald, for example, builds up a strong rhythmic counterpoint of curved strokes punctuated by linear slices and ovoid sections cut through the canvas at angles and points determined by a system of perspective projections referring to space in front of, rather than behind, the picture plane. Thorne and Graves superimpose several different imagery systems, corresponding to the layers of Pollock's interwoven skeins of paint, upon one another. Schlesinger, on the other hand, refers to Pollock's antecedents in the allover stippling of Neo-Impressionism, which he converts into images of jagged-edged spiraling comets suggesting a plunge into deep space while remaining clearly on the surface by eschewing any references to value contrasts or sculptural modeling. These original and individual interpretations of "allover" structure point to the wide number of choices still available within pictorial as opposed to decorative art. For in submitting itself to the supporting role that decorative styles inevitably play in relationship to architecture, painting renounces its claims to autonomy.

VI. THE LEGACY OF POLLOCK

To a large number of these artists, Pollock's heroism was not taking the big risk of allowing much to chance, but his success in depicting a life-affirming image in an apparent state of emergence, evolution and flux—a flickering, dancing image that never permits the eye to come to rest on a single focus. Like Pollock's inspired art, some of these paintings emphasize images that seem to be in a state of evolution. Images of birth and growth like Lois Lane's bulbs, buds and hands and Susan Rothenberg's desperate animals and figures that seem about to burst the membrane of the canvas to be born before us, or Robert Moskowitz's boldly hieratic windmill that stands erect in firm but unaggressive confrontation—a profound metaphor of a man holding his ground—are powerful metaphors. In the works of Lenny Contino and Dennis Ashbaugh, as well as in Carol Engelson's processional panels, a kind of surface dazzle and optical excitement recall the energy and sheer physical exhilaration that proclaimed the underlying image of Pollock's work as the life force itself. Because he was able to create an image resonant with meaning and rich with emotional association without resorting to the conventions of representational art, Pollock remains the primary touchstone. The balance he achieved between abstract form and allusive content now appears as a renewed goal more than twenty years after Pollock's death.

As rich in its potential as Cubism, Abstract Expressionism is only now beginning to be understood in a profound instead of a superficial way. What is emerging from careful scrutiny of its achievements is that the major areas of breakthrough of the New York School were not the "big picture," automatism,

action painting, flatness, et al., but the synthesis of painting and drawing, and a new conception of figuration that freed the image from its roots in representational art. For Cubism, while fracturing, distorting and in other ways splintering the image (something neither Abstract Expressionism nor the wholistic art that came from it did) could never free itself of the conventions of representational art to become fully abstract.

Drawing on discoveries that came after Pollock regarding the role of figuration in post-Cubist painting, artists today are at ease with a variety of representational possibilities that derive, not from Cubist figuration, but from the continuity of image with surface established by Still, Rothko, Newman and Reinhardt, who embedded, so to speak, the figure in the carpet, in such a way as to make figure and field covalent and coextensive.

In the current climate of carefully considered re-evaluation, the rejection of figure-ground relationships, which artists of the sixties labelled as superannuated conventions inherited from Cubism, is being reviewed and reformulated in more subtle and less brutal terms. Cutting the figure out of the ground to eliminate the recession of shapes behind the plane was an instant short-cut solution to a complex problem. Ripping the figure from the ground eliminated figure-ground discontinuities in a typically Duchampesque solution of negating the problem. (Interestingly, Johns, usually considered Duchamp's direct heir, backed off from the objectness of the *Flag*, in which he identified image with field, and found another solution to reconciling representation with flatness by embedding the figure in the ground in later works such as *Flag on Orange Field*.)

Short-cuts, recipes, textbook theorizing and instant solutions to difficult problems are being rejected today as much as trademarks and the mass-produced implications of seriality. Today, subtler modes of dealing with the relationship between image and ground without evoking Cubist space are being evolved. Even artists like Carl Apfelschnitt, Sam Gilliam and Ron Gorchov, who alter the shape of the stretcher somewhat, do so not to identify their painting as virtual objects, but to amplify the meaning of imagery, Apfelschnitt and Gorchov, for example, make totemic images whose sense of presence relies on metaphorical associations with shields and archaic devices; Gilliam bevels the edge of his rectangular canvas to permit freer play to his landscape illusion, insuring that his dappled Impressionism cannot be interpreted as the naive illusion of a garden through a window.

VII. POST-CUBIST REPRESENTATION

The difficulties of reconciling figuration, the mode of depicting images whether abstract or representational, with post-Cubist space has been resolved by these painters in a variety of ways. Precedents for post-Cubist representation exist in Pollock's black-and-white paintings, and more recently

in Guston's figurative style. Drawing directly in paint, as opposed to using drawing as a means to contour shape, has given a new freedom to artists like Nancy Graves, Richard Hennessy, William Ridenhour, Anna Bialobroda, Steven Sloman and Luisa Chase. In that post-Cubist representation is not based on an abstraction from the external objective world, but on self-generated images, it is a mental construct as conceptual in origin as the loftiest non-objective painting. Lacking any horizon line, Susan Rothenberg's white-on-white horse, Lois Lane's black-on-black tulips, and Robert Moskowitz's red-on-red windmill, or Gary Stephan's brown-on-brown torso have more in common with Malevich's *White-on-White* or Reinhardt's black crosses in black fields than with any realist painting. Like Dubuffet's *Cows*—perhaps the first example of post-Cubist representation—and Johns's targets and numbers, these images are visually embedded in their fields, whose surface they continue. This contiguity between image and field, enhanced by an equivalence of facture in both, identifies image and field with the surface plane in a manner that is convincingly modernist.

The possibility of depicting an image without resorting to Cubist figure-ground relationships greatly enlarges the potential of modernist painting for the future. No longer does the painter who wishes to employ the full range of pictorial possibilities have to choose between a reductivist suicide or a retrenchment back to realism. By incorporating discoveries regarding the potential for figuration with an abstract space implicit in Monet, Matisse, and Miró, as this potential was refined by Pollock and the color-field painters, an artist may choose a representational style that is not realist.

Today, it is primarily in their pursuit of legible, stable, imagistic styles—both abstract and representational—structured as indivisible wholes (another legacy of color-field painting) rather than composed in the traditional Cubist manner of adding on parts that rhyme and echo one another that modernist painters are united. Even those who make use of loosely geometric structures for painterly brushwork, like Mark Lancaster, Pete Omlor and Pierre Haubensak, do so in a highly equivocal way that does not allude to Cubic figure-ground inversions, but rather recalls Impressionist and Fauve integrations of the figure into the ground. Their images suggest poetic associations with the grid of windows, a play on the illusion of the picture as window; but they do not pretend in any way that the picture *is* in any way a window. Still others, like Thornton Willis, Vered Lieb, Susan Crile, and Frances Barth, are even freer in their use of geometry as a structuring container for color, rather than as a rigid *a priori* category of ideal forms.

In all of these cases, the representation of an image never invokes naive illusionism; to remain valid as a modernist concept, figuration is rendered compatible with flatness. This may mean nothing more radical than Clive Bell's assumption that a painting must proclaim itself as such before it is a woman, a horse or a sunrise, or Serusier's definition of a painting as a flat

surface covered with patches of color. However, it does necessitate conveying the information that the depicted image is incontrovertibly two-dimensional, that it lies on the plane, and not behind it. The contiguity of image with ground is established often as the Impressionists did, by an allover rhythmic stroking. All that in Cubism remained as vestigial references to the representational past of painting—value contrast, modeling, perspective, overlapping, receding planes, etc.—is eliminated so that the space of painting cannot be confused with real space. Once the truth of the illusion of painting is acknowledged—and *illusion, not flatness, is the essence of painting*—the artist is free to manipulate and transform imagery into all manner of illusions belonging exclusively to the realm of the pictorial, i.e., the realm of the imagination. Moreover, since the depicted illusions belong to the imagination, i.e., they are registered by the brain and the eye, surface, perceived as constituted of pigment on canvas, can be manipulated to evoke a tactile response that has nothing to do with the experience of a third dimension, but is entirely a matter of texture.

The difference between a painting that is composed, a process of addition and subtraction, and one that is constructed, through a structuring process that takes into consideration the architecture of the frame, continues to be a primary consideration. These artists take a responsibility to structure for granted, just as they reject the random, the chance and the automatic as categories of the irresponsible. In this sense, decision-making, the process of deliberation, becomes a moral as well as an aesthetic imperative.

Sifting through the modern movements, panning the gold and discarding the dross, the painters of the eighties, as we have seen, retain much from Abstract Expressionism. In many cases, there is a commitment to a kinetic or visceral metaphor. However, this appeal to empathy in the energetic and muscular images of Elizabeth Murray, Dennis Ashbaugh, Stewart Hitch, Georges Noel, Howard Buchwald, Robert Feero and Joan Thorne, or in the movement implied by Susan Rothenberg, Edward Youkilis and Joanna Mayor, has more in common with the "life-enhancing" quality Bernard Berenson identified as our empathic identification with Signorelli's nudes than with the documentary and autobiographical gestures of "action painting."

VIII. THE FUNCTION OF THE IMAGINATION

Today, the essence of painting is being redefined not as a narrow, arid and reductive anti-illusionism, but as a rich, varied capacity to birth new images into an old world. The new generation of painters who have matured slowly, skeptically, privately, and with great difficulty, have had to struggle to maintain conviction in an art that the media and the museums said was dying. Today, it is not the literal material properties of painting as pigment on cloth, but its capacity to materialize an image, not behind the picture plane, which

self-awareness proclaims inviolate, but behind the proverbial looking-glass of consciousness, where the depth of the imagination knows no limits. If an illusion of space is evoked, it is simultaneously rescinded. In one way or another, either in terms of Hofmann's "push–pull" balancing out of pictorial tensions, or by calling attention to the actual location of the plane by emphasizing the physical build-up of pigment on top of it, or by embedding the figure into its contiguous field, serious painting today does not ignore the fundamental assumptions of modernism, which precludes any regression to the conventions of realist representation.

Not innovation, but originality, individuality and synthesis are the marks of quality in art today, as they have always been. Not material flatness—in itself a contradiction, since even thin canvas has a third dimension and any mark on it creates space—but the capacity of painting to evoke, imply and conjure up magical illusions that exist in an imaginative mental space, which like the atmospheric space of a Miró, a Rothko or a Newman, or the cosmic space of a Kandinsky or a Pollock, cannot be confused with the tangible space outside the canvas, is that which differentiates painting from the other arts and from the everyday visual experiences of life itself.

The idea that painting is somehow a visionary and not a material art, and that the locus of its inspiration is in the artist's subjective unconscious, was the crucial idea that Surrealism passed on to Abstract Expressionism. After two decades of the rejection of imaginative poetic fantasy for the purportedly greater "reality" of an objective art based exclusively on verifiable fact, the current rehabilitation of the metaphorical and metaphysical implications of imagery is a validation of a basic Surrealist insight. The liberating potential of art is not as literal reportage, but as a catharsis of the imagination.

The Surrealists believed, and no one has yet proved them wrong, that psychic liberation is the prerequisite of political liberation, and not vice-versa. For most of the twentieth century, the relationship between art and politics has been an absurd confusion, sometimes comic, sometimes tragic. The idea that to be valid or important art must be "radical" is at the heart of this confusion. By aspiring to power, specifically political power, art imitates the compromises of politics and renounces its essential role as moral example. By turning away from power and protest, by making of their art a moral example of mature responsibility and judicious reflection, a small group of painters "taking a stand within the self," as Ortega y Gasset described Goethe's morality, is redeeming for art a high place in culture that recent years have seen it voluntarily abdicate for the cheap thrill of instant impact.

Because the creation of individual, subjective images, ungoverned and ungovernable by any system of public thought or political exigency, is *ipso facto* revolutionary and subversive of the status quo, it is a tautology that art must strive to be radical. On the contrary, that art which commits itself self-consciously to radicality—which usually means the technically and

materially radical, since only technique and not the content of the mind advances—is a mirror of the world as it is and not a critique of it.

Even Herbert Marcuse was forced to revise the Marxist assumption that in the perfect Utopian society, art would disappear. In his last book, *The Aesthetic Dimension*, he concludes that even an unrepressed, unalienated world "would not signal the end of art, the overcoming of tragedy, the reconciliation of the Dionysian and the Apollonian. . . . In all its ideality, art bears witness to the truth of dialectical materialism—the permanent non-identity between subject and object, individual and individual." Marcuse identifies the only truly revolutionary art as the expression of subjectivity, the private vision:

> The "flight into inwardness" and the insistence on a private sphere may well serve as bulwarks against a society which administers all dimensions of human existence. Inwardness and subjectivity may well become the inner and outer space for the subversion of experience, for the emergence of another universe.

For art, the patricidal act of severing itself from tradition and convention is equally suicidal, the self-hatred of the artist expressed in eliminating the hand, typical of the art of the last two decades, can only lead to the death of painting. Such a powerful wish to annihilate personal expression implies that the artist does not love his creation. And it is obvious that an activity practiced not out of love, but out of competition, hatred, protest, the need to dominate materials, institutions or other people, or simply to gain social status in a world that canonizes as well as cannibalizes the artist, is not only alienated but doomed. For art is labor, physical human labor, the labor of birth, reflected in the many images that appear as in a process of emergence, as if taking form before us.

The renewed conviction in the future of painting on the part of a happy few signals a shift in values. Instead of trying to escape from history, there is a new generation of artists ready to confront the past without succumbing to nostalgia, ready to learn without imitating, courageous enough to create works for a future no one can be sure will come, ready to take their place, as Gorky put it, in the chain of continuity of "the great group dance."

This is a generation of hold-outs, a generation of survivors of catastrophes, both personal and historical, which are pointless to enumerate, since their art depends on transcending the petty personal soap opera in the service of the grand, universal statement. They have survived a drug culture that consumed many of the best talents of their time; they have lived through a crisis of disintegrating morality, social demoralization and lack of conviction in all authority and tradition destroyed by cultural relativism and individual cynicism. And they have stood their ground, maintaining a conviction in quality and values, a belief in art as a mode of transcendence, a worldly incarnation of the ideal. Perhaps they, more than the generations who interpreted his lessons as

license, have truly understood why Duchamp was obsessed by alchemy. Alchemy is the science of trans-substantiation; the tragedy of Duchamp's life was that he could only study alchemy because he could not practice it. To transform matter into some higher form, one must believe in transcendence. As a rationalist, a materialist and a positivist, Duchamp could not practice an art based on the transformation of physical matter into intangible energy and light. Those who perpetuate an art that filled him with ennui are the last of the true believers; their conviction in the future of painting is a courageous and constructive act of faith.

Context

Irving Kristol
The Adversary Culture of Intellectuals (1979)

"The Adversary Culture of Intellectuals," which was originally published in 1979 in the magazine *Encounter,* established Kristol at the forefront of neoconservative political thought. In this essay Irving Kristol takes issue with the desire on the part of intellectuals to criticize the values of bourgeois culture. Kristol represented a growing number of people who by the end of the 1970s were fed up with the ever more vocal anti-capitalist stance that epitomized much of the radicalism of the 1960s and 1970s. In Kristol's view America is unique in that it is the first civilization whose intellectuals and artists are at odds with both the values and ideals of the civilization itself. In attempting to understand the roots of what he sees as the now-ingrained critical positions of anti-bourgeois intellectuals, Kristol traces their lines of rebellion from the mainstream through romanticism, socialism, and Modernism. Kristol only speaks in general terms about Modernism and does not differentiate between the more radical anti-aesthetic positions endemic of much of the art of the 1960s and 1970s and the painting of the 1980s, which was aesthetically driven. Ironically, in more radical artistic circles, the resurgence and unprecedented financial success of painting in the late 1970s and 1980s was viewed as a parallel to the neoconservative positions epitomized by Kristol.

Originally published in *Encounter* © 1979, also collected in *Neoconservation: The Autobiography of an Idea* (New York: Free Press, 1995) by Irving Kristol. Reprinted by permission of Irving Kristol c/o Writers' Representatives, Inc.

No sooner did the late Lionel Trilling coin the phrase "adversary culture" than it became part of the common vocabulary. This is because it so neatly summed up a phenomenon that all of us, vaguely or acutely, had observed. It is hardly to be denied that the culture that educates us—the patterns of perception and thought our children absorb in their schools, at every level— is unfriendly (at the least) to the commercial civilization, the bourgeois civilization, within which most of us live and work. When we send our sons and daughters to college, we may expect that by the time they are graduated they are likely to have a lower opinion of our social economic order than when they entered. We know this from opinion poll data, we know it from our own experience.

We are so used to this fact of our lives, we take it so for granted, that we fail to realize how extraordinary it is. Has there ever been, in all of recorded history, a civilization whose culture was at odds with the values and ideals of that civilization itself? It is not uncommon that a culture will be critical of the civilization that sustains it—and always critical of the failure of this civilization to realize perfectly the ideals that it claims as inspiration. Such criticism is implicit or explicit in Aristophanes and Euripides, Dante and Shakespeare. But to take an adversary posture toward the ideals themselves? That is unprecedented. A few writers and thinkers of a heretical bent, dispersed at the margins of the culture, might do so. But culture as a whole has always been assigned the task of, and invariably accepted responsibility for, sustaining and celebrating those values. Indeed, it is a premise of modern sociological and anthropological theory that it is the essence of culture to be "functional" in this way.

Yet ours is not. The more "cultivated" a person is in our society, the more disaffected and malcontent he is likely to be—a disaffection, moreover, directed not only at the actuality of our society but at the ideality as well. Indeed, the ideality may be more strenuously opposed than the actuality. It was, I think, Oscar Wilde who observed that, while he rather liked the average American, he found the ideal American contemptible. Our contemporary culture is considerably less tolerant of actuality than was Oscar Wilde. But there is little doubt that if it had to choose between the two, it would prefer the actual to the ideal.

The average "less cultivated" American, of course, feels no great uneasiness with either the actual or the ideal. This explains why the Marxist vision of a radicalized working class erupting into rebellion against capitalist society has turned out to be so erroneous. Radicalism, in our day, finds more fertile ground among the college-educated than among the high school graduates, the former experienced more exposure to some kind of adversary culture, the latter—until recently, at least—having its own kind of "popular" culture that is more accommodating to the bourgeois world that working people inhabit. But this very disjunction of those two cultures is itself a

unique phenomenon of the bourgeois era, and represents, as we shall see, a response to the emergence, in the nineteenth century, of an "avant-garde," which laid the basis for our adversary culture.

Bourgeois society is without a doubt the most prosaic of all possible societies. It is prosaic in the literal sense. The novel written in prose, dealing with the (only somewhat) extraordinary adventures of ordinary people, is its original and characteristic art form, replacing the epic poem, the lyric poem, the poetic drama, the religious hymn. These latter were appropriate to societies formally and officially committed to transcendent ideals of excellence—ideals that could be realized only by those few of exceptional nobility of character—or to transcendent visions of the universe wherein human existence on earth is accorded only a provisional significance. But bourgeois society is uninterested in such transcendence, which at best it tolerates as a private affair, a matter for individual taste and individual consumption, as it were. It is prosaic, not only in form, but in essence. It is a society organized for the convenience and comfort of common men and common women, not for the production of heroic, memorable figures. It is a society interested in making the best of this world, not in any kind of transfiguration, whether through tragedy or piety.

Because this society proposes to make the best of this world, for the benefit of ordinary men and women, it roots itself in the most worldly and common of human motivations: self-interest. It assumes that, though only a few are capable of pursuing excellence, everyone is capable of recognizing and pursuing his own self-interest. This "democratic" assumption about the equal potential of human nature, in this limited respect, in turn justifies a market economy in which each individual defines his own well-being, and illegitimates all the paternalistic economic theories of previous eras. One should emphasize, however, that the pursuit of excellence by the few—whether defined in religious, moral, or intellectual terms—is neither prohibited nor inhibited. Such an activity is merely interpreted as a special form of self-interest, which may be freely pursued but can claim no official status. Bourgeois society also assumes that the average individual's conception of his own self-interest will be sufficiently "enlightened"—that is, sufficiently farsighted and prudent—to permit other human passions (the desire for community, the sense of human sympathy, the moral conscience, etc.) to find expression, albeit always in a voluntarist form.

It is characteristic of a bourgeois culture, when it exists in concord with bourgeois principles, that we are permitted to take "happy endings" seriously (" . . . and they lived happily ever after"). From classical antiquity through the Renaissance, happy endings—worldly happy endings—were consigned to the genre of Comedy. "Serious" art focused on a meaningful death, in the context of heroism in battle, passion in love, ambition in politics, or piety in religion. Such high seriousness ran counter to the bourgeois grain, which perceived human fulfillment—human authenticity, if you

will—in terms of becoming a good citizen, a good husband, a good provider. It is, in contrast to both prebourgeois and postbourgeois *Weltanschauungen*, a *domestic* conception of the universe and of man's place therein.

This bourgeois ideal is much closer to the Old Testament than to the New—which is, perhaps, why Jews have felt more at home in the bourgeois world than in any other. That God created this world and affirmed its goodness; that men ought confidently to be fruitful and multiply; that work (including that kind of work we call commerce) is elevating rather than demeaning; that the impulse to "better one's condition" (to use a favorite phrase of Adam Smith's) is good because natural—these beliefs were almost perfectly congruent with the worldview of postexilic Judaism. In this worldview, there was no trace of aristocratic bias: Everyman was no allegorical figure but, literally, every common person.

So it is not surprising that the bourgeois worldview—placing the needs and desires of ordinary men and women at its center—was (and still is) also popular among the common people. Nor is it surprising that, almost from the beginning, it was an unstable worldview, evoking active contempt in a minority, and a pervasive disquiet among those who, more successful than others in having bettered their condition, had the leisure to wonder if life did not, perhaps, have more interesting and remote possibilities to offer.

The emergence of romanticism in the middle of the eighteenth century provided an early warning signal that, within the middle class itself, a kind of nonbourgeois spiritual impulse was at work. Not antibourgeois; not yet. For romanticism—with its celebration of noble savages, *Weltschmerz*, passionate love, aristocratic heroes and heroines, savage terrors confronted with haughty boldness and courage—was mainly an escapist aesthetic mode as distinct from a rebellious one. It provided a kind of counterculture that was, on the whole, safely insulated from bourgeois reality, and could even be tolerated (though always uneasily) as a temporary therapeutic distraction from the serious business of living. A clear sign of this self-limitation of the romantic impulse was the degree to which it was generated, and consumed, by a particular section of the middle class: women.

One of the less happy consequences of the women's liberation movement of the past couple of decades is the distorted view it has encouraged of the history of women under capitalism. This history is interpreted in terms of repression—sexual repression above all. That repression was real enough, of course; but it is absurd to regard it as nothing but an expression of masculine possessiveness, even vindictiveness. Sexual repression—and that whole code of feminine conduct we have come to call Victorian—was imposed and enforced by women, not men (who stand to gain very little if *all* women are chaste). And women insisted on this code because, while sexually repressive, it was also liberating in all sorts of other ways. Specifically, it liberated women, ideally if not always actually, from their previous condition as sex objects or work objects. To put it another way: All women were now elevated

to the aristocratic status of *ladies,* entitled to a formal deference, respect, consideration. (Even today, some of those habits survive, if weakly—taking off one's hat when greeting a female acquaintance, standing up when a woman enters the room, etc.) The "wench," as had been portrayed in Shakespeare's plays, was not dead. She was still very much to be found in the working and lower classes. But her condition was not immutable; she, too, could become a lady—through marriage, education, or sheer force of will.

The price for this remarkable elevation of women's status was sexual self-restraint and self-denial, which made them, in a sense, owners of valuable (if intangible) property. It is reasonable to think that this change in actual sexual mores had something to do with the rise of romanticism, with its strong erotic component, in literature—the return of the repressed, as Freud was later to call it. For most of those who purchased romantic novels, or borrowed them (for a fee) from the newly established circulating libraries, were women. Indeed they still are, even today, two centuries later, though the romantic novel is now an exclusively popular art form, which flourishes outside the world of "serious" writing.

This extraordinary and ironical transformation of the novel from a prosaic art form—a tradition that reached its apogee in Jane Austen—to something radically different was itself a bourgeois accomplishment. It was made possible by the growing affluence of the middle classes that provided not only the purchasing power but also the leisure and the solitude ("a room of one's own"). This last point is worth especial notice.

It is a peculiarity of the novel that, unlike all previous art forms, it gains rather than loses from becoming a private experience. Though novels were still occasionally read aloud all during the romantic era, they need not be and gradually ceased to be. Whereas Shakespeare or Racine is most "enchanting" as part of a public experience—on a stage, in daylight—the novel gains its greatest power over us when we "consume" it (or it consumes us) in silence and privacy. Reading a novel then becomes something like surrendering oneself to an especially powerful daydream. The bourgeois ethos, oriented toward prosaic actualities, strongly disapproves of such daydreaming (which is why, even today, a businessman will prefer not to be known as an avid reader of novels, and few in fact are). But bourgeois women very soon discovered that living simultaneously in the two worlds of nonbourgeois "romance" and bourgeois "reality" was superior to living in either one.

The men and women who wrote such novels (or poems—one thinks of Byron) were not, however, simply responding to a market incentive. Writers and artists may have originally been receptive to a bourgeois society because of the far greater individual freedoms that it offered them; and because, too, they could not help but be exhilarated by the heightened vitality and quickened vivacity of a capitalist order with its emphasis on progress, economic growth, and liberation from age-old constraints. But, very quickly, disillusionment and dissent set in, and the urge to escape became compelling.

From the point of view of artists and of those whom we have come to call "intellectuals"—a category itself created by bourgeois society, which converted philosophers into *philosophes* engaged in the task of critical enlightenment—there were three great flaws in the new order of things.

First of all, it threatened to be very boring. Though the idea of ennui did not become a prominent theme in literature until the nineteenth century, there can be little doubt that the experience is considerably older than its literary expression. One can say this with some confidence because, throughout history, artists and writers have been so candidly contemptuous of commercial activity between consenting adults, regarding it as an activity that tends to coarsen and trivialize the human spirit. And since bourgeois society was above all else a commercial society—the first in all of recorded history in which the commercial ethos was sovereign over all others—their exasperation was bound to be all the more acute. Later on, the term "philistinism" would emerge to encapsulate the object of this sentiment.

Second, though a commercial society may offer artists and writers all sorts of desirable things—freedom of expression especially, popularity and affluence occasionally—it did (and does) deprive them of the status that they naturally feel themselves entitled to. Artists and writers and thinkers always have taken themselves to be Very Important People, and they are outraged by a society that merely tolerates them, no matter how generously. Bertolt Brecht was once asked how he could justify his Communist loyalties when his plays could neither be published nor performed in the USSR, while his royalties in the West made him a wealthy man. His quick rejoinder was "Well, there at least they take me seriously!" Artists and intellectuals are always more respectful of a regime that takes their work and ideas "seriously." To be placed at a far distance from social and political power is, for such people, a deprivation.

Third, a commercial society, a society whose civilization is shaped by market transactions, is always likely to reflect the appetites and preferences of common men and women. Each may not have much money, but there are so many of them that their tastes are decisive. Artists and intellectuals see this as an inversion of the natural order of things, since it gives "vulgarity" the power to dominate where and when it can. By their very nature "elitists" (as one now says), they believe that a civilization should be shaped by an *aristoi* to which they will be organically attached no matter how perilously. The consumerist and environmentalist movements of our own day reflect this aristocratic impulse, albeit in a distorted way: Because the democratic idea is the only legitimating political idea of our era, it is claimed that the market does not truly reflect people's preferences, which are deformed by the power of advertising. A minority, however, is presumed to have the education and the will to avoid such deformation. And this minority then claims the paternalist authority to represent "the people" in some more authentic sense. It is this minority which is so appalled by America's

"automobile civilization," in which everyone owns a car, while it is not appalled at all by the fact that in the Soviet Union only a privileged few are able to do so.

In sum, intellectuals and artists will be (as they have been) restive in a bourgeois-capitalist society. The popularity of romanticism in the century after 1750 testifies to this fact, as the artists led an "inner emigration" of the spirit—which, however, left the actual world unchanged. But not all such restiveness found refuge in escapism. Rebellion was an alternative route, as the emergence of various socialist philosophies and movements early in the nineteenth century demonstrated.

Socialism (of whatever kind) is a romantic passion that operates within a rationalist framework. It aims to construct a human community in which *everyone* places the common good—as defined, necessarily, by an intellectual and moral elite—before his own individual interests and appetites. The intention was not new—there is not a religion in the world that has failed to preach and expound it. What was new was the belief that such self-denial could be realized, not through a voluntary circumscription of individual appetites (as Rousseau had, for example, argued in his *Social Contract*) but even while the aggregate of human appetites was being increasingly satisfied by ever-growing material prosperity. What Marx called "utopian" socialism was frequently defined by the notion that human appetites were insatiable, and that a self-limitation on such appetites was a precondition for a socialist community. The trouble with this notion, from a political point of view, was that it was not likely to appeal to more than a small minority of men and women at any one time. Marxian "scientific" socialism, in contrast, promised to remove this conflict between actual and potentially ideal human nature by creating an economy of such abundance that appetite as a social force would, as it were, wither away.

Behind this promise, of course, was the profound belief that modern science—including the social sciences, and especially including scientific economics—would gradually but ineluctably provide humanity with modes of control over nature (and human nature, too) that would permit the modern world radically to transcend all those limitations of the human condition previously taken to be "natural." The trouble with implementing this belief, however, was that the majority of men and women were no more capable of comprehending a "science of society," and of developing a "consciousness" appropriate to it, than they were of practicing austere self-denial. A socialist elite, therefore, was indispensable to mobilize the masses for their own ultimate self-transformation. And the techniques of such mobilization would themselves of necessity be scientific—what moralists would call "Machiavellian"—in that they had to treat the masses as objects of manipulation so that eventually they would achieve a condition where they could properly be subjects of their own history making.

Michael Polanyi has described this "dynamic coupling" of a romantic moral passion with a ruthlessly scientific conception of man, his world, and his history as a case of "moral inversion." That is to say, it is the moral passion that legitimates the claims of scientific socialism to absolute truth, while it is the objective necessities that legitimate every possible form of political immorality. Such a dynamic coupling characterized, in the past, only certain religious movements. In the nineteenth and twentieth centuries, it became the property of secular political movements that sought the universal regeneration of mankind in the here and now.

The appeal of any such movement to intellectuals is clear enough. As intellectuals, they are qualified candidates for membership in the elite that leads such movements, and they can thus give free expression to their natural impulse for authority and power. They can do so, moreover, within an ideological context, which reassures them that, any superficial evidence to the contrary notwithstanding, they are disinterestedly serving the "true" interests of the people.

But the reality principle—*la force des choses*—will, in the end, always prevail over utopian passions. The fate of intellectuals under socialism is disillusionment, dissent, exile, silence. In politics, means determine ends, and socialism everywhere finds its incarnation in coercive bureaucracies that are contemptuously dismissive of the ideals that presumably legitimize them, even while establishing these ideals as a petrified orthodoxy. The most interesting fact of contemporary intellectual life is the utter incapacity of so-called socialist countries to produce socialist intellectuals—or even, for that matter, to tolerate socialist intellectuals. If you want to meet active socialist intellectuals, you can go to Oxford or Berkeley or Paris or Rome. There is no point in going to Moscow or Peking or Belgrade or Bucharest or Havana. Socialism today is a dead end for the very intellectuals who have played so significant a role in moving the modern world down that street.

In addition to that romantic-rationalist rebellion we call socialism, there is another mode of "alienation" and rebellion that may be, in the longer run, more important. This is romantic antirationalism, which takes a cultural rather than political form. It is this movement specifically that Trilling had in mind when he referred to the adversary culture.

Taking its inspiration from literary romanticism, this rebellion first created a new kind of "inner emigration"—physical as well as spiritual—in the form of "bohemia." In Paris, in the 1820s and 1830s, there formed enclaves of (mostly) young people who displayed *in nuce* all the symptoms of the counterculture of the 1960s. Drugs, sexual promiscuity, long hair for men and short hair for women, working-class dress (the "jeans" of the day), a high suicide rate—anything and everything that would separate them from the bourgeois order. The one striking difference between this bohemia and its heirs of a century and a quarter later is that to claim membership in bohemia

one had to be (or pretend to be) a producer of "art," while in the 1960s to be a consumer was sufficient. For this transition to occur, the attitudes and values of bohemia had to permeate a vast area of bourgeois society itself. The engine and vehicle of this transition was the "modernist" movement in the arts, which in the century after 1850 gradually displaced the traditional, the established, the "academic."

The history and meaning of this movement are amply described and brilliantly analyzed by Daniel Bell in his *The Cultural Contradictions of Capitalism* (1976). Suffice it to say here that modernism in the arts can best be understood as a quasi-religious rebellion against bourgeois sobriety, rather than simply as a series of aesthetic innovations. The very structure of this movement bears a striking resemblance to that of the various gnostic-heretical sects within Judaism and Christianity. There is an "elect"—the artists themselves—who possess the esoteric and redeeming knowledge (*gnosis*); then there are the "critics," whose task it is to convey this gnosis, as a vehicle of conversion, to potential adherents to the movement. And then there is the outer layer of "sympathizers" and "fellow travelers"—mainly bourgeois "consumers" of the modernist arts—who help popularize and legitimate the movement within the wider realms of public opinion.

One can even press the analogy further. It is striking, for instance, that modernist movements in the arts no longer claim to create "beauty" but to reveal the "truth" about humanity in its present condition. Beauty is defined by an aesthetic tradition that finds expression in the public's "taste." But the modern artist rejects the sovereignty of public taste, since truth can never be a matter of taste. This truth always involves an indictment of the existing order of things, while holding out the promise, for those whose sensibilities have been suitably reformed, of a redemption of the spirit (now called "the self"). Moreover, the artist himself now becomes the central figure in the artistic enterprise—he is the hero of his own work, the sacrificial redeemer of us all, the only person capable of that transcendence that gives a liberating meaning to our lives. The artist—painter, poet, novelist, composer—who lives to a ripe old age of contentment with fame and fortune strikes us as having abandoned, if not betrayed his "mission." We think it more appropriate that artists should die young and tormented. The extraordinarily high suicide rate among modern artists would have baffled our ancestors, who assumed that the artist—like any other *secular* person—aimed to achieve recognition and prosperity in this world.

Our ancestors would have been baffled, too, by the enormous importance of critics and of criticism in modern culture. It is fascinating to pick up a standard anthology in the history of literary criticism and to observe that, prior to 1800, there is very little that we would designate as literary criticism, as distinct from philosophical tracts on aesthetics. Shakespeare had no contemporary critics to explain his plays to the audience; nor did the Greek tragedians, nor Dante, Racine, and so forth. Yet we desperately feel the need

of critics to understand, not only the modern artist, but, by retrospective reevaluation, all artists. The reason for this odd state of affairs is that we are looking for something in these artists—a redeeming knowledge of ourselves and our human condition—which in previous eras was felt to lie elsewhere, in religious traditions especially.

The modernist movement in the arts gathered momentum slowly, and the first visible sign of its success was the gradual acceptance of the fact that bourgeois society had within it two cultures: the "avant-garde" culture of modernism, and the "popular culture" of the majority. The self-designation of modernism as avant-garde is itself illuminating. The term is of military origin, and means not, as we are now inclined to think, merely the latest in cultural or intellectual fashion, but the foremost assault troops in a military attack. It was a term popularized by Saint-Simon to describe the role of his utopian-socialist sect vis-à-vis the bourgeois order, and was then taken over by modernist innovators in the arts. The avant-garde is, and always has been, fully self-conscious of its hostile intentions toward the bourgeois world. Until 1914, such hostility was as likely to move intellectuals and artists toward the romantic Right as toward the romantic Left. But Right or Left, the hostility was intransigent. This is, as has been noted, a cultural phenomenon without historical precedent.

And so is the popular culture of the bourgeois era, though here again we are so familiar with the phenomenon that we fail to perceive its originality. It is hard to think of a single historical instance where a society presents us with two cultures, a "high" and a "low," whose values are in opposition to one another. We are certainly familiar with the fact that any culture has its more sophisticated and its more popular aspects, differentiated by the level of education needed to move from the one to the other. But the values embodied in these two aspects were basically homogeneous: The sophisticated expression did not *shock* the popular, nor did the popular incite feelings of revulsion among the sophisticated. Indeed, it was taken as a mark of true artistic greatness for a writer or artist to encompass both aspects of his culture. The Greek tragedies were performed before all the citizens of Athens; Dante's *Divine Comedy* was read aloud in the squares of Florence to a large and motley assemblage; and Shakespeare's plays were enacted before a similarly mixed audience.

The popular culture of the bourgeois era, after 1870 or so, tended to be a culture that educated people despised, or tolerated contemptuously. The age of Richardson, Jane Austen, Walter Scott, and Dickens—an age in which excellence and popularity needed not to contradict one another, in which the distinction between "highbrow" and "lowbrow" made no sense—was over. The spiritual energy that made for artistic excellence was absorbed by the modernist, highbrow movement, while popular culture degenerated into a banal reiteration—almost purely commercial in intent—of "wholesome" bourgeois themes.

In this popular literature of romance and adventure, the "happy ending" not only survived but became a standard cliché. The occasional unhappy ending, involving a sinful action (e.g., adultery) as its effectual cause, always concluded on a note of repentance, and was the occasion for a cathartic "good cry." In "serious" works of literature in the twentieth century, of course, the happy ending is under an almost total prohibition. It is also worth making mention of the fact that popular literature remained very much a commodity consumed by women, whose commitments to the bourgeois order (a "domestic" order, remember) has always been stronger than men's. This is why the women's liberation movement of the past two decades, which is so powerfully moving the female sensibility in an antibourgeois direction, is such a significant cultural event.

In the last century, the modernist movement in the arts made constant progress at the expense of the popular. It was, after all, the only serious art available to young men and women who were inclined to address themselves to solemn questions about the meaning of life (or "the meaning of it all"). The contemporaneous evolution of liberal capitalism itself encouraged modernism in its quest for moral and spiritual hegemony. It did this in three ways.

First, the increasing affluence that capitalism provided to so many individuals made it possible for them (or, more often, for their children) to relax their energetic pursuit of money, and of the goods that money can buy, in favor of an attention to those nonmaterial goods that used to be called "the higher things in life." The antibourgeois arts in the twentieth century soon came to be quite generously financed by restless, uneasy, and vaguely discontented bourgeois money.

Second, that spirit of worldly rationalism so characteristic of a commercial society and its business civilization (and so well described by Max Weber and Joseph Schumpeter) had the effect of delegitimizing all merely traditional beliefs, tasks, and attitudes. The "new," constructed by design or out of the passion of a moment, came to seem inherently superior to the old and established, this latter having emerged "blindly" out of the interaction of generations. This mode of thinking vindicated the socialist ideal of a planned society. But it also vindicated an anarchic, antinomian, "expressionist" impulse in matters cultural and spiritual.

Third, the tremendous expansion—especially after World War II—of postsecondary education provided a powerful institutional milieu for modernist tastes and attitudes among the mass of both teachers and students. Lionel Trilling, in *Beyond Culture*, poignantly describes the spiritual vitality with which this process began in the humanities—the professors were "liberated" to teach the books that most profoundly moved and interested them—and the vulgarized version of modernism that soon became the mass counterculture among their students who, as consumers, converted it into a pseudobohemian lifestyle.

Simultaneously, and more obviously, in the social sciences, the anti-bourgeois socialist traditions were absorbed as a matter of course, with "the study of society" coming quickly and surely to mean the management of social change by an elite who understood the verities of social structure and social trends. Economics, as the science of making the best choices in a hard world of inevitable scarcity, resisted for a long while; but the Keynesian revolution—with its promise of permanent prosperity through government management of fiscal and monetary policy—eventually brought much of the economics profession in line with the other social sciences.

So utopian rationalism and utopian romanticism have, between them, established their hegemony as adversary cultures over the modem consciousness and the modem sensibility.

But, inevitably, such victories are accompanied by failure and disillusionment. As socialist reality disappoints, socialist thought fragments into heterogeneous conflicting sects, all of them trying to keep the utopian spark alive while devising explanations for the squalid nature of socialist reality. One is reminded of the experience of Christianity in the first and second centuries, but with this crucial difference: Christianity, as a religion of transcendence, of *otherworldly* hope, of faith not belief, was not really utopian, and the Church Fathers were able to transform the Christian rebellion against the ancient world into a new, vital Christian orthodoxy, teaching its adherents how to live virtuously, that is, how to seek human fulfillment in this world even while waiting for their eventual migration into a better one. Socialism, lacking this transcendent dimension, is purely and simply trapped in this world, whose realities are for it nothing more than an endless series of frustrations. It is no accident, as the Marxists would say, that there is no credible doctrine of "socialist virtue"—a doctrine informing individuals how actually to live "in authenticity" as distinct from empty rhetoric about "autonomous self-fulfillment"—in any nation (and there are so many!) now calling itself socialist. It is paradoxically true that otherworldly religions are more capable of providing authoritative guidance for life in this world than are secular religions.

The utopian romanticism that is the impulse behind modernism in the arts is in a not dissimilar situation. It differs in that it seeks transcendence—all of twentieth-century art is such a quest—but it seeks such transcendence within the secular self. This endeavor can generate that peculiar spiritual intensity that characterizes the antibourgeois culture of our bourgeois era, but in the end it is mired in self-contradiction.

The deeper one explores into the self, without any transcendental frame of reference, the clearer it becomes that nothing is there. One can then, of course, try to construct a metaphysics of nothingness as an absolute truth of the human condition. But this, too, is self-contradictory: If nothingness is the ultimate reality, those somethings called books, or poems, or paintings, or music are mere evasions of truth rather than expressions of it. Suicide is

the only appropriate response to this vision of reality (as Dostoevski saw long ago) and in the twentieth century it has in fact become the fate of many of our artists: self-sacrificial martyrs to a hopeless metaphysical enterprise. Those who stop short of this ultimate gesture experience that *tedium vitae,* already mentioned, which has made the "boringness" of human life a recurrent theme, since Baudelaire at least, among our artists.

This modern association of culture and culture heroes with self-annihilation and ennui has no parallel in human history. We are so familiar with it that most of us think of it as natural. It is, in truth, unnatural and cannot endure. Philosophy may, with some justice, be regarded as a preparation for dying, as Plato said—but he assumed that there would never be more than a handful of philosophers at any time. The arts, in contrast, have always, been life-affirming, even when dealing with the theme of death. It is only when the arts usurp the role of religion, but without the transcendence that assures us of the meaning of apparent meaninglessness, that we reach our present absurd (and *absurdiste*) condition.

Moreover, though utopian rationalism and utopian romanticism are both hostile to bourgeois society, they turn out to be, in the longer run, equally hostile to one another.

In all socialist nations, of whatever kind, modernism in the arts is repressed—for, as we have seen, this modernism breeds a spirit of nihilism and antinomianism that is subversive of *any* established order. But this repression is never entirely effective, because the pseudo-orthodoxies of socialism can offer no satisfying spiritual alternatives. It turns out that a reading of Franz Kafka can alienate from socialist reality just as easily as from bourgeois reality, and there is no socialist Richardson or Fielding or Jane Austen or Dickens to provide an original equipoise. Who are the "classic" socialist authors or artists worthy of the name? There are none. And so young people in socialist lands naturally turn either to the high modernist culture of the twentieth century or to its debased, popularized version in the counterculture. Picasso and Kafka, blue jeans and rock and roll may yet turn out to be the major internal enemies of socialist bureaucracies, uniting intellectuals and the young in an incorrigible hostility to the status quo. Not only do socialism and modernism end up in blind alleys—their blind alleys are pointed in radically different directions.

Meanwhile, liberal capitalism survives and staggers on. It survives because the market economics of capitalism does work—does promote economic growth and permit the individual to better his condition while enjoying an unprecedented degree of individual freedom. But there is something joyless, even somnambulistic, about this survival.

For it was the Judeo-Christian tradition which, as it were, acted as the Old Testament to the new evangel of liberal, individualistic capitalism—which supplied it with a moral code for the individual to live by, and which also enabled the free individual to find a transcendental meaning in life, to

cope joyfully or sadly with all the *rites de passage* that define the human condition. Just as a victorious Christianity needed the Old Testament in its canon because the Ten Commandments were there—along with the assurance that God created the world *"and it was good,"* and along, too, with its corollary that it made sense to be fruitful and multiply on this earth—so liberal capitalism needed the Judeo-Christian tradition to inform it authoritatively about the use and abuse of the individual's newly won freedom. But the adversary culture, in both its utopian-rationalist and utopian-romantic aspects, turns this Judeo-Christian tradition into a mere anachronism. And the churches, now themselves a species of voluntary private enterprise, bereft of all public support and sanction, are increasingly ineffectual in coping with its antagonists.

Is it possible to restore the spiritual base of bourgeois society to something approaching a healthy condition?

One is tempted to answer no, it is not possible to turn back the clock of history. But this answer itself derives from the romantic-rationalist conception of history, as elaborated by Saint-Simon and Hegel and Marx. In fact, human history, read in a certain way, can be seen as full of critical moments when human beings deliberately turned the clock back. The Reformation, properly understood, was just such a moment, and so was the codification of the Talmud in postexile Judaism. What we call the "new" in intellectual and spiritual history is often nothing more than a novel way of turning the clock back. The history of science and technology is a cumulative history, in which new ways of seeing and doing effectively displace old ones. But the histories of religion and culture are not at all cumulative in this way, which is why one cannot study religion and culture without studying their histories, while scientists need not study the history of science to understand what they are up to.

So the possibility is open to us—but, for better or worse, it is not the only possibility. All we can say with some certainty, at this time, is that the future of liberal capitalism may be more significantly shaped by the ideas now germinating in the mind of some young, unknown philosopher or theologian than by any vagaries in annual GNP statistics. Those statistics are not unimportant, but to think they are all-important is to indulge in the silly kind of capitalist idolatry that is subversive of capitalism itself. It is the ethos of capitalism that is in gross disrepair, not the economics of capitalism—which is, indeed, its saving grace. But salvation through this grace alone will not suffice.

NINE

Identity and Technology

Gary Hill, *Tall Ships*. 1992. Sixteen-channel video installation.
Photo by Dirk Bleicker. Courtesy Donald Young Gallery,
Chicago.

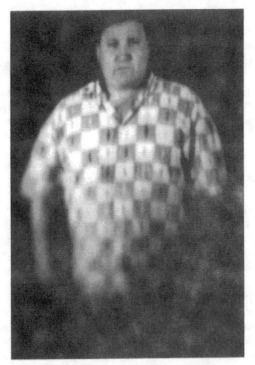

Gary Hill, *Tall Ships*. 1992. Sixteen-channel video installation. Detail. Photo by Mark B. McLoughlin, Courtesy Donald Young Gallery, Chicago.

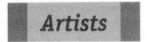

Artists

Carrie Mae Weems
Talking Art with Carrie Mae Weems
(Interview by bell hooks) 1995

Throughout the 1980s and 1990s Carrie Mae Weems created a diverse body of work that revolved around an examination of issues related to African American identity and history. Weems challenges prevailing perceptions of race, gender, and class by creating works that are a counterpoint to the images through which the dominant culture has portrayed African Americans. In her celebrated series *Untitled (Kitchen*

Table Series) from 1990, Weems uses text and staged images, creating a sequential narrative that revolves around a central female character. The fictional world of the *Kitchen Table Series* attempts to transcend race by confronting universal issues imbedded in male-female relationships. When speaking of Weems's work, the interviewer, bell hooks, states that she is "always annoyed when I read critics who are so fixated on the blackness of the images that they ignore the question of gender—of desire and power." The difficulty in moving beyond the "blackness" of these images underscores the level to which responses from white viewers to images of black people are culturally conditioned. In the interview "Talking Art with Carrie Mae Weems," which was published in 1995 in the book *Art on My Mind: Visual Politics*, Weems and the writer and cultural critic bell hooks explore the complexity of the relationships between race, image, and interpretation.

bell hooks: Carrie Mae, whenever I see your work I am deeply moved. More than any contemporary photographer creating representations of blackness, your work evokes the exilic nature of black people. Everyone forgets that when we talk about black people living in the diaspora, we're talking about a people who live in exile, and that in some ways, like all other exiles, we imagine home, we imagine journeys of return. We embark on such journeys by first looking for traces—by engaging the palimpsest that reveals the multilayered nature of our experience. Derrida's notion of palimpsest comes to mind as I look at your work. A vision, a journey through time—past, present, and future—to unravel connecting threads is ever-present in your work. There is both the evocation of exile in your work and a politics of dislocation, when, for example, you are charting your family's movement from the South to Portland, Oregon (I think about people often thinking, well, there are no black people in Portland), and you are on the move. That politics of dislocation in your work makes this new move towards Africa really exciting. Talk about this spirit of journeying, of homeland, about black people imaging some kind of static, homogeneous sense of our place.

Carrie Mae Weems: In most every black person's life today, home is where you find it, just where you find it. To me this suggests open possibility—that home can be for me Portland, Oregon, to the same extent that it can be New York or Ghana or Maui or Senegal. It doesn't matter.

bh: The specific postmodern deconstructive positionality that interrogates notions of fixed origins, of roots, is not just in this new work that lays claim to Africa as a possible site of home, but in all your work.

CMW: From the very beginning.

bh: It's there in the piece *Went Looking for Africa*. To me, this new work calls to mind Audre Lorde's sense of biomythography. You're not looking to "document" in some scientific, linear, orderly, factual way where we came from, how we got here; you are uncovering these details, but also exploring the gaps, the spaces in the shadows that facts don't allow us to see, the mystery.

CMW: Home for me is both mysterious and mythic—the known and the unknown. My search begins with the *Sea Islands* piece. That initial focus on family folklore was the beginning of my searching out a home place, trying to figure out for myself, that moment in the early 1980s, where I come from, how is that place constructed, what went on there, what was that sort of historical movement about. In any case, the movement of my family, leaving Mississippi, traveling from the South to the North,

that kind of migration. I wanted to know how I fit into that as a woman who was already starting to move around, starting to travel, and digging, digging.

bh: There is that archeological dimension to your search expressed in the work. Your journey is intensified by the way in which both race and gender situate you within a cultural context of exile. That is doubly intensified when you embrace oppositional thinking, when you resist the forms of domination that would keep you in your place. It's not like you return "to the South" or go anywhere unproblematically—you return as this person who early in her life embraced feminist thinking in a very existentially self-reflexive way. Your feminist understanding of black womanness has always inspired your work. That complex feminist sensibility is there in the *Kitchen Table* series. I am always annoyed when I read critics who are so fixated on the blackness of the images that they ignore the question of gender—of desire and power.

CMW: These images of black men and black women should speak on many levels, calling to mind in the viewer a range of issues and concerns.

bh: Your work compels recognition of race and representation even as it moves beyond race to an exploration of gender and power that has universal implications. Many of your images of black women and men raise issues about the politics of gender in our lives. I am thinking here about the *Kitchen Table* series.

CMW: Right. Well, you know, one of the things that I was thinking about was whether it might be possible to use black subjects to represent universal concerns. When we watch Hollywood movies, usually with white subjects, those images create a cultural terrain that we watch and walk on and move through. I wanted to create that same kind of experience using my subjects. Yet when I do that, it's not understood in that way. Folks refuse to identify with the concerns black people express which take us beyond race into previously undocumented emotional realms. Black images can only stand for themselves and nothing more.

bh: Then critics "read" blackness as signifying confrontation. I think your work is counterhegemonic in that it disturbs—it challenges and contests conventional perception. Contestation is different from confrontation. I think what people want, in a sense, is to see the work as confronting race, because whiteness and white viewers are centralized as the primary audience for the work. Thinking of the work as being about contestation, however, invites any viewer to work with a particular image and place themselves in relationship to the image. In this light, my favorite piece in the *Ain't Jokin* series is the *Mirror, Mirror* piece; that piece challenges me to interrogate my notions of beauty, to situate myself.

CMW: Right. For the most part, there have been only white critics who've been talking about the work. And they talk about the works of black artists, in general, in ways that centralize race, seeing only this facet.

bh: Well, two issues arise here. There is the work made by the black artist and the response to the black image. That response is shaped by the politics of location—the standpoint from which we look. I just wrote a piece for Deborah Willis's new collection of essays on photography, *Picturing Us: African American Identity and Photography.* One of the things that I wrote about was how photography has been so central to African-Americans. Nonetheless, more than any other artistic practice, it has been the most accessible, the most present in our lives. I wrote about the significance of snapshots, about the ways they enable us to trace and reconstruct a cultural genealogy through the image. This critical engagement with images has

been consistent in black life, but so little has been written about it. If the only critical writing about the work of black photographers looks at the work in a manner that sees it only through the lens of a colonizing gaze, then the universal, metaphysical dimension of that work never will be discussed.

CMW: Yes. Yes.

bh: You know, when I look at the *Kitchen Table* series what immediately surfaces is a visceral connection with a heterosexual convergence of pleasure and danger, of power and desire. Yes, the individuals are black, but the issues raised are about sexuality in general, the politics of desire—intimacy and domination.

CMW: Historically, it's been absolutely impossible for the vast majority of critics, of white audiences, and even of black audiences to come to the work and not first and foremost fixate only on the blackness of the images. As soon as blackness becomes the all-important sign, audiences assume that the images are addressing victimization. What is the level of victimization that we're looking at? Black people come to it in a different way, but posing the same question. They might be able to jump past this, or leapfrog past that quickly, but it's still the same issue. It's the issue for everyone, because we so rarely see black subjects, right?

bh: Most of your earlier work that is often seen as documentary photography isn't about victimization at all.

CMW: No. Course not. [*Laughs*]

bh: That's exactly why there has to be a challenge to critics to come back to this early work and reconsider ways of seeing and writing about it. In all spheres of cultural production, work by black artists rarely receives sophisticated critical attention from the outset. For example, much of the early critical writing about Toni Morrison's work was terrible. All too often, black artists must reach a certain prominence before the critical writing about their work stops being shallow and superficial.

CMW: The assumption that our ability as artists is restricted to our only being able to deal meaningfully with the question of race and rage overdetermines critical perception. For instance, I was at a gallery about a year ago, and a white woman was there looking at some of my new pieces, which she bought. Some of the *Ain't Jokin* pieces and earlier works were pulled for her. I was someplace in the building, checking out some other shit, and girlfriend walks in, she looks at the work, the *Sea Islands* piece. She looks at the work, and finally she asks if she can be introduced to me. They bring me over. She walks over to me, she says, "Is the work angry? But this work is not making me feel guilty." She wants me to tell her how to respond to the work because she assumes that the only legitimate response is guilt in the face of perceived rage.

bh: The other, but no less limited, way of viewing your work is to see it as many audiences, particularly white folks, do, as ethnographic documentation.

CMW: Oh, right.

bh: That's still a way of denying the complex cultural landscape presented by the images.

CMW: To see the work as ethnographic deflects away from the seriousness and makes it mostly entertaining.

bh: In much of your work, you centralize black subjectivity in ways that do not allow whiteness to rewrite itself using the black face as though it's another frontier, another blank page, which whiteness can conquer and consume. The risk that you take by breaking a certain photographic silence is that your interest, your artistic

concerns, will be overshadowed by simplistic, superficial responses to the work. Artistic work that is counterhegemonic always risks cooperation by critical practices that deny, that don't see the radical implications of a particular standpoint. Does documentary photography make these concerns more explicit?

CMW: Documentary as a genre has been very, very interesting to me, and there are aspects about it that I've always been interested in. I started out very early working in that terrain and spent a lot of time in a variety of places photographing in the tradition of Cartier-Bresson. Early on, my artistic practices were shaped by those traditions that said: This is how a photograph is made. These are the elements of a good photograph. This is the way the shit's supposed to be printed. Then you knew that you were working in that mode. And I tried that. I worked with it and there was something appealing about it, the whole idea that you were somehow describing the complicatedness of the human condition. That's what documentary was, or certainly was to me. I think part of documentary had a lot to do with the notion that you would go into somebody else's backyard and capture it and bring home the ethnic image, as trophy, but, hopefully, once you have captured the ethnic image, in the process of capturing it, you've gone through some harrowing, life-transforming experience—like Eugene Smith, who was beaten in Harlem, or Cartier-Bresson, who was shot in Zimbabwe. In your passion to document you encounter a tragic reality that transforms, so that you can come back even bigger, with your prize, and be praised for that. Well, I started to really understand what documentary was, what it really was, and I understood it even more later. However, when I started to understand it, when I learned that the terrain that I wanted to walk on couldn't be carried forth by straight documentary, my attention shifted. There was something different that I wanted to explore, work that had the appearance of documentary but was not at all documentary. It was highly fabricated work.

bh: Absolutely. Your work engages a process of defamiliarization. You take a familiar image, a familiar frame, and through a series of displacements challenge us to see it in a new way.

CMW: Right, right.

bh: I see your work as profoundly informed by the politics of displacement, where the colonizing gaze has to shift itself. It is this demand that makes the work counterhegemonic. It calls us to interrogate received perceptions. And it is not merely white people who look at the black image with the colonizing gaze. We have all been taught to look at black images with a colonizing eye.

CMW: Exactly, though it is often black folks, and other nonwhite viewers, who are most eager to shift their gaze—to make the leap and see with new eyes.

bh: Few critics place your work within the discourse about identity, nationality, or postcoloniality. Black artists and critical thinkers in Australia, aboriginal people, are rejecting the term *postcoloniality,* using *anti-colonialism.* This is a useful way to frame discussions of your work. The images you create are a form of resistance. Those persons who are most likely to be victimized by the imposition of a colonizing gaze can reach into your work and find the strength that is there. I remember that when I walked into a museum and saw *and 22 Million Very Tired and Very Angry People,* what struck me was the way you used familiar tropes in this alluring, poetic yet profoundly political way. It was so amazing. [*Carrie laughs*] Walking into that exhibit was almost like entering a Buddhist temple, calm and compassion-surrounded. The work articulated our experience as exiles in the diaspora, for one thing, in its wandering. Such border-crossing work, combining the idea of Gramsci

with Stuart Hall. There is no one-dimensional construction of blackness or of revolution in the work. Instead, it problematizes the whole notion of turning, of what we are turning toward. And yet you are constantly insisting that we cannot simply assume that what we are turning toward is—

CMW: —is better than what you're turning away from.

bh: Absolutely. [*Carrie laughs*] This is the power in the work that I think has to be called out more by critics.

CMW: I've been thinking about ways of forcing the issues, when it comes to the way in which the work gets talked about in the world. You know, I feel I can't sit back anymore and just allow people to do whatever the fuck they want to do around the work, particularly when it becomes truly disinformation.

bh: Also, Carrie, I think of you as a cultural critic, a theoretical peer. When I hear you talk about the work, you do so with a level of theoretical sophistication. Not all artists can talk about their work, placing it within theoretical frameworks—not everyone has that skill. At times the playfulness in the work may lead audiences to overlook its extreme seriousness. Wit and serious deconstruction go together. "In-your-face" contestation is an aspect of satire, irony. It ain't just funny for the sake of making folks laugh. It's saying something about the multiple ways that we approach a subject. I just finished writing about the *Ain't Jokin* pieces, the image of the black man in the window.

CMW: It's called *What are three things you can't give a black man?*

bh: You have a tension within the piece itself. On one hand you have the construction of a black person, and yet you also give us the image of a type of black male body that we rarely see represented in this culture.

CMW: Very rarely. That's right. That's right.

bh: And what is this image doing?

CMW: For me the vast majority of the *Ain't Jokin* series is constructed in that way— so there will always be this kind of tension between what you see within the photograph and what you see beneath it, with the text always cutting through. Hopefully, then, for the viewer, there would be a curious pull between what you see and the way this subject has been flipped and undermined by the power of humor, of the racist joke. For the most part, I think that that works. For example, if you look at the image of three baboons which I show in a photograph—you see a fabulous piece, a gorgeous photograph, right? And then you have a context: We would have that up on our wall and we would say, "That's a beautiful black family," right? The moment this description is made of three baboons, and that assertion is made by the text and the language that describes who they are, then something else is called into question in a very, very, very good way.

bh: In his essay "Reflections on Exile," Edward Said talks about contingency and what it means to be in a contingent world. Well, part of what it means to be in a contingent world is that meaning is constantly being reworked—that images will not always have the same meaning. And some images won't always work; earlier, we talked about the way the black artists are "blamed" if there are images that don't work.

CMW: . . . don't work, or fail.

bh: When the very nature of artistic practice is rooted in a philosophy of risk, the fact that there are sometimes images which do not work is part of the process.

CMW: That's right. That's right.

bh: In fact, let's say there are times when black people, individual black people, have seen those images and have felt crushed or humiliated by them. Is that a failure of

the work, or is it simply that, because of contingency, because of circumstance, how *they* see what they see hurts?

CMW: That's right. It could be both.

bh: Absolutely. This possibility of failure is part of a deconstructive element in your work, in the sense that much photography does not require people to think about audience while your work does. And that's part of its genius and power. So much photography doesn't lead people to think deeply about the work, to interrogate it. And the value of most prominent white photographers is not determined by audience response to their work. Yet folks will tell me, "Well, I'm troubled by Carrie Mae Weem's work, because it doesn't work with the audience." The assumption is that there is one correct response, rather than multiple responses.

CMW: Which is much more of what I'm interested in at this point.

bh: Absolutely. But that's also the fundamental critical challenge in your work to contemporary notions of the subject. I mean, there's a fundamental postmodern quality to your work that I think is often overlooked because the images are structured in a manner that appears simple, straightforward. In actuality, the meanings of the images are altered by the text. People may initially assume that these images are familiar, even ethnographic, but your use of text displaces, subverts, and changes meaning. For example, I was looking at the *Mirror, Mirror* piece, asking, "Who's really looking?" Is it the white face gazing out at the black face? Is it really the hope on the part of millions of white women in America who have anxiety about their beauty and their seductive powers, who are the ones who actually need to look in that mirror and affirm their primacy—to affirm that black women can never be more beautiful than they themselves are? Looking at this piece from diverse standpoints changes its meanings. I've seen individual black women respond to it—I see their discomfort, and I think, "God, part of what this piece does is remind us of the politics of location that is operating in all our lives." The piece displaces that sense of fixed location, because the meaning depends on the direction from which you gaze at the piece. It mirrors the postmodern emphasis on the fragmented sense of self.

CMW: After thinking about postmodernism and all this stuff about fractured selves, and so on, when I was constructing the *Kitchen Table* series, Laura Mulvey's article "Visual and Other Pleasures" came out, and everybody and their mama was using it, talking about the politics of the gaze, and I kept thinking of the gaps in her text, the way in which she had considered black female subjects.

bh: That's exactly what I was thinking, though you and I didn't know each other at the time. Her piece was the catalyst for me to write my piece on black female spectators, articulating theoretically exactly what you were doing in the *Kitchen Table* series.

CMW: All the pieces in the *Kitchen Table* series highlight "the gaze," particularly the piece where the woman is sitting with a man leaning against her, his head buried in her neck, a mirror placed directly in front of her, but she looks beyond that to the subject.

bh: Go, girl.

CMW: At the audience, right?

bh: Hm-mmm. Yes.

CMW: You know, just using that as the beginning and the turning point to flip all that shit around, and to start creating a space in which black women are looking back, right?

bh: Right.

CMW: Looking back, and challenging all of those assumptions about gaze, and also questioning who is in fact looking. How much are white women looking? How much are black men looking?

bh: Your work immediately challenges our sense of blackness.

CMW: Oh, yes.

bh: Right now so much in popular culture defines blackness as black urban experience. And, to some extent, I find your focus on the South so powerful—its evocation of our concern with return. In so many ways your work can be talked about as linked to psychoanalysis, particularly the issue of recognition and memory.

CMW: Oh sure, oh sure.

bh: We need to acknowledge that there are other complexities of blackness that are not emerging from—from the urban scene. When I think of a piece like *The Mattress Springs.* [*Sea Island* series]

CMW: That was so bad!!!

bh: We can talk for days about the multilayered textuality within that piece, because on one hand you have the notion of country and city, of primitive longing and the desire for progress.

CMW: Yeah. That was so bad, I can't even believe I made it.

bh: I know, and I think people should not look at that piece and reduce it to something simple about the South and how the folks do creative shit with trash.

CMW: Right, right, right.

bh: In *The Mattress Springs* we have this notion of the place of technology in agrarian black life. What black people do with it. And where is this sign of modern life, the mattress spring, that becomes the backdrop in a natural, pastoral world, where it appears in union with nature—not against, but a part of nature.

CMW: Right, it's linked to a whole belief system. You know, we have to make art work for us within the context of our own individual belief systems. I've often thought about this. How do you do this with photography? How do you describe complex experiences in a photograph? What are the sights of it? What should it have to look like? What does it have to challenge? To whom is it challenging? You know, who's it for? All those kinds of questions are constantly shifting for me. The moment that I think that I have it locked down is the moment in which it flips; you can't talk about the pros without talking about the cons. You can't talk about the "positives" without talking about the "negatives." And you can't talk about the truths without talking about the untruths.

bh: Well, let's say we talk about that picture of the slave quarters. The first thing that should jump out at people with that picture is that these slave quarters are made of brick—that this is not wood and that we have to think of the creativity and expressive genius of these enslaved people, working with brick. The image invites us to ask, "What do slaves and brick have in common?" You know, I kept thinking about that in relation to the whole Afrocentric focus now on ancient Egypt and kings and queens and the pyramids. And I also kept thinking about the slaves. I keep saying to people, "Well, what about the slaves who were hauling that brick?" You know, I mean there's something else going on here besides simply the narrative of kings and queens. And there's something in the work you're doing around space and housing that speaks to culture and class—raising questions of how we inhabit space, about architecture.

CMW: Well, how you inhabit space and how you construct it, as well as how you construct the architecture of your life, is the issue: How do you do that? What will

it look like? And within this context, let's say the *Sea Island* image, within this world, how will you construct the space you inhabit to make it work for you, even when it was not meant to?

bh: It's funny, because I was thinking of your work as I was reading Bernard Tschumi's new book, which is the most exciting book I've read lately: *Architecture and Disjuncture.* And I was thinking about how your photographs interact with one another to create this sense of disjuncture, starting points where you don't end up where you start off, endpoints that don't come from this logical move from A to B to C.

CMW: No, they're not, they're not linear at all. They construct something that feels on the surface to be very linear, and, as you said, simple in their construction.

bh: Tensions arise when folks look at your work, especially your new images that highlight returning to Africa, and they tell me they've talked with "real" Africans who don't see anything particularly "African" about this work. And I remind them of how many "real" Africans there are. If a few individuals don't see something in a creative work, does that mean this thing doesn't exist? Are we still stuck within some kind of Western, metaphysical, either/or dualism, where we can recognize ourselves in Africa only if African people grant us that right? This is not about ownership. That's exactly what this work in its movement, its refusal to be fixed, is asserting: that there is no ownership of blackness.

CMW: Right, and the thing that's really interesting is that the ideas that ground the work emerge from my critical reflections about stability and from ideas of wholeness. You see, wholeness has all kinds of fracture in it. It has all kinds of ruptures in it, but it is a wholeness nonetheless. For example, the wholeness might be not having a true and complete sense of Africa. Rather, we might have a sense of a construction of Africa, as seen through the eyes of one person who is on some mythical journey in search of a place she might be able to call home.

bh: That sensibility, which is what we began talking about, is what this recent work evokes. This is the spirit of exile—really, the emotional politics of exile. When Cornel West and I were preparing our book, he spoke often of the exilic nature of black people, of why the Old Testament has been so important to black believers. Everything black people in America have seen or experienced has been filtered through that primal experience of exile, and that includes a longing to return to "the promised land."

CMW: Only the promised land isn't there.

bh: It's so multifaceted—there are many promised lands.

CMW: That's right, but it's not there.

bh: It is a creation. And it's the hint of that creation that your work moves us toward. What is that homeland that we journey toward? Is it a homeland of the mind or of the emotionality, in a sense, where one—where one's longing is what ties things together. And it's interesting, because I think this is the subtextual emotional universe of your work that is often overlooked, overshadowed by the focus on race as its central metaphor and not in fact the emotional universe. And yet it's that emotional landscape in your work that gives it force and passion. The *Kitchen Table* series often makes me think of the blues. Like how a blues song may say something in words that you may not even like, you know, you may never even get all the words, but the sensibility is what takes you somewhere. I was listening to one of my favorites, Muddy Waters, and there's this line where he says, "I've had my fun if I don't get well no more." And I was saying to somebody that that is a deeply

meaningful song for our time, as so many diseases such as cancer, AIDS, all these things, really disrupt our experience of pleasure. So now, here's a song that we know emerges out of a concrete specificity within blackness and that shows this complex emotional field of choice in relation to pleasure and danger evoked in this line: "I've had my fun if I don't get well no more." Your work has a similar broad scope, deeply embedded in our culture and identity. I disagree with one of the critics who said that your work "takes us beyond abstract ideas." I thought, actually, no, her work takes us to the abstract complexity within black identity that has been denied, and that has been denied not merely by politics of race but by a politics of culture, and particularly that of vernacular culture in opposition to high culture. In part as a response to high culture's attempt to reduce vernacular culture. No one writes about the place of vernacular culture in your work, in the images.

CMW: It's not just vernacular culture—it's class. The work is very, very, class-based. It is working class–based; I think that reality shapes the pictures—the way the images are constructed. I'm very interested in ideas about blues and jazz, that expressive musical culture. That's where I function. That's where I get my shit from, my impulses from. If it's not in that, I'm generally not interested, right? But how do you again use that, how do you, you know, listen to Muddy Waters, to Bessie and Billy, and begin to construct a visual world that this music is played in, that's generated by the culture that the music creates? So in doing the *Kitchen Table* piece, it was always about how you construct it. How do you make a blues piece? What does that look like? And because of the emotional response you're talking about, that emotional sensibility is embedded in the work.

bh: Like in my favorite piece, *Jim, If You Choose.*

CMW: You understand what I'm saying!

bh: Absolutely. I wrote about that photograph in terms of the black male body, speaking about the sensibility underlying that piece. I couldn't find a single person who had written about technology in relation to this image, yet the reference that immediately came to my mind was "Mission Impossible." If you think of white patriarchy as the framework within which black men are asked to construct an identity, and that there has been a capitulation that black maleness has made to that system, then your subversive image says, "You have a choice, black man . . ."

CMW: That's right. That's right.

bh: To resist—

CMW: —this bullshit.

bh: That gender crisis you articulate with this image is there in blues music, yet is not talked about. The kind of music that Skip James sings, "Devil Got My Woman," and that whole sense of the male who is caught up in a politics of emotional vulnerability. Now, what your piece says is "Ha! Aha, world, the emotional vulnerability may not be of the black man in relation to the black woman. It may be of the black man in relation to the white man"—and the gaze, then, is really about these men looking at one another. I recently gave a paper called "Doing It for Daddy: Representing Black Masculinity as Unrequited Longing for White Male Love." And there we have it in that portrait of Jim, that sense of anguish. What is the anguish that he is feeling? And also there's the double tragedy that we can live in a world where someone can see that image and not see that anguish, and only think of it as having something to do with black men and black women. That reduces the elegance and grace of that image to the mundane.

CMW: It's not just the image that's reduced. It's our historical situation.

bh: And your process as an image-maker changes too. Because in order for people to think of these images differently, they have to think differently about the people who make these images. We all have to rethink and take another look to see that we are no longer talking about black people in a state of colonization trying to come to some primitive subjectivity. We are talking about image-makers like yourself who are engaged in ongoing processes of decolonization and reinvention of the self, whose work cannot be understood deeply because we lack a critical language to talk about contemporary radical black subjectivity.

CMW: You have given us this critical language in your work. Why is it so impossible for more critics to follow that example?

bh: Well, I think for many other writers there needs to be a demand for critical growth and change, a repositioning of the self in relation to the "other" that only comes through the politics of demand. This is what Frederick Douglass meant when he said, "Power concedes nothing without demand."

CMW: We have to challenge simplistic, traditional, fixed notions of what criticism is and develop a new vocabulary and language. And until that happens we will continue to have little understanding of how to approach the black subject. We certainly don't have any understanding of how to talk about there being aesthetic variation, what that might mean in the construction of the photographic image.

bh: More folks who are theoretical need to write more or to speak and document that speaking. I think it's an unusual historical moment, because we usually presume that artists and critics are not the same, but these days there are individual artists who are able to discuss work in a critically aware manner. More and more artists will do more of what we conventionally have thought of as the work of critics, and that artificial separation may have to be completely and utterly disrupted.

CMW: Also, I think that something else has to happen, and I think that, you know, a part of it has to do with the way in which we're educated about images. It's as simple as this, bell. I don't know how much you know about photography and various aspects of photography and the technical aspects of photography, but we have something in photography that's called a zone system.

bh: Right, right.

CMW: Well, the zone system is completely constructed around what makes white people look best. It is our system and our theory—photo theory—for understanding what a good print is, and it is based on white skin. So the very base of photography and the way that photography has been developed in the West as a science, because that's what most of it is, is based on ideas of whiteness. What would have happened, for instance, if photography had been developed in Japan? Not just cameras, but the means of photography, had been developed in Japan? The images would look very different, and what is theoretically impossible or even practically acceptable would be very, very different as well.

So in terms of artists being critics, I think they are not necessarily always the same people. I'm not a critic. You're like a brilliant woman, a fabulous woman with this incredible sensibility. And you use incredible language and so forth and you're a gifted writer. I am not a gifted writer. I'm an artist trying to figure out how to do this shit. So, though it's true that I'm talking a whole lot, and actually I'm very good on my feet when I'm up and talking, I want to use my time to make art—not to write. Yet I want to hear critics talk about work in a way that makes sense.

bh: Oh, I do agree. When I was doing more art, I was not writing.

CMW: There just needs to be more critical discussion of what we're doing and what it is we are looking at, because for the most part, not only are we coming to black images made by black artists, but we're also coming to a different kind of artistic and visual and aesthetic terrain that is just not understood.

bh: We're looking to a future where there have to be more collaborations. There has to be more dialogue. And, let's face it, there have to be alternative journals— spaces that don't simply pipe us all through the mainstream, because different ideas will not be welcomed there. If art is to be talked about differently, artists cannot rely on traditional frameworks of image making, or on institutional frameworks where image making is talked about.

CMW: Right, and who was doing the talking? Right. Who was doing the talking?

bh: The exciting thing is that work like the work you're doing makes this demand. It contests in a way that means it will no longer allow for the kind of criticism that has happened. You know, it's a process. That's why we are talking now. I began as someone who watched your work from afar, but who felt outside the loop of those critics who write about it. After we just talked, I thought, "No, I have to resist exclusion through omission and/or disregard, and enter that loop of people who write and think about Carrie Mae Weems's works." Collaborations like this dialogue will make a difference.

CMW: I'm excited when my work is talked about in a serious manner—not because it's the work of Carrie Mae Weems, but because I think there's something that's important that's going on in the work that needs to be talked about, finally, legitimately, thoroughly.

bh: We have to create a kind of critical culture where we can discuss the issue of blackness in ways that confront not only the legacy of subjugation but also radical traditions of resistance, as well as the newly invented self, the decolonized subject.

CMW: Yes. That is the critical issue for now and for the future.

Charles Ray
Charles Ray: A Telephone Conversation (Interview by Francesco Bonami) (1992)

Throughout the history of art the human figure has been revered as a subject of representation for its ability to communicate emotion. Los Angeles–based artist Charles Ray was one of a number of artists who turned to representing the human figure in the 1990s in an attempt to come to terms with the level to which powerful technological advances were expanding the layers of mediation between people and the world. In 1990 Ray finished a sculptural self-portrait complete with painstakingly

Originally published in *Flash Art International*, Milan, Italy, Summer 1992.

crafted clothes. Although this work bears his likeness, it also has an eerily robotics, mass-produced look, quite like that of a store mannequin. Ray's *Self-Portrait* (with clothes) looks like an average person, yet is stiff, distant, and emotionless. This juxtaposition creates the effect of positioning the viewer between feelings of recognition and of alienation. Ray expanded on the implications of the self-portrait through a number of works executed during the early 1990s, including a series of eight-foot-tall women titled *Fall '91* as well as a two multifigure tableaus titled *Family Romance* and *Oh! Charley, Charley, Charley . . .* Ray's "mannequins" can be interpreted as an attempt to reclaim identity in an age in which identities are manufactured through the images and objects of consumer culture. Ray's work questions the extent to which the human body has been translated into a commodity. This telephone conversation with Francesco Bonami was originally published in *Flash Art* in the summer of 1992.

In Vox, *Nicholson Baker's most recent book, the author suggests that the telephone creates a certain distance, it is not simply a means. Two people living 8,000 miles apart who speak to one another over the phone without ever seeing each other create a particular kind of intimacy; another kind of dialogue takes place when these same people share a common space. Perhaps, in the end, a more sincere intimacy arises over the phone, one which is not mitigated by the inherent, mutual judging which occurs when speaking face to face. In an interview, for example, you write your questions in advance but then can sense that the voice on the phone is too close for the questions you've prepared. You can't interview somebody by whispering things into his or her ear. What results is simply an informal conversation, no matter who is on the other end of the line. Conversations in a single physical space tend to expand and make themselves understood. Whether you're wearing a three-piece suit or lying around in your underwear changes nothing in your relationship with the speaker; all awkwardness is overcome.*

I know Charles Ray only through his work—through the bodycasts he has produced—and so enjoy as intimate a relationship with him as I might with, say, a wax dummy of Margaret Thatcher. The words alone, spoken over the phone, tell me more about him than if I were to stare into his eyes or shake his hand. The table in some New York bar which would have come between us had we met in person seems, after our phone call, an unsurmountable distance.

"What I'm doing now is a figurative sculpture called *Oh! Charley, Charley, Charley . . .* ; eight figures, all bodycasts of myself. It's a sex orgy and I'm the only participant. They are cast from plaster and then made in fiberglass. They don't have anywhere near the resolution of a Duane Hanson, but they have much more resolution than a mannequin. They have painted flesh, wigs, and some pubic hair. When I first began the project a year ago, the notion of different sex positions was really in the forefront of my mind. Each figure touches another someplace, but it's not a daisy chain per se. In a way this work isn't about sex; I made some abstract pieces that I think are much more about sex. There is one that I'm kind of working on now, it's called *Fall*.

It's an open box, 3 feet x 3 feet x 3 feet, to be embedded in a solid, acrylic cube which is 3 inches bigger. So, like Brancusi's *Kiss*—I find it really sexual—you don't know which one is falling. Is the solid acrylic cube falling on the empty box or the empty box overflowing into the acrylic cube? It's an old idea from about two years ago; at that time I did some readings on genetics and DNA. I was getting divorced from my wife, I was involved with different girl-friends and partners, you know. You realize at a certain point that you just . . . you just like sleeping with yourself.

"So I thought . . . you know the Brancusi work *The Kiss*? These two fig-ures out of one block of stone, where you can tell they are two only because of the arms, you know, true love, two become as one. I believe that too, but my work is the other side of the coin, the other proposition, a state of mind that it doesn't work, there is no 'other' out there. I am working on another group sculpture called *Family Romance*; it's a nuclear family, the dad is forty, the mother is thirty, the son is like eight, and the daughter is four. They are all naked, holding hands, but I am taking them all to the same scale, four feet three inches. So the children have come up and the parents have come down, you know. The politics are dead through scale, all leveled out at the same height. I'm not so interested in the body per se, it's simply that this old, trite problem of the mind-body relationship creates this schism which in some ways isn't really there and in other ways it's really a fallacy that it isn't there. Some of my abstract works, like *Ink Line, Ink Box*, have more of a physicality. They are located in an unspeakable part of the body, somehow, like a neurotic part, where the kinesthetic urges. The most interesting thing about those two pieces was that you want to disrupt them, like put your hand on that line. They were very nervous and neurotic, much the same as being on top of a building and wanting to jump off; everybody has that sen-sation. I hope I've gotten over it. I hope these figurative works can be as neurotic and as nervous without having to deal with a physical threat. I never set out with a program, so in working on something information comes back to me and evokes or becomes something. Like the big man-nequin lady in *Helter Skelter:* I don't want it to be about my relationship to women but the viewer's relationship, so I just push the work in one direc-tion. I push it in scale, and I hope that creates not an image but an active re-lationship to the viewer. The proportions of that mannequin are the Sears standard, so from the entrance, if no one is in the room, it just looks like a woman mannequin. When you get closer something goes wrong, you shrink or you don't catch up to it, but you know how it was years ago . . . with your mother, she looked like a dominant sphinx. I was not try-ing to make an image of women as the dominant sex, but just put the viewer back into that relationship, make it real.

"The mind-body problem is an illusion, but at the same time it isn't be-cause we have been brought up this way. Did you ever see the turning table

piece . . . a table that turns extremely slowly with objects on it also turning slowly? It was about that mind-body thing, the mental and physical relation to objects. When I made it I was smoking marijuana, lots of it; I was working on this still life and everything slowed down, and I passed out on the couch in my studio. I woke up and tried to move an object on this table, but of course I couldn't do it, right? But I thought maybe I did move it a little bit, so eventually I just did it with a motor. I wanted the viewer, before perceiving that movement, to have to give this thing an incredible amount of time. So I got interested in that moment—not that it has any specific meaning—when your perception is radically altered, when you realize that this thing was . . . something. You don't know if it was in your mind or what, you know what I mean? Virtual reality? Not really, but this piece *Oh! Charley, Charley, Charley* I'm sure one of the things it came from, I'm thinking, was virtual reality. When technology gets sophisticated enough you may get to have an orgy with yourself. I think a lot about technology; I can't carve those figures out of stone or model them out of clay. It would be a ridiculous proposition in this day and age, but if I use a laser scanner, it's the same. In both ways it would overwhelm the equation. The work has to relate to you, not to those other things, not to how it was made. I hope that the work opens some doors to the viewer, that it creates a relationship with the viewer rather than be a dogma that I have in my head. Because we have lost our relationship with the world, we are observers and not participants anymore.

"I, like many people in the '70s, experimented with drugs; they did something for me in this relation with the world but I wouldn't recommend them. I don't think they are necessary. What I do now, you know, is sailing, or I go shopping. When you go to the fucking mall, talk about taking a lot of speed. Just go in a department store; it's a very similar experience really, you know, the fishing poles, the leather belts, women's underwear, tennis shoes . . . In a way, a lot of work from the '80s got this thing wrong, quite wrong. What that first mannequin, my self-portrait, was trying to do in this weird way was reclaim consumer space on an erotic level. I don't mean erotic by taking my dick out. I mean by being a physical being. I see the revolution that happened in the East, and in a weird way it wasn't political, was it? It was a consumer revolution; people want to *buy* fucking *things*. The critique of the '80s is right on, it's true; the continuous, rapid growth of the economy is a bunch of bullshit. But at the same time there's another world to look at it. I think that somehow it's attached to sex, desire, and eroticism. So maybe it is with us and the answer is, somehow, reclaiming it in some other way, reclaiming that space. I'm not talking about being a yuppie. With that mannequin I wasn't doing a critique but creating moral territory, putting myself in the department store. I can't really put it into that type of intellectual discourse; my intellect is whatever comes out of the work."

And then we hung up.

Kiki Smith
A Diary of Fluids and Fears
(Interview by Francesco Bonami) (1993)

Kiki Smith is one of a number of artists, which includes Robert Gober, Matthew Barney, and Charles Ray, whose work ushered in a renewed interest in the human form in the art of the 1990s. Smith's work grows out of a need to claim a sense of self in an increasingly homogenous and fragmented world by focusing the viewer's attention on the most basic functions of the body. Unlike the strangely distant works of Ray, Smith's art pulls the viewer toward a visceral experience of the very makeup of the human body. Some of her early works dealing with the body were small sculptures of individual organs—such as a heart made of plaster and silver leaf and a stomach made of glass. Another early series consisted of a row of glass jars, each of which was etched with the name of a different bodily fluid—including blood, saliva, milk, sweat, tears, semen, oil, pus, mucus, urine, diarrhea, and vomit. Instead of being repulsed by these fluids, Smith venerates them.

By the beginning of the 1990s Smith's work evolved toward the depiction of life-sized figures. These uncompromising depictions of the body, which are often made from wax and pigment, counter the impulse to idealize that is evident in much of the figurative work in the Western tradition and instead focus the viewer's attention on the flesh, the form, the functions, and the inevitable decay of the body. Smith's raw and vulnerable bodies leak, ooze, and defecate. The power of these works rests in their ability to conjure up associations that range from social issues relating to disease and abuse to universal themes. For Smith, the body is uniquely and intimately experienced by each person, yet at the same time it is the locus of our shared humanity. This interview with Francesco Bonami was originally published in the January/February 1993 issue of *Flash Art*.

The attribution of significance doesn't depend on pure intellect which, in examining things analytically, attributes meaning and objective values which morals have incessantly imposed upon us. The attribution of significance depends on the body which, coming into the world and growing up under given circumstances, is provided with a certain meaning and a certain value and so feels things differently. The body does not receive the action of things; the action is only the significance that the body attributes to things.

—Umberto Galimberti, *Il Corpo* (The Body), Milan, 1987, p. 114.

Francesco Bonami: What was your relationship with your father Tony Smith?
Kiki Smith: The one of a daughter, but if you mean the daughter of an artist, I can say that my sister Seton and I participated in the making of his art. Because we grew up in the suburbs we were not involved in the art world except for people who came to visit.
FB: Until a few a years ago you were considered kind of an underground artist. Did you feel that those were the natural circumstances in which to produce art?

Originally published in *Flash Art International*, Milan, Italy, January/February 1993.

KS: I didn't consider myself "underground," I was just here doing what I was doing. During the first couple of years in New York I established my peers. I became very close with David Wojnarowicz, but then I stayed pretty much by myself for another period of time. That time was very good for me, knowing that I was doing something out of my own necessity, in a kind of a vacuum outside of the support system. So when you do get some attention you can always go back to where you came from. It is very important to know that I was involved with Collaborative Projects *[a collective which includes artists John Ahearn, Jane Dickinson, Bobby G, Jenny Holzer, Rebecca Howland, Alan Moore, Tom Otterness, Cara Perlman, Walter Robinson, and Robin Winters]* through which we did hit-and-run shows. Taking a space and making a show, or a store or a TV show, these kinds of things.

FB: This way of working is coming back again.

KS: It's really a good way. If you're not in the system you make your own system, you don't wait for somebody to let you in the door. Then the world comes to you rather than the other way around.

FB: Which role did your mother play in your being an artist?

KS: She has been very supportive. She has a beautiful sense of things physically; she is very spiritual. I took being an artist for granted. I became an artist as a default kind of thing. I didn't plan it.

FB: How did your father's death in 1980 affect your life?

KS: At the beginning most of my work was about life growing on death, as we consumed death to stay alive. But then I stopped.

FB: Does a traumatic event like that create a sense of independence?

KS: It's a liberation from your relationships; I was no longer a daughter.

FB: In 1985 you worked in the Emergency Medical Service. Was it because you were working with the body that you chose to do that?

KS: I thought it was interesting to have a different perspective on it. I was interested in people's bodies in a trauma situation. It is physically very beautiful to look at the exposure of their insides and outsides at the same time.

FB: After your Project Room at MOMA in 1990 the attention around your work escalated dramatically. Do you think that some people exploited your art now that it fits so perfectly in this kind of Body New Wave?

KS: I was doing the same kind of work for a while, minding my own business, but apparently I got in sync with this renewed interest. It seems that what I do fits in very concretely with what's going on in people's minds. For me that's useful for getting my work done, but in terms of what it means, I have no idea. I just accept it because I know attention can go away just as easily. The world is just fickle . . . it's capitalism.

FB: What kind of art has influenced you the most?

KS: I look at decorative arts a lot; I am mostly interested in that. What people do for their houses . . . for their lives.

FB: What are those wax things you've been working on since we started talking?

KS: Eye bulbs with muscles, they look like flowers. I am secretly into flowers.

FB: How has our awareness of the body changed since the '70s?

KS: The '70s were the most opulent moment in American history, when there were many radical shifts. Today, with AIDS, people seem more vulnerable. At the same time, with technology and new age medicine, we also feel more in power of our bodies.

FB: Now that the body is "liberated" how much freer are we from it?

KS: Personally, I don't feel freer than I was at ten years of age.

FB: You often use fluids in your works; what is your relationship with the voice that comes from inside us like a fluid?

KS: I just started doing things with words spilling out as fluids.

FB: Our voices are a direct, maybe the most direct, relationship with the outside reality, while fluids are more related to our own selves.

KS: Maybe because our puritanical culture is sort of centered on the voice. We are really segmented and fragmented physically, but the voice is no more a part of reality than your skin flaking off.

FB: What parts of the body are you into now?

KS: Muscles.

FB: And the nervous system?

KS: I was into that a lot. Then I thought that I still had to go through the endocrine and lymph systems and all these other things, and I realized it could be endless— the meaning you can attribute to each system.

FB: So you think the more we know about our body parts the more we are in power of ourselves?

KS: Well, you have more control of whoever is dumping their beliefs on your head. At least you know who owns you at a given moment. But to me it's more interesting to know the different meanings of what skin means to you, your liver . . .

FB: Your art appears to be very "somatic." Homer, in the Odyssey, *uses the word "soma" only with regard to the corpse, while the living body is described each time through the limbs, which are "possibilities" to express ourselves in the world. Your work seems to express that we are more like "future corpses" than spiritual entities.*

KS: It's more a way of describing our relationship of being physical and our relationship with other people's physicality.

FB: You are dealing then with the process of being, and the body is the result of this process.

KS: It's a form of being here, it's a vehicle. You write a diary with your body.

FB: Do you write this diary differently now that you are an established artist?

KS: Superficially it's different, but I am basically the same person I was twenty years ago. I have more possibilities for the things I do.

FB: But it seems that you have acquired a different perception of what you are doing. Now you are thinking to cast these eyeballs in bronze, for example. I feel that for some artists, at some point in their career the creative process becomes a kind of documentation of expired energy.

KS: You're right, it's a kind of documentation of my compulsive need to make things.

FB: What do you fear most?

KS: I want to be as present as possible in my life, not being able to do that is my worst fear. I think about it a lot even if often I am moved by fear. You can look at anything and see how life relates to it.

FB: A kind of palm reading.

KS: What is inside of you is about your history. Your body is like a mandala, you focus on a point and you see all the connections surrounding it.

FB: In the end your works are like body fluids; you create an equivalence.

KS: They express what I am in the same way. They are not trying to prove anything except that I am here, and what I care about. They create a panorama where everything is connected to yourself.

Gary Hill
Interview with Gary Hill on Tall Ships
(Interview by Regina Cornwell) (1997)

The artist Gary Hill is best known for his video installations that tackle complex and age-old philosophical themes, such as the paradoxical relationships between the mind and body and between language and experience. Hill exhibited *Tall Ships,* one of the most talked-about works in the now-famous Whitney Biennial Exhibition in 1993. This work consists of a long, unlit corridor with black-and-white images of sixteen people ranging in age, ethnicity, and gender projected directly on the wall. When the viewer enters this dark, cavelike space and proceeds down the corridor, activators are triggered and the figures walk toward the viewer until they are close to life-size. Then these figures stand seeming to stare out at the viewer until he or she walks away.

Although the graininess of the images leaves no doubt as to their origins in video, the approach of the figures and the unresolved nature of this meeting can stir complex feelings. The particular look of the video image might trigger a range of associative responses, and these responses are left dangling and unresolved in the empty space between the image and the viewer, creating a situation in which the viewer's responses might reflect back on him or her in a way that opens up the space of self-consciousness. In this interview with Regina Cornwell, which was originally published in the book *Tall Ships* in 1997, Hill describes his motivation for *Tall Ships* as follows: "Basically I wanted to create an open experience that was deliberate and at the same time would disarm whatever particular constructs one might arrive with . . . " Through the use of highly sophisticated technology, Hill explores the complex relationship between vision and consciousness.

Regina Cornwell:[1] *Tell me about* Tall Ships, *about the title itself and the experience you wanted to nurture through this installation.*

Gary Hill: During recordings for the piece I happened to see an old photograph taken in Seattle around 1930 of a "tall ship." I think they were removing the last of the old ships from the Seattle harbor. I immediately associated those huge masts and full sails with people standing, like the people I was working with. The thought of that kind of ship on the high seas—that frontal view of extreme verticality coming towards you. There's a majestic quality to it that when applied to the human figure projects a kind of power and grace. That person, however vulnerable, will come forth no matter what. It's the simplicity of the idea—humans approaching humans in the space of a work that is always slightly haunted by the notion of "ships passing in the night." I don't think I was really clear about the piece until I had this title.

What was your methodology for the production of the work? How did you direct the people and transcribe it to such an extreme space?

I wanted the whole situation to be unassuming. All the people are family, friends and friends of friends that were spontaneously gathered for the moment. I gave very little instruction during the recordings. Typically, I would have a person walk up to me while I was taping, and, after awhile, they would expect the "scene" to be over. I would leave them hanging there considerably longer than their expectation waiting for that moment of release— when someone gives in to just being there and slowly opens up in a different kind of meeting space. I eliminated the possibility of theatrics as much as possible and tried to avoid any kind of aesthetic overtone. From the time of conceiving the piece to actual production I simplified the movement of the people to only coming forward and then returning to their particular place and posture of either standing or sitting. There are a few variations on that, for instance, after coming halfway forward they might pause and go back, or they might come back a second time after beginning their return.

The people in Tall Ships *seem to be from a variety of cultural backgrounds, ages, genders, and physical types. Is there some specific significance to this fact's occurring in such an interactive piece?*

Tall Ships is not really about interactive art and it's not about multiculturalism. It's simply the idea of a person coming up to you and asking "Who are you?" by kind of mirroring you and at the same time illuminating a space of possibility for that very question to arise. Basically I wanted to create an open experience that was deliberate and at the same time would disarm whatever particular constructs one might arrive with, especially in a museum.

What is the significance of the child at the end of the hall? Being the only child and positioned at that location it seems more purposeful perhaps than other aspects of the piece.

Originally I hadn't intended to have someone at the end position, but while we were installing it, I saw that the blank void suggested too much a sense of the infinite. Without any figure there the others would seem to go on forever like the infinite reflections bounced between facing mirrors. I wanted a delimitation of the space that would retain a sense of place, and positioning a person there seemed to work. I decided on the child suggesting a future or an ongoing sense of openness and possibility.

At Documenta IX I had a sense of anxiety in the space. I couldn't see, it was really very dark, but at the same time it was an extraordinary experience . . .

I think this anxiety is very much a part of the ingress. Once you're in and over your initial trepidation then perhaps some questions arise: "What kind of a space am I in?" "How long is it?" "Who are these figures?" "How long

will they look at me?" "Am I making them move?" "Can I talk?" These questions are not so much answered as slowly illuminated both figuratively and literally. As the figures come forth they provide the light in the space. Silhouettes of other viewers begin to appear. You begin to see the shapes and shadows and light cast by the figures onto people's faces. It's very subtle, but the viewers begin to mix with the projections.

Is this a radical departure from other installations?

Well, yes and no. There are technical aspects and to some extent "content" that are very close to *Beacon (Two Versions of the Imaginary).*[2] In *Beacon* there are two different images projected out through the ends of a tube. The tube rotates very slowly in an equally darkened space, and the images continually expand and contract around the room. Technically, the projections of both *Beacon* and *Tall Ships* were obtained in the same way so the visual quality of the images is very similar. The same kind of "assemblage" projectors are used, made from small black and white monitors and surplus projection lenses. Like in *Tall Ships*, in *Beacon* there are a number of full-figured images in the opening sequence which were recorded with a rotating camera that moved counter to the projections in the installation. This in effect cancels out the movement so that it looks like a spotlight (or beacon) passes across the people, illuminating them, and this also happens to the viewers in the space as well.

How is this related to Tall Ships? *Did you have a similar connection to the people and how you worked with them?*

I used a similar approach in recording the people. With the exception of the two readers reciting the text, the people are seen looking or watching. In both works the viewers and the viewed are intertwined in a number of ways. Certainly with *Beacon* the structure was more conceptual and the people, at least the standing figures (what we referred to as "gazers" during production), were each playing a part, that is, of someone following the light. On the other hand the two readers were very much involved in finding their own voices and their relationship to one another within the Blanchot text. There's an incredible emotional undertow to those readings that I think had to do with the fact that these two people were together and they were connecting through this text in a way they hadn't before and I think it came as somewhat of a surprise. I hadn't thought of it before but it's interesting to think about the relationship between a beacon and a ship.

There also seems to be some connection with Disturbance (among the jars)[3] *especially in the way you may have worked with the performers. From what I understand there was a considerable amount of improvisation incorporated into that piece too.*

In *Disturbance* the people who recited and performed were very much left up to their own devices much like the people in *Tall Ships*. They were walking

into a kind of envelope of time whereas the participants in *Disturbance,* you could say, walked into the Gnostic texts and let come what may. In particular, the writers—philosopher Jacques Derrida and poets Bernard Heidsieck, Claude Royet-Journoud, Jacqueline Cahen, Joseph Gugliemi, and Pierre Joris—all reworked their selected texts, performing them as unique events without any knowledge of an overall script. George Quasha had a lot to do with this. In fact he suggested using the Gnostic texts in the first place, and we collaborated on selecting the specific texts and performers and worked together with the readers toward keeping their relationship to the text free and spontaneous. But even when we were finished with recording these "performances" I had no idea how everything would get woven together. So there's a shared attitude in the making of these works that I suppose has something to do with surrender, of really going with "let's see what happens." In the end it took me six months to edit the piece. There's a phrase in the *Gospel of Thomas*[4] that goes a long way if you're willing to follow it through: "What will you do when you are in the light?"

Given the complexities of the textual layering in most of your work, the absence of sound and the interactive aspects of Tall Ships *would seem to point in a new direction.*

Suspension of Disbelief (for Marine)[5] is silent too, but I think that the silence in *Tall Ships* is more active—it feels present in a way. It makes the impending contact really out in the open. One's thought is kind of naked as if you are out on "mind island" with this person and you feel there must be something to say. And what does one possibly say when it's radically stripped down to this point? I think this kind of space is also very uncomfortable for some people. Instantly they want to fill it with talking.

How does this relate to the interactivity that is involved in the piece?

The possibility of working with interactive systems has always been in the back of my mind or a thorn in my side depending on the context I'm thinking in. I wanted the interactivity to be virtually transparent to the point that some people would not even figure it out. I didn't want somebody going in there and, in a sense, playing. I mean "play" like cause and effect—I'm pushing this thing and so this is happening. I think this is the major problem with interactive work in general. You have to find a way around the mind being told where and when it may make a choice. It has to kind of dawn on the mind.

In the Pompidou *exhibition catalogue, Lynne Cooke quotes you as saying "If I have a position it is to question the privileged place that image, or for that matter sight, hold in our consciousness." In the light of your strong concern with language, especially in your single-channel tapes, there's also this quote: "Language can be incredibly forceful material: there's something about it where if you can strip away its history, get to the*

materiality of it, it can rip into you like claws, whereas images sometimes just slide off the edge of your mind as if you were looking out of a car window."

Quotes like anything have their context. I'm really looking for another way outside the current theoretical issues concerning language and image. I am still very interested in the image being experienced self-consciously rather than it merely being a given. In this sense I'm not referring to the media frame of the image and its representation but rather the process of seeing and how that's linked to thinking and language. I think this comes through particularly in my installation work in which the viewer is an integral part of the event and that she or he, in a sense, completes the "circuit" of the work. This is especially true in *Tall Ships* and to a certain extent *Beacon*. On a more strictly perceptual level this might simply be the negotiation of images that migrate through a space, as in *Suspension of Disbelief* and *Between 1 & 0*[6] where images exist for fractions of seconds and only become "seen" as part of a "swarm" of accumulated images that illuminate a kind of trace.

In your early work you were very much concerned with feedback phenomena. How has this interest continued in your more recent work?

I'm finding myself once again engaging the possibilities of feedback inherent in electronic media, however, more directly having to do with people. There is a profound difference here that has to do with a kind of presence which enfolds a real time mediation of viewer, viewed, signifier and signified that are continually shifting positions. It allows for other kinds of thinking—a kind of action that brings about a real change in the world and our sense of it. The feedback really makes possible a special state that, in turn, further engages an ontological space where, at their boundaries, art and life mutually fold into each other.

Do you see Tall Ships *and other recent works as phenomenological, insofar as you are interested in language and thinking about the constant problem of the mind/body, subject/object split?*

But I'm not thinking about the constant problem of the "mind/body, subject/object split" at all. My working methodology is not one of theorizing and then applying that to making art. In each work I find myself committed to a process that of course may involve material where such philosophical issues may seem to be relevant. But I'm committed to the idea that the art event takes place within the process. On3e has to be open to that event and be able to kind of wander in it and feel it open up; to see it through until some kind of release feels inevitable. I'm getting further and further into finding this moment in processes that involve me with people.

Today there is more and more installation work which involves media such as video or new technologies, and there is an increase of interest in it, but it is still slight. In

terms of a response from the art press, why do you think that it is so minimal and why, when it is there, it is so critically and theoretically underdeveloped?

The "object" has been revered for so long and it's so much a part of the economic base of art that to get into installation work people really have to have an experience that turns their mind and breaks their habit of wanting *things*. Even conceptual art was assimilated more easily into art culture because in the end there was still some sort of static object that you looked at, even if it was only the photographic or textual documentation put in a frame. But once you ask the viewer to enter the real time presence of the work—that is, that you want their *time*—there's another kind of expectation. Performance, installation and media art each in its own way resides somewhere between theater and cinema, on the one hand, and the plastic arts on the other. I think this is what gives them a certain flux—their "cultures" have more inputs and outputs—by nature they are more interactive and driven by intermedia tendencies. Most of the time this kind of work falls between the cracks. Either you have theoreticians applying the likes of Baudrillard and/or stealing ideas from McLuhan but nevertheless completely missing the work for the simple reason that they do not attend to the work itself. Or you have an art critic who comes from a good historical knowledge of work involving objects and images but doesn't have a clue about technological systems and is not accustomed to considering an art that is ontologically based, i.e., that seeks to extend both what art and the world *is* by exploring possibilities through new media and in new combinations.

NOTES

1. The first version of this re-edited interview conducted by Regina Cornwell was published in *Art Monthly*, October 1993, No. 170.

2. *Beacon (Two Versions of the Imaginary)* (1990): two-channel video installation (NTSC, black-and-white, sound), with two modified video monitors, two projection lenses, synchronizer, aluminum pipe, and motor.

3. *Disturbance (among the jars)* (1988): seven-channel video installation (PAL, color, sound) with seven modified video monitors (removed from their outer casings), synchronizer, white platform, and seven wood chairs. Monitors are arranged in three groups, and images flow across the screens, presenting single images and sometimes rapidly shifting views. Nine poets and a philosopher walk while reciting passages from the Gnostic Gospels, principally in French but translated and intricately improvised from and to several languages.

4. The quote from "The Gospel of Thomas" (several translations exist, including in *The Nag Hammadi Library*, ed. by James M. Robinson, San Francisco: Harper & Row, 1997) is an "original" rendering based on the free use of Gnostic texts in *Disturbance (among the jars)*. In the original interview this quote was misascribed to *The Gospel of Mary*, one of the other texts used in *Disturbance*.

5. *Suspension of Disbelief (for Marine)* (1991–1992): four-channel video installation (NTSC, black-and-white, silent) with thirty modified monitors, computer-controlled video switcher, and aluminum beam.

6. *Between 1 & 0* (1993): two-channel video/sound installation, with ten black-and-white monitors mounted on two aluminum ladders, two speakers, and spoken text.

Bill Viola
Art at the End of the Optical Age
(Interview by Virginia Rutledge) (1998)

Bill Viola began experimenting with video art in the 1970s. By the end of the 1990s he had become one of the leaders of a group of video artists whose work had moved far beyond the low-resolution, single-monitor videos of the 1970s into the creation of dynamic, richly textured moving images that often were part of physically interactive environments. Viola's contemplative works are powerful sensory environments. Drawing on sources such as the writings of St. John of the Cross and the thirteenth-century poet Jallaludin Rumi, Viola elevates moving images to a level that encourages a near mystic contemplation of reality.

In his 1996 work *The Crossing*, Viola employs two huge screens. On each a man slowly walks toward the viewer until his body just about fills the entire screen. At this point water begins to fall on the head of one man, while fire starts to burn under the feet of the other. The flowing water and the leaping flames build in intensity until both men are totally engulfed. The visceral power and metaphorical implications of *The Crossing* are endemic of Viola's work. He often uses images of elemental substances and employs slow-motion techniques, shifts in scale, and multiple images in order to turn perception into a means to contemplate reality. "Art at the End of the Optical Age" was published in *Art in America* in March 1998 at the same time that Viola's twenty-five-year retrospective, which was organized by the Whitney Museum of American Art, was on tour in the United States.

Virginia Rutledge: Bill, you've been working in video ever since the technology became generally available. How has art-world perception of the medium changed?

Bill Viola: Video is finally being accepted as just one more viable medium for art. This acceptance is a fairly recent development, but then again, so is video. [Whitney Museum director] David Ross and I were talking recently about the reception of video at the last Whitney Biennial, where several rooms were devoted to large-scale projections of some length. Many people watched the pieces in their entirety, which they would not have done ten years ago. Video then seemed out of sync, not only with the gallery system, but also with people's everyday lives. Big electronic images weren't part of our daily landscape the way they are today.

VR: You've written a lot on the medium. How have you redefined your ideas of what video is, over the years?

Originally published in **ART IN AMERICA,** March 1988, Brant Publications, Inc.

BV: Actually, technologically speaking, I don't think video is going to exist for too much longer. The technology is changing so rapidly that it simply won't be around in twenty years. Video will then be thought of as a limited practice with a finite life span, a medium that flourished briefly during the late twentieth century and early twenty-first. As a young art student seated at his computer screen said to me, "Video? Oh yeah, that's my dad's medium." Maybe "moving image" will eventually emerge as the overall genre label, as video and electronic forms continue to merge into the digital domain. The practice of video, however, the making of art with moving electronic images, will be around for a long time and continue to grow.

Early on, the format was surprisingly perishable. As I prepared for this survey show I realized with shock that my old open-reel 1/2-inch tapes, stored as carefully as possible, are already unplayable, as are some of the copies I had made on 3/4-inch tape. In one case I had to work off a 3/4-inch dub of a 3/4-inch copy of a 1/2-inch tape; there was no other way to save that work. Lately, we've been transferring everything to digital Betacam, securing its continued life. For me, video's impermanence intensifies my sense that my own work is not about the medium per se, and yet that same impermanence also makes clear that, as a medium, video is very specifically tied to this particular moment in history.

VR: Yes, and we are already seeing "video" referenced as a visual style, often with nostalgic or archaizing undertones, as in, for example, Sadie Benning's work. What do you make of the category "video installation"? It has been suggested that there is some market element to its prevalence, since collectors might be more willing to buy a video work that also exists as an object, as opposed to work whose physical form is nothing more than a video cassette.

BV: I'm not persuaded by that. It is true that there was no significant market for video until quite recently, but things have changed since Leo Castelli made the first attempts at selling videotapes in signed cassette boxes. The historical importance of the form is widely acknowledged now. I think the rise of installation work in general is just a sign that art is changing to reflect the times. There is a strong interest now in immersive kinds of experience, rather than the objective-observer paradigm that has been dominant in the West for many centuries.

VR: Yes, and I suppose one could point to a whole repressed history of immersive visual environments in art—panoramas, dioramas, *tableaux vivants,* maybe even polychrome representational sculpture of the nineteenth century. Is this interest in immersive formats something you talk about with other artists?

BV: Only occasionally. It's "in the air," as we say. Unfortunately, one of the big problems in the art world right now is the insulation of the artists from each other, and of the art world from the larger community.

VR: You live in close proximity to several prominent Southern California art schools, but you yourself don't teach. How do you see yourself participating in a community?

BV: I feel it's my responsibility to pass on what I have learned to the next generation, but I am put off by the politics and bureaucracy of the university. As a student, I got out as quickly as possible. People were generous to me when I was younger. In a way, Paik, Campus and especially David Tudor were my graduate school. I don't think there was an institution where I could have learned what I did from working with them. Artists who teach have to deal with their students in an artificial situation, but the larger problem is that artists are functionally isolated from

their audience. What they do have is their fellow artists, but even here the adversarial edge fostered by these stratified economic times and the position of the artist in society means that these connections are limited. For me, not teaching means that my contacts with other, younger artists aren't as frequent as I would like. I do hope my writings are helpful to some interested people. Of course, my art is the most important connection.

VR: You've lived in Long Beach for the last sixteen years. Would you call yourself a West Coast artist?

BV: Well, when the Lannan Foundation exhibition space—now gone, of course—showed *Stations*, in 1996, it was my first Los Angeles show in eleven years. The West Coast has a history of not fully recognizing its artists until they have achieved success elsewhere—Kienholz and Ruscha, for example. And on the other hand, I don't feel that the East Coast establishment has given postwar West Coast artists their due in making major contributions that have defined the art of our time. Living in Long Beach has worked well for me, but I don't think of myself as a Californian, really. My work is probably still best known and appreciated in Europe. More of my works have been seen in London than in any other city. Ultimately, I guess I feel that I'll always be searching for a homeland.

VR: What impact has the exhibition system had on your work and career?

BV: Most people would say I did it backwards. I had big exhibitions at major museums before I had gallery representation. My first solo show in a commercial space wasn't until 1992, when I showed at Donald Young in Seattle and at Anthony d'Offay in London. Things would be different now if it weren't for some museums and alternative spaces that showed my work early in my career, in some cases providing funds for equipment.

VR: What do you think are the prospects for art support in the future?

BV: Bleak. I was lucky in having a lot of help early on. When I was beginning to make work, there was an ecology of support that allowed video and performance to exist for long enough so that the commercial contemporary galleries had to react. My first big show in New York was at the Kitchen in 1974, and that same year established artists like Oppenheim and Acconci were showing there. It was a period of incredible ferment, and the exhibition possibilities seemed wide open. But by the end of the '70s there was already a group show of young artists who couldn't get shows at the Kitchen. So these windows of opportunity don't last long. Artists always have the choice of using established paths or rejecting them, but today there are simply fewer paths.

VR: We've talked about how one problem with exhibiting video is that when you are dealing with time-based and sound works, a large group show frequently runs the risk of creating an unintended metawork. In a way you've turned this to advantage in your survey. How did this show come together?

BV: David Ross and [stage director] Peter Sellars, the co-curators of the exhibition, along with Kira Perov, my wife and partner, and myself, worked as a team to put it all together. David and I go back a long way. We went to school together, and in a way we've had parallel careers. When David was hired as the Whitney's first video curator in 1972, he hired me as the first video preparator—we were both flying by the seat of our pants, let me tell you. Over the years we've watched each other grow, and we've always wanted to do something creative together. Peter and I met some ten years ago and became friends. His name came up as soon as

David and I started talking about the survey, because we felt it was important to work with someone who had experience with time and crafting an environment for an audience. Having the benefit of Peter's knowledge of theater and opera has been incredible. And it was Peter who focused us on the idea of presenting the show as a larger composition of interwoven parts existing in both space and time.

VR: You've been quite prolific. How did you select the works for the show?

BV: The temporal dimensions of my work required us to think of the show as a whole in order to create a coherent experience. The installation was conceived as a kind of journey among interconnected works that together make a larger statement. In the end we included most of the major pieces, which I guess speaks to the continuities within the overall body of my work. Chronology is completely disregarded in the layout, which differs from the usual career survey. It happens that the earliest work in the show is the second tape I ever made, a seven-minute black-and-white piece called *Tape I* (1972). The latest is *The Crossing* (1996), a large two-screen installation. I've been making installations side-by-side with tapes almost from the beginning, and fifteen of these installations make up the main portion of the show. But as we were devising an interconnected installation, we saw that some of the main nodal points were represented by certain tapes. We felt these needed to be in the galleries, even though I think there has yet to be a fully satisfactory solution to the problem of showing tapes in that setting. The reality is that you just can't show a ninety-minute tape in a gallery where people are in constant circulation. We ended up presenting three tapes as room installations in the galleries. Twenty-two more are shown on a screening schedule in the museum's theater.

The architecture of most museums is designed to deal with objects as if they can be isolated on neutral ground, which is an illusion. How do you apply this situation to a work like *The Stopping Mind* (1991), which is not so much an object as a system of moving images and sounds that describes the perpetual flow of consciousness? So designing the show was a creative challenge, and Peter Sellars and I worked quite closely on this. We decided also to include about 100 pages from my notebooks. These are the last things viewers see, because we wanted the encounter with the work to come first. For the same reason, there are no wall labels: we wanted, as much as possible, to avoid mediating the work.

VR: What, no audio tour?

BV: Well, I did consider an audio tour in which you would only hear poems by Jallaludin Rumi, a thirteenth-century teacher and mystic whose writings have been important to me. But that didn't go over, for some reason.

VR: At most of the show's venues you are also placing works outside the museum, sometimes in nonart sites around the host city.

BV: Re-siting the works is mainly meant to provide a productive disruption of the museum frame. Going to an art museum can seem like a trip to a department store. Everything is framed and categorized. But what happens when you unexpectedly encounter a work in the course of going about your daily life? And even if you read the publicity and make a conscious effort to see the work, there is still the idea of undertaking a journey to a place you normally wouldn't go, which can yield all sorts of unexpected experiences.

VR: Sure, like the idea of a pilgrimage. Your work draws on many sources—such as Rumi, whom you mentioned—but some of its most overt references are to Christianity, whether through use of a particular form, like the triptych, or through allusions to themes like the Crucifixion or Resurrection. Of course these themes are

found in other sacred traditions as well. Where does Christianity fit into your personal narrative?

BV: I did grow up in a Christian culture, and I don't deny that the things you mention are there, but I'm not out to illustrate any particular dogma—rather, the opposite. I'm interested in the root sources under the forms. For example, the physical form of the triptych is an expression of a cosmology so deeply ingrained in the Western mind that it has become a substratum to our thoughts—the conception of a three-fold universe. The configuration of heaven, earth and hell is not only Christian but appears in many other cultures. I am drawn to this web of connections latent in our inner lives.

VR: And yet *The Greeting* (1995), for instance, seems saturated with both Western and specifically Christian traditions, on both formal and thematic levels. What was the catalyst for that piece?

BV: Peter Sellars spotted something in my very first notebook, from 1972: "Make a piece about people greeting each other at airports." Then, over the next twenty-three years you see the idea emerge and resubmerge on the pages of the notebooks—record three women in conversation; compose a scene with pre-Renaissance picture geometry; do something with actors on the subcurrents of social interaction—until you reach 1995 where I think I'm suddenly inspired by seeing a reproduction of Pontormo's *The Visitation* and observing three women on the street corner one windy afternoon, having by then completely forgotten this underlying thread of connected ideas.

In a larger sense, though, the piece comes out of my long-standing interest in the representation of spiritual events, archetypes and cultural constructions that remain part of contemporary consciousness whether we accept them or not. They're hard wired. So that's how Christianity would fit into my thinking.

VR: Who is the "he" in *He Weeps for You* (1976)? It's one of my favorite works, even though the universalizing language, with its gender-specific pronoun, ordinarily would put me off.

BV: Yes, I know what you mean. I don't think anybody's ever asked me about the title before. In college, when I started exploring traditional religious texts from Islam and Buddhism, I had to come to terms with the archaic language in which these works have come down to us—all those "Thou hast's" and "our Father's." I had to make peace with hearing this oppressive language and not confuse it with the ideas.

The phrase "he weeps for you" just popped out of my brain when I was working on the piece. It's literally a fragment from my reading, an artifact that synthesizes a way of thinking about the world. It functions as a reference to the whole notion of religious tradition, Christian or otherwise. I also wanted to make a connection between the drop of water in the piece and tears.

VR: Thinking further along those lines, how would you say your work relates to cultural ideals of beauty? After years of critical disrepute, the notion of "beauty" has been making a bit of a comeback in some contemporary art criticism. But the work in question often seems to celebrate only "low" or popular manifestations of the beautiful, and I'm not convinced that the term has regained any authentic meaning. But people have told me your work makes them cry. Okay, I've cried. What do you think of responses like that?

BV: I don't feel tied to the fashion treadmill of the art world, and I'm not interested in propagating any form of cynicism. I see that as a toxic substance we need to purge

from the system. Cynicism is just not a tenable critical position. I believe that when something is so visually overwhelming that it makes you cry, what you are really tapping into is some undercurrent of wisdom and knowledge that gives you an insight into a fundamental truth of life. It's not "merely" emotion. The visual stuff is just the vehicle for the feeling carried to you. If that visual stuff is beautiful, then it is beauty as a form of knowledge, one of the great Renaissance ideas.

VR: Let's talk about how you use your own image in your work. You appear in a number of your early pieces. Are you aware that many people assume that you are the actor in later works such as *Deserts* and *The Crossing*? Why did you choose someone who resembles you closely?

BV: Video is particularly well-suited to self-portraiture, because it can convey such a sense of intimacy and immediacy. This has been frequently pointed out. Video's early and continuing connections with performance art, and Bruce Nauman's profound early work, are examples of this intrinsic characteristic. Video can afford the viewer the sense that he or she is being admitted into someone else's private experience, and that impression of contact with another being is crucial to the genre, I think. I haven't given much thought to my searching out an actor who looks like me, but it happened in uncanny ways. It must be some unconscious link to all those earlier pieces where I used myself as subject.

VR: From being in front of the camera you've switched to being behind it. What did you learn from the switch?

BV: The reason I appear in those early works is that I didn't think I could ever communicate to somebody else what I wanted to happen in front of the camera; also I was concerned about letting artifice into the work. But *The Passing* (1987), in which I did appear, marked some turning point. I realized then that I wanted to jump over the moment of recording to get closer to what the viewing moment was like. Before, my approach had been to try to connect the physical moment of being in front of the camera with the viewing moment behind it, which, of course, ultimately becomes the audience's point of view as well. So this was a shift in approach from making work by embodying the experience to making work by observing the experience, moving my focus from the performance to the camera, and it opened up new ways of thinking about subject and object for me. I continue to do self-portraiture and, in fact, made a series of works in that vein just last year.

Working both sides of the camera has also clarified my relation to my tools. If I had to point to one factor that drives my work, it would be technique. This doesn't mean wanting the latest, greatest technology, because I don't always use that. But the available technology is what enables you to realize whatever vision you have, and it also transmutes it. If you start with a mental image of a guy falling into water, and it matters that this movement is fluid, you have to deal with the physics of the situation before you start working with a camera. The human body falls at 33-1/3 feet per second, so that the standard high-diving board, 30 feet high, is going to give a body a fall of about a second. Video runs at 30 frames per second, and if you want fluid movement that's not enough incrementation. So you have to shoot on film, which gives you 300 frames per second, and you have to get a crew and become a director. That experience helps you see how other visions might be realized in the new material, and growth spirals out from there.

VR: You've just worked with computer-generated imagery for the first time. Could you describe this new piece?

BV: It's a fifty-foot corridor, about the width of a doorway. At its end, the corridor opens onto a black void, in which you see the image of a small, young tree. This is rear-projected on a large black screen. As you enter the corridor and start walking toward the image, your movement controls a moving-image sequence that shows the growth of the tree from new sapling to maturity and decay. The sequence goes through a blossoming period, fruit grows and falls, the leaves turn color, until finally when you have reached the end of the corridor, the leaves fade and only the pale white branches of a lifeless form remain. The piece is called *The Tree of Knowledge* because human knowledge, the "human condition," arises out of our awareness and understanding of the consequences of our temporal existence.

The thing that has excited me most about it is I've been able to work with time in a way that cameras don't allow. There are three levels of time represented in the piece: a compressed time-lapse view of the tree growing and dying, over which is mapped a seasonal kind of time, and then a real-time element represented by wind blowing the leaves and the fall of fruit. It is the closest I've been able to come to working with a long-term, almost geological sense of time; there is a suggestion of the infinite in the cyclical structure within the work—the return of the young tree from the old when you exit the corridor. What I wanted was some sense of identification, and it does seem that viewers realize that it is their movement toward the image that causes it to "age."

VR: I'm curious about the visual style of the tree. It's very realistic looking, but also unmistakably an animation drawn by a computer; it's not even as "real" looking as it could have been if you had chosen to use scanned photographic information at certain stages. How did you think about this work in relation to realist representation?

BV: I didn't want a specific kind of tree. I did a lot of research at the Huntington Gardens, photographing many different species, in order to arrive at what I view as this ideal tree. I told Bernd Lintermann, the programmer, to look at the paintings of the Northern European masters, especially Van Eyck and Hans Memling. Ironically, we started with software that gave us as biologically accurate a model of growth as possible, but soon made various deviations that actually enhanced the image's realism—we made the trunk gnarl rather more rapidly than would happen in nature, for example. As we all know, conventions of realism are often more powerful than reality itself! Think about sound in the movies. It's completely unrealistic, but it works.

That's mainly why I didn't use sound: I didn't want this tree, or rather this experience of a sense of time, to be objectified. Among other things, I didn't want viewers to relate the experience of the work to the experience of a typical movie, or to be confused about the work's particular relation to reality. I want viewers to experience it, as much as possible, as a mental image.

I think the piece works because it maintains some fundamental natural connections to real life. Yes, the image is an animation, but it is not fantastical looking. And while the overlap of time frames in the work is quite unrealistic from the point of view of a tree's natural biological growth, it has a dimension of authenticity that really refers to the human experience of time. Of course this idea is an ancient one embedded in many cultures' use of the tree as an image for the structure of time, as in a genealogy.

VR: Much of your previous work is concerned with the experience of recording the physical world, and here you are making a piece with no real-world referent. Does your use of simulated imagery carry with it any metaphysical implications?

BV: Something I am thinking about all the time is how the fundamental message of all religious teachings is that whatever the conventions for representing reality at a given moment in time, they must not be thought to be absolute. Islamic theology describes God, Allah, the true reality, as being surrounded by 70,000 veils of light and darkness. When we compare the gold sky in medieval paintings to the blue sky in our vacation snapshots, we tend to look at the medieval image and say we're seeing symbolism. But it may as well be Photo-Realism since for the medieval person the world was infused with the divine, which could only be represented by gold. The thing is not to privilege one abstraction over another, not to confuse the vehicle with the idea it addresses.

I'd say that my use of simulated imagery reflects to some degree where the culture at large is going—toward a renewed concern with conceptual reality. We've evolved through the period of privileging the optical, a convention that crystallized during the Renaissance. This way of thinking, which is associated with the development of mathematically based perspectival systems, is in fact a quite specific philosophical mode of looking at the world. We're just now coming to the end of that way of thinking. That's very, very significant, because if you want to understand a culture, you follow its forms of truth. For over 500 years, our culture has been preoccupied with the optical as the measure of reality, but now that we've begun to see our own bias, we are beginning to shift from that preoccupation into an understanding of the category of information itself as the main conveyor of reality. And the transition periods, when the truth becomes embodied in multiple conflicting forms, are always the most interesting.

VR: We seem to be in a confusing moment now, as regards the relation of visual information to truth. Look at how frequently special-effects-driven movies rely on narratives of catastrophe for their structure.

BV: There is a lot of unease out there. At the turn of the last century, when new technologies like the telephone began to emerge, the mood was one of excitement and unlimited possibility. Now we worry about whether our computer system will survive the millennial zero crossing, and the mood is almost apocalyptic. Special effects have made it difficult to decide when or if to suspend our disbelief. We can no longer tell when an optical image is rendered, modified or real. We can assume for now that the talking heads who give us television news are part of the same world we inhabit, but there will be no certainty in the future that this is so.

VR: Maybe we won't care.

BV: A generation gap is certainly evident between the children of the electronic age and their predecessors, who may not even be aware of this crisis of representation and identity. You see this split very clearly in the development of the Internet— hoaxes and alter egos have already become routine in cyberspace.

VR: Nevertheless, despite this overall shift away from the optical, the computer graphics industry itself is driven by a quest for optical realism, which is still considered the state-of-the-art special effect. Are you suggesting that this is just a stage in the culture's transition away from realism and, if so, toward what?

BV: Fifty years from now I don't think optical realism is going to be an issue in visual communication anymore. Experience is so much richer than light falling on your retina. You embody a microcosm of reality when you walk down the street— your memories, your varying degrees of awareness of what's going on around you, everything we could call the contextualizing information. Representing that

information is going to be the main issue in the years ahead—how the world meets the mind, not the eye.

VR: How does working with computer imaging compare with working with a camera?

BV: It's not as different as one might think, especially as I become accustomed to working in a directorial mode. I have to work closely with the person who does the actual programming. But my camera skills actually translate pretty well, once I understood that not only is the image virtual, so is the camera eye itself. Within its system the computer creates an image based on the principles of how the camera—or its model, the eye—receives light. This image can then be manipulated to appear as it might if viewed through a variety of virtual lenses to produce a wide-angle look, a close-up, varying degrees of resolution and so on—the entire vocabulary of photographic effects, and more.

I am still working with light, finally; the thinking is much the same; only the mechanics of making are different. Speed becomes more of a factor. When the animations are complex, it can take hours for even the most advanced computer to render them. The animations for *The Tree of Knowledge* were rendered on a high-powered Silicon Graphics computer called a "reality engine." It's the same machine used to make effects for Hollywood movies like *Jurassic Park* or *Twister*. This isn't like squeezing paint out of a tube—it's very specialized, complex and expensive. So one difference is that I have to rely on someone else to implement my ideas in a technology that's still new to me. But the most liberating difference for me creatively is that in the digital world you no longer have to rely on light as the basis for making an image—the direct connection to the outside world is broken.

VR: What are your thoughts on interactivity? It doesn't seem to me that we have seen much truly accomplished interactive work in mainstream art contexts.

BV: I agree. First, there is a temptation to push the technology further than it is really able to go; often things simply don't work the way they are supposed to. But it's not just a technology problem. Interactive works often try to offer too many possibilities, so that the parameters of the work end up being too wide. I'm not sure that the social experience sought by the artist is always sufficiently well defined to be meaningful.

VR: I think many people dislike the idea of being observed when they interact with an art work, just as we don't particularly want someone looking over our shoulder at the ATM.

BV: That's a problem I deliberately set out to avoid in *The Tree of Knowledge*, which is set up for a solo performer, if you want to call the viewer that. The piece affords a limited interaction that happens on a single axis specified by the physical architecture. It's a simple, immediate connection that doesn't seem to induce performance anxiety. For now, it seemed one of the only plausible ways I could work with interactivity.

VR: Is there a technological tool you want that doesn't yet exist?

BV: I'm always interested in new equipment, because it may offer the means to say something differently, but I guess I've always accepted the capabilities of currently available technology. The linear development of technology is a given, something imposed on me, but my relationship to it has gradually changed. In the past the rapid evolution of the tools often inspired me or offered a point to take off from. But now the limits I'm primarily concerned with are internal. My current working process is a little like writing certain kinds of music. If you accept a given

array of instruments, then to some degree the music you write must be written for those instruments. Five or ten years from now, I might make *The Tree of Knowledge* differently because of new advances in technology, but the piece as made in 1997 would still be valid. The work is just the container for the idea, and the design of the container can change.

VR: Computer-simulated imagery is most often a prohibitively expensive kind of work to produce, both in terms of equipment and skills. Does this costliness become a factor in your work?

BV: Yes, and it's a sobering thought. In a way I feel as if I've returned to the days when video technology was in its infancy, when to make a reasonably sophisticated work was quite expensive, often cumbersome, and usually required a whole new set of skills. Learning them can be very interesting, but it's not always an option, for a variety of reasons. Until now I've always been fully conversant with the technologies I use for my work, knowing firsthand how to shoot, edit, even build a camera, but it's not yet clear how far I can continue to learn everything myself with digital techniques. This will be something I'm thinking about over the next couple of years, as the survey travels and I have this extended opportunity to look at a big chunk of my past. Maintaining the concentration to do new work may be tricky, but I have a surprising number of as-yet-undone pieces that I want to make, some of which go back fifteen or twenty years. I can't articulate it, but I feel that I was given some kind of overall vision when I was young, and I've been working from it and fleshing it out all this time. Realizing that may be the best thing to come out of putting this survey show together, because until now I wasn't fully conscious of this body of ideas that have been guiding me all along. Going back to my notebooks was what made it evident to me, and I'd like to think that this realization will allow me to take the work to another level.

Critics

Lane Relyea
Art of the Living Dead (1992)

One of the distinguishing trends in American art of the 1990s was the number of artists centered in Los Angeles who were garnering the attention of the art world. At least as far back as the 1950s there had been a small, yet very active community of progressive artists in Los Angeles. However, the rise of artists such as Mike Kelley, Charles Ray, and Raymond Pettibone, coupled with renewed interest in already established artists such as Chris Burden and Paul McCarthy, reinforced the claim that Los Angeles was becoming the center of the most exciting progressive

tendencies in art. One of the most pivotal museum exhibitions that defined a uniquely Los Angeles sensibility was the 1992 exhibition *Helter Skelter: L.A. Art in the 1990s* at the Los Angeles Museum of Contemporary Art, which brought together the above-mentioned artists along with many others.

Taking the Beatles' song that became the mantra of the murderer Charles Manson as its title, this exhibition focused on work that communicated the raw, visceral, abject underbelly of this city of freeways, shopping malls, theme parks, and Hollywood. In the essay "Art of the Living Dead," which was originally published as part of the exhibition catalog, Lane Relyea sees a connection between much of the work in this exhibition and Pop art, particularly in their preoccupation with "a society that has already been flattened into a representation." Nevertheless, Relyea comments on the distinct increase in the level of penetration that consumer culture has made into our experiential and psychic life from the 1960s to the 1990s. This is best summarized by the shift away from the slick, optimistic vibrancy of Pop art to the dysfunctional and sardonic displays of alienation featured in *Helter Skelter*.

In a society where no one can any longer be recognized by others, every individual becomes unable to recognize his own reality. Ideology is at home; separation has built its world.

—Guy Debord, *Society of the Spectacle*

To induce a collective content for the imagination is always an inhuman undertaking, not only because dreaming essentializes life into destiny, but also because dreams are impoverished, and the alibi of an absence.

—Roland Barthes, *Mythologies*

Los Angeles, it should be understood, is not a mere city. On the contrary, it is, and has been since 1888, a commodity; something to be advertised and sold to the people of the United States like automobiles, cigarettes and mouth wash.

—Morrow Mayo, *Los Angeles*

Knock Knock. It's two in the morning on Sunday, August 10, 1969; Charles Manson stands at the front door of a house in the Los Feliz district of Los Angeles. The residents, Leno and Rosemary LaBianca, who returned home from vacation less than an hour earlier, are still awake, reading the newspaper in their living room.

"Who's There?" Perhaps for a split second, far in the back of the LaBiancas' minds, somewhere behind all the suspicion and fear automatically aroused by such an unexpected midnight visit (remember, too, the paper the couple was reading at the time blared the story of Sharon Tate's butchering just the night before)—perhaps in their minds a faint mix of excitement and curiosity stirred. After all, doesn't the prospect of human encounter still inspire hope? Isn't that what makes living in society still tolerable—the idea, though less and less corroborated by experience, that meeting other people opens the

way to endless possibilities, that it represents a bottomless resource of knowledge and adventure, that it promises an ever-unfolding of the world?

The door to the LaBiancas' world swung open that night, but what ensued only doomed the members of this particular meeting to remain strangers for eternity. Who knows what the LaBiancas thought of Manson (it's hard to say if they even recognized him as their murderer; as he tied them up he repeatedly assured them they wouldn't be hurt). Manson, on the other hand, made clear what he thought of the couple. Not that he recognized them—on the contrary, he obviously saw them less as strangers than completely estranged, removed; in his eyes, the LaBiancas belonged to a different species. Moreover, they typified that species; to Charlie they were no more than display animals in the wax museum society presented itself as, only abstractions, examples to be used in the delivery of his crude poli-sci lectures. And so his pupils, as instructed, turned the LaBiancas' bodies into writing tablets, their blood into ink.

Ironically, Manson's actions consigned the lifetime vagrant to an exactly inverted fate. He too suffered being misidentified, being reduced and abstracted, having his radical differences with society reconciled for him. But his metamorphosis entailed no intimacy or specificity, and not a drop of blood—in fact, he personally wasn't that much involved. Manson wanted to make society pay for not understanding him; society retaliated by showing that it did. Thus Manson was subjected to a shallow, commercial acceptance, at once inflated and impoverished through public consumption. As his profile came into focus, he grew both more recognizable and yet more strange, more two-dimensional and opaque. Some officials, including prosecuting Deputy D.A. Vincent Bugliosi, fashioned him a junior Hitler (in *Helter Skelter* Bugliosi observes that "both were vegetarians; both were little men").[1] Some thought Manson worse, a pure, virile form of evil, infecting the vulnerable youth who flocked to his side. Others argued that he himself was too impressionable, a zombie brainwashed by years in prison, stints in Scientology (Manson graduated "theta-clear") and the Church of the Final Judgment, by hippie aphorisms, LSD, the Beatles. A few tried splitting the difference: according to them, after "Helter Skelter" co-songwriter John Lennon declared the Beatles more popular than Jesus, Manson, who fancied himself the Son of God, naturally felt compelled to follow orders.

Still others recognized Manson as a tortured soul, himself a victim of society's abuses. Just as Norman Mailer discovered in convicted bank-robber Jack Abbott a spokesperson for the oppressed[2] (Abbott, after Mailer's praise helped leverage his parole, contradicted the Pulitzer prizewinner by promptly stabbing a New York waiter to death), Yippie activist Jerry Rubin, fresh from visiting Manson in jail, reflected that "Manson's soul is easy to touch because it lays quite bare on the surface." Manson was elected a fellow countercultural hero by Bernardine Dohrn, who told a Students for a Democratic Society convention, "Offing those rich pigs with their own forks and knives

and then eating a meal in the same room, far out! The Weathermen dig Charles Manson."

And so on. Manson clones lurked everywhere (according to hippies who complained to the *New York Times*, hitchhiking was among Manson's many victims—no one dared pick up long-haired kids anymore).[3] Mobilizing some of the most fundamental ideas Puritan America held about itself, Manson was catapulted to prominence not just on the merit of his acts but on his manner, too—he was the counterculture's counter-moralist, star of the American Dream's nightmare flipside, transgressing the model of the self-made preacherman who ambitiously ventures the dusty frontier fanning word of apocalypse and salvation. In short, Manson had a message. But as a preacher, he was both effective and mute: it was not his words but his picture in the paper that grabbed people. Manson, his fans and assailants agreed, was "charismatic." In fact, being both expressive and photogenic (much more so than the many other mass murderers this country boasts, including poker-faced Ted Bundy) is what qualified Manson to become such a sensation, to gain full-on celebrity status. Even he seemed to anticipate his eventual superstardom: while walking on Venice Beach after leaving the LaBiancas' home, Manson was stopped by two unwitting policemen and asked what he was up to. His alleged reply was "Don't you know who I am?"

Transformed from a mass murderer into a mass phenomenon, Manson came to symbolize merely the notion of hedonistic bloodthirst and generational clash, his ecstatic facial expressions the catchy packaging on whatever anybody wished to make of such issues. Mostly what people made was money. In fact, the real effect of the Manson craze was anything but divisive and threatening; rather, it unified and soothed, bringing the country together in a debate that was largely beside the point. But such recuperation of '60s upheaval was not limited to Manson; it advanced on many fronts, as love-ins turned into *Laugh-In* and *Love Boat*, liberation into alternative lifestyles, altered consciousness into an industry of New Age counseling and self-help. Over the following years Manson would resurface in person (e.g., his recent interview with Tom Snyder), but each time his presence seemed to dim. Like the Wizard of Oz, here was this huge facade, formidable yet hollow, and behind it the man himself, a small, stammering idiot.

Of course, at this point we're no longer really talking about Manson's fate; in a sense, we're talking about our own. Upon his makeover into a commodity and the extinguishing of his threat through acceptance, Manson the monster—the "mad dog devil killer fiend leper," as he described his own public image—swept the culture, but in so doing glossed over him personally and the dark significance of his murderous deed. In Charlie's place we were presented with a new and improved zombie, this one infinitely more presentable and sociable, a grimacing puppet sent back out to proselytize the masses anew. Only now he mouthed softcore platitudes that sold papers, fashionable

sociology, repressive police campaigns. But it wasn't Manson who suffered this reform; we did. Before we could establish a direct relationship with his terrorism and reflect upon the introduction of such deep, impassioned despair and madness into our knowledge and doubts about the world, Manson was integrated for us, slotted all too quickly and easily into contemporary history's cast of characters. Or, rather, that history's mediated likeness, a parade of emptied, hypnotized robots who together peddled alienation by pretending to experience and interpret our needs and desires for us. Manson was reformed all right: he was now a hired mercenary, a loyal soldier in the army of ghosts that occupied social life. Watching Manson's odyssey, we too couldn't help but suffer a morbid demise, from being witnesses of a crime to being the audience of a spectacle. Here Manson stood before us, an empty shell, a crater marking the site of a once diabolically rich substance now completely stripmined. No longer could he inspire us to madness or scare us to death. Now he only bores us stiff.

Such is life, or the lack of it, in the mass marketplace. If the sardonic grins of murderers and lunatics still muster a trace of fear within us, it's because their recklessness threatens not our already decimated moral order but the mechanized daily routines whose very emptiness structures our lives. If they arouse a mix of fascination and contempt, it's not because we find their perversions so incomprehensible; rather, it's because their baroque and violent detachment from society mocks our own, more run-of-the-mill and passive remove. Exile isn't what it used to be. It no longer seems so epic, a dramatic choice or cruel punishment; it's become instead an ordinary fact of life. We're all individuals, all unique—this is the sales pitch unceasingly beaten into our brains. But the air-conditioned, unaffecting isolation we find ourselves confined to today bears only a faint resemblance to the noble loneliness ingrained in the myths of our pioneer roots, or the profound solitude fabled in such books as Thoreau's *Walden* or Joseph Conrad's *Heart of Darkness*. In these accounts, the act of severing one's ties to the social apparatus carries a sublime consequence—floating out beyond human contact, outside history, one is brought face to face with the eternal and the universal, the result of which is to have one's ultimate beliefs either affirmed or obliterated forever. We, however, don't experience the exhilaration or horror of independence, the divine Light or unfathomable Darkness; what we feel is alienation, not from losing touch with society but from joining in with it, from the very mode by which we exchange things with one another. Today, we typically feel lost even when standing in a crowd.

As the expansion of the marketplace proceeds, so too does the occupation of social life, and with its advance we are herded further and further away from a direct understanding of our own reality, as if consigned to distant grandstands overlooking the shadowy animation we no longer quite recognize as the world we've made. If, as Merleau-Ponty has said, "we see as far as our hold on things extends," then under the present regime, where it's mandatory to sell away our time, energy, and the fruits of our labor, blindness

is the price we pay for survival. Is it any wonder that we react with horror to the knock at the door? Switch on the TV, open the paper: out pour a stream of zombies—new appliances, travel packages, fantasies of excessive luxury—all of which are meant to dodge our recognition, to appear new and wondrous, and yet beneath whose innocence we can still detect traces of flesh and blood, of living, breathing history, whether it's that of the factory workers who produced the merchandise, or of the citizens whose town or country is rented to tourists, or of the ruling class that safeguards its privileges by encouraging absolutely everyone to dream about them. Welcome to the horror show we call a free society, in which we're watchdogged twenty-four hours a day by sweet-talking Frankenstein monsters, inert matter brought to life by our very sweat and misery, only now the beasts have turned against us, and as our masters they demand we recognize their concerns—their relative status, their novelty and transience—as our own.

Yet, as all-encompassing and permanent as this twisted social arrangement seems, cracks do emerge in it, unrest trickles through the grandstands, and occasionally voices rise to denounce the tyranny of alienation, to call the grisly puppet show by its real name. "The spectacle in general, as the concrete inversion of life, is the autonomous movement of the nonliving." So bellowed Guy Debord, an exemplary, albeit rhapsodic heckler, in *Society of the Spectacle*.[4] From Marx on, chroniclers of our shopping-mall afterlife have observed that commodities, although by-products of our desire to create things for ourselves and each other, end up reflecting only their relation to other commodities. Cleansed of their histories, of the evidence that they've in fact been fabricated, they undergo a seemingly magical transformation, from owing their appearance to the actions of others to becoming actors themselves. Socializing and interfacing, competition and cohesion—all are aspects of their world, not ours; we sit as if a captive audience, envying these vampires whose lives, though sustained by our blood, seem more whole and adequate than ours will ever be. Even worse, we end up losing sight of our communal stakes in the acts of creating, giving, and reciprocating. Hence the path of exploitation and control today is marked not just by actual carnage—by the wounds suffered from having the tokens of social exchange ripped from us—but by what follows, namely the lies and cover-ups, the blindspots and lapses of memory. This is where authority and profiteering now reside, in the yawning invisibility, the spreading disconnectedness, the massive forgetting and erasure that characterizes contemporary experience. Comodification sucks the world of life, then turns around and promotes the falsehood that only ghosts truly live. As dissatisfied spectator Roland Barthes details in *Mythologies*, it's a process that "has turned reality inside out, it has emptied it of history and filled it with nature, it has removed from things their human meaning so as to make them signify a human insignificance . . . it is, literally, a ceaseless flowing out, a hemorrhage, or perhaps an evaporation, in short a perceptible absence."[5]

Sounding like Boris Karloff with a Ph.D., Barthes here appraises more than just the bodysnatched lifeforms found on supermarket shelves; he's

referring also to the morbid figures of speech that dwell inside our heads, emerge from our mouths, crowd our national debates, populate opinion polls, and emcee our mass entertainment. Since our ability to produce a sense of ourselves is among the powers we sell away in order to get by, it, too, is something we recover only by buying it back. We look to the marketplace, its walking-dead stereotypes and fashion plates, for sales tips on how to fit in, on which identities, opinions, acquaintances, habits, etc., will open doors for us, make us popular, keep us employed. But the more we orient ourselves toward the dead, the more we open up our liveliness to their invasion, and the better able they are to fend off exhaustion and oblivion. As Barthes describes it, bodysnatched speech, or "myth," is "a language which does not want to die: it wrests from the meanings which give it its sustenance"—namely, our moments of real passion, insight, rage—"an insidious, degraded survival, it provokes in them an artificial reprieve in which it settles comfortably, it turns them into speaking corpses."

Speaking corpses—what a fitting metaphor, just gruesome and icy enough. It seems especially appropriate when you consider the gray pall coloring most of our nation's recent political and cultural debates, particularly those whose leading characters—say, Robert Mapplethorpe and Willie Horton—were, at the time they were being discussed, either dead or imprisoned. All the better to eviscerate them, to scoop out of them their particular histories, everything in their lives that made them authentic beings, that molded and marked them in distinct ways, that distinguished them from the wax dummies in shopping store windows. Once hollowed out, they could then be assigned new roles, their heads filled with imported ideas. And those performing the surgery, who unflinchingly turned the techniques of commodification on human lives, of course wiped their hands clean, feigned innocence; it's assumed that, like all commodities, Mapplethorpe and Horton belong to no history, are not complex constructs, but rather just appeared out of nowhere with one, simple message to deliver: "Yes, freedom of expression should be restricted for certain people, especially gay men"; or "Yes, government entitlements should be rolled back and police repression increased for the Black underclass." Swung out for display as if hung by their feet, Mapplethorpe and Horton are pointed to not as pawns, as planted evidence in ideological inquisitions, but rather as the plotting masterminds behind such inquiries, as the very instigators of the discourses that directly oppress them.

It's a dirty trick, everyone knows that, but saying so matters little. You can't blow the whistle on the spectacle. Sure, you can try, but rebellion, like all gestures, is gladly recognized by society—only what's recognized is merely the hotly sought luster of the thing, its exchange value; the core meaning from which that luster radiates is considered beside the point. Even instances of blunt honesty ultimately seem dishonest, since all that counts is the appearance of truth. "In a world which really is topsy-turvy," Debord sighs, "the true is a moment of the false." Theft, blackmail, bald-faced lying, "the autonomous

movement of the nonliving"—theses things can no longer be isolated and confined. Sadly, what can be isolated today are the heat and depth of our significant moments, those fleeting, unexploitable snatches of real meaning glimpsed now and then on the periphery of our experiences—when exchanging secrets between friends, when shooting glances, when sharing intimacies. But we glimpse such things seldomly, whereas we witness their erasure always. If, as Debord tells it, the spectacle "is the sun which never sets over the empire of modern passivity," "the guardian of sleep," then what is eclipsed by the one dream we're all subjected to is not an underlying reality so much as that reality's forced disappearance. What we occasionally perceive on the margins of the dream is something lost; we intuit the lives we've surrendered, feel the distance between them and what we now settle for. In short, we become conscious of our blindness. And this realization weighs on the shiny images, it strains all the dream's newborn facade. So that in those odd moments when the spectacle hesitates between distractions, and we find what appears as a crack in the dream, what comes pouring through at us is not some shining light pointing toward escape, but more likely an unbelievable panic, incredible resentment, a sense of profound dispossession. The dark emptiness of the dream becomes apparent, it fills with horror, and we find ourselves all alone, cut off, in the midst of a raging nightmare.

Knock Knock. "Who's There?" It's Tony Smith, the Minimalist sculptor, packed in a car with three of his students from Cooper Union, driving at night down the New Jersey Turnpike. Only it's some time in the early '50s and the construction of the turnpike isn't finished yet. The road is unmarked and unlit, completely abandoned, with no lines or railings, just fresh asphalt unblemished by wear and tear, winding endlessly into distant nothingness, a pristine, alien landscape possessing what critic Peter Plagens once listed as the main characteristics of "the L.A. Look"—youthful cleanliness, spatial expanse, industrial prettiness, and, "most vaguely and most importantly," optimism[6]—except here all the lights are turned off, as if this were the dark side of a happy-face moon: "The experience on the road," Smith recalls, "was something mapped out but not socially recognized. I thought to myself, it ought to be clear that's the end of art. Most painting looks pretty pictorial after that. Later I discovered some abandoned airstrips in Europe—abandoned works, Surrealist landscapes, something that had nothing to do with any function, created worlds without tradition. Artificial landscape without cultural precedent began to dawn on me."[7]

Enthralled by this vision of a dawning, unprecedented new world, in which art and artificiality shed their boundaries as they absorb all of life, Smith bids only a faint shrug to the passing of the former world, in which art and life were practiced separately. (Debord, an ocean away, simultaneously nods, though more mournfully, "Everything that was directly lived has moved away into a representation.") Numerous reports were issued at the

same time, all claiming to have witnessed this death, as though the planet had suddenly, almost imperceptibly started spinning backwards and everything from then on appeared to be standing on its head. Not everyone, though, shared Smith's glee; some saw in this passing more than just a victory for art. In his essay "Art and Objecthood," Michael Fried, the leading champion of high-modernist painting during the early '60s, in fact argued that art, too, had vanished along with everything else. And he cites Smith's remarks about his midnight pleasure cruise as if they were the words of the confessing murderer.

The case Fried makes against Smith and his Minimalist cohorts—Robert Morris, Donald Judd, et al.—rests almost entirely on the boxes they made. In these stark, hollowed-out containers, Fried finds evidence of multiple crimes. For one thing, their very emptiness proves that what was previously considered the central concern of visual art—its long history of grappling with pictorialism, which constituted the heart of its tradition, its very "essence"—had been purged, stolen away. According to Fried, being hollow is how Minimalist boxes achieve the look of "non art." And looking like "non art" only proves them to be imposters and frauds, since, the alarmed formalist gravely intones, "quality or value . . . are meaningful, or wholly meaningful, only within the individual arts."

Fried also alleges a cover-up, stressing the fact that the vacant interiors of these boxes are quite literally sealed off from the viewer. This he sees as an attempt to replace art's historical interest in visibility with a new interest in invisibility, to re-route aesthetics away from frankness and coherence toward anticipation and emptiness. Hoping to ward off this apparent threat to art's integrity, Fried makes a desperate plea for the old order: art, he declares, should be "at every moment . . . wholly manifest . . . as if a single, infinitely brief instance would be long enough to see everything, to experience the work in all its depth and fullness, to be forever convinced by it." He then turns an accusing finger at Morris and Smith, whose works rely on the denial rather than the affirmation of art's essence, on art's demise and resurrection as a ghost. Caretaker Morris is quoted by Fried as saying, "More and more I've become interested in pneumatic structures . . . [they] have a dreamlike quality for me, at least like what is said to be a fairly common type of American dream." And from Smith, Fried coaxes this spooky admission: "I didn't think of [my artworks] as sculptures but as presences of a sort."

"Something is said to have presence," states Fried as if passing sentence, "when it demands that the beholder take it into account, that he take it seriously—and when the fulfillment of that demand consists simply in being aware of it." He concludes that the sole objective of Minimalist artworks is merely to gain attention. And to do this, they invariably stoop to deceit. Rather than an honest account, what they present to viewers is a secret; the very function of Minimalist boxes is to raise the question of their hidden insides. And the persistence of this question—the fact that an answer never

follows, the moment of truth never arrives—is how these works sustain their beholder's interest. Standing before such a box, one encounters less the thing itself than a premonition of something more, something held in view but out of reach; one experiences a sense of anticipation, of hype. This is how Minimal art *captivates an audience,* a phrase that appropriately suggests a cunning trick, entailing both charisma and control.

The curtain rises, the new world dawns. And Fried's words, like the art they were summoned to defend, eventually hollow into echoes and fade like ghosts. The band strikes up a lullaby; life goes on, but it does so seemingly outside our control, something we contemplate rather than experience directly, something held in view but out of reach, like a drama enacted on an inaccessible stage, whose characters are strung like puppets to a spotlight, the "sun which never sets" over the show that never ends, a moonbeam forever illuminating a world turned upside-down. We concede the stage and take our seats, empowered only to applaud or heckle what continues in our wake, this afterlife, history unfolding as a dream, "the autonomous movement of the nonliving." Of course, unfolding along with it is a new art history, one forged by a pioneering generation of young artists, American Dreamers who realize the unique task facing them—how to represent a society that has already been flattened into a representation, how to portray a way of life that, in existing foremost as an image, has already had all its life squeezed out of it.

This is the grim crusade to which both Pop art and Minimalism devote themselves. If Pop artworks generally seem preoccupied with consumerism's hyperbolic grammar—how its logos, slogans, and stereotypes interact as a vocabulary—then Minimalism concerns how this language relates to us. Both make solicitation their top priority; turning their interests out toward the audience, these works literally prey on their viewers, like circus barkers trying to drum up business. Pop does so on the level of imagery; it boasts the same enticements that Smith attributes to the unfinished turnpike and Plagens claims for L.A.—namely, a glistening pleasurescape that suggests youth, techno-exoticism, adventure, optimism. Yet Pop's approximation of consumerism, just like consumerism's approximation of life, doesn't completely conceal the deadly banality, the system of standardization and boredom, that undergirds its otherwise fiery facade.

No doubt, the expressionless caskets and tombs of Minimalism are much more explicitly depressed, yet on the level of physical display they are, as Fried discerned, also more aggressively pandering than Pop's advertisements. In the end, both types of art mingle spectacle with monotony, titillation with repetition (think of Lichtenstein's dots, Warhol's and Judd's ordered curiosities). It makes sense, then, that succeeding generations of artists would take the next logical step and splice the two genres together, imposing Pop imagery onto Minimalist structures. Ergo, Jeff Koons places vacuum cleaners inside oversized Larry Bell-like display cases, Haim Steinbach arranges discount merchandise on Judd's wallbound forms, and Allan McCollum exhibits identical urns

ordered in rows, the only difference between each vessel being the color it's painted.

Much art made today still employs this formula, a mix of lecherous winking and mechanical routine, wild slapstick and ice-cold salesmanship. Indeed, it's a description that fits the majority of the works in this exhibition. Llyn Foulkes's paintings, for example, are exemplary slices of American afterlife, balancing giddy pathology and paralyzing detachment, shameless sensationalism and matter-of-fact simplicity. However, there are some big differences between consumer aesthetics then and now. For one thing, though Pop's influence continues to be strongly felt, its vibrancy is fading (perhaps the reason stems from a change in the nation's economic condition: back in the '60s we generally consumed on earnings, whereas today we consume on debt). In recent neo-Pop artworks—say, by Richard Prince, Christopher Wool, Cady Noland—Pop's original optimism is gone, its youthful energy spent. What instead characterizes such contemporary references to consumer culture is recycled waste, insulting good-ol'-boyishness, a fuck-you attitude, extremism (hence the images of militants, bikers, porno stars). There's also the example of Cindy Sherman's photographs, which have gone from cataloging stereotypes of women to envisioning horrific hags, witches, and deflated rubber sex dolls. Ditto Jenny Holzer's art, in which her aphorisms have grown increasingly private and morose. Overall, the come-ons we encounter in today's art are more sardonic, grotesque, defeated, blackmailing. We are still the spectacle's captive audience, but there's now something rancid in the blood it sucks from us; now our very resentment and panic at watching social life invaded and colonized, not to mention having its vitality sold back to us, is showing up in the commodities themselves.

Minimalism's legacy also extends into the present, and it too finds expression today in morbid and depressing art. For proof, you again need only look at the output of the artists in this show—a majority have, at one point or other in their careers, either made actual caskets or prominently featured them in their paintings and drawings. Included in this category are Paul McCarthy's sealed boxes in which he's stored videotapes of his performances, as well as various sculptures by Liz Larner and Charles Ray. For instance, in *Ink Box* (1986), Ray took the top off a large steel box and filled it with printer's ink; in a similar piece, he filled a marble box with Pepto Bismol. As for Larner, her *Used To Do The Job* (1987) is a huge solid block of congealed gunk—wax, ash, tar, weird chemicals, you name it. Larner's piece is both a wink and a gross-out, a display case advertising total mayhem, a commodified chain-saw massacre. But like Ray's works, what really makes Larner's grim cube bewitching is the fact that it appears sealed off, packaged; it's haunting precisely because it's only a virtual disaster, not a real one.

Although Minimalism and Pop art share a preoccupation with their audience, at the same time they exhibit a certain imperviousness to it as well—both offer not dialogue so much as echoes, reflections of the world that look

mechanical and dead. But then, how else do you capture the distinctive features of our hyperalienated society? Robbed of the time of our lives, we in turn try to recuperate that time through commodified leisure, as if such metered, quantified fun could truly make up for the vacuousness of our metered, quantified toil, as if one absence could compensate for another, their accumulation somehow rendering the world whole again. An art of echoes offered to amputated viewers, Pop and Minimalist works supply the final term in an equation of permanent dependency—they look like how we feel, inadequate, incomplete, needy. Indeed, some of the most poignant pieces to emerge in the wake of Minimalism are rooms with basically nothing in them: Lucas Samaras's *Mirrored Room* (1966), Vito Acconci's *Seedbed* (1972), Chris Burden's *White Light/White Heat* (1975), Bruce Nauman's *Room With My Soul Left Out/ Room That Does Not Care* (1984). A similarly evacuated site in this exhibition, Richard Jackson's *Big Time Ideas* (1986–1991), is occupied only by a sense of time passing, although here time is organized like a massive military parade, alien history marching on, the clock faces as resolute and impassive as death masks. As with the other rooms, Jackson's leaves viewers feeling neither alone nor accompanied, but rather stalked by a premonition, a presence that preys on their isolation yet at the same time can't be confronted directly.

The ghosts that haunt these empty chambers, as well as those Fried claims inhabit Minimalist boxes, materialize far more fully in another genre that followed Minimalism, performance art. In his 1977 essay "Pictures," Douglas Crimp argues that performance provides a crucial link between Minimalism and the neo-Pop of Sherman, Prince, et al.; in fact, Crimp describes this progress as an ever-intensifying of Fried's worst nightmare. "What disturbed Fried about minimalism," Crimp writes, "was not only its 'perverse' location between painting and sculpture, but also its 'preoccupation with time—more precisely, with the duration of experience.' . . . And in this, too, Fried's fears were well founded. For if temporality was implicit in the way minimal sculpture was experienced, then it would be made thoroughly explicit—in fact the only possible manner of experience—for much of the art that followed."[8]

Crimp points out that what was said about Minimalist works—that they "required the presence of the spectator to become activated," that in this way they privileged the audience over the artist, that you literally "had to be there"—is doubly true for performance pieces. Yet Crimp stops short of arguing that this sudden emphasis on the viewer precipitated a new era of artistically conducted direct address and dialogue. Quite the opposite; in the end, according to Crimp, even "performance becomes just another way of 'staging' a picture." Or rather, just another way of picturing alienation— although rendered in real flesh and blood, performance art still retains the structure of separation that characterizes theater; it actually emphasizes, in a Brechtian sense, the barrier between the artwork and its onlooker. Performance pieces generally prove that when taking the stage, no matter how

urgent or reasoned your message, it's impossible not to make a spectacle of yourself. Indeed, much in the same way Larner and Ray view the display case as a torture chamber, for many performance artists the stage represents something like the twilight zone—Crimp even describes performances by Robert Longo and Jack Goldstein as having "that odd quality of holograms, very vivid and detailed and present and at the same time ghostly, absent."[9]

This nightmarish quality, the unreal realness Crimp describes, gets rephrased several times over by the art in this show. For instance, Ray's two mannequins, *Self Portrait* (1990) and *Male Mannequin* (1990), appear human only to the extent that they seem mummified. They resemble the artist in very different ways: one is naked and looks stripped of identity, like a typical dummy except for a conspicuously realistic crotch and penis; the other, fully clothed, is nearly indistinguishable from the real-life Ray. These zombies split the artist in two, separating his public and private appearances—he comes across as part Clark Kent, part Superstud. But the mannequins also make Ray out to be all robot, a simple fashion statement underneath which is just another dick. Evoking a similar kind of tension—between life and its mysterious disappearance—Meg Cranston's *Jane and John Doe* (1991) mourns the deaths of Angelenos whom the county morgue can't identify. It may seem callous, this prosaic tallying of the monthly body count, but how else do you weigh the loss of already absent lives?

Three artists in this show—Chris Burden, Mike Kelley, and Paul McCarthy—have spent much of their careers creating performance pieces, and in these works it's been what Crimp perceives as the genre's ghostly reality that gets pushed to the limit. Whether it's Burden's harrowing self-mutilations, or McCarthy's gooey self-debasements, or Kelley's associative reveries, tantrums, and screeds, viewers are presented with the human body and mind placed under the most demanding situations, all enacted up-close and for real, in the flesh and in our faces. But even with our noses pressed against the glass, we can't help but recognize the visceral events on stage as alien, ghostly not only in the sense that they exist as hollow representations, but also in that they represent what's missing in our experience of them. Confronted with these massive expenditures of energy, what's most striking is how disconnected they seem, bottled and abstracted; in turn we feel bottled ourselves, immobile and anxious, the kind of anxiety associated with dreaming—the anxiety of wanting to act, to wake up, and not being able to.

Images of the stage and staged events figure prominently in other works by artists included in this exhibition. McCarthy's *Garden* (1991), like his *Bavarian Kick* (1987), presents a slapstick theater of mindless actions executed by faceless actors, in which sexual abandon gets choreographed as a crude comedy routine (heavy emphasis on the routine). There are also Megan Williams's drawings, which are frequented by puppets, clowns, cartoon characters, and the like, usually lost in some manic, spotlit activity. In fact, they are literally lost, legible only as wisps and swipes and various body parts like eyeballs and

fists, as if Williams were trying to capture the impossible, nonstop tumult of children's cartoons in each of her single, static images. The drawings end up accommodating two seemingly opposite qualities—they appear at once furiously animated and delicately remembered.

Images remembered from childhood—or, more precisely, from adolescence—form another conspicuously repeated component of this show. Particularly in the work of Victor Estrada, Raymond Pettibon, Jim Shaw, and Robert Williams, dispossession and alienation are pictured in terms of a dysfunctional relationship with the adult world of responsibility, rules, seriousness, commitment, etc. Adolescents really have no place in society—having outgrown the heavenly grace and innocence of childhood, they lounge in a purgatorial state, angled toward but not yet delivered into adult life. They have yet to choose the roles, stances, and professions that must be adopted in order to get accepted and fit in.[10] On the outside looking in, adolescents are forced to weigh consumer society's Faustian bargain, whereby independence is won through submission to the market, visibility gained by recognizing yourself as just another commodity.

For Estrada, Pettibon, Shaw, and Williams, the adolescent mind represents—as the stage does for Burden and McCarthy, and the display case for Ray and Larner—a place wherein things get overheated and explode. Attracted only to consumer culture's techno-gadgets and fashion plates, and not to the discourse by which such things are rationalized, the teen imagination grasps these zombies straight on, mutating them from bloodless lifeforms into galloping monsters. Hence the comic carnivals rendered in these artists' work—Estrada's screaming heads, wide-eyed naifs and elastic clowns; Pettibon's hard-boiled dicks and moles, hard-luck cases and blood-thirsty strangers; Shaw's jingoistic hippies and cult leaders; Robert Williams's cowboys and bimbos, flaming hot rods and science projects run amok.

Where these artists part company is over how each views his juvenile behavior. On the one hand, Robert Williams's art approaches teen delinquency from the vantage of pop-culture magazines, movies, etc., where it's been made over into a marketable, seamless identity. Thus, for all their turbulent, bad-boy subject matter, formally his paintings are very tight and deliberately rendered (despite his ill manners, Williams gets an A for effort). This marriage of right and wrong gets pictured differently by Pettibon and Shaw, whose art is characterized less by gloss and more by disruption and doubt. Pettibon's drawings, for example, evoke teen sensibility by looking literally awkward and overwrought; not only are his pen-and-ink pulp hispters stiffly rendered and overworked, but they're given captions that teeter uneasily between melodramatic cliché and looping non sequitur. It's by trying too hard to maintain their cool that Pettibon's images lose it, but it's also through this failure that his art succeeds. Neither tracing his figures correctly nor getting their lines right, Pettibon puts his finger on the restless anxiety underlying adolescent experience.

Shaw's art, like Pettibon's, seems to represent the viewpoint of a kid who suffers from his impressionability, who is overly vulnerable to society's manipulations of both his desires and moral inclinations, who ends up feeling torn between knowing what he likes and knowing better. Here an open mind proves easy prey for our culture's endless sales pitches—and what's being sold, it turns out, is everything from furniture to fascist world-views. To the credulous youth looking for some orientation in a society without any, culture comes across as inseparable from education, and education as inseparable from ideological recruitment. Shaw's works enlist in various belief systems, but all end up victims of the same bad trip, sharing the same look of dumbfounded intoxication, whether they're under the influence of maniacal headgames, twisted conspiracy theories, sexy utopian visions, phony religions, or mortifying morality tales. Like Pettibon's stabs at acting hip, Shaw's desperate attempts to find a moral order that can bring the world into focus are rendered poignant precisely by their being doomed to failure. No wonder that in his latest series of works, a dark curriculum titled "My Mirage" (1986–1991), there emerges here and there the ghostly presence of Prof. Charles Manson, disaffected youth's Mr. Rogers, the ultimate mindfucker.

The adolescent sensibility that pervades this show seems significant not only for what it conjures—dispossession, anti-social behavior, susceptibility—but also for what it sets itself against, namely leadership and expertise, not to mention their shared institution, school. Tellingly, one of the most salient characteristics of today's art world is the pivotal role played by schools as technical training grounds for artists. Nearly every artmaker nowadays is an MFA-brandishing, accredited professional; all eyes are on the blackboard. A straightforward relationship now exists between learning in school and succeeding in the marketplace—what an artist knows ends up determining whether he or she is in or out. This, perhaps, is one of many things the darkness in this show addresses: the commodification of books, of learning, of what passes for intelligence. Countering the notion of art as an educational tool, higher learning's highest achievement, the art collected here opts for the unschooled, for riot over reason, dirty jokes over smart answers. In the context of this exhibition, books are seen as just one more bad dream, an image of adequacy and completeness that, like the display case and the stage, turns out to be empty, scary, a lie. This is perhaps what people mean nowadays when they complain about the tyrannical importance assumed by "critical thinking" in contemporary art. Perhaps they're imagining something like the swarming, cloudy, foul nightmares on display here when they condemn theory, when they say that it's all just a load of bullshit.

On the other hand, to describe the art mentioned thus far as juvenile, detached, solicitous, needy, etc., is not the same as saying that it is disengaged or regressive. Actually, the opposite seems true: much of the work discussed—especially Minimalism, performance, and what I've been calling neo-Pop work—has not distanced but rather brought art closer to social issues, at times

aligning it with recent progressive struggles to change the status quo. Yet it's also true that, as art nears the heart of our society's problems, it's more likely to run up against the specter of commodification and dispossession, because these are the processes tearing apart the kind of social coherence needed to communicate directly and effectively with one another, to build trust and understanding, to organize. How do you talk about change when interaction itself has become so mediated and disconnected? How can we speak on our own behalf when our lives have become so fragmented—between work and leisure, home and office, privacy and professionalism—that it's nearly impossible for us to recognize ourselves and our interests?

The image of "helter skelter" could be used to describe both our suffering and our overcoming of alienation. Indeed, the phrase has been taken to mean all things chaotic, from apocalyptic warfare to rocking-good fun, from a violent purging of the social order to a festive triumph of society over order, from running scared to running wild. To a certain extent, just as the expressions of mayhem vary in this show, so do our experiences of it vary in our day-to-day lives; the problem, of course, is that the more oppressive kind tends to be accepted as business as usual, what makes the world go 'round, while the liberating kind typically belongs to the scattered, underground history of our most meaningful moments. Reporting the worst of the bad news, Nancy Rubins's and Manuel Ocampo's art movingly portrays the kind of brutal helter skelter that characterizes current events, city life, the nightly news, this country's official domestic and foreign policies. Displayed here are the charred remains, the path of broken lives and cultural debris, left in the wake of colonial conquest (colonization being a process active both at home and abroad). The emptiness in this work is haunted by large, collective ghosts, the victims—whole communities, their beliefs and ways of life— sacrificed to today's ever-consolidating economic, political, and religious World Orders ("anti-kultura" is the tagline appropriately given this campaign in many of Ocampo's paintings).

Contrasting the show's mainly sinister tone, Lari Pittman is the only artist to deliver something like unabashedly good news. Rather than elaborate the nightmares that result from our being forced to only dream about our lives, Pittman sees a world in which we suffer and enjoy the consequences of living our dreams. Granted, there are plenty of dark images in his work—of graves, houses ablaze, rotting plants, animals weeping, couples squabbling. But overall these represent only inevitable, even desired elements of larger wholes, moments that perpetuate ongoing cycles. Balancing them are images of light, growth, escape, love, and reception. It could even be argued that Pittman's paintings stand apart from the show's other work by actually measuring up to Fried's requirements for a healthy picture, looking "at every moment . . . wholly manifest, as if a single, infinitely brief instance would be long enough to see everything, to experience the work in all its depth and fullness." Yet Pittman's work accomplishes this on its own

terms, without the standoffish, universalizing abstraction and the tenor of timeless, immutable truth that distinguished '50s painting. Not only are his images specific and partisan, but they're rendered in an explicitly unheroic, popular language, in motifs and conventions seemingly borrowed from architectural drawings, hotel lobby decor, technical illustrations, cocktail napkins, etc. While these tired symbols appear reawakened by the protean convulsions of Pittman's universe, their accessibility in turn keeps the paintings open and friendly, even flirtatious. Against the forever arrested come-ons of the commodity, Pittman's art glimpses breathy, swirling outbreaks of social contact, in which seduction, rather than being an empty promise, carries serious consequences: people have sex, argue, break up; wandering eyes suddenly fixate, wink, begin to cry; questions beget more questions; romance dies and is reborn. The world of separation melts away; in these bittersweet melodramas, life unfolds kaleidoscopically, unraveling and reopening with each and every encounter.

Sounds utopian? Perhaps. Yet we sense such a polymorphous world exists; we visit it whenever we find ourselves lost in thought or in conversation, guessing and joking, having what we know more challenged than confirmed, being led to discover and doubt things about ourselves and each other, feeling like we could be led to believe anything. We recognize this world as ours because we continue to make it; in turn, we see in things and in each other not lifeless certainties but living possibilities. The end of the spectacle is not the end of the world. Out beyond the reach of the spotlight, where the frozen images that dictate the meanings of what we say and do begin to thaw, our fears and desires are brought to life, not put to rest. Here is a world in which everything is possible and nothing predestined, in which we not only produce meaning but also play with its indeterminacy, a world without separation as the world without end—curiosity satisfied not by answers but by clues; lies remedied not by truths but by questions; blindness cured by envisioning not how things are but how they might be. Imagine it: the effort to get to know others taking on the air of a tireless adventure. Imagine social life transformed from a police line-up into a masquerade ball. Someone approaches you and inquires, **"Who's there?"** Searching for an accurate response, you find yourself thinking up a million answers instead of just one.

NOTES

1. Vincent Bugliosi with Curt Gentry. *Helter Skelter* (New York: W. W. Norton & Company, Inc., 1974). All quotes by or about Charles Manson are from this source.

2. See Norman Mailer's introduction in *Jack Henry Abbott, In the Belly of the Beast* (New York: Random House, 1981).

3. Actually, Manson clones appeared almost instantly. Rather than draw a direct connection between the murders of Sharon Tate and the LaBiancas, police initially

hypothesized that the latter was committed by "copycats" inspired by the former. Real copycats did show up, including doctor and ex-Green Beret captain Jeffrey MacDonald, who eventually was convicted of slaughtering his wife and two kids in 1970. MacDonald's story to police was that the crime was carried out by four acid-zonked hippies who broke into his house chanting "kill the pigs." See Joe McGinniss, *Fatal Vision* (New York: New American Library, 1983).

4. Guy Debord, *Society of the Spectacle* (Detroit: Black & Red, 1977). All quotes by Debord are from this source.

5. Roland Barthes, "Myth Today," in *Mythologies,* trans. Annette Lavers (New York: Hill and Wang, 1972). All quotes by Barthes are from this essay.

6. Peter Plagens, "The L.A. Look," in *Sunshine Muse* (New York: Praeger Publishers, Inc., 1974).

7. Michael Fried, "Art and Objecthood," in Gregory Battcock, ed., *Minimal Art* (New York: E. P. Dutton, 1968). All quotes by Fried, Smith, and Robert Morris are from this essay.

8. Douglas Crimp, "Pictures," in Brian Wallis, ed., *Art After Modernism: Rethinking Representation* (New York: The New Museum of Contemporary Art, 1984).

9. Douglas Crimp, "The Photographic Activity of Postmodernism," *October* 15 (Winter 1980).

10. For a full discussion of adolescent sensibilities in recent art, see Howard Singerman, "The Artist As Adolescent," *Real Life Magazine* 6 (Summer 1981).

Elisabeth Sussman
Coming Together in Parts:
Positive Power in the Art of the Nineties (1993)

Since it opened in 1931, the Whitney Museum of American Art in New York has held biennial exhibitions that highlight recent artistic trends. The 1993 biennial exhibition featured many of the artists whose art continued to have a major impact on artistic practice throughout the 1990s, including Mike Kelley, Charles Ray, Kiki Smith, Gary Hill, Bill Viola, and Matthew Barney. This exhibition, which was curated by Elisabeth Sussman, featured work that was diverse in materials, techniques, and sensibilities. Yet one of the commonalites found in much of the work was a focus on the human body as a vehicle through which the artists came to terms with a range of important political and social issues—the simulated bodies in the uncanny and disorientating works of both Charles Ray and Gary Hill, the visceral and physically abject bodies created by Kiki Smith, and the hybrid beings in the work of Matthew Barney. Much of the work in this exhibition embodied the psychological fallout created by issues such as the AIDS epidemic, the relentless advance of technology, the unsettling implications of genetic engineering, and the proliferation of the bodily ideals and stereotypes of the mass media. "Coming Together in Parts: Positive Power

in the Art of the Nineties" by Elisabeth Sussman was originally published in the catalog to the 1993 Whitney Biennial Exhibition.

A recent work by Robert Gober on exhibition in the "1993 Biennial" is an edition of bundles of newspapers. Stacked and tied for carrying out to the garbage recycling bins, these newspapers are actually fabricated. On their top pages, Gober intersperses real stories and photographs, culled from weeks and months of newspaper reading, with stories and images that he has created. These articles cover the usual combination of everyday banalities (ads for home cleansers) to more critical issues such as environmental disasters and cutbacks in welfare. The leitmotif of the majority of the articles is the ongoing debate over the body and sexuality that has been at the center of our cultural struggles. Thus abortion, homosexuality, birth control, and references to the AIDS epidemic dominate the reporting. Among the most notable of the invented images is a photograph that shows Gober in a wedding dress captioned "Having it all." These newspapers have appeared in several exhibitions, most recently in an installation at the DIA Center for the Arts, New York. They can be succinctly described as allegorical representations of life and death, with the newspapers functioning as signifiers of community, of the public, and of the everyday. Fashioned as they are to highlight content related to the artist's political concerns, the newspapers became political statements of identity. But Gober addressed this identity within a collective context, within a larger vision of the social.

I consider Gober's newspapers paradigmatic of the 1990s. For although sexual, ethnic, and gendered subjects motivate the content of recent art, these identities fragment but do not destroy the social fabric. Paradoxically, identities declare communities and produce a decentered whole that may have to be described as a community of communities. Hence the Gober newspapers are also a record (its meaning constructed) of the everyday: of the communities and the individuals which make up those communities, the economic, environmental, and political struggles of our time. The Gober work is a signature piece for the early nineties, for it is an attempt to present a specific point of view, in a form that represents a traditional aspect of collective life, and it is precisely this representation of a refigured but fragmented collectivity that has been lacking in current art production and that this exhibition attempts to present.

I am not using collectivity in the sense of a socio-political organization alone. I do not mean to characterize the art of the last two years by sociological analysis, but to recognize that art production springs up from a relation of cultures and identities (in the plural). It is their rich interrelations that make up the social reality which underlies the art of this Biennial.

Looking at art in terms of such things as class, gender, or nation runs a risky course. Such art work is most often regarded by the art world as propaganda or agitprop. But the art in the Biennial, like all art related to the important issues of our time—our identities, allegiances, environment, relationship

to technology—must be considered with three important criteria in mind. First of all, despite a widespread belief to the contrary, art committed to ideas is not lacking in what are thought of as the traditional aesthetic qualities, for instance, sensuality, contradiction, visual pleasure, humor, ambiguity, desire, or metaphor. Second, works of art that are related to particular cultural positions are not unchanging. We must not fall into easy essentialist definitions or ideas of groups that are monolithically united. Identities, ethnicities, nationalisms, or technologies must also be described as at times shifting, and, like culture, must be conceived of as always being in a state of process or conflict, or what Homi Bhabha calls negotiation.[1] The concept of a border that encircles, binds in, and can be crossed is useful here. Feminism, for instance, is a viable identity term only if, as Judith Butler says, it "presupposes that 'women' designates an undesignatable field of differences, one that cannot be totalized or summarized by a descriptive identity category," and "that becomes a site of permanent openness and resignifiability."[2] Similarly, nature cannot be easily defined as our more sophisticated world of technology creates infinite possibilities. "Either one adopts a sort of veneration before the immensity of 'that which is' or one accepts the possibility of manipulation."[3]

The third criterion for viewing the art in this Biennial is a willingness to redefine the art world in more realistic terms—not as a seamless, homogeneous entity but as a collectivity of cultures involved in a process of exchange and difference. This process is embedded, for instance, in the irony of Mike Kelley's Biennial work: cheap banners made from signs found around college campuses for the groups—gays, straight women, black power, male heterosexuals—vying for the allegiance of the malleable pre-ideological American adolescent.

Finally, two other generalizations characterize the artists of this Biennial. First, they realize their ideas along a spectrum that runs from a direct engagement with the material thing or situation to a more conceptual engagement through replica, history, memory, and technology. Second, as the discussions of artists' works will indicate, a major synthesis of interest that has fully emerged in the early 1990s is the body. This is indeed a collective subject, approached by many artists and critics in different ways and with many different suppositions of what constitutes or is part of the physical (including sex and gender) and social (including psychological) body. It is the interplay of these elements that describes the art of the early 1990s.

I will begin with four artists who, on significant levels, involve the technological and the replica in their representation of the body, whether individual or communal: Gary Hill, Charles Ray, Cindy Sherman, and Shu Lea Cheang.

The work of Gary Hill and Charles Ray achieves its impact phenomenologically, through manipulations of space and scale and through the uncanniness we experience in the contrast between the real thing—person or object—and its replica, or simulacra. In his work *Tall Ships*, Hill has created

what I would call a virtual space, one that orients the viewer in a notion of a social space. This space relies on the principles of perspective (developed in Italy in the fifteenth century), perceived as an established vanishing point from the vantage of the spectator.[4] *Tall Ships* is a long darkened corridor. What is remarkable about this perspectival space is that it is not limited to the single view of one spectator, though it may work that way; rather, it can be triggered by a group of spectators entering intermittently in real time, thus emulating the multiperspectival movement of the crowd. The entrance of the viewer(s) interactively sets off a series of projected images: thirteen to sixteen people, placed along the sides and at the end of the corridor, begin to walk toward the viewer, at different moments, from the multiple vanishing points. They are at first small, seen from a distance, but as they come closer they grow larger, and their approach becomes nearly confrontational in a face to face with the spectator. The movements of the spectator determine the action of the projected images; their turning and returning along a path of emptiness. Hill selected the people for his projected images in Seattle, his home; he arrived at ethnic and gender diversity randomly.

Tall Ships is the cybernetic representation of community in 1993. It gives us a simulated "community," which relates it to Gober's newspapers, but here constrained by its darkness, spareness, and silence; it is at the edge of integration and disintegration. We as spectators trigger action and at the same time question our "liveness." We are in a technological mental space similar to Ridley Scott's 1982 film *Blade Runner*, where androids, "near-perfect replicas of human beings, genetically engineered,"[5] interact with the fictional characters of the film.

What links the work of Hill and Charles Ray is the desire to picture a collectivity—a group—which achieves its impact phenomenologically, through manipulations of space, scale, and psychology, the latter achieved through the uncanny relationship of the simulacra to the real. The common ground shared by Ray and Hill is not instantly apparent, for their media are very different: Hill is closer to the cinematographer while Ray, in the Biennial, fabricates objects related to consumer culture. Ray uses phenomenological means to suggest psychological pathologies about fantasies of pleasure and power and the confusion of sexualities that reside in the most commonplace early childhood environments. His cinematic parallels are the films of David Lynch. Both break down the normalcy of that collective utopian subculture of American life, the suburb, and eroticize the events that lie beneath its banal technicolor surface. ("Do suburbs," writes J. G. Ballard, "represent the city's convalescent zone or a genuine step forward into a new psychological realm, at once more passive but of far greater imaginative potential, like that of a sleeper before the onset of REM sleep?"[6])

Ray's work is a 45-foot hook-and-ladder truck parked in front of the Museum for the duration of the Biennial. Up close it becomes apparent that this truck is a replica, a toy scaled up to the size of "the real thing." Inside the

Museum, Ray has installed a four-figure sculpture of a "family"—father, mother, daughter, and son—all nude, all in the same less than 5-foot height. In its pairing of the collective family and the firetruck, Ray's work introduces a gendered psychology, recalling again Gober's newspapers with their sexually centered texts and images. Scale creates the psychological tension: the macho fantasy of the little boy promised in the phantasmic magnified scale of the product-glossy firetruck is also repeated by the reduced scale of the nude family, brought down to a physical size where an erotic imaginary interplay can be enacted.

Cindy Sherman's recent photographs are of sculptural constructions, made of mannequins that certainly share the robotic erotic fantasy of Ray's figures. But if Ray's mannequins are, like Dorothy's Kansas, purposefully banal and mundane, Sherman's set us down in the Hollywood of Oz. Sherman has taken sexual fantasies straight out of psychoanalytical rationalizations and placed them in a visual realm, one that can be likened only to the technological feats of special effects cinematography. Using the fairly simple means of combining body parts ordered from medical supply catalogues, she creates bodies, at once frightening and humorous, to explore theoretical combinations and crossovers of sexuality that break down, confuse, and complicate earlier, more essentialist understandings of male and female. Sherman does not abandon the foundation of her own imagery in the mass media, such as her photographs based on *film noir* stills, but she is now exploring the cinematic world of science fiction, a world of cyborgian possibilities, reminiscent of the creation of the animated characters in David Cronenberg's film of William Burroughs's *Naked Lunch*.[7] Sherman's photograph of a woman(?) with a "borrowed" bib of breasts, suggests the imaginative distortions at the base of the "invented" sexuality that is the artist's own brand of science fiction.

The psycho-technological mapping of the body is accomplished in close up in Sherman's photographs. Shu Lea Cheang's *Those Fluttering Objects of Desire*, another technological mapping of the body, uses technology's quotidian presence as both the friend and foe of a sense of community. In this installation, the telephone and the TV screen (paradigms, of a sort, of our technological landscape) appear both for and against a more traditional view of community, the community here being the collective relationships of women. Reflecting bell hooks's positive emphasis on "the confessional moment as a transformative moment,"[8] the spectator may dial a telephone and hear a text written by one of a number of women (all women of color who are performance artists or writers) whom Shu Lea Cheang invited to participate. They also appear on TV monitors talking about sexuality in a confessional mode. The telephone is the tantalizing instrument of communication. At the same time, the director, by forcing the confession to take place on the private connection of a telephone, also undercuts the more public quality of confession in a traditional oral culture, where we are in a physical relationship to the

people with whom we speak. As bell hooks remarked, "I think the telephone is *very dangerous* to our lives in that it gives us such an illusory sense that we are *connecting*."[9] Underscoring the critical reading of the technology is the link viewers-listeners may make to the realm of pornography—to the peep show and 900 telephone numbers. Nonetheless, this collective of women's voices and images talking about their various sexualities, their bodies, has a positive power, resembling the congregation of women in Spike Lee's *Jungle Fever*, with the significant difference that the *auteur* of *Those Fluttering Objects of Desire* is herself a member of the community of women she portrays.

Hill, Ray, Sherman, and Cheang exploit the dynamic relationships of technology and the imaginary in representations of body and community. Two other artists focus attention on the body—here on the woman's body—in its social and political sphere as well as its biological condition. Janine Antoni and Kiki Smith may be said to share a certain critical orientation, although their work speaks for the different positions that the woman's body has come to represent. Both envision a body that is not idealized in the classical sense. Whether the body is fragmented or connected (or not even present, as with Antoni), what is important to both artists is the emergence of the repressed or the abject, that stuff about the body that the mother must clean up or teach the child to overcome. Julia Kristeva has called the maternal the "trustee of that mapping of the self's clean and proper body. . . ."[10] The abject body is the body as substance—bile, tissue, excrement, blood, vomit—and it has emerged in the earlier work of Cindy Sherman, Mike Kelley, and Kiki Smith.

Janine Antoni's contribution to the Biennial broadens and humorizes the relation of body and substance, moving away from a strictly psychoanalytic to a cultural base. The culture her work represents is the consumer fetishism of female youth and beauty, and she explores that fetishism by establishing a performative relationship between raw material and the commodity. Antoni critiques a patriarchal community where eating is transgressive and the fat woman is an obvious taboo. Antoni's performative gesture is to progressively bite away, chew up, and spit out chocolate and lard from large, modernist-looking geometric cubes, the sculpture of the Minimalists. The masticated lard is then mixed with pigment and remolded into lipsticks which are placed in packages, resembling large candy boxes, fabricated from the recycled chocolate. These "cosmetics" are displayed in a mirrored cube that in this context reads as something between corporate architecture and modernist sculpture.

If Antoni presents a critique of a particular subculture—let us call it the stereotypical female of mass-media magazines—then Kiki Smith represents another feminist identity—the woman of connection, the woman who defines her difference through her relationship with others. Connection is the structural metaphor that links the work here. Smith presents not the single body, but the relations among bodies, as for instance in her untitled work

of three lightboxes, which display overlaid photos, taken in 1982, of parts of her body and the body of David Wojnarowicz coated in blood. The overlay of the photos fuses the two bodies, which are further connected by a tangle of electrical cords that suggests veins or lymphatic systems. This theme of connection is reinforced in the plaster sculpture of a body in a fetal position attached to a representation of the mother's body by the umbilical cord. A separate sculpture places casts of a pair of female feet (Smith's mother's) on a shelf above a field of broken glass, meant to recall the tears one supposes were shed over the interrelated issues of connection, rebellion, and loss, emotions at the base of the mother-daughter relationship.

The importance of connection that Kiki Smith makes eloquent in the language of the body is a theme taken up by other artists in this exhibition. Nancy Spero, Ida Applebroog, and Jimmie Durham deal with connection (or its opposite) by addressing the reinvestment or reinsertion into memory, through image and text, of what is viewed as forgotten, overlooked, or lost. In their Biennial works and others before, they exhume images and information from history and the media and transform them into innovative formats of sculpture and installations of printing and painting. What unites Applebroog, Durham, and Spero is that their revisionism and tinkering with the canons have been consistently expressed through dissent, eroticism, parody, and humor. Spero connects the unknown and the forgotten with the celebratory or Dionysian. Her Biennial wall installation is based on a *New York Times* article of 1987; the hanging body of a woman is derived from a 1941 photograph of a previously nameless Jewish woman from the Minsk ghetto, finally identified half a century later as Masha Bruskina, active in the partisan resistance to the Nazi occupation of the Soviet Union. Through an iconic reinsertion, Spero reclaims for collective memory a moment in the history of radical women's political action. She reinforces this concept with a second wall installation devoted to the imagery of the Cuban-American artist Ana Mendieta who, like Masha Bruskina, died a violent death at a young age. Spero willfully counters martyrdom (political and artistic) with Dionysiac female figures printed on the museum walls, which interact subliminally with the violence of her other works.

Applebroog and Durham allow the ridiculous and the absurd to fragment and mediate the violence and horror of the histories they want to foreground in our collective memories. Key images of Applebroog's recent art are drawn from the historical reservoir of illustrated books—some meant particularly for children. Among these are fairy-tale volumes which, in the days before TV and films for the youth market, formed the collective and influential behavior models for many children raised in Europe and America. Applebroog's images reveal a funny, erotic violence that lurks in the so-called diversions and pleasures of childhood. In her Biennial work, she expands on the family relationships and the stories of forgotten people that formed her earlier narratives—always fragmented and distorted by non sequiturs. Some

of the focal points of her 1993 pieces—Hansel and Gretel, Santa Claus with a child on his lap—are rendered in a style lying somewhere between cartoon and classic illustration. These are joined by painted images, transformed from photos culled from magazines and newspapers, which in Applebroog's sculptural painting installations appear absurd and carnivalesque.

Jimmie Durham, by contrast, revises the canon by subverting it, by showing its artificiality. His way of insertion into collectivity is to reveal the absurdity of national history or cultural identity as universals, when in fact they are actually constructed. Attached to pseudo-primitivist sculptural objects are texts acknowledged to make up "Western civilization"—an excerpt from Homer in Greek, an excerpt from a Shakespeare play, a paragraph in German from a Thomas Mann novel. Stripping these texts from their original narratives defamiliarizes them, estranging them from the idea of a common culture just as, by analogy, the language of the Native American is estranged from non-Native culture. (Durham is a Cherokee.) Durham's collectivity of literature, much of which is assumed to be, like the Bible, the basis for the development of culture, gives out hints of literary delight, but does not cohere into the transcendent uplifting, monolithic tradition that a modernist like T. S. Eliot assumed as a universal in the first half of the century.

Nan Goldin wants to preserve what she has known, what she has lived through, what she has lost as documenter of and participant in an extended family, a community spread across continents, some living, some now dead. Returning to her ongoing subject matter—her widespread group of friends— she has assembled a collection of photographic portraits. Goldin began this work in the 1970s with *The Ballad of Sexual Dependency,* a slide show installation accompanied by a sound track of songs. This signature work is a "document" or "diary" of her life, whose themes of sexual dependency, sexual love, and transgression resonate with the desire not to see sexual longing as deviancy or transgression, nor to fix it within more socially acceptable "romance." Sexuality is faced honestly in all its many permutations. Goldin's work for the Biennial contains similar ideas, here dealing more with the subjects of birth, death, and loss. Her photographic project documents a community in a quasi-cinematic vein, paralleling in style and format the aesthetic and environment of its subject and location.

The works of painters Kevin Wolff and Peter Cain are also specific to a particular time and to a configuration of specific communities. Both represent images familiar to male groups, groups obviously as heterogeneous and multiple as groups of women. In fact, the work of both artists is coded. Cain replicates a Mercedes 500 SL #1 taken from a car advertisement. Although presented as a fetishized symbol—the meaning of which is known to particular groups (or markets, in advertisers' language), it becomes in the artist's hands a cipher. Similarly drained of its original meaning is the hand gesture of the gang member that is the starting point for Kevin Wolff's paintings. Both artists allude to the meanings encoded in images related to the subcultures

they observe, and both allow these messages to initiate abstraction. Cain's and Wolff's paintings are analagous to the sculpture of Charles Ray: for all three, the psychological impact emerges from the coexistence of the image's alteration and its high-definition realism.

Chris Burden and Allan Sekula move from the subject position contained in an analysis of many cultural viewpoints to a broader collective view, not unlike the work of Gober and Hill, but focusing instead on the physical world. Burden ironicizes the technological utopia of complete control by power; Sekula exposes the incompleteness or arbitrariness of the so-called documentation of historical fact. Burden's *Fist of Light,* a cube filled with the highest intensity of light (and perhaps, therefore, impossible for the viewer to enter) is a homemade model of fission or nuclear reaction. The miniaturization of a totalizing concept is a leitmotif of Burden's work. This phenomenological method (similar to that of Ray and Hill) makes understandable but also parodies the idea of a larger-than-life terror—nuclear power. The reduction of this monumental concept makes it just one more model that must interact with many others in a collective consciousness. Burden accomplishes this interaction without sacrificing the terror of what he is dealing with.

Sekula undertakes the documentation of a global system: the flow of goods, people, capital, and arms through the ports of the world. His somewhat mock-burlesque title for his photographic project is *Fish Story.* Using the sea as a realist base capable of allegory (in the manner of Herman Melville and Joseph Conrad), Sekula, in this still uncompleted project (he will show two sections of it in this Biennial) intersperses images with texts from many sources, some written by the artist, others quoted from widely varying sources (Aristotle to Ronald Reagan). The images break down roughly into two sequences: one is essentially shot around the port and harbor of Los Angeles and is thus local. (Sekula was brought up near the harbor of San Pedro.) The other sequence, *Loaves & Fishes,* shot mainly in Poland, Rotterdam, and Barcelona, is meant to be more global, and contains an isolated reference to the Persian Gulf War. Of course, the local and global are seen as interrelated, and the allegorical underpinnings of the project are signaled by a photo in the Los Angeles sequence of an ancient Roman harbor. However, within these sequences photographs are out of order (no one sequence clearly covers any single site) as Sekula shifts from place to place. His work is a conversation with the romanticism of modernist photography (Alfred Stieglitz's *Steerage,* for instance). Sekula wants to redefine a form of reportage that is not constrained by the institution of photojournalism; his reportage marries incompatibilities (travel views, glimpses of popular experiences, working-class daily life, cosmopolitan concerns) at the risk of the legibility that one expects from photojournalism and the documentary.[11] Sekula's project thus hovers between the descriptive and the allegorical in a montage of intuitively related facts. Ultimately, he undermines what appears to be collective—the controlled,

organized, and purposeful international system of shipping—by suggesting sites of resistance, spaces of psychological complexity.

While Sekula's project represents a global collective, Andrea Fraser's subject is as local as one can get in this context. For her subject is the Whitney Museum, in which the "1993 Biennial Exhibition" has attempted to organize many subcultures or identities into a whole that reveals constant conflict among parts. Fraser has always treated museums and their various components as her theme, asking what these places are and, most important, for whom they exist, and what people want from them. (Her most famous work is a performance as a museum docent, attempting to interface between the museum and its public.) For this exhibition, she has written and produced an audiotape, gleaned from interviews with the curators and the director, the people who created the collective we call the Biennial. I am one of her subjects. In this process, Fraser has reduced to one narrative a group of voices that speak differently. By allowing unanimity, disjunction, and contradiction to simultaneously appear in a museum text, she offers a paradigm of the hopes and fears of community life.

NOTES

1. See Homi Bhabha's essay "Beyond the Pale: Art in the Age of Multicultural Translation," *1993 Biennial Exhibition* catalog, pp. 62–73.

2. Judith Butler, "Contingent Foundations: Feminism and the Question of 'Postmodernism,'" in Judith Butler and Joan W. Scott, eds., *Feminists Theorize the Political* (New York: Routledge, 1992), p. 16.

3. Paul Rabinow, "Artificiality and Enlightenment: From Sociobiology to Biosociality," in Jonathan Crary and Sanford Kwinter, eds., *Incorporations* (New York: Zone, 1992), pp. 249–250.

4. Hubert Damisch, "Six Notes and Some Queries Concerning a Phenomenology of So-Called 'Virtual' Images," in Peter Weibel, *On Justifying the Hypothetical Nature of Art and the Non-Identicality Within the Object World*, exh. cat. (Cologne: Galerie Tanja Grunert, 1992).

5. Donald Albrecht, "'Blade Runner' Cuts Deep into American Culture," *The New York Times*, September 20, 1992, p. 19.

6. J. G. Ballard, "Project for a Glossary of the 20th Century," in Crary and Kwinter, *Incorporations*, p. 273.

7. Jody Duncan, "Borrowed Flesh: Special Effects in Naked Lunch," in Ira Silverberg, ed., *Everything Is Permitted: The Making of Naked Lunch* (New York: Grove Weidenfeld, 1992), p. 90. For instance, the Mugwump (Burroughs's guide and nemesis) created for the film "as a tall, lanky creature with facial features being a cross between a wolf and Burroughs himself," is described by Cronenberg, who followed the Burroughs text, as "an old junkie—emaciated and with the 'look of borrowed flesh' . . . to emphasize its nonhumaness."

8. Interview with bell hooks by Andrea Juno, in *Angry Women (Re/Search,* no. 13 [1991]), p. 80.

9. Ibid., p. 87.

10. Julia Kristeva, *Powers of Horror: An Essay on Abjection* (New York: Columbia University Press, 1982), p. 72.

11. Conversation with the artist, Los Angeles, January 1992.

Eleanor Heartney
Video in Situ (1995)

When the viewer entered Bill Viola's video installation *Slowly Turning Narrative,* which was part of the exhibition *Video Spaces* held at the Museum of Modern Art in 1995, it must have seemed hard to remember the days when artists' videos were shown on single TV monitors in darkened rooms. Viola's *Slowly Turning Narrative* consists of a twelve-foot-high wall that rotates on a vertical axis with a screen on one side and a mirror on the other. The face of a man and a collage of images—including a carnival at night, a shopping mall, and children playing with fireworks—are simultaneously projected onto this rotating screen/mirror. The images come together on the screen, but when they hit the mirror they reflect back out at the viewer and onto the walls in the dark room. These overlapping and reflecting images create the impression of a glimpse into the consciousness of the man.

During the early 1990s a number of artists began to use video as the starting point for the creation of complex multimedia environments. The exhibition *Video Spaces* highlighted this recent development in video art by featuring the work of eight international artists. By the mid-1990s video art was not only considered as being on par with other art media, but it was ubiquitous, particularly at the major international art exhibitions. In "Video in Situ," which was originally published in the October 1995 issue of *Art in America* as a review of the Museum of Modern Art exhibition *Video Spaces,* Eleanor Heartney points out that as complex multimedia environments become the norm in exhibitions of contemporary art, the viewer's experiences of art become closer to the experiences of entertainment and spectacle. This, along with the expensive nature of creating and displaying video installations, has the potential to change the relationship among the artist, the audience, and the museum.

Early practitioners of video art lauded its egalitarian bent, its anticommercial essence and its potential for political commentary. But something peculiar happened on the way to art-world acceptance. In the struggle to break out of its presentational limitations—those small dark rooms with uncomfortable chairs—video artists began to explore modes of display which would give

Originally published in **ART IN AMERICA,** October 1995, Brant Publications, Inc.

video art equal weight with other genres of contemporary art. One result of this exploration was the video installation. Taking on aspects of sculpture, performance and stage-set design, and often requiring multiple channels and multiple monitors, laserdisks and computer-controlled switching equipment, the video installation has become a high-tech, multimedia spectacle. In the process, it has moved far from video's philosophical origins.

Video Spaces, presented this summer at the Museum of Modern Art, was an exhibition of eight recent video installations by some of the most innovative practitioners in the field. It appeared at a time when the video installation has begun to achieve widespread attention. Gary Hill's traveling retrospective [see *A.i.A.*, June '95], Bill Viola's presence at the Venice Biennale [*A.i.A.*, Sept. '95], and the forthcoming Lyon Biennial's focus on video and video installation (along with computer art, virtual reality and film) only hint at the persuasiveness of the form.

Organized by MOMA's video curator, Barbara London, *Video Spaces* was designed to suggest the range of current approaches, content and formats being undertaken by contemporary video installation artists. London gathered an international group—the artists hail from the United States, Germany, Japan, France and Canada—and deliberately avoided any overt thematic organizational principle. It was all the more striking, then, that the work exhibited continually returned to a rather anxious examination of the formal, technological and social paradoxes presented by the medium.

One theme that emerged prominently was the psychological, social and political meaning of the image culture which has been spawned by video's kin, television and film. Stan Douglas's *Evening* (1994) involves the restaging of television newscasts from 1969 and 1970. Douglas focuses on the moment when television news was beginning the slide from journalism to "infotainment." Using actors to read news stories which follow nine developing events from this era (they include the Chicago Seven trial, the My Lai massacre and its aftermath, and the murder of Black Panther leader Fred Hampton), Douglas highlights the incongruity between the "happy talk" mode of presentation and the gravity of the stories reported.

Technically, Douglas's contribution was the least complex in the show. Three staged newscasts, interspersed with real archival footage in black and white, were projected side by side on a large screen. Viewers had the option of standing underneath one of three pods, from which the voice of one of the three newscasters was clearly audible, or standing elsewhere while the three audio tracks blended in a cacophony of meaningless noise. Occasionally each screen went blank, except for the words "Place Ad Here," indicating a commercial slot and reminding us that, from the network's point of view, television news is simply a vehicle for advertising.

Douglas investigates how the media creates our sense of history. French artist Chris Marker suggests how it shapes our fantasy life. Marker,

an influential filmmaker, is a mysterious figure who refuses to be photographed and has adopted a deliberately bland American moniker. Here, he explored the origins of Hollywood's dream machine in a work entitled *Silent Movie* (1994–1995).

Marker's installation was dominated by a video tower, composed of five monitors, which was meant to mimic the utopian aspirations embodied in visionary Russian architecture from the 1920s. The monitors presented vintage film clips along with fabricated sequences which mimic the conventions of silent film, including lots of dissolves, superimpositions, irises and subtitles. The imagery, which included speeding trains, screen-filling eyeballs which dissolve into cameras, soft-focus heroines and closeups of hands picking up coins or spinning roulette wheels, also conjured up the silent film era, with all its glamour and high-toned surrealism.

Extending the masquerade were humorous fake movie posters on the gallery walls advertising more or less plausible imaginary films (*It's a Mad Mad Mad Dog*, a Rin Tin Tin movie directed by Oliver Stone Sr., Douglas Fairbanks as William the Conqueror in *How the Channel Was Won*, "directed by Cecil B. DeMille with a cast of dozens"). The sly simulation of a bygone era meshed nicely with Marker's creation of filmic illusion.

A somewhat less sanguine meditation on cinema's effects appeared in Tony Oursler's *System for Dramatic Feedback* (1994). The entire back wall of this installation was filled with a projection of movie viewers looking up in a dark theater as they eat their popcorn. Arranged before them was a peculiar construction designed to test our voyeuristic pleasure in the discomfort and pain of others. To enter the space, the viewer had to pass by a tiny rag doll whose white fabric head was covered with the video projection of a human face. The doll grimaces and cries piteously for help in a disconcertingly convincing manner. Inside, a massive construction of rags and stuffed clothing formed the backdrop for other distressing video scenarios which became evident as the viewer moved around it. One could see a hand slapping a bare butt, a nude female body endlessly rotating, a man's face apparently crushed beneath the weight of the installation with eyes that roll in captive agony, and a penis that stiffens and relaxes. But, although they operate on the same principle as the doll entrance, animating otherwise inert fabric with glimpses of human flesh subjected to various indignities, these projections were less effective. They tended to become lost in the complicated structure, and some were virtually invisible on the patterned cloth.

The viewer's superior scale and position, as well as the presence of the bug-eyed peanut gallery behind, contributed to the uncomfortable realization that cinematic pleasure depends on a distancing mechanism whereby technology transforms the pain of others into entertainment.

Meanwhile, German artist Marcel Odenbach showed an interest in real pain, in particular as manifested in the violence of German history. Although his contribution to the show, *Eine Faust in der Tasche Machen* (Make a Fist in

the Pocket), 1994, contained some remarkable imagery, ultimately he seemed to be attempting too many things. As in Oursler's installation, a videotape projected on the back wall of the gallery set the stage for this work. Here it offered idyllic scenes of Thailand, including a closeup image of a Caucasian man getting a foot massage, as well as violent images of skinhead riots in Germany. On the wall opposite this projection, Odenbach had installed a row of video monitors which offered archival footage of the international uprisings, demonstrations and government reprisals which dominated the news in 1968. (For both Odenbach and Douglas, this moment seems to represent a time when it was still possible to believe that the media's dramatic ability to bring the news home might liberate rather than anesthetize its audience.) Interspersed with this footage were clips of Nazi book burnings and clacking typewriters. There seemed to be a message here about the unhealthy relationship between political violence and the media, but it was diffused by the eclecticism of the work's references.

A second theme which emerged from this exhibition was the changing perception of human identity in an electronic era. Lurking behind this change, of course, is the Frankenstein myth, updated now to include our ambivalent feelings about the effect of developments like virtual reality, the Internet and cyberspace on our individual and collective psyches.

Judith Barry and Brad Miskell provided a darkly amusing fantasy of an apocalyptic future where machines and human bodies have apparently fused. Titled *HardCell* (1994), it consisted of a wood crate torn open in several places to reveal pulsing innards which equally suggested human organs or the exposed wires, tubing and other mechanical hardware of some huge, damaged computer. As rubber sacs inflated and deflated, a spinelike column shifted in space, lights flickered on and off and monitors revealed interference patterns or bits of sci-fi text, one thought of Hal in *2001* (another paradigm of technology run amok).

Things seemed less catastrophic in Bill Viola's *Slowly Turning Narrative* (1992), which offered an electronic model for the workings of human consciousness. Images projected onto a central turning screen flashed onto, slid off of and were reflected over the walls of a darkened gallery. A mirror on one side of the screen caused the stationary viewer to momentarily become part of this kaleidoscope of images.

Gary Hill took the opposite tack in *Inasmuch As It Is Always Already Taking Place* (1990). Instead of suggesting that technology can re-create the shifting, impressionistic landscape of the mind, he used it to express a disjointed experience of the body. Slightly moving fragments of a male body (Hill's own, as it turns out) were distributed among an assortment of monitors which ranged in size from tiny to normal. The fragments were not arranged in any discernible order, but instead became elements of an almost abstract human landscape which seemed to comment on the incoherence

which technology has visited, not just on our consciousness, but on our physical sense of ourselves as well. A nearly inaudible audio track of Hill reading from a text contributed to the disjointed effect. The small scale of this work offered a marked contrast to the carnivalesque quality of the other works in the show. Forcing the viewer to draw close in an almost uncomfortable intimacy with the minuscule monitors, Hill demonstrated the effectiveness of restraint.

The final work in the exhibition seemed to stand by itself, transcending issues of media, technology and human-machine interface to provide a poetic meditation on the fragility and resonance of love. *Lovers* (1994), by Teiji Furuhashi, one of the founders of the Japanese performance group Dumb Type, consisted of a succession of ghostlike projections of figures which materialized and dematerialized across the four walls of the darkened gallery. Sometimes they walked slowly, sometimes they leapt through the air and sometimes their paths crossed and they seemed to embrace. But this contact was only illusory, for it was clear that their images were simply passing through each other. When a single viewer occupied the space, one figure appeared before him or her and seemed to gesture invitingly.

Lovers was somewhat reminiscent of Gary Hill's *Tall Ships*, which was one of the star attractions of the 1993 Whitney Biennial. However, while the moving figures in Hill's work often assumed confrontational poses, Furuhashi's work was lyrical and even elegiac in tone. These figures might be figments of dreams or memory, messengers from another realm where humans no longer require corporeal bodies.

By no means intended to offer a comprehensive survey (one can think of any number of other artists who might also have been included), *Video Spaces* made the case for the video installation as a fully mature art form. It also suggested that while the genre has moved away from a gee-whiz infatuation with the possibilities of technology, it remains haunted by the implications of the world that technology is bringing into being. If technology can make past and present seem to coexist, and can even alter our records, and hence our memories, of history, will "reality" cease to have any meaning? Are we more like our machines, or are they becoming more like us? If we alter our consciousness, do we also alter our world?

The exhibition also demonstrated the art world's pull toward entertainment and spectacle. The works here may have dealt with complex issues, but their modes of presentation are engaging and user friendly, owing more to MTV than to the minimal and conceptual models which inspired early practitioners of video art. However, installations of this scale and technical complexity require institutional funding and support. Given the extreme probability that government and private arts funding, at least in this country, will be increasingly scarce, one wonders about the future of video installation. Who will be able to pursue this form? What kind of partnerships will be

devised to make it possible? Major funders for this exhibition included the Samsung Corporation and the Japan Foundation. Is this indicative of the future of art patronage in this country?

Thus, in more ways than one, *Video Spaces* seemed to point toward a future in which the relationships between art, audiences and institutions may be quite different from those in place today. Mary Shelley's Frankenstein monster may have been reduced by popular culture into a harmless cartoon, but the questions she raised about science, art and humanity are with us still.

Context

Jean Baudrillard
The Work of Art in the Electronic Age
(Interview by La Sept*)* (1988)

By the mid-1980s French philosopher Jean Baudrillard had established himself as one of the leading intellectuals of Postmodernism. In this interview with *La Sept*, "The Work of Art in the Electronic Age," which was originally published in *Block* in the fall of 1988, Baudrillard discusses both the influence electronic images have on art as well as his theory about the distinction between reality and hyper-reality, which he defines as a state of being so dependent on images that the power of the "authentic" reality is gone. In a society faced with a condition of hyper-reality, which is how he categorizes our present situation, Baudrillard sees the traditional role of the artist as a creative individual making unique objects as important but anachronistic.

For Baudrillard the artist needs to work with the mediated system of electronic and reproducible images, albeit with an ironic strategy. In this essay Baudrillard calls for "a way of playing with the media, to accept the deed of this system, of this entire integrated circuit and set it in play and perhaps not disrupt it, yet make it reversible—it's possible—and perhaps still obtain some critical results." The title of this article mimics Walter Benjamin's famous 1936 essay "The Work of Art in the Age of Mechanical Reproduction," which discusses the ramifications of the potential for endless reproduction on the notion of authenticity in art.

We are in the age of electronic communications; do you think that this communication has fundamentally changed the way in which we see and understand the world or is it merely an accelerated form of technical reproduction?

Baudrillard Live: Selected Interviews, by Mike Gene. 1988. Routledge. Reprinted with permission from Taylor & Francis.

I think we have a kind of transformation, yes, perhaps not a revolution in the subversive sense of the term, but a transformation of the relations of exchange. It is often said that we are within communication and we are perhaps no longer exactly within exchange. At this time, what has changed is that the means of communication, the medium, is becoming a determinant element in exchange and quite often dominates its function, even technologically—as McLuhan has it—dominates the content, the message, the subject communicated, the very substance of communication. So there is an inversion of terms of some sort, where what was a means of communication gains a kind of finality, and possibly also a counter-finality, and then the strategies which revolve around the medium, the communication media, become more essential than the strategies which concern the contents.

The reality of images counts for more . . .

Yes, it seems that from this point a sort of proliferation occurs, a saturation of the field of the medium. That is, as long as one has things to say and there is something to be exchanged between speakers, there is meaning, so it gets said and the process is limited. The medium gets the upper hand, basically, when images—or discourses—begin to proliferate, apart even from the meaning which they bear. There is a sort of—I don't want to say cancer; that would be borrowing a bit too much from modern pathology—but something similar. There is a kind of autonomy now of the systems of images and systems of discourse which has got the upper hand over meaning.

So then, where is reality still situated?

That's the entire problem. Is there still reality? I would rather say that we are in hyper-reality. Effectively, everything can be an object of communication. Communication is completely generalized; it is no longer only discourse, but everything, which is an object of communication: architecture, art, have as their first end, it seems, to communicate, before even that of bearing a meaning. So where is the reality of what must be said, of what one wants to say? One almost has the impression that communication is a collective enterprise: the medium must function. There is a kind of obligation, a collective categorical imperative to make the media function at all costs. It's of little consequence whether the contents are completely real or unreal, or hyper-real; the important thing is that the medium continues to roll. So communication is drawn into this cycle of panic. It seems to become immediately an unlimited, proliferating system. There is a kind of imperialism of communication.

When you say hyper-reality, you might specify, in relation to reality, the reality of my daily life . . .

Yes, we can say for example that for events, politics, history, from the moment where they only exist as broadcasts by the media and proliferate, nearly globally, their own reality disappears. In the extreme case the event

could just as well not have taken place—there are examples. It has taken place on the level of the screen. They are screen events and no longer authentic events—I am not sure if one can speak of authenticity, but nevertheless an ordinary reality which has a historical actuality that disappears behind the mediating hyper-reality of things. And here then, one can question indefinitely the degree, the rate of reality which continues to be shown. It's something else which is taking place: circuits are functioning. They can nourish themselves with anything, they can devour anything and, as Benjamin said of the work of art, you can never really go back to the source, you can never interrogate an event, a character, a discourse about its degree of original reality. That's what I call hyper-reality. Fundamentally, it's a domain where you can no longer interrogate the reality or unreality, the truth or falsity of something. We walk around in a sphere, a megasphere where things no longer have a reality principle. Rather a communication principle, a mediating principle.

Therefore we are all becoming images?

Yes, in one way or another . . . not only are there screens and terminals in technical terms, but we ourselves, the listeners, the TV spectators, become the terminals of all this communications network. We ourselves are screens. Lastly, the interlocutors are no longer exactly human beings. That sounds pejorative, but it's like that. The play has settled to one from screen to screen. It is almost dialogues between terminals or between different media. In a way it is the medium conversing with itself, this intense circulation, this type of auto-referentiality of media which includes us in its network. But it's somewhat of an integrated man–machine circuit. And at the present the difference between man and machine is very difficult to determine.

And that goes for artists, works of art?

Absolutely. I believe a work of art no longer has any privilege as a singular object of breaking through this type of circuit, of interrupting the circuit in some sense—because that is what it would amount to, a singular, unique appearance of an object unlike any other. However, for the communication system and that of the media there is no privileged object. All are substitutable and the work of art has finished up in there, it has been plugged into the same circuit. That does not mean that it may not have an authentic origin, but this will become less and less retrievable through the consumption of media, perhaps on screens but equally the large exhibitions where thousands attend and the crowd itself constitutes a kind of medium; the perception which one has of greatness is even constituted today by a crowd of spectators who are no longer amateurs, lovers of culture, in the traditional sense of the term. We are obliged to take this massive consumption into account. It is not merely the irruption of television or reproducibility, reprography, or things of that ilk. Rather, the irruption of the mass even into aesthetic

consumption changes, in my opinion, the status of the art work. Can we still talk of a "work"? It's becoming something else. It is not exactly a commodity but it passes into the condition of a sign which must be able to circulate like any other. Therefore its own time and place, its uniqueness, is effectively removed.

Thus change of medium—the work becomes image—change of consumption . . .

Yes, the change would perhaps be that while the work of art creates its own space, it invents itself, it takes its inspiration from itself, it has a quite unique reality, it becomes itself an object on the screen, it is transmitted by the screen. The change is perhaps this. One passes from what was a stage, the stage of the work, the stage of the theater, the stage of representation, even the stage of politics—one can generalize this phenomenon—to the screen. But the screen has quite another dimension: it is superficial, it only communicates images, not a particular time and place. In the end it makes everything circulate in one space, without depth, where all the objects must be able to follow one after the other without slowing down or stopping the circuit. But the work of art is made for stopping, in the end it is made to interrupt something, to arrest the gaze, to arrest contemplation. If there is an aesthetic pleasure or aesthetic relationship there it must arise from this species of sublime moment which is a moment of immobility, of contemplation, which corresponds also to the moment of creation in the artist. But then for the media none of this works. It is not that which counts. You have to move on in any case. It is a bit like what was being said about the *Mona Lisa* in Japan, with five seconds to look at it.

But if the work of art has fallen, has been banalized like the other products of communication, how is it that we consume so many of them? The state, individuals, businesses . . .

You have answered yourself. Because it's been banalized, so many are consumed, I would say. Because it is reproduced in an indefinite number of examples, it becomes a bit like holograms in the end; it has also cloned itself, in a way. And that is really the principle of consumption; it is as if everything becomes sign and image—in fact, it is more and more necessary for this to happen. There is no limit to consumption. There is a kind of limit to creation, but not to consumption. You enter into an indefinite series, the seriality of things, and then it is imperative for it not to stop. It is rather like the principle of television: the screen must always be filled, the void is not permitted, and as we are somewhat screens ourselves now, transformed into reflecting screens, there must always be images there, so they are filled in by something or other. And then, perhaps, there is the fact that banalization quite simply involves commercialization, entrance into the market, and that strategies of competition, of course, also enter into it, but there is more to it than simple market strategies, a profusion of images is needed. The screen,

the image, the sign, the modern message, the media require profusion, pro-liferation; there must be plenty for everyone. This is not the case for the work of art, of course, which creates a personal, privileged relationship . . .

There you seem to be returning to a kind of nostalgia for the aura . . .

Not exactly. What I have said sounds like that and it is difficult to say it in another way because the discourse brings in an element of nostalgia. But you could conceive of . . . well, many things; of course something has been lost, but Benjamin said this well. In my opinion, Baudelaire before him had a more modern vision of things—the idea of the absolute commodity. If we enter into the era of the commodity, or that of the media, one could say this of us. For him, the modern artist should not try to revalorize, resacralize tra-ditional art or aesthetics, but go further into the commodity. You had to go some way towards the absolute object, the absolute commodity, and he had a lovely formula: the modern artist owes it to himself to give the commodity a heroic status while the bourgeoisie only gives it, in advertising and all that, sentimental status. So when I say that, yes, of course nostalgia is there, the discourse is necessarily ambivalent. There is a background of nostalgia, and it is not possible to say it in another way since we are in discourse and thus still in something not yet entirely mediated, and then I think that it is possi-ble nevertheless to have a vision there, not a more cynical vision, no there is perhaps a new aesthetic as a result of mediation, of disappearance, really. To go further in this direction and to really play the commodity, but at the power of two or the power of ten. To play the media, but in a sense with an almost ironic strategy.

It makes me think of Andy Warhol . . .

Yes, Andy Warhol, for instance. It's not a solution but it is the other road and the spirit, that's not nostalgic, but rather an ultra-radical practice of media-tion. It has its grandiose, but also its sublime, which is nevertheless of the cool sort; it's a cool strategy, while one may suppose that the strategy of the traditional art work was more warm, of another order, really.

And so, in your opinion, what remains of the order of traditional aesthetic or nostalgic creation? There cannot be an avant-garde—more disenchantment is still needed.

There are perhaps two paths. There is perhaps a path which continues the history of art, if I can call it that, where artists like Bacon and all those con-tinue to work as creative individuals. We can't abandon this path, it still ex-ists, but in my view it is true to say that it's no longer exactly contemporary. It is anachronistic in some ways, but wonderful all the same. In my opinion our modern—or postmodern, I don't know—condition is really that of me-diation and it is there that strategies are worked out or, indeed, another des-tiny, where one can talk of the disappearance of art. Art is perhaps in the

process of playing out its own disappearance—in my opinion this is what it has been doing for the last century. The problem posed today is perhaps that we have reached the end of this process and that we are entering a period where art no longer does anything else than stimulate its own disappearance because it has already disappeared in reality, because the media have already carried it off, because the system has. So in my opinion it's difficult to say the game is up. Not exactly, but it is also difficult to think that there still might be a real history for art.

Therefore, instead of resistance do we accept the deed of mediation, banalization and go as far as possible?
Yes, that would seem a less banal strategy, let's say, than that of nostalgia.

So what about you in all this, your own identity?
Well, yes, obviously to say that is still to speak as the subject of a discourse. But I don't think that need be a contradiction, but it is a paradox, surely. Because if the media have done away with it and if the work of art itself is really threatened, so is critical discourse, analytical discourse, just as much. That is to say that my position, to the extent that I make an analysis like this, is also paradoxical, because it no longer normally has any reference itself. It is there on the screen, that's obvious: I am on the screen, you are too, so we are already in another stratosphere and we are really talking, perhaps, there of something which has been lost. But I don't see the possibility of passing to the other side. You have to accept the deed, in my opinion, and then there are ambivalent strategies. There are double strategies.

You mean more experts than mediators?
Yes, but there is perhaps a way of playing with the media, to accept the deed of this system, of this entire integrated circuit and set it in play and perhaps not disrupt it, yet make it reversible—it's possible—and perhaps still to obtain some critical results, or sublime ones. But you have to take into account that these are fragile strategies.

Difficult therefore to . . . How are you . . . are you an image?
We are in a false situation now, it's true; you have to work within the paradox, the paradox of communication, which is in effect that everywhere there is communication and no one any longer has anything to say to anyone, or almost, while the paradox of language or of the work of art would be that there is something to say but the medium is no longer there. The message is there but the medium no longer responds. Or else in the opposite sense the medium is there, but there is no longer any message. Finally, we will now be in this paradoxical situation perpetually.

Do you think that one can still think?

Because I think it, it must be true. But nothing will be able to prove it any more than one can elaborate a truth outside a system like this. One will have to work with the hyper-reality of this system and enter the sphere of the floating signifier, of floating meaning or non-meaning, with risky strategies, etc. This is what I believe must be done. One must abandon the objective radical position of the subject and of the message.

But economic power relations are determining, all the same?

I myself am in no position to speak about it. I don't think so but it's a bit stupid to say that. As for myself, they are not determining. They are themselves mediated, they themselves pass into another sphere. I no longer believe that there are objective power relations nor objective strategies of this kind. In a way, they themselves have lost their own reality principle. Before, we could have made an infrastructure of it, a determining causality and everything, but today, no, they are entering too into a hyper-real zone where it is all connected with the media, all connected with advertising, etc., and even power relationships, even objective strategies are obliged to do their own advertising, to make their own image before being decrypted or decoded, before taking action. So they no longer have the material force they might have had before, if they ever had any. But perhaps sides have already been taken. Myself, I privilege in analysis things other than the economic, but perhaps that is debatable.

Hakim Bey
The Information War (1995)

In his essay "The Information War" Hakim Bey sees traces of gnosticism in the rhetoric of contemporary culture that places emphasis on information as opposed to bodily experience. By rejecting matter, the Gnostic attempts to reach a spiritual realm beyond the body. In Bey's view "the excessive mediation of the Social, which is carried out through the machinery of the Media . . . serves a religious or priestly role, appearing to offer us a way out of the body by redefining spirit as information." The emphasis on abstract thinking as opposed to physical experiences, which is a primary feature of an "information age," is most evident in highly developed countries where densely built environments, white-collar jobs, and leisure spent engrossed in media is the norm. Bey's intent is not to demonize information but to begin to use the body as the point of reference for the establishment of a system of

values concerning information. Looking back on the artists discussed in this chapter, alienation from the body is one of the principal undercurrents in the art of the 1990s. Whether in the sculptural work of Kiki Smith and Charles Ray or in the video work of Gary Hill and Bill Viola, the human body has reestablished itself in the center of artistic practice.

Humanity has always invested heavily in any scheme that offers escape from the body. And why not? Material reality is such a mess. Some of the earliest "religious" artifacts, such as Neanderthal ochre burials, already suggest a belief in immortality. All modern (i.e., postpaleolithic) religions contain the "Gnostic trace" of distrust or even outright hostility to the body and the "created" world. Contemporary "primitive" tribes and even peasant-pagans have a concept of immortality and of going-outside-the-body (ecstasy) without necessarily exhibiting excessive body hatred. The Gnostic trace accumulates very gradually (like mercury poisoning) until eventually it turns pathological. Gnostic dualism exemplifies the extreme position of this disgust by shifting all value from body to "spirit." This idea characterizes what we call "civilization." A similar trajectory can be traced through the phenomenon of "war." Hunter-gatherers practiced (and still practice, as amongst the Yanomamo) a kind of ritualized brawl (think of the Plains Indian custom of "counting coup"). "Real" war is a continuation of religion and economics (i.e., politics) by other means, and thus only begins historically with the priestly invention of "scarcity" in the Neolithic and the emergence of a "warrior caste." (I categorically reject the theory that war is a prolongation of "hunting.") World War II seems to have been the last "real" war. Hyperreal war began in Vietnam with the involvement of television, and recently reached full obscene revelation in the Gulf War of 1991. Hyperreal war is no longer "economic," no longer "the health of the state." The Ritual brawl is voluntary and nonhierarchic (war chiefs are always temporary); real war is compulsory and hierarchic; hyperreal war is imagistic and psychologically interiorized ("pure war"). In the first, the body is risked; in the second, the body is sacrificed; in the third, the body has disappeared. (See P. Clastres on war, in *Archaeology of Violence*.) Modern science also incorporates an antimaterialist bias, the dialectical outcome of its war against Religion—it has in some sense become Religion. Science as knowledge of material reality periodically decomposes the materiality of the real. Science has always been a species of priestcraft, a branch of cosmology, and an ideology, a justification of "the way things are." The deconstruction of the real in postclassical physics mirrors the vacuum of unreality which constitutes "the state." Once the image of Heaven on Earth, the state now consists of no more than the management of images. It is no longer a force but a disembodied patterning of information. But just as Babylonian cosmology justified Babylonian power, so too does the "finality" of modern science serve the ends of the Terminal State, the postnuclear state, the "information state." Or so the New Paradigm would have it.

And "everyone" accepts the axiomatic premises of the New Paradigm. The New Paradigm is very spiritual.

Even the New Age with its gnostic tendencies embraces the New Science and its increasing etherealization as a source of proof-texts for its spiritualist world view. Meditation and cybernetics go hand in hand. Of course the information state somehow requires the support of a police force and prison system that would have stunned Nebuchadnezzar and reduced all the priests of Moloch to paroxysms of awe. And modern science still can't weasel out of its complicity in the very-nearly-successful conquest of Nature. Civilization's greatest triumph over the body.

But who cares? It's all relative isn't it? I guess we'll just have to "evolve" beyond the body. Maybe we can do it in a "quantum leap." Meanwhile the excessive mediation of the Social, which is carried out through the machinery of the Media, increases the intensity of our alienation from the body by fixating the flow of attention on information rather than direct experience. In this sense the Media serves a religious or priestly role, appearing to offer us a way out of the body by redefining spirit as information. The essence of information is the Image, the sacral and iconic data complex which usurps the primacy of the "material bodily principle" as the vehicle of incarnation, replacing it with a fleshless ecstasis beyond corruption. Consciousness becomes something which can be down loaded, excised from the matrix of animality and immortalized as information. No longer "ghost-in-the-machine," but machine-as-ghost, machine as Holy Ghost, ultimate mediator, which will translate us from our mayfly-corpses to a pleroma of Light. Virtual reality as CyberGnosis. Jack in, leave Mother Earth behind forever. All science proposes a paradigmatic universalism—as in science, so in the social. Classical physics played midwife to capitalism, communism, fascism, and other modern ideologies.

Postclassical science also proposes a set of ideas meant to be applied to the social: relativity, quantum "unreality," cybernetics, information theory, etc. With some exceptions, the postclassical tendency is towards ever greater etherealization. Some proponents of Black Hole theory, for example, talk like pure Pauline theologians, while some of the information theorists are beginning to sound like virtual Manichaeans.[1] On the level of the social these paradigms give rise to a rhetoric of bodylessness quite worthy of a third-century desert monk or a seventeenth-century New England Puritan—but expressed in a language of postindustrial, postmodern feel-good consumer frenzy. Our every conversation is infected with certain paradigmatic assumptions which are really no more than bald assertions, but which we take for the very fabric or *Urgrund* of reality itself. For instance, since we now assume that computers represent a real step toward artificial intelligence, we also assume that buying a computer makes us more intelligent. In my own field I've met dozens of writers who sincerely believe that owning a PC has made them better (not "more efficient," but better) writers. This is amusing—but the same feeling

about computers when applied to a trillion dollar military budget churns out Star Wars, killer robots, etc. (See Manuel de Landa's *War in the Age of Intelligent Machines* on AI in modern weaponry.) An important part of this rhetoric involves the concept of an "information economy." The post-Industrial world is now thought to be giving birth to this new economy. One of the clearest examples of the concept can be found in a recent book by Bishop Hoeller, a man who is a libertarian, the bishop of a Gnostic Dualist Church in California and a learned and respected writer for *Gnosis* magazine:

> The industry of the past phase of civilization (sometimes called "low technology") was big industry, and bigness always implies oppressiveness. The new high technology, however, is not big in the same way. While the old technology produced and distributed material resources, the new technology produces and disseminates information. The resources marketed in high technology are less about matter and more about mind. Under the impact of high technology, the world is moving increasingly from a physical economy into what might be called a "metaphysical economy." We are in the process of recognizing that consciousness rather than raw materials or physical resources constitutes wealth.[2]

Modern neo-Gnosticism usually plays down the old Manichaean attack on the body for a gentler greener rhetoric. Bishop Hoeller for instance stresses the importance of ecology and environment (because we don't want to "foul our nest," the Earth)—but in his chapter on Native American spirituality he implies that a cult of the Earth is clearly inferior to the pure Gnostic spirit of bodylessness:

> But we must not forget that the nest is not the same as the bird. The exoteric and esoteric traditions declare that earth is not the only home for human beings, that we did not grow like weeds from the soil. While our bodies indeed may have originated on this earth, our inner essence did not. To think otherwise puts us outside of all of the known spiritual traditions and separates us from the wisdom of the seers and sages of every age. Though wise in their own ways, Native Americans have small connection with this rich spiritual heritage.[3]

In such terms (the body = the "savage"), the Bishop's hatred and disdain for the flesh illuminate every page of his book. In his enthusiasm for a truly religious economy, he forgets that one cannot eat "information." "Real wealth" can never become immaterial until humanity achieves the final etherealization of downloaded consciousness. Information in the form of culture can be called wealth metaphorically because it is useful and desirable—but it can never be wealth in precisely the same basic way that oysters and cream, or wheat and water, are wealth in themselves. Information is always only information about some thing. Like money, information is not the thing itself. Over time we can come to think of money as wealth (as in a

delightful Taoist ritual which refers to "Water and Money" as the two most vital principles in the universe), but in truth this is sloppy abstract thinking. It has allowed its focus of attention to wander from the bun to the penny which symbolizes the bun.[4] In effect we've had an information economy ever since we invented money. But we still haven't learned to digest copper. The Aesopian crudity of these truisms embarrasses me, but I must perforce play the stupid lazy yokel plowing a crooked furrow when all the straight thinkers around me appear to be hallucinating.

Americans and other "First World" types seem particularly susceptible to the rhetoric of a "metaphysical economy" because we can no longer see (or feel or smell) around us very much evidence of a physical world. Our architecture has become symbolic, we have enclosed ourselves in the manifestations of abstract thought (cars, apartments, offices, schools), we work at "service" or information-related jobs, helping in our little way to move disembodied symbols of wealth around an abstract grid of Capital, and we spend our leisure largely engrossed in Media rather than in direct experience of material reality. The material world for us has come to symbolize catastrophe, as in our amazingly hysterical reaction to storms and hurricanes (proof that we've failed to "conquer Nature" entirely), or our neo-Puritan fear of sexual otherness, or our taste for bland and denatured (almost abstract) food. And yet, this "First World" economy is not self-sufficient. It depends for its position (top of the pyramid) on a vast substructure of old-fashioned material production. Mexican farmworkers grow and package all that Natural food for us so we can devote our time to stocks, insurance, law, computers, video games. Peons in Taiwan make silicon chips for our PCs. "Towel-heads" in the Middle East suffer and die for our sins. Life? Oh, our servants do that for us. We have no life, only "lifestyle"—an abstraction of life, based on the sacred symbolism of the Commodity, mediated by the priesthood of the stars, those larger-than-life abstractions who rule our values and people our dreams—the media-archetypes; or perhaps "mediarchs" would be a better term. Of course this Baudrillardian dystopia doesn't really exist—yet.[5] It's surprising, however, to note how many social radicals consider it a desirable goal, at least as long as it's called the "information revolution" or something equally inspiring. Leftists talk about seizing the means of information-production from the data monopolists.[6] In truth, information is everywhere—even atom bombs can be constructed on plans available in public libraries. As Noam Chomsky points out, one can always access information—provided one has a private income and a fanaticism bordering on insanity. Universities and "think tanks" make pathetic attempts to monopolize information—they, too, are dazzled by the notion of an information economy—but their conspiracies are laughable. Information may not always be "free," but there's a great deal more of it available than any one person could ever possibly use. Books on every conceivable subject can actually still be found through interlibrary loan.[7] Meanwhile someone still has to grow

pears and cobble shoes. Or, even if these "industries" can be completely mechanized, someone still has to eat pears and wear shoes. The body is still the basis of wealth. The idea of Images as wealth is a "spectacular delusion." Even a radical critique of information can still give rise to an overvaluation of abstraction and data. In a *prositu* zine from England called *NO*, the following message was scrawled messily across the back cover of a recent issue:

> As you read these words, the Information Age explodes . . . inside and around you—with the Misinformation Missiles and Propaganda bombs of outright Information Warfare.
> Traditionally, war has been fought for territory/economic gain. Information Wars are fought for the acquisition of territory indigenous to the Information Age, i.e., the human mind itself. . . . In particular, it is the faculty of the imagination that is under the direct threat of extinction from the onslaughts of multi-media overload . . . DANGER—YOUR IMAGINATION MAY NOT BE YOUR OWN. . . . As a culture sophisticates, it deepens its reliance on its images, icons and symbols as a way of defining itself and communicating with other cultures. As the accumulating mix of a culture's images floats around in its collective psyche, certain isomorphic icons coalesce to produce and to project an "illusion" of reality. Fads, fashions, artistic trends. U KNOW THE SCORE. "I can take their images for reality because I believe in the reality of their images (their image of reality)." WHOEVER CONTROLS THE METAPHOR GOVERNS THE MIND. The conditions of total saturation are slowly being realized—a creeping paralysis—from the trivialization of special/technical knowledge to the specialization of trivia. The INFORMATION WAR is a war we cannot afford to lose. The result is unimaginable.[8]

I find myself very much in sympathy with the author's critique of media here, yet I also feel that a demonization of "information" has been proposed which consists of nothing more than the mirror image of information-as-salvation. Again Baudrillard's vision of the Commtech Universe is evoked, but this time as Hell rather than as the Gnostic Hereafter. Bishop Hoeller wants everybody jacked-in and downloaded and the anonymous post-situationist ranter wants you to smash your telly, but both of them believe in the mystic power of information. One proposes the pax technologica, the other declares war. Both exude a kind of Manichaean view of Good and Evil, but can't agree on which is which. The critical theorist swims in a sea of facts. We like to imagine it also as our Maquis, with ourselves as the "guerilla ontologists" of its datascape. Since the nineteenth century the evermutating "social sciences" have unearthed a vast hoard of information on everything from shamanism to semiotics. Each "discovery" feeds back into social science and changes it. We drift. We fish for poetic facts, data which will intensify and mutate our experience of the real. We invent new hybrid "sciences" as tools for this process: ethnopharmacology, ethnohistory, cognitive studies, history of ideas, subjective anthropology (anthropological poetics or ethno-poetics),

dada epistemology, etc. We look on all this knowledge not as "good" in itself, but valuable only inasmuch as it helps us to seize or to construct our own happiness. In this sense we do know of "information as wealth"; nevertheless, we continue to desire wealth itself and not merely its abstract representation as information. At the same time we also know of "information as war";[9] nevertheless, we have not decided to embrace ignorance just because "facts" can be used like a poison gas. Ignorance is not even an adequate defense, much less a useful weapon in this war. We attempt neither to fetishize nor to demonize information. Instead we try to establish a set of values by which information can be measured and assessed. Our standard in this process can only be the body. According to certain mystics, spirit and body are "one." Certainly spirit has lost its ontological solidity (since Nietzsche, anyway) while body's claim to "reality" has been undermined by modern science to the point of vanishing in a cloud of "pure energy." So why not assume that spirit and body are one, after all, and that they are twin (or dyadic) aspects of the same underlying and inexpressible real? No body without spirit, no spirit without body. The Gnostic Dualists are wrong, as are the vulgar dialectical materialists. Body and spirit together make life. If either pole is missing, the result is death. This constitutes a fairly simple set of values, assuming we prefer life to death. Obviously I'm avoiding any strict definitions of either body or spirit. I'm speaking of "empirical" everyday experiences. We experience "spirit" when we dream or create; we experience "body" when we eat or shit (or maybe vice versa); we experience both at once when we make love. I'm not proposing metaphysical categories here. We're still drifting and these are ad hoc points of reference, nothing more. We needn't be mystics to propose this version of "one reality." We need only point out that no other reality has yet appeared within the context of our knowable experience. For all practical purposes, the "world" is "one."[10] Historically however, the body half of this unity has always received the insults, bad press, scriptural condemnation, and economic persecution of the spirit half. The self-appointed representatives of the spirit have called almost all the tunes in known history, leaving the body only a prehistory of primitive disappearance, and a few spasms of failed insurrectionary futility.

Spirit has ruled—hence we scarcely even know how to speak the language of the body. When we use the word information we reify it because we have always reified abstractions—ever since God appeared as a burning bush. (Information as the catastrophic decorporealization of "brute" matter.) We would now like to propose the identification of self with body. We're not denying that the body is also spirit, but we wish to restore some balance to the historical equation. We calculate all body hatred and world slander as our evil. We insist on the revival (and mutation) of "pagan" values concerning the relation of body and spirit. We fail to feel any great enthusiasm for the information economy because we see it as yet another mask for body hatred. We can't quite believe in the information war, since it also hypostatizes

information but labels it "evil." In this sense, "information" would appear to be neutral. But we also distrust this third position as a lukewarm cop-out and a failure of theoretical vision. Every "fact" takes different meanings as we run it through our dialectical prism[11] and study its gleam and shadows. The fact is never inert or neutral, but it can be both good and evil (or beyond them) in countless variations and combinations. We, finally, are the artists of this immeasurable discourse. We create values. We do this because we are alive. Information is as big a mess as the material world it reflects and transforms. We embrace the mess, all of it. It's all life. But within the vast chaos of the alive, certain information and certain material things begin to coalesce into a poetics or a way-of-knowing or a way-of-acting. We can draw certain pro tem conclusions, as long as we don't plaster them over and set them up on altars. Neither information nor indeed any one "fact" constitutes a thing-in-itself. The very word *information* implies an ideology, or rather a paradigm, rooted in unconscious fear of the silence of matter and of the universe. Information is a substitute for certainty, a left over fetish of dogmatics, a *super-stitio*, a spook. "Poetic facts" are not assimilable into the doctrine of information. "Knowledge is freedom" is true only when freedom is understood as a psycho-kinetic skill. Information is a chaos; knowledge is the spontaneous ordering of that chaos; freedom is the surfing of the wave of that spontaneity. These tentative conclusions constitute the shifting and marshy ground of our "theory." The TAZ wants all information and all bodily pleasure in a great complex confusion of sweet data and sweet dates—facts and feasts—wisdom and wealth. This is our economy—and our war.

NOTES

1. The new "life" sciences offer some dialectical opposition here, or could do so if they worked through certain paradigms. Chaos theory seems to deal with the material world in positive ways, as does Gaia theory, morphogenetic theory, and various other "soft" and "neohermetic" disciplines. Elsewhere I've attempted to incorporate these philosophical implications into a "festal" synthesis. The point is not to abandon all thought about the material world, but to realize that all science has philosophical and political implications, and that science is a way of thinking, not a dogmatic structure of incontrovertible Truth. Of course quantum, relativity, and information theory are all "true" in some way and can be given a positive interpretation. I've already done that in several essays. Now I want to explore the negative aspects.

2. Stephan A. Hoeller, *Freedom: Alchemy for a Voluntary Society* (Wheaton, IL: Quest, 1992), pp. 229–230.

3. Hoeller, *Freedom: Alchemy for a Voluntary Society:* 164

4. Like Pavlov's dogs salivating at the dinner bell rather than the dinner—a perfect illustration of what I mean by "abstraction."

5. Although some might say that it already "virtually" exists. I just heard from a friend in California of a new scheme for "universal prisons"—offenders will be allowed to live at home and go to work but will be electronically monitored at all times, like Winston Smith in *1984*. The universal panopticon now potentially coincides one-to-one with the whole of reality; life and work will take the place of outdated physical incarceration—the Prison Society will merge with "electronic democracy" to form a Surveillance State or information totality, with all time and space compacted beneath the unsleeping gaze of RoboCop. On the level of pure tech, at least, it would seem that we have at last arrived at "the future." "Honest citizens" of course will have nothing to fear; hence terror will reign unchallenged and Order will triumph like the Universal Ice. Our only hope may lie in the "chaotic perturbation" of massively linked computers, and in the venal stupidity or boredom of those who program and monitor the system.

6. I will always remember with pleasure being addressed, by a Bulgarian delegate to a conference I once attended, as a "fellow worker in philosophy." Perhaps the capitalist version would be "entrepreneur in philosophy," as if one bought ideas like apples at roadside stands.

7. Of course information may sometimes be "occult," as in conspiracy theory. Information may be "disinformation." Spies and propagandists make up a kind of shadow information economy, to be sure. Hackers who believe in freedom of information have my sympathy, especially since they've been picked as the latest enemies of the Spectacular State, and subjected to its spasms of control-by-terror. But hackers have yet to "liberate" a single bit of information useful in our struggle. Their impotence, and their fascination with Imagery, make them ideal victims of the Information State, which itself is based on pure simulation. One needn't steal data from the post-military-industrial complex to know, in general, what it's up to. We understand enough to form our critique. More information by itself will never take the place of the actions we have failed to carry out; data by itself will never reach critical mass. Despite my loving debt to thinkers like Robert Anton Wilson and T. Leary I cannot agree with their optimistic analysis of the cognitive function of information technology. It is not the neural system alone which will achieve autonomy, but the entire body.

8. "Nothing Is True," *NO* 6, Box 175, Liverpool L69 8DX, UK.

9. Indeed, the whole "poetic terrorism" project has been proposed only as a strategy in this very war.

10. "The 'world' is 'one'" can be and has been used to justify a totality, a metaphysical ordering of "reality" with a "center" or "apex": one god, one king, etc., etc. This is the monism of orthodoxy, which naturally opposes Dualism and its other source of power (evil)—orthodoxy also presupposes that the one occupies a higher ontological position than the many, that transcendence takes precedence over immanence. What I call radical (or heretical) monism demands unity of one and many on the level of immanence; hence it is seen by orthodoxy as a turning-upside-down, or saturnalia, which proposes that every one is equally divine. Radical monism is "on the side of" the many—which explains why it seems to lie at the heart of pagan polytheism and shamanism, as well as extreme forms of monotheism such as Ismailism or Ranterism, based on

"inner light" teachings. "All is one," therefore, can be spoken by any kind of monist or anti-dualist and can mean many different things.

11. A proposal: the new theory of Taoist dialectics. Think of the yin/yang disk, with a spot of black in the white lozenge, and vice versa—separated not by a straight line but an s-curve. Amiri Baraka says that dialectics is just "separating out the good from the bad"—but the Taoist is "beyond good and evil." The dialectic is supple, but the Taoist dialectic is downright sinuous. For example, making use of the Taoist dialectic, we can reevaluate Gnosis once again. True, it presents a negative view of the body and of becoming. But also true that it has played the role of the eternal rebel against all orthodoxy, and this makes it interesting. In its libertine and revolutionary manifestations, the Gnosis possesses many secrets, some of which are actually worth knowing. The organizational forms of Gnosis— the crackpot cult, the secret society—seem pregnant with possibilities for the TAZ/Immediatist project. Of course, as I've pointed out elsewhere, not all Gnosis is dualistic. There also exists a monist Gnostic tradition, which sometimes borrows heavily from Dualism and is often confused with it. Monist Gnosis is anti-eschatological, using religious language to describe this world, not Heaven or the Gnostic Pleroma. Shamanism, certain "crazy" forms of Taoism and Tantra and Zen, heterodox sufism and Ismailism, Christian antinomians such as the Ranters, etc.—share a conviction of the holiness of the "inner spirit," and of the actually real, the world. These are our spiritual ancestors.

Bibliography

Alloway, Lawrence. *American Pop Art*. New York: Collier Books, 1974.

Armstrong, Elizabeth, and Joan Rothfuss. *In the Spirit of Fluxus*. Minneapolis: Walker Art Center, 1993.

Auslander, Philip. *Democracy's Body: Judson Dance Theater, 1962–1964*. Ann Arbor, MI: UMI Research Press, 1983.

Battcock, Gregory, ed. *Idea Art*. New York: E. P. Dutton, 1973.

Battcock, Gregory, ed. *Minimal Art: A Critical Anthology*. Reprt. Berkeley: University of California Press, 1995.

Battcock, Gregory, ed. *The New Art*. New York: E. P. Dutton, 1966.

Battcock, Gregory, and Robert Nickas, eds. *The Art of Performance: A Critical Anthology*. New York: E. P. Dutton, 1984.

Baudrillard, Jean. *Jean Baudrillard: Selected Writings*. Mark Poster, ed. Stanford: Stanford University Press, 1988.

Beardsley, John. *Probing the Earth: Contemporary Land Projects*. Washington, DC: Hirshhorn Museum and Sculpture Garden, Smithsonian Institution, 1977.

Benjamin, Walter. *Illuminations*. Harry Zohn, trans. New York: Harcourt, Brace and World, 1968.

Berman, Marshall. *All That Is Solid Melts into Air: The Experience of Modernity*. New York: Simon and Schuster, 1982.

Blurring the Boundaries: Installation Art 1969–1996. San Diego, CA: Museum of Contemporary Art, 1997.

Cage, John. *Silence*. Cambridge, MA: MIT Press, 1966.

Chicago, Judy. *Through the Flower: My Struggle as a Woman Artist*. Introduction by Anaïs Nin. Garden City, NY: Doubleday & Company, 1975.

Chomsky, Noam. *Language and Politics*. C. P. Otera, ed. Montréal, QU and Cheektowaga, NY: Blackrose Books, 1988.

Clearwater, Bonnie, ed. *Defining the Nineties: Consensus-Making in New York, Miami, and Los Angeles*. North Miami, FL: Museum of Contemporary Art, 1966.

Crane, Diana. *The Transformation of the Avant-Garde: The New York Art World, 1940–1985*. Chicago: University of Chicago Press, 1987.

Crimp, Douglas. *Pictures*. New York: Artists Space, 1977.

Crow, Thomas, Yve-Alain Bois, Elisabeth Sussman, David Joselit, Hal Foster, and Bob Riley. *Endgame: Reference and Simulation in Recent Painting and Sculpture*. Boston: The Institute of Contemporary Art, 1986.

The Decade Show: Frameworks of Identity in the 1980s. New York: Museum of Contemporary Hispanic Art/The Studio Museum in Harlem, 1990.

Ferguson, Russell, et al., eds. *Out There: Marginalization and Contemporary Cultures*. New York: The New Museum of Contemporary Art; Cambridge, MA: MIT Press, 1990.

Ferlinghetti, Lawrence. *A Coney Island of the Mind*. Norfolk, CT: New Directions, 1955.

Fineberg, Jonathan. *Art Since 1940: Strategies of Being*, 2d ed. Upper Saddle River, NJ: Prentice Hall, 2000.

Foster, Hal, ed. *The Anti-Aesthetic: Essays on Postmodern Culture*. Port Townsend, WA: Bay Press, 1983.

Foster, Hal. *Recoding: Art, Spectacle, Cultural Politics.* Seattle, WA: Bay Press, 1985.

Frascina, Francis, and Jonathan Harris, eds. *Art in Modern Culture: An Anthology of Critical Texts.* New York: Icon Editions/HarperCollins Publishers, 1992.

Frascina, Francis, and Charles Harrison, eds. *Modern Art and Modernism: A Critical Anthology.* New York: Harper & Row, 1982.

Frascina, Francis, et al. *Modernism in Dispute: Art Since the Forties.* New Haven, CT: Yale University Press in association with The Open University, 1993.

Gablik, Suzi. *Has Modernism Failed?* New York: Cambridge University Press, 1995.

Geldzahler, Henry. *New York Painting and Sculpture: 1940–1970.* New York: The Metropolitan Museum of Art, 1969.

Ginsberg, Allen. *Howl and Other Poems.* San Francisco: City Lights Books, 1956.

Godfrey, Tony. *The New Image: Painting in the 1980s.* New York: Abbeville, 1986.

Goldstein, Ann, and Mary Jane Jacobs. *A Forest of Signs: Art in the Crisis of Representation.* Los Angeles: Museum of Contemporary Art, 1989; Cambridge, MA: MIT Press, 1989.

Greenberg, Clement. *The Collected Essays and Criticism, Vol. 1: Perceptions and Judgements, 1939–1944.* Chicago: University of Chicago Press, 1986.

Greenberg, Clement. *The Collected Essays and Criticism, Vol. 2: Arrogant Purpose, 1945–1949.* Chicago: University of Chicago Press, 1986.

Guilbaut, Serge. *How New York Stole the Idea of Modern Art.* Chicago: University of Chicago Press, 1983.

Happenings & Fluxus. Koeln: Koelnischer Kunstverein, 1971.

Harrison, Charles, and Paul Wood. *Art in Theory: 1900–1990.* Oxford: Blackwell Publishers, 1992.

Haskell, Barbara. *Blam! The Explosion of Pop, Minimalism, and Performance, 1958–1964.* New York: Whitney Museum of American Art, 1984.

Heartney, Eleanor. *Critical Condition: American Culture at the Crossroads.* New York: Cambridge University Press, 1987.

Heiferman, Marvin, and Lisa Phillips. *Image World: Art and Media Culture.* New York: Whitney Museum of American Art, 1989.

Hertz, Richard, ed. *Theories of Contemporary Art.* Englewood Cliffs, NJ: Prentice Hall, 1985.

Hess, Thomas B., and Elizabeth C. Baker, eds. *Art and Sexual Politics: Women's Liberation, Women Artists, and Art History* (1973). Reprt. New York: Collier Books, 1975.

hooks, bell. *Art on My Mind: Visual Politics.* New York: New Press, 1995.

Hughes, Robert. *American Visions: The Epic History of Art in America.* New York: Alfred A. Knopf, 1997.

Huyssen, Andreas. *After the Great Divide: Modernism, Mass Culture, Postmodernism.* Bloomington: Indiana University Press, 1986.

Irwin, Robert. *Robert Irwin.* New York: Whitney Museum of American Art, 1977.

Joachimides, Christos M., Norman Rosenthal, and Nicholas Serots, eds. *A New Spirit in Painting.* Berlin: Martin-Gropius-Bau, 1982.

Johnson, Ellen. *American Artists on Art.* New York: Harper & Row, 1982.

Judd, Donald. *Complete Writings, 1959–75.* Halifax: The Press of the Nova Scotia College of Art and Design; New York: New York University Press, 1975.

Kaprow, Allan. *Assemblage, Environments, and Happenings.* New York: Harry N. Abrams, 1966.

Kaprow, Allan. *Essays on the Blurring of Art and Life.* Berkeley: University of California Press, 1993.

Kardon, Janet. *The East Village Scene.* Philadelphia: Institute of Contemporary Art, University of Pennsylvania, 1984.

Kingsley, April. *The Turning Point: The Abstract Expressionists and the Transformation of American Art.* New York: Simon and Schuster, 1992.

Kirsch, Andrea, and Susan Fisher Sterling. *Carrie Mae Weems.* Washington, DC: National Museum of Women in the Arts, 1993.

Kramer, Hilton. *The Revenge of the Philistines: Art and Culture, 1972–1984.* New York: Free Press, 1985.

Krauss, Rosalind E. *The Originality of the Avant-Garde and Other Modernist Myths* (1985). Reprt. Cambridge, MA: MIT Press, 1994.

Krauss, Rosalind E. *Passages in Modern Sculpture.* New York: Viking Press, 1977.

Kruger, Barbara. *Remote Control: Power, Cultures, and the World of Appearances.* Boston: MIT Press, 1994.

Levin, Kim. *Beyond Modernism: Essays on Art from the '70s and '80s.* New York: Icon Editions/Harper & Row, 1988.

Lippard, Lucy R. *Changing: Essays in Art Criticism.* New York: E. P. Dutton, 1971.

Lippard, Lucy R. *Eva Hesse.* New York: New York University Press, 1976.

Lippard, Lucy R. *From the Center: Feminist Essays on Women's Art.* New York: E. P. Dutton, 1976.

Lippard, Lucy R. *Mixed Blessings: New York in a Multicultural America.* New York: Pantheon, 1990.

Lippard, Lucy R. *Overlay: Contemporary Art and the Art of Prehistory.* New York: Pantheon Books, 1983.

Lippard, Lucy R. *Six Years: The Dematerialization of the Art Object from 1966 to 1972: A Cross-Reference Book of Information on Some Esthetic Boundaries.* New York: Praeger, 1973.

Marshall, Richard. *New Image Painting.* New York: Whitney Museum of American Art, 1978.

McEvilley, Thomas, and Lisa Phillips. *Julian Schnabel: Paintings 1975–1987.* London: Whitechapel Art Gallery; New York: Whitney Museum of American Art, 1987.

McHarg, Ian. *Design with Nature.* New York: Doubleday/Natural History Press, 1971.

McLuhan, Marshall. *Understanding Media: The Extension of Man.* New York: McGraw-Hill, 1965.

McShine, Kynaston. *Information.* New York: Museum of Modern Art, 1970.

McShine, Kynaston. *Primary Structures: Younger American and British Sculptors.* New York: The Jewish Museum, 1966.

Meyer, Ursula. *Conceptual Art.* New York: E. P. Dutton, 1972.

Monte, James, and Marcia Tucker. *Anti-Illusion: Procedures/Materials.* New York: Whitney Museum of American Art, 1969.

Morgan, Robert C., ed. *Gary Hill. (Art and Performance.)* Baltimore and London: The Johns Hopkins University Press, 2000.

The New American Painting: As Shown in Eight European Countries 1958–1959. New York: The Museum of Modern Art, 1959.

Nochlin, Linda. *Women, Art, and Power and Other Essays.* New York: Icon Editions/Harper & Row, 1988.

Oldenburg, Claes, and Emmet Williams. *Store Days.* New York: Something Else Press, 1967.

Pincus-Witten, Robert. *Postminimalism.* New York: Out of London Press, 1977.

Piper, Adrian. *Out of Order, Out of Sight, Vol. 1: Selected Writings in Meta-Art, 1968–1992; Vol. 2: Selected Writings in Art Criticism, 1967–1992.* Cambridge, MA: MIT Press, 1996.

Plagens, Peter. *Sunshine Muse: Contemporary Art on the West Coast.* New York: Praeger, 1974.

Poster, Mark, ed. *Jean Baudrillard: Selected Writings.* Stanford, CA: Stanford University Press, 1988.

Postman, Neil. *Amusing Ourselves to Death: Public Discourse in the Age of Show Business.* New York: Penguin Books, 1986.

Reiss, Julie H. *From Margin to Center: The Spaces of Installation Art.* Boston: MIT Press, 2000.

Rosenberg, Harold. *The Anxious Object: Art Today and Its Audience.* New York: Horizon Press, 1966.

Rosenberg, Harold. *De-Definition of Art.* New York: Collier Books, 1972.

Sandler, Irving. *The Triumph of American Painting: A History of Abstract Expressionism.* New York and Washington, DC: Praeger Publishers, 1970.

Schimmel, Paul. *Helter Skelter: L.A. Art in the 1990s.* Los Angeles: The Museum of Contemporary Art, 1992.

Schjeldahl, Peter. *The Hydrogen Jukebox: Selected Writings of Peter Schjeldahl, 1978–1990.* Introduction by Robert Storr. Berkeley: University of California Press, 1991.

Seitz, William C. *The Art of Assemblage.* New York: The Museum of Modern Art, 1961.

Siegel, Jeanne, ed. *Art Talk: The Early '80s.* New York; DaCapo Press, 1988.

Smithson, Robert. *The Writings of Robert Smithson.* Nancy Holt, ed. New York: New York University Press, 1979.

Sonfist, Alan, ed. *Art in the Land: A Critical Anthology of Environmental Art.* New York: E. P. Dutton, 1983.

Sontag, Susan. *On Photography.* New York: Farrar, Straus and Giroux, 1973.

Steinberg, Leo. *Other Criteria: Confrontations with Twentieth-Century Art.* London, Oxford, New York: Oxford University Press, 1972.

Stiles, Kristine, and Peter Selz, eds. *Theories and Documents of Contemporary Art: A Sourcebook of Artists' Writings.* Berkeley: University of California Press, 1996.

Storr, Robert. *Dislocations.* New York: The Museum of Modern Art, 1991.

Sussman, Elisabeth. *Mike Kelley: Catholic Tastes.* New York: Harry N. Abrams and Whitney Museum of American Art, 1993.

Sussman, Elisabeth, et al. *1993 Biennial Exhibition.* New York: Whitney Museum of American Art, 1993.

Szeeman, Harald. *Live in Your Head: When Attitudes Become Form, Works, Concepts, Processes, Situations, Information.* London: The Institute of Contemporary Arts, 1969.

Tomkins, Calvin. *The Bride and the Bachelors.* New York: Viking, 1968.

Tomkins, Calvin. *Off the Wall: Robert Rauschenberg and the Art World of Our Time.* Garden City, NY: Doubleday, 1980.

Tomkins, Calvin. *Post- to Neo-: The Art World of the 1980s.* New York: Henry Holt and Company, 1988.

Tucker, Marcia. *The Decade Show: Frameworks of Identity in the 1980s.* New York: New Museum of Contemporary Art, Museum of Contemporary Hispanic Art, and Studio Museum in Harlem, 1990.

Varnedoe, Kirk, and Adam Gopnik, eds. *Modern Art and Popular Culture: Readings in High and Low.* New York: The Museum of Modern Art and Harry N. Abrams, 1990.

Wallis, Brian, ed. *Art after Modernism: Rethinking Representation.* Foreword by Marcia Tucker. New York: The New Museum of Contemporary Art; Boston: David R. Godine, 1984.

Wallis, Brian, ed. *Blasted Allegories: An Anthology of Writings by Contemporary Artists.* (Documentary Sources in Contemporary Art, 2.) New York: The New Museum of Contemporary Art; Cambridge, MA: MIT Press, 1987.

Warhol, Andy. *The Philosophy of Andy Warhol (From A to B and Back Again).* New York: Harcourt, Brace, Jovanovich, 1975.

Weschler, Lawrence. *Seeing Is Forgetting the Name of the Thing One Sees . . . Robert Irwin.* Berkeley and Los Angeles: University of California Press, 1982.

West, Cornel. *Keeping Faith: Philosophy and Race in America.* New York, London: Routledge, 1993.

Wojnarowicz, David. *Memories That Smell Like Gasoline.* San Francisco: Artspace Books, 1992.

Wolfe, Tom, and E. W. Johnson, eds. *The New Journalism.* New York: Harper & Row, 1973.

Index